KU-735-658

FRA·ANGELICO T⁰ LEONARDO
ITALIAN·RENAISSANCE
DRAWINGS

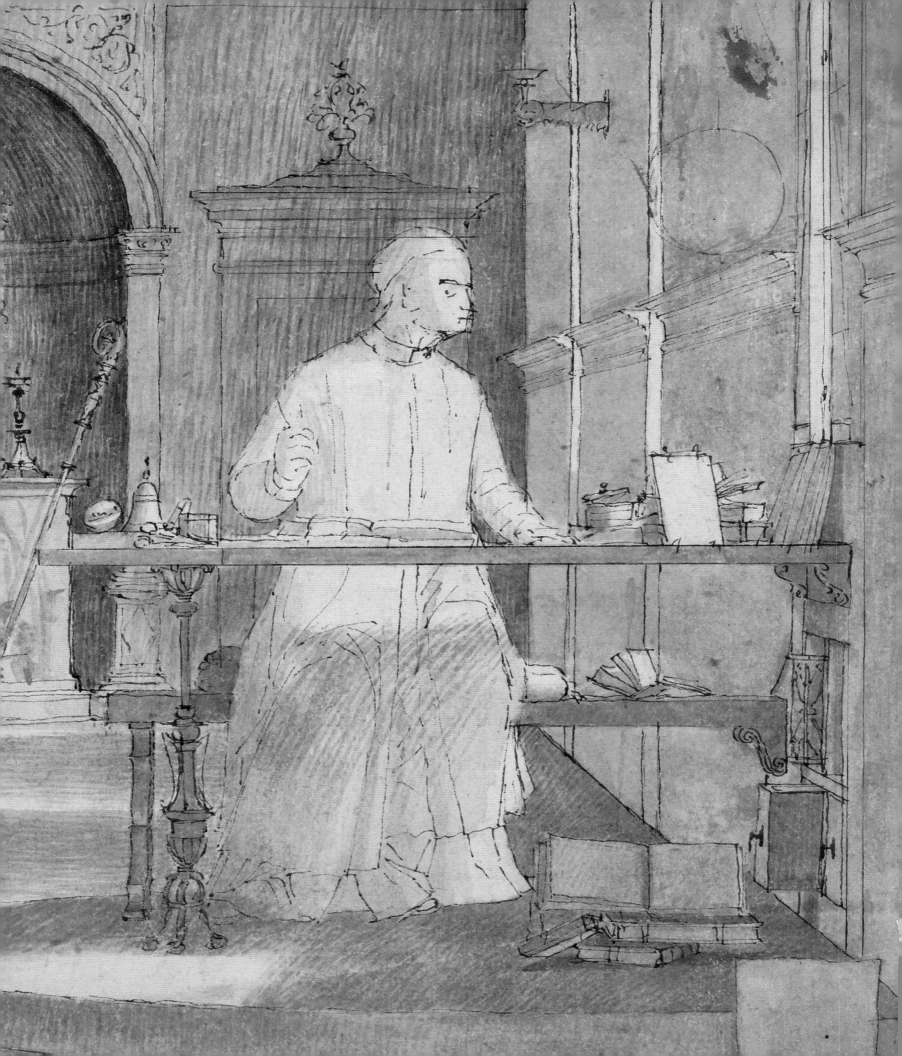

FRA·ANGELICO T̩ LEONARDO
ITALIAN·RENAISSANCE
DRAWINGS

Hugo Chapman and Marzia Faietti

THE BRITISH MUSEUM PRESS

Homo sum, humani nihil a me alienum puto
Terence, Heauton Timoroumenos, v. 77

THE AUTHORS DEDICATE THIS
PUBLICATION TO THEIR FRIEND
AND COLLEAGUE, ANTONY GRIFFITHS.

This book is published to accompany the exhibition
at the British Museum, London
from 22 April to 25 July 2010,
and the Galleria degli Uffizi, Florence
from 1 February to 30 April 2011.

© 2010 The Trustees of the British Museum
Text © 2010 individual contributors

Hugo Chapman and Marzia Faietti have asserted
the right to be identified as the authors of this work.

Text by Italian authors translated and
edited by Daniel Godfrey.

First published in 2010 by the British Museum Press
A division of the British Museum Company Ltd
38 Russell Square, London WC1B 3QQ
www.britishmuseum.org

A catalogue record for this book is
available from the British Library.

ISBN (HARDBACK) 978-07141-2668-5
ISBN (PAPERBACK) 978-07141-2667-8

Designed by Philip Lewis
Printed in Italy by Graphicom SRL, Verona

FRONTISPIECE Detail of no. 80, p. 267
PAGES 12–13 Detail of no. 19, p. 135
PAGES 86–7 Detail of no. 22, p. 141

Papers used in this book are natural, recyclable products made
from wood grown in sustainable forests. The manufacturing
processes conform to the environmental regulations of the
country of origin.

© **Mixed Sources**
Product group from well-managed
forests, controlled sources and
recycled wood or fibre
www.fsc.org Cert no. CQ-COC-000015
© 1996 Forest Stewardship Council
FSC

CONTENTS

SPONSOR'S FOREWORD

BP is delighted to support the BP Special Exhibition, *Fra Angelico to Leonardo: Italian Renaissance drawings*, an exhibition that brings together for the first time 100 graphic masterpieces from the two best collections of Italian Renaissance drawings: the Gabinetto Disegni e Stampe degli Uffizi in Florence and the British Museum in London.

This ground-breaking show charts the development of drawing throughout Italy during a uniquely creative period, featuring works from artists now synonymous with the Renaissance including Raphael, Michelangelo and Leonardo da Vinci.

BP's long-standing partnerships with world-class institutions such as the British Museum enable public access to excellence in arts and culture. Over the past 30 years over 25 million people have attended BP-supported events in the UK.

We hope you enjoy this publication and all that the British Museum has to offer.

TONY HAYWARD
GROUP CHIEF EXECUTIVE, BP

DIRECTORS' FOREWORD

The central place of Italy in the history of European art has always been assured. It is the country where, as Vasari most engagingly asserted, the history of art began and where it remained domiciled for centuries. But throughout most of that time the periods that dominated perceptions were the sixteenth and seventeenth centuries – the years of the High Renaissance and the Baroque. These came to be seen as the central years, and it was works of this period that collectors fought to acquire.

The rise of interest in the culture and paintings of the Italian fifteenth century only became established in the second half of the nineteenth century, and nowhere more strongly than in Britain. Poets such as Robert Browning put the quattrocento at the centre of their imaginative works, and artists such as Edward Burne-Jones based themselves entirely upon it. An entire generation of art lovers in Britain was brought up to admire above all the work of the years from Masaccio (1401–28/9) to the sack of Rome in 1527, which was seen as marking the end of the Renaissance and the beginning of Mannerism. Even today there is a far greater public affection for the works of the fifteenth century than for those of later centuries.

In their passion for the quattrocento, the British placed Florence at the centre of their affections, and it became and has remained the focus of their love for Italy. Herbert Horne and Frederick Stibbert, two English collectors who settled in Florence in the late nineteenth century, left their houses and contents to the city, where they can still be visited. In the British Museum the years from 1883 to 1912 were those of the Keepership of Sir Sidney Colvin in the Department of Prints and Drawings. He was a force in British culture of the time: his closest friends were writers and artists, and it was he who built up the Museum's collection of drawings. Inevitably (as it now seems) it was the Italian Renaissance that preoccupied him, and any drawing or engraving of this period was automatically preferred to any other. Since there were many opportunities on the market then, he was very successful, and he established a tradition of expertise in this field that led to the pioneering catalogue of A. E. Popham and Philip Pouncey in 1950.

Italians had no such need to discover the art of their own country; they lived with it. But the Medici in Florence were great collectors as well as great patrons of artists, and by the end of the seventeenth century had already assembled with the aid of the best historians of the period the astonishing wealth of Italian drawings that is now in the Uffizi. Thus two different routes, both described more fully in the essays in this catalogue, led to the establishment of what are recognized as the two greatest collections of Italian quattrocento drawings in the world.

So the project to combine the two collections, by selecting 50 of the most important drawings from each, and showing them in both cities, is a dream come true for all lovers of the Italian Renaissance. That this has come about is the result of the close collaboration and friendship of colleagues in the two cities: Marzia Faietti and Giorgio Marini in Florence, and Antony Griffiths and Hugo Chapman in London. They have been supported by a team of assistants, and the occasion has been used to launch a pioneering project to study the drawings using new technology.

No exhibition can be put on without the support of sponsors, and we thank BP for its munificent help with this exhibition.

Neil MacGregor
Director
The British Museum

Cristina Acidini
Soprintendente per il Patrimonio Storico, Artistico ed
Etnoantropologico e per il Polo Museale della città di Firenze

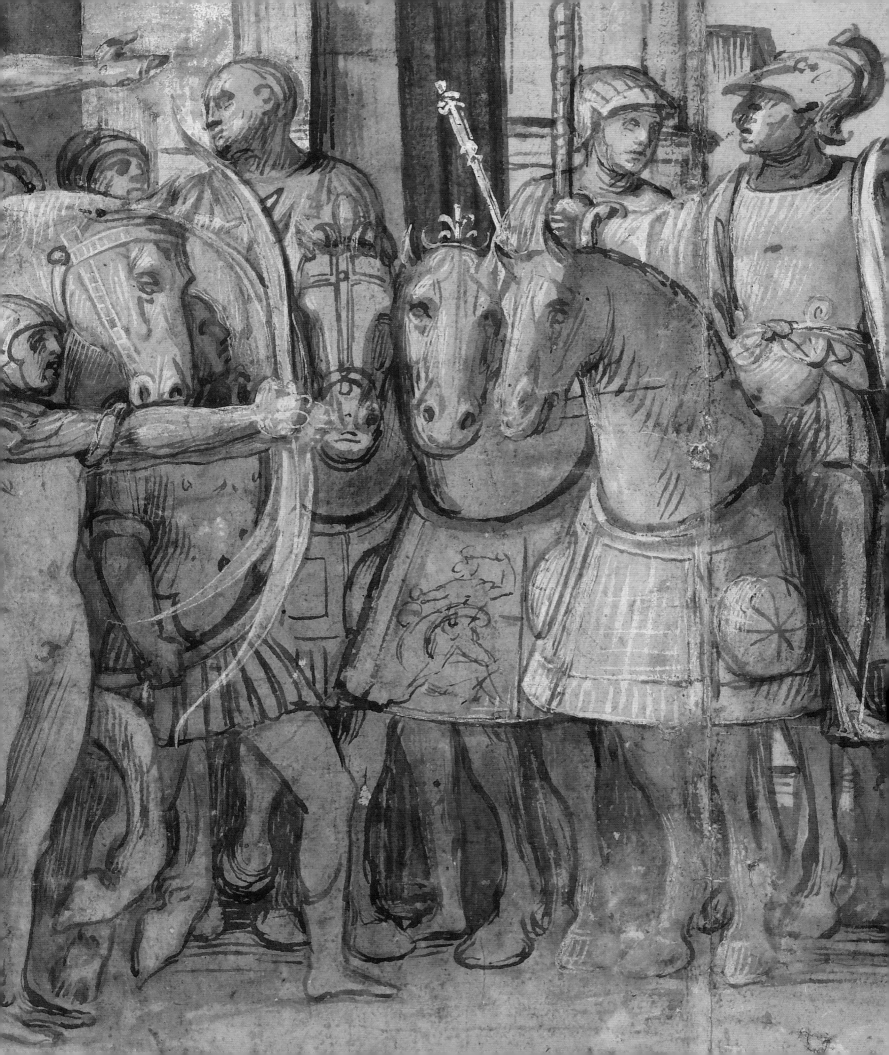

ACKNOWLEDGEMENTS

The authors wish to pay tribute to the friendship and guidance that Antony Griffiths, Keeper of Prints and Drawings at the British Museum, has offered to each of them over the years. The respect we share for his achievements as a scholar and administrator, not to mention the benefit we have gained from his wise practical counsel, were instrumental in ensuring that the planned collaboration between our two museums came to fruition and worked so smoothly. For this and so much else we remain in his debt.

From the British Museum we would like to thank Daniel Godfrey for his skilful and sympathetic translation of the Italian entries into English. He was also responsible for tracking down comparative illustrations for this publication. Stefano Jossa provided help on points of translation and Nicoletta Norman did much useful scanning. For the photography of the drawings in London and in Florence we are grateful to Ivor Kerslake. We would like to acknowledge our gratitude to David Saunders, Keeper of Conservation and Scientific Research who so enthusiastically supported the idea of a programme of non-invasive analysis and research of the technique of all the British Museum drawings. This achieved results that added significantly to our understanding of the drawings and we would like to thank the team responsible from the Department of Conservation and Scientific Research: Jenny Bescoby and Judith Rayner of the Western Pictorial Art Conservation section and Satoko Tanimoto, Giovanni Verri and Catherine Higgitt of the Science section. Both Dr Tanimoto and Dr Verri are Mellon Research Fellows and we are very appreciative of The Andrew W. Mellon Foundation for funding these posts. We are grateful to Neil MacGregor, the Director of the British Museum, for his support of the exhibition, and we are keenly aware of the help we have been given by the staff of the Deparment of Prints and Drawings.

From the Uffizi we wish to thank above all the Soprintendente Cristina Acidini and all the staff of the Gabinetto Disegni e Stampe, among whom the scientific knowledge of the recently joined Alessandra Griffo will play an important part in the Florentine showing of the exhibition.

For the publication we are indebted to Caroline Brooke Johnson at the British Museum Press for her skilful navigation through the reefs and rapids of book production aided by Melanie Morris and Lily de Gatacre, the copy editor Mary Scott, the proofreader Alison Effeny and the designer Philip Lewis. We would like to acknowledge the friendship and forbearance of Claire van Cleave, David Ekserdjian and Tom Henry who kindly read through the introduction and made numerous improvements to it. A number of friends and scholars were also generous in sharing their specialist knowledge: Carmen Bambach, Caroline Brooke, Cammy Brothers, Mirjam Foot, George Goldner, Laurence Kanter, Philippa Marks, Charles Robertson, Carl Strehlke, Luke Syson and Lucy Whitaker.

Finally, the authors would like to express their gratitude to the hard work and dedication shown by the youthful team of scholars at the Gabinetto who took on the challenge of writing entries for this publication. The energy and enthusiasm they have shown has been an inspiring feature of this project. The perceptiveness of their entries bodes well for the continuing vitality of Italian drawing scholarship.

Hugo Chapman
Curator
The British Museum

Marzia Faietti
Director

Giorgio Marini
Curator

Gabinetto Disegni e Stampe degli Uffizi

Detail of no. 73 (opposite)

DATES OF THE LIVES OF
THE EXHIBITED ARTISTS

Dates are taken from *The Grove Dictionary of Art* online (Oxford).
The artists are listed according to their sequence in the catalogue.
The places of birth and death are only listed when known.

Gherardo di Jacopo Starnina
(Florence, *c.* 1360–Florence, 1413)

Giovannino de' Grassi
(first documented Milan, active 1380s–98)

Anonymous Sienese
(active late 14th century–early 15th century)

Lorenzo Monaco
(*c.* 1370/75–Florence, 1425/30)

Parri Spinelli
(Arezzo, 1387–Arezzo, 1453)

Stefano da Verona
(1374/5–*c.* 1438)

Antonio di Puccio Pisano, called Pisanello
(Pisa or Verona, *c.* 1395–*c.* 1455)

Guido di Pietro, called Fra Angelico
(Vicchio di Mugello, *c.* 1395/1400–
Rome, 1455)

Fra Filippo Lippi
(Florence, *c.* 1406–Spoleto, 1469)

Benozzo di Lese, called Benozzo Gozzoli
(Florence, *c.* 1420/22–Pistoia, 1497)

Paolo di Dono, called Paolo Uccello
(Florence, *c.* 1397–Florence, 1475)

Jacopo Bellini
(Venice, *c.* 1400–Venice, 1470/71)

Gentile Bellini
(Venice, ?1429–Venice, 1507)

Andrea Mantegna
(Isola di Carturo, 1430/31–Mantua, 1506)

Cosmè or Cosimo Tura
(Ferrara, *c.* 1430–Ferrara, 1495)

Marco Zoppo
(Cento, *c.* 1432–Venice, 1478)

Tommaso d'Antonio Finiguerra,
called Maso Finiguerra
(Florence, 1426–Florence, 1464)

Antonio Pollaiuolo
(Florence, *c.* 1432–Rome, 1498)

Piero Pollaiuolo
(Florence, *c.* 1441–Rome, *c.* 1496)

Francesco di Giorgio Martini
(Siena, 1439–Siena, 1501)

Alessandro Filipepi, called Sandro Botticelli
(Florence, 1444/5–Florence, 1510)

Giuliano Giamberti, called Giuliano da Sangallo
(Florence, *c.* 1445–Florence, 1516)

Andrea del Verrocchio
(Florence, 1435–Venice, 1488)

Lorenzo di Credi
(Florence, *c.* 1456–Florence, 1536)

Pietro Vannucci, called Perugino
(Città della Pieve, *c.* 1450–Fontignano, 1523)

Leonardo da Vinci
(Anchiano, near Vinci, 1452–Amboise,
near Tours, 1519)

Domenico Bigordi,
called Domenico Ghirlandaio
(Florence, 1448/9–Florence, 1494)

Luca Signorelli
(Cortona, *c.* 1450–1523)

Filippino Lippi
(Prato, *c.* 1457–Florence, 1504)

Raffaellino del Garbo
(Florence, *c.* 1466–Florence, after 1524)

Piero di Cosimo
(?Florence, 1461/2–Florence, ?1521)

Giovanni Antonio Boltraffio
(Milan, *c.* 1467–Milan, 1516)

Master of the Pala Sforzesca
(Milan, active *c.* 1490–*c.* 1500)

Bartolommeo Suardi, called Bramantino
(?Milan, *c.* 1465–Milan, 1530)

Andrea Solario
(Milan, *c.* 1465–Milan, 1524)

Alvise Vivarini
(1442/53–1503/5)

Bartolommeo Montagna
(Orzinuovi, near Brescia, or Biron,
near Vicenza, *c.* 1450–Vicenza, 1523)

Giovanni Battista Cima
(Conegliano, near Treviso, ?1459/60–
Conegliano or Venice, 1517/18)

Vittore Carpaccio
(Venice, ?1460/66–Venice, 1525/6)

Jacopo de' Barbari
(?Venice, *c.* 1460/70–Mechelen
or Brussels, 1516)

Ercole de' Roberti
(Ferrara, *c.* 1455/6–Ferrara 1496)

Lorenzo Costa
(Ferrara, *c.* 1460–Mantua, 1535)

Amico Aspertini
(Bologna, 1474/5–Bologna, 1552)

Bartolommeo di Paolo, called Baccio
della Porta or Fra Bartolommeo
(Florence, 1472–Florence, 1517)

Michelangelo
(Caprese, 1475–Rome, 1564)

Raphael
(Urbino, 1483–Rome, 1520)

Titian
(Pieve di Cadore, *c.* ?1485/90–Venice, 1576)

RENAISSANCE ITALY *c.* 1500

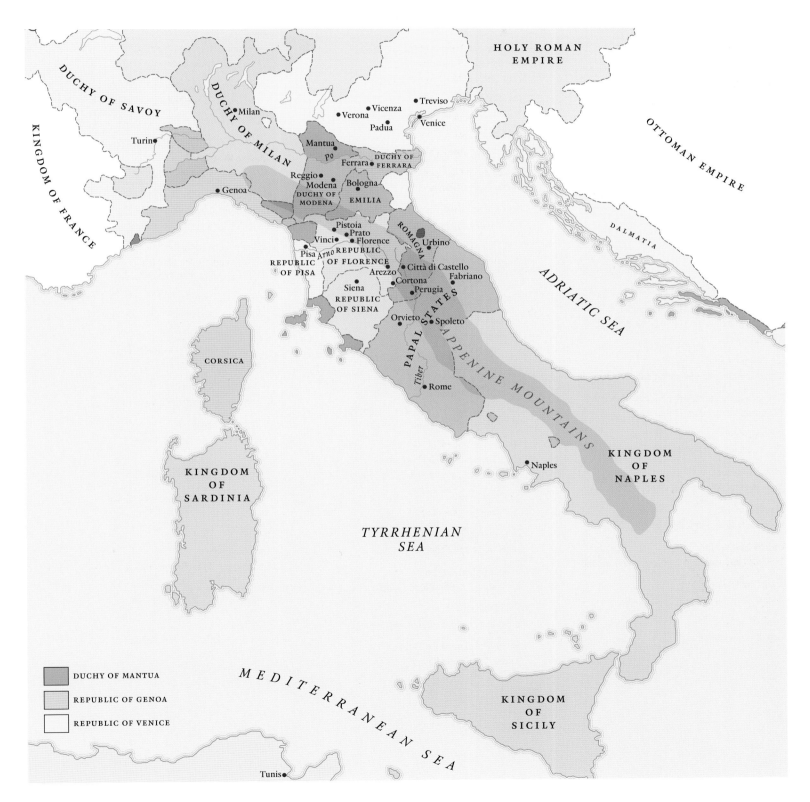

DUCHY OF SAVOY

DUCHY OF MILAN

KINGDOM OF FRANCE

HOLY ROMAN EMPIRE

OTTOMAN EMPIRE

Milan

Turin

Genoa

Verona

Vicenza

Treviso

Padua

Venice

Mantua

Po

Ferrara

DUCHY OF FERRARA

Reggio

Modena

DUCHY OF MODENA

Bologna

EMILIA

ROMAGNA

DALMATIA

Pistoia

Prato

Vinci

Florence

Urbino

Pisa

Arno

REPUBLIC OF FLORENCE

Città di Castello

REPUBLIC OF PISA

Arezzo

Fabriano

Cortona

Perugia

Siena

REPUBLIC OF SIENA

PAPAL STATES

APPENINE MOUNTAINS

ADRIATIC SEA

Orvieto

Spoleto

Tiber

Rome

CORSICA

KINGDOM OF SARDINIA

KINGDOM OF NAPLES

Naples

TYRRHENIAN SEA

MEDITERRANEAN SEA

KINGDOM OF SICILY

Tunis

DUCHY OF MANTUA

REPUBLIC OF GENOA

REPUBLIC OF VENICE

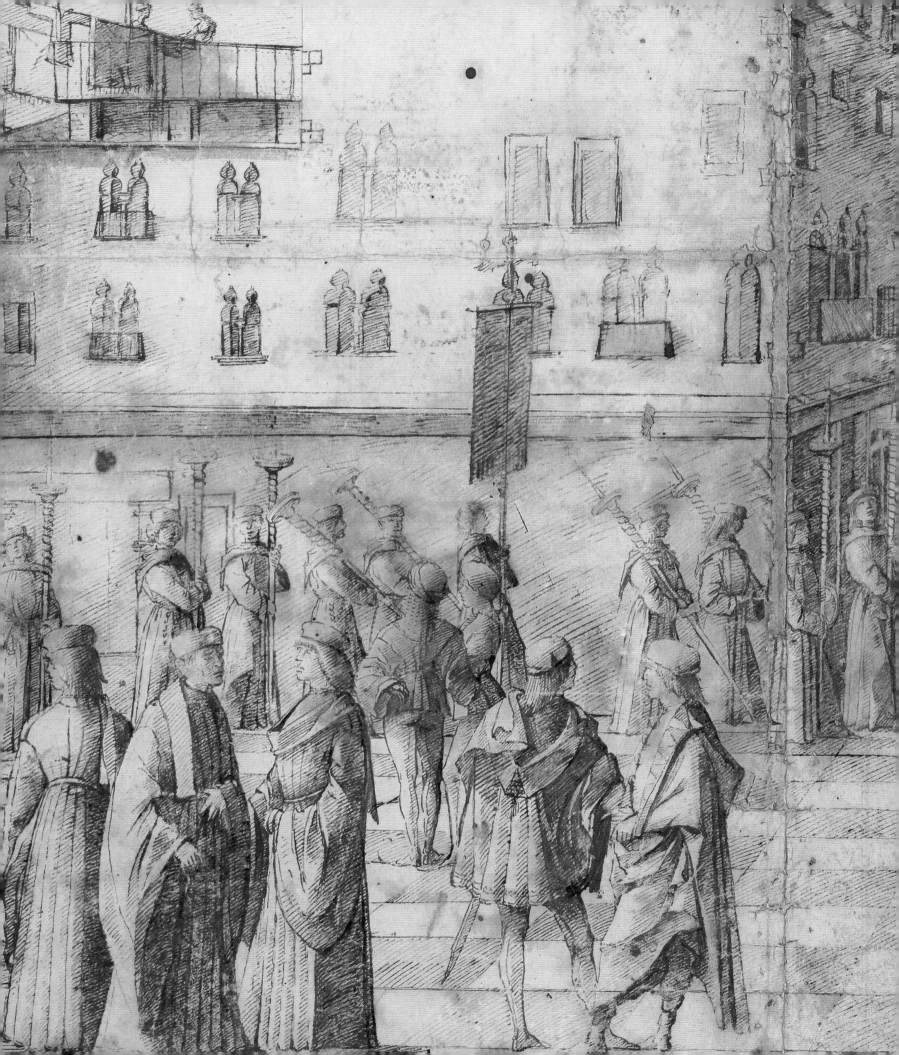

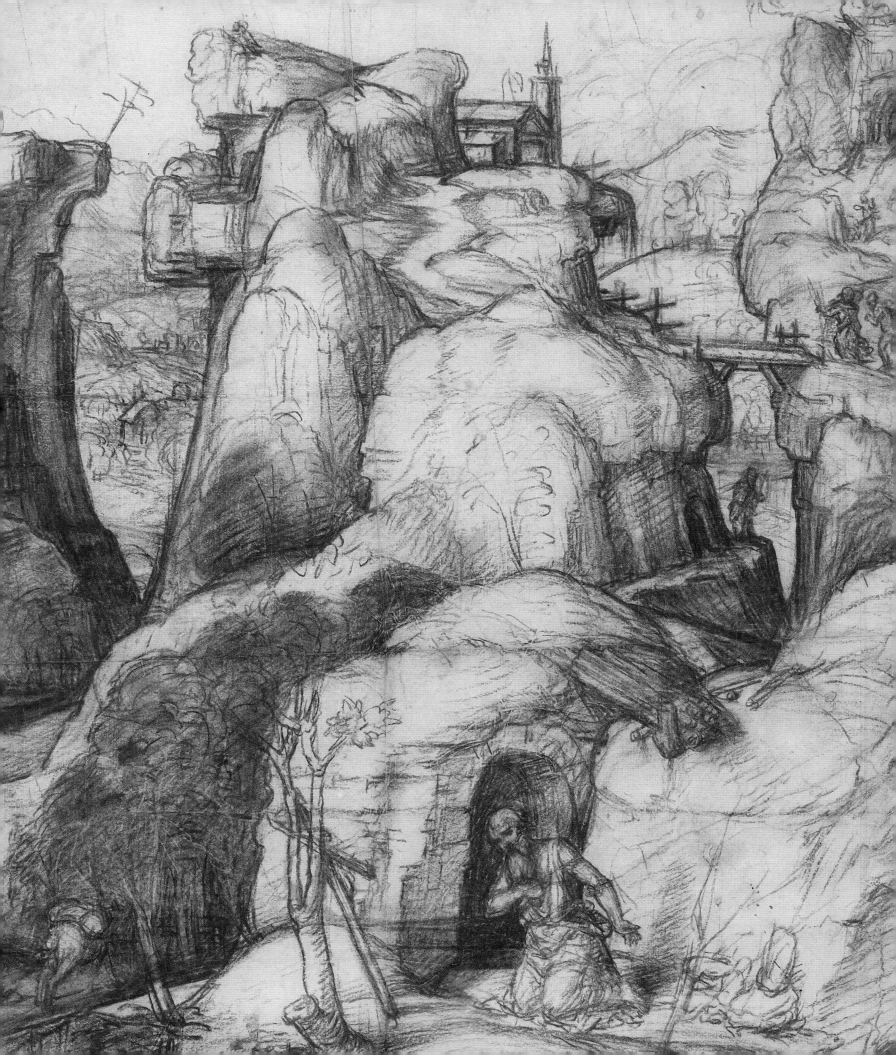

INTRODUCTION

T HE IDEA OF HOLDING an exhibition on Italian fifteenth-century drawings developed out of one dedicated to the drawings of Michelangelo (1475–1564) at the British Museum in 2006.[1] The opening room of the Michelangelo exhibition included two early pen studies by the sculptor from the 1490s alongside three in the same medium by his master, the Florentine painter Domenico Ghirlandaio (1448/9–94), from the mid-1480s, the period when Michelangelo was briefly his apprentice. The comparison revealed the younger artist's debt to Ghirlandaio in the manner in which he used the pen, and more generally in his meticulous preparation of every detail on paper before picking up his paintbrush or chisel. The drawings exposed the falseness of the elderly Michelangelo's account in his 'authorized' biography of 1553, written by his young follower Ascanio Condivi (1525–74), in which he presented himself as a virtually self-taught genius who owed little to his time in Ghirlandaio's studio. Even taking account of Michelangelo's brief apprenticeship, it is undeniable that his artistic development was exceptionally rapid and by the early 1500s, when he returned to Florence from Rome to carve the colossal marble *David*, he had moved far beyond his master. The monographic nature of the 2006 exhibition neither allowed the background of this shift in Michelangelo's way of drawing to be explored, nor enabled his graphic works to be compared with those of his contemporaries.

If the initial impetus of the present undertaking was to tease out the strands that led to the revolution in Florentine art at the beginning of the sixteenth century, it soon became apparent that these stretched back well into the previous century. Michelangelo's intensely sensual, tactile representations of male nudes in motion from the early 1500s, such as the *Youth beckoning* (no. 92), are like no other drawing, yet at the same time their key characteristics – sculptural three-dimensionality achieved through the use of light, and a combination of naturalism and a classically inspired idealization in the description of their bodies – are central and defining features of Renaissance art that first took shape in the early decades of the fifteenth century in Florence. Similarly Michelangelo's way of working with drawing as a central element of the process towards designing a finished work, a pattern that was broadly followed by his contemporaries in other artistic centres such as Milan, Bologna and Venice, can be seen as a template that gradually evolved during the course of the fifteenth century.

The inspiration of and identification with Italy's classical heritage, as implied by the term *rinascita* (rebirth or its equivalent in French, *renaissance*) used by the Tuscan painter and writer Giorgio Vasari (1511–74) in his 1550 edition of *Le vite de' più eccelenti architetti, pittori et scultori italiani* (*Lives of the Artists*; fig. 1), was not confined to Florence.[2] The naturalistic, classically inspired art, governed by a mathematically based perspective that regulated the recession of figures and buildings in pictorial space, was certainly pioneered in Florence by, among others, the painter Masaccio (1401–28/9) and the sculptor Donatello (1386/7–1466), but these innovations were taken up and developed by artists across Italy. The regional variations in how artists chose to interpret this new style reflect Italy's diversity, as in the fifteenth century it was not a unified country but rather a patchwork of city states, kingdoms, dukedoms, principalities and territories, some of which were controlled directly or owed allegiance to the Church headed by the pope in Rome (see map on p. 11). The variation in how these lands and municipalities were ruled was just one manifestation of numerous differences in practical matters such as law, monetary currency, weights and measures, ways of calculating time and differing calendars, dialects and customs.

Detail of no. 70

15

In spite of Italy's regional character, the fact that the peninsula's inheritance from ancient Rome included a common Tuscan-based language rooted in Latin meant that its inhabitants could travel and communicate with each other freely. This mobility also extended to artists, which explains the spread of Renaissance innovations throughout the peninsula and across the Alps to northern Europe. Italy's banking and commercial links with the Mediterranean and northern Europe ensured that it remained open to foreign artistic innovations, such as the introduction of oil paint, while well-established trade routes also encouraged northerners, like the Nuremberg painter and printmaker Albrecht Dürer (1471–1528), to voyage south. Italian artists also crossed the Alps, including the Venetian Jacopo de' Barbari (c. 1460/70–1516; no. 82), best known for his monumental woodcut print of the late 1490s showing a bird's-eye view of his native city, who travelled in 1500 to Germany in search of patronage and later moved to the Netherlands. Leonardo da Vinci (1452–1519; nos 48–57), the key figure in the development of drawing in the second half of the century, is a prime example of how artists and the regional schools to which they belong cannot be treated in a monolithic, self-contained manner. His training and early years were spent in Florence, yet Leonardo spent more time as a court artist in Milan in northern Italy and he ended his life at the French court. The selection of Leonardo's drawings in this book includes works from his periods in both Florence and Milan and it also highlights the diverse responses that he inspired among his contemporaries in Florence (Lorenzo di Credi, Filippino Lippi and Fra Bartolommeo) and Lombardy (Boltraffio, Solario and Bramantino).

The ambitious aim to chart the development of Italian fifteenth-century drawing would be impossible were it not for the collaborative nature of the venture between the British Museum and the Gabinetto Disegni e Stampe degli Uffizi in Florence. By joining forces it is possible to include, in a selection of just over 100 works, examples of all the major regional schools that have a significant graphic legacy from the fifteenth century. The survival rate of quattrocento (fifteenth-century) drawings is uneven, and thus it cannot be assumed from the absence of studies by artists from cities such as Genoa or Naples (artistic centres whose graphic legacies are well documented in subsequent centuries) that artists from there did not draw during the period. Rome is represented by drawings for Roman commissions by outsiders who worked there, like the design (no. 66) for the Carafa chapel in S. Maria sopra Minerva by the Florentine painter Filippino Lippi (c. 1457–1504; nos 65–8), yet the absence of native-born artists is not unique to the fifteenth century. It is found in many later centuries too. The one exception in the period, and indeed one of the few Roman artists of any note in its history, was Giulio Pippi, called Giulio Romano (c. 1499–1546), whose career after an apprenticeship in Rome with Raphael (1483–1520; nos 96–100) was spent serving the ruling Gonzaga family in Mantua in northern Italy. Although Florentine drawings predominate in the selection, due to the higher survival rate of graphic material from there than elsewhere, there is ample opportunity to compare them with those by artists in northern Italy, in particular Venice, whose distinct artistic culture is well represented.

The selection's starting point of around 1400 roughly coincides with the first stirrings of the classical revival centred on Florence, a city that had a long tradition of artistic innovation – beginning with Giotto (1267/75–1337), the founding father of Florentine painting – allied with wealth based on banking and the cloth industry that encouraged patronage of the arts. By the beginning of the century Florence was also politically stable after a small number of rich merchant families in the early 1380s had established an oligarchic republican government that cemented their control of the city. Florence's expansion into the surrounding region of Tuscany culminated in 1406 with the capture of Pisa, which gave it access to the sea.

While the political and social conditions in Florence were favourable to artistic innovations, it was a triumvirate of exceptionally gifted individuals who shaped the emergence of the new style. The most influential of the three was the architect

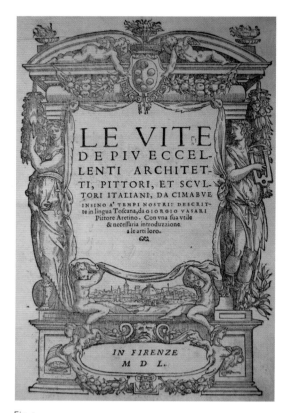

Fig. 1
Anonymous Florentine, frontispiece to Vasari's
Lives of the Artists, 1550. Woodcut, 19.5 × 13 cm.

Filippo Brunelleschi (1377–1446), best known for his design of the dome of Florence Cathedral, and whose loggia of the Ospedale degli Innocenti (the Foundling Hospital) begun in 1419 was the first unequivocally classical building in the city. He also painted two, now lost, topographical views of the Baptistery and the Palazzo Vecchio, as demonstrations of his system of linear perspective that created, through the convergence of lines towards a single point, the illusion of three-dimensionality on a two-dimensional surface. Another key figure was Donatello, whose classical inspiration in his sculpture was founded on his study of antique remains in Rome during the early 1400s, in the company of his friend Brunelleschi, and who was the first to employ perspective to give an effect of depth in reliefs such as his *St George and the Dragon* now in the Museo Nazionale del Bargello, Florence. The youngest of the trio was Masaccio, who in his fresco paintings in two Florentine churches, S. Maria del Carmine and S. Maria Novella, combined the new science of perspective with a similarly rational approach to light in order to model figures that appeared to have volume and substance. The works of Donatello and Masaccio were crucial to the emergence of a more naturalistic, empathetic approach to sacred art that sought to engage the viewer through the directness and realism of the actions and emotions of the protagonists.

The chronological symmetry of the selection is, however, disrupted by the choice of a cut-off point of around 1510. The reason for this extension of our period into the first decade of the new century is to allow for the inclusion of examples from the beginning of the careers of three artists, Michelangelo, Raphael and the Venetian painter Titian (active *c*. ?1485/90–1576; no. 101). During the decade between 1510 and the death of Raphael in 1520, the work of these three artists achieved a grandeur and equilibrium that brings the strands of naturalism and classicism developed in the fifteenth century to a climax, hence the description of this period as the High Renaissance. The careers of Michelangelo and Raphael are not followed after their moves to Pope Julius II's court in Rome in 1505 and 1508/9 respectively, where this final flowering of the Renaissance was most potently expressed. The Vatican projects of both artists ushered in a new artistic era, whose significance and ramifications it would be impossible to do justice to in an exhibition of this scale. The inclusion of Titian's *Study of a young woman* from the Uffizi (no. 101) is more controversial in light of the rarity and contentiousness of his graphic corpus. However, his drawing style, no less than that of Michelangelo and Raphael, can be seen to have been shaped by long-standing regional trends, as is revealed by a comparison between his study and those by two painters of an earlier generation from Venice and its surrounding region of the Veneto, Stefano da Verona (1374/5–*c*. 1438; no. 7) and Jacopo Bellini (*c*. 1400–70/71; no. 16).

The fact that the selection is so comprehensive in representing the major artists of the period is due to the complementary nature of the two collections (for the formation of these holdings see the essays on pp. 76–85). The much smaller collection in London cannot match the unrivalled depth and scale of the Gabinetto's holdings, especially of works by Florentine artists such as Maso Finiguerra (1426–64; nos 26–8), Fra Filippo Lippi (*c*. 1406–69; nos 11–12) and his son Filippino, Lorenzo di Credi (*c*. 1456–1536; nos 42–4) and Fra Bartolommeo (1472–1517; nos 87–90). That is not to say the Uffizi does not boast superlative examples by non-Florentine artists, as is shown by its drawings by Stefano da Verona, the Sienese artistic polymath Francesco di Giorgio (1439–1501; no. 35), the Venetian painter Vittore Carpaccio (?1460/66–1525/6; nos 79–81), his Ferrarese contemporary Lorenzo Costa (*c*. 1460–1535; nos 84–5) and Raphael, the son of the court painter to the Montefeltro family in Urbino in central Italy.

The British Museum's strength lies in the geographical spread and balance of its holdings of Italian Renaissance drawings, with most significant artists of the period represented. The rare gaps in the Uffizi's collection, such as works by the Veronese-born painter and medallist Pisanello (*c*. 1395–*c*. 1455; nos 8–9), can be filled by examples from London. In a few cases artists who should ideally be included are either missing or represented poorly in the two collections. Perhaps the most glaring

omission is the Venetian painter Giovanni Bellini (active *c.* 1459–1516), whose father, Jacopo, and brother, Gentile (?1429–1507; nos 17–18), feature prominently. While both collections possess a few examples that have a strong claim to be by Giovanni (such as the small *Pietà* study in the British Museum), none of them comes close to matching the impact of his best drawings, like the *Nativity* (Courtauld Gallery, London; fig. 2) or the *St Mark healing Anianus* in the Kupferstichkabinett, Berlin, and it seemed wiser to exclude him altogether rather than represent him inadequately.[3]

Although the choice of works necessarily concentrates on the period's most significant artists, not least Leonardo, whose pivotal importance is reflected in the inclusion of ten drawings by him, it does include less familiar names. Sometimes this selection was prompted by a desire not to overlook artists, such as the Tuscan painter Parri Spinelli (1387–1453; nos 5–6) or the Padua-trained Marco Zoppo (*c.* 1432–78; no. 25), whose talents were perhaps best expressed in drawing rather than in paint. The desire to illuminate the function of drawings in Renaissance artistic practice also required the inclusion of works by less widely known artists. This explains the selection of four examples by the mid-century Florentine goldsmith Finiguerra, three of them from the large group of his work at the Uffizi, because they illuminate the vital importance of drawing in the working of his studio (nos 26–8). The exhibition also provides an opportunity to include some outstanding drawings by artists who are, thanks to the poor survival rate of their graphic work, little known as draughtsmen even to specialists. Examples in this category include the magnificent study by the Milanese painter Bartolommeo Suardi, known as Bramantino (*c.* 1465–1530; no. 73), and the Dürer-inspired watercolour of a partridge by Barbari (no. 82).

The selection is heavily weighted towards preliminary drawings for paintings, with very few made in preparation for architecture and sculpture. The only architectural designs are on the verso of a figure study (no. 39) by the Florentine architect Giuliano da Sangallo (*c.* 1445–1516), and the only sculptural drawings are by Michelangelo (see nos 92–5). In the case of architecture this omission is deliberate since fifteenth-century architectural studies are rare, and the British Museum (unlike the Gabinetto) never aimed to acquire works in this field.[4] While the focus of attention is largely concentrated on painters, the role of drawing in a wider context has not been neglected. The Italian word for a drawing, *disegno*, also encapsulates the mental formulation of design that precedes the creation of the physical object. The dual ability to conceptualize a design, and then to realize that mental image on paper, was a vital skill for any artist wishing to convey his ideas for others to put into practice. The much-quoted inscription written by Finiguerra or one of his pupils below a study of a workshop assistant sketching sums up the vital importance of drawing: 'I want to be a good draughtsman and become a good architect' (see fig. 1, no. 26).

The ability to draw also opened up other avenues of potential diversification for artists of the period. A volume of drawings representing the history of mankind, the so-called *Florentine Picture Chronicle* (no. 34), conceived by goldsmiths in the orbit of Finiguerra, is a unique example of a collective graphic project intended to create a finished work of art. The development of printmaking, demonstrated in the exhibition by engravings based on drawings by the Paduan painter Andrea Mantegna (1430/31–1506; no. 22) and Finiguerra (no. 28), proved a more practical and enduring outlet for design flair than the experimentation with making drawing books, here uniquely represented by the *Chronicle* and Zoppo's album (no. 25). The preciousness of the latter is signalled by the use of vellum, an expensive but hardwearing material made from treated calf, sheep or goat skin. The figure study by the Florentine painter Sandro Botticelli (1444/5–1510; no. 37) from the Uffizi for a tapestry and Leonardo's drawing of military machines (no. 54) are more straightforward examples of the designing versatility of Renaissance artists.

The number of painters in the selection who worked as manuscript illuminators is another demonstration of the breadth of artistic activity in this period: these include two Florentine painters, Lorenzo Monaco (*c.* 1370/75–1425/30) and Fra Angelico

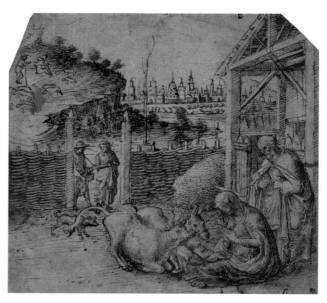

Fig. 2
Giovanni Bellini, *Nativity, c.* 1475. Pen and ink, 20.1 × 21.2 cm. The Courtauld Gallery, London.

(1395/1400–1455; no. 10), at the beginning of the century, and Pietro Perugino from Perugia (*c.* 1450–1523; nos 45–7) and the Bolognese painter Lorenzo Costa (nos 84–5) at the close. A skill in drawing underpinned success in that field quite as much as it did on a larger scale, as can be judged from Fra Angelico's delicate pen-and-wash drawing on vellum of *King David* cut from a Psalter (no. 10).

The significance of underdrawing in Renaissance paintings (the preliminary outline of a composition executed before paint was applied to the panel or wall surface) for the study of drawings from the same period has not been ignored in the present study (see fig. 27, p. 47). Indeed the same scientific imaging techniques have been used to reveal hitherto unseen drawings (for an explanation of those used in the analysis of the drawings see appendix on pp. 330–31) hidden beneath prepared grounds or ink, perhaps most startlingly in the case of Mantegna's *Virgin and Child* (no. 23). The recognition of the significance of these findings in the study of paintings has not, however, extended to including an example in the selection of underdrawings on an unfinished panel. Although the techniques and materials of the two activities of underdrawing and drawing are closely linked, their functions are distinct, since a drawing on a panel or canvas, unlike one on paper or vellum, was intended as the foundation of a painting, with the lines and shading of the underlying design guiding and, in some cases, amplifying the contours and tonality of the paint applied above it.[5] Despite the differences, the expanding corpus of images of underdrawings will undoubtedly provide an invaluable sense of the graphic language of artists whose works on paper have either survived in small numbers, or have been totally lost.

The inclusion of studies by goldsmiths whose expertise in making small-scale figures in bronze and silver often extended to larger sculptural works in metal and stone, such as the Florentine trio of Finiguerra, Antonio Pollaiuolo (*c.* 1432–98; nos 29–32) and Leonardo's master Andrea del Verrocchio (1435–88; nos 40–1), is proof that sculpture has not been excluded, although none of the drawings by them in the catalogue relate specifically to their work in this field. Preparatory studies for sculpture are exceptionally rare in this period.[6] Sadly neither collection boasts any of the few securely attributed sculptural studies by the Florentine Lorenzo Ghiberti (1378–1455), his Sienese contemporary Jacopo della Quercia (*c.* 1374–1438) or the northern Italian Agostino Busti, called Bambaia (*c.* 1483–1548). The Uffizi pen-and-wash drawing for a relief of the Virgin and Child, generally thought to be by one of two Florentine marble carvers, Antonio Rossellino (1427–*c.* 1478/81) or Desiderio da Settignano (*c.* 1430–64), could not be lent on conservation grounds.[7]

The selection unashamedly concentrates on the greatest draughtsmen of the age, yet this has not disbarred the inclusion of five works, including an entire album (the *Florentine Picture Chronicle*; no. 34), which despite the best scholarly efforts remain anonymous. In general, the attribution of very few Renaissance drawings can be proven incontrovertibly, as for the most part they are working studies for the private use of the artist and his assistants in the studio and not meant to be recognized as his production outside this circle. Leonardo's inscribed and dated landscape study in the Uffizi, no. 49, is a rare exception, a documented, unimpeachable drawing (fig. 3). Even the present selection, made up of some of the most celebrated works in the collections of the two museums, includes works that are still subject to scholarly debate. Where an attribution has, in our view wrongly, been recently doubted (a case in point is Antonio Pollaiuolo's *St John the Baptist*, no. 30), the reasons for accepting it are given in the entry. However, the focus in the catalogue section of the book is fixed firmly on the drawing itself, endeavouring to answer nuts-and-bolts issues of how it was made (such as the sequence of execution and its likely function in the artist's design process), rather than an analysis of each work's critical history. The ebb and flow of scholarly debate on issues such as attribution and dating is largely ignored since references to monographs, where such information can be found along with more extensive listings of bibliography, are always provided. For the same reason, the details of past owners of the drawings have been kept to the minimum with no

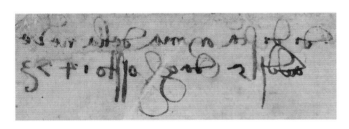

Fig. 3
Pen and ink inscription by Leonardo da Vinci
on no. 49.

reference to the dates of the auctions, lot numbers or catalogue descriptions of any of the British Museum works. (This is not relevant to the Uffizi drawings because of the very different histories of the two collections; for this see pp. 81–5.) Those seeking this information about British Museum drawings can find it in the online catalogue accessible via the museum's website.[8]

Bringing together drawings from two collections, the majority of which have never before been seen together, will doubtless raise new questions and provoke further debate about attribution, function and date. In such discussions it is easy to take for granted the contribution of past scholars in the field whose work forms the bedrock of our present knowledge. The repetition of certain bibliographic citations in the catalogue entries is indicative of the debt owed to pioneering studies in the field, such as Bernard Berenson's volumes on Florentine Renaissance drawings, Bernhard Degenhart's and Annegrit Schmitt's volumes on the corpus of Italian drawings from 1300 to 1450, and Hans Tietze and Erica Tietze-Conrat's book on Venetian drawings from the fifteenth and sixteenth centuries. Working in a museum one is acutely aware of the mainly unsung contribution of past curators and conservators in sorting, organizing and ensuring the physical well-being of the drawings in their care. In addition to these vital practical curatorial duties, our understanding of the Renaissance drawings in the two institutions is hugely dependent on the notes and publications written by those same scholars: in London, Campbell Dodgson, Sidney Colvin, A. E. Popham, Philip Pouncey, John Gere and Nicholas Turner; and in Florence, Pasquale Ferri, Odoardo Giglioli, Giulia Sinibaldi, Anna Forlani Tempesti, Gianvittorio Dillon, Giovanni Agosti and Anna Maria Petrioli Tofani. The present undertaking is nourished by the scholarship that they and other specialists have contributed to the field of quattrocento drawings, and it will have succeeded if it inspires a new generation to continue the study and appreciation of the graphic treasures in our two collections.

The function and survival of Italian fifteenth-century drawings

Exhibitions of Renaissance works such as paintings, sculptures, tapestries and medals inevitably require careful explanation of their original location and purpose, so that the visitor can gain some sense of how such objects were received and viewed at the time. In this way elements of the design that might otherwise be neglected, such as the direction of light or the inclusion of a particular saint, can be shown to have been dictated by the setting of an object or the wishes of the patron. While it is obvious that today's exhibition viewers are far removed from the intended audience, they can at least appreciate that the works on view were made to be looked at and admired. This is not the case in the present undertaking, as the majority of drawings in the selection were never planned to be seen by anyone outside the artist's workshop. Drawing was overwhelmingly a utilitarian activity either directed towards the design of a finished work, or as a means of developing and exercising the coordination between hand and eye that made it the cornerstone of artistic training. Although the artists represented doubtless never imagined that their working studies would be framed and put on view, and some of them, like Michelangelo, may have preferred to have kept them secret, it is precisely the insights that drawings afford us concerning the minds and decision-making of their creators that make them so fascinating.

A comparison between the painting of the *Lamentation* by the Milanese painter Andrea Solario (c. 1465–1524) in the Musée du Louvre, Paris (fig. 1, no. 74), and his study for it in the British Museum (no. 74), provides a clear example of what can be learnt about how the final appearance of the work was affected by the preceding process of design. The study shows a slight change in the narrative from that eventually

represented in the painting, one that subtly affected its emotional tenor. The crosses in the middle of the drawing, as opposed to the far distance in the painting, indicate that Solario originally intended Christ's followers to be gathered around his corpse soon after it had been taken down. The timing explains the raw intensity of grief of the mourners, expressed most potently in the headlong motion of one of the women towards Christ's lifeless body. In the painting the emotions of the mourners are more tempered because the narrative has been moved to the later moment just preceding the placement of Christ's body into the tomb (the classical sarcophagus just visible behind the figures). Thanks to the drawing, it is possible to speculate that the artist or his French patron, most likely Cardinal Georges d'Amboise (1460–1510), felt the reflective, meditative pathos of this slightly later episode was more appropriate to the painting's function as a devotional focus above an altar where Mass, a daily Christian ritual centred on Christ's redemptive gift of his flesh and blood to his believers, was celebrated.

Storehouse of ideas

An artist's stock of drawings was a form of intellectual capital: a valuable storehouse of ideas and motifs that could be useful in the production of future paintings, and an asset that could be passed down to the son or pupils who took over the running of the workshop after his death. An example of how drawings formed part of an artistic inheritance is documented in the 1471 will of Anna Bellini, the widow of the Venetian painter Jacopo, who left her son, Gentile, 'all works of plaster, marble and relief, drawn pictures [presumably a reference to unfinished paintings with an underdrawing but no colours] and all books of drawings'.[9] One of the books of drawings left to Gentile was almost certainly the album now in the British Museum that he in turn bequeathed to his brother, Giovanni, in his will of 1507 (no. 16). The double-sided vellum sheets (fig. 4, and no. 2) from a dismembered Lombard model book of animals and birds from the beginning of the fifteenth century is a good example of how drawing provided the means of retaining and passing on a repertory of motifs for inclusion in paintings or manuscript illuminations.

The dynastic nature of many Renaissance workshops meant that drawings constituted an important part of an artist's legacy to his heirs, both as a means of continuing a familial style and as an aid to the preparation of finished works. An excellent illustration of this is the legal agreement concerning the 14 volumes of drawings left by Finiguerra.[10] These volumes were in the custody of his brother and fellow goldsmith, Francesco (1439/40–1513), and it was agreed that on his death they should pass to another member of the family who worked either as a goldsmith or a painter rather than to Maso's cobbler son, Pierantonio. The value of this legacy is underlined by the safeguards put in place to prevent Francesco selling any of the volumes, enshrined in Pierantonio's right to borrow them for a specified period from his uncle and to be shown all of them every three years. The possession of drawings passed from master to pupils could on occasion be of crucial importance, as is demonstrated by the tussle over the commission for the decoration of the Sala di Costantino in the Vatican Palace that Raphael had barely begun by his death in 1520. Raphael's young pupils managed to retained control of the project, despite the rival lobbying of the Venetian painter Sebastiano del Piombo (1485/6–1547) backed by Michelangelo, partly because they retained the preparatory studies for it by their dead master.[11]

Preserving and collecting drawings

The number of surviving Italian fifteenth-century drawings must represent a small fraction of those that were made, especially during the first 50 years of the century. Major painters like Fra Angelico (no. 10), Gentile da Fabriano (c. 1385–1427) and

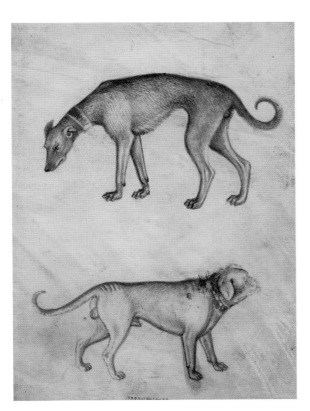

Fig. 4
Follower of Giovanni de' Grassi,
Two dogs, c. 1400–10. Watercolour and bodycolour on vellum, 16 × 12.1 cm.
British Museum, London.

From the same model book as no. 2.

Paolo Uccello (*c.* 1397–1475; no. 15) are represented by a handful of surviving studies, often of contested authenticity, while others, such as Masaccio, his Florentine compatriot Andrea del Castagno (before 1419–57) and the Venetian Carlo Crivelli (?1430/35–*c.* 1495), are unknown as draughtsmen.[12] The poor survival rate of early fifteenth-century drawings is exemplified in the present catalogue by the fact that Lorenzo Monaco's study in the Uffizi from around 1407–9 (no. 4) for the left wing of an altarpiece now in the National Gallery, London (illustrated as fig. 1, no. 4), is the sole example that relates to his work as a painter.[13] Clearly there are huge gaps in the coverage of Italian drawing in the period, yet even so the numbers are far higher than those by the great artists of northern Europe, where our knowledge of the graphic styles of painters such as Jan van Eyck (*c.* 1395–1441), Hugo van der Goes (*c.* 1440–82), Hans Memling (1430/40–94), and Rogier van der Weyden (*c.* 1399–1464) is either very small or non-existent. Even for Italian painters it is impossible to gain a sense of how many drawings a typical artist might have produced in the course of a career. Leonardo, whose scattered notebooks and codices in Windsor Castle and elsewhere number some 2,000 drawings, cannot be taken as typical, as such a high proportion of his graphic output relates to his study of non-artistic matters.[14] The corpus of almost 150 drawings by Filippino Lippi is exceeded only by Jacopo Bellini, Pisanello and Leonardo, but even this sizable number must represent a small percentage of his complete graphic output. If they are parcelled up between the 32 years of his career, beginning with his apprenticeship in Botticelli's studio at the age of 15 or 16 in 1472 until his death in 1504, they add up to the meagre total of less than five a year.

Despite the losses, the very fact that studies by most of the leading painters of the time survive at all, when compared to the rarity of drawings from the fourteenth century, is significant. There are two main reasons why more fifteenth-century Italian drawings were preserved. First, for reasons that will be discussed later, Italian artists drew much more frequently than their predecessors, and this obviously increased the probability that some portion of their graphic output would be preserved. Secondly, those fifteenth-century studies that had been retained in the handing down of studio material from one generation to the next were less likely to be discarded, since in the sixteenth century they became a saleable commodity with the advent of connoisseurs and scholars who began to collect drawings. There is some evidence that there were even earlier collectors of drawings who were not professional artists. As early as 1335 a memorandum by the notary and banker from the northern Italian city of Treviso, Oliviero Forzetta (*c.* 1300–73), records his wish to buy in Venice certain books of drawings of animals and figure studies by the Venetian painter Angelo di Tedaldo (active 1324–44) and his two sons.[15] In the following century the 1466 will of the Veronese calligrapher, Felice Feliciano (1433–79), who was a friend of Mantegna and Zoppo, mentions his collection of drawings by 'several excellent masters'.[16] Vasari in his 1568 biography of the Florentine sculptor Pietro Torrigiano (1472–1528) in the *Lives of the Artists* alleged that the garden of S. Marco in Florence, set up as an informal art academy in the 1480s by Lorenzo de' Medici, better known as Lorenzo the Magnificent (1449–92), included among the didactic material gathered there, drawings and cartoons by artists such as Masaccio, Uccello, Fra Angelico, Fra Filippo Lippi and other masters from Florence and further afield.[17] A more securely documented example of a patrician collector is the Venetian Gabriele Vendramin (1484–1552), whose renowned collection of paintings and antiquities included an album of drawings by Jacopo Bellini, most likely the one now in the British Museum (no. 16), as well as one of animal studies by the Lombard painter and illuminator Michelino da Besozzo (active 1388–1450).

Vasari himself was an avid collector of drawings, which he pasted into volumes as a pictorial adjunct to his fundamental history of Italian art, *Lives of the Artists*, published in two editions in 1550 and 1568. Studies by Perugino and the Florentine painter Raffaellino del Garbo (*c.* 1466–after 1524) in this selection were once part of Vasari's collection of drawings pasted in his multi-volume *Libro de' Disegni* (Book of Drawings) and retain his pen-and-wash architectural framing surrounds, sometimes augmented

Fig. 5
Enlarged detail of the collector's mark of
Jonathan Richardson senior on no. 45.

with figures (nos 47, 69). Vasari's pride in his collection is expressed in his frequent reference in the *Lives* to drawings contained in '*nostro Libro*' (our book). Before the appreciation of drawings gained a wider currency, it was principally artists who preserved the graphic legacy of their predecessors for sentimental as well as practical reasons, as is demonstrated by Vasari's acquisition of studies purportedly by the thirteenth-century artist, Giotto, from a descendant of Ghiberti. Drawings were always much cheaper to buy than paintings, which was another factor in the tradition of artists collecting drawings which continued for many centuries, most notably perhaps in England. The custom of collectors, or their executors, applying a printed or impressed stamp with initials or a design to mark their ownership means that it is sometimes possible to trace the provenance of drawings back through many centuries. In this way drawings once owned by English artists such as Sir Peter Lely (1618–80), Jonathan Richardson senior (1665–1745; fig. 5) and junior (1694–1771), Sir Joshua Reynolds (1723–92) and Sir Thomas Lawrence (1769–1830) are readily identifiable (for the latter see the essay on the formation of the British Museum's Italian holdings, pp. 76–9). Nevertheless, even in the infancy of the collecting of drawings, artists did not have the monopoly in the field, and Vasari's fellow collectors in Florence included the writer Vincenzo Borghini (1515–80), as well as the patrician Niccolò Gaddi (1537–91), who acquired five volumes of the *Libro* after Vasari's death in 1574.[18]

The roots of the growing taste for the collecting of drawings can be traced back to the development in the fifteenth century of works on paper destined to be viewed outside the workshop. Perhaps the most obvious examples are finished drawings made as gifts or for sale as autonomous works of art in their own right. The term 'presentation drawing' was coined by the great Hungarian scholar of Michelangelo Johannes Wilde (1891–1970), to describe the exquisitely finished chalk studies made by the sculptor from the 1520s onwards as gifts for his dearest friends, such as the Roman aristocrat Tommaso de' Cavalieri (*c.* 1519/20–87) and the poet and religious reformer Vittoria Colonna (1490–1547).[19] Leonardo is often cited as Michelangelo's precursor because he is known to have made a now lost drawing of *Neptune* for his Florentine friend, the silk dealer Antonio Segni (1457–1512) in the early 1500s.[20] The degree of refinement and polish of Leonardo's drawing *Bust of a warrior* from the second half of the 1470s (no. 50) would suggest that it was an earlier example of a drawing made as a finished work of art. The same holds true of the pen-on-vellum drawing of Hippo executed at around the same time by Francesco di Giorgio (no. 35). The practice can be traced back even further to Pisanello's signed drawing on vellum of three fashionably dressed men from the 1430s (no. 8), which has plausibly been claimed as the first known example of a presentation study.[21] Mantegna, a court artist in northern Italy like Pisanello a generation before him, made similarly finished drawings, an example of which is included in the exhibition (no. 22), as did his successor in Mantua, Lorenzo Costa. Uniquely, the *Judith and Holofernes* now in the Uffizi, a sadly damaged example of an autonomous drawing made for presentation, was signed and dated by Mantegna 'ANDREAS MANTINIA MCCCCLXXXXI FEBR'.[22] For both Pisanello and Mantegna, such works may have offered a relatively quick means of meeting the demand to supply a work by their hand, while at the same time not endangering relations with their courtly patrons whose permission they required to accept outside painting commissions. It is a sign of the unparalleled fame of both Pisanello and Mantegna that a finished drawing was deemed an acceptable substitute for a painting, and as such they are precursors of Leonardo and Michelangelo who employed their graphic skills to create works as precious tokens of their artistic gifts.

Portrait drawings

Another type of finished drawing is represented by the red- and black-chalk portrait (no. 86) of a member of the Achillini family, probably the writer Giovanni (1466–

1538), by the Bolognese painter Amico Aspertini (1473/5–1552). The use of two colours, its imposing scale (39 x 28.5 cm) and level of finish are factors that suggest it was made as a substitute for a painted portrait, rather than a preparatory study for one. The light-stained paper also indicates that it was framed and hung. Later evidence for drawings being displayed in frames is provided by a handful of sixteenth-century inventories that give detailed descriptions of drawings, such as the posthumous listing of the collection of the Cavaliere Francesco Baiardo (1486–1561),[23] a Parmese aristocrat best known for his patronage of the painter Parmigianino (1503–40); that of the Roman scholar, Fulvio Orsini (1529–1600); and his fellow Roman Antonio Tronsarelli (?1528–1601).[24] It is likely that earlier artists made independent portrait drawings, such as one on vellum '*al naturale*' of a member of the patrician Quaratesi family recorded in the workshop book of the Florentine painter Apollonio di Giovanni (*c.* 1416–65).[25] However, there is no sure way of knowing which of the surviving drawn portraits from the first half of the quattrocento belong to this category. In view of this uncertainty it is sensible to remain open-minded as to whether a drawing is an independent portrait, or made in preparation for a painting, especially when the two categories were not necessarily mutually exclusive. The pictorial quality and use of coloured chalks in Leonardo's cartoon for a portrait of the Marchesa of Mantua, Isabella d'Este (1474–1539), in the Louvre suggests that it may well have served both functions.

The poor survival rate of preparatory studies for painted portraits is probably due to their specific function, which made it difficult to reuse them for the preparation of other paintings. They also had an inherent obsolescence related to the lifespan of the sitter, which increased the likelihood that they would be discarded from the inherited workshop stock of drawings.[26] For aesthetic reasons, more finished portrait drawings stood the best chance of being preserved, such as those in coloured chalks or pastel by Leonardo's Milanese followers Giovanni Antonio Boltraffio (*c.* 1467–1516; fig. 51) and Bernardino Luini (*c.* 1480/85–1532), rather than sketchier examples.[27] The concentration on the severe features of the middle-aged woman in Ghirlandaio's drawing (no. 61), her dress only sketchily indicated, would suggest that it is more likely a study for a portrait rather than an independent portrait drawing, since the representation of costume as a prime signifier of wealth and status was unlikely to be passed over by the sitter. This latter point is evident from Ghirlandaio's pen drawing in the British Museum related to the Tornabuoni Chapel commission in the Florentine church of S. Maria Novella, which is dedicated solely to ensuring that the cut and detail of a dress are correct (fig. 6). The unidentified member of the Tornabuoni family or their circle portrayed in the fresco must have lent the article of clothing to Ghirlandaio so that he could make a study of it, most likely modelled by a young apprentice in the painter's studio. The black chalk study of a male head by Luca Signorelli (*c.* 1450–1523; no. 64) is even more difficult to categorize. It is so vivid and particular in the description that it must be a drawing of an individual, but it is impossible to determine whether it was made as an intimate portrait, or as a life drawing to be used as the basis for one of the many characterful figures in his paintings. Boltraffio's life study of a woman in the Uffizi (fig. 51) provides firm evidence of a portrait, perhaps the wife of one of the artist's patrons, being used as the starting point for the features of a figure in a sacred narrative, in this case those of the Virgin in an altarpiece now in the Louvre, Paris.[28]

Among graphic works that were intended to be seen outside the studio, portrait drawings stand apart because they were made in the presence of the sitter. Unlike a painted portrait, the speed of drawing meant that a talent for capturing a likeness could be witnessed and swiftly judged. Proof that this facility could be an important asset for a court artist is provided by a 1493 letter to the Duke of Milan, Ludovico Sforza (1452–1508) from his ambassador at the imperial court at Innsbruck. The ambassador reported with proprietorial pride how '*nostro pinctore*' (our painter), Leonardo's Milanese pupil Giovanni Ambrogio de Predis (*c.* 1455–*c.* 1508), had spent

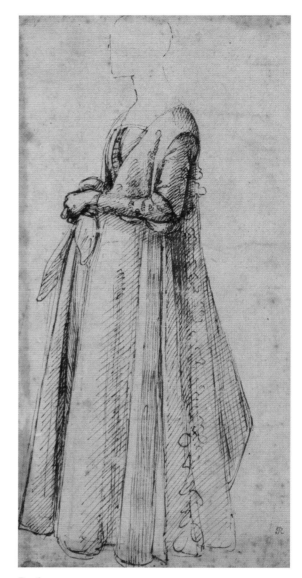

Fig. 6
Domenico Ghirlandaio, *Costume study*, *c.* 1486–90. Pen and brown ink, 24.1 × 11.7 cm. British Museum, London.

Related to the *Birth of the Baptist* fresco in the Tornabuoni Chapel in S. Maria Novella, Florence.

two hours making a drawing of the Duchess of Saxony, and then a portrait of her lady-in-waiting. The same afternoon he made a drawing of the Empress Bianca Maria Sforza (1472–1510) with one of her female attendants. The ambassador went on to describe how Predis's drawing of Ludovico Sforza, Bianca Maria's uncle, was judged by Maximilian I, Holy Roman Emperor (1459–1519) and his wife to be superior to a Flemish portrait drawing. He also wrote that Predis's portrait was much admired because it conveyed the Duke's serious and lordly visage ('*una cera molto grave e signorile*').[29] A slightly different example of how the immediacy of drawing could allow a patron to direct and be party to the creative process is provided by reports of the 2nd Duke of Ferrara, Ercole I d'Este (1431–1505), spending four days in 1493 with his court painter, Ercole de' Roberti (*c.* 1455/6–96), as he worked on the cartoon of some 'history or fable' while his bored courtiers waited outside.[30]

Contractual drawings

This selection does not include any certain examples of another category of graphic work intended to be seen outside the artist's studio – the contract drawing. A contract drawing was both a means of formalizing initial discussion between artist and patron as a visual record agreed between the two parties of the intended appearance of the finished work, and a point of reference if either of them wished to change their minds about the design. This practice seems to have originated in the late 1300s in large-scale architectural projects that were too complex to describe in a written agreement. The earliest surviving example is related to the construction of the façade of Orvieto Cathedral at the beginning of the fourteenth century.[31] According to a recent study of fifteenth-century artistic contracts, reference to drawings becomes more common in the second half of the century although there are earlier mentions of them.[32] These include two related to Fra Angelico, the first of which was a drawing supplied for the 1433 contract for a lavish painting commissioned by the Florentine linen drapers' guild (the Linaiuoli triptych now in the Museo di S. Marco, Florence); the second was in 1447, when he was reimbursed for the cost of the paper for the scheme he had submitted for the frescoes in the S. Brizio Chapel, Orvieto Cathedral.[33]

While references to accompanying drawings in fifteenth-century contracts are not uncommon, the two have rarely remained together (the 1466 document now in the Getty Research Institute, Malibu, between the Paduan painter Pietro Calzetta (*c.* 1430/40–86) and his patron, Bernardo de Lazara, regarding the decoration of the Corpus Christi chapel in the Santo, the Basilica of S. Antonio in Padua, is a rare exception).[34] As a consequence it is usually impossible to be certain if surviving finished compositional studies from the period were made for such a function. Certainly none of the works in the exhibition has a legal agreement between artist and patron or between artist and specialist craftsman (such as those for altar frame designs), as is the case, for example, on the reverse of a drawing dated December 1583 in the British Museum for a processional banner to be painted by the Venetian artist of Greek descent, Antonio Vassilacchi (1556–1629; fig. 7).[35]

Despite the absence of such conclusive evidence, the selection does include drawings which seem, on the basis of their careful finish and lack of changes, to have been made to show a patron the intended form of the finished work. The drawing by the Ferrarese painter Cosmè or Cosimo Tura (*c.* 1430–95) for a composition of the *Virgin and Child with saints* (no. 24) is perhaps the best example of such work. The fact that Tura wrote '*horo*' (gold) ten times to denote the use of this material in the panels behind the figures is a clear sign that it was intended to be shown to a patron, one whom the artist clearly felt needed reassuring that the painting would look sufficiently opulent (fig. 8). The drawing may well have been pinned to a letter or contract since it has been carefully folded and has a pinhole through the centre of each fold.[36] Other drawings in the selection that may have served a comparable function include

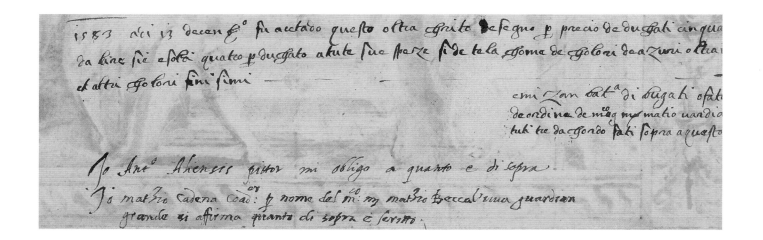

Totila's assault on Perugia by the Florentine painter Benozzo Gozzoli (*c.* 1420/22–97; no. 13), Filippino Lippi's *Triumph of St Thomas Aquinas* for the fresco in the Carafa chapel in S. Maria sopra Minerva in Rome (no. 66), and Carpaccio's *Vision of St Augustine* for the Scuola di S. Giorgio degli Schiavoni in Venice (no. 80).

Fig. 7
Antonio Vassilacchi, *Witnessed contract between artist and patron to paint a processional banner according to the design drawn on other side*, 1583. Pen and brown ink, 41.4 × 10.7 cm. British Museum, London.

The informal use of drawings between artists and patrons

The use of drawing as a means of informal communication between artist and patron also became more established in the period. An early instance of this is the spidery pen sketch with measurements beneath it for an altarpiece frame that Fra Filippo Lippi added to the bottom of a letter of 1457 to Giovanni Cosimo de' Medici (1421–63).[37] In the imaginary dialogue between the Florentine sculptor and architect Antonio Pietro Averlino, known as Filarete (*c.* 1400–*c.* 1469), and his patron, the Duke of Milan Francesco I Sforza (1401–66), in the *Trattato di architettura* (Treatise on Architecture) written in Milan (1461–4), there is repeated mention of the importance of drawing in ensuring that the client's verbal instructions had been correctly interpreted by the designer: 'make me a little sketch to show me that you understand.'[38] Filarete's treatise presented an idealized dialogue between an architect and a receptive, well-informed client, yet in respect of the importance of drawing as a means of communication between professional and amateur it can be seen to prefigure the extraordinary series of letters and designs that Michelangelo sent from Florence in the second half of the 1520s to his patron in Rome, the Medici Pope Clement VII (1478–1534). The latter avidly followed developments on various Medici building projects in Florence centred on S. Lorenzo, and to keep him happy Michelangelo was advised 'always to send drawings of what you are doing to please the pope'.[39]

The employment of graphic means of communication could occasionally work in the opposite direction, as is the case with the notoriously fussy and prescriptive patron, Isabella d'Este, who in 1502 commissioned a drawing to be sent along with precise written instructions to Perugino in Florence to explain the complex allegory, the *Combat of Love and Chastity* (now in the Louvre, Paris), with which she wished to decorate her private sanctum, the *Studiolo*, in the Mantuan ducal palace.[40]

The sending of a drawing could sometimes have a more light-hearted, diversionary function, as can be divined from a letter written by Mantegna from Rome in 1489 to his employer, the 4th Marchese of Mantua, Francesco II Gonzaga (1466–1519), the husband of Isabella d'Este. In this the painter described at length the outlandish appearance and behaviour of a Turkish prince held captive in the Vatican and promised to send the Marchese a drawing of him when he had successfully captured his likeness: 'when I see him I will immediately send your excellency a drawing. I would send it

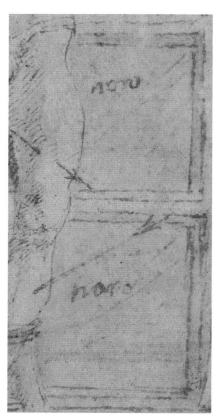

Fig. 8
Pen and ink inscription by Cosmè (or Cosimo) Tura on no. 24.

now, but I haven't quite got it yet, because sometimes he looks one way, sometimes another, like a man in love, so I can't get it from memory.'[41] Mantegna's brother-in-law, Gentile Bellini, had been similarly moved to draw the exotic appearances and costume of some of the people he encountered during his sojourn in Constantinople in 1479–81; two of these sheets are included (nos 17–18).

Drawing albums

Other examples of drawings intended for an existence outside the artist's studio include two albums in the British Museum: the earlier of the two by Zoppo dating from the 1460s (no. 25), and the other from a decade or so later, the so-called *Florentine Picture Chronicle* (no. 34). Both must have been intended for sale, although unfortunately in neither case is the identity of the patron or buyer known. Nevertheless, the fact that considerable time was spent making these volumes of carefully finished drawings, notwithstanding the uncompleted state of the *Chronicle*, suggests that there was a market for such works, although it is likely to have been a limited one since the two British Museum albums are the only known examples of their kind. The function of the third and earliest album in the exhibition, Jacopo Bellini's so-called *London album* from the 1450s (no. 16), has been much debated, with most scholars believing it to have been created as a storehouse of compositional ideas for the artist and his heirs.

Drawing in artistic training

The examples of graphic works that were intended to be seen outside the artist's studio were undoubtedly important in spreading a wider awareness of drawing; however, it is important to stress that such studies were exceptional. For the most part drawing was related to workshop training and the preparation of finished work. The importance of drawing in training the coordination of hand and eye, and for gaining an understanding of basic artistic skills, such as the disposition of light and shade to create relief, is expressed in the artist's manual (*Il libro dell'arte*) written by the Tuscan painter Cennino Cennini (*c.* 1370–*c.* 1440). Similar sentiments are articulated by the Florentine architect and writer Leon Battista Alberti (1404–72), whose literary skills in Latin and Italian, intellectual curiosity and physical vitality embody the ideal Renaissance '*uomo universale*' described by the Swiss historian Jacob Burckhardt (1818–97) in his hugely influential 1860 work, *Die Kultur der Renaissance in Italien* (translated into English 18 years later as *The Civilization of the Renaissance in Italy*). Alberti's reference to the importance of drawing in training in his pioneering treatise on painting written in Florence in 1435, originally in Latin (*De pictura*; On Painting) and followed the next year by an Italian version (*Della pittura*), was repeated in Leonardo's notes for a never completed publication on the same theme begun in Milan in the late 1480s. Confirmation of the role of drawing in the formation of a young artist is provided by the 1467 contract related to the apprenticeship of a boy to Francesco Squarcione (*c.* 1395–1468), a modestly talented Paduan painter who ran an early form of artistic academy that included Mantegna and Zoppo among its students. Squarcione promised to teach the boy his method of perspective, the proportions of the human figure and to provide drawings to copy: 'always keep him with paper in his hand to provide him a model, one after another, with various figures in lead white and correct these models for him.'[42] Squarcione's collection of drawings was one of the didactic resources he used to attract pupils, the most talented of whom he tried to retain through adoption, but details are sketchy as to what it included apart from a study by Calzetta, who worked alongside Mantegna in

the Ovetari Chapel in the church of the Eremitani, Padua, and a cartoon of nudes by (? Antonio) Pollaiuolo. The latter work is mentioned in 1474 as one of 18 drawings that Squarcione's son was trying to retrieve from a pupil of his deceased father who had borrowed and never returned them.[43]

The practice of making drawn copies as a means of analysing and absorbing the style of the original is well documented by examples in museum collections. The majority of these are anonymous even when they are of excellent quality, as is the case with the pen drawing in the British Museum, *Saint Lucy before the tribunal*, copied from the fresco dating from the 1370s by the northern Italian painter Altichiero (active 1369–93) in the Oratory of S. Giorgio, Padua (fig. 9).[44] To judge from the British Museum's collection, drawn copies after paintings are more numerous than those after sculpture, despite Alberti's advice to the contrary: 'it would please me more to [have you] copy a mediocre sculpture than an excellent painting. Nothing more can be acquired from paintings but the knowledge how to imitate them; from sculpture you learn how to imitate it and how to recognise and draw the lights.'[45] Unsurprisingly, the favoured models for copies after sculpture were antique works, such as the colossal marble *Horse tamers* on the Quirinal Hill in Rome, as in no. 14, probably drawn by Gozzoli, since these were the best preserved, most accessible and most impressive examples of classical art for Renaissance artists to study. Drawings after contemporary sculpture are less numerous, yet they were certainly made, as is

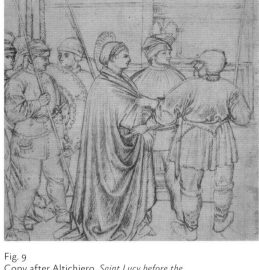

Fig. 9
Copy after Altichiero, *Saint Lucy before the tribunal*, c. 1390–1410. Pen and brown ink, 15.8 × 15.9 cm. British Museum, London.

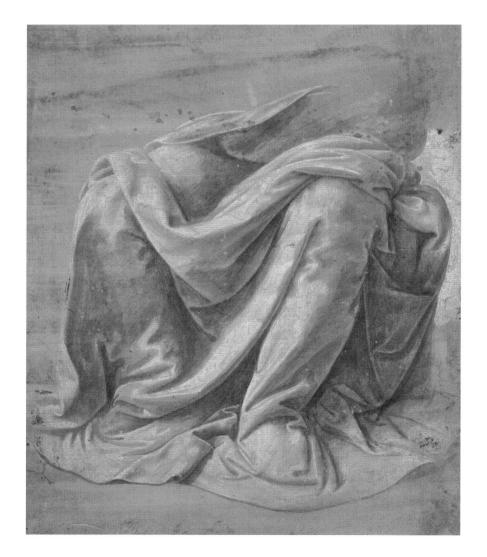

Fig. 10
Attributed to Lorenzo di Credi after Leonardo da Vinci, *Drapery study*, c. 1480–90. Brush and grey ink, heightened with lead white, on pink preparation, 26.4 × 21.7 cm. British Museum, London.

This is copied from a brush and tempera drapery drawing on linen generally ascribed to Leonardo in the Louvre, Paris.

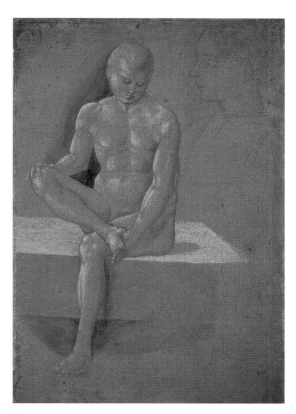

Fig. 11
School of Benozzo Gozzoli, *A nude model*,
c. 1450–70. Metalpoint over stylus indications,
grey-brown wash, heightened with lead white,
on pink-purple preparation, 22.6 × 15 cm.
British Museum, London.

The pose of the model is inspired by a famous
antique bronze known as the *Spinario* (the thorn
puller) in the Musei Capitolini, Rome.

shown by Michelangelo's study of Donatello's marble *David* now in the Museo Nazionale del Bargello, Florence, on the verso of no. 94, or Raphael's free interpretation of Michelangelo's unfinished *St Matthew* (Galleria dell'Accademia, Florence) on the verso of no. 99.[46]

There are sufficient examples of copies made after drawings to make it clear that Squarcione was not an isolated adherent of this method of instruction. A fine example of such a work is the copy, probably by Lorenzo di Credi, in the British Museum (fig. 10) after a drapery study in the Louvre generally ascribed to Leonardo, a fellow student in Verrocchio's workshop.[47] It is likely that there are more such drawings that have not been identified as copies because the original drawing has disappeared. The selection of suitable models for a young artist to copy was judged extremely important by Cennini: 'take pains and pleasure in constantly copying the best things which you find done by the hand of the great masters … take care to select the best work every time, and by the master who has the greatest reputation.'[48] From the perspective of a master painter heading a workshop, it made practical sense to instruct his pupils to draw in his style by supplying them with examples to copy, because this would make them more effective in the production of collaborative studio enterprises, such as large-scale mural decorations and altarpieces. A dispersed album of drawings from around 1450–70 by pupils of Gozzoli gives a flavour of workshop instruction with copies made after now lost studies by their master. These include a life drawing of a model adopting a pose inspired by the classical bronze *Spinario* that was copied by two different assistants; one is in the British Museum (fig. 11) and the other in Rotterdam.[49]

The technical proficiency resulting from an artistic education centred on drawing is readily appreciable from the selected works. The habit of drawing as a means of processing, analysing and recording the surrounding world remained a life-long legacy of such a training. This impulse connects Pisanello's study of a putrefying corpse on a gibbet with Leonardo's anatomical drawing of a male leg (nos 9, 57). For Leonardo in particular, the act of drawing was absolutely essential to the way in which he sought to understand the workings and structure of the human body and countless aspects of nature, from the beating of a bird's wings to the flow of water. Leonardo's scientific interests are not represented in either of the two collections, yet something of the curiosity that drove him, and his search for graphic means to convey the variety and complexity of the natural world, are already present in his celebrated landscape study from the Uffizi that was drawn when he was just 21 years old (no. 49). Leonardo's omnivorous interest in the natural world, and his graphic study of it to record and process his observations, is not typical of most of his artistic contemporaries.

Artists as designers

The majority of studies in the present exhibition are directed towards the production of a painting, although there are exceptions, such as Botticelli's tapestry design (no. 37), that serve as reminders that the dominant taxonomy of the modern museum, with pictures kept separately and elevated above the decorative arts, is not one that accords with Renaissance values. Painters were routinely asked to turn their hand to designing a whole range of objects. Mantegna at the Gonzaga court in Mantua is known, for example, to have been called on to design a shield with Latin verses in antique lettering; jugs and drinking vessels; tapestries and embroideries; sculptures, including a planned monument to the Roman poet Virgil; architecture; and court festivities. Requests for similarly diverse designs are also recorded in payments to Mantegna's younger contemporary, Cosmè Tura, at the Este court in nearby Ferrara. An ability to draw was a fundamental constituent of successful design both in the expression and refinement of the initial concept, as well as conveying the design to the craftsmen responsible for making the finished object. It has recently been argued

that the distinctiveness of Tura's draughtsmanship was a deliberate strategy on his part to differentiate himself from his artistic rivals at court, the singularity of his calligraphy marking out his paintings and his work as a designer.[50] If this is true of Tura then it could also apply to other artists, such as Tura's fellow court artist in northern Italy, Mantegna, and the Florentine Antonio Pollaiuolo, all of whom developed a highly individual graphic style that distinguishes their work across a variety of media.

The activities of court and non-court artists, such as Antonio Pollaiuolo and Finiguerra in Florence, in supplying designs for others were certainly nothing new. Giotto is meant to have designed the bell-tower of Florence Cathedral in the 1330s, and Ghiberti and Donatello supplied drawings for stained glass for the same building. However, it was not until the 1460s and 1470s that a skill in *disegno* was first recognized, at least in written records, by patrons as a defining feature of an artist's work. It is not coincidental that both the Florentine artists, Pollaiuolo and Finiguerra, each described as a '*maestro di disegno*' (the term encompassing a mastery of drawing and design) by the Florentine merchant Giovanni Rucellai (1403–81), were involved in the new technique of engraving brought to Italy from Germany.[51] This technological breakthrough opened up a new avenue for artists to profit from and to gain renown through the duplication of their designs. Early examples of drawings that were engraved include Mantegna's *Virtus Combusta* (no. 22) and Finiguerra's *Moses on Mount Sinai* (no. 28), although it is unlikely that either was created specifically as a design for a print (Mantegna is known, however, to have executed studies specifically to be engraved).[52]

Preparing paintings

The various stages of the preparation on paper that preceded painting a picture are well represented in the selected works. In general the number of surviving studies for any painting from the period is small. An exception is the group of 16 drawings by Raphael, two of which are included (nos 99–100), made in connection with the altarpiece of *The Entombment* now in the Villa Borghese, Rome. What fraction this represents of the total number of preparatory studies he made for the composition is impossible to tell; however, it is clear that the artist took particular pains over the commission due to the altarpiece's location in S. Francesco al Prato, one of Perugia's most important churches. The extent to which an artist felt the need to plan the detail of a painting must have depended on the individual, as well as the demands of the patron, the nature and complexity of the composition, and whether it was a commission outside his normal production. A rough idea can perhaps be gained by looking at sequences of studies by later artists such as the French painter Charles Le Brun (1619–90), whose position as the Premier Peintre du Roi meant that the bulk of his drawings in his studio at his death passed to the royal collection and are now in the Louvre, Paris. Using an example of a fairly simple composition, the poses of the ten figures in the altarpiece of the *Descent from the Cross*, now in the Musée des Beaux-Arts, Rennes, were prepared by Le Brun and his studio in no less than 20 single-sided drawings.[53] While it would be dangerous to conclude that Le Brun's careful preparation mirrors the practice of all Renaissance artists, his academic rigour was consciously modelled on the working methods of Italian painters like Michelangelo and Raphael.

On the basis of the methodical working procedures of artists such as Ghirlandaio and Filippino Lippi, it is possible to gain an idea of the different stages of preparation in the course of working out the final form of a painting. Where a couple of drawings survive for the same work, as is the case with Filippino Lippi's *Resurrection of Drusiana* (nos 67–8), it is generally straightforward to work out the order of their execution, yet it is probably mistaken to infer from this that the preparatory practices of artists in the period were invariably uniform or linear. This is underlined by the difficulty of working out a clear sequence in the few cases where there are a substantial number

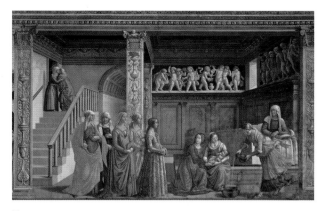

Fig. 12
Domenico Ghirlandaio, *Birth of the Virgin*,
1486–90. Fresco. Tornabuoni Chapel,
S. Maria Novella, Florence.

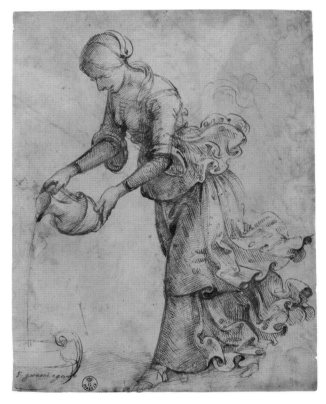

Fig. 13

A study for the figure on the far right of the
Birth of the Virgin fresco above (no. 58).

of studies for a single commission, such as those related to Raphael's *Entombment*. It is nonetheless safe to assume that the starting point for most paintings was an exploratory drawing in which the position and groupings of the figures, and perhaps their relationship with the architectural or landscape setting, were roughly sketched out. Vasari wrote about these kinds of drawings, which he described as sketches (*schizzi*) in the introductory section on technique in his *Lives of the Artists*:

> sketches … are in artists' language, a sort of first drawing, made to find out the manner of the poses, and the first composition of the work. They are made in the form of a stain, and are put down by us only as a rough draft of the whole. Out of the artist's creative fury they are quickly expressed, with the pen or other drawing instrument or with charcoal, only to test the spirit of that which occurs to him.[54]

Rapid inventive drawings of this kind in the selection include examples by – among others – Mantegna, Perugino, Filippino Lippi, Costa and Raphael. The majority of such drawings are executed in pen, often with wash to show the direction of lighting. There are exceptions to this, with artists choosing to compose in chalk or in metalpoint, as in Filippo Lippi's *St Jerome* on the verso of no. 12.

Once the layout of the composition had been established, the next stage was to make more detailed studies of individual figures or groups of figures. A key focus of such drawings was lighting because the illusion of three-dimensionality depended as much on the consistent lighting of all elements in the composition as it did on the application of perspective. For this reason Vasari recommended the use of drawing media that could be manipulated for tonal effects – hence black and red chalk, pen and wash with white heightening or, for the more skilful, pen alone with the white of the paper left as a highlight. The diversity of this kind of considered study is reflected in drawings of individual poses, such as Ghirlandaio's *Woman pouring from a jug* (no. 58; fig. 13) and *St Jerome* (no. 77) by the Venetian painter Giovanni Battista Cima (?1459/60–1517/18), as well as in studies of individual details, like those of heads by Verrocchio (nos 40–1), Lorenzo di Credi (no. 42) and the Venetian artist Alvise Vivarini (1442/53–1503/5; no. 75). Antonio Pollaiuolo's repeated studies of St John the Baptist's hands on both sides of his drawing of the saint (no. 30) give an idea of the extent to which some artists might explore variants of a pose.

DRAPERY STUDIES

The posture and movement of figures in paintings normally needed to be articulated through the clothes covering their forms, and in order to work out this aspect of the composition many artists would make specialized drapery studies. These were executed in a variety of media including silverpoint (Boltraffio, no. 71), brush and wash (Ghirlandaio, no. 60) and distemper on linen (Fra Bartolommeo, no. 89). In the finished painting the significance of drapery in providing a sense of animation to an otherwise static figure, or in reinforcing a particular movement or gesture, can easily be overlooked, and it is therefore instructive to note how much attention was paid to it in preparatory drawings. An emphasis on drapery links the anonymous Florentine studies of four saints from the early 1400s (no. 1) with the figure study executed in the 1490s by Bartolommeo Montagna (*c.* 1450–1523; no. 76), a painter from the city of Vicenza located east of Venice, although the artistic means of describing it are very different. Detailed examinations of drapery were often directed towards enlivening the surfaces of figures, as in Spinelli's double-sided drawing (no. 6) or in Lorenzo di Credi's beautifully executed, if somewhat vacuous, explorations of variants on a sheet in the Uffizi (no. 43). In the hands of the most gifted artists, drapery could add more than just a sense of three-dimensional substance to a figure, as for example with the folds that take on the quality of a panoramic landscape in

Mantegna's *Man lying on a stone slab* (no. 21), or the monumental heaviness of the robes that impart such a physical presence and authority to Michelangelo's so-called *Philosopher* (no. 91).

The manner in which seemingly small changes to the arrangement of the drapery could affect the reading of a figure's attitude and mood is demonstrated by Fra Bartolommeo's two studies (nos 88–9) of Christ for his fresco of the *Last Judgement* for S. Maria Nuova, Florence (now Museo di San Marco, Florence; see fig. 1, no. 88). In the earlier of the two, the chalk drawing in the Uffizi, the artist had it in mind to have Christ looking down to his right towards the condemned souls with his right arm raised to damn them. The flow to the right of Christ's pose is mirrored by the heavy folds of his drapery on the right side of his body; these amplify his silhouette so that he appears even more magisterial. In the London brush-on-linen study Christ's gaze and upper body are to the front, the iconic stillness of the pose reinforced by the spare elegance of his drapery folds. The nuances of pose and drapery that Fra Bartolommeo thus explored before fixing on the finished solution can be followed in no fewer than four studies (the other two are in Rotterdam, figs 1–2, no. 89), a further indication of the vital importance of drawing in his working practice.[55]

FINISHED DRAWINGS AND CARTOONS

The refinements worked out in individual studies of figure and costume might be distilled at the next stage into a finished design that could serve as a template for the painted composition. Such a drawing might have the added purpose of demonstrating to the patron the intended form of the finished work. A documented example of such an occurrence is the 1485 contract for the Tornabuoni Chapel in S. Maria Novella in Florence, in which the patron, the Florentine banker Giovanni Tornabuoni (1421–97), ordered that the frescoes could not be painted by Ghirlandaio until he had first seen compositional drawings of them.[56] This category of finished drawing shown to Tornabuoni is now commonly referred to as a *modello*, a terminology sanctioned by fifteenth-century precedent although it should be noted that it was one also applied to three-dimensional sculptural or architectural models.[57] Finished compositional drawings were a distillation of the artist's previous drafts and they are recognizable by the much more studied, controlled pace of execution, as can be seen from a comparison between Filippino Lippi's fluid sketch for the *Raising of Drusiana* (no. 67) and his *Triumph of St Thomas Aquinas* (no. 66), and the two drawings by Costa (nos 84–5). It is rarely the case that the painting concurs exactly with the finished compositional drawing because the artist almost inevitably continued to revise his ideas, even while working with the paintbrush in hand. Moreover, it cannot be assumed that a highly pictorial drawing was necessarily the final one just because it is the most finished surviving study. It seems likely that Lippi made more studies for the *Aquinas* composition, since the London drawing differs in so many details from the fresco, and it also includes alternative solutions to the architecture at the lower edge.

In the case of Carpaccio's *Vision of St Augustine* (no. 80) it seems improbable that the changes in detail between it and the canvas would have required another detailed drawing, although he almost certainly would have made a specialized study for the figure of the saint, whose costume and features are only lightly indicated in the London sheet. The level of detail in Carpaccio's drawing is unlike anything else in his graphic corpus, such as the *Triumph of St George* (no. 79), and indeed it stands out even when compared to finished compositional designs by his northern Italian contemporaries, such as the examples by Bramantino (no. 73) and Solario (no. 74). It is possible that the level of finish of the St Augustine drawing is related to Carpaccio's highly abstract rendering of the subject matter, which is faithful to the miracle's textual source: a letter allegedly written by Augustine described a blinding light accompanied by the voice of the recently deceased St Jerome. The Venetian painter's rejection of the

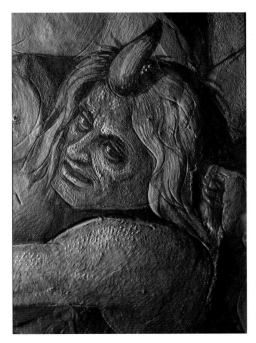

Fig. 14
Luca Signorelli, *A devil* (detail from the *Last Judgement: the Damned*), 1499–1503. Fresco, S. Brizio Chapel, Orvieto Cathedral.

The contours of the cartoon have been incised into the wet plaster before painting.

Fig. 15
Infrared reflectograph detail of Raphael's *Road to Calvary*, c. 1504. Egg tempera and walnut oil on panel, National Gallery, London.

The traces of pouncing beneath the underdrawn outlines of the figures demonstrate the use of a pricked cartoon.

conventional solution of showing St Jerome appearing to Augustine, as his compatriot and contemporary Giovanni Mansueti (active 1485–1526/7) did in his painting of the subject now belonging to the Ministry of Culture, The Hague, presumably required his pictorial solution to be scrutinized in advance with particular care.[58] How Carpaccio proceeded to enlarge the composition to that required for the canvas except by freehand reckoning is a mystery, since like all his designs of comparable type there is no squaring and the contours have not been incised with a stylus to transfer them to another sheet.

A finished drawing might be judged a sufficient guide to make an underdrawing on the panel, canvas or on the foundation layer of plaster (the *arriccio*), or for greater precision an artist might choose to create a 1:1 scale drawing known as a cartoon, a word derived from the Italian for a large sheet of paper, *cartone*. The use of cartoons for the production of stained glass and textile patterns is discussed by Cennini, and drawn templates of this kind are known to have been used by fourteenth-century painters for repeated decorative motifs (akin to the pricked design of a patterned relief found on the Ghirlandaio *Visitation* study, no. 59).[59] The contours of the cartoon could be transferred to the wall or panel either through incising the lines with a sharp instrument (fig. 14), or by laboriously pricking the outlines with a pin and dusting or pouncing charcoal or chalk dust through the holes to the surface below (fig. 15). The method of transfer can be divined from looking at the underdrawing or incisions visible to the naked eye due to the thinning of the paint over time, or by infrared reflectography. The idea of preparing cartoons for paintings was an innovation that developed in the 1430s and 1440s through the practice of painters working in central Italy like Uccello, Domenico Veneziano (active 1438–61) and Piero della Francesca (c. 1415–92). The advantage of making same-size drawings rather than drawing freehand on the wall or panel was the ability to plan details carefully in advance, such as a consistent scale from the foreground to the background figures, and the precision such preliminary work ensured in the resulting underdrawing.

The accuracy in the transmission of a design from paper to the finished painting meant that an artist running a busy workshop, an enterprise that inevitably involved artists of varying levels of skill and experience, had a better chance of maintaining the quality and stylistic homogeneity of the output. Ghirlandaio is the classic example of a painter whose success at running a highly efficient, productive workshop centred on his skills as a designer, and this was a model that was developed even further by Raphael after his move to Rome. A cartoon had the added advantage that it could be used repeatedly, if necessary with the pose reversed by turning it over, as Piero della Francesca did for the two flanking angels opening up the pavilion to reveal the pregnant Virgin in his fresco of the *Madonna del Parto* painted for S. Maria di Momentana, Monterchi, in Tuscany. The possibilities for using cartoons for large-scale production of paintings was quickly realized, as is perhaps best exemplified by the group of more than 150 pictures by the Pseudo Pier Francesco Fiorentino, an anonymous Florentine painter operating a workshop from the late 1450s to the mid-1490s, whose stock of figures was derived from Francesco Pesellino (c. 1422–57) and Filippo Lippi (and to a lesser extent his son Filippino).[60] Perugino can be shown to have reused cartoons for altarpieces and smaller devotional works when he was running productive studios in Florence and Perugia in the 1490s.[61]

For most of the period covered in this book the high cost of paper meant that artists made cartoons only for small-scale work, such as Raphael's *St George* (no. 97), or for important details in larger ones, like the *Head of Charity* by Piero Pollaiuolo (no. 33). It was relatively straightforward to make a cartoon for a small-scale painting but, in the case of an altarpiece or a fresco cycle, making a same-size drawing of the principal figures entailed pasting together numerous sheets of paper and scaling up the preliminary studies. The principal method of enlarging was through squaring as can be seen on, for example, Signorelli's group of shepherds (no. 62) or Raphael's study for the main group in the *Entombment* (no. 100). The contents of each square in

the drawing would be copied to one of a larger dimension on a cartoon, or using a grid ruled directly on to the painted surface. Raphael's study has two slightly different squaring grids, the first in red chalk and stylus overlaid by a slightly smaller one in pen and ink. The first of these allowed him to copy the group of figures, most likely from a previous smaller-scale study and, when he had finished, the second grid would have facilitated his copying the design to the surface of the panel.

The survival of different categories of drawings

Cartoons related to smaller paintings, embroideries and fragmentary figures from mural schemes survive in relatively large numbers from the latter part of the fifteenth and early sixteenth century, in contrast to the few that are known for large-scale commissions, such as Raphael's *School of Athens* cartoon in the Pinacoteca Ambrosiana, Milan, for the fresco in the Stanza della Segnatura in the Vatican Palace. The fragility of multi-sheet cartoons accounts for the loss of the two pioneering examples of the genre, Leonardo's *Battle of the Standard* and Michelangelo's *Bathers*, which were executed in the first decade of the sixteenth century in preparation for the central sections of abortive battle murals in the Palazzo Vecchio in Florence. This is another example of the uneven survival rate of certain classes of drawings that was mentioned previously in reference to portrait studies. Broadly speaking, the more useful a drawing could be in the preparation of different kinds of paintings, the more likely it was to be preserved. Hence figure drawings, whether of an individual pose, such as Antonio Pollaiuolo's *St John the Baptist* (no. 30) or Perugino's *Sibyl* (no. 46), or a specific detail of one, such as Verrocchio's and Lorenzo di Credi's studies of female heads (nos 40, 42), survive in greater numbers because their content could be adapted for figural ideas in all kinds of painted compositions. This process can be seen at work in the transformation of the Turkish janissary recorded in Gentile Bellini's drawing, based on first-hand observation from his period in 1479–81 at the court of Sultan Mehmet or Mehmed II (1432–81) in Constantinople (no. 17), to that of the persecutor directing the archers in the fresco of the *Martyrdom of St Sebastian* painted between 1492 and 1494 by the Umbrian painter Bernardino Pintoricchio (*c.* 1452–1513), in the Borgia apartments in the Vatican Palace (fig. 2, nos 17–18). How Pintoricchio got hold of the Venetian's studies of Turkish figures made a decade earlier, or more likely copies made after them, can only be guessed at, but it underlines the fact that the portability of drawings made them an ideal conduit for the spreading of new artistic ideas and motifs.

Much less likely to be preserved either by an artist or his heirs were initial composition studies, as such rapidly sketched inventions were of limited value once the final design had been reached. It is fair to assume that drawings of this kind must have been a common starting point in the design of all but the most basic paintings, yet this is not reflected in what has come down to us from the period. For example, even a fairly elastic interpretation of what constitutes an exploratory compositional study only accounts for a little more than 10 per cent of the 353 drawings included in A. E. Popham and Philip Pouncey's catalogue of Italian fourteenth- and fifteenth-century drawings in the British Museum. The unequal rates of survival for compositional as against figural studies in the passing down of graphic material from one generation to the next, not to mention how highly they were valued and therefore looked after by subsequent collectors, can hardly be overstated. Against this background the survival for more than 500 years of early compositional studies like the ones by Lorenzo Monaco (no. 4) and Mantegna (no. 20) is even more remarkable.

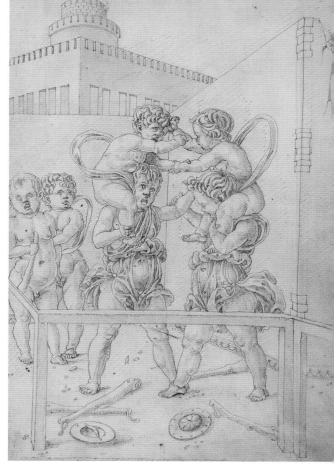

Fig. 16
Marco Zoppo, *Rosebery album* (no. 25), folio 3 recto: *Fighting children*; verso: *Head of a man with a helmet, c.* 1455–65. Pen and brown ink on vellum, 21.8 × 15.8 cm. British Museum, London.

Zoppo's drawings in the *Rosebery album* are executed on vellum made from treated calf, sheep or goat skin. The recto is drawn on the smooth side of the vellum sheet and the verso on the hairy side (the slightly speckled surface is due to the hair follicles). In the album the openings alternate between smooth and hairy to ensure visual unity.

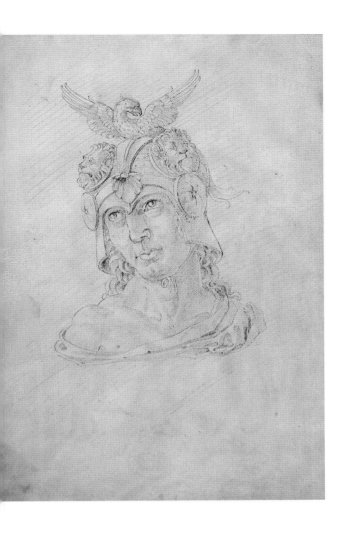

The technique of Italian Renaissance drawings

Drawing surfaces

WOODEN TABLETS

The works in the catalogue are all drawn on one of two materials, vellum or paper. The small panels of close-grained wood, box (*bosso*) or seasoned fig (*figàro ben vecchio*), prepared with a bone ground that Cennini recommended for apprentices to begin drawing on with metalpoint, are not represented since there are no known Italian examples. A few such drawings by northern European artists from the period survive, such as the seven panels attributed to the Netherlandish illuminator, Jacquemart de Hesdin (active 1384–d. after 1413) in the Pierpont Morgan Library, New York, and the 14 maplewood tablets by a Bohemian hand, *c.* 1400–10, in the Kunsthistorisches Museum, Vienna.[62] The advantage of tablets covered with bone, or wax, which performed the same purpose, was their impermanency, as the efforts of the apprentices could be erased without spending money on vellum or paper. In the view of Alberti in *Della pittura* (1436), such advantages were outweighed by the miniaturist tendency that the scale of the tablets engendered. He recommended instead that artists would be better off making large drawings because learning on small panels might potentially mask flaws in their work: 'in small drawings every large weakness is easily hidden; in the large the smallest weakness is easily seen.'[63]

VELLUM

Vellum was an expensive material to produce because the calf, sheep or goat skin required extensive preparation to make it a suitable drawing surface. It had to be washed several times, treated with lime, the hair removed, stretched, scraped to pare away impurities and then rubbed with chalk and pumice to smooth the surface. Its use declined during the course of the fifteenth century due to the increasing popularity of paper, a trend that was greatly accelerated when the printing press with movable type was imported to Italy from Germany in 1465. By the end of the century books were being printed in more than 80 locations in Italy, with more than 150 presses in operation in Venice alone.[64] As paper production increased it became much cheaper than vellum. A concrete example of the price differential can be gleaned from a 1476 inventory of a Florentine stationer, where 500 sheets of Bolognese papers measuring roughly 35 × 50 cm (*mezzano*) were valued at 110 *soldi* (0.22 *soldi* for a single sheet) as against 3 *soldi*, the price of just over 14 pieces of paper, for a single leaf of burnished goat kid vellum of the same dimensions (*capretto; formato mezzano Bolognese, rasati*).[65] The costliness of vellum counted in its favour for drawings intended to impress, hence its use for presentation works such as Pisanello's *Three men* (no. 8), Zoppo's *de luxe* drawing album (no. 25), and Francesco di Giorgio's *Hippo* (no. 35). Zoppo's album has been rebound and the order of its contents changed, but according to the old numbering it followed the so-called 'Gregory's Rule' found in most vellum codices that openings of the smoother and lighter coloured flesh side alternate with those of the hair side where the follicles could sometimes darken and coarsen the surface (fig. 16).[66] The durability of vellum also made it ideal for drawings that needed to be hard-wearing enough to withstand multiple usages in the studio, such as model-book pages like no. 2, or compendia of architectural or engineering studies, like the volume in the British Museum of military and civil machinery designs by Francesco di Giorgio and his studio.[67]

Fig. 17
Jost Amman, *The papermaker*, 1568. Woodcut,
7.9 × 6 cm. British Museum, London.

This is taken from a book with 133 woodcuts,
Panoplia omnium illiberalium mechanicarum
(Book of Trades), published in Frankfurt in 1568.

PAPERMAKING

The technique of papermaking invented by the Chinese in the first century AD
passed to the Islamic world and then through the Muslim occupation of southern
Spain to Europe by the mid-twelfth century.[68] The process was known in Italy by
the thirteenth century, initially in Liguria and then Fabriano, where technological
advances in the production meant that Italian paper manufacturers long dominated
the European paper trade.[69] The raw material of paper was linen flax from old clothes,
and hemp from sails and ropes, which were moistened to hasten decomposition,
washed and beaten to a fibrous pulp by water-driven stamping hammers. A woodcut
by the Swiss artist Jost Amman (1539–91) representing a papermaker at work includes
the latter mechanism in the background (fig. 17). Amman's print shows the papermaker
or vatman dipping his mould, a wire screen mesh with a detachable wooden-frame
surround, into the pulpy aqueous mixture contained in the vat. The vatman had to
be skilled to ensure that an even layer of pulp was deposited on the screen when the
excess water drained away. He worked in tandem with a coucher (from the French
to lie something down) who would take the mould with the wet sheet and give his
partner a new one in return. The coucher would turn the screen upside down to
deposit the soggy sheet on to a woollen blanket called a felt, the short fibres of
which can often be seen embedded into the paper surface. In Amman's print the
youthful coucher is depicted carrying a pile of felts to the press in the background.
After several pressings to squeeze out moisture the sheets were hung on lines in
drying lofts for a couple of days. The penultimate stage was to dip the paper into
a thin gelatinous mixture of glue-like animal size to make it impervious to ink. The
sheet was then pressed, dried for the last time and, depending on the quality of
the paper, the surface was polished.

The impress of the papermaking mould can be seen when paper is held to the light, since the paper is thinner where the wires pressed against it. The chain lines are the thicker parallel lines, while at right angles to them is the fine mesh of the metal screen, the laid lines (fig. 18). From the late thirteenth century Italian paper manufacturers in Bologna and Fabriano began to identify their wares through sewing a shaped piece of wire, known as a watermark, to the wire screen of the mould. Similar watermarks could be used by the mill for long periods so they rarely provide a secure method of dating; however, when a comparable type is found on drawings, documents or in books from a particular region they can be a useful pointer. For example, similar Milanese watermarks of an eight-petalled flower are found on drawings by Leonardo, his pupil Boltraffio and Bramantino (fig. 19).[70] When two drawings were executed on pieces of paper with identical watermarks and structure, as is the case with the flower watermarks on Leonardo's two studies of a child with a cat (nos 51–2), it is strong evidence that they were executed at much the same time since they must come from the same batch of paper acquired from a stationer (*cartolaio*).

TONE AND COLOUR OF PAPER

The appearance of Renaissance paper was never entirely uniform as it was affected by the quality of the raw materials, the efficiency of the mechanism in reducing the rags to fibres and the purity of the water. The best-quality paper had a smooth, even surface and a creamy tint, qualities still visible in the Bellini album (no. 16) where the pages have not been exposed to light. Cheaper poor-grade paper is identifiable through its greyer shade and lumpier surface due to the cloth not having been sufficiently broken down. Such paper can be seen in Mantegna's study of *St James on his way to execution* (no. 20).

The use of blue paper, made either from blue rags or through dyeing the fibrous pulp with indigo, is generally associated with Venetian artists in the second half of the fifteenth century, such as Vivarini (no. 75) and Cima (no. 78), as well as those who followed them, like Jacopo Tintoretto (1519–94) and Paolo Veronese (1528–88). The

Fig. 18
The structure of the paper including the chain and laid lines and watermark are revealed in this infrared reflectograph of no. 93 seen from the recto.

Fig. 19
Milanese eight-petalled flower watermarks found on paper used by Leonardo, Boltraffio and Bramantino (nos 57, 71, 73).

19 (57)

19 (71)

19 (73)

manufacture of blue paper was not, however, limited to the Veneto and there are a number of examples of fifteenth-century drawings on it by non-Venetian artists.[71] The chromatic possibilities of blue paper combined with wash and white heightening are exemplified by Carpaccio's double-sided drawing in London (no. 81). The blue tone of the paper rarely survives in such excellent condition and has more often faded to a muted green-grey through exposure to light, as can be seen by comparing the tonality of the two sides of the Titian portrait sheet (no. 101). Cream or off-white paper could be coloured by rubbing red chalk to produce a warm flesh tone ideal for figure drawing, as seen behind the main figure in Botticelli's *Abundance* (no. 36), or the same material could be turned into a powder and mixed with water so that it could be brushed on, as in Leonardo's study of a leg (no. 57). More opaque grounds, akin to the ones used for metalpoint drawings, are occasionally encountered as in the brick-red background seen in Cima's *St Jerome* (no. 77).

MEASUREMENT AND COST OF PAPER

The measurements of the paper on which the drawings were executed have similarly been subject to change. It is fair to assume that most studies were executed on larger sheets that have been trimmed down, either to remove damaged areas, or by the action of collectors and dealers multiplying their holdings by division. Obvious examples of trimmed sheets include the Parri Spinelli (no. 6), the Signorelli head (no. 64), and the Michelangelo study in the Uffizi (no. 94) that has the lower half of his study after a Donatello marble (figs 20–21). The formats and sizes of paper made in Bologna, one of the major centres of paper manufacture in Italy along with Fabriano in the Marches, are known from a record of them carved into a stone slab from the late fourteenth or early fifteenth century originally located in the Società degli Speziali, the trade guild to which the papermakers belonged: *imperiale* (51 × 74.1 cm), *reale*, or royal (45.2 × 61.7 cm), *mezzana* (35.2 × 50.3 cm) and *rezzuta* (32.1 × 45.1 cm).[72] To give a sense of these measurements, the central sheet of the Piero di Cosimo landscape at 45 × 51.8 cm (no. 70), or the Bramantino *St Sebastian* at 40.4 × 57.2 cm (no. 73), are not far off the dimensions of a Bolognese *reale* sheet. Artists must have routinely cut down royal sheets to size, as for example is the case with Raphael's *St George* (no. 97), and later collectors have probably reduced the dimensions of most Italian Renaissance drawings even further.

Despite the increase in its production, paper was an expensive commodity in the Renaissance: in the mid-fifteenth century it is reckoned that a sheet of the best paper cost a week's wages of an agricultural labourer.[73] A measure of the expense of the material is the way in which artists were commonly either supplied or reimbursed for the cost of buying paper: Tura is known to have received paper in 1457 to make cartoons (*modelli*) for tapestry hangings with the Este arms to be woven in Bruges, while the Sienese painter known as Sodoma (1477–1549) was bought a quire, 24 or 25 sheets, of royal-size paper at a cost of 12 *soldi* (*quinterno di carta reale*) in 1506 in preparation for painting in fresco the cloister of the monastery of Monte Oliveto Maggiore near Siena.[74] The cost of paper explains why artists used it sparingly, hence the frequency with which both sides of the sheet were drawn on. In the majority of cases the artist simply turned the sheet over when he had run out of room on one side, as with the Pollaiuolo *St John the Baptist* (no. 30) or Verrocchio's female head (no. 40), but it cannot always be assumed that recto and verso are contemporaneous. The stylistic difference between the two sides of one of Michelangelo's drawings (no. 91), the figure on the recto probably predating the head on the verso by about eight years, indicates that the notoriously parsimonious sculptor went through his stock of studies to find one with an unused reverse. His master, Ghirlandaio, was no less sparing in his use of paper, as he reused the verso of the sheet on which he had drawn a study of a *Visitation* for the fresco in the Tornabuoni Chapel in S. Maria Novella for a pricked cartoon of a decorative moulding found in the fictive frames that divide the scenes (no. 59).[75]

Fig. 20
Donatello, *David*, c. 1408–10. Marble, h. 191 cm. Museo Nazionale del Bargello, Florence.

Fig. 21
Verso of no. 94

This truncated copy by Michelangelo after Donatello's *David* demonstrates that the original sheet was at least twice as large as it is now.

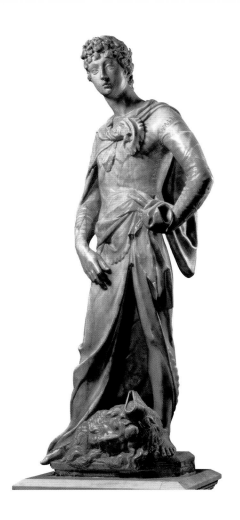

Drawing materials

METALPOINT

During the period covered in this catalogue the drawing materials favoured by artists changed, most notably in the steep decline of metalpoint after 1500. As the name implies, metalpoint was a sharp-ended stick of soft metal, usually silver or a silver alloy, hence the common description of the medium as silverpoint, which left a mark when used on a drawing surface coated with calcined bone to give it sufficient roughness or 'tooth' so that a deposit of the metal would be left on the surface.[76] The preparation of the paper or vellum was time-consuming as it required several layers of calcined bone to be brushed on and the surface to be burnished, or polished, so that it was uniform. The preparation or ground would often be tinted with pigment so that the dark lines of the metalpoint, often augmented by the addition with a brush of lead-white highlight (a chemical compound formed by the reaction between lead and weak vinegar fermented in manure), would stand out. The colours of the prepared papers used for metalpoint in the present selection give an idea of the range of shades available to artists, with darker hues of blue and purple contrasting with lighter ones in grey, sandy yellow or pink (fig. 22). Metalpoint was a particularly challenging medium because the options for correcting a line were limited: either the artist had to rub it with a moistened finger or cloth, thereby disrupting the evenness of the ground (as can be seen in the amended area in no. 1); or the offending area could be covered over with a fresh ground. Ultraviolet-induced luminescence imaging has revealed that in the lower right corner of no. 71 Boltraffio painted a blue ground to hide an abandoned drapery study (see fig. 2, no. 71).

The tonal range of metalpoint was limited, which meant that shifts from dark to light had to be achieved through changes in the density of the hatching – the closer the lines the darker the tone. Leonardo's *Warrior* (no. 50) is a virtuoso example of what could be achieved with metalpoint. In Leonardo's eyes the permanency of metalpoint was an advantage, and he advised young artists to build up a store of the 'positions and actions of men' by jotting them down in a notebook with coated pages so that they could not be erased.[77] Metalpoint was well suited to sketching because it did not require recharging with ink like a pen, so that the artist could draw uninterruptedly. The spontaneity and liveliness of metalpoint in the hands of a talented draughtsman are exemplified by Filippino Lippi's two studies in the medium, one of posed models and the other an improvised drawing of two figures for a fresco (nos 65, 68).

The catalogue includes an example of a metalpoint drawing by Raphael (no. 96), who was the last great exponent of the technique. He may well have been encouraged to take it up by Perugino, who was skilled in its use, and Raphael's example doubtless inspired the occasional use of the technique in Rome in the 1520s by his Florentine pupil Perino del Vaga (1501–47), and by his keen posthumous admirer, Parmigianino. After this date it was rarely employed by artists south of the Alps.[78] The precision and linearity of silverpoint were qualities that recommended its use to central Italian artists, but the more atmospheric approach of Venetian artists, with light and shade rather than contour in the ascendancy during this period, meant that it was rarely employed by Venetians except at the beginning of the century.[79] The exception to this is Jacopo Bellini, who used silverpoint in his vellum album now in the Louvre, an anomaly that can perhaps be explained by his training with the central Italian artist, Gentile da Fabriano.[80] (Pisanello's employment of silverpoint may also be traced back to Gentile, as he was most likely a fellow pupil of his in Venice in the period 1408–14, along with Bellini.)[81]

(11)

(12)

(13)

(61)

Fig. 22
Details of differently coloured prepared grounds for metalpoint drawings in clockwise order from top left: Filippo Lippi (nos 11 recto and 12 recto); Domenico Ghirlandaio (no. 61); and Benozzo Gozzoli (no. 13).

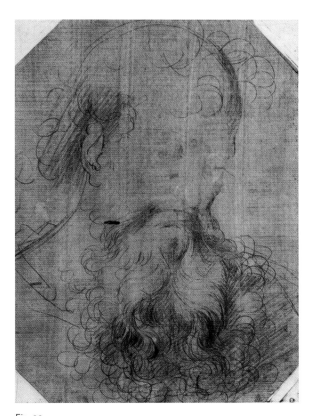

Fig. 23
Infrared reflectograph of no. 47.

The silverpoint is almost entirely transparent
to infrared radiation, while leadpoint is opaque.
This contrast allows the different media used
for the drawing to be seen clearly.

A significant factor in the decline of metalpoint in the latter part of the fifteenth century was the increasing popularity of oil rather than tempera (egg yolk) as a binder for pigments. The precision and forethought required in drawing in metalpoint, with tonal gradations from light to dark achieved through slight changes to the density of the parallel hatching, was an ideal preparation for the technique of painting in tempera. The rapid drying of the egg binder and the inability to blend the colours when working in tempera meant that the artist had to build up the shading and colour through repeated thin applications of pigment, the transitions between the tones blended and softened by the intermeshing of the hatched brush strokes. The ability to manipulate and mix oil paint gave painters new freedom and encouraged much greater tonal contrasts, and as a consequence they gravitated towards drawing techniques like pen and wash or chalk that mirrored the qualities of the new painting medium.

LEADPOINT

Leadpoint is a form of metalpoint, but it differs in not needing a prepared ground as the soft metal leaves a mark on untreated paper or vellum. It had the added advantage that the line could be easily erased with a piece of bread. Leadpoint was convenient to use but its sharpened tip quickly wore smooth, and its soft, lustrous line did not adhere well to paper, as can be seen from the faintness of the drawings in the London Bellini album (no. 16). Leadpoint underdrawing, recognizable by the thin, slightly shiny quality of the line and verified by X-ray fluorescence (XRF) examination, can be seen beneath some of the pen sketches of a child playing with a cat by Leonardo (nos 51–2), and it was also utilized by Michelangelo to study the Virgin and Child in the Uffizi sheet (no. 94). The slight difference in colour between the tarnished brown of silverpoint and the darker hue of leadpoint can be observed in the Filippino Lippi study of nudes (no. 65). Infrared reflectography has shown that the study was drawn using the two techniques (the silver-based material is transparent while lead is opaque to infrared radiation). The figure on the left was drawn with a metalpoint made up of silver and a little tin while the one on the right was made with lead-based metalpoint. Lippi added a few curls of hair in leadpoint to the seated figure on the left, which demonstrates that the right-hand figure was drawn later. In all likelihood there is no significance to Lippi using two different metalpoints on the same sheet in this instance: he probably simply reached out for the nearest one to hand when he decided to fill the space on the right of the sheet.[82] Conversely, in Perugino's study of a male head (no. 47), the combination of the two techniques was unquestionably premeditated. The leadpoint was used for the contours and for the man's hair and curly beard, while the sharp precision of silverpoint was reserved for the detailed description of the features, most notably the downcast eyes. This dichotomy is shown best in infrared, which detects leadpoint, whereas the silverpoint is almost transparent (fig. 23).

STYLUS OR BLIND STYLUS

The last form of metalpoint is a stylus, sometimes known as a blind stylus: a stick of hard metal like iron that left no metallic deposit, but was capable of scoring the paper with its sharpened end. The stylus allowed the artist to experiment with figural and compositional ideas with complete freedom, without risking ruining a relatively expensive piece of paper by marking it with chalk or ink. When this process was complete, the scored lines of the preferred solution served as a preliminary guide when the artist turned to more visible drawing materials. The practice of making a preliminary stylus underdrawing was widespread, as can be seen from its use among the works in the catalogue by Filippo and Filippino Lippi, Uccello, Jacopo Bellini, Mantegna, Leonardo and Raffaellino del Garbo (fig. 24), Michelangelo and Raphael.

It often goes undetected, as the surface of most drawings has generally been flattened over the centuries.

The other use of a stylus was to press down on the contours of a design so as to transfer it either to the other side, or to another piece of paper (to facilitate the process a sheet of paper blackened with chalk could be pressed against the back to act in a manner identical to carbon paper duplicating documents in old-fashioned typewriters). The black chalk outlines of the figure in the Boltraffio drawing (no. 71) were probably made using this transfer method as is shown by the evenness of the contours, as was the reversed copy of Leonardo's design on the verso of no. 56, created by incising the outlines from the recto.

BLACK CHALK

The material of black chalk, in geological terms a type of soft carbonaceous schist, seems not to have been commonly used at the end of the fourteenth century, at least in Tuscany, to judge from Cennini's description of it in his manual: 'I have come across a certain black stone, which comes from Piedmont; this is a soft stone; and it can be sharpened with a penknife.'[83] However, Cennini's stated preference for charcoal may not have been shared by his contemporaries since the underdrawing in the double-sided anonymous Sienese study from the early 1400s (no. 3) seems to be black chalk. Black chalk was sufficiently dense to allow its tip to be sharpened to a point, so that it could register fine detail and changes in emphasis through lightening or increasing downward pressure, while at the same time it allowed subtle gradations of tone by blending areas of shade with a fingertip or a stump (a coil of leather, paper, or felt with blunted ends). Although black chalk is occasionally present in drawings executed before 1450, it is only in the second half of the century that its use became more widespread both in north (with artists such as Mantegna, Carpaccio and Vivarini) and central Italy (including Antonio Pollaiuolo, Verrocchio and Leonardo). The Tuscan painter Luca Signorelli was particularly sensitive to the expressive and atmospheric possibilities of black chalk for figure studies, as can be seen in his use of it (combined with red chalk) in his study of devils (no. 63).

CHARCOAL

The density and variety of a black chalk line differ from the soft evenness and brittleness of one drawn in charcoal – sticks of wood carbonized by placing them in an airtight container in the embers of a fire – although the two techniques are often difficult to tell apart. As the scientific method of analysing carbon-based techniques, Raman spectroscopy (see appendix on p. 331), cannot differentiate between black chalk and charcoal, the only way of doing so is by examination under a microscope, where the powdery quality of a charcoal line differs from a harder, more defined one in black chalk. Such distinctions are admittedly often hard to make, especially when the surface of the paper has been rubbed. Microscopic analysis has revealed that the Signorelli study of shepherds (no. 62) is definitely charcoal; the Verrocchio head of a woman is also probably in the same medium (no. 40).[84] The ease of drawing with charcoal, as well as the ability to brush it across the surface of the paper to create broad areas of tone, made it a favoured technique for large-scale drawings like cartoons. Piero Pollaiuolo used it even in the relatively compact cartoon of the head of *Faith* (no. 33), as did Filippino Lippi for the sketch of Drusiana on the verso of no. 67, while Piero di Cosimo did the same in his much larger landscape (no. 70). Charcoal, as well as chalk, could be soaked in linseed or olive oil to darken the tone; the velvety tones of some of the contours of the Piero di Cosimo are due to this combination, and it is likely that oiled charcoal was also used in Verrocchio's female head. This also helped the soft, splintery charcoal medium to bond better with the paper.

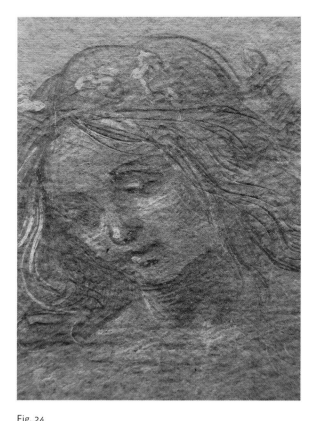

Fig. 24
Detail of no. 69

Raffaellino's scoring of the surface of the paper with a stylus to make a preparatory underdrawing is visible in raking light.

RED CHALK

Red chalk, an earth pigment formed from clay coloured by iron oxide, is one of the most ancient drawing materials, but it was little used in Italy until the second half of the fifteenth century. It is hard to account for this, since red chalk was used to rub the surface of the paper to give it a warm tone, as is the case with the Sienese and the Lorenzo Monaco drawings from the early 1400s (nos 3, 4), and mixed with water and applied with the brush as in Pisanello's volume of drawings (the so-called *Album rouge*) in the Louvre, Paris.[85] The earliest example of red chalk used as a drawing material in the present catalogue is Piero Pollaiuolo's head of *Faith* from the late 1460s, in which it is combined with charcoal (no. 33). Leonardo is generally credited as a pioneer in the use of red chalk on its own from the 1490s following his move to Milan (no. 55). In his studies for the *Last Supper* fresco begun *c.* 1495 in the refectory of S. Maria delle Grazie, Milan, Leonardo brought a new naturalism to drawing the figure by exploiting the warmth and flesh-coloured tones of the medium, qualities that would be explored further by later Florentine artists like Michelangelo, Andrea del Sarto (1486–1530) and Jacopo Pontormo (1494–1557). In common with all chalks, red chalk was subject to variation in its density and colour. The sharp, etched quality of the hatching in Leonardo's Milanese period drawing (no. 55) denotes his use of a hard piece of chalk, the tip of which could be sharpened, while he employed a softer, crumblier stick for his later study of a leg (no. 57).

CHALKS AND THE USE OF LEAD WHITE

The colouristic effects of combining two chalks of different colours (red, black or the rarely encountered white chalk, as found in Titian's portrait, no. 101) are sometimes explored in drawings of the period, as is the case with Signorelli's and Aspertini's use of red and black chalk (nos 63, 86).[86] However, it is more common to find red or black chalk combined with lead white brushed on as a highlight. The opaqueness of lead white also led to its use as a form of correcting fluid to obscure details that the artist wished to cover over, as can be seen in one of the Lorenzo di Credi drawings (fig. 25), in which the medium has become transparent over the centuries, so that the once-concealed passage is now visible. Lead white is also prone to discoloration, darkening to a blackish tone. This process of transformation of the lead white from light to dark is generally incorrectly described as oxidation (conversion into an oxide or an oxygen-containing compound), but in fact chemical reaction with sulphur-containing compounds in the atmosphere is likely to be involved in most cases, leading to the formation of black lead sulphide.

PEN AND INK

The favoured drawing instrument throughout the fifteenth and sixteenth centuries was unquestionably pen, a feather quill whose tip was sharpened to a point and then dipped into ink. The nib could be trimmed to various thicknesses so that it could produce lines of remarkable thinness, as in Pisanello's description of corpses (no. 9) and Gentile Bellini's two Middle Eastern costume studies (nos 17–18), or much sturdier ones as favoured by Finiguerra in the two drawings from the Uffizi (no. 26). The natural springiness of the pen made it react to the slightest change of pressure, the sharpened nib flexible enough to make straight and curved lines of varied lengths and thicknesses. This variety is exemplified by Antonio Pollaiuolo's study of *St John the Baptist* (no. 30), which includes long, flowing contours and multi-directional shading of varied widths used for the internal modelling. The responsiveness of the pen made it the preferred instrument for spontaneous, fast-paced inventive drawing when the artist wanted to stimulate and then keep up a flow of ideas with only minimal interruption to recharge the nib with ink. The continuity of Renaissance drawing practice is underlined by the fact that Lorenzo Monaco in the early 1400s and Michelangelo a century later both reached for the pen to sketch out ideas for figural poses.

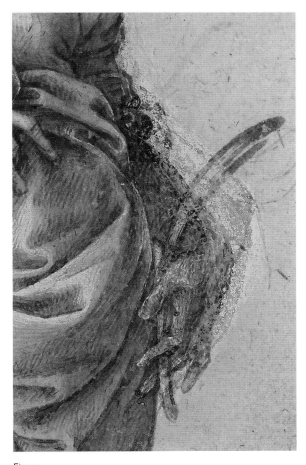

Fig. 25
Detail of no. 43

The artist has used lead white to cover over part of the figure's left arm; over the centuries the pigment has become more transparent so that this alteration can be seen.

The colour of the ink in such studies would have quickly turned from dark grey to an intense black, but this same chemical ageing process has resulted in a further alteration of the colour from black to the familiar chocolatey brown tones of most Italian Renaissance drawings. It should therefore be kept in mind that all drawings described as pen and brown ink were originally pen and *black* ink. The change in colour was due to an Italian preference for iron-gall ink that was not chemically stable like the black carbon ink (soot mixed with water and a gum binder) commonly used by their northern counterparts. Iron-gall ink was made from crushed gallnuts, the fibrous spherical growths formed on the bark of oak trees around eggs laid by insects such as gall wasps. The tannins and gallic acid from these gallnuts were extracted by infusing them in water or wine and then mixing the liquid with copper or iron sulphate. The resulting ink was acidic and this sometimes resulted in it eating away the paper in heavily inked passages. If an artist used two separate batches of ink in a single drawing, variations in the recipe and the raw materials sometimes caused them to age at a different rate, so what originally appeared uniformly black can now be differentiated through the variation in colour of the two inks. Such changes can be witnessed in the darker accents of Fra Bartolommeo's retouches to the Virgin and Child in no. 87 and the golden-brown hue found in parts of Michelangelo's so-called *Philosopher* (no. 91).

WASH AND LEAD WHITE

The tonal range of pen and ink could be widened by combining it with two media applied with a brush: wash for shadows and lead white for highlights. Most often the wash consisted of the ink employed in the drawing mixed with water, and possibly some form of binder like gum arabic. By altering the dilution of the wash its transparency and tone could be varied, as is exemplified in Bramantino's masterful use of the medium in no. 73, executed entirely with the brush. The pictorial combination, '*molto alla pittoresca*', as described by Vasari in *Lives of the Artists* (1550 and 1568), of ink and wash with highlights supplied by white heightening or by leaving the paper blank, was already known to artists at the beginning of the century, as is shown in no. 3. However the expressive possibilities were greatly extended during the course of the century with different regional accents. For Florentine artists wash allowed the sculptural three-dimensionality of figures in space to be enhanced, both in single figures (as in Ghirlandaio's drapery study, no. 60) or for compositional studies such as Filippino Lippi's drawing for the Carafa Chapel, in which differing shades of wash are adroitly deployed to clarify the spatial recession of the architectural setting (no. 66). The tightly controlled layered effect of wash and white heightening over an underdrawing, seen in Botticelli's *Abundance* (no. 36) and in Lorenzo di Credi's *Astronomy* (no. 44), is probably linked to the stratified working procedure of painting in tempera (albeit often mixed with oil) that both Florentines continued to favour.

The combination of pen and wash to achieve the effect of contour and mass, as employed by Florentine artists, is much less marked in the Venetian Carpaccio's use of them in his *Vision of St Augustine* (no. 80). Instead the light-filled chamber and the many objects in it are apprehended through the pattern of light and shade, the veils of wash laid in with vertical brush strokes so that the surfaces shimmer and vibrate in the blinding divine light pouring in from the right. The work of the Milanese artist Bramantino has elements of both approaches, to which he added an astringent sense of abstract geometrical form expressed in the jagged peaks of the background and the severe classicism of the architectural setting (no. 73). The colouristic effects of wash and white highlights could be further enriched by the use of coloured paper or ground. Unsurprisingly in view of the particular attention paid to light and atmosphere in their paintings, as well as the ready availability of indigo imported from the Middle East for the region's textile industry, it was predominantly artists from the Veneto such as Cima, Carpaccio and Montagna who explored such combinations.

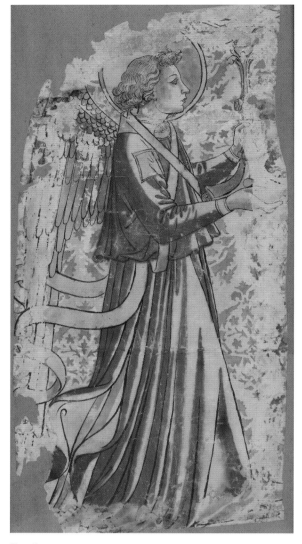

Fig. 26
Anonymous Florentine, *Two candle-bearing angels*, c. 1460–70. Brush and black ink, watercolour, the background stencilled in blue to imitate damask, 77.9 × 39.5 cm and 79.5 × 38.6 cm. British Museum, London.

Mass-produced drawings of this kind, made from a stencil and brightly coloured in watercolour, were probably manufactured as decorations for a religious festival. Such drawings were rarely kept, and thus extremely few survive.

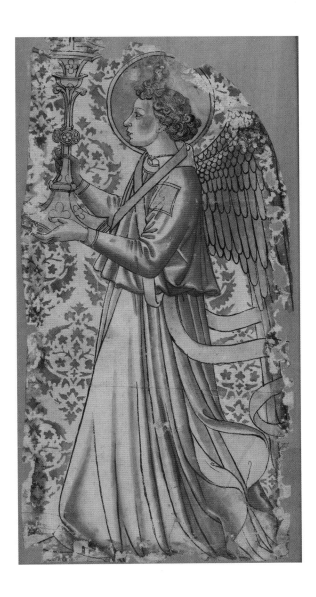

Curiously, the medium of watercolour, pigments ground up in gum water, which offered even greater opportunities to explore nuances of colour, seems to have been relatively rarely used by Italian artists in the fifteenth and sixteenth centuries, even though it was well known from manuscript painting.[87] The scope that watercolour offered to record with great precision the colours and hues of the natural world underlies both examples included in this book: Barbari's study of a partridge (no. 82), and the double-sided Lombard animal model book (no. 2) where it is combined with bodycolour, sometimes described as gouache (water-based paint rendered opaque by the addition of white paint or pigment). The scientific objectivity of Barbari's rendering of the dead bird's plumage in watercolour is anticipated by earlier natural history and botanical studies in the medium, by northern Italian artists such as Giovanni de' Grassi (d. 1398; fig. 1, no. 2) and Pisanello, yet it is likely that his immediate inspiration was drawings in the medium by Dürer.[88] Barbari must have seen watercolours, like the celebrated *Hare* of 1502 now in the Albertina in Vienna, on visits to the German's studio in Nuremberg while the Venetian was in the service of the Emperor Maximilian from 1500 to 1503. From the evidence of a pair of Florentine brush drawings in the British Museum of candle-bearing angels dating from around 1460–70, probably used for temporary decorations at some religious festival (fig. 26), colour may have been more common in popular, cheaply produced graphic works. The ephemeral nature of the latter meant that they were rarely preserved, and as a consequence survive in far fewer numbers than drawings by the generally more elite artists represented in the present publication.[89] The angels are hand-coloured from outlines derived from a cartoon or stencil (an almost identical pair was formerly in the Kupferstichkabinett in Berlin), with a stencilled background imitating damask.

The opacity of bodycolour, chalk white or lead pigments, found in the red ribbon and fire in Mantegna's *Virtus Combusta* (no. 22) is matched by that of Fra Bartolommeo's drapery study on linen that has been described variously as distemper, an aqueous paint composed of pigments held together by animal glue, or tempera where the binder is egg yolk.[90] Drapery studies of this kind that straddle the boundary between drawing and painting were briefly in vogue with Florentine painters in the last quarter of the fifteenth century, but the practice of making such drawings by artists like Fra Bartolommeo (no. 89) was not taken up by successive generations, who preferred to make comparable studies either in pen and wash or chalk. The selection published here does not include an example of a drawing executed in oil paint on paper, a technique seemingly pioneered by the aged Giovanni Bellini in the first decade of the sixteenth century and known through a handful of examples, such as the study of two men in the Fondation Custodia, Institut Néerlandais, in Paris.[91] It comes as no surprise that such a painterly method of drawing first evolved in Venice, where the northern European technique of oil painting first gained widespread acceptance, and the majority of sixteenth-century oil on paper studies are Venetian (the British Museum has 80 of them by Domenico Tintoretto, 1560–1635, the son of the more celebrated painter Jacopo). There were also a few adherents of the technique in central Italy, such as the Sienese artist Domenico Beccafumi (1484–1551) and the Urbino-born painter Federico Barocci (c. 1535–1612).

In conclusion, the techniques and materials used by artists during the course of the fifteenth century were subject to change, with the gradual decline in metalpoint and vellum, and the rise of the more convenient and tonally more flexible media of red and black chalk. At the same time the continuing practice of drawing in pen should not be forgotten, a point made clear by the similarities between the pen figure studies of Parri Spinelli and Michelangelo, despite the gulf of about 60 working years between them. An increasing sensitivity on the part of artists in the second half of the

century to the possibilities of light, both in formal and narrative terms, which was linked to the spread of oil paint, also motivated a greater use of wash, sometimes combined with white heightening, to study these effects. The expansion of paper-making in the last part of the century that made it readily available was unquestionably the single most important factor in encouraging artists to draw more.

Mention has been made of standard techniques for various types of drawing, such as pen for initial compositional sketches or chalk or pen and wash for more detailed drawings, but it would be misleading to be overly insistent on such divisions because artists could be highly individualistic in such matters. Such idiosyncrasies are apparent in the way two Florentine contemporaries, Ghirlandaio and Filippino Lippi, chose to study the poses of individual figures at much the same stage in the preparation of a painting, in pen and metalpoint respectively (nos 58, 68). Recognition of the need for caution in establishing drawing typologies should not, however, stand in the way of pondering why an artist might have used a particular technique at a given moment, such as Raphael's decision to draw his large-scale compositional drawing for the Borghese *Entombment* only in pen (no. 100). It is no less valid to make broad generalizations about the differing ways that artists from regional schools in Italy used a particular technique, and to a lesser extent their preference for one medium over another. Lastly the materials and practices established, and in some cases pioneered, in the fifteenth century, set the pattern for artists until the advent of pencil, synthetic chalks and crayon in the early nineteenth century.

The development of drawing during the Italian Renaissance

Drawing before 1400

The problem of assessing the status of drawing in the early 1400s is that despite the evidence of written sources that testify to drawings having been made by fourteenth-century artists (a category that broadly includes all those born before 1375), tangible evidence for them doing so is extremely limited. If model books are counted as one item, and underdrawings on panels, frescoes and manuscript are excluded, the number of autonomous drawings that survive probably does not exceed a hundred.[92] The overwhelming majority of Italian drawings from that period are anonymous, and only two of them can be considered to be preparatory for surviving paintings. The more securely attributed of these is by Spinello Aretino (1350/52–1410), one of the most important Tuscan painters in the generation before Lorenzo Monaco, and the father of Parri (nos 5, 6). A sketchy pen study of *The Reading of the Miracles of Thomas Becket for his canonization by Pope Alexander III* (Pierpont Morgan Library, New York) is related to a scene in Spinello's 1408 fresco cycle of Pope Alexander's conflict with Emperor Frederick Barbarossa in the Palazzo Pubblico, Siena. The other, in the Louvre, Paris, is a much more highly finished drawing (and thus less certainly produced in preparation for the painting) connected to *The Presentation of the Virgin* fresco in the Baroncelli Chapel in S. Croce, Florence, painted in the late 1320s by the Florentine Taddeo Gaddi (*c.* 1300–66).[93] Owing to the rarity of fourteenth-century drawings, the judgement of the graphic capabilities of artists from the period depends on what can be gleaned from underdrawings executed in charcoal or more commonly *sinopia*, a drawing using a red earth pigment found in Egypt, in the Balearic Islands and in Cappadocia, and named after Sinope, the Turkish city on the Black Sea, where it was traded and exported. The *sinopia* underdrawing was applied with a brush on the foundation layers of rough plaster (*arriccio*) so that the artist could map out the entire composition on the wall. This initial design was successively

covered up as the artist applied smooth wet plaster on top of it, consisting of a day's work or *giornata*, on which he painted in fresco. The *sinopia* designs beneath frescoes are only visible when the thin layer of frescoed plaster has either fallen off or been carefully lifted. In recent decades these examples have been augmented by a growing number of underdrawings detected beneath the paint layers on fourteenth-century panels using infrared reflectography, such as the one in pen and ink found on panels by Duccio (active 1278–1318/19) in the National Gallery, London, from the enormous altarpiece, known as the *Maestà*, completed in 1311 for Siena Cathedral.[94]

It has been plausibly suggested that the rarity of trecento drawing is due to an artistic preference for composing directly on the wall rather than making preparatory studies, and that the increasing popularity of drawing around the mid-fifteenth century is related to the decline in this preparatory method in favour of the greater precision of cartoons.[95] It is certainly true that Cennini's discussion in *Il libro dell'arte* of drawing in relation to preparing for paintings on walls and panels is confined to charcoal underdrawing and never mentions any kind of prior study on paper or vellum. At the same time there are artists such as Parri Spinelli, Pisanello and Gozzoli who are known to have executed *sinopie* underdrawings and to have made preparatory drawings, although admittedly they all belong to a later artistic generation than Cennini's.[96] The survival of a group of drawings by Spinelli, two of which are included in the catalogue (nos 5–6), means that it is possible to contrast them with his summary *sinopie* such as the one originally beneath his *Crucifixion* in the Palazzo Comunale, Arezzo (fig. 27).[97] Although no drawings for the Arezzo fresco survive, it seems probable that he must have made some, since the polish and level of detail of

Fig. 27
Parri Spinelli, *The Crucifixion*, 1440s. Sinopia underdrawing and finished fresco, 121 × 90 cm. Palazzo Communale, Arezzo.

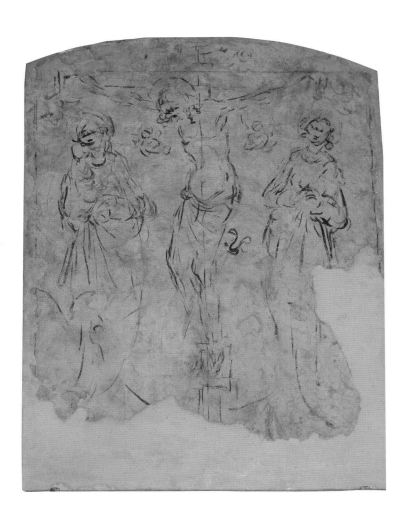
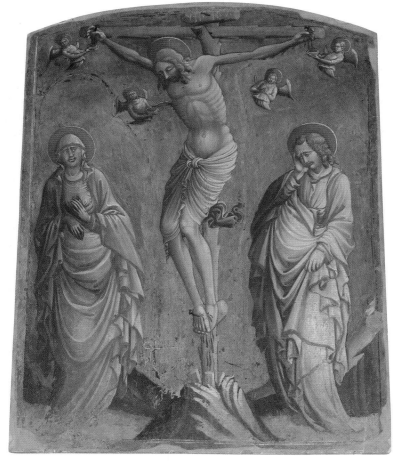

the finished figures are absent in the *sinopia*. The conservatism of Spinelli's art makes him an unlikely candidate to be an innovator in preparing his paintings using both media of drawing and *sinopie*. His likely model was his father, who is known from the aforementioned study, as well as from written sources, to have made preparatory drawings while also making *sinopie*.[98] The absence of drawings cannot, in short, be taken as sure evidence that fourteenth-century artists did not draw, although it is fair to assume that the scarcity of paper and the preciousness of vellum meant that they did so far less frequently than those who followed them.

The model book in the fifteenth century

Vellum was a drawing material predominantly reserved for finished drawings, not for exploring figural or compositional ideas, which is presumably why Lorenzo Monaco and Parri Spinelli chose to make their drawings on paper (nos 4–6). The durability of vellum was ideally suited to the construction of a model book, a pictorial archive of useful examples of animal or figural poses specifically put together by an artist to insert into paintings or the decorated borders of manuscripts, and as a means of transmission of these motifs to successive generations. The history of model- or pattern-book drawings stretches back to Antiquity: the earliest surviving example is a second-century BC papyrus fragment in the Ägyptisches Museum und Papyrussammlung, Berlin, with eight squared drawings of animals, birds and an Egyptian deity. Model books comprise some of the rare surviving graphic works from the medieval period, most famously the parchment album in the Bibliothèque Nationale, Paris, by the Frenchman Villard de Honnecourt (active 1220–40).[99] In Italy the largest number of model books from the late 1300s and early 1400s derive from Lombardy, the region geographically and culturally most closely connected to northern Europe; a double-sided vellum sheet of animals in the British Museum of *c*. 1400–10 (no. 2) must originally have belonged to such a book. Nine further drawings by the same anonymous hand from this model book (see fig. 4 on p. 21 and fig. 2, no. 2), probably put together by a follower of the Lombard painter and miniaturist Giovannino de' Grassi, are known. Ten pen-and-wash studies on vellum of animals drawn in Florence around 1450 (although they have been dated half a century earlier) now in the Cabinet Edmond de Rothschild in the Louvre, Paris (see fig. 28), are perhaps the last Florentine examples of pages from such a model book.[100] There are, however, later examples of model books from elsewhere, such as the so-called *Libretto di Raffaello* (Galleria dell'Accademia, Venice) assembled by an Umbrian apprentice of Perugino or Raphael in the first quarter of the sixteenth century.[101]

Despite the difference in date, region and technique, the London drawings (no. 2) and those in Paris (fig. 28) are broadly similar in the two-tiered division of the page with the animals represented more or less in profile, the most recognizable and most easily copied viewpoint. The lack of animation strongly suggests that both artists were copying the animals from another model book, which itself may well have been derived from earlier patterns. Two of the animal groups in the Rothschild album are replicated, for example, on a page from a late fourteenth-century Lombard model book now in the Louvre (a drawing also copied by Pisanello) and it is likely that others were derived from similar sources.[102] Some idea of the circulation of model-book drawings can be gained from the repetition of various of the animals in the Paris album, such as the dogs attacking the boar in fig. 28, also seen in the background of the Jacob and Esau opening from the *Florentine Picture Chronicle* (no. 34) and in a Florentine engraving from the 1460s (illustrated as fig. 4, no. 34). It is impossible to ascertain whether the *Chronicle* artist and the Florentine printmaker were looking at the Louvre album, or if they knew the motifs from a common source, perhaps an earlier set of Lombard drawings circulating around Florentine studios in the mid-fifteenth century. The use of model books can be deduced from the repetition of figures and animals in

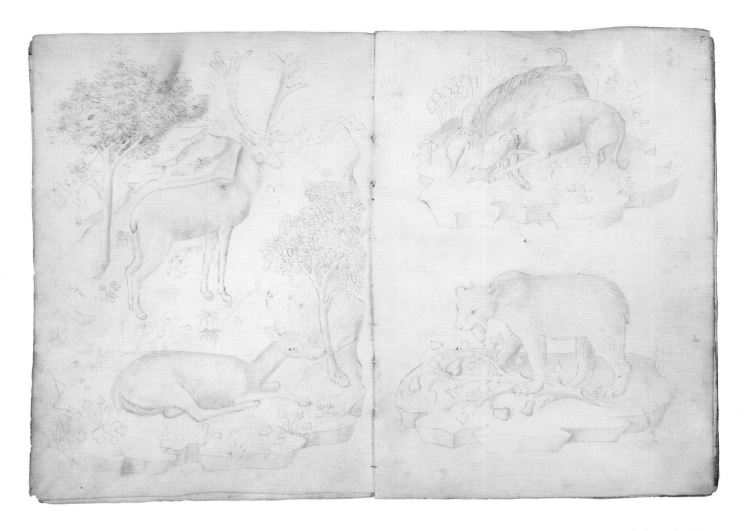

Fig. 28
Anonymous Florentine, *Rothschild album: animals*, c. 1450. Pen and brown ink, brown wash, 19.5 × 13.5 cm, each page. Cabinet Edmond de Rothschild, Musée du Louvre, Paris.

The dogs attacking the boar at the upper right are a motif also found in the *Jacob and Esau* in the *Florentine Picture Chronicle* (no. 34).

the works of contemporary Florentine painters, for example in the mythological and biblical scenes painted on *cassoni* (chests) and *spalliere* (panels inset into furniture or panelling) made in the productive studio of Apollonio di Giovanni and his partner Marco del Buono (?1403–after 1480).[103]

The decline of the model book has generally been regarded as symptomatic of a shift from a traditional acceptance of established models and patterns to the more inventive, personal approach of artists in the fifteenth century, in keeping with the Swiss historian Burckhardt's thesis that one of the defining characteristics of the Renaissance period was a growth of individualism.[104] This may broadly be true, yet there are also practical reasons underlying this change, largely related to the widening availability of paper that made it practical for artists to draw as part of their day-to-day activities in preparing their paintings, thereby forming a collection of compositional and figural ideas far more extensive than the contents of a traditional model book. These graphic storehouses were commonly used by artists as a means of shortening the process of inventing poses, as is demonstrated by the way in which Cima reused his study of *St Jerome* (no. 77) made for one altarpiece as the basis for the same figure in a later painting. The ubiquity of this practice explains why Michelangelo, ever keen to elevate himself above his artistic contemporaries, fed the story to his biographer Condivi that his tenacious visual memory meant that he never repeated the same pose.[105] Even this statement was not quite accurate since Michelangelo did occasionally recycle his figural ideas, specifically the group of two men hoisting up a lookout in the centre of no. 95, which reappears in his drawing, now in the Ashmolean Museum, Oxford, of the *Worship of the Brazen Serpent* executed a quarter of a century later in around 1530.[106]

Record-making drawings

Although the practice of creating a graphic archive in the form of a model book appears to wither away in the second half of the century (with the exception of studies recording classical sculptures and architecture), there are sheets that seem to have been made with a similar function in mind. An example of one such drawing is the sheet of hands in the Albertina, Vienna, drawn in metalpoint by Raffaellino del Garbo (fig. 29), which from its meticulous finish appears to be a collection of studies copied from rougher, preparatory sketches like those found in no. 69.[107] Comparable examples of neat copy drawings in the selection, probably based on scruffier, more impromptu *ad vivum* studies, include Pisanello's hanged men (no. 9), Gentile Bellini's two Middle Eastern figures (nos 17–18) and Finiguerra's drawings of figures and a cockerel (nos 26–7). The likely dependence of these record-type drawings on studies made from life is a significant indicator of the swelling tide of naturalism in fifteenth-century Italian art; the transition from the stylized simplification of the Lombard animals in no. 2 to the vivid naturalism of Pisanello's studies of animals and birds (fig. 30) neatly encapsulated in Francis Ames-Lewis's pithy description of the switch from 'model book to sketch book'.[108] Raffaellino del Garbo's sheet in the Albertina is an example of *ricordo* or record-making drawing that died out in the sixteenth century, probably due in large part to the exponential growth in printmaking that supplied artists with such a vast repertoire of images that they no longer bothered to make studies of this kind. Already in the period covered in this publication, the utility of prints as a visual source can be seen by Carpaccio basing the Middle Eastern costumes of two figures in his Uffizi study of the *Triumph of St George* (no. 79) on a woodcut by the Dutch artist Erhard Reuwich (active 1474–88), an illustration in the best-selling guide to travelling to the Holy Land by Bernhard von Breydenbach (*c.* 1440–97) published in Mainz in 1486 (fig. 2, no. 79).

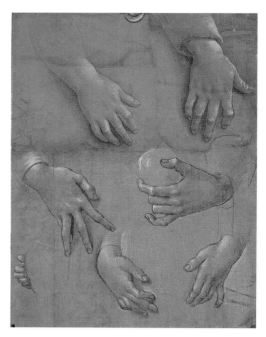

Fig. 29
Raffaellino del Garbo, *Studies of hands*, *c.* 1500–10.
Metalpoint, heightened with lead white, on grey preparation, 32 × 24.4 cm. Albertina, Vienna.

Drawing albums

The inclusion of the three albums in this catalogue makes plain that bound collections of drawings did not always have to be linked to the practicalities of the studio. The Zoppo volume (no. 25) and the *Chronicle* (no. 34) were unquestionably made as luxury items at much the same time (1460s or 1470s), in the case of the former almost certainly on commission since the homoerotic undertone of some of its contents was most likely tailored to suit the tastes of a specific patron.

It has sometimes been suggested that Zoppo was illustrating some now lost text, yet this seems highly unlikely in view of the disparate subject matter with drawings that range from the Virgin and Child, and scenes of classical myth and history, to images of young men (fig. 31) which, as in Pisanello's earlier vellum drawing (no. 8), appear to be the Renaissance equivalent of a nineteenth-century fashion plate.[109] The diversity of the narratives on the right-hand pages of Zoppo's volume is given a visual coherence through the classically inspired profile heads of both sexes on the left. The limitations of the format inspired Zoppo to exert his creative ingenuity in finding fresh variations (figs 32–3).

The unfinished *Chronicle* is by contrast thematically coherent. It is an idiosyncratic interpretation of mankind's development based on a long literary and pictorial tradition. The group of artists responsible for making it clearly felt confident that the figures depicted needed no written description aside from labels giving the names of the protagonists, and occasionally the geographical location. The function of Jacopo Bellini's album (no. 16) is less clear-cut, but the prevailing view that it was made as a didactic store of compositions ignores the impracticality of the format, caused by the artist having initially drawn the narratives on the right-hand page, and only later deciding to expand them to the left. The lopsided effect of this expansion would have made the majority of the compositions of limited practical use had the album been

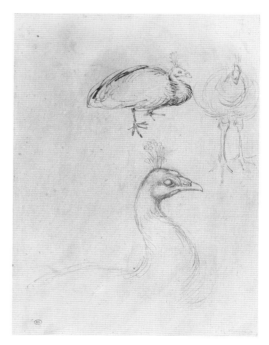

Fig. 30
Pisanello, *Peacocks*, *c.* 1440.
Black chalk, pen and brown ink on paper rubbed with red chalk, 25 × 18.4 cm.
Musée du Louvre, Paris.

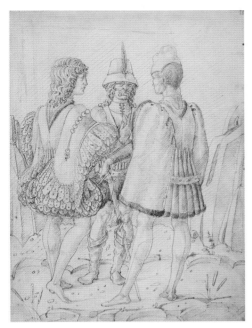 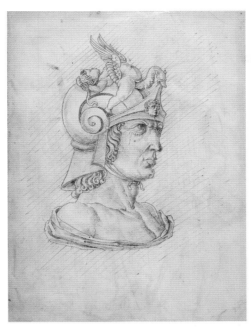 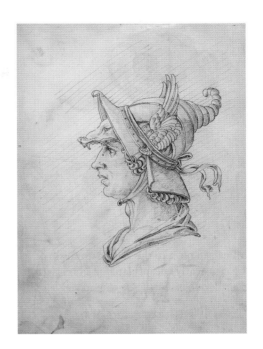

Fig. 31
Marco Zoppo, *Rosebery album* (no. 25), folio 7
recto. *Three young men in conversation*, *c.* 1455–65.
Pen and brown ink on vellum, 21.8 × 15.8 cm.
British Museum, London.

Figs 32–33
Marco Zoppo, *Rosebery album* (no. 25), folios
10 verso and 5 verso, *Warrior heads*, *c.* 1455–65.
Pen and brown ink on vellum, 21.8 × 15.8 cm.
British Museum, London.

intended to supply models for paintings. Bellini's album makes more sense if it
is likened to Zoppo's album, with both intended to show off the artists' gifts for
storytelling and visual fancy.

The development of compositional drawing in the fifteenth century

The Bellini album is perhaps the best example of the liberating effect of paper in
allowing artists to experiment with a freedom not open to previous generations.
To take just one example, in successive openings Jacopo juxtaposed two scenes of
the Crucifixion: the first seen from an unusual side-on viewpoint, the bases of the
crosses obscured by a line of horsemen, and the other a more conventional frontal
view, remarkable for the dense crowd of silent onlookers gathered in a semi-circle
around the three Maries tending to the fainting Virgin Mary (fig. 34). For a modern
viewer a change in viewpoint to emphasize different aspects of a narrative – the
fragility of Christ's body suspended high above the crowd in the first, or the isolation
of Christ's female followers hemmed in by soldiers in the second – is such a familiar
cinematic trope that it is difficult to comprehend Bellini's innovation in employing
it to give a fresh perspective to one of the most familiar images of Christian art. The
Venetian painter had greater freedom for experimentation in the album because the
compositions were not intended exclusively as blueprints for paintings. The contents
give a clear sense of the liberating effect that drawing had in allowing artists to
explore ideas.

The aim of most compositional drawings in our selection was to work out the
most effective means of conveying visually in paint a narrative, predominantly a
biblical episode or an episode from the life of a saint, or the organization of a group
of figures where the narrative element was more muted. Examples of the second

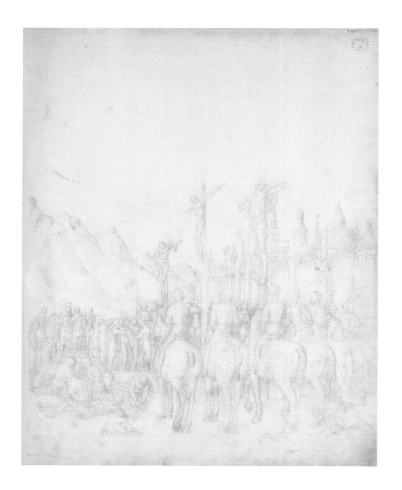
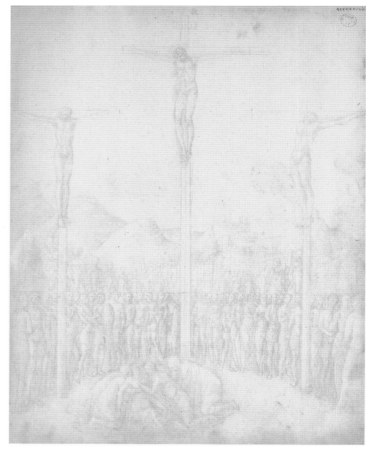

Fig. 34
Jacopo Bellini, *London album* (no. 16), folios
76 recto and 77 recto: *The Crucifixion*.
Leadpoint, some of the lines drawn with a ruler,
41.5 × 33.5 cm. British Museum, London.

category include Lorenzo Monaco's study for the placement of two ranks of saints witnessing Christ's coronation of the Virgin Mary in the central panel of the National Gallery altarpiece (no. 4, and fig. 1, no. 4), and Tura's idea for a *sacra conversazione* with four saints flanking the enthroned Virgin and Child in an open-sided loggia (no. 24). The idea of saints witnessing a sacred event, underlying their role as mediators between mankind and the divine realm, is much the same in the designs of Lorenzo Monaco and Tura. The difference between them is in the emphasis in the latter's work on the engagement with the viewer. The gestures and attributes of the figures, which in the earlier work serve principally to identify them, have an added dimension in Tura's to stimulate the viewer to empathize and contemplate the particular deeds and suffering of each saint. For example, in Tura's drawing St Francis's crucifix and stigmata (the wounds of the crucified Christ that miraculously appeared on his body) immediately identify him, while at the same time bringing to mind his intense devotion centred on the sacrifice of Christ, the figure located immediately to his right in the composition. The interconnected narrative threads also include the Virgin Mary, whose introspective faraway gaze conveys the weight she bears through the knowledge, shared with the viewer, of her son's destiny that will ineluctably lead to her cradling the bloodied adult corpse of the child seated contentedly on her lap. The development in paintings during the period of a more nuanced, richer and empathetic approach to narrative necessitated artists planning their work more carefully to work out the gestures, expressions and poses that would connect the protagonists to each other, and most potently project their emotions and actions to the viewer.

The manner in which Bellini and Tura designed their compositions does not differ fundamentally from the rare surviving examples of this category of study from

the early 1400s, represented by an anonymous Sienese work and by Spinelli (nos 3, 5). The drawings belong firmly to the earlier artistic tradition of Cennini in the treatment of space, shown by the way in which the architectural backgrounds do not converge towards a single vanishing point, as well as the inconsistencies of figural scale. Such details in no way lessen the clarity in which the two artists recount the narratives; indeed it could be argued that they positively enhance this aspect since the flexibility in the depiction of space allowed them freedom to manipulate the design, to enhance or diminish details of the scene as they wished. The two artists adopted slightly different approaches, with the New Testament scenes studied on both sides of no. 3 pared down to the essential narrative, while the rectangular format allowed Spinelli latitude for a more anecdotal approach so that the scene of baptism is enlivened by the surging ranks of townsfolk, with women at the forefront, approaching from the city gate to watch. The adoption of linear perspective based on Brunelleschi's pioneering investigations around 1413 gradually brought an end to the stylized spatial approach seen in Spinelli's drawing.[110] This advance ushered in a visual coherence that enhanced the sense of a continuum between real and imaginary space, yet it required artists to plan their compositions more carefully as Spinelli's spatial shorthand, with its diminutive city walls and gateway, became outmoded.

Jacopo Bellini's *London album* demonstrates the difficulty of acquiring full mastery of the complexity of one-point perspective, since the recession of the buildings and figures in his ambitious spatial constructions is never entirely coherent. Bellini's drawings may lack the geometrical rigour exemplified in the study of a chalice attributed to his Florentine contemporary Uccello (no. 15), but in spite of this he was acutely alive to the possibilities of how the manipulation of spatial recession could be used to focus attention on the narrative, or conversely distract attention away from it. The visual games played out in the album support the idea that it was made to be leafed through; the artist repeatedly uses sharply recessed arcades or flights of ascending stairways to take the eye back into pictorial space, thereby requiring the viewer to track back to find the diminutive protagonists of the narrative amidst the architecture.

By the latter part of the century a command of perspective had become almost second nature, as can be seen from the fluency of Perugino's freehand design of the *Adoration of the Magi* of 1486 (no. 45), in which the architecture of the loggia and the proportions of its slender columns echoed by the trees are used to articulate the space so that the crowds of figures can be plotted in relation to them. Similar exercises in planning the arrangement of groups of figures in depth include Carpaccio's *Triumph of St George* (no. 79) and – to a level of detail unprecedented in any other compositional drawing of the period – Leonardo's *Adoration of the Magi* (no. 53). The development of the use of perspective also encouraged artists to consider how space itself could be used as a dynamic and potentially dramatic element in the composition, as it is in Bramantino's *Martyrdom of St Sebastian* (no. 73). In the drawing the artist heightens the tension through the space that separates the saint from the group of soldiers about to fire arrows at him. This gap heightens the saint's isolation and his stoical acceptance of his fate. The arrows that are about to tear into his flesh are not shown, but their effect is anticipated by the menacingly jagged tip of the mountain visible through the same gap, its peak almost but not quite touching the contours of Sebastian's still unmarked body.

The way in which painters could heighten the affective power of their work was treated in considerable depth in Alberti's treatise on painting, although the focus was exclusively on classical themes and the precedents cited were – aside from a single reference to a painting by Giotto – confined to ancient descriptions of lost paintings. The theoretical nature of Alberti's writings on art are those of a humanist intellectual, not a practising artist; nonetheless his attentive study of the new Florentine art of Masaccio and Donatello following his return to his ancestral city in 1434 meant that the treatise contained a great deal of informed and practical advice. This was largely

directed at how painters might treat *istorie*, the complex classical narratives and allegories that he advocated as the pinnacle of artistic achievement. For Alberti such subjects were a means by which painters could demonstrate that their work was primarily a product of the intellect or *ingegno*, the quality of invention and imagination needed to come up with the pictorial conception. The kind of composition that Alberti advocated consisted of a small number of figures (no more than nine or ten) of varied age and posture, who communicated the narrative or allegory through appropriate and naturalistic actions, gestures and expressions.

How many artists had access to, or indeed the inclination to read, manuscript copies of Alberti's treatise (the first printed edition was published in 1540) is impossible to fathom, although not surprisingly those who wished to follow his lead in writing about art, such as Filarete and Leonardo, certainly did so. The close attention paid to Alberti's treatise by hugely influential painters like Mantegna and Leonardo did much to promulgate his ideas on art, even to artists who were perhaps unaware that they derived from the Florentine's writings. It seems extremely likely that the ambitious and intellectually minded Raphael was a reader of Alberti, since his painting of the *Entombment* of 1507 (fig. 1, no. 99) follows the treatise's principles to the letter. The influence of Alberti even extended to Raphael's preparation for the altarpiece as he drew some of the figures in the nude, as recommended by the Florentine in order to understand their poses fully. For the figure of Christ in the painting Raphael studied a Roman sarcophagus showing the dead hunter Meleager, a classical work praised in the treatise for the skill with which the lifeless body was depicted: 'everything hangs, hands, fingers and head; everything falls limply.'[111] The two compositional studies for the painting (nos 99, 100) demonstrate how carefully Raphael calibrated the two groups of figures, linked by the movement of Mary Magdalene to touch Christ's body for the last time.

It is not surprising that Raphael also sought inspiration from an engraving of the *Lamentation* by Mantegna, the fifteenth-century artist who came closest to fulfilling the Albertian ideal of a painter. The Paduan combined a highly developed gift for naturalistic detail in his painting, not least in applying the rules of perspective and geometry that Alberti reckoned governed the perception of nature, with the imaginative and inventive resources capable of bringing to life the written texts and shattered fragments of the ancient world. Mantegna and Alberti certainly knew each other, since the Florentine architect was in Mantua on a number of occasions between 1459 and his death in 1472. However, Mantegna had already absorbed the precepts of *Della pittura* by the time he made the study of *St James on his way to execution* around 1454–6 for the now lost fresco in the Ovetari Chapel in Padua (no. 20). His understanding of modern Florentine art was not exclusively reliant on the treatise, because he must have absorbed it at first hand from Donatello, one of the pioneering artists in Florence whose work shaped Alberti's thoughts. There were also other examples of Florentine art in Padua, such as Uccello's lost frescoed 'giants' in the Palazzo Vitaliani painted in 1445.[112] Donatello was in Padua from 1443 to 1453 working on a bronze equestrian monument honouring the mercenary captain Gattamelata and on the sculpted figures and reliefs in the same material for the high altar of the church of S. Antonio, known as the Santo. The Florentine's orchestration of figures, perspective and classical architectural settings in his narrative reliefs for the Santo altarpiece had an enormous influence on Mantegna's Ovetari Chapel, a work tragically destroyed by a bomb in 1944. The central importance of drawing for Donatello is underlined by an anecdote recounted in a treatise on sculpture written in 1504 by the Paduan humanist, Pomponio Gaurico (*c*. 1481–1528).[113] When a visiting ecclesiastic, Cardinal Balbo, expressed a wish to see Donatello's abacus, that is to say the mathematical aid that the cleric believed underpinned his mastery of perspective, the sculptor replied that he had no other calculator than the one he always carried with him. He added that if Balbo wished to understand his secret, then he should bring him pen and paper and soon he would admire whatever story he wished, as well as drawings of figures nude

and clothed. In other words the artist's inventiveness ('*ingeniosim*') was innate and needed no help aside from a sheet of paper to be expressed.

Mantegna's pen compositional drawing for the Ovetari fresco was drawn over an earlier black-chalk drawing of a classical bust in a roundel. The two halves of the design, with St James healing a lame man en route to his martyrdom on the left, are connected through the contrasting movements of the two soldiers in the foreground: one stepping backwards in amazement at witnessing the miracle, and the other pushing against his spear to hold back the angry crowd on the right. Through this formal device the painter gives a sense of the larger significance of the saint's healing: the transformative power of the Christian faith contrasted with the brutality of the pagan world. The dynamism and cohesion of Mantegna's design are unprecedented, and in the absence of comparative graphic works by Masaccio and Donatello it is probably not exaggerated to claim it as the first truly Renaissance compositional study to survive, along with Filippo Lippi's near contemporary drawing in the Cleveland Museum of Art of *The Funeral of St Stephen* for the fresco cycle in Prato Cathedral (1452–66).[114] Mantegna's modernity is highlighted by a comparison with Finiguerra's coeval *Moses on Mount Sinai* (no. 28). The latter is admittedly a conflation of more than one biblical episode, yet the fractured quality of the action is due more to Finiguerra's having broken the Israelites up into small groups linked by similar attitudes and gestures. This piecemeal approach to composition, closely linked to his conception of figures as assemblages of motifs derived from his collection of drawings, is the opposite of the holistic design ideas of the young Mantegna.

The style of painting designed to move and engage the viewer championed by Alberti demanded and depended on extensive preparatory studies to work out the most effective composition, and to fine tune the poses and expressions of the principal protagonists. Leonardo's unfinished *Adoration* of 1480–1 (fig. 1, no. 53) went beyond Alberti in his ambition to orchestrate large numbers of figures, some of whom are linked through gestures and action to the central action, while others, such as the battling horsemen in the background, act as a kind of counterpoint. A sense of how much Leonardo's composition seized the imagination of his Florentine contemporaries can be gauged from Filippino Lippi's study for the scene of St John resurrecting Drusiana depicted in the Strozzi Chapel in S. Maria Novella, Florence (no. 67, and fig. 1, no. 67). The animation of Lippi's figures, who react individually and collectively to the saint's miracle, is modelled on the adoring crowd gathered around the Christ Child in the *Adoration*. A measure of how much planning was required to thread such a composition together can be gained from monitoring Lippi's attention to the poses of the bearers of the bier on which the resurrected Drusiana is carried. The artist studied each of their poses twice in the compositional drawing and two further studies of them are known, one of which is included in this selection (no. 68, and fig. 1, no. 68). The figures in the separate metalpoint studies do not correspond particularly closely to their counterparts in the fresco, which makes it likely that Lippi made additional, now lost, drawings of the poses. Lippi's interest in characterization and in elaborating details of costume and architectural settings, even at this preliminary stage of high-tempo invention, is strikingly different to that of his contemporary Domenico Ghirlandaio. The latter's much more utilitarian, stripped-down approach to composition is apparent in his study of the *Visitation* from the mid-1480s for the Tornabuoni Chapel, also in S. Maria Novella (no. 59).

Lippi's drawings appear to have been studied by Lorenzo Costa, a Ferrarese painter whose career was spent in Bologna, perhaps during an undocumented trip to Tuscany in the mid-1490s, since the two Uffizi examples of his work (nos 84–5), correspond so closely to the two distinct compositional styles of the Florentine.[115] (Costa's admiration was shared by others in Bologna, as Filippino Lippi was commissioned to paint an altarpiece, dated 1501, for the Bolognese church of S. Domenico).[116] The spontaneity and brio of Costa's depiction of St Cecilia disputing with the prefect (no. 85) are matched in Lippi's exploratory compositional studies, such as

the *Drusiana* (no. 67), while the clarity and concision of the Bolognese artist's use of pen and wash in the *Coronation of the Virgin with Saints* (no. 84) echo the Florentine's *Triumph of St Thomas Aquinas* (no. 66). The neatness of both of the latter sheets probably indicates that they had a common function as presentation works made to win the patron's approval of the design.

The Tuscan inflection of Costa's pen drawings derived from Lippi, and to a lesser extent Fra Bartolommeo, was taken up by other painters in the city, such as Aspertini. For this reason the way that Bolognese artists worked out their compositional ideas on paper stands apart from the prevailing northern Italian tradition. The changes of mind in the position of figures and the general expressive freedom of Costa's *St Cecilia* are notably different from the more measured approach of Venetian compositional studies, such as the one in the British Museum by Gentile Bellini related to the *Procession in the Piazza San Marco* painted in 1496 for the Scuola di S. Giovanni Evangelista (fig. 35), or Carpaccio's *Triumph of St George* (no. 79). A Venetian sensibility in the nuanced employment of wash for dramatic effect can be seen in the *Lamentation* (no. 74) by Solario, a Milanese artist counted among Leonardo's Lombard followers, but whose drawing style owes more to the time he spent at the beginning of his career in Venice in the first half of the 1490s.

The differences between the compositional drawings of Spinelli and those of Raphael reveal the profound changes that had occurred in the seven decades that separate their work. The development of perspective, the emphasis on naturalism in the representation of figures and the natural world, as well as the onus on painters to find original and arresting ways of depicting the subjects given to them, all contributed to making drawing a crucial step towards the success of the final work.

Fig. 35
Gentile Bellini, *Procession in the Piazza San Marco*, *c.* 1496. Pen and brown ink, over red chalk, 13 × 19.6 cm. British Museum, London.

A study for Gentile's *Procession with the relics of the True Cross* painted in 1496 for the Sala della Croce of the Scuola di S. Giovanni Evangelista in Venice and now in the Galleria dell'Accademia, Venice.

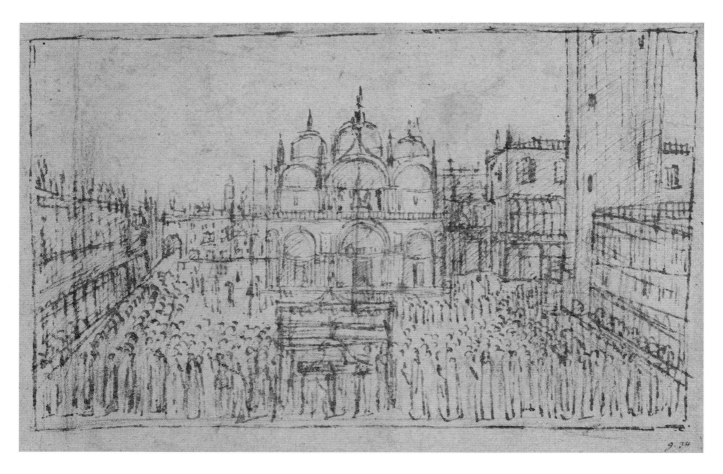

The greater availability of paper in the second half of the century encouraged artists to explore and experiment with compositional variants with a freedom not open to their predecessors. At the same time the immediacy and responsiveness of drawing, especially in pen, was harnessed by central Italian artists such as Leonardo and Filippino Lippi to accelerate the inventive process, the speed of the nib keeping pace and encouraging further streams of invention. The developmental progress of compositional drawing in the fifteenth century is, thanks to the patchy survival rate of this category, frustratingly difficult to piece together. Yet from what has been preserved it is fair to conclude that the compositions of many of the paintings that we associate most closely with the period, such as Piero della Francesca's *Flagellation* (Palazzo Ducale, Urbino), Mantegna's frescoes of Gonzaga courtly life in the Camera Picta in the Palazzo Ducale in Mantua, and Botticelli's *Birth of Venus* in the Uffizi (fig. 1, no. 36), first came to life and were refined in now lost drawings.

Figure drawing in the fifteenth century

What holds true of compositional drawings, in terms of the trend towards greater naturalism and complexity, also extends to studies of the protagonists whose expressions and actions convey the narrative and sentiment of the work. The speed of development was much swifter in figure drawing because the ground had already been prepared by the naturalistic and highly expressive direction of much trecento art flowing from the work of Giotto. Whether the naturalistic style of Giotto and his followers in central Italy, or of those in northern Italy inspired by his frescoes in the Arena chapel in Padua such as Altichiero, depended to any degree on life drawing is debatable. There is certainly no mention made of any such practice by Cennini apart from generalized statements recommending the study of nature ('*la più perfetta guida*').[117] The monumentality of Giotto's painted figures, and the economy through which they convey their emotional and mental states, was hugely influential, above all in Florence where the short-lived Masaccio took up his mantle in his frescoes in the Brancacci Chapel (*c.* 1425–8) that have the added dimension of perspective to enhance the naturalism. Echoes of these two Florentine titans can be discerned in the study of a mournful woman, probably the Virgin looking up at her son on the cross, by Masaccio's contemporary, Filippo Lippi (no. 11), and in Michelangelo's so-called *Philosopher* from the beginning of his career (no. 91). The young Michelangelo's keen sense of being part of a specifically Florentine artistic legacy, headed by Giotto and then passed to Masaccio and Donatello, is signalled by the drawn copies he made after their works.[118]

The importance of classical art

A potent source of inspiration for figural ideas for all fifteenth-century artists, including Michelangelo, was ancient cameos, coins and, most importantly, sculptures. Literary descriptions by classical authors, such as Pliny the Elder and Lucian, had been the only source of knowledge for artists to gain a sense of the appearance of ancient paintings prior to the discovery at the end of the fifteenth century of the frescoed decorations in Nero's palace complex, the Domus Aurea (Golden House), on the Palatine in Rome. The strong identification of humanists and the educated classes with their classical forebears encouraged artists to follow suit, but just as the study and appreciation of Latin texts had never died out, so there was already a well-established tradition of Italian artists seeking inspiration from antique art, exemplified by the Pisa pulpit completed in 1260 by Nicola Pisano (*c.* 1220/25–*c.*1284).

It is a measure of this unprecedented engagement, and indeed competition, with classical culture that Botticelli in a painting in the Uffizi and Mantegna in a late

drawing in the British Museum (fig. 36) tried their hands at recreating a painting by Apelles, the so-called *Calumny of Apelles* described by Lucian. The Greek painter's skill in finding a pictorial form to attack the slanderous claim of a rival painter that he had been part of a conspiracy to overthrow his Egyptian patron, King Ptolemy I, was the model for another drawn allegorical invention in the same vein by Mantegna, the *Virtus Combusta* (no. 22). The Paduan painter shared with his ancient counterpart a bleak view of the dominance of Folly and Ignorance, an attitude fostered perhaps by their common experience of the vicissitudes and backbiting of court life, yet his admiration also had a competitive edge. Mantegna's invention was even more complex and recondite than Apelles' original, since it had the added, more optimistic dimension, developed in a related composition (a section now only known through an engraving; see fig. 2, no. 22), which showed that Virtue could be rescued by Reason in the guise of Mercury, inventor of the arts and god of knowledge. A comparable mixture of emulation and competition can be sensed in Michelangelo's dynamic interpretation of the pose of the *Apollo Belvedere* statue for a sentry intended for his unrealized *Battle of Cascina* fresco, the poise and stasis of the marble replaced by an unstable equilibrium (fig. 37 and no. 92).

The great diversity of classical art over a period of more than half a millennium explains why it remained such an enduring source for artists until the modern age, since classical precedents could be found that echoed any shift in taste between the poles of naturalism and artifice. An example of how individual artistic sensibilities could shape the interpretation of a classical model can be seen from a comparison between the drawings by Gozzoli (no. 14) and Raphael (no. 97), inspired by the colossal second-century sculptures known as the *Dioscuri* or *Horse tamers* on the Quirinal Hill in Rome (fig. 1, no. 14). When the artists saw them, they were in the fragmentary state shown in an engraving from the first half of the sixteenth century (fig. 38). In the drawing of *c*. 1447–9 attributed to Gozzoli, the group comprising the horse and his tamer is given a naturalistic edge by bringing them off their pedestal and placing them in closer proximity to each other, slightly increasing the scale of the horse so

Fig. 36
Andrea Mantegna, *The Calumny of Apelles*, *c*. 1504–6. Pen and brown ink, brown wash, 20.6 × 37.9 cm. British Museum, London.

This drawing is based on a lost allegorical painting by the ancient Greek artist Apelles. The work was described by the classical author Lucian, a text popularized by Alberti's version of it in his treatise on painting, *Della Pittura* (1436).

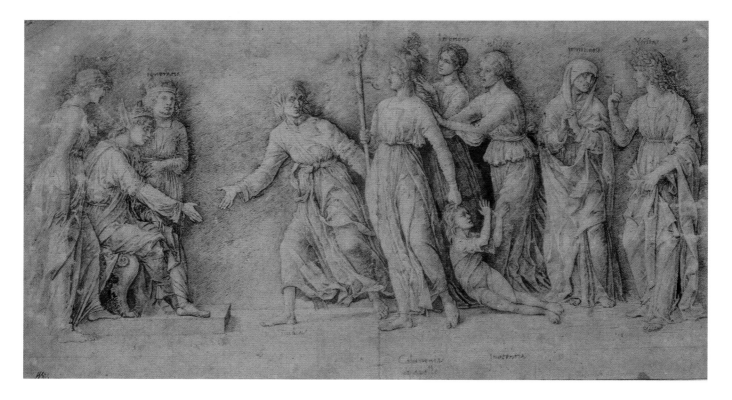

Fig. 37
Apollo Belvedere, c. AD 117–38. Marble,
h. 224 cm. Vatican Museums, Vatican City.
A Roman version possibly after an original by
the 4th-century BC Greek sculptor Leochares.

Fig. 38
Anonymous artist, *Horse tamers,* before 1545.
Engraving, 37 × 50.5 cm. British Museum,
London.

This is from a collection of plans and views of
Rome, the *Speculum Romanae Magnificentiae,*
issued between 1545 and 1577.

that it is, unlike in the original, larger than the man. The striding pose and backward
tilt of the nude is toned down, and the stylization of the two forms is reduced, as
seen in the addition of a flowing mane and tail. The study can be interpreted as an
attempt to recreate the original naturalistic motif of horse and groom that the classical
sculptor, who was, according to the later and inaccurate inscription on the base,
the famous Greek sculptor Phidias, used as the starting point for his idealized,
monumental treatment that evokes mankind's subjugation of the natural world.

A similarly utilitarian approach towards classical art can be seen in the afore-
mentioned *Spinario*-inspired nude (fig. 11) from a dismembered Gozzoli studio
model book. If Gozzoli's drawing of a man and horse was intended as a workshop
model there is no record of him ever using it in one of his paintings, but an idea of
how it could have been utilized is provided by Raphael's cartoon for the *St George*
where the thickset horse is closely modelled on the Quirinal prototype. It seems
highly probable that Raphael had seen and made drawings of the sculpture on an
undocumented trip to Rome in the early 1500s, which he used as the basis for his
representation of a Christian saint's steed, a classical allusion that would have been
appreciated by his courtly humanist patrons in Urbino. The Uffizi drawing is an
early instance of Raphael's imaginative yet scholarly engagement with classical art,
an objectivity exemplified by the red-chalk drawing now in the National Gallery
of Art, Washington, that he made around a decade later after the same horse.[119] The
Washington sheet bears pen measurements of the sculpture made by an assistant,
while Raphael's punctiliousness with regard to recording archaeological detail
extended to marking the joint between the two pieces of stone from which the body
and head of the horse were carved.

A mirror image of Gozzoli's interpretation of classical sculpture through the
experience of making life drawings is provided by Raffaellino del Garbo's study for
the Risen Christ, related to an altarpiece from the late 1490s now in the Galleria
dell'Accademia in Florence (no. 69, and fig. 1, no. 69). The wreath of vine leaves, the
clinging drapery and the exposed genitalia indicate that a source of inspiration was an
antique sculpture of Dionysus or Bacchus, perhaps one like the Roman marble based
on a Greek prototype of the god in the British Museum that was excavated in Libya
in the nineteenth century (fig. 39).[120] Yet the drawing is not a copy after an antique
marble, since the proportions and musculature are recognizably those of a willowy

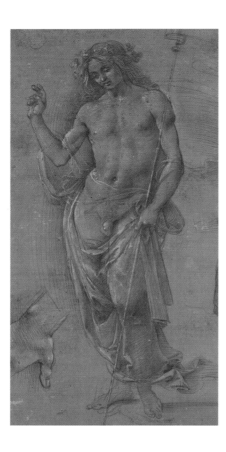

Fig. 39
Anonymous Roman, *Dionysus or Bacchus*, h. 1.75 m.
British Museum, London.

Roman version of a lost Greek original of the
3rd century BC. Excavated in the 19th century
from the Temple of Dionysus, Cyrene, in Libya.

Fig. 40
Detail of no. 69

adolescent, the inclusion of realistic touches such as pubic hair demonstrating that
the artist was drawing from a model, most likely a studio apprentice. The aim of the
drawing from the outset was unquestionably to study the pose of the Risen Christ,
hence the blessing gesture and the inclusion of the flagstaff for the Resurrection
banner. The androgynous youthful beauty of the model and his langorous pose
clearly triggered an association in the artist's mind with sculptures of Bacchus, the
ancient god of wine. The classical touches are therefore an imaginative flourish, a
dimension of artistic invention seen more prosaically in the fluttering drapery and
flag that the artist was able to conjure in his mind and put down on paper without
actually needing to see them before him. Raffaellino del Garbo's study exemplifies
how, in the private domain of drawings, artists could explore ideas and associations
between two divinities, one Christian and the other one of the most licentious and
hedonistic in the pagan pantheon, that were unthinkable in works destined to be
seen outside the studio. As such it is a precedent for Michelangelo's transformation,
in a sheet from the early 1530s at Windsor, of the pose of the pinioned Tityus about
to have his liver torn out and eaten by an eagle to that of the Resurrected Christ,
a switch achieved purely through tracing the outlines from recto to verso and
adding the outlines of a tomb.[121]

Life drawing

The practice of life drawing was a vital constituent in developing the quickness of
mind and hand to allow the kind of imaginative leaps found in Raffaellino del
Garbo's study, and it is significant that his master, Filippino Lippi, was a prolific
maker of rapid metalpoint studies of this kind. The drawing in the British Museum
(no. 65) is a relatively rare example of Lippi studying nude, or almost nude, models,

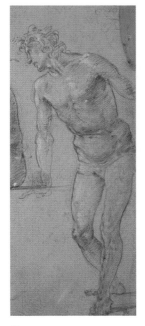
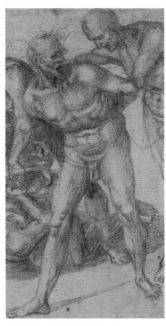

Fig. 41
Detail of no. 65

Fig. 42
Detail of no. 63

using silverpoint and leadpoint. The different techniques imply that the studies were made in two separate sessions perhaps from the same model, yet characteristically Lippi sought to connect the two by the way in which the model on the right seems to be leaning forward to peer at the object, perhaps a drawing, balanced on the knee of the other. Lippi's preference for pairing figures in his life drawings added a narrative dimension that tested his abilities to connect the two in some way, while rapidly recording the poses in metalpoint and white heightening. The fruits of Lippi's dedication to this kind of dynamic, pressurized approach to life drawing can be seen in the ease with which he was able to interrelate and animate groups of figures in larger compositions, such as in the two studies for the Carafa and Strozzi chapels (nos 66–7), and by his seemingly effortless formulation of complex poses as with the Uffizi sheet of the two bier carriers for the *Resurrection of Drusiana* (no. 68).

A number of Florentine painters in the last quarter of the fifteenth century, including Botticelli, Lorenzo di Credi, Raffaellino del Garbo and Leonardo, shared Lippi's enthusiasm for using metalpoint as a medium for life studies. The wide diffusion of the practice in Florence is testified by the numerous examples of this type of study found in museum collections under various attributions: Florentine School, Studio of Filippino Lippi/ Botticelli, or under the name of Davide Ghirlandaio (1452–1525), the brother of Domenico, whose graphic oeuvre was an imaginative (and now largely discredited) construction on the part of the American scholar Bernard Berenson in *The Drawings of the Florentine Painters* (first published 1903 and with a revised edition in 1938).[122] Paradoxically the unparalleled popularity of silverpoint as the preferred method for training artists in life drawing in Florence (a choice echoed in Umbria, in part because of its use by the Florentine-trained Perugino, and in Lombardy through the advocacy of Leonardo) coincided with the gradual replacement by oil of tempera as a binding medium for paints (for a fuller description of this change see p. 41), a switch that meant that most artists trained in metalpoint at the end of the fifteenth century did not commonly use this expertise during their working careers.

The replacement of silverpoint in favour of the more tonal graphic techniques of chalk, ink and wash in central Italy occurred a generation earlier in Venice because the northern European technique of oil painting had already taken root there, after it had been introduced in the mid-1470s by the Sicilian painter, Antonello da Messina (c. 1430–79). Among central Italian artists working at the end of the century the Tuscan painter Signorelli took from his master Piero della Francesca the use of cartoons and the adoption of oil paint, hence his championing of chalk, particularly black chalk, for figure drawings. The medium imparted a sculptural solidity through the combination of precise contours and blended, directional hatching that the linear medium of metalpoint could not match. The differing qualities of the two techniques are highlighted by a comparison between two figure studies in similar poses: a leadpoint academy by Filippino Lippi (fig. 41) from the mid-1480s and a red- and black-chalk figure by Signorelli taken from an unused study of c. 1500 for the Cappella di S. Brizio in Orvieto Cathedral.

Filippino Lippi's relatively large graphic corpus provides ample evidence for the central importance of life drawing to the way in which he designed his paintings. The same is probably also true of many fifteenth-century artists of the preceding generation, despite the rarity of examples of studies in this category among their surviving works. Filippino's father, Filippo, is a case in point. His fluid invention of figures and compositions in the two metalpoint drawings in the exhibition (nos 11–12) implies long practice of studying models, yet such works have not survived. A comparable lacuna is found with Mantegna, and again it is impossible to imagine that his skill in putting together figures in his compositional design for the Ovetari Chapel fresco (no. 20), or his treatment of the naked torso of the reclining figure in no. 21, was not rooted in life drawing. Perhaps the best evidence of Mantegna's formative experience of life drawing and copying classical sculpture (the latter

probably from casts in the collection of his master Squarcione) is the ease with which he was able to imagine the rotation of a reclining figure in an early small-scale pen study from around the mid-1450s in the British Museum (fig. 43).[123] From the speed of Mantegna's penwork it cannot be entirely ruled out that he was working from a model, either real or a jointed wooden figure, rather than from his imagination, since Parri Spinelli made a comparably rapid notation of a contorted pose, in a sheet in the Uffizi from *c.* 1430–50 , which seems almost certainly to be a life study (fig. 44).

The stimulus for Mantegna to make life drawings need not necessarily have come from Tuscan artists in Padua such as Donatello, because a northern Italian precedent for the practice had been established by Pisanello. The Veronese artist's interest in studying dead and living animals and birds was one that developed out of a naturalistic Lombard tradition, but he broke new ground in the drawings he made from life models. The small number of studies in this category includes examples of clothed figures, as is the case with a drawing in the National Gallery of Scotland, Edinburgh, of a studio assistant adopting the pose of a hanged man with his hands tied behind his back related to no. 9, as well as a few nudes.[124] Amongst the latter is perhaps the earliest Italian drawing of a female nude, from *c.* 1425–35, in the Museum Boijmans Van Beuningen, Rotterdam, that actually appears to have been based on first-hand observation of a model (fig. 45).[125] It is hard to assess whether Pisanello's example was widely followed in northern Italy because the number of surviving drawings is so much smaller than those from central Italy. Jacopo Bellini's generalized description of figures, both clothed and nude, in the *London album* (no. 16) does not suggest that drawing from live models was part of his normal artistic practice. This is probably not true of his son Gentile, whose two Middle Eastern costume drawings (nos 17–18) are almost certainly derived from studies made when he was in Turkey. Among Gentile's Venetian contemporaries there is scant evidence of life drawing: rare surviving examples include the studies of hands by Vivarini on the reverse of no. 75 and Carpaccio's black-chalk drawing of a male torso in the British Museum made in relation to a painting of the Dead Christ (fig. 2, no. 75 and fig. 1, no. 81 respectively).[126] It seems improbable that Vivarini and Carpaccio were isolated advocates of life drawing in Venice, since in the following century it was a practice that can be documented for a number of the city's leading painters, such as Titian, Paris Bordone (1500–71), Jacopo Tintoretto and Palma Giovane (*c.* 1548–1628).[127]

The way in which life drawing could affect an artist's study of sculpture and vice versa, as seen in the drawings attributed to Gozzoli and Raffaellino del Garbo, also holds true of draughtsmen in northern Italy. For example, Mantegna's and Pisanello's desire to study the poses from different viewpoints in the London and Rotterdam drawings (figs 43, 45) can be traced back to their shared interest in relief and free-standing sculptures, both antique and modern, that encouraged the spectator to look at them from varied angles and perspectives. An idea of Pisanello's interest in sculpture can be gauged from drawn copies made after his drawings by an artist in his circle, while in the case of Mantegna, with the exception of a pen study after a Trajanic relief (most likely a copy after a lost original), it is his paintings that supply evidence of his study of sculpture both from antiquity and by Donatello.[128] The study of sculpture was so important to fifteenth-century painters because it provided a key to mastering the convincing depiction of the body while in motion, or in a state of muscular tension suggesting imminent movement. It also encouraged them to analyse how the three-dimensionality of sculpted forms could be replicated in two dimensions through the deployment of light.

It is not by chance that a number of the period's most innovative artists, such as Antonio Pollaiuolo, Verrocchio and Francesco di Giorgio, received their initial training as goldsmiths before turning to painting. The division between sculpture and painting was in any case blurred by sculptors such as Donatello producing pictorial low reliefs, and painters, such as the Florentine Neri di Bicci (1418–92) or his Sienese contemporary, Neroccio de' Landi (1447–1500), gilding and colouring

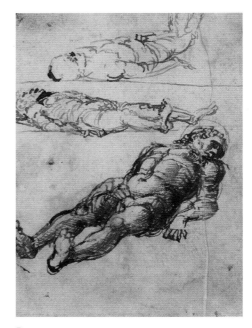

Fig. 43
Andrea Mantegna, *Three studies of a reclining figure*, *c.* 1455–65. Pen and brown ink, 12.2 × 8.8 cm. British Museum, London.

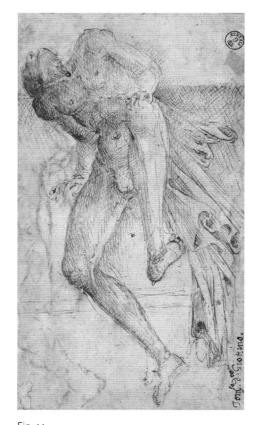

Fig. 44
Parri Spinelli, *A reclining male nude*, *c.* 1430–50. Pen and brown ink, 18.6 × 10.3 cm. Gabinetto Disegni e Stampe degli Uffizi, Florence.

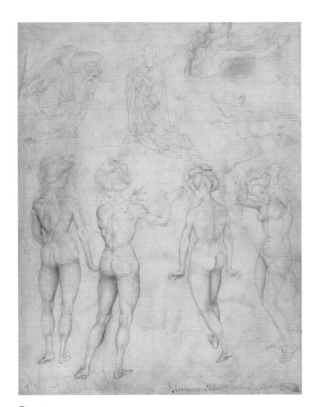

Fig. 45
Pisanello, *Studies of female nudes and an Annunciation*, 1425–35. Pen and brown ink, on vellum, 22.3 × 16.7 cm. Museum Boijmans Van Beuningen, Rotterdam.

reliefs in gesso and marble.[129] A goldsmith's sculptural conception of forms existing three-dimensionally so that they can be viewed from diverse angles and distances is already present in Finiguerra's studies of hands on the two sheets from the Uffizi (no. 26), and it was a way of thinking that was taken up and developed by his younger contemporary, Antonio Pollaiuolo. The latter's large engraving, *Battle of the Nudes*, datable to the period 1470–90 (fig. 46), is the clearest demonstration of how his sculptural sensibility infused his two-dimensional work, as in the mirroring of the poses of the central protagonists so that together they present an almost 360-degree viewpoint. This kind of pivotal presentation of poses, which is also found in the figures on the right in Mantegna's Ovetari study (no. 20), was one that successive generations of artists in the second half of the century mastered through drawing, both from life models and after sculptures. These two categories of drawings might be amalgamated in studying casts taken from different parts of the body, a practice that dates back as far as Cennini, who provided practical advice on how such moulds should be made. Another crossover between the two disciplines was the use by painters of lay models (jointed wooden or clay mannequins) in order to study the fall and lighting of drapery, with the material dipped in clay or wax in order to fix the folds. The simplified forms of these models are detectable in the drapery studies of Ghirlandaio and Fra Bartolommeo (nos 60, 89).

The mental agility that resulted from this course of studying sculpture is apparent in the quick figural studies by Leonardo, Michelangelo and Raphael, all of whom were capable, without recourse to a model, of rotating variants of a pose in their mind and then sketching them on paper. This mental and imaginative facility is one of the defining qualities that marks out supremely gifted draughtsmen. The practice of life drawing was also instrumental in enabling artists to gain a comparable ability to visualize and manipulate lighting to enhance the three-dimensional effect of their painted figures. This process of transformation from the observed to an enhanced, idealized version of nature can be witnessed in the two sides of Verrocchio's charcoal drawing of a female head (no. 40). The immediacy of the sketch of a young woman, lit from the top left, leaning her head on her right hand on the verso argues in favour of it having been drawn from life. The quick notation of features and lighting was the starting point for the study on the other side, where the artificiality of the woman's fantastic coiled coiffure is offset by the naturalistic rendering of light that

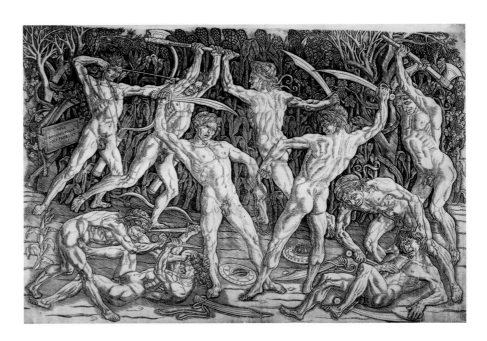

Fig. 46
Antonio Pollaiuolo, *Battle of the Nudes*, c. 1470–90. Engraving, 41.6 × 59.4 cm. British Museum, London.

establishes its form in space. Verrocchio also transformed the downward look of the model to one where the eyes are obscured by the exaggeratedly large eyelids fringed by lashes. The inability to detect exactly where the gaze of the woman is directed, allied to the inscrutability of the expression of her slightly pursed mouth, which has a hint of the smile shown in the life study on the verso, gives the head an air of veiled mystery. This ambiguity was almost certainly intentional, as it meant that this carefully worked drawing could serve as a reference for a Virgin gazing down at her son as well as for a nymph or goddess in reverie.

Verrocchio's skill in showing just enough of an expression and state of mind to engage the viewer into interpreting these signs was one that Leonardo would take to new heights in his painting. But it was one that he initially struggled to master, as can be seen from the trials he experienced with the downward gaze of the idealized head studied in his early drawing in the Uffizi (no. 48). Leonardo clearly understood the means by which his master had imparted a sense of consciousness behind the lowered eyes, even if he was not yet quite capable of replicating it entirely successfully in his own drawing. His probing, analytical mind was far ahead in his comprehension of Verrocchio's subtleties of that of his fellow pupil, Lorenzo di Credi, whose comparable head study is executed with great technical finesse yet lacks a comparable feeling of inner animation (no. 42).

Leonardo

The inclusion of ten drawings by Leonardo, one-tenth of the selection, demands an explanation as to why he merits being singled out in this fashion. It should be stated from the outset that the chosen examples form a group of drawings that with a few exceptions relate to his activities as a painter. This focus is an appropriate one for a selection so heavily weighted towards designs for paintings; in addition his studies in this category were the graphic works that had the greatest influence on his artistic contemporaries. Nevertheless it should be acknowledged that the limitations of the British Museum's and the Uffizi's holdings mean that Leonardo's multifaceted genius, the scope of his interests in the natural world, technology and science documented in the Royal Collection's unsurpassed collection of his drawings, is barely touched on. The only indications of Leonardo's interests beyond art are the drawings of military machines (no. 54) and a red-chalk *écorché* (an anatomical study of a body or limb with the skin removed to show the muscles) of a male leg (no. 57).

Raised in the Tuscan hilltown of Vinci, Leonardo's artistic education only began in 1464 when he joined his father in Florence. At some point in the 1460s Leonardo was apprenticed to the goldsmith, sculptor and painter Verrocchio, but there is no certainty as to when this occurred. The regulations of the Florentine guild of painters (the Medici e Speziali, whose members were doctors and pharmacists, with painters included because the mixing of pigments was judged similar to making medications) specified that an apprentice had to be at least 14 years old. There are, however, examples of younger boys being taken on – such as the 12-year-old Michelangelo working in the studio of the Ghirlandaio brothers – so that rule would not have precluded Leonardo joining Verrocchio not long after his arrival in Florence. The 1460s and 1470s were an exceptionally busy period for Verrocchio as he juggled major bronze projects in Florence, including the tomb of Cosimo de' Medici (1389–1464) in S. Lorenzo, the *Incredulity of Thomas* group for Orsanmichele and a monumental candelabrum for the Palazzo della Signoria; and the making of a giant copper ball for the lantern of Florence Cathedral. He experienced mixed success in painting: his failure to win a share of a cycle of panels depicting the Virtues for the Mercanzia Palace (see no. 33) was partly made up for by a commission for an altarpiece for Pistoia Cathedral. While it may seem odd that Verrocchio's predominantly sculptural workshop attracted apprentices whose future direction would lie in painting (Leonardo,

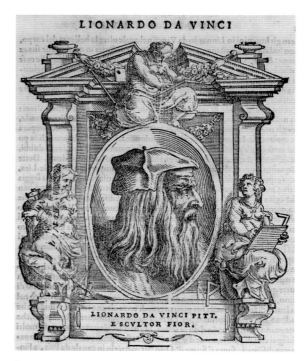

Fig. 47
Cristoforo Coriolano, Leonardo from Vasari's *Lives of the Artists*, 1568. Woodcut, 12.1 × 10.5 cm.

Perugino, Lorenzo di Credi and perhaps Domenico Ghirlandaio), this was also true in the first half of the century of Ghiberti, whose assistants on the two bronze doors for the Florentine Baptistery included Uccello and Gozzoli.

The output of Verrocchio's studio did include paintings, for the most part small-scale domestic devotional works; it is just not certain the extent to which the sculptor actually participated in their execution. The *Virgin and Child* in the Gemäldegalerie, Berlin, is the one work that is thought to have the best chance of being entirely by him (fig. 2, no. 48).[130] It seems to be the case that Verrocchio was happy to delegate the bulk of painting production to his pupils working under his supervision and presumably guided, at least in part, by his drawings (although evidence of this is lacking since connected examples of such studies have not survived). This devolved method of working can be seen in the altarpiece, known as the *Madonna di Piazza*, in Pistoia Cathedral, commissioned in the mid-1470s that seems largely, if not entirely, to be the work of Lorenzo di Credi. The delegation also extended to Credi making preliminary studies for the two standing saints in the painting, although it is unlikely he was entirely responsible for its design, since Verrocchio is recorded as having supplied a contractual drawing at the outset.[131] The difficulty of identifying which pupil in Verrocchio's workshop executed various Virgin and Child panels is complicated by some of them being the work of more than one hand. For example, the *Virgin and Child with angels* in the National Gallery, London, seems to be partly the work of Lorenzo di Credi, who painted the waxy fleshed child and the angel on the right, but not the angel and the adoring Virgin, which may conceivably be by Verrocchio.[132] It has been suggested that the young Leonardo's hand is discernible in parts of other Verrocchio collaborations from the 1470s, such as in the National Gallery's *Tobias and the Angel*, and even in some of the metalpoint and wash additions overlaying a black-chalk underdrawing in a study of *Venus and Nymph* in the Uffizi (illustrated as fig. 1, no. 40), plausibly connected to a commission for a jousting banner that the sculptor is known to have made in 1475 for Giuliano de' Medici (1453–78).[133] The one universally recognized example of Leonardo collaborating with his master is the left-hand angel and parts of the landscape in Verrocchio's *Baptism of Christ*, a panel commissioned for the monastery of S. Salvi outside the city walls of Florence and now in the Uffizi (fig. 1, no. 41).[134]

At the age of 20 in 1472, Leonardo joined the painters' confraternity, which signalled that he was regarded as an independent master, but despite this his association with Verrocchio continued. He was still part of the sculptor's household in 1476 when he was accused and acquitted of sodomy. During his period in Verrocchio's workshop he produced independent paintings, such as the Uffizi *Annunciation*, the *Madonna with the Carnation* (Alte Pinakothek, Munich) and the portrait of the Florentine noblewoman Ginevra de' Benci now in the National Gallery of Art, Washington. His first public commission was the *Adoration of the Magi* panel now in the Uffizi (fig. 1, no. 53), ordered in 1481 for the monastery of S. Donato a Scopeto just outside the walls of Florence. He abandoned the altarpiece in an unfinished state when he left to work in the Sforza court in Milan sometime between September 1481 and April 1483, thereby beginning an almost 20-year absence from Florence.

Verrocchio's significance for Leonardo as a draughtsman

As the majority of the drawings in this selection date from the period before Leonardo's departure for Milan, it is worthwhile considering what his drawings owed to his master. Unfortunately only around ten studies by Verrocchio survive, none of which relate directly to his work either as a sculptor or painter, so it is hard to gain an understanding of the role played by drawing in the functioning of his studio. The technical proficiency of the works by his pupils in the exhibition provides strong evidence that Verrocchio was an adherent of the traditional Florentine

drawing-centred model of training, one that Leonardo would later espouse when he was responsible for the artistic education of his Milanese pupils in the 1490s.

The manner in which drawing could be used to shape the nascent style of a young artist may have been particularly important to Verrocchio, due to his wish to delegate to his pupils the execution of the bulk of the paintings issuing from his workshop. His success in fostering a studio style founded on drawing can be seen from the stylistic similarities between the study of a female head by Verrocchio (no. 40), and those by Leonardo (no. 48) and Lorenzo di Credi (no. 42). Mention has already been made of the mixed success of Credi and Leonardo in capturing the dreamy introspectiveness of Verrocchio's figure, but more importantly what unites them is the shared observation of light to establish the three-dimensionality and geometry of the head. The smoky (*sfumato*) indeterminacy of Verrocchio's charcoal modelling of the head, with a gradual transition between highlight and shadow so that there are no sharp boundaries between the two, was taken up by Leonardo in his own drawings, as can be seen in the Uffizi red-chalk profiles (no. 55), and in the chiaroscuro illumination (the contrasting play of light and shadow) that was to become such a defining and influential feature of his work as a painter. The sculptural sensibility that Verrocchio brought to drawing was his most significant legacy to his pupils. Leonardo may well have also had first-hand experience of sculpting in Verrocchio's studio: in his letter of self-introduction written in the early 1480s to Ludovico Sforza, the list of accomplishments that he offered included the ability to sculpt in marble, bronze and clay. No certain sculptures by his hand survive to back up this claim, yet mention of a 'narrative of the passion made in relief' in an inventory of his works, probably made soon after his transfer to Milan, shows that he did sculpt on occasion.[135]

The extent to which Verrocchio's work as a sculptor shaped Leonardo's drawing is highlighted by the silverpoint *Warrior* probably made during the second half of the 1470s (no. 50). The work is inspired by a lost relief by Verrocchio known through copies in various media (see fig. 1, no. 50). Leonardo adhered so closely to the form of the sculpture in the strict profile view, and the play of the fluttering ribbons attached to the helmet parallel to the frontal plane, that it would be feasible for the drawing to be translated into a relief. The evocation of the crisp modelling and milky luminescence of marble must have been even stronger when the creamy ivory prepared paper on which it was drawn was fresh and unblemished. It seems improbable that Leonardo's highly finished drawing was really a design for a sculpture; a more likely function was as a tour-de-force demonstration of virtuosity. If the work was a demonstration or presentation piece, it was one that simultaneously acknowledged Leonardo's ties with Verrocchio, while also perhaps marking his initial salvo in the theoretical debate about the relative merits of painting and sculpture (the so-called *paragone* or comparison) that Renaissance writers such as Alberti adapted from classical criticism. In his later writings on the subject Leonardo acknowledged that low reliefs, such as the one that inspired the *Warrior*, were closest to painting; nonetheless, he still claimed that painters needed to be more skilful because it was inherently harder to create the illusion of three-dimensionality in a two-dimensional medium: 'the major cause of wonder that arises in painting is the appearance of something detached from the wall or other flat surface, deceiving subtle judgements with this effect, as it is not separated from the surface of the wall. In this respect the sculptor makes his works so that they appear to be what they are.'[136]

Leonardo was to take the practical grounding he received in Verrocchio's studio in the fundamental aspects of painting, such as the treatment of light and perspective, and the naturalistic rendering of figures exhibited in workshop paintings such as the so-called *Ruskin Madonna* in the National Gallery of Scotland, Edinburgh (fig. 48), in hitherto unimagined directions, driven by an intellectual curiosity that ranged far beyond the needs of a practising artist. A measure of the different order of Leonardo's perception and ambition in his analysis of his master's work can be seen

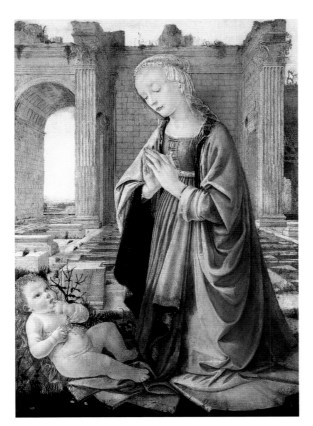

Fig. 48
Andrea del Verrocchio and studio, *The Virgin and Child (Ruskin Madonna)*, 1470s. Tempera and oil on canvas, transferred from panel, 106.7 × 76.3 cm. National Gallery of Scotland, Edinburgh.

in the ways that he and his fellow pupil, Perugino, used elements of the Edinburgh painting, such as the ruined classical setting and the demarcation of the pictorial space through architecture, in their respective drawings for *Adoration* compositions from the 1480s (nos 45, 53). The perspectival construction presented in Leonardo's study for the background of the S. Donato a Scopeto panel (no. 53) is unrivalled among fifteenth-century Italian drawings for its complexity. Through the tight gridlines the artist sought to map out the position of the figures scattered throughout the extensive pictorial vista, the difficulty of the task intensified by the intricate structure of the ruins on the left. Perugino's drawing for a lost fresco of the *Adoration* (no. 45) is far simpler, yet more visually coherent than Leonardo's earlier work, his lucid command of space by means of the columns of the ruined loggia (a motif perhaps echoing the cloister of S. Giusto alle Mura where the fresco was located) a legacy of a training that probably included a stint with Piero della Francesca as well as Verrocchio. The figures in Perugino's composition are disposed so that those in the background are more or less in the same plane to reduce the complexities of scale taken on by Leonardo. It is notable that Perugino's brilliantly concise drawing is a practical design for a painting that could be executed. By contrast, the lack of resolution of Leonardo's study is also to be found in the unfinished panel, his ambition to weave together the animated crowd of figures in the foreground with those behind them exceeding his ability to execute it in paint.

Leonardo's significance as a draughtsman

Leonardo's desire to push painting to new dramatic and expressive heights explains why Vasari famously broke the chronology of his *Lives of the Artists* to place him in the third age, the *maniera moderna*, along with artists of the succeeding generation such as Raphael and Michelangelo. Leonardo's status as a pioneer of the grander, more expansive art of the High Renaissance may have been enhanced to later eyes by his failure to complete the *Adoration*. The unresolved state and variable finish of the panel makes it endlessly open to interpretation as to how it might have looked had Leonardo brought it to completion. The more tangible aspects of the painting, such as the articulation of a highly expressive crowd around a central focus, can be seen to have influenced Leonardo's contemporaries, as in Filippino Lippi's study for the *Resurrection of Drusiana* (no. 67). Inevitably it was Raphael who grasped most profoundly what Leonardo was trying to achieve in terms of the spatial disposition of figures, and the use of light to isolate particularly important details, and echoes of Leonardo's *Adoration* appear in Raphael's studies of 1508–9 for his fresco of the *Disputa* in the Stanza della Segnatura in the Vatican (like the *Adoration* a composition pivoted around a central motif), and in his final painting, the tenebrous *Transfiguration* now in the Vatican Pinacoteca.[137]

Raphael was no less quick in seeing the possibilities of Leonardo's spontaneous method of composing a rapid stream of variants of a pose or design in pen, as in the two studies of the *Virgin and Child with a cat* (nos 51–2). This way of drawing can again be linked back to the practice of Verrocchio, who in a double-sided study in the Louvre (see fig. 1, no. 51) sketched a series of kinetic poses of standing and seated infants. Verrocchio's ability as a sculptor to imagine the poses of the figures in three dimensions, which allowed him to pivot and reverse them at will in his mind, was a skill that he passed down to his pupil Leonardo, as can be seen in his seamless rotation of the seated Christ Child in the three studies on the verso of no. 52 (fig. 49). What Leonardo added to this form of drawing was his realization that a blur of variant positions of a limb or a pose, the form of one intermingling with those that had come before, was the graphic equivalent of the suggestive indeterminacy of the stains on walls that he recommended artists should use as a stimulus to fire their creativity, in his notes for his unfinished treatise an art:

I cannot forbear to mention among these precepts a new device for study which, although it may seem but trivial and almost ludicrous, is nevertheless extremely useful in arousing the mind to various inventions. And this is, when you look at a wall spotted with stains, or with a mixture of stones, if you have to devise some scene, you may discover a resemblance to various landscapes, beautified with mountains, rivers, rocks, trees, plains, wide valleys and hills in varied arrangements; or, again, you may see battles and figures in action; or strange faces and costumes, and an endless variety of objects.[138]

The open-ended nature of this kind of 'brainstorming' method of drawing, encapsulated in another of his studies for the *Virgin and Child with a cat* in the British Museum (fig. 50), was central to Leonardo's way of working. Such was the fertility of his imagination and his love of graphic invention that he clearly found it hard to move from the preparatory stage to the actual business of painting, a process that demanded he select which of the myriad variants contained in his studies should form the basis of the picture. In its most extreme form, the rapidity of the flow of ideas could result in a drawing so dense with revisions that the pen contours coagulated to form an impenetrable thicket of lines, as in no. 56.

This style of spontaneous drawing was taken up by other artists (a fact that suggests that Leonardo allowed contemporaries to view his graphic works) as can be seen in Michelangelo's studies for the poses of the Infant Baptist and the Christ Child for the marble *Taddei tondo* on the verso of no. 92, and Fra Bartolommeo's quickly penned sketches for a *Virgin and Child with the Child Baptist* (no. 87). The closest equivalent to the speed and intensity of Leonardo's approach is provided by Raphael's sheet of studies of the Virgin and Child (no. 98). The young artist, with characteristic purposefulness, utilized the variants on the page as the starting point for various paintings of the theme, a genre of work with which he established his name during the period when he was predominantly in Florence (1504–8). The significance of the adoption of this method of drawing was twofold. It fostered compositional and figurative innovation because it made artists improvise, thereby encouraging them to move away from existing formulae. It could, however, only be applied to the interaction of a relatively small number of figures, since multi-figured designs were too complex and time-consuming to allow a spontaneous flow of variants to pour out on the page. The pace of execution vital to the success of this kind of drawing imparted dynamism and movement to the study which could, in the hands of the most skilful artists, transfer to the finished work. There is no means of defining how large a part it played in developing the flowing movement and rhythmic groupings found in Raphael's mature works, such as the *School of Athens* in the Stanza della Segnatura in the Vatican Palace, but it is notable that spontaneous, rapid drawing in the manner of Leonardo remained a permanent feature of his compositional method.[139]

The final aspect of Leonardo's drawings that makes them so significant to the development of Italian art is the unparalleled level of naturalness he brought to drawing. The fruits of his concentrated observation of the forms and forces of nature are already present in the landscape drawing of 1473 (no. 49) in the precise rendering of the geological structure of the cliff on the right, and the flickering pen lines to capture the shimmering evanescence of the distant landscape. Even if the drawing is almost certainly not, despite the precise detailing of the day it was made, an exact record of a particular location, it is unquestionably a work that is steeped in Leonardo's experience of studying and observing the mountainous landscape around his native Vinci. Equally the quick sketches of the Virgin and Child with a cat are unlikely to record at first hand such an interaction. The arched back of the cat appealing to be stroked, or its struggles to escape the overenthusiastic embrace of the child, are details probably furnished from his memory of witnessing such moments, the actions of the protagonists perhaps recorded in rapid metalpoint notations in a

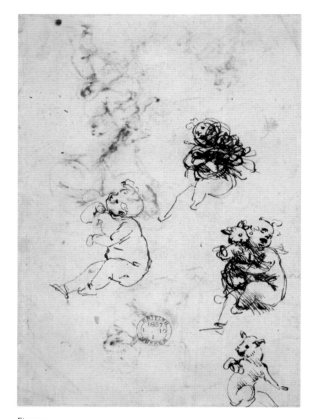

Fig. 49
Verso of no. 52

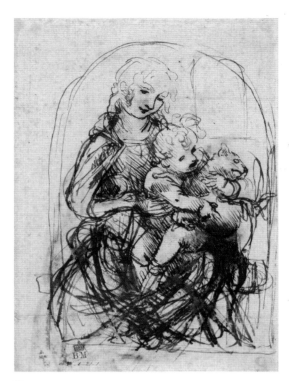

Fig. 50
Leonardo da Vinci, *Virgin and Child with a cat*,
c. 1478–81. Pen and brown ink, over stylus,
13 × 9.4 cm. British Museum, London.

The verso is illustrated on p. 78.

sketchbook, something he later recommended his pupils should always carry around with them.[140]

One of the many paradoxes in Leonardo's art and character is that the naturalism of his preparatory drawings was directed towards the production of paintings that are often profoundly unnatural and artificial, as in the notion of seating the adult Virgin Mary on the lap of her elderly mother as studied in no. 56. This kind of conceit was entirely in keeping with the taste of the period, and Leonardo's brilliance in formulating compositions that invited symbolic interpretation was a factor in his exalted status (as can be judged from the perceptive reading of his composition of *The Virgin and Child with St Anne and the Infant Baptist* in a letter written in 1501 by the Carmelite Fra Pietro da Novellara to Isabella d'Este and in a poem written by the Bolognese writer Girolamo Casio (1465–1533), the friend and patron of Boltraffio).[141] Modern viewers may perhaps struggle to reconcile this aspect of Leonardo with his detached 'scientific' observation of human anatomy seen in no. 57, yet the two are perhaps less contradictory than they first appear. Leonardo's study of the structure and workings of nature provided him with the knowledge of how far those forms could be credibly manipulated and pushed beyond the boundaries of realism for artistic effect. This ability can be seen in the Uffizi study of two heads (no.55), in which the symbolic juxtaposition of youthful beauty and aged decay takes on a more profound dimension through the rendering of naturalistic detail in the contrast between the lustrous tautness of the skin of the first and the wrinkled desiccation of his counterpart. Leonardo's ability to infuse a sense of observed naturalism in his painted representation of gesture, expression, landscape, light or the countless other areas of man and nature that excited his interest, was a lesson that was absorbed by the successive generation. The fact that few stop to consider the impossible torsion of the woman catching the fainting Virgin Mary in Raphael's *Entombment* (see fig. 1, no. 99), or that of Adam reaching up towards God's life-giving touch in Michelangelo's *Creation of Adam* on the Sistine Chapel ceiling goes to show how successfully this aspect of Leonardo's art had been learnt.

Leonardo in Milan

The importance of Leonardo's drawings in providing his contemporaries with an accessible means of gaining an understanding of his art cannot be overestimated. He was a daunting artist to imitate, as much for his technical brilliance as for the scale of his ambition in specifying the intellectual training required to be a painter. In his unfinished treatise *On Painting* begun in Milan, he described how the painter's mandate to articulate human actions and nature touched on all aspects of knowledge, from the branching system of a tree to the workings of the human eye. This impractical call for his fellow artists to embrace his own polymath interests is leavened by much sound advice on the importance of drawing in the training of artists, doubtless derived from his own experience in Verrocchio's studio and from what he had learnt when he began to have pupils of his own, such as Boltraffio, in Milan in the early 1490s. The efficacy of his method is demonstrated by the crystalline precision of Boltraffio's observation of light in his silverpoint and white heightening drapery study of the Risen Christ for the *Resurrection* altarpiece now in the Gemäldegalerie, Berlin (no. 71 and fig. 1, no. 71). The drawing is closely modelled on Leonardo's metalpoint studies of the same period, such as those related to the Sforza equestrian sculpture or the study for the head of the Virgin, now in the Louvre, that he supplied to help Boltraffio paint the *Madonna Litta* in the Hermitage Museum, St Petersburg (see fig. 1, no. 72).[142] The collaborative nature of Leonardo's workshop in the production of paintings, with the delegation of execution based on the guidance of preparatory drawings, as in the *Madonna Litta*, or two pupils dividing up a commission, as is the case with Boltraffio and Marco d'Oggiono (c. 1467–1524) in

the *Resurrection*, can be seen as yet another echo of Verrocchio's working practice. The drapery in the *Resurrection* altarpiece based on the drawing, almost certainly painted by d'Oggiono (whom some scholars contend executed the British Museum study, not to mention the *Madonna Litta*), is a remarkably accurate transcription of the drawing, so much so that the hypnotic intensity of the detail in the description of the folds dominates the composition.

The static quality of the Berlin painting and the lack of animation in the technically accomplished female head, probably executed by the anonymous follower of Leonardo, the so-called Master of the Pala Sforzesca (active *c.* 1490–*c.* 1500; no. 72), underlines the understandable difficulty that his Milanese followers found in deconstructing the Florentine's work, let alone imitating it successfully. In regard to the metalpoint study, the unremitting clarity of its description of the features and contours robs it of the naturalness found in Leonardo's *Warrior*, in which the linearity of the medium is combined with tonal subtlety, so that light rather than internal modelling describes the forms and textures. Learning from Leonardo's drawings was made much easier when he switched from metalpoint to the more tonal and atmospheric medium of red or black chalk during the course of the 1490s. It was the medium that Leonardo predominantly employed to study the expressive heads of the apostles in *The Last Supper* and in unrelated works from the period, like the profiles from the Uffizi (no. 55). The subtleties of Leonardo's *sfumato* lighting were far easier to imitate in chalk, thanks to the ease with which its tones could be blended together. Leonardo's most gifted pupil, Boltraffio, was able in chalk studies, such as the Uffizi life study (fig. 51) for the Virgin in the *Pala Casio* of 1500 now in the Louvre, to approach the psychological depth and presence of his master's figures.[143] Boltraffio provides the clearest demonstration of the way in which Leonardo's drawings offered the most accessible means for his pupils to navigate and select the features of his art that they felt capable of absorbing. It did not necessarily follow that the adoption of a Leonardesque style of drawing would simplify this process. The individuality of Lombard artists' responses to the presence of Leonardo in Milan is clearly expressed in the brush-and-wash studies by Bramantino (no. 73) and Andrea Solario (no. 74), neither of which share much in common with his graphic manner (although the latter's chalk studies are much closer to the Florentine's). Yet it was through drawing that both artists successfully integrated some of the innovations of Leonardo's work without losing their own distinctive styles, as in Bramantino's use of light to direct attention to select details in his composition, or the range of naturalistic gestures and expressions employed by Solario to heighten the pathos of his work.

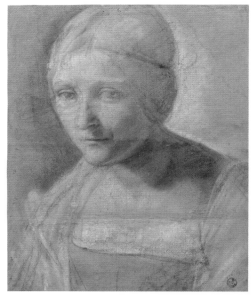

Fig. 51
Giovanni Antonio Boltraffio, *A woman, c.* 1500. Charcoal, black and white chalk, on faded blue paper, 38.4 × 31.1 cm. Gabinetto Disegni e Stampe degli Uffizi, Florence.

A study for the Virgin in the altarpiece commissioned for S. Maria della Misericordia, Bologna, by the Bolognese writer Girolamo Casio and now in the Louvre, Paris.

The legacy of fifteenth-century drawing

The categories of drawings and the use of them in the working life of an artist, as well as the materials used to make them, pioneered during the course of the fifteenth century, remained little changed until the advent of synthetic chalks, graphite pencils and mechanized paper production using wood pulp in the late eighteenth and early nineteenth centuries. The only discontinuity between the drawing materials likely to be found in an Italian studio in 1500 and its counterpart two centuries later would be the absence of silverpoint, and the relegation of vellum to specialized categories such as botanical or natural history studies. In terms of the practical use of drawings beyond the period covered by this exhibition, the only significant change was that artists routinely prepared large-scale compositions using 1:1 cartoons from the sixteenth century onwards, a practice that can be traced back to Michelangelo's and Leonardo's short-lived cartoons executed around 1504–5 for their unrealized battle frescoes in the Palazzo Vecchio in Florence.

The readiness of sixteenth-century patrons to contemplate painting projects on a grand scale required artists with the requisite skills in drawing and design to take

on such commissions. The drawing-based artistic training that had developed in the fifteenth century was steadily codified and formalized in the establishment of art academies in the following centuries, the earliest of which was the Accademia del Disegno, founded in Florence in 1563 by Vasari. The drawing of an artist's studio by Vasari's Flemish associate Giovanni or Jan Stradanus (1523–1605; fig. 52) presents a synthetic and idealized vision of the didactic programme of the Florentine academy, with the young assistants given the choice of studying a skeleton, a sculpture of Venus or an *écorché* nude. Drawing was no less important to those artists who took a more pragmatic view of artistic education, directed towards the formation of pupils whose style of working would blend seamlessly with their own. The success of fifteenth-century artists such as Verrocchio in instilling a workshop drawing style would be imitated by artists down the ages, from Jacopo Tintoretto in the sixteenth century to the Roman Carlo Maratta (1625–1713) a century later. Similarly the innovation of directing and maintaining the standards of a workshop's production through the control of the design process, as witnessed in the practice of Ghirlandaio, Perugino and other artists of the fifteenth century, was replicated many times by their successors.

Fig. 52
Giovanni Stradano or Stradanus, *The practice of the visual arts*, 1573. Pen and brown ink, brown wash, heightened with lead white, 43.6 × 29.3 cm. British Museum, London.

This was engraved, in reverse, in 1578 by the printmaker Cornelis Cort (1533–78), like Stradanus a Netherlandish artist who made his career in Italy.

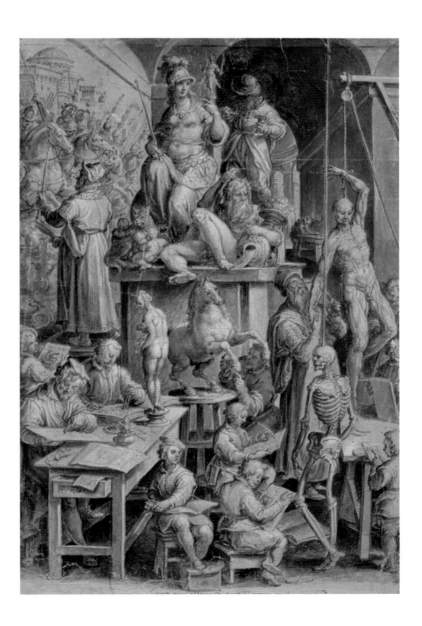

It was a working model that was vital to the ability of Raphael to keep up with the unprecedented flood of commissions that came his way after he had made his name in papal Rome, not least because the scale of the undertakings was often much larger than those executed by artists of the previous generation. In addition he was required to utilize his design abilities for an ever-wider field of activities: printmaking, silver and tomb design, secular and ecclesiastical architecture, tapestries and as a recorder of the city's antiquities. The age of the international artist presaged by the travels of artists such as Gentile Bellini, Solario and Barbari (not to mention the market for Netherlandish paintings in Italy) came to fruition in the shape of Dürer and Raphael due to their involvement in printmaking, a technological advance that brought their design skills to a European-wide audience. The first forays of this northern European innovation in Italy can be witnessed in this publication with the prints made after drawings by Finiguerra and Mantegna, the second of whom certainly grasped the potential of engraving as a means of promulgating his name far beyond the confines of Mantua.

By the close of the fifteenth century the practice of drawing was established as a vital constituent of artistic education and the means by which painters developed compositions and figural ideas before beginning work. While the individual styles of artists naturally evolved over the centuries in directions unimagined by their Renaissance counterparts, the function and mode of drawing in the progression from initial sketch to cartoon broadly followed the pattern established during the swift development of the medium during the course of the fifteenth century. Just to take one example, the study in the British Museum (fig. 53) by Salvator Rosa (1615–73) for his painting of *The Resurrected Christ* from the early 1660s is uncannily close in its kinetic vigour to Leonardo's studies of the Virgin and Child with a cat (nos 51–2 and figs 49–50), although whether the Neapolitan artist was aware of this debt to the Florentine is doubtful.[144] By the same token it does not lessen the originality of Michelangelo or Raphael in so harmoniously combining the idealized classical beauty of ancient Roman sculpture with a naturalistic rendering of the body, as seen in the latter's study of *c.* 1511–12 for a sibyl for the Chigi Chapel in S. Maria della Pace, Rome (fig. 54), to see their achievements as building on the graphic work of Gozzoli's *Horse tamer*, Raffaellino del Garbo's *Risen Christ* and Filippino Lippi's *Two nudes*.[145] The part played by Michelangelo's and Raphael's artistic predecessors was not simply formal, because the design process that they followed to create their works was a model that they had inherited from their masters. No less significant is the manner in which the creativity of both artists had been fostered, expanded and found its most fluent expression in the medium of drawing. The revolutionary developments in Italian Renaissance art were rehearsed and took shape on paper, and the practice of drawing was vital to producing the enquiring, analytical, observational and creative reflexes of the artists whose works define the period.

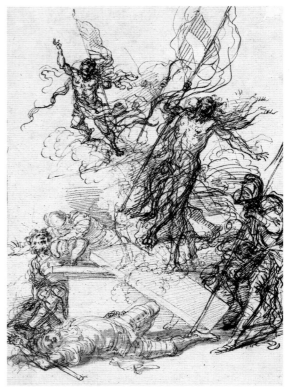

Fig. 53
Salvator Rosa, *The Resurrected Christ*, c. 1662.
Pen and brown ink, grey wash, 36.1 × 25.8 cm.
British Museum, London.

A study for a painting executed for S. Maria in Montesanto, Rome.

Fig. 54
Raphael, *A sibyl*, c. 1511–12. Red chalk,
26.1 × 16.5 cm. British Museum, London.

A study for the figure painted in fresco
immediately to the right of the arch, in the
Chigi Chapel, S. Maria della Pace, Rome.

1 *Michelangelo Drawings: Closer to the Master.*

2 Perhaps the best-known example of Vasari's use of the term in the 1550 edition is found in the preface to the second part of the *Lives*; see Vasari 1971, vol. 3, p. 5.

3 Goldner 2004, figs 76–77, 82–3. For recent discussion of Giovanni Bellini drawings, see Faietti in Padua 2006, pp. 81–9

4 The only exceptions among the Italian drawings are a handful by Michelangelo that were included among 36 miscellaneous drawings bought from the artist's descendant in 1859.

5 For methods of detecting underdrawings and the understanding thus gained of artistic working methods in relation to 15th- and 16th-century works in the National Gallery, London, see London 2002.

6 For the rarity of Renaissance sculpture studies see Goldner 1989.

7 38F, illustrated in colour in Florence 1992, no. 7.2. The drawing's recent loan record meant that it could not be included in a two-venue exhibition such as the one related to this publication on grounds of light exposure.

8 The database can be found: www.britishmuseum.org/research.aspx. The history of the Gabinetto's collection is given in Miriam Fileti Mazza's recent publication (2009).

9 'Omnia laboreria de Zessio, de marmore et de relevijs, quadros dessignatos et omnes libros de dessignijs'; Eisler 1989, Appendix E, p. 532. For the interpretation of 'quadros dessignatos' see Fletcher 1998, p. 136.

10 Carl 1983, pp. 518–22.

11 This is reported in Sebastiano del Piombo's letter to Michelangelo in Florence; see Shearman 2003, vol. 1, 1520/58, p. 615.

12 For an attribution of Masaccio for a drawing in the Uffizi see Goldner 1994.

13 There are a handful of drawings on vellum related to his activities as an illuminator, such as the underdrawing of an initial 'A' in the British Museum (1860,0616.42) and the highly pictorial tempera on vellum, *Journey of the Magi*, in the Kupferstichkabinett, Staatliche Museen, Berlin; see Florence 2006a, nos 42, X–XI.

14 I am grateful to Martin Clayton for coming up with this approximate total. This figure is doubled if one counts every scrap of paper with sketches and diagrams plus all the pages in his notebooks; Bambach in New York 2003, p. 5.

15 Gargan 1992, pp. 509–11. The Tedaldo family were clearly known as draughtsmen, as in Angelo's will of 1324 he records that he and his sons supplied numerous drawings ('avemo fate molto desegnadure') for two of his Venetian contemporaries, the painter Pietro Zapparin and the stonecutter Paolo da Giordano. Gargan points out the likelihood that some of the Tedaldo drawings were copies after the antique.

16 Feliciano's will was published by Mardersteig 1939, pp. 106–8.

17 Vasari 1976, vol. 4, p. 125; see also Petrioli Tofani in Fusconi, Petrioli Tofani *et al.* 1992, pp. 11–12.

18 Ibid. pp. 14–22. For Gaddi as a collector see Acidini 1980.

19 Wilde used the term 'presentation sheet' in his entry on some of the Michelangelo drawings in Windsor Castle; see Popham and Wilde 1949, nos 424, 431.

20 Biographical details on Segni are found in Alessandro Cecchi's essay 'New Light on Leonardo's Florentine Patrons' in New York 2003, pp. 121–39.

21 By Luke Syson in London 2001, p. 74.

22 No. 16 in Florence 2001.

23 For Baiardo's recently discovered birth date see Gasparotto 2002, p. 386. I am grateful to David Ekserdjian for pointing this article out to me.

24 The inventory of Baiardo's framed drawings and prints is given in Popham 1971, vol. 1, Appendix I, pp. 264–5; for Orsini and Tronsarelli see Hochmann 1993, pp. 82–91 and Lafranconi 1998, pp. 545–50. Michelangelo's drawing of *Cleopatra* was also framed in the Medici collection; see p. 81 in present publication.

25 For Apollonio di Giovanni as a portrait draughtsman, see Callmann 1974, no. 79 of Bottega book list, p. 78.

26 Examples of drawings that can be connected to surviving painted portraits include Francesco Bonsignori's (c. 1460–1519) drawing in the Albertina, Vienna (see Giorgia Mancini's entry in Verona 2006, no. 86), and two metalpoint portraits in the Biblioteca Ambrosiana, Milan, of members of the Sforza family by Boltraffio and the Master of the Pala Sforzesca; see Bora in Milan 1987, nos 3, 9. There are a number of studies by Pisanello for portrait medals; see Paris 1996, nos 118, 121, 125, 255–6, 298.

27 Boltraffio's portrait in the Ambrosiana and Luini's from the Albertina are discussed and illustrated in Bora's essay in Bora, Fiorio, Marani *et al.* 1998, pp. 102, 115–16, figs 4.13, 4.33.

28 For the possible identification of the sitter see Agosti in Florence 2001, no. 34.

29 For this see Shell in Bora, Fiorio, Marani *et al.* 1998, p. 124; for an English translation, see Gilbert 1980, pp. 139–40.

30 Hope 1981, p. 318.

31 White 1959, pp. 269–73.

32 See O'Malley 2005, especially chapters 7, 8.

33 For the text of the 1433 contract see Pope-Hennessy 1952, p. 169; the Orvieto one can be found in Serafini 1911, doc. 5, p. 99.

34 This is illustrated and discussed in O'Malley 2005, pp. 201–2, figs 85, 85B–C. An earlier example of the juxtaposition of contract and drawing can be found in a 1340 contract on two glued sheets of paper now in the archive of the Monte dei Paschi di Siena. It is related to the construction of the Sansedoni palace in Siena; see Toker 1985.

35 The Vassilacchi drawing's registration number is 1895,0915.850. For examples of designs made for altar frames, see Humfrey 1993, pp. 150–51.

36 As was first observed by my colleague Jenny Bescoby.

37 Ruda 1993, no. D4, pl. 15.

38 Filarete 1965, vol. 1, p. 67, and 1972, vol. 1, p. 149.

39 Barocchi and Ristori 1973, vol. 3, no. DCIII, p. 21.

40 C.M. Brown, 'Digest of the correspondence concerning the paintings commissioned for the "Studiolo" in the Castello (1496–1515)', in Campbell 2006, doc. 39, p. 291.

41 The letter is illustrated and the text transcribed in Mantua 2006, no. II.18, pp. 173–4; English translation in Gilbert 1980, pp. 33–4.

42 The Italian text is given in De Nicolò Salmazo in Padua 2006, pp. 17–18; for an English translation see Gilbert 1980, pp. 12–13.

43 Squarcione's collection is discussed in London 1998a, pp. 29–30.

44 Popham and Pouncey 1950, no. 1.

45 Alberti 1975, Book III, p. 100; in English (trans. Spencer) 1966, p. 94.

46 An earlier example in this category is the workshop of Pisanello copy in the Ambrosiana, Milan, after a Luca della Robbia relief (see Paris 1996, nos 97–8).

47 Popham and Pouncey 1950, no. 115, as after Leonardo and copied from the drawing in the Louvre (inv. 2255). The attribution to Credi was first made in Robinson 1869.

48 Cennini 1960 and 1971, chapter XXVII.

49 For illustrations of the album see Degenhart and Schmitt 1968, vol. 1–4, pls 327–35. Recent discussion of the material includes Ames-Lewis 1995a and Elen 1995, no. 23.

50 Campbell 1997, pp. 14–16.

51 Perosa 1960, vol. 1, pp. 23–4.

52 Such as the *Risen Christ between St Andrew and St Longinus* in the Staatliche Graphische Sammlung, Munich, rediscovered by David Ekserdjian; see his entry in London 1992, no. 44.

53 Beauvais 2000, nos 1353–72.

54 Vasari 1966 , vol. 1, p. 117; Vasari 1960, p. 212. The

55 For the other drawings in this sequence see Fischer in Rotterdam 1990, under no. 6.

56 The contract is found in Cadogan 2000, pp. 350–1.

57 For discussion of this term see Glasser 1965, pp. 116–18, and the letters of Michael Hirst and Carmen Bambach in *Art Bulletin*, no. 74, 1992, pp. 172–3. Examples of the discrepancies of Renaissance usage of the terms *modello* and *disegno* are given in Thomas 1995, p. 109.

58 Mansueti's painting is reproduced as fig. 18 in Roberts 1959.

59 The use and history of cartoons is exhaustively treated in Bambach 1999a.

60 Holmes 2004.

61 See Hiller von Gaertringen 1999 and id. 2004, pp. 335–50.

62 Scheller 1995, nos 19–20.

63 Alberti 1966, p. 94.

64 A succinct history of 15th-century printing in Italy is provided by Steinberg 1996, pp. 30–7, and by Santoro 1994, pp. 47–69.

65 Martini 1956, pp. 45–6.

66 For further elaboration on this, see Elen 1995, pp. 436–7.

67 Popham and Pouncey 1950, no. 55. Another category in which the toughness of vellum was prized was sketchbooks, for example Aspertini's so-called 'London I' in the British Museum.

68 A history of papermaking is given in Hunter 1978.

69 For Italian improvements in papermaking see R.L Hills, 'Early Italian papermaking, a crucial technical revolution' in Cavaciocchi 1992, pp. 73–97.

70 Similar to Briquet 1923, vol. 2, 6599 and 6603, which can be compared to the watermark found on a drawing of c. 1490 by Leonardo at Windsor (Clark and Pedretti 1968, vol. 1, no. 12632).

71 For this point see Piera Giovanna Tordella's essay, 'Guercino e il disegno: teoria e tecnica' in Florence 2008a, p. 23. To her list of drawings on blue paper from the first half of the 15th century can be added the anonymous study in the British Museum; Popham and Pouncey 1950, no. 283.

72 The slab is illustrated and accurate measurements from it are given in Bambach 1999b, fig. 6. The measurements given here are the maximum ones including the borders on the slab.

73 Ornato, Busonero, Munafò and Storace 2001, vol. 1, p. 172.

74 For Tura see Molteni 1999, p. 221. The reference to the Monte Oliveto *Libro d'amministrazione* was kindly supplied to me by Tom Henry. Claire van Cleave has pointed out to me that in February 1447 Fra Angelico was also reimbursed 35 *bolognini* for 500 sheets of paper from Perugia; Serafini 1911, doc. 5.

75 Bambach 1999a, pp. 138–40.

76 XRF examinations of the Boltraffio, Filippino Lippi and Perugino metalpoint drawings from London have all revealed the use of silver-based metalpoint. In the last two lead-based metalpoint was also detected.

77 Kemp 1989, p. 199.

78 The latest use of it in Italy to be found in the British Museum's collection is the *Virgin and Child* from the 1550s (Pp,3.210) by Parmigianino's pupil Girolamo Mazzola Bedoli (c. 1500–69). North of the Alps the Netherlandish painter Hendrik Goltzius (1558–1617) made a number of silverpoint drawings, perhaps in emulation of earlier masters of the technique such as Dürer and Lucas van Leyden (?1494–1533).

79 As in the Venetian model book, eight sheets of which were incorporated into the Paris Bellini album; see Elen 1995, no. 4.

80 See Vasari 1878, vol. 3, pp. 149–50. Bellini's apprenticeship with Gentile probably began when the latter was in Venice (1408–14), and may have continued in

importance of this kind of drawing to Federico Barrocci is described by his biographer Bellori 1976, p. 205.

Florence in the early 1420s if he is identifiable with the 'Jacobi Petri pictoris de Venetiis', a pupil of Gentile and a member of his household, mentioned in Florentine legal documents in connection with an assault on a Florentine youth in 1424. The identification of this reference with Jacopo Bellini is not accepted by all; see Eisler 1989, p. 530, as his father's name was Niccolò and not Pietro as he is described in the Florentine document.

81 For Pisanello's early training see London 2001, pp. 8–16.

82 An example of Lippi's combination of the two metals is found in a drawing in Dresden; see Melli in Florence 2006b, no. 22.

83 Cennini 1960 and 1971, chapter XXXIIII.

84 These observations were made by Jenny Bescoby and Judith Rayner.

85 See 'notes sur quelques carnets et groupe de dessins démembrés' in Paris 1996, n. 69, p. 460.

86 Absent from the selection are any examples of the use of pastel, powdered pigments with a liquid binder. The technique was pioneered by Leonardo and was taken up by some of his Milanese followers such as Luini. For discussion of coloured drawing media in the period see McGrath 1997.

87 The exceptions to this are finished presentation drawings like the Paduan or Vicentine c. 1460 series of Christ and the Apostles in the British Museum (Popham and Pouncey 1950, nos 312–25) or the recently published design attributed to the Venetian sculptor Tullio Lombardo (? c. 1455–1532); see Pincus and Shapiro Comte 2006.

88 For botanical and natural history drawings in watercolour see Pächt 1950.

89 Popham and Pouncey 1950, nos 276–7.

90 The technique of comparable drapery studies by Leonardo and his circle is described as tempera; see F. Viatte in New York 2003, nos 13–17.

91 For these drawings see Goldner 2004, pp. 246–50.

92 This rough estimate is based on Degenhart and Schmitt's publications on southern, central (1968) and Venetian (1980) drawings. I am mindful that this does not include Lombard drawings and is therefore very approximate.

93 Degenhart and Schmitt 1968, vol. 1–1, nos 22, 165. The attribution of Aretino's drawing is clarified by Weppelmann 2003. The Gaddi drawing is not counted as autograph in the most recent monograph; see Ladis 1982, p. 246.

94 London 1989b, nos 3a–c.

95 See Procacci 1961, pp. 13–14 and its review by Muraro 1963, pp. 156–7.

96 For Pisanello's sinopie in the Ducal Palace in Mantua, see Woods-Marsden 1986 and 1988, and London 2001, pp. 48–55. There are only a few figure studies that relate to the fresco. It seems likely that Pisanello made a worked-up drawing of the whole composition for reference as he covered over the sinopie with a fresh layer of plaster for each day's work, of roughly a square metre; Woods-Marsden 1988, pp. 122–3. No such drawings for the cycle survive by Pisanello (compositional drawings are extremely rare in his corpus), but this is probably linked to the vagaries in the preservation of practical working drawings.

97 Procacci 1961, pls 58–9.

98 Spinello Aretino's surviving drawing in the Pierpont Morgan Library and its relevance to his working methods are analysed in Weppelmann 2003.

99 Scheller 1995, nos 1, 14.

100 Ibid. no. 32; Elen 1995, no. 18.

101 Florence 1982, nos 83/1–56; Elen 1995, no. 43.

102 Paris 1996, nos 181–2.

103 See Callmann 1974, pp. 30–5.

104 For a fuller analysis of the matter see Scheller 1995, Epilogue pp. 78–88.

105 London 2005, p. 216. Condivi 1998, p. 64; in English 1999, p. 107.

106 Tolnay 1975–80, vol. 2, no. 266. For later examples of the reuse of figure drawings see Nova 1992.

107 Berenson 1938, vol. 2, no. 771; vol. 3, fig. 250.

108 Ames-Lewis 1981a, pp. 69–79.

109 London 1998a, pp. 34–40.

110 For the development of perspective in the 15th century, see Kemp 1990, pp. 9–52.

111 Alberti 1966, p. 73.

112 Borsi 1992, no. 22. For a useful bibliography pertaining to the links between Alberti and Mantegna, see Faietti 2008b, n. 2, pp. 228–9.

113 Gaurico 1999, p. 143.

114 Illustrated in colour in New York 1997, no. 3.

115 Faietti in Bologna and Vienna 1988, p. 218. In the recent monograph on Costa the influence of Lippi is brushed aside; Negro and Roio 2001, p. 13.

116 Zambrano and Katz Nelson 2004, no. 62, pl. 297.

117 Cennini (trans. Thompson) 1960 and 1971, chapter XXVIII.

118 His drawn copies after Giotto and Masaccio are in the Louvre and in the Staatliche Graphische Sammlung, Munich and the Albertina, Vienna; see Tolnay 1975, vol. 1, nos 3–5. For recent discussion of Renaissance and classical art, see Faietti in Athens 2003, vol. 1, pp. 445–54.

119 Nesselrath 1982, p. 357. The drawing was formerly at Chatsworth, Derbyshire, see Jaffé 1994, vol. 2, no. 315.

120 Greek and Roman Department, 1861,0725.2.

121 Tolnay 1975–80, vol. 2, no. 345; Joannides in Washington and Fort Worth 1996, no. 12.

122 Berenson 1938, vol. 2, nos 771 B–862 A. For a critique of this grouping see Popham and Pouncey 1950, no. 148.

123 Popham and Pouncey 1950, no. 12 (as attributed to Giovanni Bellini). The case for the generally accepted attribution to Mantegna was recently put in Paris 2008, nos 54–55, although there are dissenting voices such as Goldner's publication of it as by Giovanni (Goldner 2004, pp. 227–31). The drawing styles of the brothers-in-law were extremely close in the 1450s and 1460s and, while it is still kept under Mantegna's name in the British Museum, it would be unwise to be too dogmatic on this question.

124 The National Gallery of Scotland drawing was no. 152 in Paris 1996. Examples of studies after nudes were included in the same exhibition as nos 40–2, 52.

125 The Tuscan drawing of a female nude dated to around 1430 in the British Museum (Popham and Pouncey 1950, no. 273) may perhaps predate the Pisanello, but the unnatural proportions suggest it was not based on first-hand observation.

126 Popham and Pouncey 1950, no. 32 verso.

127 Examples by these artists are included in Whistler 2004.

128 The so-called vellum 'travel sketchbook' by a member of Pisanello's studio dating from the period 1427–8 includes a number of studies after classical and modern sculptures (for a concise discussion of this group, see Paris 1996, pp. 465–7), while the Albertina pen copy after a Trajanic frieze traditionally ascribed to Mantegna may plausibly be an early copy after a lost drawing by him; see Caroline Elam's entry in Paris 2008 (no. 159). Donatello's influence on Mantegna is registered most clearly in his early paintings, such as the St Mark from the late 1440s now in the Städel Museum, Frankfurt.

129 Thomas 1995, pp. 59–60.

130 Covi 2005, pp. 188–92, fig. 188.

131 The two studies are in the Louvre and in Edinburgh; Bambach in New York 2003, nos 7–8. For the painting see Covi 2005, fig. 169; mention of the drawing is given in a 1485 document, ibid. doc. 51, p. 350.

132 Covi 2005, fig. 203. The history of the painting's attribution is given by Brown, who attributes it to Perugino; see Brown 1998, n. 92, pp. 186–7. I am grateful to Luke Syson who showed me the painting in the National Gallery's conservation studio and whose ideas on the two hands I have followed.

133 For these attributions see Brown 1998, pp. 47–56, 124–5. Carmen Bambach (1999a, pp. 260–1) also tentatively suggested that Leonardo may have reworked Verrocchio's female head in the British Museum (no. 40) in brush and grey ink, but she appears to have rethought this idea subsequently, since there is no mention of this medium nor the sheet's possibly being by two hands in her entry in the Leonardo exhibition held in New York in 2003.

134 Brown (1998, pp. 136–45) argues for the figure of Christ also being by Leonardo's hand.

135 Kemp 1989, p. 264.

136 Ibid. p. 44.

137 The Disputa studies showing Raphael's study of the Adoration are in Windsor and Chantilly; Joannides 1983, nos 197–9.

138 Richter 1883, vol. 1, no. 508.

139 As shown by the pen study in the Wallraf-Richartz Museum, Cologne; Joannides 1983, no. 416.

140 Kemp 1989, p. 199.

141 The letter is transcribed in New York 2003, pp. 520–1. For Casio's relationship to Leonardo see Pedretti 1951; Villata 1999, doc. 336, p. 290. I am grateful to David Ekserdjian for alerting me to this poem.

142 The Louvre drawing was no. 21 in Paris 2003. For the controversial attribution of the Madonna Litta, which most scholars agree is the work of Boltraffio, and the various related drawings, see Marani 2003, pp. 165–7.

143 Agosti in Florence 2001, no. 34.

144 The study (Pp.5.104) came to the British Museum as part of the Payne Knight Bequest, 1824.

145 Pouncey and Gere 1962, no. 36.

The collection of Italian fifteenth-century drawings in the British Museum

HUGO CHAPMAN

By the standards of the Gabinetto Disegni e Stampe degli Uffizi and indeed other European museums that have their roots in royal or aristocratic holdings, such as the Albertina in Vienna named after its founder Duke Albert of Saxe-Teschen (1738–1822), the British Museum is a newcomer in acquiring a collection of Italian Renaissance drawings. The interests of the Irish physician, naturalist and antiquarian Sir Hans Sloane (1660–1753), the acquisition of whose wide-ranging collection led to the formation in 1753 of the British Museum as the world's first national museum founded as a public institution, were those of an Enlightenment man of science, and his collection of prints and drawings was principally directed towards providing visual material for his intellectual studies.[1] The 440 Italian drawings that he owned are for the most part undistinguished, so much so that well over half of them have not yet been mounted. Perhaps more by chance than judgement Sloane did occasionally acquire an Italian drawing of outstanding quality, such as Andrea del Sarto's red chalk study for his *Birth of the Baptist* fresco in the Chiostro dello Scalzo in Florence, or Annibale Carracci's vivid sketch in the same technique of a monkey grooming the head of a young man.[2] Only eight of his Italian drawings date from the fifteenth century and the most exceptional of them, the Jacopo de' Barbari watercolour study of *A dead grey partridge* (no. 82), only came to light in the 1920s when A.E. Popham picked it out from an album in the Department of Manuscripts.[3]

For nearly a century following the Museum's foundation the growth of its drawing collection depended on the generosity of a handful of public-spirited individuals who bequeathed their collections. The first of these was the Museum's former trustee, the reclusive Revd C.M. Cracherode (1703–99), whose bequest included 662 drawings as well as an album by the Bolognese seventeenth-century painter Giovanni Francesco Grimaldi.[4] In contrast to Sloane, Cracherode was guided by a highly developed sense of aesthetic quality with a preference, typical of English collectors of drawings of the period, for polished, pictorial works by well-known sixteenth- and seventeenth-century painters, such as Guercino, Parmigianino and Salvator Rosa. Cracherode's taste did not extend to early Italian drawings (there is nothing from his collection in A.E. Popham and Philip Pouncey's catalogue of 1950 of the British Museum's holdings), and the sole example of his bequest in the present selection is Raphael's spirited sheet of pen studies dating from the first decade of the sixteenth century (no. 98). Indirectly Cracherode's bequest gave rise to the Department of Prints and Drawings when it was discovered in 1806 that some of his famed Rembrandt etchings had been stolen by the caricaturist and dealer, Robert Dighton. The negligence of William Beloe from the Department of Printed Books in allowing Dighton unsupervised access to the prints, compounded by the absence of an inventory against which the losses could be checked, persuaded the Museum's trustees that a specialist department was needed, and two years later one was created, with its own room, locked with a special key.

In 1824 the Museum's collection was enriched by the bequest of more than 1,000 drawings, of which 277 were by the French seventeenth-century landscape painter Claude Lorrain, from the collection of Richard Payne Knight (1751–1824), whose inherited wealth stemmed from ironworks in the west of England. Knight was a first-rate classical linguist and scholar despite never attending university, and his interest in antique art (later manifested in a superlative collection of classical bronzes

Fig. 55
Attributed to the Master of the Pala Sforzesca
(active *c.* 1490–*c.* 1500), *Male head*, 1490s.
Metalpoint on blue preparation, 11.8 × 7.9 cm.
British Museum, London.

The right-to-left direction of the shading denotes
that the artist was right handed.

and cameos) led to his travel to Italy in the 1770s, including a trip to Sicily to study Greek remains.[5] On his return to England he established his reputation as an opinionated and combative classical scholar and arbiter of taste through his discourse on the classical worship of Priapus, circulated among his fellow members of the Society of Dilettanti, and his *Analytical Inquiry into the Principles of Taste* published in 1805. Like his friends before him, Cracherode and Charles Townley, the great collector of Roman marbles, Knight was appointed a trustee of the Museum in 1814, even though he had earlier been an outspoken critic of its purchase of the Elgin marbles. The high quality of Knight's drawings undoubtedly reflects his acumen as a connoisseur, as well as the unique opportunities afforded by the revolutionary upheavals in France and Napoleon's subsequent invasion of Italy in 1796, both of which brought historic collections to the market. For the sake of his collection Knight braved the turmoil of Paris in 1791 where he bought some Italian drawings from the Abbé de Tersan; perhaps at the same time he acquired three studies, including the Pietro Perugino head on a Vasari mount (no. 47), from the cleric's friend and fellow aristocrat, the Marquis de Lagoy.[6] Knight was also active in the safer environment of London salerooms as early as 1787, when he bought a number of now untraceable works from the posthumous sale at Christie's of the lawyer Matthew Duane, and his name is to be found among the purchasers in major auctions of drawings of the period: one such was that of the German-born reproductive engraver Conrad Martin Metz in 1801 where Knight bought Andrea Mantegna's *Virtus Combusta* (no. 22).

Knight's interest in fifteenth-century art is confirmed by his ownership of Mantegna's painting of the *Adoration of the Shepherds*, now in the Metropolitan Museum of Art, New York, but his real passion was, like Cracherode's, for later Italian drawings. As a result the Museum's collection of early Italian drawings was uneven, as is clear from the account of a visit in 1831 to the Print Room by the Frankfurt-born painter and Raphael scholar Johann David Passavant.[7] Some of Knight's drawings admired by Passavant feature in these pages, such as the study inspired by the Quirinal *Horse tamer* by Gozzoli (no. 14), then thought to be by Antonio Pollaiuolo, the aforementioned Perugino head, the two Gentile Bellini drawings of Turkish costume (nos 17–18) and Mantegna's *Virtus Combusta* (a work that Passavant ingeniously if erroneously ascribed to Sandro Botticelli on the basis of the subject matter's similarity to the Florentine's Uffizi painting of the *Calumny of Apelles*). There are also surprises, like Passavant's acceptance that the famously left-handed Leonardo could have drawn a profile head in metalpoint, which from the direction of the shading was clearly executed by a right-handed artist, perhaps the Florentine's mysterious Milanese follower, the Master of the Pala Sforzesca (fig. 55).[8]

In 1830, a year before Passavant's visit, the Museum had been unable to take up the offer to purchase for £18,000 the 4,000 Old Master drawings and seven albums belonging to the recently deceased portrait painter Sir Thomas Lawrence. It was a collection of such magnificence in Italian, Netherlandish and German works that it would have elevated the Print Room's holdings above all others. The asking price was substantial, not least for a museum that up to that point had never acquired a single drawing, yet it was probably less than half of what Lawrence had spent in amassing the collection. Around the beginning of his collecting career Lawrence spent £10,000 alone in 1823 buying the predominantly Italian drawings owned by William Young Ottley. The latter was a pioneering scholar, collector and dealer of early Italian drawings, prints and illuminations whose two-volume publication, *An Inquiry into the Origin and Early History of Engraving*, published in 1816, was instrumental in sparking the fashion for collecting fifteenth-century Florentine engravings and *nielli*, small-scale compositions engraved on silver plates.[9] His knowledge and collection had been enriched by his period in Italy between 1791 and 1799 coinciding with the French invasion in 1796, a period when Italian owners of works of art were faced with the unenviable choice between a sale at a reduced price or the risk of looting by the

invading army. As a result Ottley gained an unequalled knowledge of Italian art so that he was able, for example, to discern in Earl Spencer's sale in 1811 that a so-called Gentile Bellini 'scripture or saint subject' was a study by the young Mantegna for the Ovetari chapel in Padua (no. 20).

Lawrence went on to buy other collections with a reckless disregard for the cost, which eventually led to him owing huge sums to the art dealer, Samuel Woodburn. After the painter's executor had failed in 1830 to sell the collection en bloc to various national institutions, Woodburn acquired it for £16,000. The dealer still hoped that parts of his friend's collection would be kept together and to this end he organized in 1835–6 a series of ten exhibitions at his gallery in St Martin's Lane, each consisting of around a hundred works by one or more masters culminating in the ninth and tenth dedicated respectively to Raphael and Michelangelo. This strategy was vindicated by the sale of some parts, such as Claude and Titian drawings sold to the banker William Esdaile, and in 1839 the future King William II of the Netherlands spent more than £21,500 on acquiring a number of works by Michelangelo, Raphael, Correggio and other Italian masters (Woodburn subsequently bought most of these back at the posthumous sale of the royal collection in 1850). The public-spirited Woodburn's quest to retain some of Lawrence's treasures in a British institution was finally rewarded in 1842, with the sale of a substantial group of drawings by Michelangelo and Raphael to the Oxford University Galleries (now the Ashmolean Museum).[10]

The three-year keepership of the aged and ailing William Young Ottley that ended with his death in 1836 did little to revive the flagging fortunes of the Department of Prints and Drawings after the failure of the Lawrence sale, and it was his successor, Henry Josi, appointed at only 34 years old, who managed to persuade the trustees that the Museum should be an active participant in the art market. Within months Josi had secured the purchase of John Sheepshanks' cabinet of 7,000 Dutch and Flemish seventeenth-century prints and drawings. This was the first of many acquisitions made by Josi and his successor as Keeper, William Hookham Carpenter (from 1845 to 1866), which in the space of 30 years transformed the department's holdings, perhaps most notably in the unrivalled collections of early Italian engraving and *nielli* following Ottley's publication. While Josi and Carpenter's energies were largely directed towards prints, with an antiquarian bias towards collecting early examples of printmaking from both north and south of the Alps, the holdings of drawings also flourished under their care. By the end of Carpenter's keepership in 1866 more than 800 Italian drawings of all periods had been purchased, beginning with a Giovanni Battista Piranesi in 1840 and then after a six-year hiatus with the next acquisition, the Pisanello *Three men* (no. 8).

The growth in the collection of early Italian drawings can be judged by comparing the descriptions given by another learned German visitor, the Director of the Berlin Museum, Gustav Waagen, in his encyclopaedic three-volume account of Victorian art collections published in 1854, *Treasures of Art in Great Britain*, and the supplementary volume issued three years later.[11] In that interval the Bellini album, the Perugino *Adoration* (no. 45), two Leonardo pen studies, one of which belonged to the series of early designs of the *Virgin and Child* (fig. 56), and two Raphael drawings, including the ex-Lawrence *Entombment* (no. 99) donated by Chambers Hall in 1855, had been added. Inevitably there were a few acquisitions that have not stood the test of time, such as the female head in metalpoint that Waagen was inclined to accept was by Francesco Pesellino, as suggested by Carpenter, but in reality is a mid-sixteenth-century copy after a Girolamo Mazzola Bedoli painting now in Munich, but such misjudgements of quality were rare.[12]

In 1860, when Christie's organized the posthumous dispersal of Samuel Woodburn's stock, a substantial quantity of which were ex-Lawrence drawings, the government of the day in belated recognition of the importance of the collection provided a Treasury grant of £2,500 for purchases. The glut of so many important works on the market severely depressed the prices and among the drawings bought at the sale were

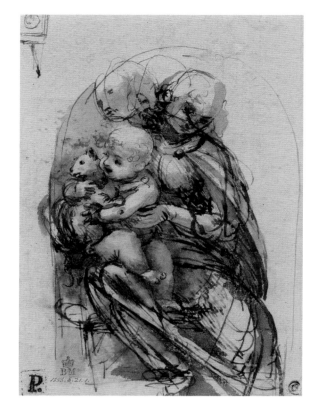

Fig. 56
Leonardo da Vinci (1452–1519), *Virgin and Child with a cat*, c. 1478–81. Pen and brown ink, brown wash, over stylus, 13 × 9.4 cm. British Museum, London.

The recto is illustrated on p. 69.

the ex-Ottley Mantegna *A man lying on a stone slab* (no. 21), the Filippino Lippi *Triumph of St Thomas Aquinas* (no. 66), Leonardo's *Virgin and Child with a cat* (no. 51), at £94. 10s. the most expensive of the fifteenth-century purchases, and the *Military machines* (no 54). Another buyer at the Woodburn-Lawrence sale was the museum curator, dealer and collector, Sir John Charles Robinson, whose catholic taste is demonstrated by his ownership of Piero della Francesca's *Baptism* and El Greco's *Christ expelling the money-changers from the temple* (both National Gallery, London). As a leading member of the Fine Arts Club, which he founded, and its successor, the Burlington Fine Arts Club formed in 1866, Robinson was at the epicentre of Victorian decorative and fine art collecting in London at a time when the appetite for the Italian Renaissance was at its zenith, fuelled by the quattrocento inflections of painters such as Edward Burne-Jones and the enthusiasm of critics such as Walter Pater, whose famous essay on Leonardo was published in *Studies in the history of the Renaissance* (1873).

Robinson was buying at the Lawrence-Woodburn sale on behalf of a new client, the hugely wealthy Scottish aristocrat and landowner John Malcolm of Poltalloch who that same year had bought Robinson's entire collection of more than 500 drawings.[13] Robinson's passion for the Italian Renaissance meant that drawings from this period were strongly represented, with works such as the Filippo Lippi double-sided silverpoint study (no. 11), a bargain buy at the 1860 sale for £2. 10s., due to it having being wrongly catalogued as by the late fifteenth-century Lombard painter, Gaudenzio Ferrari, and Botticelli's *Abundance* (no. 36) formerly owned by the fierce critic of the National Gallery, Morris Moore. In 1862 Malcolm joined the Fine Arts Club, followed six years later by his closest friend William Mitchell, a notable collector of early German woodcuts, and the Scotsman continued to seek advice from Robinson. The latter acted as one of Malcolm's buyers in the 1866 sale of the Oxford cleric the Revd Dr Henry Wellesley, where the ex-Ottley *Three shepherds and an angel* by Luca Signorelli (no. 62), and an early Raphael silverpoint study (no. 96), were among the 61 Italian drawings purchased.

Malcolm's collection of almost a thousand drawings, forty per cent of which were Italian with remarkable holdings of the greatest artists like Michelangelo, Leonardo and Raphael, plus more than 300 mainly early Italian prints, was a prize that the British Museum long had in its sights. When the collector died, aged 88, in 1893, the then Keeper, Sidney Colvin, with the help of William Mitchell, managed to persuade his heirs to lend the works to the department. Malcolm's son generously donated Michelangelo's *Epifania* cartoon to the Museum, where it now hangs permanently in the Prints and Drawings gallery, but he felt unable to do so for the entire collection and after negotiations with Colvin he offered to sell it for £25,000 in May 1895. Parliament duly voted the sum and the prints and drawings were registered in September 1895. With the arrival of the Malcolm collection the Museum's holdings of Italian Renaissance drawings were at last comparable to those of its counterparts in Paris and Berlin. Colvin was aware that the Museum's new status required curators whose scholarship matched European, particularly German, standards, and he set about recruiting university-trained staff capable of meeting this task. Aside from his own publications, such as his 1898 catalogue of the *Florentine Picture Chronicle* (no. 34) formerly in the collection of John Ruskin, Colvin's appointments of Campbell Dodgson and Arthur Hind led to their ground-breaking studies of fifteenth-century Italian and northern European prints. The department's scholarly reputation was further enhanced by the arrival in 1912 of A. E. Popham, who became one of the foremost experts of Italian drawings; his 1950 publication, co-authored with Philip Pouncey, of the fourteenth- and fifteenth-century Italian drawings initiated the influential series of catalogues on the Museum's Italian holdings.

During the twentieth century the rarity and expense of Italian quattrocento drawings meant that relatively few additions to the Museum's collection were made in this area, with the department's scarce resources generally deployed on acquiring

works from later and less fashionable periods. Although numerically few in number there were important arrivals, such as the album of Marco Zoppo pen drawings donated in 1920 by the 5th Earl of Rosebery (no. 25), a delicate Filippo Lippo study of a *Crucifixion* acquired from the Christie's auction of Henry Oppenheimer's collection, Vittore Carpaccio's luminous *Vision of St Augustine* presented by the Art Fund in 1934 (no. 80), and Popham's purchase in 1952 of a Leonardo drawing of a horseman battling with a dragon.[14] Popham's friendship with the British-born Austro-American collector Count Antoine Seilern meant that in 1946 he generously donated to the Museum more than 1,500 drawings, the majority of them Italian, which he had bought from a descendant of the Victorian manuscript-collector Thomas Phillipps, who had in turn acquired them from the Lawrence-Woodburn sale in 1860. Seilern's anonymous gift of the Lawrence-Woodburn drawings that he did not wish to add to his own collection (now part of the Courtauld Institute of Art) included 34 fifteenth-century works catalogued by Popham and Pouncey, including examples by Carpaccio, Mantegna and Signorelli.[15] The explosive rise of prices of Old Master Drawings since the 1980s has meant that the fifteenth-century holdings have changed little since Popham and Pouncey's publication except for the addition of an early study on vellum by Zoppo (sadly too fragile to travel, hence its exclusion from the present selection), acquired in 1995 with the assistance of the Art Fund and the Heritage Lottery Fund. The Zoppo, in common with the majority of the collection, is freely available for study in the imposing Print or Students' Room in the Edward VII building (fig. 57), the department's fifth location in its 200-year history, where it moved just before the outbreak of the First World War. The holdings of the Department of Prints and Drawings have become even more accessible since 2007 through the on-line database, which includes all the drawings, the majority of them with digital scans that can be downloaded without cost for research and study purposes, available through the British Museum website, which this year has attracted more than four million visits.[16]

Fig. 57
A view of the Students' Room in the Department of Prints and Drawings, British Museum, London.

1 For Sloane's collection see Griffiths in Houston 1996, pp. 21–9.
2 Sl.5226.86 and Ff.2.115.
3 The album contains a number of drawings by the English ornithological artist George Edwards (1694–1773). It may well be that the de' Barbari drawing was pasted into the album after it had entered the British Museum.
4 Griffiths in Houston 1996, pp. 43–51.
5 For Knight's activities as a drawings collector, see Clarke in Manchester 1982, pp. 93–109.
6 Lagoy's friendship with Tersan is noted in de Moustier 2008, pp. 190–93.
7 Passavant's *Kunstreise durch England und Belgien* (Frankfurt 1833), was translated into English three years later; the relevant section in the latter is Passavant 1836, vol. 2, pp. 91–109. All his references to Italian drawings in the British Museum are now entered into the Museum's database, available on the web at www.britishmuseum.org/research.aspx

8 Popham and Pouncey 1950, no. 126.
9 For Ottley as a collector of Italian drawing see Gere 1953. Around a quarter of the thousand Italian drawings from Lawrence's collection in the British Museum originally belonged to Ottley.
10 The best account of this sale is given in Joannides 2007, pp. 1–44.
11 Waagen 1854, vol. 1, pp. 224–8 and id. 1857; vol. 4, pp. 26–33.
12 Popham 1967, no. 230.
13 For details of Malcolm's life and collection see Coppel in London 1996, pp. 7–20.
14 The Lippi is no. 149 in Popham and Pouncey's 1950 catalogue. The Leonardo drawing (1952,1011.2) is little known because it came too late to be included in the catalogue.
15 The Seilern drawings were registered as 1946,0713.1-1576. The Carpaccio, Mantegna and the two Signorelli drawings are Popham and Pouncey 1950, nos 32, 160, 238, 240.
16 www.britishmuseum.org/research.aspx

History of the Gabinetto Disegni e Stampe degli Uffizi

MARIA ELENA DE LUCA

The Gabinetto's collection of drawings is Europe's oldest and owes its origins to the ruling dynasty of Florence, the Medici, for whom the acquisition and commissioning of art was an integral part of statecraft. Yet the early members of the Medici dynasty do not appear to have collected works on paper: the inventory of the collection of Lorenzo the Magnificent (1449–92) lists paintings, sculptures, tapestries and natural curiosities but not drawings.[1] By contrast, the inventory of Grand Duke Cosimo I de' Medici (1519–74) mentions drawings by Michelangelo including a framed *Cleopatra*, reflecting the stature of the artist, considered by Cosimo to be the symbol of Florence's artistic supremacy.[2] Cosimo employed Giorgio Vasari (1511–74) to promote Florence's artistic prowess through all the means at his disposal: in print through the monumental *Le vite de' più eccelenti architetti, pittori et scultori italiani* (*Lives of the Artists*), published in two editions in 1550 and 1568; in painting through the decoration of the Salone dei Cinquecento in the Palazzo Vecchio; and in architecture through, most notably, the construction from 1560 of the Uffizi to house both the Medici collections and administrative offices.

The importance of Vasari's *Lives of the Artists* lies not just in the pre-eminence the publication accords to Florentine art but in the emphasis given to drawing (*disegno*) as the 'father' of all arts. This view was further expounded in Vasari's multi-volume *Libro de' disegni* (Book of Drawings), which contained examples of the drawings of Vasari's predecessors and contemporaries.[3] The *Libro* served as the visual complement to the *Lives*, and references to it are frequent in Vasari's printed texts (see no. 69 and pp. 22–3). The *Libro* was dispersed upon Vasari's death, although a significant number of its sheets was donated to Grand Duke Francesco I de' Medici (1541–87) and subsequently passed on to the Gabinetto in the Uffizi Gallery.[4] Both references by Vasari to his drawings in his writings and his interventions to the drawings themselves[5] help to identify the Uffizi drawings that once belonged in the *Libro*.[6]

The relationship between Cosimo I and his artistic adviser Vasari was matched three generations later by Cardinal Leopoldo de' Medici (1617–75; fig. 58),[7] brother of Grand Duke Ferdinand II (1610–70), and Filippo Baldinucci (1625–96), an antiquarian and art historian as well as an amateur artist and, towards the end of his life, a collector of drawings.[8] Baldinucci acted as artistic adviser to the cultured and literary Leopoldo, and helped his patron form a substantial collection of paintings, sculptures, medals and gems, acquired through a wide network of agents who included artists and merchants, diplomats and clerics.[9] Baldinucci also furthered his patron's interest in drawings and Leopoldo rapidly amassed a large collection of graphic works, which were relatively inexpensive and easy to handle and transport. Baldinucci compiled a list of his patron's holdings of drawings, which recorded around 4,000 works in June 1673.[10] A second list in September of the same year recorded 8,000 graphic works while annotations to this list show that, by 1675, the year of Leopoldo's death, the collection consisted of 12,000 graphic works.[11]

In June 1673 Baldinucci, in addition to the list, drew up a guide to Leopoldo's agents in which the artists' names were arranged according to those whose work the cardinal most wished to own. This systematic approach to the acquisition of drawings was mirrored by Baldinucci's organization and classification of the collection: Leopoldo's drawings were arranged in books described as '*particulari*' (particular) when dedicated to a single artist and '*universali*' (universal) when containing drawings

Fig. 58
Giovanni Battista Gaulli (1639–1709), *Cardinal Leopoldo de' Medici, c.* 1667. Oil on canvas, 73 × 60 cm. Galleria degli Uffizi, Florence.

by more than one artist.[12] The drawings categorized by artist were further classified by school and period, allowing the viewer to follow stylistic developments both within and between schools, 'without reading and purely by sight'.[13] Baldinucci's concern for style as a means of classification was reflected in his *Notizie de' professori del disegno da Cimabue in qua* (*Facts on the Masters of Drawing from Cimabue Onwards*), an updated version of Vasari's *Lives* for his own time, published from 1681. Communication with Leopoldo's agents was further aided by Baldinucci's dictionary of art terms, published in the same year.[14] Baldinucci was also interested in art techniques, as is demonstrated by his history of engraving on copper, published in 1686.[15]

The Medici line ended with the death of Gian Gastone de' Medici (1671–1737), after which Francesco Stefano of the Austrian house of Lorraine (1708–65) took over as ruler of Tuscany. The last living descendant of the Medici dynasty, the Electress Palatine Anna Maria Luisa (1667–1743), drew up an agreement with Francesco in which it was stated that 'nothing of civic embellishment or public utility in drawing visitors to Florence would be taken or removed from the capital of the Grand Duchy'.[16] The Medici collections were thus linked indissolubly to Florence. Francesco Stefano was succeeded by Pietro Leopoldo of Lorraine (1747–92), who greatly enriched the Duchy's graphic holdings with acquisitions that included the Gaddi collection in 1776 consisting of 800 sheets, eight volumes of architectural drawings and 8,000 prints, and in 1779 the Hugford collection comprising more than 3,000 drawings, as well as the Michelozzi collection with more than 1,000 drawings. Thanks to these and other acquisitions, the Uffizi collection consisted of 29,000 sheets by the end of the eighteenth century.

Pietro Leopoldo's concern for Florence's artistic patrimony was matched by the zeal of the Director of the Uffizi from 1775 to 1793, Giuseppe Pelli Bencivenni (1729–1808). Pelli compiled an inventory of the objects in the gallery[17] as well as an index of drawings (*Indice generale dei disegni*), in which each sheet was described separately for the first time, a work that still constitutes the basis for the inventorial identification of the Gabinetto's drawings.[18] He also produced an inventory of the greatly increased collection of engravings.[19] It was drawn up according to modern criteria, and each engraving included information on the producer of the work, the type of engraving, its subject and a concordance of monograms and names.

In 1793 Pelli was succeeded as director by Tommaso Puccini (1749–1811). Puccini's energies were absorbed by the upheaval involved in transporting the collection to Palermo in 1800 to avoid appropriation by the Napoleonic army, and its return in 1803. The next director, Antonio Ramirez di Montalvo, could dedicate himself exclusively to the ordering and conservation of the collection. In 1828 he produced a report for Grand Duke Leopold II (1797–1870), Florence's last independent sovereign, on the poor condition of the drawings, in part caused by worms and the glue used for the mounts. Montalvo recommended the breaking up of Baldinucci's volumes in which the drawings were still kept, the cleaning and repair of the paper and the remounting of each drawing on separate supports, to be housed in mahogany cases.[20] These recommendations were taken up.

The unification of Italy meant that the collections of the Medici and the Lorraine became the property of the newly founded Kingdom of Italy in 1861. There followed an increase in donations, notably from the sculptor Emilio Santarelli (1801–86), whose collection contained 12,667 drawings.[21] Significant donations were received from the architects Giuseppe Martelli (1792–1876) and Pasquale Poccianti (1774–1858), and the painters Antonio Ciseri (1821–91) and Stefano Ussi (1822–1901).

Donations were augmented by the acquisition of entire collections. These included in 1906 the Malevezzi collection, a rare example of a group of drawings assembled in Bologna in the eighteenth century,[22] and in 1907 the Geymüller collection, an exceptional group of 227 architectural drawings acquired at a cost of 10,000 lire. The latter collection in particular found a natural home in the Gabinetto: Heinrich von Geymüller (1839–1909) was a Swiss architectural historian

Fig. 59
Jacques Callot (1592–1635), *A spectacle in the Medici Theatre in the Uffizi to celebrate the marriage of Caterina de' Medici to Ferdinand Gonzaga*, 1617. Etching, 26.6 × 19.4 cm. The British Museum, London.

who had studied in the Gabinetto, where he had made various significant discoveries with the help of the staff of the Gabinetto,[23] including a study by Bramante for St Peter's in Rome.[24] Geymüller's collection also contained a group of works that had belonged to the Medici aide Niccolò Gaddi (1537–91), an important early collector of drawings.[25]

The Gabinetto's collection grew during this time under the diligent curatorship of Carlo Pini and Pasquale Nerino Ferri. Ferri worked his way up at the Gabinetto, starting his employment there in 1871 and remaining for 40 years, producing inventories that in 1911 covered the entire collection amounting to more than 90,000 works on paper.[26] Ferri's manuscript index still serves today as the Gabinetto's principal archive, notwithstanding the catalogues of significant sections of the drawings' collection published in the second half of the twentieth century.[27]

The Gabinetto's collection now contains more than 150,000 works. The electronic cataloguing of the entire collection begun in 2005 under the direction of the present Director Marzia Faietti. Just as the Medici dynasty collected art contemporary to them, the modern-day Gabinetto has made significant acquisitions of contemporary works on paper, including a collection of engravings by Giorgio Morandi (1890–1964) in 1977, and works by Sol LeWitt (1928–2007) and Chimei Hamada (b. 1917) in 2007, Omar Galliani (b. 1954) in 2008, and most recently Armando Donna (1913–94) in 2009.[28]

The Gabinetto has been housed since the early twentieth century on the site of the former Teatro Mediceo (Medici Theatre), constructed in 1568 on the first floor of the Uffizi by the architect Bernardo Buontalenti (1531–1608; fig. 59). Between 1952 and 1960 the architect Edoardo Detti (1913–84) designed spaces for the administration, consultation, display and storage of the Gabinetto's collection (fig. 60). The old wooden cases in which the drawings were kept were replaced with metal equivalents for conservation purposes to prevent damage by worms and dust. At the same time the drawings began to be mounted to allow for safer handling. Detti's furnishings, including single- and double-sided frames for the display of prints and drawings, are still in use and give a flavour of the functional style in vogue in the 1950s; as with all such interventions, they inevitably reflect the period in which they were conceived.

Cardinal Leopoldo's collection was kept in his lifetime in the Pitti Palace, the main residence of the Medici, but after his death, the collection was moved to the Uffizi, where it became more accessible. It was housed in the Ponente and then in the Levante corridors, and only given a dedicated space during the reign of Pietro Leopoldo.[29] Pelli's assistant Luigi Lanzi used the word 'Gabinetto' for the first time in his guide to the Uffizi published in 1782, *La Real Galleria di Firenze*:

> The fourteenth '*gabinetto*' [room] differs from the others in its appearance, which resembles a library. Along the walls and in the centre of the room are low cases in which both prints and drawings are housed, mounted in many splendidly bound volumes. On the wall space above the shelves are hung drawings of various artists from the Gabinetto's collection.[30]

Lanzi's description is significant because it anticipates the display of the collection in the nineteenth century. In 1854 a selection of drawings was exhibited in the three rooms at the end of the Ponente corridor. From 1867 to 1890 the drawings were displayed instead in the Vasari corridor, the famous passage linking the Uffizi to the Pitti Palace across the Ponte Vecchio. This practice of displaying fragile works on paper in natural light for long periods would today appal any curator of drawings, yet at the time it met with approbation for the public access it gave to objects that had until then been seen very rarely. This gave rise to the inventorial category '*Esposti*' (displayed), given to the permanently exhibited drawings in Ferri's manuscript catalogue, shortened to 'E'.[30]

The *Esposti* category drawings were chosen on the basis of quality, with a preference for those with a clear link to a completed work. Many *Esposti* drawings are thus

preparatory to paintings which in the nineteenth century and still today are celebrated for their significance in the history of Italian Renaissance art. For example, Andrea Verrocchio's *Head of an angel* (no. 41) is pricked to transfer the composition, and Sandro Botticelli's *Pallas* (no. 37) is both squared and pricked: given the clear preparatory purpose of these drawings it is no surprise they were both listed as *Esposti*, 130 E and 201 E respectively. The low numbers signify the importance of the drawings, and demonstrate that they were selected for permanent display at an early date.[33]

In contrast to Botticelli's fame in the nineteenth century,[32] it is interesting to observe that in Baldinucci's list of Leopoldo's *desiderata*, Botticelli is placed in the sixth and last category of names of artists whose drawings the cardinal least wished to own (if at all).[34] It might be asked when the *Pallas* entered the collection given that Leopoldo's interests lay elsewhere. It would seem likely that it belonged to the oldest part of the collection, and may well have actually belonged in Vasari's *Libro*.[35] That the *Libro* contained drawings by Botticelli is vouched for by Vasari: 'Sandro Botticelli drew much and unusually well, to the extent that people went to great lengths to possess his drawings. In our book there are several examples by him, drawn with accomplishment and skill.'[36]

The unbroken Florentine provenance of Botticelli's *Pallas* illustrates the remarkable history of the Gabinetto's holdings of fifteenth-century Italian drawings. The appreciation of individual artists has fluctuated over time, and the way their drawings have been displayed and conserved has also changed. It is thanks to the efforts of generations of collectors and curators to conserve and describe the objects that the history of the collection can be described so fully and traced back so far. Moreover their shared passion for collecting and preserving Italian Renaissance drawing has resulted in the unrivalled strength of the Gabinetto's holdings.

Fig. 60
Edoardo Detti Gallery for temporary exhibitions, *c.* 1960, in the Gabinetto Disegni e Stampe degli Uffizi, Florence.

1 M. Spallanzani and G.G. Bertelà, *Libro di inventario dei beni di Lorenzo il Magnifico*, Florence 1992. It is conserved at the Archivio di Stato, Florence.

2 Ms. Guardaroba Mediceo 65, c. 164, Archivio di Stato, Florence. The inventory of the Palazzo Vecchio was drawn up 1560–70. See Fileti Mazza 2009, p. 2, n. 6. A number of the drawings by Michelangelo in Cosimo's collection, including the *Cleopatra*, were given back to the Buonarroti family in the early 17th century when Michelangelo the Younger converted the family house on Via Ghibellina into a museum. Cosimo also owned Michelangelo's two drawn *Annunciations* for Marcello Venusti (c. 1512–79), one of which is in the Uffizi today (inv. 229 F).

3 J. Kliemann and A. Manno, 'Vasari, IV: Collection', in Grove Art Online, accessed August 2009.

4 Another group of drawings with a Vasari provenance arrived in the Gabinetto with the acquisition of Mariette d'Agincourt's collection in 1798. (See Ragghianti Collobi 1974, vol. 1, p. 4).

5 Vasari's interventions included the strengthening of contours and the adding of wash, and the restoration and cutting of sheets. Ibid., vol. 1, pp. 7–8.

6 A number of drawings in this book have mounts by Vasari (nos 47, 69); these works, however, belong to the British Museum. No. 3 in this catalogue from the British Museum has a mount that does not accord closely with Vasari, and might thus be an imitation of his style.

7 Leopoldo was one of the founders in 1657 of the Accademia del Cimento, an organization that promoted the scientific discoveries of Galileo Galilei (1564–1642). It ceased activity in 1667 after the publication under Leopoldo's patronage of *Saggi di naturali esperienze* edited by the Accademia's secretary, Lorenzo Magalotti.

8 Four volumes of Baldinucci's collection passed to the Pandolfini family and subsequently to the Strozzi, from whom they were acquired by Dominique Vivant Denon (1747–1825), who directed as head of the Musée Napoléon the systematic looting of art and its transport to Paris during the rule of Napoleon. The volumes are now in the Département des Arts Graphiques, Musée du Louvre. See P.G. Tordella, 'Documents inédits sur l'entrée au musée du Louvre de la collection de dessins de Filippo Baldinucci', in *Revue du Louvre*, vol. 46, 1996, nos 5–6, pp. 78–87. Jacob Bean identified a group of 200 sheets as formerly belonging to Baldinucci in Christ Church, Oxford (see Byam Shaw 1976, pp. 10–11).

9 Fileti Mazza 2009, p. 12.

10 F. Baldinucci, *Registro de' disegni per tenere S.A. Rev. ma. 12 giugno 1673*, Gabinetto Disegni e Stampe degli Uffizi, Florence, ms. III, cc. 37, 738.

11 Id., *Lista de' Nomi de' Pittori, di mano de' quali Disegni [...]*, Biblioteca Nazionale Centrale, Florence; Postillato 97.

12 The drawings were mounted on numbered sheets, which were then bound together in volumes covered in '*sommacco*', leather stained with sumach leaves.

13 Baldinucci 1845, vol. 1, p. 11.

14 Id., *Vocabolario toscano dell'arte del disegno*, Florence 1681.

15 Id., *Cominciamento e progresso dell'arte dell'intagliare in rame*, Florence 1686.

16 R. Galluzzi, *Istoria del Granducato di Toscana sotto il governo della Casa Medici*, Florence 1781, vol. 9, p. 486.

17 G. Pelli Bencivenni, *Inventario Generale della Real Galleria di Firenze compilato nel 1784*, 1784, Biblioteca degli Uffizi, Florence, ms. 113, class III, vol. 1, cc. 321–408.

18 Id., *Inventario dei disegni*, [1775/1784], Gabinetto Disegni e Stampe degli Uffizi, Florence, ms. 102. There is an earlier version of the inventory, Biblioteca degli Uffizi, Florence, 463/ 3.1-2-3.

19 Id., *Inventario generale delle stampe staccate e libri ornati con esse della R. Galleria compilato nel 1779, 1782 e 1783*, Disegni e Stampe degli Uffizi, Florence, ms. 463/18.1-2 (reproduced in Fileti Mazza 2009, pp. 89–210).

20 *Gli Uffizi. Catalogo Generale*, Florence 1980, p. 1179.

21 E. Santarelli, I.E. Burci and F. Rondoni, *Catalogo della raccolta di disegni autografi antichi e moderni donata dal prof. Emilio Santarelli alla Reale Galleria di Firenze*, Florence, 1870. See A. Forlani Tempesti *et al* (eds) *Disegni italiani della collezione Santarelli, sec. XV–XVIII*, exh. cat., Gabinetto Disegni e Stampe, Florence 1967.

22 On the Malvezzi collection, see R. Sassi, 'Il tecnico bolognese Giovanni Battista Natali: (1575–1650 circa)', in *L'Archiginnasio*, 2008, no. 101, pp. 119–75.

23 Pini identified a drawing by Baldassarre Peruzzi (1481–1536, Gabinetto Disegni e Stampe degli Uffizi, inv. 2 A) on the basis of Geymüller's discovery of a copy in the Latarouilly collection in Paris. See J. Ploder, 'La figura di Heinrich von Geymüller (1839–1909), studioso e collezionista nella ricerca storica', in Florence 2006 (as cited in n. 24), p. 26.

24 Gabinetto Disegni e Stampe degli Uffizi, Florence, inv. no. 20. A. J. Ploder (ed.), *Bramante e gli altri. Storia di tre codici e di un collezionista*, exh. cat., Gabinetto Disegni e Stampe, Florence 2006.

25 Acidini 1980.

26 A. Petrioli Tofani, 'Pasquale Nerino Ferri, primo direttore del Gabinetto Disegni e Stampe degli Uffizi', in P. Barocchi and G. Ragionieri (eds), *Gli Uffizi, quattro secoli di una galleria* (Papers from a conference held in Florence in 1982), Florence 1983, p. 423.

27 A campaign of cataloguing began as a government initiative under the direction of A. Forlani Tempesti, 1965–81. Petrioli Tofani 1986; id. 1987; id. 1991; id. 2005.

28 A. Petrioli Tofani (ed.), *Giorgio Morandi: Mostra delle acqueforti donate dalle sorelle dell'artista*, Florence 1978. M. Faietti (ed.), *Omar Galliani: Notturno*, Milan 2008. For the acquisitions and donations in the 20th century see the catalogues of exhibitions held in the Gabinetto: *Acquisizioni: 1944–1974*, 1974; *Dieci anni di acquisizioni, 1974–1984*, 1985; *Dieci anni di acquisizioni, 1984–1994*, 1995.

29 G. Chiarini, 'Per la ricostruzione della collezione di disegni del cardinale Leopoldo de' Medici', in *Paragone*, vol. 33, no. 387, 1982, pp. 44–81.

30 L. Lanzi, *La Real Galleria di Firenze accresciuta, e riordinata per comando di S.A.R. l'Arciduca Granduca di Toscana*, Florence 1782, pp. 148–55. The room Lanzi describes corresponds to the present Room 19 beside the Sala della Tribuna. Cf. G. Cambiagi, *L'antiquario fiorentino o sia guida per osservar con metodo le cose notabili della citta di Firenze, 3 ed. corr., e di copiose notizie accresciuta*, Florence 1778, p. 175.

31 Ferri 1881a; id. 1881b; id. 1890.

32 The first *Esposti* drawings appear to have been arranged chronologically. Hence the low numbers of nos 1 and 4 in this catalogue, inv. 14 E and 11 E respectively. The *Esposti* numbers reach inv. 1795 E.

33 In the 19th century Florence was home to many foreign collectors and scholars, such as the Englishman Herbert Horne (1864–1916), author of one of the first biographies of Botticelli, who lived in a veritable museum furnished in a 15th-century style. For the Horne collection, see C. Garofalo (ed.), *Da Raffaello a Rubens: disegni della Fondazione Horne*, exh. cat., Museo Horne, Florence, Livorno 2000.

34 The collation of Baldinucci's *Registro* and Pelli's *Indice Generale dei disegni* shows that Leopoldo did not add to his holdings of drawings by Botticelli. Give Leopoldo's low regard for Botticelli's graphic works, it seems unlikely he collected them before 1673 and that they therefore belong to the original nucleus of the Medici collection.

35 On the history of Vasari's *Libro* see Kurz 1937, pp. 32–44.

36 Vasari 1971, vol. 3, p. 520.

Catalogue

Catalogue entries by

EB	ELENA BONATO
CC	CRISTINA CASOLI
HC	HUGO CHAPMAN
MF	MARZIA FAIETTI
CG	CRISTIANA GAROFALO
DG	DANIEL GODFREY
EM	ELISA MAGGINI
GM	GIORGIO MARINI
MMR	MARIA MADDALENA ROOK
IR	ILARIA ROSSI
RS	RAIMONDO SASSI

Note to the reader

The entries in this book are broadly arranged chronologically according to the dates of the drawings, with artists roughly grouped geographically.

The verso details are only given in the catalogue-entry heading when the drawing is shown double-sided in the exhibition.

All drawings are on paper unless otherwise stated.

Measurements are given height before width. Verso measurements are given only when the orientation differs from that of the recto.

Provenance of the Uffizi drawings refers to inventories of the collections, which are listed in full on p. 329.

Literature is limited to the most relevant citations.

1 A draped figure; two saints holding a cross; and St Bartholomew holding a knife

c. 1400–10

Leadpoint (some lines drawn with a ruler), silverpoint (on all figures except one upper left; some lines drawn with a ruler), touches of pen and ink on the upper two figures, grey-brown wash, heightened with lead white, on light grey preparation, 27.5 × 18.4 cm
Gabinetto Disegni e Stampe degli Uffizi, Florence (14 E)

PROVENANCE

Ferri, Disegni Esposti (1879–1881); Reale Galleria degli Uffizi (L. 930)

LITERATURE

Bellini in Florence 1978, no. 27 (as Starnina)

This drawing was little known prior to its inclusion as Starnina in an exhibition in 1978.[1] Starnina, whose work had hitherto been gathered under the name the Master of the Bambino Vispo (or 'lively child'), had recently been identified as a key figure in bringing a new linear grace to Florentine painting, inspired by Spanish and northern European art he had seen in Valencia in the 1390s.[2] The attribution to the Florentine artist is tentative, as it depends solely on comparison with paintings. However, the voluminous draperies with looping folds across the body, the edges of the material falling in

Fig. 1
Gherardo Starnina, *Saints Peter and Mary Magdalene*, *c.* 1404–7. Tempera and gold on panel, 139 × 79.2 cm.
Martin von Wagner Museum der Universität, Würzburg.

sinuous twists, as well as the rather flattened feet peeping out from underneath the robes, in Starnina's panel with St Peter and St Mary Magdalene in Würzburg (fig. 1), are features shared with this drawing. The small heads and elongated proportions of the drawn figures differ from those in the Würzburg painting, yet they match those in Starnina's smaller-scale works such as *An Evangelist* in Amsterdam (fig. 2), perhaps from the same polyptych as the German panel.[3] The saint's delicate features and the manner in which he clasps the book from beneath his drapery in the painting are also paralleled in the drawing.

The drawn figures are all presumably saints. The one lower right is most likely St Bartholomew, holding the knife with which he was flayed alive. The similarity in pose of the two figures holding crosses suggests that they are alternative ideas for the same saint, perhaps Andrew who was crucified.[4] The ruled compartments were drawn before the figures, as is shown by the hair of the lower saints having been drawn over the grid. It is unclear if it was designed with a specific work in mind or as a reference sheet.[5] Frontally posed standing saints are a common feature in altarpieces of the period, both as large-scale figures flanking the central scene, like those in the Würzburg painting, or in much smaller panels, such as the Amsterdam one. The more contained figures would be suitable for either context, whereas the cross and the trailing drapery of those on the right would preclude them being for a narrow panel.

The artist used a combination of drawing media. Probably the first figure to have been drawn – the one at the upper left – is the sketchiest of all, with a few touches of pen and white heightening over the leadpoint under-drawing. For the other figures the artist went over the leadpoint with silverpoint, and then used a brush to add small strokes of grey-brown wash and lead white to give a sense of volume through the lighting. Unlike in Parri Spinelli's drawings of around twenty years later (nos 5–6), the surface play of the drapery is secondary to

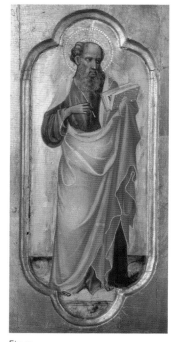

Fig. 2
Gherardo Starnina, *An Evangelist*, *c.* 1404–7. Tempera and gold on panel, 35 × 14 cm. Rijksmuseum, Amsterdam.

the sculptural three-dimensionality of the forms.

This sheet is freely drawn, with many changes of mind between the underdrawing and the silverpoint. The artist's willingness to rethink the poses even extended to erasing part of the trailing drapery of the upper right figure. The change in tone of the preparation shows where a moistened cloth or finger has been used, not entirely successfully, to rub out this area. The artist then shortened the fold of drapery in pen and added a few accents to the surrounding area. Pen was also employed to fix some of the contours of the saint to the left.

The drawing provides a valuable insight into how a Florentine artist at the beginning of the fifteenth century went about the task of inventing figural poses. The fluency of execution indicates that the artist, most likely Starnina or a close follower, was well practised in drawing. HC

2 Recto: Two studies of a cheetah with a blue collar and leash

c. 1400–1410

Watercolour and bodycolour on vellum, 16.4 × 12.3 cm

Verso: An eastern goat and a ram

c. 1400–1410

Watercolour and bodycolour on vellum
British Museum, London (1895,1214.94)

PROVENANCE
Acquired from Colnaghi, London, in 1895

LITERATURE
Popham and Pouncey 1950, no. 289; Ames-Lewis and Wright in Nottingham and London 1983, no. 15; Elen 1995, no. 7; Schmitt 1997, nos XV–XVI

This double-sided drawing comes from a model, or pattern, book of animals and birds made at the beginning of the fifteenth century in Lombardy, northern Italy. The function of such collections was as a studio repertory of motifs for inclusion in paintings or manuscript illuminations. Although vellum was expensive, its durability was well suited to withstanding sustained workshop use. This was important due to the dynastic nature of many Renaissance workshops, where the model book constituted an important part of an artist's legacy to his heirs. In Lombardy, the region in Italy where the model-book tradition seems to have been most established, the favoured subject matter was animals, often, as here, including exotic imports such as cheetahs and leopards, which were prized at north Italian courts for their hunting prowess. (The enduring appeal of such animals to this courtly culture is shown by Jacopo Bellini's depiction of cheetahs in the British Museum album some forty years later; see no. 16.)[1] The popularity of animal drawings can be explained by their versatility as a motif that could be inserted in all kinds of works both religious and secular, ranging from the margins of illuminated Psalters to secular fresco decorations.[2]

The present work is one of ten brush-on-vellum studies of animals from the same album

Fig. 1
Giovannino de' Grassi and workshop, *Opening of a model book* (15v–16r), *c.* 1380–1400.
Pen and brown ink, watercolour, 26 × 17.5 cm, each page
Biblioteca Civica Angelo Mai, Bergamo.

Fig. 2
Follower of Giovannino de' Grassi, *A cheetah and a leopard*, *c.* 1400–10. Watercolour and bodycolour on vellum, 16.5 × 12.2 cm.
Klassik Stiftung, Weimar.

Recto

Verso

that were dispersed in the 1890s. The British Museum acquired it, along with another double-sided drawing of dogs and wolves (illustrated as fig. 4 on p. 21), from the dealers Colnaghi in 1895. The Pierpont Morgan Library in New York has another pair whose earliest known owner was the London-based prints and drawings collector John Mitchell (1820–1908).[3] Mitchell also owned six drawings from the same album, which the Kunstsammlungen at Weimar acquired at the sale of his drawings collection in Frankfurt in 1890. This group was unknown until their publication in 1997 by Annegrit Schmitt, who named the artist responsible the Master of the Animal Model-book of Weimar.[4] Except for three sheets of birds drawn only in brush and brown ink, the drawings are homogeneous in technique and the neat presentation of the animals, predominantly in profile, on both sides of the vellum.

This uniformity suggests that the drawings are the work of a single hand and were made at much the same time. The lack of revisions to the outlines indicates that they are fair copies of existing drawings. Comparisons have frequently been made with the album now in the Biblioteca Civica Angelo Mai, Bergamo, by the Lombard painter and miniaturist Giovannino de' Grassi and his studio (fig. 1).[5] Although there is no direct correlation between any of the Weimar Master's drawings and those by Giovannino de' Grassi, a connection between the two artists is suggested by the general similarity in their manner of depicting animals, as well as the repetition of certain details, like the blue collars sported by the cheetah in the Bergamo album, also found in the depictions on the recto of this sheet and in one of the Weimar drawings (fig. 2). Two brush-and-wash drawings on vellum of dogs in the Teylers Museum, Haarlem, offer further

evidence of a link with Giovannino de' Grassi: one is a copy in reverse of a model found in the Bergamo album, while the other corresponds closely, but not exactly, with a dog found on the other drawing in the British Museum by the Weimar Master.[6] The likelihood is that the artists responsible for this and the Haarlem drawings were both copying now lost drawings by their master Giovannino de' Grassi. The present work exemplifies how model-book drawings acted as a conduit through which motifs spread from workshop to workshop, a process of transfer that almost inevitably resulted in alterations due to the varying levels of skill of the copyists. HC

3 Recto: Christ and the woman of Samaria
c. 1390–1410

Pen and brown ink, brown wash, heightened with lead white (partly discoloured), over black chalk, on paper rubbed (now unevenly) with red chalk, 27.5 × 20.8 cm
Inscribed in an old hand: '16. ugolino'

Verso: Christ healing the man born blind
c. 1390–1410 (ILLUSTRATED OVERLEAF)

Pen and brown ink, brown wash, over black chalk, on paper rubbed (now unevenly) with red chalk
British Museum, London (1895,0915.680)

PROVENANCE

G. Vasari (?), his mount with attribution 'GALANTE DA BOLOGNA/PITTORE' and with later inscription in Dutch or German: 'geb. in Bologna 1427'; Sir T. Lawrence (L. 2455); S. Woodburn; Sir J.C. Robinson (L. 1433); J. Malcolm; acquired from Col. J. Wingfield Malcolm, 1895

LITERATURE

Pouncey 1946, pp. 168–72; Popham and Pouncey 1950, no. 269; Degenhart and Schmitt 1968, vol. 1–1, no. 109; Ames-Lewis 1992, p. 359

This is a rare example of a compositional study from the beginning of the fifteenth century, but unlike the roughly contemporaneous Lorenzo Monaco drawing (no. 4) it can neither be related to a surviving painting, nor securely attributed. It depicts two episodes from St John's Gospel in the New Testament.[1] The recto shows Christ's meeting with a Samarian woman at Jacob's Well, when he identified himself as the Messiah who offered all 'a spring of water welling up to eternal life'. Christ's disciples led by Peter look on. The verso illustrates Christ healing a blind man by administering a poultice, which he instructed him to wash off in a fountain.

The drawing on the verso is certainly a working study, as there are numerous smaller changes between the sketchy underdrawing and the pen lines that followed. The most obvious alteration is to the position of Christ's right hand, which was originally blessing, not touching, the blind man. The fact that the blind man is drawn in chalk and pen over the basin shows that the depiction of him washing his eyes was an afterthought. Once this change was made, the artist extended the back wall of the fountain, going over the mountain backdrop, to bind the figures together.

The drawing was traditionally attributed to Galante da Bologna, an obscure follower of the Bolognese painter Lippo di Dalmasio (died

c. 1410). Galante's name is written on the mount, which is like those from the *Libro de' Disegni* (Book of Drawings) assembled by the artist and writer Giorgio Vasari (1511–74).[2] Whether it is a page from the *Libro* is debatable, since the style of the mount and the handwriting differ from secure examples (such as nos 47, 69).[3] The true nationality of the artist is shown by the similarities in the drawing's composition to panels in the *Maestà*, the enormous high altar of Siena Cathedral completed in 1311, painted by Duccio di Buoninsegna (active 1278–1319).[4] The general composition of the recto, as well as

details such as the faceted well-head raised on two steps, is inspired by Duccio's *Maestà* panel now in the Museo Thyssen-Bornemisza, Madrid (fig. 1). Comparable analogies can be made between the verso and Duccio's *Healing of the blind man*, once part of the *Maestà* and now in the National Gallery, London.[5] Further evidence of the draughtsman having been Sienese is the sixteenth-century attribution to Duccio's contemporary, Simone Martini (*c.* 1284–1344; '*di m[aestr]o Simone Memmi da Siena*'), written on a companion double-sided drawing by the same hand at Chatsworth,

Fig. 1
Duccio di Buoninsegna, *Christ and the woman of Samaria*, *c.* 1310–11. Tempera and gold on panel, 43.5 × 46 cm. Museo Thyssen-Bornemisza, Madrid.

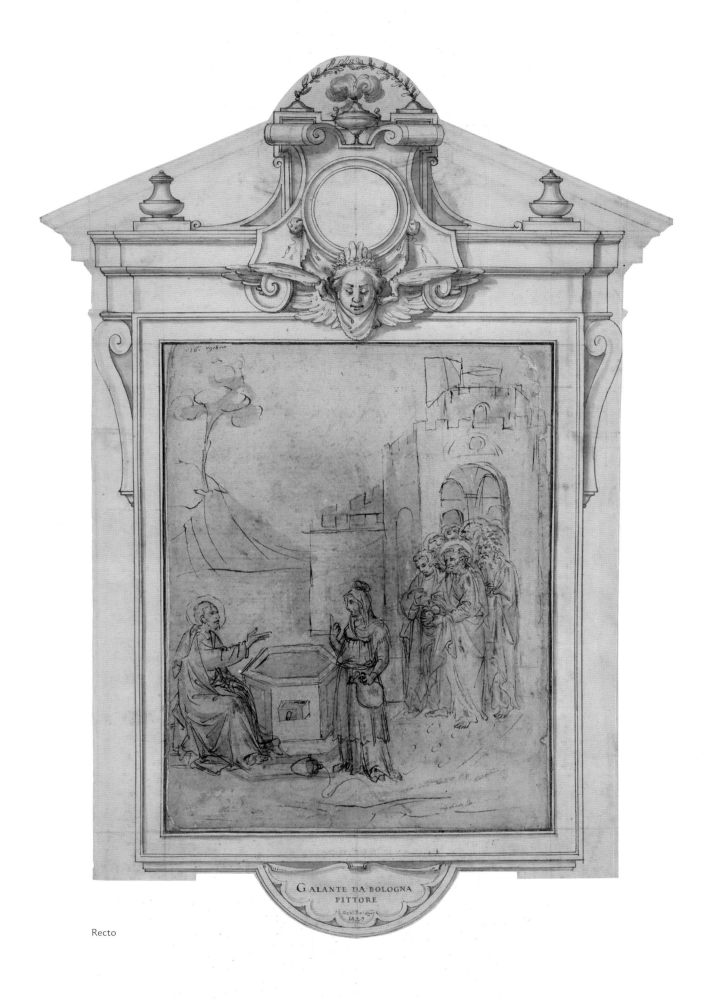

GALANTE DA BOLOGNA
PITTORE

Recto

Fig. 2
Anonymous Sienese, *Christ before Caiaphas*,
c. 1390–1410. Pen and brown ink, brown wash,
heightened with lead white (partly discoloured),
over black chalk, on paper rubbed with red chalk,
22.1 × 18.2 cm. The Duke of Devonshire, Chatsworth.

depicting subsequent scenes of Christ's life
(fig. 2).[6] The influence of Simone's Martini's
graceful style is also discernible in the drawing,
most notably in the figures of Christ and the
woman of Samaria on the recto.

The British Museum and Chatsworth
drawings must be studies for the same com-
mission, perhaps most likely a fresco cycle of
Christ's life.[7] In the absence of the finished
work it is extremely hard to date the drawings,
not least because citations of Duccio's work
by Sienese painters can be found until the late
fifteenth century.[8] This difficulty is reflected
in the two suggestions so far advanced as to
the identity of the draughtsman: Lippo Vanni
(active 1340–75) and Andrea di Bartolo (active
1389–1428).[9] There is insufficient evidence
to support either attribution; however, the
anonymity of the two sheets does not detract
from their importance in showing that late
Gothic artistic practice in Siena around 1400
encompassed the making of preparatory
compositional studies. It is hazardous to
extrapolate too much on the basis of only
two drawings; nonetheless they indicate that
the rarity of such works from this period may
owe more to poor rates of survival than to
painters not actually making preparatory
studies on paper. HC

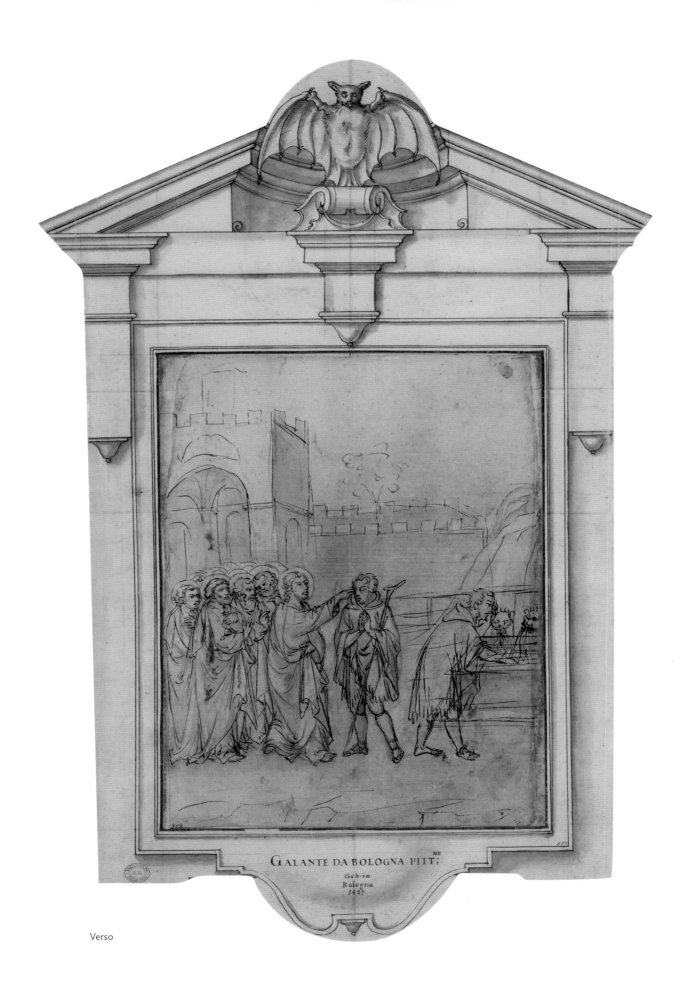

GALANTE DA BOLOGNA PITT:
Geb: in
Bologna
1427

Verso

4 Recto: Six kneeling saints

c. 1407–9

Pen and brown ink, over black chalk, on paper rubbed with red chalk, 24.5 × 17.5 cm

Verso: St Benedict enthroned with an angel

c. 1407–9

Pen and brown ink, the figure on right in charcoal or black chalk only,
the saint enclosed within a lightly drawn leadpoint rectangle, incised diagonal and
vertical lines at the bottom, on paper rubbed with red chalk
Gabinetto Disegni e Stampe degli Uffizi, Florence (11 E)

PROVENANCE

Fondo Mediceo (Nota 1687); Reale Galleria degli Uffizi
(L. 930)

LITERATURE

Berenson 1938, vol. 2, no. 1391; Degenhart and Schmitt
1968, vol. 1–2, no. 170; Petrioli Tofani 1972, no. 4; Bellini
in Florence 1978, no. 28; Eisenberg 1989, pp. 124–5,
143–4 (recto as workshop of Lorenzo Monaco);
Gordon 2003, p. 183 (recto as workshop retouched
by Lorenzo Monaco); Melli in Florence 2006a, no. 33

The recto is the earliest known preparatory study for an extant panel painting. It is related to the high altarpiece painted by Lorenzo Monaco for the Camaldolese monastery (the order to which the painter belonged) of S. Benedetto fuori della Porta a Pinti in Florence. The altarpiece's main tier, consisting of seated saints either side of a central panel of the *Coronation of the Virgin*, is in the National Gallery, London (fig. 1).[1] The London painting is now generally thought to be the prototype for the similar painting dated 1414, now in the Uffizi, executed for S. Maria degli Angeli, although this order is reversed by some scholars.[2] The recto is a first idea for the lower two ranks of saints in the left panel. The verso figure of

St Benedict (*c.* 480–543) is most likely a rejected idea for the central panel. It shows him seated on a throne similar to the one in the *Coronation*, holding an open book of his Rule (the precepts of religious life followed by the Camaldolites) and a bundle of rods for corporal punishment. To the right is the upper half of an adoring figure, presumably an angel, faintly drawn in black chalk. The saint would have been an appropriate subject for the altarpiece in a church dedicated to him: in the finished work scenes from his life are depicted in the predella (the narrative scenes situated beneath the main panel). The recto must post-date the verso because St Benedict is shown on the left in the first tier of figures. As he would not have been

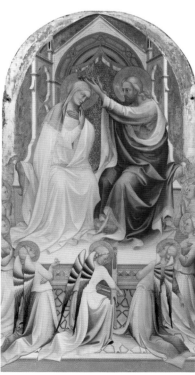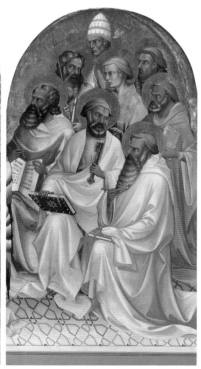

Fig. 1
Lorenzo Monaco, *S. Benedetto
Altarpiece*, main tier, *c.* 1407–9.
Tempera on panel, 264.9 × 365.8 cm.
National Gallery, London

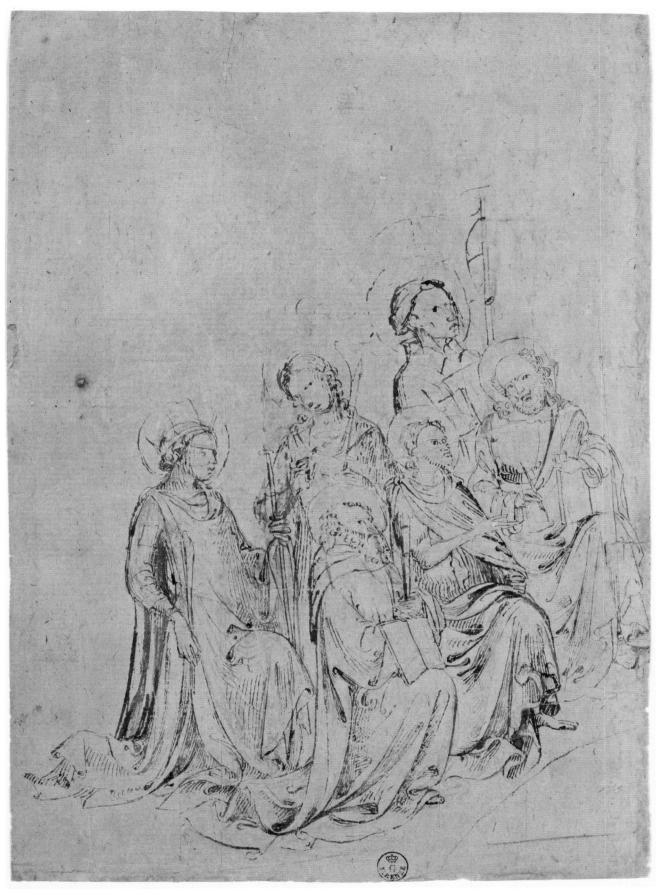

Recto

depicted twice, the recto must follow on from the decision not to depict Benedict in the central panel.

In common with no. 3, both sides of the paper were rubbed with red chalk to create a warm-coloured ground.[3] The purpose of this was to provide a mid-tone between the shaded and the highlighted areas, thereby avoiding the more sharply contrasting effect of ink on uncoloured off-white or cream paper. The tonal effects are less apparent because of the absence of white lead highlights, as seen in comparable works (for examples nos 3, 11). The figures on both sides of the drawing were first lightly drawn in black chalk. Traces of the underdrawing are more visible on the recto, but can just be detected to the right of the saint's book on the verso. Although the two sides were drawn in the same technique, the stylistic difference between them has often led scholars to question whether they are by a single hand.

The verso has been accepted by all modern scholars as Lorenzo Monaco. The figure is drawn with great brio, as seen in the way in which his rather forbidding expression is conjured up with a few flicks of the pen. No less skilful is the way in which the folds of the saint's habit are defined through light and shade. The rhythmical surface play of the drapery that animates the static pose is rounded off by the cloth fanning out as it reaches the floor, the billowing folds indicated by hook-like strokes. While there is little sign in the figure of the artist changing his mind, apart from the adjustments to the position of the book and the saint's right hand, this is not true of the much more sketchily drawn throne on which he sits. Only half of this is drawn, and the artist has not bothered to clarify the form of the throne's backboard.

The disparity between the fluency of the verso and the tentativeness of the description of the saints on the recto is striking. The strongest argument for accepting that the latter is also by Lorenzo Monaco is that it is a study with differences for the National Gallery

painting. The most obvious change between them is that St Stephen, recognizable by his tonsure and flag in the second row, has been moved one place to the left in the painting. The youthful saint beside Stephen in the drawing, presumably male despite his long hair, as the only female in the altarpiece is the Virgin, is replaced in the painting by the bearded St Paul.[4]

While it is possible that Lorenzo delegated to an assistant the task of composing the group, in view of the importance of the commission this seems improbable, especially as recent archival discoveries date the London painting before the Uffizi one.[5] This sequence makes it untenable that the recto is by an assistant working from an earlier study by his master.[6] Indeed it seems more likely that this drawing was consulted for the Uffizi painting. The semi-circular outline in the bottom right corner of the recto may indicate that the idea of placing the attendant saints on a rainbow found in the later altarpiece was one developed, and then rejected, for the earlier commission.

The difference between the two sides of the sheet can be explained by them having been drawn at slightly different stages of the compositional process. The artist's principal focus in the verso was how the figure should be lit rather than his pose, and this explains why the nib of his quill was so loaded with ink to create the thick lines and pools of shadow.[7] By contrast, on the recto the lines are much thinner, shorter in length and more tentative, because it was drawn when the artist was working out the figural poses, with only cursory attention to the lighting, guided by a chalk or charcoal underdrawing. The order in which the saints were drawn in ink is unclear. Normally a right-handed draughtsman would start at the left, but in view of the difference in ink it is likely that St Matthew, the figure holding a pen at the right end of the first row, was drawn first. The figures do not overlap because their contours were established in the underdrawing. Either through interruption or the need to mix a fresh batch of ink, a different

shade was used for the remaining figures with the artist employing it to add a little shading to St Matthew's drapery.

The precise and detailed description of St Matthew contrasts with the much more summary treatment of the remaining ones. The pace of execution seems to have steadily quickened, as can be seen from the way in which St Stephen is defined almost without any shading. The saints in the second row are inexplicably larger in scale than those in front of them: a quirk also found in Lorenzo Monaco's paintings.[8] Despite the breakneck pace of execution, the essential elegance of the artist's style is still discernible in the sweeping folds of St Benedict's draperies and those of the saint on the left of the row behind him, probably Miniato, as well as in the graceful upraised gesture of the hand of the unidentified saint to his right. The changes in ink and in execution of the group on the recto are admittedly puzzling, but the most plausible hypothesis is that both sides are by Lorenzo Monaco.[9] The alternative explanations – either to divide the recto between him and an assistant, or to assign it entirely to someone in his workshop – seem even less likely. HC

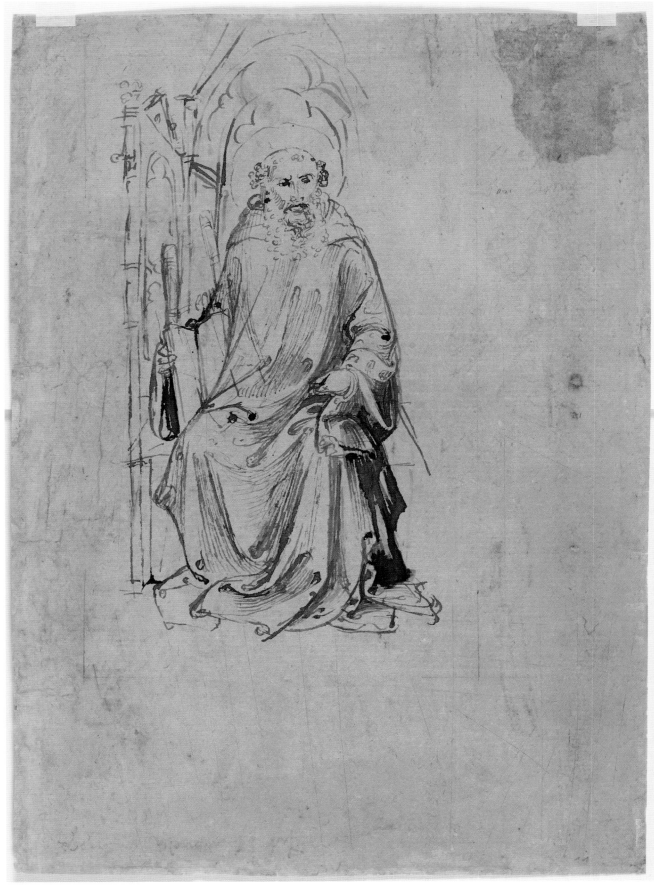

Verso

5 # Recto: A scene of baptism outside the walls of a city

c. 1435–45

Pen and brown ink, over black chalk, 29.1 × 40.8 cm
Inscribed by Filippo Baldinucci (1625–1697): 'Tom°: de.^{to} Giottino'

Verso: A standing and a seated saint

c. 1435–45

Pen and brown ink
Inscribed by Baldinucci: 'Giottino'
Gabinetto Disegni e Stampe degli Uffizi, Florence (8 E)

PROVENANCE

Fondo Mediceo (Nota 1687); Reale Galleria degli Uffizi (L. 930)

LITERATURE

Berenson 1938, vol. 2, no. 1837 E; Degenhart and Schmitt 1968, vol. 1–2, no. 213; Bellini in Florence 1978, no. 37; Zucker 1981, pp. 429–30

Twenty-seven pen drawings, many of them double-sided, survive by Parri Spinelli, a little-known painter from Arezzo in Tuscany.[1] This remarkable total, which far exceeds any of his Tuscan contemporaries, perhaps owes something to the painter, historian and fellow Aretine, Giorgio Vasari (1511–74). The latter's partiality is clear from the substantial biography he accords him in the second edition (1568) of *Lives of the Artists*. In this Vasari praises Parri's skills as a draughtsman and mentions that some of his pen drawings are in his *Libro de' Disegni* (Book of Drawings). There is, however, no evidence to show that Vasari owned any of the 16 drawings by the artist in the Uffizi. Vasari's description of Parri's drawing style did not prevent a number of the studies in the Uffizi, including the present one, being mistakenly attributed to the shadowy mid-fourteenth-century Florentine artist Tomasso di Stefano, called Giottino, by Filippo Baldinucci, the curator of the huge drawings collection amassed by his master Cardinal Leopoldo de' Medici (1617–75) that forms the nucleus of the Gabinetto's holdings.[2] It was not until the end of the nineteenth century that Parri was identified as the artist responsible for the Uffizi drawings, and subsequently further works were recognized in other collections.[3] None of the drawings is preparatory for any of Parri's surviving paintings in Arezzo from the 1430s and 1440s, but the attribution has never been questioned because of the similarities between the elongated swaying figures with looping arcs of drapery in both media (see fig. 27 on p. 47). In addition, a drawing by him in Berlin is also inscribed, possibly by Vasari, identifying it as by Parri Spinelli.[4]

Parri was the son of Spinello Aretino (1350/52–1410), one of the leading Tuscan painters of his day, but the sober monumental style of his father seems to have had little effect on his formation. The attenuated elegance of Parri's figures, their curving forms emphasized by complex patterns of drapery, owe more to Florentine International Gothic artists such as Lorenzo Monaco and Starnina, as well as the goldsmith and sculptor Lorenzo Ghiberti (1378–1455), whose studio he is said by Vasari to have worked in after Spinello's death. Parri's highly personal interpretation of these Florentine models, untouched by the advent of the Renaissance, is seen to good effect in the present drawing. In contrast to the Lorenzo Monaco pen drawing (no. 4), cross-hatching was used extensively on both sides by Parri to indicate shadow and to enhance the solidity of the forms. On the recto the artist began by making a black chalk underdrawing, vestiges of which are most plainly visible in the area of the city walls to the left of the gate. The artist seems to have followed this underdrawing closely as there are only a few indications of him changing his mind, like the alteration to the corbels above the gateway, and this sureness of touch is also demonstrated in the evenness of pressure on the nib, only broken by a few, more heavily inked areas.

The measured execution of the recto contrasts with the much more energetic, exploratory nature of the studies of the two saints on the verso, the left-hand one drawn over the walls of the city perhaps indicating that the artist's original intention was to reprise the baptism scene but with the composition reversed.[5] He seems to have drawn the figures directly with the pen without any underdrawing and as a consequence of this there are a number of revisions, most notably to the right hand of the seated saint. The artist appears to have used two separate batches of ink, with the city walls on the left and some of the altered passages now appearing darker, but it is impossible to know if this difference in tone was intentional, as both inks were doubtless black when originally drawn on the page and have only gradually oxidized to differing shades of brown over time. HC

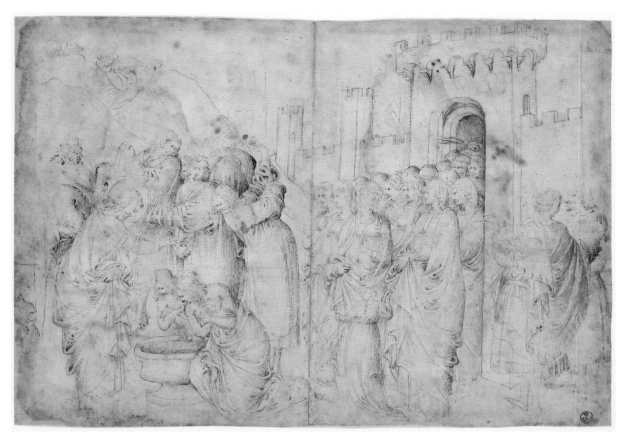

Recto

Verso

101

6 St Peter holding a key

c. 1435–45

Pen and brown ink, 27.4 × 13 cm
British Museum, London (1895,0915.480)

PROVENANCE

J. Malcolm; acquired from Col. J. Wingfield Malcolm, 1895

LITERATURE

Berenson 1938, vol. 2, no. 1837 G; Popham and Pouncey
1950, no. 186; Ames-Lewis and Wright in Nottingham
and London 1983, no. 27; Degenhart and Schmitt 1968,
vol. 1–2, no. 222; Zucker 1981, pp. 428–9; Elen 1995,
under no. 13

This double-sided drawing is unrecorded prior
to it being registered as Parri Spinelli when it
was acquired by the British Museum in 1895
as part of the Malcolm collection. Aside from
the scepticism expressed by the then Keeper
of Prints and Drawings, Sidney Colvin, this
attribution has never subsequently been
questioned as the figures are so like those in
the artist's paintings.[1] The irregular shape
of the drawing is probably due to it having
been cut from a larger sheet, probably by an
unscrupulous collector or dealer wanting to
increase his holdings through recourse to
the scissors.

The pose of the St Peter on the recto is
similar to that of the left-hand saint on the
verso of the Uffizi double-sided drawing (no. 5),
although the two figures differ markedly in
the level of finish and detail, most notably as
regards the elaboration of the drapery folds.
The absence of any alterations to the contours
in the recto of no. 6 indicates that the artist was
probably guided by a previous study of the pose
akin to the one on the Uffizi sheet. The artist
also made a similarly finished drawing of
St Peter, formerly in the van Beuningen collec-
tion, Rotterdam, which differs from the present
one only in the direction of the saint's bending
pose and in the simplification of his drapery.[2]

The existence of two variant studies would
suggest that he was trying to finalize the pose
for a painting, but if so the finished work has
not survived. Parri's figure studies cannot be
dated with any precision because none of them
is related to a painting, and also because his
style as a painter remained virtually unchanged
between his earliest known work at the end
of the 1420s and those made 20 years later.
However, the similarities of the pose and
costume of St John in Parri's *Crucifixion* fresco
in S. Domenico, Arezzo, datable to the 1430s,
to the St Peter studied in the London and
Rotterdam sheets gives some indication as
to when they might have been drawn.[3]

The figure of the Risen Christ standing
before a column on the verso (fig. 1) was
brought to a comparable level of finish, but
the artist subsequently decided to revise the
position of the figure's right hand and rework
the drapery, especially on the right side, using
a quill with a thicker nib and a different, now
darker, shade of ink.

The *St Peter* perfectly accords with Giorgio
Vasari's description of Parri's style in his
second (1568) edition of *Lives of the Artists*:

> Parri made his figures much more slender
> and tall than any other painter who
> preceded him, and where others made them
> at most 10 heads high, he made his 11 and
> even 12; nor were they lacking in grace, for
> they were always supple and arched either
> to the right or left, to give them more spirit,
> as he expressed it. The drapery was very full
> and delicate, and in his figures it fell from
> above the arms to the feet.[4]

HC

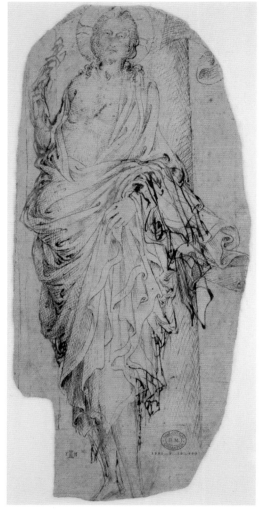

Fig. 1
Verso: *The Risen Christ*

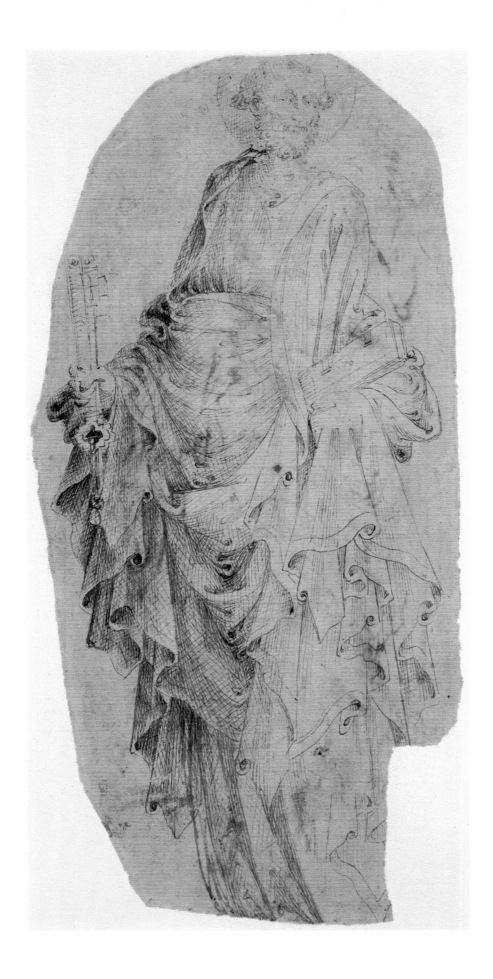

7 Charity

c. 1425–38

Pen and brown ink, 22.4 × 14.3 cm
Inscribed in an old hand: 'Giotto' and in a more modern one: 'Spinello'
Gabinetto Disegni e Stampe degli Uffizi, Florence (1101 E)

PROVENANCE

Fondo Mediceo (Nota 1687); Reale Galleria degli Uffizi
(L. 930)

LITERATURE

Bellini in Florence 1978, no. 54; Karet 2002, no. 2

This drawing was kept under the old attribution to the Florentine painter Giotto (1267/75–1337) until the end of the eighteenth century when it was transferred to Spinello Aretino, and then a century later to his son Parri Spinelli.[1] It was not until the 1930s that it was identified as Stefano da Verona, a Lombard painter whose graphic corpus consists of a dozen freely executed pen figure studies (four of which are in the Uffizi).[2] This attribution is given some measure of support by a fifteenth- or early sixteenth-century inscription, 'de Stefano', on a drawing by the same hand in Berlin.[3] None of the drawings can be directly related to the handful of paintings by the artist, but they are sufficiently alike to be credibly by the same hand. These ties are well illustrated by the similarities between the curly headed Christ Child and his gracefully elongated mother in the signed *Adoration of the Virgin* (Brera, Milan; fig. 1) from the mid-1430s and the figures in the present drawing. The homogenous nature of Stefano's drawings suggests that they may be fortuitous survivors from an album or portfolio of studies executed around the same time, most probably the final two decades of his life in view of their stylistic links with the Brera painting.

This drawing is typical of the artist's bold and unfettered pen style. The freedom of execution rules out Stefano having made it as an example for a model book; more likely it was made as a study for a now lost painting. The subject matter of a woman holding or nursing a child seems to have been a favourite of the artist, as it occurs in seven other drawings by him.[4] The figures in this study were drawn directly on the paper, the material on which all his drawings were executed, with no preliminary underdrawing. The freedom and variety of the

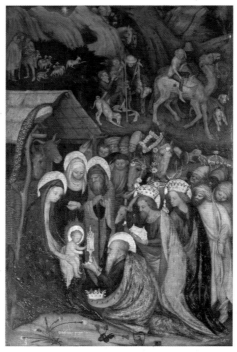

Fig. 1
Stefano da Verona, *Adoration of the Magi*, 1435 (?). Tempera on panel, 72 × 47 cm. Pinacoteca di Brera, Milan.

pen strokes that define the forms, as well as the use of cross-hatching in the shallow U-shaped depressions of Charity's dress, are reminiscent of the contemporaneous study of saints by Parri Spinelli on the verso of the Uffizi drawing (no. 5). The willowy grace of the figures in both works is a characteristic feature of the International Gothic style, although of the two artists it was Stefano who was more closely attuned to the sophisticated northern European courtly roots of this style. This was owing to his training by his father, Jean d'Arbois, an itinerant French artist who worked in Burgundy, for Duke Philip the Bold, and in Pavia. For geographical and political reasons Lombardy and the Veneto, the regions where Stefano worked in northern Italy, were also much more open to the influence of northern European art than Parri's native Tuscany.

Where Stefano and Parri differ is in their use of contours to define the silhouette of the figures and the drapery folds. In Parri's drawings contour lines are the predominant means of modelling, whereas in the present one this is largely achieved through light and shade with only minimal internal modelling. The contours of the two infants are, for example, softened through short hatching strokes, and Charity's long hair is used to avoid hard outlines in the definition of her upper body. Some details, such as the shaded left leg of the left-hand child, are described predominantly by shading with the barest indication of outline. The shape of the leg is also isolated by the different direction of the pen strokes behind it. The differing length and direction of the predominantly parallel shading creates volume, although it imparts little sense of the underlying shape so that curved forms, like the left forearm of Charity, are flattened out. Nonetheless Stefano's manner of drawing through the manipulation of light and shade anticipates later artists from the Veneto, such as Cima (no. 78), Carpaccio (no. 81) and Titian (no. 101), as well as those from his native Lombardy like Bramantino (no. 73). HC

8 Three men

c. 1433

Pen and brown ink, over black chalk, on grey washed vellum, 24.8 × 33.7 cm
Signed (?) at lower left: 'PISANVS F'
British Museum, London (1846,0509.143)

PROVENANCE

Acquired from Mr Smith of Compton Street, London
for £1 10s., 1846

LITERATURE

Popham and Pouncey 1950, no. 219; Fossi Todorow 1966,
no. 84 (among uncertainly attributed works); Cordellier
in Paris 1996, no. 59; id. in Verona 1996, no. 28; Syson and
Gordon in London 2001, no. 32; Degenhart and Schmitt
2004, vol. 3–2, under no. 739 (as workshop of Pisanello)

The figures in this drawing are dressed in
thigh-length overgarments with flared sleeves
resembling bird wings, known in northern
Italy as *pellande*, a word derived from the
northern European term *houppelande* where
this courtly fashion originated.[1] The curved
outlines of the clothes that amplify the forms
of the figures are complemented by the hats,
the broad-brimmed one at the left topped with
flowers, and by the mass of garlanded curls of
the right-hand courtier. Pisanello's focus in the
drawing is on the extravagant costumes of the
three courtiers, with the differing positions
of the figures permitting the fine detailing of
the clothes to be seen, such as the bird-like tail
at the back or the fluted gathering of material
around the waist at front and rear.

The middle figure's moustache signifies
that he is a foreigner, as the Italian custom in
the first half of the fifteenth century was to be
clean-shaven. Pisanello would have observed
this northern fashion amongst the retinue of
the Holy Roman Emperor Sigismund, whom
he encountered in Ferrara or Mantua in 1433.
The artist made two portrait drawings of
the Emperor, and might well have sketched
members of his retinue as he was to do five
years later with those of the Byzantine
Emperor John VIII Palaeologus.[2] The present
drawing may well also date from the 1430s
as the facial type, minus the moustache, of
St George in Pisanello's fresco in S. Anastasia
in Verona (*c.* 1434–8) matches that of the
central figure in the drawing.[3]

The authorship of the drawing has been
questioned by some scholars as there are
no comparably finished figure drawings by

Fig. 1
The central figure in ultraviolet-
induced luminescence.

Fig. 2
Pisanello, *Costume and architectural studies*, 1430s.
Pen and brown ink, 24.8 × 17.6 cm. Musée du Louvre, Paris.

Pisanello. The strongest argument in favour of
it being by him, rather than a copy, is the quality
of draughtsmanship, which is far superior to
works from his studio.[4] In ultraviolet-induced
luminescence the faded and abraded pen lines
can be seen more clearly, revealing the delicacy
that has been lost in details such as the head
of the moustached man in the centre with his
ermine wrap (fig. 1). Even with the naked eye
the nuances of textures and lighting registered
through subtle variation of direction and
pressure in the pen lines can be appreciated:
the springy bushiness of hair, the softness of the
fur and the broken outline of the tassels, their
motion suggested by the flickering pen strokes
that define them. Such subtleties are paralleled
in Pisanello's naturalistic pen studies of birds

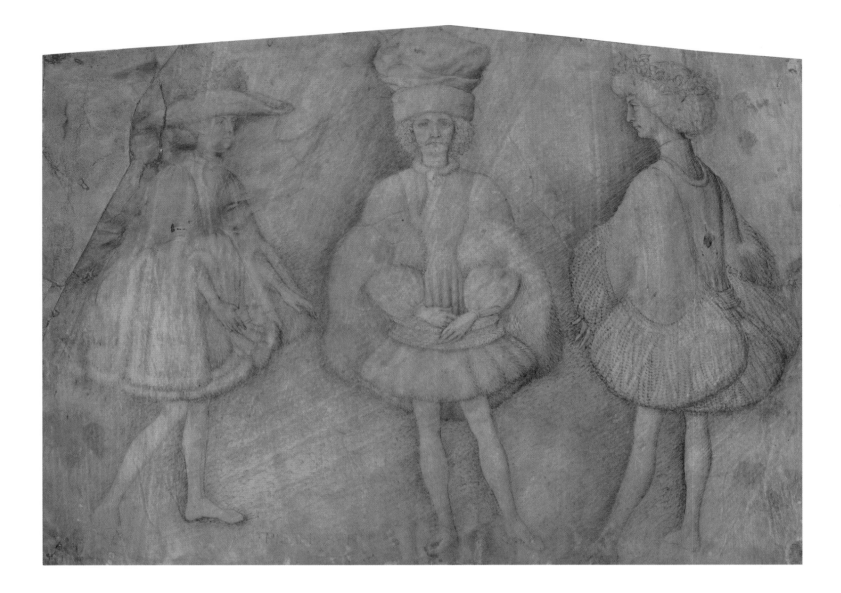

and animals, like the studies of horses in the Louvre related to the S. Anastasia commission, and it seems more logical to conclude that the present drawing is a damaged work by his hand rather than a uniquely brilliant replica.[5]

If it is accepted that the drawing is by Pisanello, there is no reason to doubt the authenticity of his signature using the Latinized form of his name, as in the study, inspired by a classical coin, of the Roman empress Faustina in the Louvre, and on the reverse of the self-portrait medal executed after his design in the late 1440s or early 1450s.[6] The signature denotes that Pisanello conceived this meticulously detailed drawing as a finished work of art worthy of presentation or sale. The subject was one that would have appealed to Pisanello's courtly patrons in northern Italy, whose taste in fashion he recorded in drawings, such as the one in the Louvre (fig. 2) that may have been a source for the right-hand figure.[7] That a drawing, hitherto a class of artistic production that remained firmly in the artist's studio, could be viewed as an autonomous work of art is evidence both of Pisanello's brilliance as a draughtsman and his unparalleled fame. As such it is a work that prefigures Mantegna's finished drawings, such as no. 22, and the presentation studies made a century later by Michelangelo.[8] HC

9 Studies of hanged men; and a woman and a child

c. 1434–8

Pen and brown ink, over leadpoint, 28.3 × 19.3 cm
British Museum, London (1895,0915.441)

PROVENANCE

B. Cavaceppi; W.A. Lestevenon; Marquis de Lagoy
(L. 1710); Sir T. Lawrence (L. 2455); Sir J.C. Robinson;
J. Malcolm; acquired from Col. J. Wingfield Malcolm, 1895

LITERATURE

Popham and Pouncey 1950, no. 220; Fossi Todorow 1966,
no. 11; Woods-Marsden 1987, pp. 49–50; Cordellier in
Paris 1996, no. 151; id. in Verona 1996, no. 43; Syson and
Gordon in London 2001, no. 34; Degenhart and Schmitt
2004, vol. 3–1, pp. 21–2; de Moustier 2008, p. 194

The hanged men are connected to the *St George and the Princess of Silene* of *c.* 1434–8, on the entrance arch of the Pellegrini chapel in S. Anastasia, Verona (fig. 1).[1] This much-damaged fresco represents the moment before St George rescued the princess from a dragon, and is based on the version of the story related in *The Golden Legend*, a thirteenth-century compilation of the lives of the saints by Jacopo da Varagine. The drawing relates to the two corpses on the gallows in the background of the fresco, a touch of realism not mentioned in the textual source. It was perhaps introduced as a reminder of the inevitability of death in a narrative that celebrates the princess's miraculous escape from that fate.

The drawing is one of three related to the hanged men in the fresco.[2] The earliest of these is a pen study in the National Gallery of Scotland, Edinburgh, from a posed model, seen from behind and with his hands behind his back, which is related to the pose of the criminal on the left in the fresco.[3] The model in the Edinburgh drawing has his stockings tied to his doublet, yet this is not the case in the painting where putrefaction and the elements have begun to strip the two bodies bare. The study of the two criminals in the Frick Collection, New York (fig. 2), corresponds closely to the finished work.[4] While most scholars have assumed that the Frick drawing was studied from two corpses on a gallows, it could well have been made from a model, altering such details as the rope and the angle of his feet and neck. It seems much more

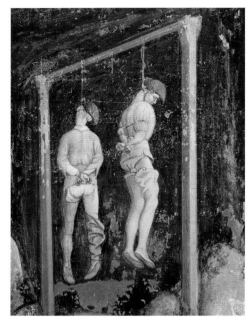

Fig. 1
Pisanello, *St George and the Princess of Silena* (detail), *c.* 1434–8. Fresco, 223 × 620 cm (overall size). S. Anastasia, Verona.

plausible, for example, that the artist adjusted the stockings on a model to make the two larger-scale studies of this detail, rather than doing the same with a corpse on a gibbet.

The precise, rather dry regularity of the line in the studies on the present sheet sets it apart from the Edinburgh and Frick studies.[5] The difference in handling is due to it being most likely a compilation of motifs taken from other drawings and not a first-hand sketch. Although it is commonly stated that the drawing shows three corpses seen from different angles, they are in fact six separate figures. In the lower pair, one has shoes while the other has one bare foot, while the four above are differentiated by details of their sleeves and stockings. Pisanello did not flinch from depicting the details of decay, as seen in the empty eye sockets and gaping mouth of the lower left-hand criminal, although in the fresco itself such horrors are alluded to more subtly, through the inclusion of a large crow perched on the gallows' crossbeam. The

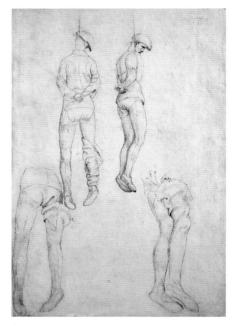

Fig. 2
Pisanello, *Studies of hanged men and legs*, *c.* 1434–8. Pen and brown ink, over leadpoint, 26.2. × 17.8 cm. Frick Collection, New York.

much more perfunctorily drawn figures at the top of the sheet can, with the exception of the left-hand one, be traced back to the Frick sheet. The most plausible function of the sheet was to allow Pisanello to experiment with various poses for the two hanged men. The artist added further variation by reversing the position of the two corpses in the Frick drawing, rotating the left-hand figure 180 degrees and changing his stockings, while using the same figure for the corpse second from the left. The fact that the solutions explored in this drawing were rejected in favour of those in the earlier Frick study is a reminder that the progression from drawings to finished work might well involve backward steps and wasted effort. The two costume studies at the bottom, the woman in profile (perhaps a dwarf in view of her proportions) in an old-fashioned high-collared dress, appear unrelated to the S. Anastasia commission.[6] HC

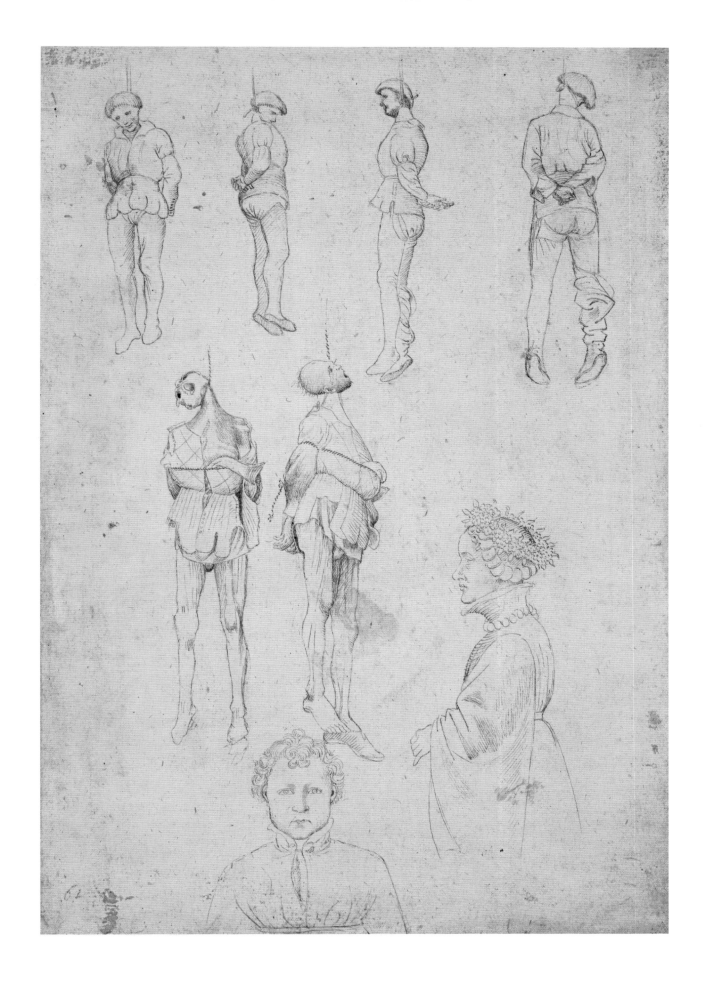

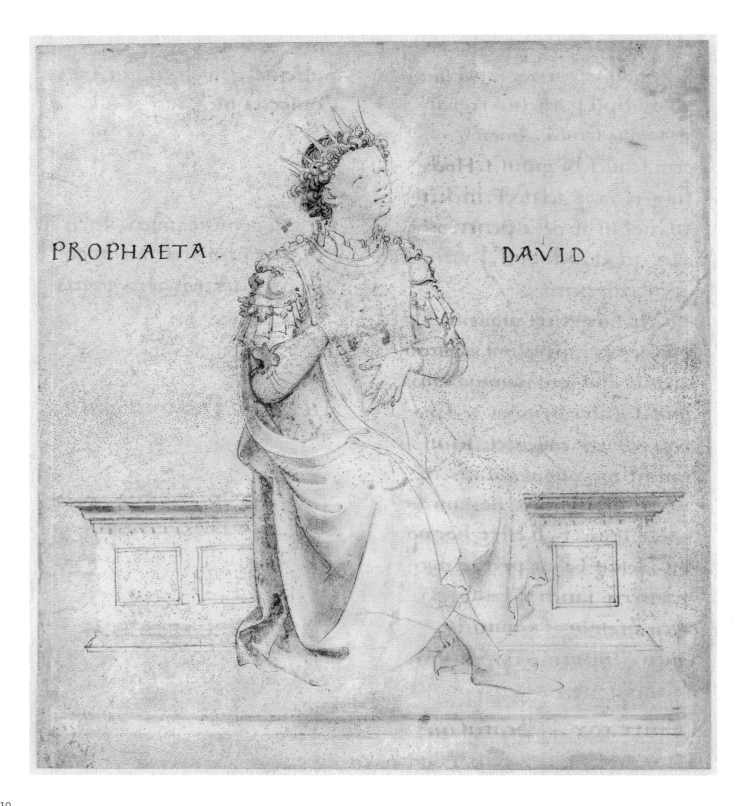

PROPHAETA. DAVID.

GUIDO DI PIETRO, called FRA ANGELICO (c. 1395/1400–55)

10 King David

c. 1430

Pen and brown ink, with purple wash, over stylus indications, on vellum, 19.7 × 17.9 cm
Inscribed by the artist (?): 'PROPHAETA. DAVID.'
British Museum, London (1895,0915.437)

PROVENANCE

Revd Dr H. Wellesley; J. Malcolm; acquired from
Col. J. Wingfield Malcolm, 1895

LITERATURE

Berenson 1938, vol. 2, no. 162; Popham and Pouncey 1950,
no. 2; Degenhart and Schmitt 1968, vol. 1–2, no. 369;
Palladino in New York 2005, no. 26; Melli 2009, pp. 63–4

The Latin inscription indicates that the figure, sitting on a classical stone seat raised on a plinth, is the prophet, King David. He wears a crown and ornate armour with masks on each shoulder (fig. 1), and casts his gaze heavenwards, offering the playing of his psaltery, an ancient stringed instrument, to God. David was believed to be the author of the Psalms and was equally venerated as an ancestor and a prefiguration of Christ.

The figure is drawn on the hair side of a vellum sheet that once formed part of an illuminated manuscript, as is revealed by the verso (fig. 2), which contains part of the index to the original volume, as well as the word '*incipi[t]*' (it begins) in red ink, to the right of the 'amen' on the first line. This demonstrates that the sheet derives from a Psalter, a Book of Psalms arranged according to the liturgical calendar, and recited daily in religious institutions. It has been suggested that the artist reused a vellum sheet for this drawing, but from the thematic correspondence between the two sides of the sheet it would appear the drawing was intended to decorate the Psalter, facing the first Psalm, '*Beatus Vir*'. It was usual to mark the beginning of a section or a pause for reflection in the text with a large image in this way.

Fra Angelico's work as a painter of manuscript miniatures is affirmed by Vasari, who states that Angelico was 'no lesser an excellent painter and miniaturist than he was a devout monk'.[1] Fra Angelico was a Dominican who lived the majority of his religious and artistic life cradled in the monasteries of S. Domenico in Fiesole and S. Marco in Florence, where illuminated manuscripts were in constant use.

Fig. 1
Detail of no. 10 showing the mask on
David's right shoulder.

Despite the fact there are few graphic works attributable to the Dominican artist, the quality of this work has convinced the majority of scholars of its autograph status.[2]

The figure was drawn in pen and ink, and then delicately modelled with a soft purple wash in the areas of shade. The divine nature of the light is suggested by its high source that envelops the figure, the shading in wash unifying the prophet's form with the bench on which he sits. The perspectival lines of the bench and its base create a sense of space around the figure and demonstrate Fra Angelico's confident adoption of the stylistic innovations of the early Renaissance, tending to confirm the dating of the drawing to the beginning of the 1430s.

Much of the surface of the figure is left unpainted, the bare vellum giving David's cloak a diaphanous appearance. Fra Angelico's description of the prophet combines the exquisite delicacy of a manuscript illumination, visible in details like his billowing curls of hair around the base of his crown, with a sense

of volume reflecting the work of Masaccio, a formative influence on the artist, as is seen in the solid modelling and the fall of light. He nevertheless moderates Masaccio's monumental manner with his own decorative sensibility, which recalls Gentile da Fabriano and Lorenzo Monaco, in whose circle he learnt his profession.

The elegance of the figure, and its intimate placing in space, are characteristic of Fra Angelico's style, and recall his miniature of the *Virgin Annunciate* in the Gradual (the liturgical book containing the chants for the Mass), now in the Museo di S. Marco,[3] Florence, executed in the mid- to late 1430s, as well as the figures in his multi-panelled *St Lucy* altarpiece of c. 1430.[4] MMR

Fig. 2
Verso: The index and opening of a psalter, c. 1430.
Pen and brown ink over ruled lines.

11 Recto: A standing woman

c. 1460–69

Silverpoint and black chalk, with brown wash, heightened with lead white,
over stylus, on pink preparation, 30.7 × 16.6 cm

Verso: A standing figure

Silverpoint (with some details in leadpoint), grey-brown wash,
heightened with lead white, on ochre preparation
British Museum, London (1895,0915.442)

PROVENANCE

J. Richardson sen. (L. 2184); B. West (L. 419); Sir T.
Lawrence (L. 2445); Sir J.C. Robinson (L. 1433); J. Malcolm;
acquired from Col. J. Wingfield Malcolm, 1895

LITERATURE

Berenson 1938, vol. 2, no. 1387 (recto: as Filippo Lippi),
no. 747 (verso: as Fra Diamante); Popham and Pouncey
1950, no. 150; Degenhart and Schmitt 1968, vol. 1–2,
no. 360; Marchini 1975, p. 129; Ruda 1993, pp. 331–4,
nos D8, D2; Goldner in New York 1997, no. 2

This study is not related to a known painting,
but would appear to be the lamenting Virgin
at the foot of the cross. John Malcolm's
adviser, J.C. Robinson, rejected Richardson's
attribution to Gaudenzio Ferrari (*c.* 1475/80–
1546) and was the first to claim Lippi drew
this sheet, an opinion that has been almost
universally accepted.[1] The drawing is generally
acknowledged as one of the best examples of
the artist's mature style.

The hands and the cloak are depicted with
numerous quick strokes of the silverpoint,
which serve to reflect the anguished expression
on the face of the woman, while the subtle
modelling demonstrates the artist's concern
to give the figure a sense of volume. Lippi's use
of chiaroscuro and harmonious tonal range,
combined with his extraordinary ability to
embody emotion, make him one of the most
significant painters of the early Renaissance.

A mixture of techniques is used to create
the intense emotion and vitality of the figure.
The pink preparation of the paper containing
bone white and red lead sets off the initial
drawing in silverpoint. The artist subsequently
gave greater substance to the figure with delicate
yet thicker strokes in black chalk. The volume
of the cloak is conveyed by the application of
white pigment and diluted ink to provide the
highest and darkest tones. The anatomy of
the figure and its weighty mantle display
Lippi's ability as a draughtsman, as well as

his confidence in employing a wide range of
graphic media.

The statuesque and emotional qualities
of the figure, swathed in elaborate and
asymmetrical drapery, accord with the artist's
monumental late works such as the frescoes
in Prato and Spoleto cathedrals, suggesting
a date in the 1460s. This is confirmed by this
drawing's similarity to one in the Uffizi, the
so-called 'butler',[2] a preparatory study for
the figure to the right in the *Banquet of Herod*,
frescoed in the mid-1460s in the high altar
chapel of Prato Cathedral, and an example
of the artist's late style.

The verso contains a standing male or
female figure turned in three-quarters profile
to the left, and holding what may be a book
in the left hand. There are alterations in the
contours of the right hand. Compared with the
figure on the recto, the modelling is simpler, in
part due to a different level of finish. This more
static feel, accentuated by the figure's pose and
the loss of the head, has led some scholars to
doubt the attribution to Lippi.[3] Those who
uphold its attribution consider the more
simplified and rigid strokes to indicate an
earlier date than the recto, noting the closeness
of the pose and drapery to Lippi's works of the
1430s such as the *Doctors of the Church* in the
Accademia Albertina in Turin.[4] This would
require an improbably long gap between
the execution of the recto and verso, whose
differences are more convincingly explained
by the verso's more unfinished state compared
to the recto. Furthermore, the short, parallel
and close folds of the drapery, and elegant
description of the hands of the verso figure are
seen in frescoes from Lippi's maturity such as
The Dormition of the Virgin in Spoleto Cathedral,
and in particular the standing figure dressed
in white to the left in *The Funeral of St Stephen*
in Prato Cathedral.[5] MMR

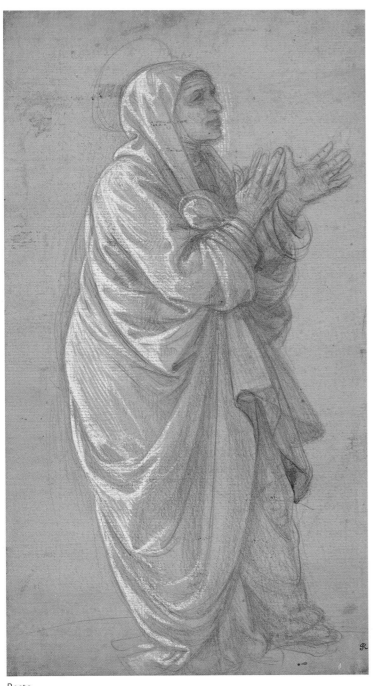

Recto

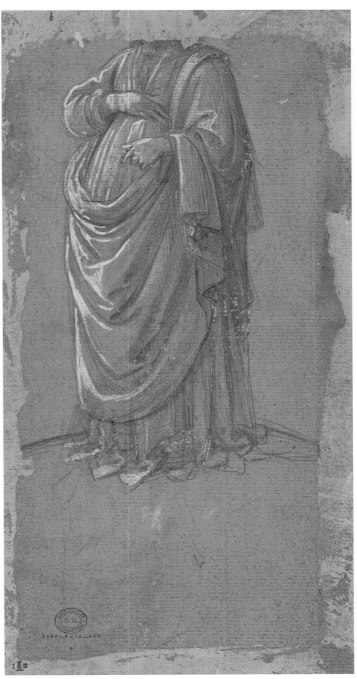

Verso

113

12 Recto: Virgin and Child with two angels

c. 1460–65

Metalpoint (? silverpoint), heightened with lead white, on ochre preparation, 33.3 × 23.9 cm

Verso: The penitent St Jerome; ornamental motifs

Metalpoint, brown wash, heightened with lead white, over black chalk,
on pink-orange preparation
Gabinetto Disegni e Stampe degli Uffizi, Florence (184 E)

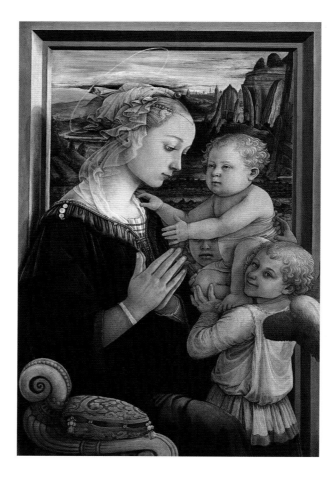

Fig. 1
Filippo Lippi, *Virgin and Child with two angels*, *c.* 1460–5. Tempera on panel, 91.4 × 63.5 cm. Galleria degli Uffizi, Florence.

PROVENANCE

Fondo Mediceo-Lorenese (Pelli after 1775–before 1784); Reale Galleria degli Uffizi (L. 930)

LITERATURE

Berenson 1938, vol. 2, no. 744 A (as Fra Diamante); Degenhart and Schmitt 1968, vol. 1–2, no. 532 (recto: Fra Diamante after Lippi; verso: Fra Diamante); Petrioli Tofani 1972, no. 9 (verso not autograph); Marchini 1975, p. 220; Angelini in Florence 1986b, no. 29; Petrioli Tofani 1986, pp. 80–1; De Marchi in Florence 1992, no. 7.1; Ruda 1993, no. DW4 (recto: studio), no. D 6 (verso: Filippo Lippi); Ciseri in Rome 2000, no. 5.1

This drawing is largely executed in metalpoint, a medium that requires the paper to be prepared with pigment, in this case a warm ochre applied with visible brush strokes. White is applied with a brush to convey the unusual fall of light from the upper right. The composition corresponds closely to a late panel painting by Lippi dated to the mid-1460s, *Virgin and Child with two angels*, in the Uffizi, Florence (fig. 1).[1]

So close are the drawing and painting that the drawing has often been considered to be a copy by a studio hand from the completed painting.[2] The balance of opinion, however, gives the sheet to Lippi, in recognition of the dynamic, exploratory nature of the metalpoint, which in places differs considerably from the painting, for example in the altered volutes of the Virgin's wooden throne and in the Christ Child's legs. The drawing also displays alterations, most visibly in the position of Christ's outstretched right arm, and in the head of the angel turned to the right.

The sole concentration on the figures in the drawing reveals that the panoramic landscape against which the figures are seen in the panel was separately conceived. The four protagonists form a tight group: the Virgin is absorbed in prayer, her palms pressed together while the Christ Child extends his arms towards his mother, underscoring the close relationship between the two. The angel who holds Christ turns his head outwards, engaging the viewer. Barely indicated beneath the Child's left arm is the face of a second angel, more clearly visible in the panel. The compositional and narrative innovations that Lippi introduced into a highly conventionalized iconography were influential on his contemporaries, especially on his apprentice Botticelli.[3]

The participation of the angels in the scene suggests that an underlying theme of the picture is the 'mystic marriage' of the Virgin to her divine son, with the angels as companions to the bride, a theme derived from the Old Testament Song of Songs.[4] The solemnity of the nuptials is emphasized by the elegance of the Virgin, who reflects the highest canon of contemporary beauty in the delicate lines of her face and high forehead. Her dress is worthy of a Florentine noblewoman and the elaborate headdress includes a pearl, which is possibly a symbolic reference to the Gospel description of the kingdom of heaven.[5] The Virgin's transparent veil and its delicate folds falling over her right ear are marvellously

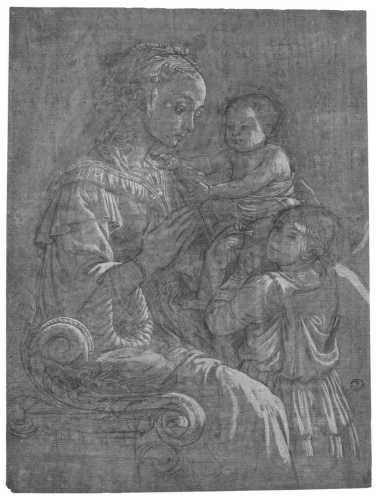

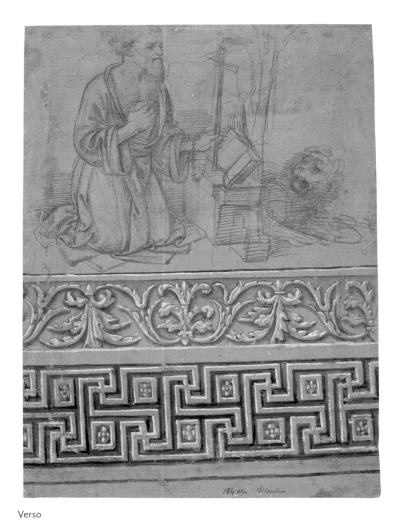

Recto Verso

described by Lippi. The grace of the depiction is characteristic of the late phase of Lippi's career to which this drawing is dated.

The verso contains a *Penitent St Jerome* drawn in the same orientation as the recto. The saint is represented in an act of self-mortification, clasping a stone to his chest as he contemplates the cross, initially drawn further to the left and with the crossbar at a different angle. Such alterations in quick and summary strokes give an immediacy which accords with Lippi's style seen in no. 11. Although *St Jerome* and the unrelated decorative motifs are not unanimously given to Lippi, there are suggestive correspondences in both pose and drapery between the drawn St Jerome and the saint in Lippi's *Annunciation* panel of *c.* 1455 in the Uffizi.[6] MMR

13 Totila's assault on Perugia
c. 1461

Metalpoint (? silverpoint), pen and brown ink, heightened with lead white,
stylus (in the architecture), on purple preparation, 31.6 × 42 cm
Gabinetto Disegni e Stampe degli Uffizi, Florence (333 E)

PROVENANCE

Ferri, Disegni Esposti (1879–1881); Reale Galleria degli
Uffizi (L. 930)

LITERATURE

Berenson 1938, vol. 2, no. 534 C; Degenhart and Schmitt
1968, vol. 1–2, no. 416; Angelini in Florence 1986, no. 7;
Petrioli Tofani 1986, p. 148; Dillon in Florence 1992,
no. 10.5; Cole Ahl 1996, pp. 77–9; Mencarelli in Perugia
1996, no. 11; Melli 2000, pp. 169–92; id. in Montefalco
2002, pp. 123–4

The drawing illustrates the siege of Perugia
by the barbarian general Totila in the sixth
century and the subsequent martyrdom of
St Herculanus, the patron saint of the city.
The events unfold from the foreground to
the background: in the lower left Totila sits in
front of his tent listening to the words of an
informer dressed as a cleric, who discloses that
the fattened calf thrown from the city walls by
the Perugians was a ruse to disguise the end of
their food reserves. Above Totila the soldiers
slaughter the animal and begin the assault of
the city at the Marzia Gate. After the city's
capitulation, its bishop, St Herculanus, is
martyred, and his flayed and decapitated
body thrown from the city walls on the
right (a detail now visible only in ultraviolet-
induced luminescence, figs 1–2). The church of
S. Ercolano built around Herculanus's grave in
the fourteenth century, the octagonal structure
seen in the centre of the composition, still
stands today. The Perugia of Gozzoli's day
acts as both a backdrop and a protagonist in
the narrative, its high medieval walls receding
along the top of the sheet and allowing the
entire paper surface to be filled with incident.
This makes Gozzoli's sheet a very early example
of topographical drawing, predating Gentile
Bellini's work (no. 19).

This drawing is related to the frescoes
chronicling the *Lives of St Lewis and St Herculanus*
in the Priors' Chapel of the Palazzo dei Priori
in Perugia, a commission given in 1454 to the
native Perugian painter Benedetto Bonfigli
(*c.* 1420–96).[1] The drawing documents that
Gozzoli tried to gain the commission either in
1454 when it was awarded to Bonfigli, or more
likely in 1461 when the slow pace of execution
forced the patrons to threaten that another
artist would be brought in to complete the
cycle. The drawing would appear to be a
presentation drawing for a patron in which
Gozzoli displays his talent in pictorial narrative,
rather than a preparatory study for a fresco,
given its precious appearance and the saturated
purple of the prepared ground brushed on the
paper, which is quite unlike the light tones of
unworked plaster.[2] Gozzoli was not untested
in Perugia, having producing an altarpiece
for the oratory of S. Girolamo where foreign
students attending the university of Perugia
were accommodated, the so-called Sapienza
Nuova, in 1456,[3] and was known for his
proficiency in fresco painting, having
collaborated with the older Fra Angelico
in Rome and Orvieto, and undertaken
many independent commissions, notably
in Montefalco and Viterbo.[4]

The purple ground displays Gozzoli's
vivid chromatic sensibility, also seen in no. 14.
Gozzoli first drew the architecture with a
stylus on the prepared paper.[5] He then took up
the metalpoint and pen and ink, applying white
to convey the fall of light. These media have
sunk into the purple support over time, greatly
impeding the legibility of the sheet, although
some measure of its original state can be gained
through ultraviolet images made for this exhi-
bition, which reveal the variety and complexity
of Gozzoli's drawing (figs 1–2). The details
revealed in the ultraviolet images include the
tightly packed buildings behind the city walls,
and the animated rows of soldiers who echo
the crowded procession of the Magi in
Gozzoli's fresco in the chapel of the Palazzo
Medici Riccardi in Florence (1459–61).[6] MMR

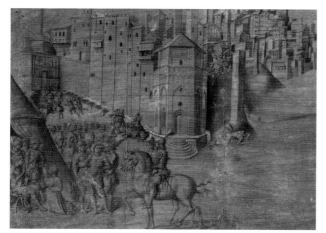

Fig. 1
The drawing in ultraviolet-induced luminescence.

Fig. 2
Detail of fig. 1 showing martyrdom.

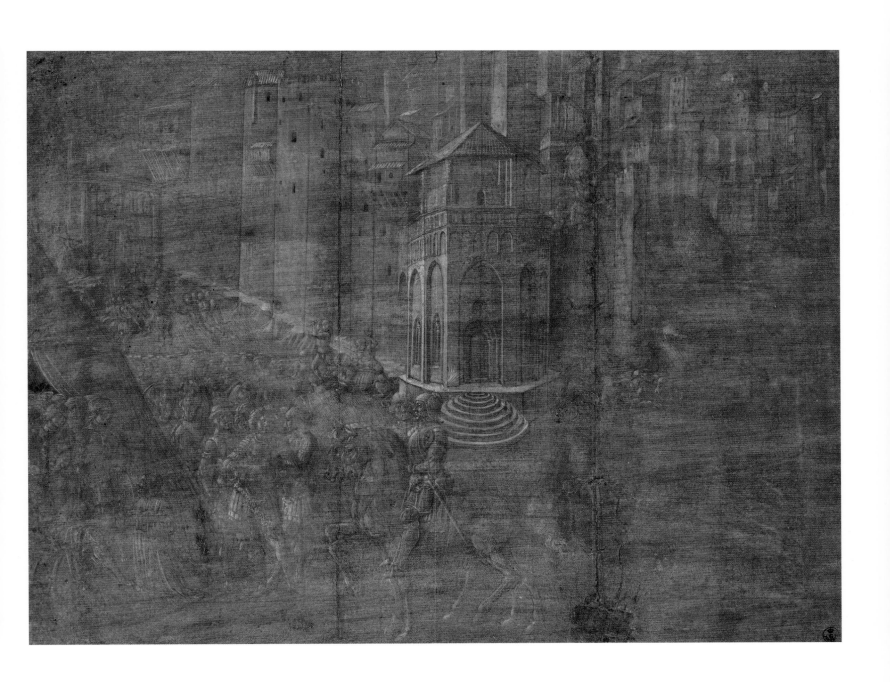

117

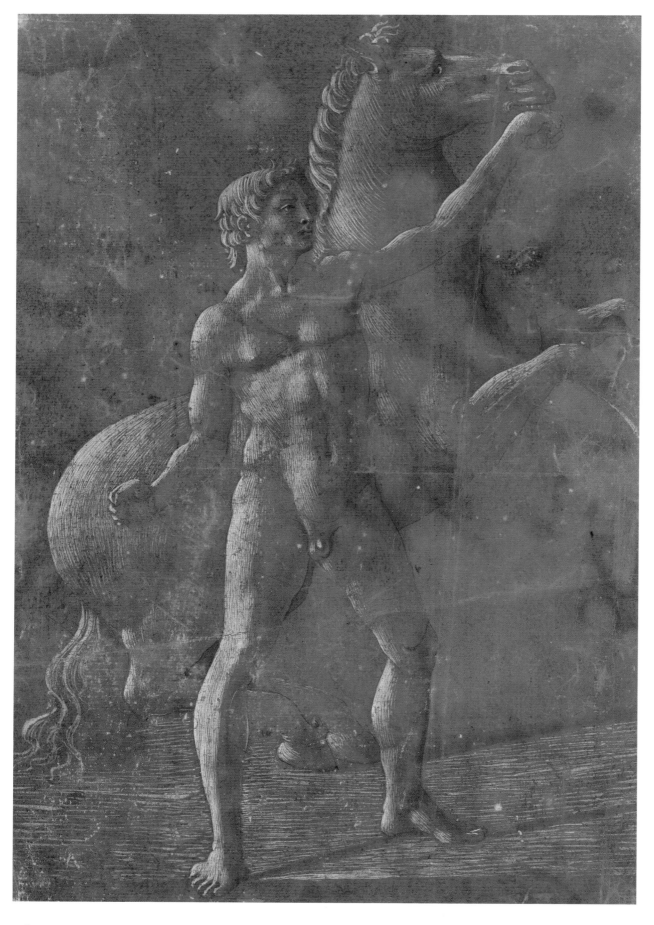

14 A nude man with a horse

c. 1447–9

Metalpoint, grey-black wash, heightened with lead white, on blue preparation, 35.9 × 24.6 cm
British Museum, London (Pp, 1.18)

PROVENANCE

F. Fagel; W.Y. Ottley; bequeathed by Richard Payne
Knight Bequest, 1824

LITERATURE

Berenson 1938, vol. 2, no. 986 (as Francesco Granacci);
Popham and Pouncey 1950, no. 152 (as studio of Filippo
Lippi); Ragghianti Collobi 1954, p. 600 (as Pesellino);
Grassi [1960], no. 35 (as Domenico Veneziano); Degenhart
and Schmitt 1968, vol. 1–2, no. 373 (as Fra Angelico);
Ames-Lewis 1981a, p. 94; Natali in Florence 1992, no. 1.1;
Melli in Montefalco 2002, pp. 124–5 (as Pesellino); Padoa
Rizzo 2003, p. 52; Roani in Athens 2003, vol. 1, no. I.13;
Melli 2009, pp. 68–9 (as Pesellino)

When Gozzoli first arrived in Rome from
Florence some time between 1447 and 1449, he
found a city engaged in fervid preparations for
the papal jubilee year of 1450, Pope Nicholas V
having set in motion an ambitious project for
the renewal of Rome. Gozzoli had travelled to
assist Fra Angelico in the execution of frescoes
in St Peter's and the St Nicholas Chapel in the
adjoining Vatican Palace. This brought Gozzoli

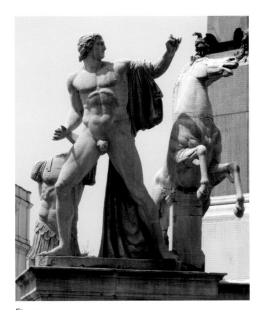

Fig. 1
One of the two *Dioscuri* or *Horse tamers* on the
Quirinal Hill, Rome, colossal Roman marble sculpture
after a Greek original, 4th century BC.

into direct contact with Roman antiquity,
and he made drawings from sculpted reliefs,
statues and unearthed classical fragments.

This striking drawing is dated to Gozzoli's
Roman years, inspired by the colossal antique
marble sculptures of the *Dioscuri* or *Horse tamers*
(fig. 1, and fig. 38 on p. 59) on the former site
of the Baths of Constantine on the Quirinal
Hill. The sculptures remained visible beyond
antiquity and thus became a symbol of the city.
It was not until the seventeenth century that
the marble figures were correctly identified as
the *Dioscuri*, as the twin gods Castor and Pollux
were known; nevertheless the dynamism and
monumentality of the group exerted a strong
fascination on Renaissance artists, for whom
the study of antique statuary was considered
essential (see no. 97).[1] This drawing is not
archaeologically accurate, offering instead a
more naturalistic interpretation of the nude
male body, with his muscles in tension as he
controls the rearing horse. The freedom with
which Gozzoli interpreted the classical model
is shown in the way that he combined the
left-hand *Dioscuro*, omitting the cloak draped
over the extended left arm, with the horse
held by his twin.

The debate over the attribution of this
sheet has recently been reopened by Lorenza
Melli, who favours Gozzoli's near contemporary,
the Florentine painter Francesco Pesellino
(*c.* 1422–57).[2] However, the solid anatomy of
the nude man is in keeping with Gozzoli's
style, as is the precise underdrawing in
metalpoint recently revealed by infrared
reflectography, even allowing for the squiggle
over the right thigh as if the artist's hand had
been jolted (fig. 2). Over the underdrawing a
dark wash was used for shadows, but it is the
highlights in white following the shapes of
the bodies which convey most effectively the
fall of light over solid form, appearing to
shimmer against the saturated blue ground.
It has been suggested that the artist used
a posed mannequin, a common workshop
practice at the time that allowed for more
prolonged observation, but this would seem

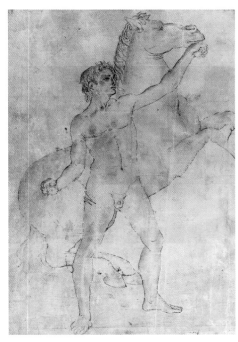

Fig. 2
Infrared reflectograph of no. 14, showing
metalpoint underdrawing.

unnecessary given the artist's free adaptation
of the sculpture.[3]

Gozzoli's sensibility for three-dimensional
form had no doubt been increased by his earlier
collaboration with Lorenzo Ghiberti on the
east door of the Baptistery in Florence between
1444 and 1447. He also seems to align himself
with the theories of Alberti, who in his *Della
pittura* (1436) encouraged artists to study
closely the fall of light and the way it reveals
the projections and hollows of a body,
making it appear as if 'in relief'. Alberti also
recommended the study of 'sculpted things' in
order to depict highlights effectively.[4] MMR

Attributed to PAOLO DI DONO, called PAOLO UCCELLO (*c.* 1397–1475)

15 Study of a chalice

c. 1450–70

Pen and brown ink over ruled stylus and compass, the sheet extended, 34.9 × 24.3 cm
Gabinetto Disegni e Stampe degli Uffizi, Florence (1758 A)

PROVENANCE

Ferri, Disegni di Architettura (1885); Reale Galleria degli Uffizi (L. 930)

LITERATURE

Berenson 1938, vol. 2, no. 2768; Parronchi 1964 pp. 532–48 (Piero della Francesca); Degenhart and Schmitt 1968, vol. 1–2, no. 314; Bellini in Florence 1978, no. 78; Ragghianti, Rossi and Soddu 1986, pp. 85–92; Kemp in Washington 1991, no. 139; Galluzzi in Florence 1992, no. 9.24; Roccasecca in Florence 2001b, no. VI.1.2 (anonymous)

This intricate network of lines in pen and ink forms a many-faceted chalice or vase seen from slightly above and from a perspective of perfect symmetry to either side of the vertical line down its centre. The lower edge of the paper has been added in a later period and the missing portion of the chalice's foot redrawn.[1] Uccello was renowned for his application of perspective in his paintings and this sheet has been traditionally attributed to him, along with two drawings of a *mazzocchio*, a stuffed roll of fabric worn on the head to support a turban or coiffure (fig. 1), whose form is very similar to those at the top of the chalice and over its foot.[2]

Vasari considered Uccello's interest in perspective excessive, describing the artist's *mazzocchi* as '*ghiribizzi*' (capricious things), while Donatello's dismissive observation that such drawings were only suitable for intarsia (decorative inlay) may not have been unreasonable, since they are analogous to wooden intarsia panels whose geometric designs were often based on a system of vanishing orthogonals.[3] Masters of intarsia were much in demand to decorate choir stalls and sacristy furnishings, as well as from patricians, as is seen in the sumptuous illusion of objects in cupboards that Federico da Montefeltro commissioned in the 1470s for his *Studiolo* in the Palazzo Ducale, Urbino.

This drawing is an exercise in representing three-dimensional form on a two-dimensional surface, achieved through the rigorous analysis of an object in its pure geometric form, ignoring its material substance and illumination. The drawing has more than 2,000 intersection points that are configured by the eye to suggest the surface of the object, its geometrical form first mapped out in ruled stylus. Photographing the drawing with angled lighting to emphasize the incised grooves reveals the network of stylus incisions that surrounds the object and suggests how the lines that make up its form extend into space (fig. 2).

The attribution to Uccello is not uncontested and other names have been put forward, including Piero della Francesca,[4] whom Vasari records as having produced 'a vase of many aspects revealing simultaneously its front, back, sides, base and mouth'.[5] Piero was equally interested in the science of representation, although to different, less abstract effect, and in his later career wrote one of the earliest treatises on perspective, *De prospectiva pingendi*. The lack of documentary and stylistic evidence means

Fig. 2
No. 15 shown in raked light to reveal stylus incisions.

that the debate over attribution remains open.

This drawing is a pure exercise in geometric representation and neatly illustrates the way Renaissance artists sought to apply reason to the description and investigation of the visual world, whose mathematical principles were understood to govern every aspect of the divinely created universe. MMR

Fig. 1
Attributed to Paolo Uccello, *Study of a mazzocchio*, c. 1450–70. Pen and brown ink over stylus, 10.3 × 26.7 cm. Gabinetto Disegni e Stampe degli Uffizi, Florence.

121

16 A tournament: from an album of 99 folios

c. 1455–60 (ILLUSTRATED OVERLEAF)

Leadpoint (some of the architecture drawn with the aid of a ruler and compass),
41.5 × 33.6 cm, each page
British Museum, London (1855,0811.53 verso/54 recto)

PROVENANCE

Possibly the album left by Anna Bellini, widow of the artist, to her son Gentile in 1471, who in turn left it in 1507 to his brother, Giovanni; Gabriele Vendramin; Jacopo Soranzano; Marco Cornaro, Bishop of Vicenza; Count Bonomo Algarotti; the Corniani family; acquired from Bonetto Corniani by Giovanni Maria Sasso in 1802 (a note by Sasso states that on Cornaro's death it was acquired by Avvocato Vecchia from whom it was acquired by Bonetto Corniani); sold by Sasso's executor in 1803 to Girolamo Mantovani, from whom inherited by his nephew Domenico; purchased for the British Museum by Rawdon Brown in 1855 from Mantovani for £295.4s.

LITERATURE

Popham and Pouncey 1950, no. 21; Eisler 1989, pls 119–20; Degenhart and Schmitt 1990, vol. 2–6, pp. 493–5; Elen 1995, no. 21

More drawings survive by Jacopo Bellini, the father of Giovanni and Gentile, than any other Venetian fifteenth-century artist, thanks to this album and another like it in the Louvre in Paris. The Louvre volume consists of 93 vellum pages much the same size as the London ones (from 42.2 to 42.8 cm in height and from 28.3 to 29.3 cm in width), with leadpoint or metal-point drawings, the majority of which have been gone over in pen and ink by more than one hand.[1] For reasons of space the following discussion largely concentrates on the *London album*, but the Parisian one cannot be ignored completely since the two are so closely linked.

The provenance of the two albums

It is generally assumed that the two albums are among the '*omnes libros de dessignijs*' (all the books of drawings) left to Gentile Bellini in the will of 1471 made by Jacopo's widow, Anna.[2] The next mention of the *Paris album* is it being in Smyrna (Izmir) in Turkey in 1728, where it was acquired by a French royal agent, but it did not enter the Louvre's collection until 1884. The pages of the *Paris album* are numbered 1 to 95 and these correspond to an index written in Italian, but not by Jacopo, at the end that describes their subjects. Gaps in the numerical

sequence make clear that a dozen sheets are missing from the album. From the Turkish provenance it is assumed that Gentile presented or sold the album to the Ottoman Sultan Mehmed II in Constantinople (modern day Istanbul) during his 1479–81 visit there (see nos 17–18).

The *London album* was most likely the one belonging to Jacopo that Gentile bequeathed to his brother, Giovanni (active *c*. 1459–1576), in his will of 1507, as it seems to have remained in Venice until its purchase by the British Museum in 1855. It can plausibly be identified as the 'large album of leadpoint on wove paper by Jacopo Bellini' recorded in 1530 as in the collection of the wealthy Venetian patrician Gabriele Vendramin (1484–1552) by Marcantonio Michiel.[3] Vendramin's collection was one of the most celebrated in Venice and included antique sculptures and coins, paintings by Giorgione and Titian and, according to Michiel, a number of drawings including a book of animal studies by the Lombard painter and illuminator Michelino da Besozzo (active 1388–d. after 1450). The collection was dispersed during the course of the seventeenth century and it is not known when or how the album passed to Jacopo Soranzo (1686–1761), but after this date the history of the *London album* is recorded.[4]

The structure and technique of the London album

The *London album* consists of 99 pages numbered in Roman numerals in the upper right corner of each right-hand page. The album pages are all made of the same paper, 50 sheets of which bear a watermark of a pair of scales within a circle. (The watermark is the manufacturer's mark attached to the paper mould, which is visible in the finished sheet when it is held up to the light, see p. 37.) The volume's homogenous structure disproves the idea that it was an assemblage of studies put together over a protracted period.[5]

The album is not in its original state, as it was taken apart when it came to the Museum so that a margin could be added to each sheet. Before this intervention it seems to have been constructed in an identical fashion to the *Paris album*, albeit of paper rather than parchment. It almost certainly originally consisted of 51 large sheets (roughly 41.5 × 68.1 cm), folded in half and divided up into ten quires or gatherings of five, except for the last one which contained six.[6] Each of the ten quires was originally stitched together separately and it is likely that Jacopo made the studies before they were put together as an album, because in this state the pages could be kept flat, thereby avoiding the problem of drawing in the awkward innermost margin or gutter of a bound volume. The present arrangement of the album does not necessarily follow the sequence in which the drawings were made, because before the left-hand drawings were added (as will be discussed below) the artist was free to arrange the quires as he wished. Once he had decided to draw on the left-hand pages he no longer had this freedom. The album is missing three sheets: one carefully removed before the album was numbered, perhaps by the artist; and the first and last pages that were probably blank and served as endpapers. These were most likely discarded when the album was taken apart; at the same time its late fifteenth- or early sixteenth-century leather binding was enlarged to take account of the increased size of the sheets.

The London drawings are executed in leadpoint, a medium with a silvery tone that had the advantage of not requiring the paper to be prepared with a ground, and that could be erased if necessary. Unfortunately leadpoint is prone to rubbing, and over time the action of leafing through the album has caused the drawings to become very faint. Twenty-three of the drawings, or just less than a quarter, have some contours gone over in ink, with the extent of this retouching divided roughly equally between a few touches of pen and much more extensive, but never complete, reworking. The

pen additions are by more than one hand as they vary in quality from sensitive reworking, such as that found in the study of a lion on the verso of the second page, to crude tracing of the leadpoint contours to deadening effect.[7] Eight of the drawings have also been touched with brown wash while the studies of lions in the second opening or double-page spread have additional green wash. The pen and brush additions were perhaps preliminary investigations by Jacopo, or more likely his heirs, to make the leadpoint contours more permanent, as occurred in the *Paris album*. Gentile Bellini's readiness to rework Jacopo's drawings is documented in a 1493 reference to him offering to sell to Francesco II Gonzaga (1466–1519), the Marquis of Mantua, a view of Venice made by his father, which required two months of pen retouching.[8]

Execution, subject and function of *the* London album

The majority of drawings in the *London album*, like the *Tournament*, fill both sides of an opening because Jacopo never rotated the volume 90 degrees to the right, as he did in the *Paris album*, to make the page horizontal rather than vertical. The pages were not, as they might first appear, drawn at the same time because in most cases Jacopo originally executed just the right-hand page, only later deciding to extend the composition to the left sheet.[9] The only exceptions to this are the openings where Jacopo extended the extremities of a large-scale figure begun on the right side on to the edge of the left-hand page, such as the tip of an angel's wing or a foot and ankle.[10]

This two-stage development can be seen in the *Tournament* opening. The right-hand page with the knights jousting, watched by a crowd of dignitaries from a first-floor loggia, is a self-contained composition with the recession organized around a vanishing point roughly in the middle of the sheet. Although Jacopo did his best to disguise the fact that the two sides

Fig. 1
Jacopo Bellini, *Rustic figures walking to the right* (from the *London album*, fol. 34), *c*. 1455. Leadpoint, 41.5 × 33.6 cm.

are not an integrated whole, comparison reveals that neither the recession nor the figure scales quite match. Problems of scale often occur in the drawings, as can be seen in the present example in the disparity between the battling knights and the chatting pair of grooms who appear more or less on the same plane. In an effort to join together the two halves, Bellini added the rear quarters of the left-most horse; thereby upsetting the balance of the original design, which had a comparably truncated steed on the right edge.

For most of the openings Jacopo managed to come up with ways to extend the scene to the left through the addition of a landscape or townscape. Occasionally the narrative suffered as a result, as is the case with the incongruous crowd of soldiers on the left side of the thirty-fourth opening, who placidly observe Judith fleeing with the decapitated head of their general Holofernes.[11] In the drawings where the right-hand figures were contained more or less on the same plane it was relatively straightforward for the artist to keep to the same scale when continuing the scene to the left. However such consistency was problematic when the original compositions included figures receding backwards, as the artist habitually exaggerated the recession to increase the impression of spatial depth. Perhaps mindful of this problem Jacopo tended in the second

half of the album either to reduce to a minimum the number of figures in the architectural settings in the left-hand drawing, or to make independent studies that had no connection with the composition on the right – for example, in the seventy-seventh opening a *Crucifixion* on the right is matched with an unrelated study of a circle of elegantly dressed courtiers observed by two friars.[12]

The majority of the drawings are of familiar biblical or saintly narratives with the occasional classical scene, such as Hercules fighting with the Nemean lion or the drunken Silenus on his donkey. Other drawings in the album appear to invite stories to be invented around them: knights in combat or on horseback; two different treatments of unidentified warriors holding severed heads; a horse rearing up wildly after having thrown his rider in a piazza; groups of naked women shown in a tented pavilion or in another instance fighting one another; and a satyr riding a gigantic lion fleeing from soldiers. These fabulous scenes are leavened by ones inspired by contemporary life: bucolic scenes with peasants and farmers (fig. 1); exotic animals like cheetahs and lions kept in courtly menageries; and glimpses of urban life, like children swimming in a canal and the two drawings of a friar, perhaps an unusually youthful St Bernard of Siena (1380–1444), preaching from a wooden pulpit in a

square (fig. 2). A run of five pages has rows of small empty circles on them, now covered over with a brushed-on application of white bone or chalk dust, which were perhaps intended to be filled with copies of classical coins.

The general scholarly consensus about the function of the *London album* is that it is a collection of compositional and figural ideas for the use of Jacopo's workshop.[13] This is a description that fits better the more eclectic nature of the Paris volume and its more informal organization, with upright compositions sometimes facing horizontal ones. In one instance the *Paris album* demonstrably functioned as a model book because Giovanni Bellini, Jacopo's younger son, used the pose of one lion from a sheet of variants in the album for the animal in his early painting of *St Jerome* in the Barber Institute of Fine Arts, University of Birmingham.[14] Admittedly in the *Paris album* only two pages of lions in different positions (one of them from an earlier model book that Jacopo recycled to save the cost of buying new vellum sheets), and the same number of classical monuments with Latin inscriptions, could be described as model-book exempla from the way in which they gather together related motifs on the same page. In the *London album*, only the page with two rows of three paired saints (90 verso) and the few examples of animal studies come close to this tradition, and the few single figures, such as the nude warrior with a severed head (60 recto), tend to be so specific in their action that they were clearly not designed as models for stock types to insert into paintings.

The notion that the compositional drawings in the London volume were made as guides for painted compositions is also at odds with the upright format of the right-hand pages, when most narrative paintings were horizontal. By contrast the majority of comparable drawings in the *Paris album* are horizontal. Admittedly the format of the *London album* was rectified by extending the drawings to the left page, but the resulting composition was generally unbalanced and could not be turned into a

Fig. 2
Jacopo Bellini, *A friar preaching* (from the *London album*, fol. 82), c. 1455. Leadpoint, 41.5 × 33.6 cm.

painting without major revision. The choice of religious subjects in the volume is no less quixotic with, for example, four treatments of the rarely painted *Flagellation* and none of the most common, the Virgin and Child.

The alternative view that the album was a work of art in its own right is perhaps more persuasive, although the provenance demonstrates that it was retained by the family.[15] (Confusingly the *Paris album*, which seems to have been made as a store of compositional ideas to be retained, was given away or sold by Gentile, but this is perhaps an indication that by the early 1480s its contents were too outmoded to be of much help in designing paintings.) The consistency of the format of the *London album* strongly suggests it was made as a book of drawings to be leafed through akin to Marco Zoppo's Rosebery album (no. 25). The variety of subject matter from one opening to the next, with the different treatment of certain repeated themes, such as the Nativity or St George fighting the dragon, would fit the album having been made specifically by Jacopo to showcase his inventiveness. One feature that the aged artist clearly wanted to highlight strongly in the elaborate architectural settings that are such a feature of the album was his interest in perspective. This was a long-standing concern, to judge from a lost treatise on aerial perspective dedicated to him in the 1440s by its author, the University of Padua scholar Giovanni da Fontana. Jacopo probably picked up the rudiments of perspective from Florentine artists active in Venice or the Veneto in the 1440s, such as the sculptor Donatello (resident in Padua for a decade from 1443) and the painter Andrea del Castagno, and also from studying the work of his son-in-law, the Paduan painter Andrea Mantegna. Jacopo was ambitious and inventive in creating the illusion of profound recession in many of the drawings, but his perspective was empirical and lacked the mathematical rigour of his son-in-law, who had fully mastered the science.[16] The depiction of space in the *London album* drawings ranges from the sophisticated, as in the *Tournament*

scene, to the use of pictorial conventions found in works of the previous century, such as the steep upward tilt of the landscape of his *Baptism of Christ* (15 recto). This variety can perhaps be explained by Bellini sometimes referring back to compositional drawings from much earlier in his career when his powers of invention flagged, an understandable occurrence when faced with the task of filling almost a hundred pages.

Jacopo's motivation in making the album to impress potential patrons with his awareness of contemporary artistic trends can be paralleled in the references to Donatello and Mantegna in Marco Zoppo's double-sided drawing on vellum from the 1460s in the British Museum (a work that is sadly too delicate to be included in the exhibition).[17] A more straightforward example of an artist using a drawing as a means of display is provided by Leonardo's virtuoso *Warrior* (no. 50). The contents of the *London album* are well suited to the taste of Jacopo's patrons in Venice and in the northern courts. Scenes such as the *Tournament* and the varied depictions of knights, for example, were likely to have appealed to courtly patrons such as the Este family, the ruling dynasty of Ferrara; Lionello d'Este (1407–50) commissioned illuminations for a story of *Lancelot*, one of the legendary Arthurian knights whose deeds were also celebrated in the decoration of a room in the palace of his wife, Margherita Gonzaga. Jacopo's ties with the Este family are documented by a lost portrait of Lionello that, from a poetic tribute penned by the Venetian humanist Ulisse degli Aleotti in 1441, is known to have been judged superior to one by Pisanello.[18] Aleotti's likening of Jacopo to the classical sculptor Phidias is not particularly revealing of the artistic tastes of the northern Italian courtly elite who patronized Bellini. The poetic Latin encomium to Pisanello written by Basinio da Parma, a courtier of Lionello d'Este, of 1447/8 is more helpful in that regard, in its praise for the painter's lifelike descriptions of nature and animals.[19] Jacopo's evocative depictions of airy landscapes, animals

and rustic scenes in the album seem to cater to the same literary taste for naturalistic detail – for example, the wind-blown trees in Pisanello's paintings that Basinio mentions in his text are echoed in the bending cypresses included in the background of fig. 2.[20]

Date of the London album *and its relationship to the* Paris album

The dating of the *London album* on the basis of the late fifteenth- or early sixteenth-century inscription at the beginning ('*Di mano di ms [messer] iacopo bellino veneto 1430 in venetia*') is not credible. The general consensus is that it was executed in the mid-1450s, although there is no sure evidence to back this up. An approximate dating is provided by the inspiration of Donatello's bronze *Gattamelata* sculpture in Padua (1447–53) for two drawings of an equestrian monument (26 verso and 78 verso). Stylistically the album is in keeping with three predella panels of the *Adoration*, *Crucifixion* and *Descent into Limbo* split between museums in Ferrara, Venice and Padua, which are generally thought to have been designed, but not necessarily painted, by Jacopo, *c*. 1455–60.[21] The general resemblance in composition of Giovanni Bellini's *Agony in the Garden* painting of *c*. 1465 in London's National Gallery to Jacopo's drawing of the subject in the album (43 recto) provides a possible *terminus post quem* for the *London album*.

Less convincing is the suggestion that Mantegna's slightly earlier treatment of the *Agony in the Garden* (*c*. 1460), also in the National Gallery, was inspired by Jacopo, whose daughter he had married in 1452/3. By the time of the marriage Mantegna had already established himself as the first truly modern Renaissance artist in northern Italy, through the astonishing illusionism and sophistication of his evocation of the classical world in his lost frescoes in the Ovetari chapel, Padua (1448–57; see fig. 1, no. 20). Rather than Mantegna seeking inspiration from Jacopo, it seems more likely

Fig. 3
Jacopo Bellini, *Death of the Virgin* (from the *Paris album*,
fol. 27), *c.* 1450–55. Pen and ink, over leadpoint, on vellum,
42.2 × 29.3 cm. Musée du Louvre, Paris.

Fig. 4
Jacopo Bellini, *Death of the Virgin* (from the *London album*,
fol. 67), *c.* 1455. Leadpoint, 41.5 × 33.6 cm.

that the reverse is true and that the *London album* represents a valiant attempt by the aged artist to show his awareness of his son-in-law's achievements. The stylistic homogeneity of the London album suggests that it was executed in a concentrated period, with the decision to extend the compositions to the left-hand pages made soon after the completion of the right-hand ones.[22]

One of the most controversial questions concerning the two albums is their chronological order. The general consensus is that the sketch-like London drawings were preliminary studies for the more ambitious compositions in Paris.[23] The German scholars Bernhard Degenhart and Annegrit Schmitt are alone in arguing the reverse based on stylistic grounds. In their view the Paris volume was put together in a haphazard manner over a protracted period, from 1430 to 1455, with the London one made between 1455 and 1465. Aspects of

this hypothesis seem untenable, however, in the light of Albert Elen's study of the structural similarities between the two albums that make it most unlikely that they were put together a quarter of a century apart. For practical reasons it is also implausible that Bellini filled the pages of the Paris volume in the random fashion implied by Degenhart and Schmitt, who date successive openings sometimes to an interval of a decade or more. Nonetheless their suggestion that the Paris book precedes the London one is worth considering.

The relationship between the two albums can be seen through the comparison of two versions of the same subject, the *Death of the Virgin* (figs 3–4). According to Degenhart and Schmitt the Paris drawing was done a decade or more before the London one, a dating based on the view that the ornate complexity of the architectural setting of the vellum drawing is less developed than the simpler, and therefore

more 'modern', one in leadpoint. The London drawing certainly does appear a stripped-down and to some extent 'improved' version of the Paris one: the figures are closer to the picture plane; the building is more sober and classical in design; and Jacopo has blocked off the view through the recessed arch behind the Virgin's body so that the eye is no longer pulled back so precipitously. If the Paris drawing is indeed the earlier of the two (it should be admitted that most scholars have thought the opposite), the gap between them may be no more than a couple of years. It is noticeable, for example, that Jacopo struggles no more successfully in either drawing to cope with the foreshortening of the Virgin's body, and both works share a formulaic system of figural scale that makes all the protagonists appear of identical height.

The differences between the two books perhaps stem more from their differing functions. The complexity of the architectural

setting of the Paris *Death of the Virgin*, with the building enlivened by numerous decorative flourishes, has elements that seem suited to be used as the basis for large-scale painting like two lost canvases of the Passion that Jacopo painted for the Scuola Grande di S. Marco in the 1460s. The level of detail in the description of the architecture in the *Paris album* meant that it could be plundered and reconfigured to supply the setting for numerous painted compositions. The *London album* is simpler, and more concise in its detail, because its contents were designed to be leafed through so that the entire work collectively impressed the viewer through the variety of its contents.

Bellini's simplification of the compositions also had a practical aspect, as it made the drawings quicker to produce. This is perhaps most noticeable in the way in which the buildings in the *London album* are made up of lines drawn with a ruler or a compass, without the decorative embellishments found in their Parisian counterparts. The impression that the *London album* was produced at speed is strengthened by the many examples where Bellini changed a detail without rubbing out his first attempt – for example, in *A tournament*, the page depicted in the left foreground of the right-hand sheet was originally intended to hold a lance, but the artist decided instead to show him holding a staff. The faint outlines of the lance are still visible.

The drawings in the *London album* still retain the ability to enthral and delight, their faded state a testament to Jacopo's success in creating a work that encourages repeated viewings. The greatest innovation of the album is that it was made as an independent work of art in its own right, and therefore anticipates Zoppo's Rosebery album by about a decade (no. 25). The informality of the execution and the depiction of subjects that have no parallels in paintings of the period flowed from the album having being conceived as such from the outset. No less remarkable is the way in which the atmospheric tonality of Jacopo's drawings, with the figures and landscapes described more by light and shade than contour (a quality somewhat exaggerated by the rubbing that has caused the outlines to blur and lose definition over the centuries), anticipates the graphic style of Venetian painters of successive generations such as Cima, Carpaccio and Titian. For Jacopo's heirs, Gentile and Giovanni, the significance of the album in their formation is hard to quantify, yet it is surely not coincidental that it contains in embryonic form important aspects of their mature styles. Jacopo's ambition to marshal figures in an architectural setting, while at the same time wishing to evoke the animation and variety of urban life, in openings such as *A tournament*, lies at the heart of Gentile's achievement. The Uffizi drawing of San Lio attributed to Gentile (no. 19) manages what Jacopo tried, but was not quite capable of achieving, in its rigorous perspective recession of the buildings with the diminution of the figures calibrated by the tiled pavement of the piazza. The album's influence on Giovanni is more intangible, but arguably it had a greater impact on him than on Gentile, since it does not seem far-fetched to trace the solemn pathos of his religious paintings, most notably his series of Virgin and Child compositions, to Jacopo's depiction of themes such as the *Crucifixion* and the *Entombment* in the album. Equally, Giovanni's numinous feeling for the beauty of the natural world expressed in paintings such as the *St Francis* in the Frick Collection in New York, a pictorial vision akin to that found in St Francis's writings, must surely have been nurtured by his father's empathy for landscape and rural life expressed so vividly in the drawings.[24] HC

17, 18 **A Turkish janissary; and a woman in Middle Eastern costume**

c. **1480** (ILLUSTRATED OVERLEAF)

Pen and blackish brown ink, the outlines of the woman incised, 21.5 × 17.5 cm and 21.4 × 17.6 cm
The second drawing inscribed: *'orlo'* (hem), *'rosso'* (red), and *'oro'* (gold) for different portions of the turban,
'arzento' (silver) for the trimming of the bodice, *'azuro'* (blue) for the lining of the skirt, and *'neg°'* (black)
for the border
British Museum, London (Pp, 1.19 and Pp, 1.20)

PROVENANCE

Bequeathed by Richard Payne Knight, 1824

LITERATURE

Popham and Pouncey 1950, nos 7–8; Andaloro 1980,
pp. 202–3 (as ?Costanzo); Meyer zur Capellen 1985,
nos E 7–8 (as after Gentile); Raby in Washington 1991,
under no. 108, p. 212 (as Costanzo or after Costanzo);
Meyer zur Capellen in Meissner 1994, vol. 8, p. 487;
Campbell and Chong in Boston and London 2005,
nos 25–6

These were described as Gentile Bellini's portraits of the Ottoman Emperor Mehmed II and his wife in the British Museum's 1824 inventory of the Payne Knight Bequest. This identification of the sitters has long been abandoned, but the drawings are still generally related to Bellini's trip from 1479 to 1481 to the Ottoman capital Constantinople (modern-day Istanbul). Gentile, the elder son of Jacopo Bellini (no. 16), was sent there following Mehmed's request to the Venetian Senate in August 1479 to send him 'a good painter'. The mission was as much diplomatic as artistic, since good relations with the Turks were vital to Venice's trade in the eastern Mediterranean, especially as the Republic had only just made peace with the Ottomans. Gentile's selection was further confirmation of his high standing in the city; he had earlier been commissioned to produce now lost paintings for the seat of Venetian government, the Sala del Maggior Consiglio, in the Doge's Palace.

The only artistic output that remains from Gentile's period in Constantinople is a severely damaged portrait of Mehmed (National Gallery, London); a pen and watercolour drawing with gold heightening of a seated Turkish scribe (Isabella Stewart Gardener Museum, Boston); and seven pen studies of figures in Middle Eastern costume (the present pair, three in the Louvre, Paris, and two in the Städel Museum in Frankfurt).[1] The pen drawings are of varied quality and cannot be by one hand. The opportunity to study all of them together in the 2005–6 Boston and London exhibition, *Bellini and the East*, confirmed that the present pair

and the *Young Greek woman* in the Louvre (fig. 1) were by far the best of the group and that the others were either workshop or later copies. The Louvre drawing also has colour notes written by the same hand found on the costume of no. 18. Whether the handwriting is Gentile's is frustratingly difficult to confirm due to the scarcity of comparable examples.[2]

The evidence in favour of Gentile being the painter of the present drawings is admittedly circumstantial, since the costume studies are so different from the few sketchy compositional and architectural drawings by him.[3] The suggestion that the Louvre drawing (fig. 1) and the British Museum pair are, along with the four other studies, all copies of lost studies by Gentile, does not take into account the brilliance of the execution that is markedly superior to the other four. The subtlety of the lighting in areas such as the concertina folds

Fig. 1
Gentile Bellini, *Young Greek woman*, c. 1480. Pen and brown ink, 25. 4 × 17.5 cm. Musée du Louvre, Paris.

of the costume in no. 18, and the rendering of detail with minute strokes of the finely cut quill pen, as in the patterned sole of the soldier's shoe, demonstrate a sensitivity and technical competence far beyond the reaches of even the most talented copyist. It is noticeable in this regard that even the best of the four copies lack the delicacy of the hatching that is so important in imparting the tactile qualities of the materials and objects depicted in the Gentile drawings: seen, for example, in the difference in weight and pliancy between the woman's cotton headscarf and her woollen robe in no. 18.

The quality of the drawings has led other scholars to suggest that they are too good to be by Gentile and must instead be the work of the shadowy Costanzo di Moysis (active 1474–1524), sometimes known as Costanzo da Ferrara, who was at Mehmed's court at the end of the 1470s after having been sent there by his employer the King of Naples.[4] This attribution depends on reading a cryptic Persian inscription written on the Boston drawing as a reference to Costanzo di Moysis, an interpretation that has been rebuffed in the most recent publication on the work.[5] All that survives of Costanzo's work as an artist is an impressive bronze portrait medal of Mehmed. As he seems to have been born in Venice (his link with Ferrara was through his wife), Costanzo cannot be ruled out on account of the Venetian spellings in the colour notes on the London drawing. Nonetheless there is little to support the notion that Costanzo was a more skilled artist than Gentile. The meticulousness of the drawings seems consistent with the near pedantic literalness of Gentile's description of textiles and jewels in paintings such as the *Virgin and Child* in the National Gallery, London, or his portrait of Caterina Cornaro from the Szépmüvészeti Múzeum, Budapest.

All the drawings, originals and copies alike, have in common the way in which the figures are shown isolated on the page. The precision of the penwork and the lack of interruption or change of pressure in the line indicate that the

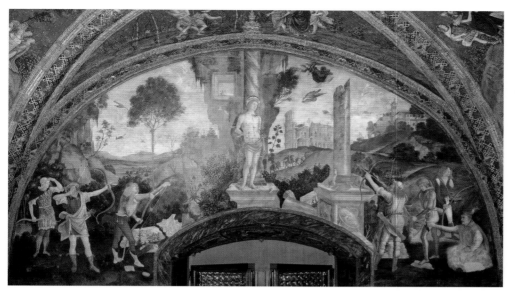

Fig. 2
Bernardino Pintoricchio and studio, *Martyrdom of St Sebastian*, 1492–4. Fresco, Borgia apartments, Vatican Palace.

Fig. 3
Detail of fig. 2

drawings are careful copies made from life studies recording costume details, akin to those that Pisanello made of the Byzantine Emperor John VIII's retinue in Ferrara forty years earlier.[6] The function of the drawings as records of exotic clothes and peoples explains the colour notes on the drawing of the woman, the annotations serving the dual purpose of an aide-memoire and as a guide for assistants who had never seen such clothes. The weaponry and tall felt hat of the male figure mark him out as a janissary, the elite corps of the Ottoman army who also guarded the sultan.[7] Identifying the woman is more problematic. In the recent exhibition it was astutely noted that the woman in the drawing is probably not Middle Eastern, as her face is not covered by a veil. Had she been from the region, it surely would have been in the presence of a man. The sitter is more likely a non-Muslim dressed in a fanciful mix of Eastern costumes topped by a funnel-shaped hat, which is not found in any other contemporary representations of Turkish women.[8]

There is no trace of Gentile ever having used the costume studies in the few paintings that survive after his return to Venice in 1481, but a sense of their value as first-hand records of the diverse people he had seen in Constantinople can be felt through the appearance of some of the figures in fresco cycles in Rome and Siena by the Umbrian painter, Bernardino Pintoricchio (*c.* 1452–1513). His first citation of Gentile's models was in the Borgia apartments in the Vatican

Palace executed between 1492 and 1494, and the second in the Piccolomini Library in Siena (1505–7). Of the two British Museum drawings, only the seated janissary was used by Pintoricchio. The figure appears in reverse and with his right arm raised in the lower right of the *Martyrdom of St Sebastian* in the Borgia apartments (fig. 2).[9] The presence of a Turk at a first-century Roman martyrdom may seem incongruous to modern eyes, yet it is in keeping with the similarly anachronistic blending of contemporary buildings with antique ruins like the Colosseum in the background. Further-more his direction of the martyrdom, signified by his gesture of command to the archers to start firing at the saint, may have been intended to refer to the contemporary menace of the Turks to Christendom that Pintoricchio's patron, Pope Alexander VI, was trying to combat by his efforts to organize a crusade against them.

How Pintoricchio got hold of Gentile's drawings (or more likely copies after them) is mysterious, but one possible conduit was the Venetian painter's brother-in-law, Andrea Mantegna. The latter was in Rome from 1488 to 1490 on the orders of Pope Innocent VIII, who commissioned him to paint in fresco the chapel of the Belvedere, the papal villa whose decoration he had entrusted to Pintoricchio and his studio. Both artists must have met at that time, and one can only speculate that this led to Mantegna allowing the Umbrian painter to make copies after the drawings he had earlier taken from Gentile's works. HC

131

17

18

Attributed to GENTILE BELLINI (?1429–1507)

19 The Campo San Lio, Venice

c. 1490–1507

Pen and brown ink, brown wash, 44.2 × 59.1 cm
Gabinetto Disegni e Stampe degli Uffizi, Florence (1293 E)

PROVENANCE

Fondo Mediceo (Nota 1687); Reale Galleria degli Uffizi
(L. 930)

LITERATURE

Hadeln 1925, pp. 45–6 (as Bellini); Molmenti 1906, vol. 2,
p. 67 (as Mansueti); Parker 1927, no. 38 (as Mansueti);
Tietze and Tietze-Conrat 1944, no. 265 (as Bellini);
Meyer zur Capellen 1985, no. D 4 (as Bellini); Fortini
Brown 1988, p. 153 (as Bellini); Fletcher 1998, p. 145
(as Bellini)

The fidelity of this view of Campo San Lio,
located east of the Rialto bridge on the
Piazza San Marco side, can be checked against
Jacopo de' Barbari's woodcut *View of Venice*
of 1500 (fig. 1) and the square's little-changed
appearance today.[1] The elevated viewpoint
aggrandizes the space, an effect magnified by
the invention of a canal in the foreground that
turns it into a theatrical stage.[2] Most scholarly
commentary has revolved around the drawing's
relationship to the *Miracle at the Bridge of
San Lio* painted in 1494 by Gentile's pupil,
Giovanni Mansueti (active 1485–1526/7), for
the Scuola Grande di S. Giovanni Evangelista
(fig. 2), a lay religious confraternity dedicated
to St John the Evangelist founded in 1261.
The canvas is from a cycle recording miracles

Fig. 1
Jacopo de' Barbari, *View of Venice* (detail), 1500.
Woodcut, 134 × 281 cm (overall). British Museum,
London.

associated with the Scuola's most sacred
possession, a relic of the True Cross mounted
in a processional cross. The painting records
a funeral of a Scuola member, whose doubts
about the relic resulted in it becoming so heavy
on the bridge leading to San Lio that it had to be
taken off and replaced by an ordinary crucifix.

The right-hand section of both works is
similar, yet the differences in viewpoint and
detail make it hard to credit that Mansueti could
have relied solely on the drawing. Equally, the
Uffizi sheet cannot be a study for the painting
since the funeral and the True Cross are not
represented, and another key element in the
story, the bridge, barely features. The position-
ing of the figures in space measurable by
the tiled pavement and the general command
of recession, revealed in deft touches like the
sunlit walls in the centre that pull the eye
backwards, are much more sophisticated
than Mansueti's habitually tightly packed and
detailed compositions. The Uffizi sheet seems
more likely to be the work of his master
Gentile Bellini, whose three works for the
same cycle, all now in the Accademia, share
with the drawing a comparable level of
compositional and spatial discipline.[3]

The topographical accuracy of Gentile's
representations of Venice in his canvases for
the Scuola Grande di S. Giovanni Evangelista
were presumably based on his making detailed
studies of the settings, yet none survive. The
Uffizi drawing appears to lack any definable
narrative: varied groups of figures converse in
the foreground, among them nobles and
citizens in long gowns; bearded Byzantines in
brimmed hats; and turbaned Middle Eastern-
ers, while in the background members of a
Scuola walk across the square. The latter are
not in procession as the candle-holders are
empty and they appear to be waiting for one of
their members to bring out a crucifix from the
church to proceed. The observation of everyday
detail of Venice and its citizens typically found
in Gentile's paintings, which adds an air of
reported truth to the miraculous events they
depict, thus takes centre stage.

The present work is the earliest surviving
topographical drawing of Venice, although
Gentile cannot be claimed as the originator of
the genre as his father Jacopo is known to have
drawn a now lost view of the city.[4] The scale
of the image with no visible underdrawing
suggests it was made as a finished work in its
own right, but why this particular square was
chosen is unknown. The attribution to Gentile
remains a tentative one since the dry precision
of the penwork, perhaps stemming from
it being a careful copy from earlier drawn
prototypes, is not readily comparable with the
more refined costume drawings (nos 17–18)
or the two much sketchier compositional
studies by his hand (see fig. 35 on p. 56).[5]
However, differences in scale, function and
date could plausibly explain this stylistic
diversity. Gentile's topographical abilities
in paint and on paper, the latter demonstrated
by Francesco II Gonzaga, Marquis of Mantua,
commissioning him in the 1490s to supply
drawings of various cities (Venice, Genoa and
Cairo) for murals in his villa at Gonzaga, makes
him the most plausible candidate to have
executed the present work.[6] HC

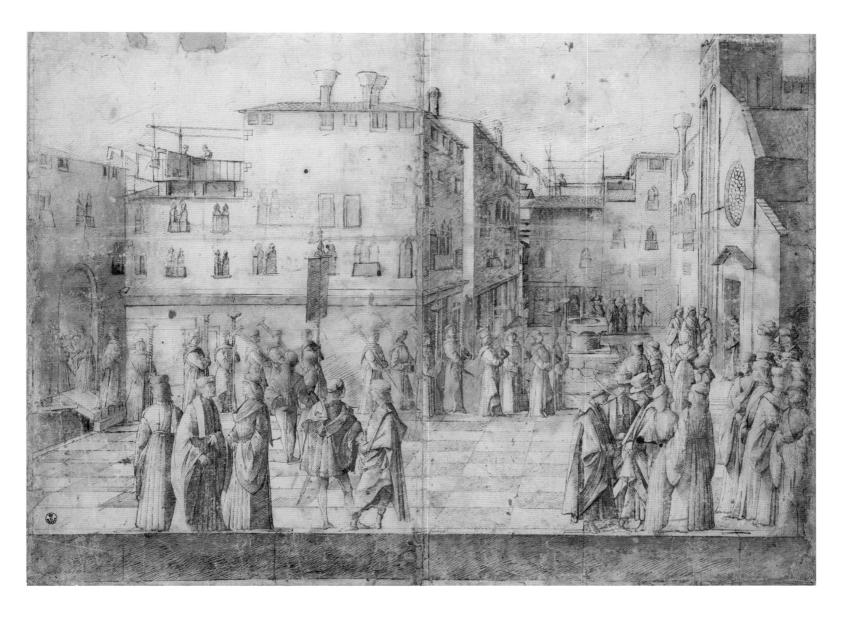

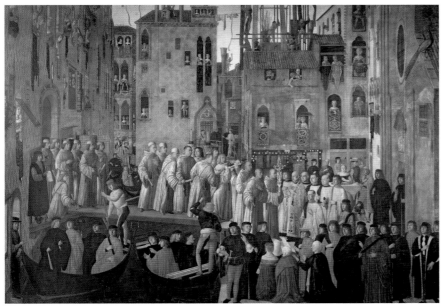

Fig. 2
Giovanni Mansueti, *Miracle at the Bridge of San Lio*, 1494. Oil on canvas, 318 × 458 cm. Galleria dell'Accademia, Venice.

20 St James on his way to execution

c. 1454–6

Pen and brown ink, the roundel study in black chalk over incised compass lines, 16.4 × 25.6 cm
Inscribed in an old hand, upper left corner (almost invisible and only legible in an infrared
reflectograph): 'Mantenga [sic] is wrote [sic] on the back'
British Museum, London (1976,0616.1)

PROVENANCE

Earl Spencer (L. 1530); W.Y. Ottley; Sir T. Lawrence
(L. 2445); J. Malcolm; A.E. Gathorne-Hardy; acquired from
the Gathorne-Hardy collection in lieu of estate duty,
1976, with a contribution from the bequest of Richard
William Tuck

LITERATURE

Kristeller 1901, pp. 101–102; Lightbown 1986, p. 48,
no. 176; Ekserdjian in London and New York 1992, no. 11;
De Nicolò Salmazo 1993, pp. 80–82; Chapman in London
1998a, no. 7; Lincoln 2000, pp. 33–4; De Nicolò Salmazo
2004, pp. 125–6; Santucci 2004, pp. 64–5; Saccomani in
Padua 2006, no. 29a; Van Cleave 2007, p. 56

This the only known study for the frescoes
dedicated to the lives of St James and
St Christopher in the Ovetari Chapel in the
church of the Eremitani in Padua, completed
in February 1457. The chapel was hit by a
bomb in 1944, and all that survives are the
badly damaged scenes of the *Assumption of
the Virgin*, the *Martyrdom of St Christopher* and
St Christopher's decapitated body carried to burial.
Although the English connoisseur W.Y. Ottley
(1771–1836) had recognized this link, the
drawing was not published as by Mantegna
until 1901. Mantegna frescoed St James on the
way to execution after the violent death of the
painter and sculptor Nicolò Pizzolo (?1421–
53), to whom the fresco had originally been
assigned.

The thematic fulcrum of the composition
is to the left, where the standing St James
witnesses the conversion of the scribe Josiah,
prostrate before him, while to the saint's
left stands a man miraculously cured of his
paralysis.[1] The basic composition of the
figures is reflected in the fresco, yet there are
also significant differences: in the drawing the
architectural backdrop is barely described,
the angle of vision is less steeply from below
and the cured man, absent in the fresco, is
placed between St James and the soldier.[2]

The sheet is a touchstone for the re-
construction of Mantegna's use of pen and
ink. The earlier attribution of the sheet to
Mantegna's brother-in-law, Giovanni Bellini,[3]

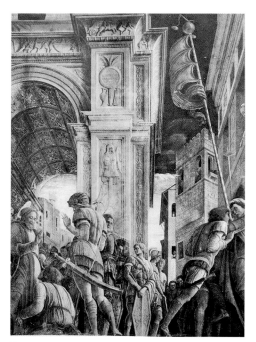

Fig. 1
Andrea Mantegna, *St James on his way to execution*,
c. 1453. Fresco, formerly Ovetari Chapel,
Eremitani Church, Padua.

is unsustainable on account of both the style
and the clear connection between drawing and
fresco. The sheet has been associated with
Donatello's graphic style and in the Gathorne-
Hardy collection it was attributed to Donatello
himself,[4] but the connection is unproven given
the lack of drawings securely attributed to the
Florentine sculptor.[5] Nevertheless, Donatello's
sculpture was a fundamental influence on
Mantegna, inspiring a graphic language that
recalled the restrained three-dimensionality
(*stiacciato*) of the sculptor's bas-reliefs.[6]

The artist has employed lines of pure
contour and hatching, whose predominantly
diagonal strokes vary in length and direction
from long and vertical parallel strokes (seen
especially in St James's tunic) to a passage with
hatching drawn as if the artist were left-
handed, running from left to right, seen in the
leg of the soldier in the centre. The contours of

the figures are reinforced, yet interrupted and
on occasion overlapped, by the parallel hatching.
Passages of cross-hatching are almost completely
absent. Mantegna was both an engraver and
a painter and was thus interested in northern
European prints, especially those by the
German printmakers 'Master of the Playing
Cards' and Master ES, both of whom worked
in the Upper Rhine and in whose works
shadow is conveyed with parallel hatching;
such techniques may have influenced
Mantegna's handling of the pen.[7]

This drawing displays a vast range of marks
and lines that are also seen in Mantegna's later
drawings, although rarely as complete, they
too show an almost complete lack of cross-
hatching. This is seen, for example, in the *Two
studies for Christ at the column* in the Courtauld
Institute of Art;[8] *Three studies for St John the
Baptist* in the Walker Art Gallery, Liverpool;[9]
the *Deposition* in the Pinacoteca Tosio-
Martinengo, Brescia;[10] and in the *Three saints*
in the Pierpont Morgan Library, New York.[11]
In contrast two sheets in the British Museum
display hatching that is crossed in places: *Three
studies of a reclining figure* (see fig. 43, p. 62) and a
Standing saint.[12] The latter drawing in particular
reveals Mantegna's interest in conveying volume
and desire to emulate sculpture. This is also
seen in the saint and central soldier in this sheet,
although the figure to the far right, who is nude
in accordance with Alberti's precepts in *Della
pittura*, is drawn in rapid parallel strokes that
give a two-dimensional effect.

Mantegna displays a graphic language in
this drawing that would come to characterize
the style of Florentine engraving, later to be
described as the 'Broad Manner'. Its principal
exponent was Francesco Rosselli (1448–
c. 1513),[13] who consistently employed parallel
hatching in broad strokes. This style is in
contrast to the finer strokes, both parallel
and crossed, used by such engravers as Baccio
Baldini (?1436–87) and the Master of the
Vienna Passion.[14] This style was subsequently
known as the 'Fine Manner'. Mantegna's
drawings of this period were to serve as

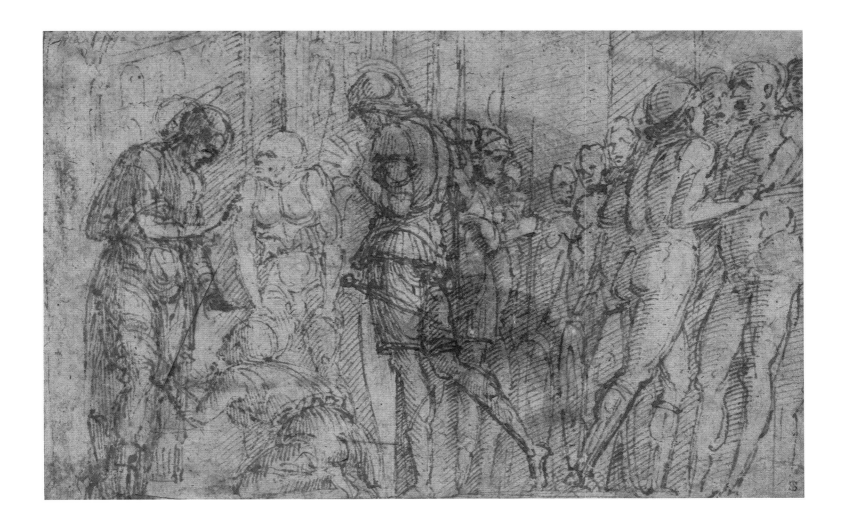

models for Rosselli in the last two decades of the fifteenth century.

Visible in the centre of the sheet beneath the pen lines is a chalk drawing of a male bust-length figure in a roundel (fig. 2). It was drawn first on the sheet, and was perhaps intended as a decorative element for the background architecture.[15] The evolution of Mantegna's graphic style, with ever more subtle and thin strokes conveying delicate passages of chiaroscuro, is well displayed in two other exhibited sheets (nos 21, 23). MF

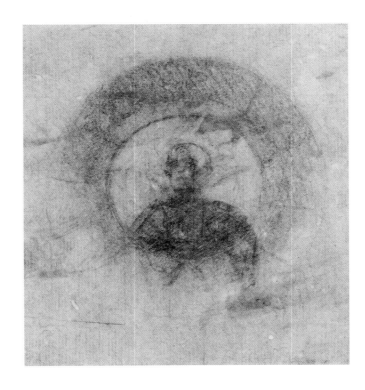

Fig. 2
Infrared reflectograph of no. 20 showing a black chalk head in roundel.

21 Man lying on a stone slab

c. 1475–85

Black chalk or charcoal, pen and brown ink, over incised
ruled lines for sides of the slab, 20.3 × 13.9 cm
British Museum, London (1860,0616.63)

PROVENANCE

W.Y. Ottley; Sir T. Lawrence (L. 2445); S. Woodburn;
acquired at Christie's 1860 sale of Lawrence-Woodburn
collection for £21

LITERATURE

Kristeller 1901, p. 405 and no. 8; Popham and Pouncey
1950, no. 155; Tietze and Tietze-Conrat 1955, p. 205;
Byam Shaw 1978, no. 36; Lightbown 1986, no. 185;
Ekserdjian in London and New York 1992, no. 43;
Christiansen 1993, p. 608; Fletcher 2001, pp. 34–6, 38–9;
De Nicolò Salmazo 2004, p. 194, no. 13; Van Cleave 2007,
p. 56; Thiébaut in Paris 2008, under no. 84

Mantegna's drawings of the late 1470s and
1480s have finer, more closely drawn lines in
comparison with his earlier *St James on his way
to execution* (no. 20). Cross-hatching is also
absent in these mature drawings, which recall
the highly finished appearance of *niello* plates,
small-scale compositions engraved on metal
plates in which the incised lines were filled
with a black substance, with their firmly
defined outlines giving an effect of relief.[1]

The present drawing and *Virgin and Child
enthroned with an angel* (no. 23) are fine examples
of Mantegna's late style, on which the influence
of engraving has been repeatedly stressed.
Equally significant is a third drawing in Munich,
The Risen Christ between Sts Andrew and Longinus
(fig. 1), a study for an engraving with the same
orientation.[2] Some art historians have identified
the theoretical influence of Alberti in the dark
contours that partially outline the figures in
these drawings.[3] Alberti describes in his treatise
Della pittura the three attributes of painting
('circumscription', 'composition' and 'reception
of light'). Alberti's definition of the first attribute
seems particularly relevant to Mantegna's use of
attenuated line and clear contour:

> Circumscription is the process of delineating
> the external outlines on the painting. They
> say that Parrhasius the painter, with whom
> Socrates speaks in Xenophon, was very
> expert in this and studied these lines very
> closely. I believe one should take care that
> circumscription is done with the finest

possible, almost invisible lines, like those
they say the painter Apelles used to practise
and vie with Protogenes at drawing.
Circumscription is simply the recording
of the outlines, and if it is done with a very
visible line, they will look in the painting,
not like the margins of surfaces, but like
cracks. I want only the external outlines
to be set down in circumscription and
this should be practised assiduously. No
composition and no reception of light
will be praised without the presence of
circumscription. But circumscription by
itself is very often most pleasing.[4]

For many years it was believed that the
present drawing was either a preparatory study
or a variant of the painting of the *Dead Christ* in
the Brera, Milan. Alberta De Nicolò Salmazo
(2004) has also recently suggested that it may
belong to a later stage in the compositional
study for the painting.[5] This last consideration
would help to explain the viewpoint used in
the drawing, which concentrates less on the
dramatically foreshortened figure. However,
any possible connection is disproved by the
pose, which shows that the man is still alive,
and by the absence of the stigmata, which are
clearly visible in the Brera painting. A more
convincing explanation is the identification of
the scene with the Gospel account of the raising
of a widow's son in Naim (Luke 7:11–17), as
proposed by Lightbown (1986), who also
suggested the raising of Lazarus as a more
probable alternative subject, although this
last suggestion is unlikely since the figure is
not completely enveloped by the shroud. On
the other hand, one possibility that cannot
be completely excluded is that the sheet is
an academic study from life, as proposed by
David Ekserdjian, although the naturalism is
mediated by reference to antique statuary
(generally identified as a Roman sculpture
of the *Dying Gaul* type).[6] Despite the antique
prototypes, Mantegna has here produced a
highly original motif, perhaps intended as
a detail for a larger composition.

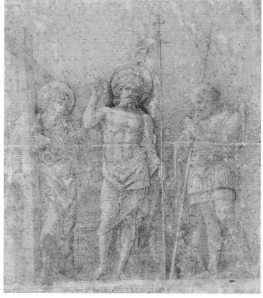

Fig. 1
Andrea Mantegna, *The Resurrected Christ between
St Andrew and St Longinus*, 1470s. Pen and brown ink,
brown wash, 35 × 28.5 cm. Staatliche Graphische
Sammlung, Munich.

Whatever its function, in this drawing
Mantegna combines the essential elements of
his style – his predilection for antique statuary
and compositions in perspective – with a study
of drapery that contributes to the sense of the
figure's volume. MF

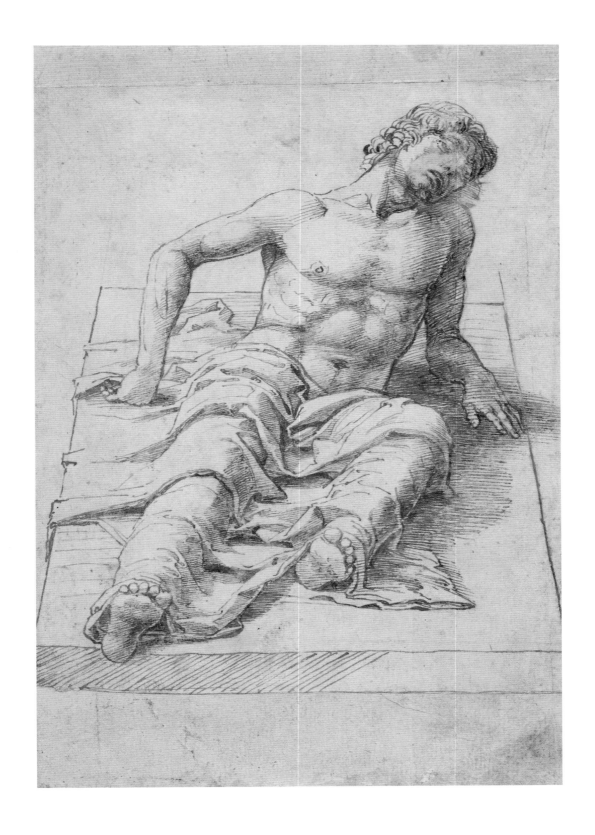

22 Allegory of the Fall of Ignorant Humanity ('*Virtus Combusta*')

c. 1490–1506

Leadpoint (?), pen and brown ink, coloured wash, heightened with lead white,
with a black over red (vermilion) background, on paper with a light brown wash,
28.6 × 44.1 cm (including a strip, about 1.3 cm wide, added or reattached to the lower edge)
Inscription: 'VIRTVS COMBVSTA'; and signed (?) 'AM' in monogram
British Museum, London (Pp, 1. 23)

PROVENANCE

Casa Giovanelli, Venice; J. Strange; C. M. Metz; Richard
Payne Knight Bequest, 1824

LITERATURE

Kristeller 1901, no. 6; Popham and Pouncey 1950, no. 157;
Ekserdjian and Landau in London and New York 1992,
no. 147; De Nicolò Salmazo 2004, p. 194, no. 20;
Tanimoto *et al.* 2009, pp. 35–40

This refined and technically elaborate drawing for presentation to a patron has an erudite subject. It belongs to a group of drawings executed from 1490 onwards that recall the iconography and style of Mantegna's paintings for Isabella d'Este's *Studiolo* in the Mantuan ducal palace. The composition is close to the painting of *Pallas expelling the Vices from the Grove of Virtue* and the drawing of the *Calumny of Apelles* (fig. 36, p. 58).[1]

The subject is a moral allegory, the meaning of which has evoked much debate: the fascination lies in the multiple possible identities of the characters represented.[2] To the right the fat and unlovely figure of Ignorance sits regally on a globe supported by three sphinxes. In her left hand she holds a rudder, an attribute, together with the globe, which she shares with Fortune. Ignorance is flanked by two women,

one emaciated and old, the other young and blindfolded, Avarice and Ingratitude respectively. To the left a satyr representing Lust plays a hornpipe opposite ass-eared Error (sometimes identified as Folly), who leads a blind woman to the edge of a precipice. Behind the blind woman is a man with his head tied in a sack and a dog on a lead, perhaps Deceit. To the extreme right are laurel branches on fire representing Virtue squandered under the reign of Ignorance, referred to in the inscription below, '*Virtus Combusta*' (Virtue in flames).

It has been suggested that the composition was intended to include a lower half, the composition of which is recorded in the engraving by Giovanni Antonio da Brescia (active 1505–25, fig. 2), who also engraved the upper half of the composition represented in the present drawing (fig. 1).[3] The lower half shows a pile of fallen human bodies, one of which is being rescued by Mercury, the god of knowledge, while to the far left the woman depicted mutating into a tree is identified as '*Virtus Deserta*' (Deserted Virtue). One of the blocks below her bears the inscription '*Virtutis. A.I.*', standing for '*Virtuti semper adversatur Ignorantia*' (Ignorance is always opposed to Virtue). This expression is found in two letters from Mantegna to his patron

Francesco II Gonzaga dated 31 January 1489 and 28 November 1491.[4]

The engravings are best understood as distinct works intended to be seen together and sharing iconography and meanings. Close observation shows substantial differences in the handling of the engraver's tool between the two engravings. This suggests that *Virtus Combusta* is based on a pen drawing in the fine and vibrant manner of Mantegna's maturity (as seen in the *Calumny of Apelles* mentioned earlier) while the *Virtus Deserta* is derived from a now lost monochrome drawing, similar to no. 22, in which the engraver evoked comparable tonal and pictorial effects.[5]

Mantegna's original pairing may have represented the antagonism between Virtue in the form of Mercury (the inventor of the arts and god of knowledge, logic and eloquence) and Ignorance, or that between Virtue and Fortune, or between Mercury and the conflated figures of Ignorance and Fortune. Another hypothetical subject would be a dispute between Lust and Chastity. In Alberti's *Virtus*, a dialogue falsely considered to be a Latin translation of the Greek writer Lucian, Virtue chose to be transformed into a tree rather than undergo the incessant assaults of Fortune, paralleling Daphne's metamorphosis in flight from Apollo.

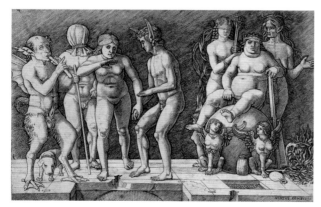

Fig. 1
Giovanni Antonio da Brescia after Mantegna,
Virtus Combusta, *c.* 1500–5. Engraving, 27.9 × 42.4 cm.
British Museum, London.

Fig. 2
Giovanni Antonio da Brescia after Mantegna,
Virtus Deserta, *c.* 1500–5. Engraving, 30 × 43.3 cm.
British Museum, London.

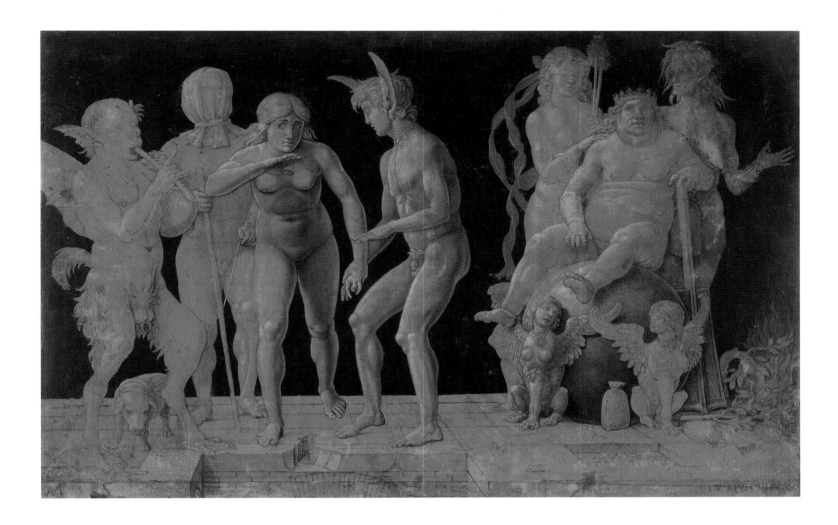

Mantegna would appear to have arrived at his unique subject by fusing parts of Alberti's *Virtus* with those of Lucian's *De Calumnia* or *Slander*.

The Venetian physician Michelangelo Biondo wrote in his *Della nobilissima pittura* (1549) of having seen a work by Mantegna in Mantua, that is sometimes identified as this drawing, but this is mistaken.[6] Nor, despite appearances, is this a preparatory drawing for a grisaille (a monochromatic grey painting) or for an engraving (despite da Brescia's engraved version).[7] It is, rather, an autonomous drawing whose technical experimentation and chromatic sensibility are consistent with Mantegna's late style.[8]

This elaborate mix of media and techniques displays Mantegna's late taste for grisaille figures painted as if in marble or bronze relief (a significant example of which is the *Introduction of the cult of Cybele in Rome* in the National Gallery, London), with a brilliant rendering of the obscurity induced by the ignorance of which Lucian speaks at the beginning of *De Calumnia*: '…we walk as if in a dark room, or rather, we are all blind …and in all actions we are on the point of falling.'[9]

The black background against which the figures stand out would seem to allude to Alberti's recommendations in his treatise *Della pittura* on the use of black and white.[10] Mantegna's monochrome paintings and drawings such as this one demonstrate the primary concept of artifice (*simulazione*) upon which his visual investigations of the world are based.[11] MF

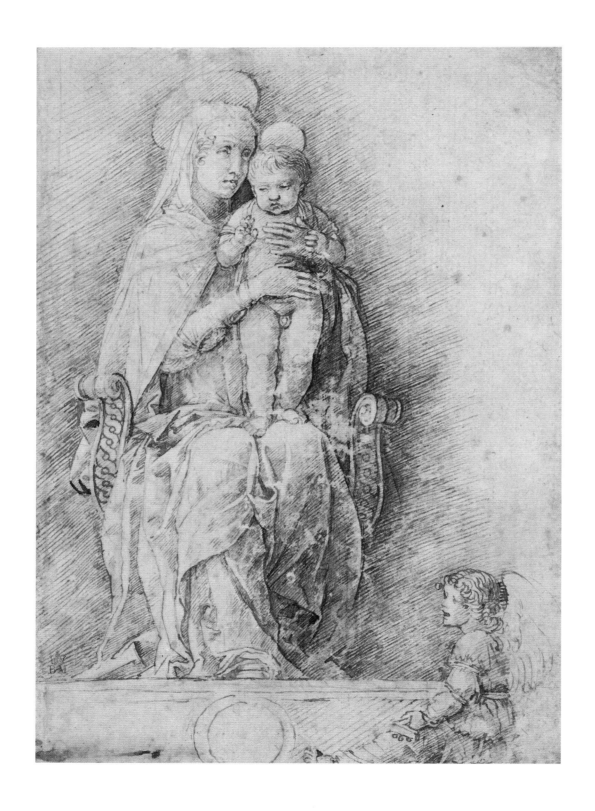

23 Virgin and Child enthroned with an angel

c. 1480–90

Black chalk, pen and brown ink, brown wash, 19.6 × 13.9 cm
British Museum, London (1858, 0724.3)

PROVENANCE

Count N. Barck (L. 1959); acquired from W.B. Tiffin, 1858

LITERATURE

Kristeller 1901, pp. 404–5, no. 3; Popham and Pouncey 1950, no. 159; Lightbown 1986, no. 190; Ekserdjian in London and New York 1992, no. 49; De Nicolò Salmazo 2004, no. 15; Van Cleave 2007, p. 56; Thiébaut in Paris 2008, pp. 212–13

Mantegna's late drawings such as this create an effect of relief through delicate gradations of chiaroscuro, employing ever more attenuated strokes of the pen against a shaded background that projects the figures from the picture surface in a similar manner to *niello* plates.

Like *Man lying on a stone slab* (no. 21), this drawing displays a subtle luminosity in which the aggregation of dark contours appears to be the artist's response to Alberti's definition of 'circumscription' in his *Della pittura* (see no. 21).[1] The influence of engraving is also evident: in the 1480s Mantegna created what was to be considered his graphic masterpiece, the engraving of the Virgin and Child in which the

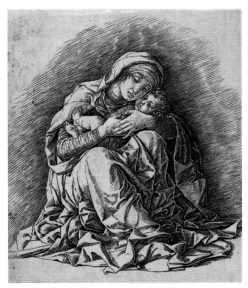

Fig. 1
Andrea Mantegna, *Virgin and Child*, *c.* 1480–90.
Engraving, 24.7 × 21 cm. British Museum, London.

artist attained a new luminosity, and the cross-fertilization between drawing and engraving reaches full expression (fig. 1).[2] The closeness of this engraving to the drawing poses the question of whether the drawing might not be a preliminary idea for an engraving, with the plinth and the sitting angel on the right remaining incomplete. However, scientific investigations conducted in preparation for this exhibition have revealed a black chalk underdrawing, including a cloth of honour behind the Virgin and the heads of two cherubs decorating the rear part of the throne (fig. 2).

Most scholars link the drawing to a painting. Lightbown thought it was a first idea for the *Madonna of Victory* in the Louvre; Ekserdjian suggested it might be the central panel of a triptych, probably never completed and De Nicolò Salmazo proposed a fresco of a *sacra conversazione* for one of the walls of Pope Innocent VIII's lost chapel in the Belvedere of the Vatican Palace. De Nicolò Salmazo also considered that the elegant composition and stylization of the Virgin's drapery accord in style with the paintings *The Virgin and Child* in the Uffizi and the *Pietà* in Copenhagen.

Without ever employing cross-hatching, Mantegna achieves in his last drawings a chiaroscuro of great delicacy, using frequent and delicate strokes, which take on the appearance of both the 'Fine' and 'Broad Manner' (the classification favoured by some scholars of Florentine engraving of the end of the fifteenth century based on the hatching and quality of the line), reclaiming the delicate tonal contrasts of early Northern European engraving.

Mantegna's synthesis of engraving techniques in his draughtsmanship was original and ahead of its time. In the *Speculum lapidum* written by the Pesaro-born doctor and astrologer, Camillo Lunardi, published in Venice in 1502 with a dedication to Cesare Borgia, Mantegna is praised for his naturalism and described as the one 'who has opened up for posterity the rules of painting'.[3]

Lunardi's words are illuminated if we compare them with the well-known passage in

Fig. 2
Infrared reflectograph of no. 23 showing black chalk underdrawing.

Joachim Camerarius's biography of Dürer published as a preface to *De symmetria* in Nuremberg in 1532, which mentions Dürer's interest in Mantegna and the German artist's sorrow at learning of Mantegna's death before he could visit Mantua.[4] Camerarius lauds Mantegna's study of antiquity (as had Ulisse degli Aleotti in his much earlier poem of *c.* 1448–9),[5] yet considers Mantegna's art to have a certain rigidity caused by a hand 'unused to following the intellect and swiftness of the soul'.[6] Camerarius recounts that it was precisely Mantegna's admiration of Dürer's 'facility and steadiness of hand in the knowledge of reality and art' that encouraged Mantegna to ask the younger German artist to visit him.[7]

Mantegna's severely linear style in pen and ink combined with his rigorous handling (reflecting Lunardi's 'rules and methods of painting') is a consequence of great diligence: 'I am a painter who pays close attention to the most insignificant line.'[8] MF

24 Virgin and Child with saints

c. 1460

Pen and two shades of brown ink, two shades of brown wash,[1] 14.8 × 21.2 cm
Inscribed: '*horo*' (eight times); '*ho*' (twice)
British Museum, London (1885,0509.1613)

PROVENANCE

J. Richardson sen. (L. 2184): acquired from A. Grahl
(L. 1199) for £76, 1885

LITERATURE

Parker 1927, no. 21; Popham and Pouncey 1950, no. 256;
Ruhmer 1958, pp. 37–8, no. 44, pp. 174–5; Ferretti in Milan
1991, no. 84; Campbell 1997, pp. 63, 79, 97; Toffanello
1997, pp. 17–19; Chapman in London 1998a, no. 13;
Molteni 1999, pp. 195–6; Manca 2000, no. 14; Campbell
in Boston 2002, no. 1

Only a bare handful of drawings survive by Cosmè Tura, painter to the Este court in Ferrara from the late 1450s to the mid-1480s, and the attribution of this sheet is thus based on the links of style and subject with Tura's paintings.[2]

The drawing has the symmetry required of a devotional design. In the centre are the Virgin and Child within a throne decorated with dolphin-shaped arms and an open scallop

Fig. 1
Detail of St Sebastian with arrows
in flight.

shell (the lower half larger than the upper one) supporting a cherub. This inventive decoration recalls Tura's panel of an enthroned muse in the National Gallery, London of 1455–60, and suggests that the drawing is also dated to early in Tura's career.[3] Flanking the throne to the left is St Francis who bears the wound in imitation of Christ's passion; to the right is St Dominic who holds his hands together in prayer (the abraded surface makes this difficult to discern). In contrast to the monastic founders are the bound and stripped bodies of the martyrs St Sebastian and St Agatha to the far left and right respectively. St Sebastian's body is riddled with arrows, several still in flight (fig. 1), and is drawn to a slightly larger scale than the other saints.[4] St Agatha's gruesome martyrdom is evoked by the pincer attached to her left breast, her gaze cast heavenwards. The contours of her right side (our left) display the only significant alterations in the drawing. The saints are placed within a loggia beyond which landscapes are glimpsed to the far sides. The architraves in the upper corners were no doubt intended to match a frame to heighten the illusion of real space, as in Mantegna's S. Zeno altarpiece in Verona of 1456–9.[5]

Tura drew directly in pen and ink, employing clear contours and precise diagonal hatching. Wash was added last, to convey the fall of light from the right, visible in the mullions of the panelling. The drawing gives no indication of scale but may have been intended for a small, perhaps portable, devotional work given the horizontal format of the composition and the relatively low position of the Virgin and Child (a larger work would have permitted greater elevation for the Virgin).[6] The intended support of the painting is demonstrated by the word '*horo*' (gold) written in each of the backdrop panels, since gold was applied over a layer

of bole (red clay tinted with iron oxide, commonly mixed with size and used as a base for gilding on panel paintings during that period) on a gesso panel. Tura would not have needed to indicate the use of gold for himself and this, combined with the clarity of the composition, suggests the drawing is a prospective design for a patron based on a previous study, a very early example of such a drawing (see no. 66).[7] The drawing may also have had a contractual function by which Tura committed himself to this design and the use of the costly gold.[8]

The recent conservation of the sheet provides evidence to support this view. It has long been clear that the drawing had been folded horizontally (the cause of the damage to Christ's face), but the lifted verso reveals that the sheet had in fact been symmetrically folded five times to create a small envelope (5.5 × 7.4 cm) containing the drawing on the inside (fig. 2). Six of the rectangles formed by the folding have a puncture mark that corresponds to the drawing having been pinned once folded, possibly to attach it to a contract or letter.[9] Tura's drawing is rare graphic evidence of the dialogue between patron and painter; it is not known whether the design was turned into a painting.[10] DG

Fig. 2
Verso of no. 24 shown in raking light, displaying the creases caused by the folding of the sheet.

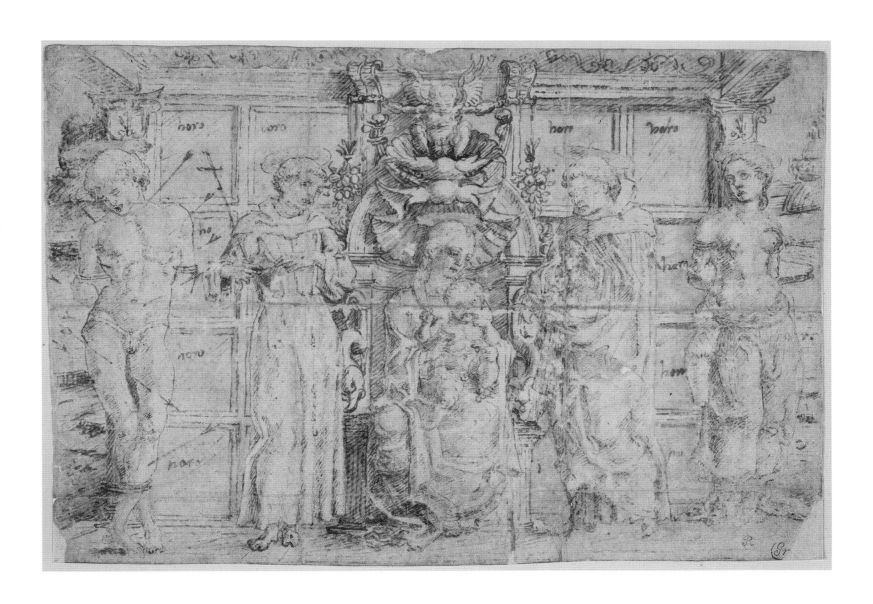

25 A young man, bust-length and facing to the left; and three putti and a dog with four figures behind: from the *Rosebery album* of 26 folios

c. 1455–65

Pen and brown ink, brown wash on the right-hand compositional drawing, on vellum,
21.8 × 15.8 cm, each page
The right-hand page inscribed by the artist: 'MIII' and later numbered upper right '23'
British Museum, London (1920,0214.1 17 verso and 18 recto)

PROVENANCE

Matteo Macigni; Giambattista de Rubeis; Pietro Antonio Novelli; S. Woodburn; Alexander Barker; Baron Mayer de Rothschild; presented to the British Museum in 1920 by Archibald Philip Primrose, 5th Earl of Rosebery and 1st Earl of Midlothian

LITERATURE

Dodgson 1923; Popham and Pouncey 1950, no. 260; Ruhmer 1966, pp. 77–81; Armstrong 1976, pp. 228–319, 417–23; id. 1993, pp. 79–95; Elen 1995, no. 29; Chapman in London 1998a, no. 15

History

The album takes its name from its donor to the Museum in 1920, Lord Rosebery (1847–1929), the former prime minister who had inherited it from his wife, Hannah de Rothschild. It had been acquired as Andrea Mantegna from the posthumous auction in 1854 of the dealer Samuel Woodburn's stock by Alexander Barker, a notable mid-nineteenth-century collector of furniture, ceramics and Old Master paintings, including Piero della Francesca's *Nativity* (National Gallery, London).[1] Before Woodburn it belonged to the Venetian artist, Pietro Antonio Novelli (1729–1804), whose son Francesco engraved its contents as *Disegni del Mantegna*, in 1795.[2] Prior to its arrival in England the album was rebound and the pages mounted on dull, blue-surfaced paper with gilt edges.

Zoppo's patron is unknown, but he may well have had links with Padua, the university

city where the artist was trained before his departure to live in Venice in 1455, as the album was found there by the writer and artist Giovanni Battista de Rubeis (1750–1819). Before that it belonged to Matteo Macigni, an academic who is known to have died in Padua in 1582; his inscription on fol. 26 verso (originally fol. 1), '*Questo libro fié de mi mattio macigni fio de mr ruberto macigni*' (fig. 1), records that he inherited it from his father, Ruberto, a Florentine nobleman who became a Venetian citizen in 1500.[3] Zoppo's drawings are datable on stylistic grounds to relatively early in his career, around 1455–65, and not enough is known about Ruberto, described by the nineteenth-century antiquarian Giuseppe Campori as a '*gran letterarato*', to know the circles he inhabited in Padua or Venice in which he might have encountered the volume's patron.[4]

Contents

The album consists of 26 leaves, of which 24 are drawn on both sides and two are blank on one side, making a total of 50 drawings. They are executed in pen and brown ink, some with broadly applied areas of brown wash and, in one example, the *Virgin and Child*, blue wash (fol. 2; fig. 2 overleaf). The album in its present state does not follow the alternation of flesh-side openings with hair-side openings (the so-called Gregory's Rule), but it would do so

if the drawings were put back according to the old, and possibly original, numbering in Arabic numerals inscribed in the upper-right corner of most of the drawings. Combined with the stylistic unity of the drawings this shows that the studies were made specifically to be bound in an album. The numbering gives no reason to suppose that the album is not complete, although as will be discussed below there may originally have been more drawings.[5]

The drawings can be divided into two types, with figurative compositions on the rectos and the studies of bust-length figures on the versos, all but two of them male, which give the album a visual coherence (figs 16, 32–3 on pp. 35, 51).[6] The drawings on the rectos can also be subdivided by subject. The largest group is the ten drawings of putti or children (for example fol. 18). There are eight drawings of figures in conversation (such as fol. 10 illustrated as fig. 31 on p. 51). Five of the remaining nine studies are of classical subjects, three of which can be identified, such as the suicide in his bath of the Roman philosopher Seneca before Nero (fol. 23; fig. 4 overleaf).[7] Two drawings of classical themes, wrestling men and fighting centaurs (fols 20, 24), elude precise identification, and the same is true of two scenes with figures in contemporary costume, including one of a huntsmen encountering three naked women bathing in a woodland pool (fols 22, 26). The idea that the drawings illustrate a single lost text seems untenable in view of the variety of subjects.[8]

Fig. 1
Detail of fol. 26 verso showing Matteo Macigni's inscription.

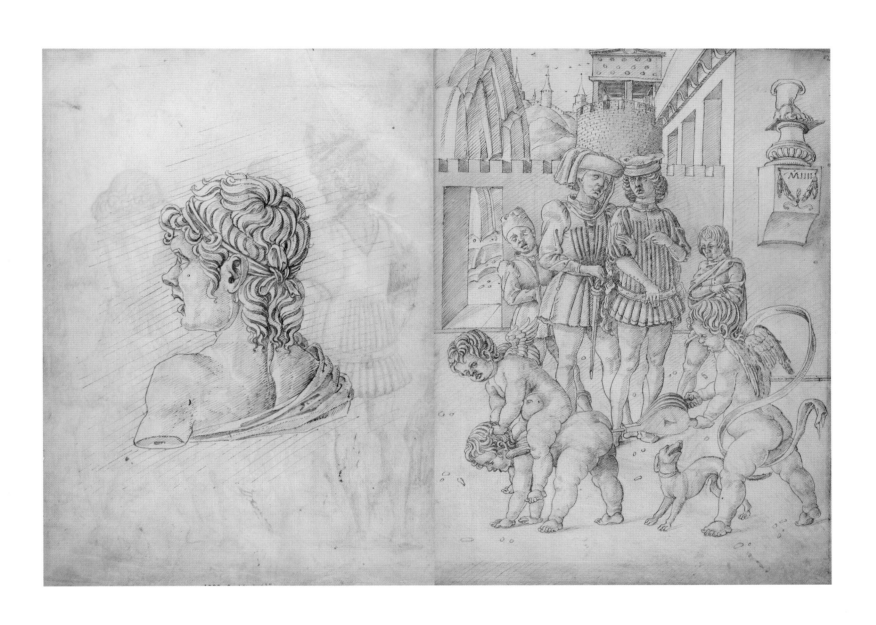

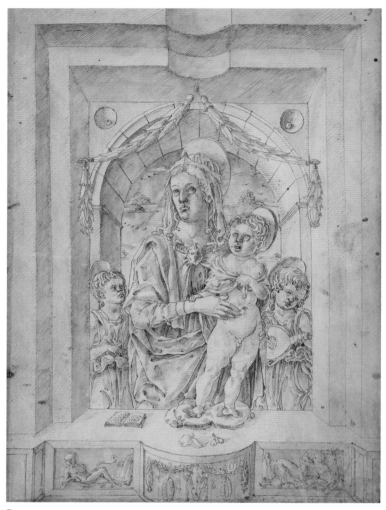

Fig. 2
Marco Zoppo, *Virgin and Child* (from the *Rosebery album*; fol. 2).
Pen and brown ink, brown and blue wash, on vellum, 21.8 × 15.8 cm.
British Museum, London.

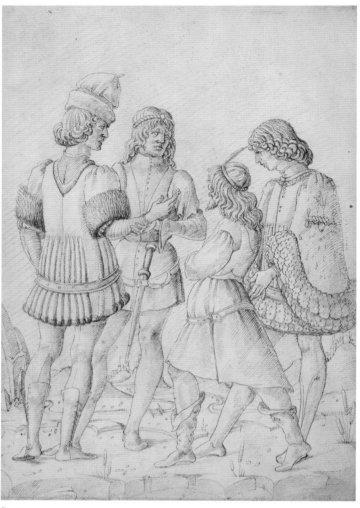

Fig. 3
Marco Zoppo, *Four men* (from the *Rosebery album*; fol. 17).
Pen and brown ink, on vellum, 21.8 × 15.8 cm. British Museum,
London.

Function

The *Rosebery album* was clearly made as an independent work of art, its high level of finish comparable to that of the slightly later album of drawings showing the history of mankind, the so-called *Florentine Picture Chronicle* (no. 34). It differs from the Florentine work in being the work of a single hand and in not having a single narrative thread. The manner in which the album showcases Zoppo's gift for invention, an aspect perhaps most clearly demonstrated in the array of fantastic headgear sported by the figures on the left-hand pages, is similar to Jacopo Bellini's contemporaneous volume of drawings (no. 16). The contents of Bellini's album often seem to invite the viewer to invent a story to explain what is happening in the drawing, and a similar open-ended approach to narrative is also present in some of Zoppo's scenes on the right-hand pages, such

as in fol. 17 (fig. 3), where the older man's arm on the left is held by a younger companion as he addresses a courtier wearing a garment like the one shown in the Pisanello study (no. 8).[9] The drawing is just one instance where the actions of the male figures seem to denote a physical or emotional intimacy, most clearly expressed in the opening on display (fol. 18 illustrated on p. 147), where the putti in the foreground are watched by an arm-in-arm couple, the one on the left pointing down to his companion's phallic dagger. This strongly suggests that Zoppo's album was, unlike the *Chronicle* or Bellini's volume, designed to appeal to a particular patron.

Aside from the homosexual allusions the drawings also seem designed to amuse a classically educated viewer who would pick up Zoppo's playful references to antiquity, such

as the enormous foot on a pedestal in the background of fol. 18 or the inclusion of a drilled hole for a wooden joint as in an antique marble in the upper arm of the youth on the opposite page. An idea of the circulation of the album amongst a sophisticated elite can be ascertained from the hitherto unobserved relationship between Zoppo's Seneca drawing and one of three monochrome roundels of classical subjects painted in fresco in the late 1490s by the Milanese artist Cesare Cesariano (1476/8–1543), in the fictive framework around the *Baptism of Christ* in the Baptistery of Reggio Emilia (figs 4–5).[10] Stylistically the other two roundels, a scene of clemency with a classical king freeing a vanquished enemy and Marcus Curtius riding his horse into a chasm, could also be based on Zoppo, which would signify that the *Rosebery album* once contained more

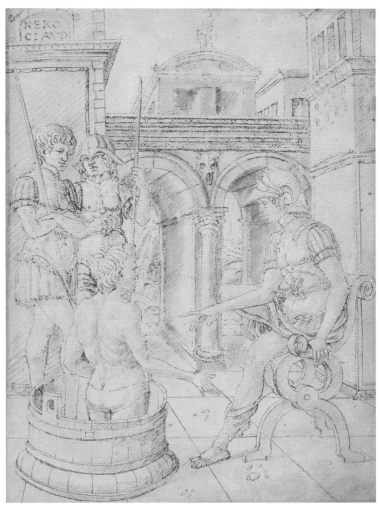

Fig. 4
Marco Zoppo, *Death of Seneca* (from the *Rosebery Album*; fol. 23).
Pen and brown ink, on vellum, 21.8 × 15.8 cm. British Museum, London.

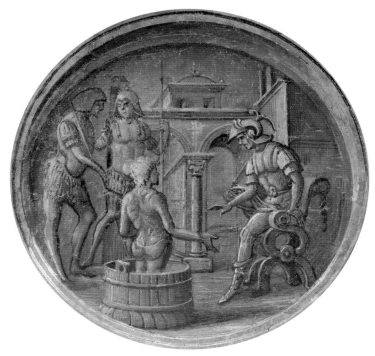

Fig. 5
Cesare Cesariano, *Death of Seneca roundel in fictive frame of the baptism of Christ*, c. 1497–99. Fresco, Baptistery of S. Giovanni Battista, Reggio Emilia.

drawings.[11] It is unclear if knowledge of Zoppo's volume was via the classically inspired painter Cesariano, a pupil in Milan of the architect Donato Bramante (?1433/4–1514) and best known for the first printed translation in 1521 of the ancient Roman architectural treatise of Vitruvius, or his patron the bibliophile Bishop of Reggio Emilia, Bonfrancesco Arlotti (1422–1508). The latter was educated in Bologna from 1450 to 1470 and taught philosophy in Ferrara where he mixed with leading humanists at the Este court, such as Guarino da Verona (1374–1460), a pioneering scholar and teacher of Latin and Greek. Arlotti was sent to Rome as the Ferrarese ambassador in 1473 before returning to his native Reggio Emilia as its bishop in 1491. The inclusion of three roundels depicting famous classical exemplars of virtue and courage above the *Baptism* is proof of

Arlotti's relaxed attitude towards combining the sacred and profane, a quality also vouch-safed by his friendship with the aristocratic Platonic philosopher Pico della Mirandola (1463–94), who attempted to synthesize classical, Christian and Judaic thought. While there is no evidence that Arlotti owned the Rosebery volume, his background in the humanist courtly circles of northern Italy is one that he may well have shared with Zoppo's patron. HC

26 Studies of hands and the head of a man with a hat (A); and studies of hands and a man with a sword (B)

1450s

Black chalk, pen and brown ink (two shades in 26A), brown wash, 19.1 × 13.5 cm and 19.4 × 13.5 cm
26B numbered upper- right corner: '24'
Gabinetto Disegni e Stampe degli Uffizi, Florence (90 F and 94 F)

PROVENANCE

Fondo Mediceo (Nota 1687); Reale Galleria degli Uffizi
(L. 929)

LITERATURE

Degenhart and Schmitt 1968, vol. 1–2, under no. 620,
figs 885–6; Angelini in Florence 1986b, nos 133 and 103;
Cecchi in Florence 1992, nos 6.2–6.3; Elen 1995, under
no. 25; Melli 1995, nos 21, 24

The Florentine goldsmith Maso Finiguerra was a prolific draughtsman, and the three exhibited studies by him from the Uffizi (see also no. 27; a fourth, no. 28, is from the British Museum) come from a collection of almost a hundred drawings by him there. Giorgio Vasari mentions Finiguerra's prowess as a draughts-man in the 1568 edition of *Lives of the Artists*: '[he] drew much and very well, and in our book there are many pages of costumes, nudes and compositions drawn with wash.'[1] His and the Uffizi's collection most likely come from the 14 albums of drawings of various sizes that Finiguerra bequeathed to whichever member of his family took over his workshop (see p. 21).[2]

Despite Finiguerra's contemporary fame as a draughtsman, the Uffizi drawings were until the 1970s generally attributed to the School of Antonio Pollaiuolo.[3] The doubts arose from the difficulty of assessing Finiguerra's style, due to the paucity of surviving works in other media, and the negative effect on his reputation caused by Vasari falsely claiming him as the inventor of engraving. His connection with printmaking derives from his work as a maker of *nielli*, small-scale compositions engraved on silver plates in which the incised lines were filled with a black substance (*niello*). Two *niello* paxes (small devotional images kissed by the priest and congregation during Mass) by him survive in the Bargello in Florence; further designs are recorded by sulphur casts or printed impressions. The links between these *nielli* designs and the bulk of the drawings traditionally attributed to Finiguerra in the Uffizi and the Louvre strongly suggest they are

by the same artist.[4] Finiguerra is also known to have supplied the Florentine woodworker and architect Giuliano da Maiano (1432–90) designs for intarsia panels (compositions formed by differently coloured pieces of wood) for Florence Cathedral. The recognition of his skills as a designer can be gauged by the description of him as a *maestro di disegno* (master of drawing/design) by the Florentine patrician, Giovanni Rucellai (1403–81), a term also applied to Antonio Pollaiuolo.[5]

It is Finiguerra's skill as a designer of figures and small-scale figurative compositions that is reflected in his drawings, all of which are executed in pen and ink, often with wash. In the present pair, the clear definition and crispness of the pen outlines over a black chalk underdrawing, with sparing use of wash in both to indicate the shading, correspond closely to the linear quality and limited tonal range of *nielli*. In the two drawings the artist does not seem to be thinking of a specific composition, rather it is a collection of studies of hands in various actions and poses based on observation of models, probably apprentices, in the studio, as can be seen from the inclusion of the torso of a figure clothed in a laced jerkin in the upper right of no. 26A. A study of a hand holding a hammer is found on the verso of the same sheet. In both drawings the studies of hands are juxtaposed with fanciful creations: a bust-length bearded man in a hat in one, and a cloaked figure with a sword in the other.

Drawings such as these served as a reposi-tory of figural ideas that could be used by Finiguerra to speed up the compositional process: for example, the study on no. 26A could have been utilized for a figure commonly represented writing, such as Zacharias or an Evangelist. In addition to the model-book function of such studies, the practice of drawing from life, which included making studies from nude models, was clearly important to Finiguerra in honing his artistic skills, both in the wielding of the engraving burin and to widen the repertoire of poses and gestures at

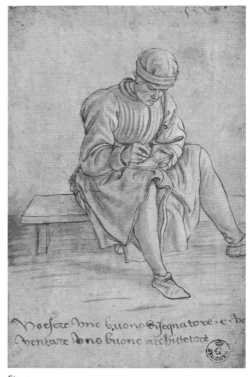

Fig. 1
Maso Finiguerra, *A youth drawing or writing*, 1450s. Black chalk, pen and brown ink, brown wash on paper rubbed with red chalk, 19.4 × 12.5 cm. Gabinetto Disegni e Stampe degli Uffizi, Florence.

his command. The perception of drawing as a means of artistic improvement is expressed in an inscription by Finiguerra, or one of his pupils, on a study in the Uffizi: 'I want to be a good draughtsman and become a good architect' (fig. 1).[6] HC

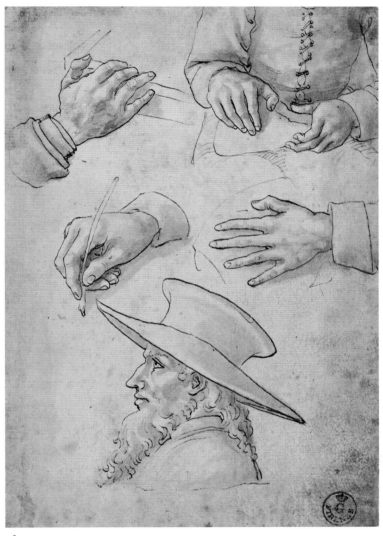

26A

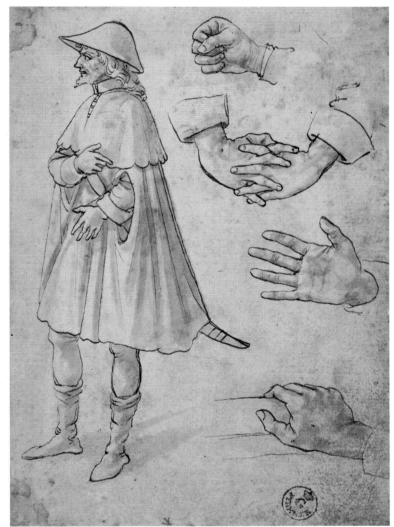

26B

151

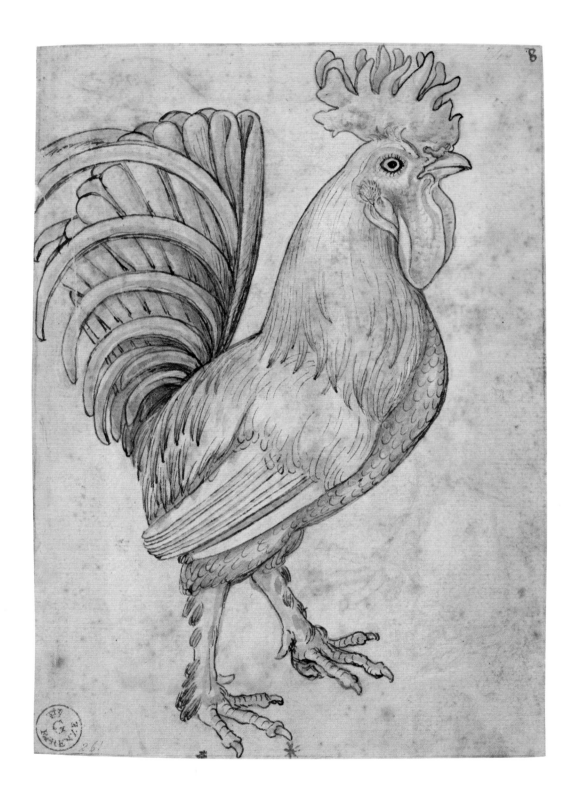

TOMMASO D'ANTONIO FINIGUERRA,
called MASO FINIGUERRA (1426–64)

27 A cockerel

1450s

Black chalk, pen and brown ink, brown wash, 19.6 × 13.5 cm
Numbered upper-right corner: '8'
Gabinetto Designi e Stampe degli Uffizi, Florence (745 Orn)

PROVENANCE

Fondo Mediceo (Nota 1687); Reale Galleria degli Uffizi
(L. 929)

LITERATURE

Degenhart and Schmitt 1968, vol. 1–2, under no. 620,
fig. 941; Angelini in Florence 1986b, no. 150; Tongiorgi
Tomasi in Florence 1992, no. 9.10; Elen 1995, under no. 25;
Melli 1995, no. 1

This is one of 14 studies of birds and animals in
the group of just under a hundred drawings by
Maso Finiguerra in the Uffizi. The Florentine
goldsmith is known to have left 14 volumes of
drawings of various sizes on his death and the
Uffizi group is most likely a remnant of this
bequest. Finiguerra's drawings of figures and
animals belong to the long-established tradi-
tion of workshop models in providing clearly
defined, easy to copy examples that could be

Fig. 2
Maso Finiguerra, *A duck in flight*, 1450s.
Pen and brown ink, brown wash, 15.5 × 14.1 cm.
Gabinetto Disegni e Stampe degli Uffizi, Florence.

utilized by workshop assistants and his artistic
heirs to insert into compositions of all kinds.
Drawings of animals and birds were a stock
constituent of such repositories of examples, as
can be seen from no. 2 from a Lombard model
book put together around fifty years earlier,
because they were such an invaluable resource
to add interest to a wide range of narratives.
This kind of study is normally associated with
north Italian artists, most notably Pisanello,
but the vivid representation of birds and
animals in the panels and framework of the
Gates of Paradise bronze doors of the Florentine
Baptistery by Finiguerra's putative master,
Lorenzo Ghiberti, suggests that there was
also an established tradition in Florence, even
though the drawings on which they were
based have not survived.[1]

　　From the stylized nature of the representa-
tion of the cockerel it is uncertain if the artist
was making a deliberately simplified drawing
from nature, or was relying on a pre-existing
study either by himself or by another artist.
The study of the cockerel's feet on the verso
(fig. 1) seems more realistic in the representa-
tion of the clumps of feathers on the legs and

the dried, scaly quality of the skin. It seems
impractical that a copy of part of the recto
should have been made on the verso (their
relative positions makes it impossible that
they were traced one from the other). The
most plausible explanation is that it is a second
attempt by Finiguerra to perfect this particular
detail. The head of the duck at the top seems
an abandoned attempt to draw the bird shown
in another Uffizi drawing (fig. 2).[2] HC

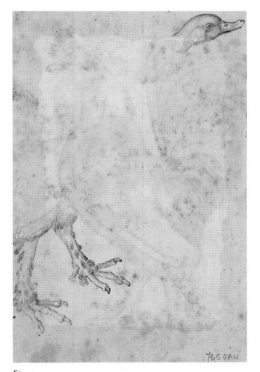

Fig. 1
Verso of no. 27. *Studies of birds*, 1450s.
Pen and brown ink, brown wash.

TOMMASO D'ANTONIO FINIGUERRA,
called MASO FINIGUERRA (1426–64)

28 Moses on Mount Sinai, and the Brazen Serpent below

c. 1455–64

Pen and brown ink, brown wash, on vellum, 28.2 × 41.6 cm
British Museum, London (1898,1123.4)

PROVENANCE

J.P. Zoomer (L. 1511); Earl of Yarmouth, either Robert
Paston (d. 1682) or his son, the last Earl (d. 1732);
acquired for £5 from Reverend E. Spero in 1898

LITERATURE

Hind 1938, vol. 1, under no. B.III.5; Popham and Pouncey
1950, no. 210 (as attributed to Pesellino); Degenhart
and Schmitt 1968, vol. 1–2, under no. 620, fig. 937;
Oberhuber in Washington 1973, pp. 7 and 52; Kubiak
1974, pp. 95–8; Landau and Parshall 1994, pp. 108–12;
Zucker 1994, p. 81; Melli 1995, no. 125; Whitaker 1998,
p. 51

In the upper part of this drawing Moses is
depicted receiving tablets of the Law from God
while his brother Aaron waits for him (Exodus
31). Below them the Israelites are under attack
by fiery serpents sent by God to punish their
faithlessness. To the left stands the brazen
(brass) serpent on a pole that God directed

Moses to erect in order to cure anyone who
looked at it (Numbers 21). The pairing of these
two episodes is unusual, as in the Bible the
Israelites' worship of the Golden Calf follows
Moses' descent from Mount Sinai (Exodus 32).
Instead the granting of law is juxtaposed with
God's punishment of man's disobedience, as
well as his eventual forgiveness. A comparable
message of retribution and mercy is found in
Finiguerra's *Flood* in Hamburg (fig. 1), executed
in the same technique on vellum and of almost
identical dimensions (28.5 × 41.3 cm).[1]
The London and Hamburg drawings were
probably preceded by a drawing in Frankfurt
(illustrated as fig. 2, nos 31–2) which depicts
five scenes from Genesis that once again treat
the troubled interaction between God and
man. The Frankfurt drawing is in the same
technique on vellum and is much the same
size (28.5 × 41 cm).[2]

The Frankfurt drawing's borrowings from
Lorenzo Ghiberti's *Gates of Paradise, c.* 1426–
52, from the Florentine Baptistery have
generally led scholars to date it to around 1450,
five years or so earlier than the London and
Hamburg works, which are far closer in style
to Fra Filippo Lippi and Alesso Baldovinetti.[3]
Echoes of Ghiberti's reliefs are still discernible
in the present drawing since its composition
and landscape recall the *Moses* panel, and some
of the poses (such as the man in the centre with
both hands raised) are adapted from the same
source. In view of the related theme of all
three drawings, it seems likely that they were
conceived at the same time, although they may
have been executed over a protracted period.
Such complex and relatively large drawings
seem ill suited as models for either intarsia
panels or small-scale *nielli* (the two main fields
in which Finiguerra is recorded as a designer).
Finiguerra's otherwise unprecedented use of
costly vellum indicates that these were likely
finished works of art in their own right.

The three drawings provide an insight into
the way in which Finiguerra mined his reper-
tory of poses and gestures, studied in sheets
such as nos 26–7, to construct the narrative.
The London drawing is more skilfully woven
together than the Hamburg one, where
jarring divergences in figural scale indicate
Finiguerra's difficulty in assimilating his studio
life-studies to form a coherent composition.
Even so the figural groups in the present work
still seem to have been built up in an additive
fashion with individual gestures and poses
reprised with minor variations, as can be seen
from the similarities between the central figure
with his hands raised in alarm and one further
to his right.

The compositions of the present drawing
and the Hamburg sheet were both engraved by
the Florentine printmaker, Francesco Rosselli.[4]
In both cases the outlines must have been
traced to the plates, because the figures

Fig. 1
Maso Finiguerra, *The Flood*, *c.* 1455–64. Pen and brown ink,
brown wash, on vellum, 28.5 × 41.3 cm. Kunsthalle, Hamburg.

correspond so closely (fig. 2). It seems unlikely
that the drawings were made specifically
for Rosselli, as he was only 15 or 16 when
Finiguerra died. The date of the print is
uncertain, with some scholars assigning it to
around 1470 and others to the second half of
the 1480s.[5] The engraver omitted the drawing's
landscape background (the walled town on the
left appears in another Rosselli engraving),[6]
and he added a few details, such as decorative
hems. The engraving can only have had a
limited circulation because the shallowness
of the parallel hatching meant that relatively
few impressions could be taken from the plate
before it wore down.[7] HC

Fig. 2
Francesco Rosselli, *Moses on Mount Sinai with the
Brazen Serpent attacking the Israelites below*, c. 1470–90.
Engraving, 29.3 × 42 cm. British Museum, London.

29 Recto: Hercules and the Hydra
c. 1460

Pen and brown ink, 24 × 16.9 cm (including a modern 0.5 cm strip of paper added in the middle of the sheet)[1]

Verso: Two dogs with collars, one on a leash
c. 1460

Black chalk or charcoal
British Museum, London (т,11.8)

PROVENANCE

J. Richardson sen. (L. 2183); W. Fawkener Bequest, 1769

LITERATURE

Berenson 1938, vol. 2, no. 1905; Popham and Pouncey 1950, no. 225; Ettlinger 1978, no. 32, p. 160; Ames-Lewis and Wright in Nottingham and London 1983, no. 39; Bartoli in Florence 1992, no. 2.28; Wright in London 1999, no. 47; Wright 2005, p. 168, and no. 2, p. 505

The sheet has been cut in half horizontally, probably because a collector wanted to turn it into two separate drawings. The greater discolouration of the lower section is perhaps a sign that at some point the study of dogs was the preferred side for display (verso).[2] When the drawing came to the British Museum as part of the 1769 bequest of William Fawkener it was thought to be by Domenico Ghirlandaio, and it was not until the end of the nineteenth century that it was correctly identified as Pollaiuolo.[3] The attribution to the Florentine goldsmith, sculptor, painter and *maestro di disegno* has never subsequently been doubted because the drawing corresponds closely with a small-scale painting by Pollaiuolo of *Hercules and the Hydra* in the Uffizi (fig. 1), which is recorded at the beginning of the seventeenth century as part of a diptych with the *Hercules and Antaeus* in the same collection.[4]

Both Uffizi paintings are much-reduced versions of two of the three lost canvases on a grand scale (about 3.5 metres square) representing the Labours of Hercules (the third one showed Hercules and the Nemean Lion) that Antonio and his younger brother Piero executed for the *sala grande* of the Medici Palace in Florence. The drawing can be confidently linked to this lost work because Hercules attacks the many-headed Hydra with a burning torch (to cauterize the wounds so as to neutralize the monster's ability to sprout multiple heads from the stump of a severed one), as in Cristofano Robetta's engraved copy in reverse after the painting. In the Uffizi panel

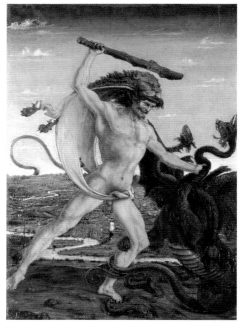

Fig. 1
Antonio Pollaiuolo, *Hercules and the Hydra*, 1470s. ?Oil on panel, 17 × 12 cm. Galleria degli Uffizi, Florence.

Pollaiuolo replaced the torch with a club. The Medici paintings, and the present study, can be dated to around 1460 thanks to the artist's reference in a letter of 1494 to his having executed them 34 years previously.

The spontaneity and rapidity of the present work would suggest that it was drawn at a fairly early stage in the design process of the over life-size figure of Hercules for the Medici Palace. If so, Pollaiuolo's preliminary concept needed little revision, except for some minor adjustments to the position of the paws of the lion pelt and to Hercules' left arm. The drawing's main focus is on Hercules' pose, with the Hydra peremptorily sketched in a few sweeps of the pen, sometimes with the nib on its side to release a smear of ink to evoke the sinuous curl of its serpentine form. One of the Hydra's

coils is clamped around Hercules' ankle tugging him to the right, thereby adding to the sense of the headlong clash of the two adversaries. Although Vasari asserts that Pollaiuolo was the first artist to make anatomical studies, the expressive but infeasible torsion of the left shoulder does not support such a claim. It is unlikely that Pollaiuolo even referred to a model since Hercules' position could not be held for any length of time. The lunging kinetic pose was in any case much favoured by Pollaiuolo across his varied artistic output, perhaps based on his study of similar figures in ancient Roman sarcophagi reliefs.[5]

Aside from the detailed description of Hercules' fierce expression and the billowing lion skin that heightens the sense of rapid movement, there is relatively little internal modelling of the musculature. Instead the artist concentrated on defining the action through the wiry contour. The way in which Pollaiuolo emphasizes the diagonal axes of force and areas of maximum muscular tension in his figure, such as the outlines of the tensed left thigh and outstretched arm, by pressing down harder on the nib to thicken the outline, brings to mind the pen drawings of the young Michelangelo, such as no. 92. The similarities of handling can perhaps be best explained by a common sculptural sensibility that led both artists to pay particular attention to conveying the weight and torsion of figures in two dimensions. HC

Recto

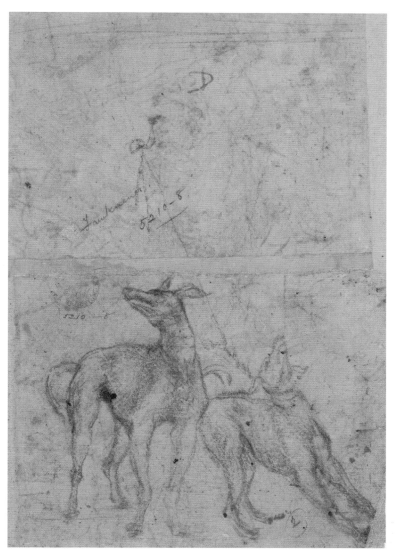

Verso

157

30 Recto: St John the Baptist

?1470s

Pen and brown ink, one of the studies of the left hand of the saint in black chalk, 27.9 × 19.4 cm
Inscribed by the artist: 'ECE A' on the banderol held by the saint, 'Giovanni',
several individual letters and 'Saverstro di Jachopo' at the lower edge of the sheet

Verso: Right forearm and left hand of the saint

?1470s

Black chalk, 19.4 × 27.9 cm.
Gabinetto Disegni e Stampe degli Uffizi, Florence (699 E)

PROVENANCE

Fondo Mediceo (Nota 1687); Reale Galleria degli Uffizi
(L. 930)

LITERATURE

Möller 1935, p. 17 (as Salvestro di Jacopo); Berenson 1938,
vol. 2, no. 1903; Petrioli Tofani 1972, no. 13; Ettlinger
1978, no. 29, p. 160; Carl 1982, p. 138 (as Salvestro di
Jacopo); Angelini in Florence 1986b, no. 163; Cecchi in
Florence 1992, no. 6.4; Wright in Cropper (ed.) 1994,
pp. 142–3 (as ? Salvestro di Jacopo); Galli 2005, pl. 27
(as Salvestro di Jacopo); Wright 2005, pp. 165–8, and
no. 12, p. 509; Melli 2007, pp. 67–9 (as Salvestro di Jacopo)

Pollaiuolo's depiction of John the Baptist as
an emaciated hermit praying fervently for the
arrival of the Messiah, his mouth open and his
gaze directed upwards, recalls Isaiah's descrip-
tion of such a forerunner: 'the voice of him
that crieth in the wilderness'.[1] The prototype
for the figure is undoubtedly the bronze figure
of the Baptist that the Florentine sculptor
Donatello (1386/7–1466) cast for Siena
Cathedral in 1457 (fig. 1).[2] The sculpted figure

Fig. 2
Detail of no. 30 verso

differs from the drawn one in his declamatory
pose, yet there are strong similarities in the
emphasis on the saint's spiritual fervour.

The studies of the feet and hands of the
saint, first in pen and then in chalk, around
the main figure demonstrate Pollaiuolo's fine
tuning of gesture and posture to perfect the
pose.[3] The artist seems to have been particu-
larly exercised by the position of the Baptist's
left hand holding the banderol with the words
'*Ecce Agnus Dei*' (Behold the Lamb of God). In
the black chalk drawing he developed the idea
shown in the small pen study above it, of the
saint wrapping his fingers around the tubular
end of the rolled-up banner, while on the
verso, drawn with the sheet turned length-
ways, he reverted to the position shown in
the full-length figure study on the other side.
The proportions of the forearm are noticeably
sturdier than those on the recto, indicative
perhaps of his use of a studio assistant to
model the pose.

The searching, more descriptive quality of
the penwork contrasts with the directness and
pace of the same artist's *Hercules and the Hydra*
(no. 29). Despite the obvious differences the
latter study provides the closest stylistic match
among Antonio's small surviving graphic corpus
of around a dozen works. The closest link

between the two is unquestionably the emphasis
on outline, the inflections of the tensile contour
line the key element in elucidating the dynamics
of the pose. The scholars who doubt that the
present drawing is by Antonio point out that
the contours of the shoulders and arms lack
the precision of Pollaiuolo's other figure
studies, such as the *Adam* and *Eve* (nos 31–2).
Exploratory figure drawings in pen by other
artists, such as Leonardo's *Virgin and Child with
a cat* or Michelangelo's *Youth beckoning* (nos 52
and 92), include contour outlines that are simi-
larly hesitant and groping, yet because of the
size of their graphic corpus it is easy to find
comparisons that prove such infelicities are
not alien to their way of drawing. Unfortunately
this is not the case with Antonio and as a result
the drawing has sometimes been ascribed to his
brother Salvestro di Jacopo, who is recorded
as his assistant in 1460 and 1466, because his
name is written on the sheet along with that of
another brother, Giovanni, who followed their
father into the poultry business.[4] Despite the
uncertainties as to the hand responsible for the
inscriptions, it seems improbable that a drawing
of this exceptional quality could have been
drawn by anyone except Antonio.[5]

The drawing cannot be connected to a
surviving work by the artist, although the
sketchy setting of a cave opening and scrubby
plants makes it more likely that it is an idea for
a painting rather than a sculpture. The Baptist
was the patron saint of Florence and it is
tempting to link the drawing with Vasari's
mention of a now lost painting by Pollaiuolo
made for the Porta della Catena, above the
main staircase in Palazzo Vecchio.[6] The drawing
cannot be dated with any precision, although
an approximate idea can be gleaned from simi-
larities in pose between the figure and those of
the Baptist preaching in two of the surviving
27 embroidered panels of the saint's life that
Pollaiuolo designed for Florence Baptistery
vestments in the period 1469–80.[7] HC

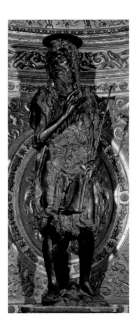

Fig. 1
Donatello, *St John
the Baptist*, 1457.
Bronze, 185 × 51 cm.
Siena Cathedral.

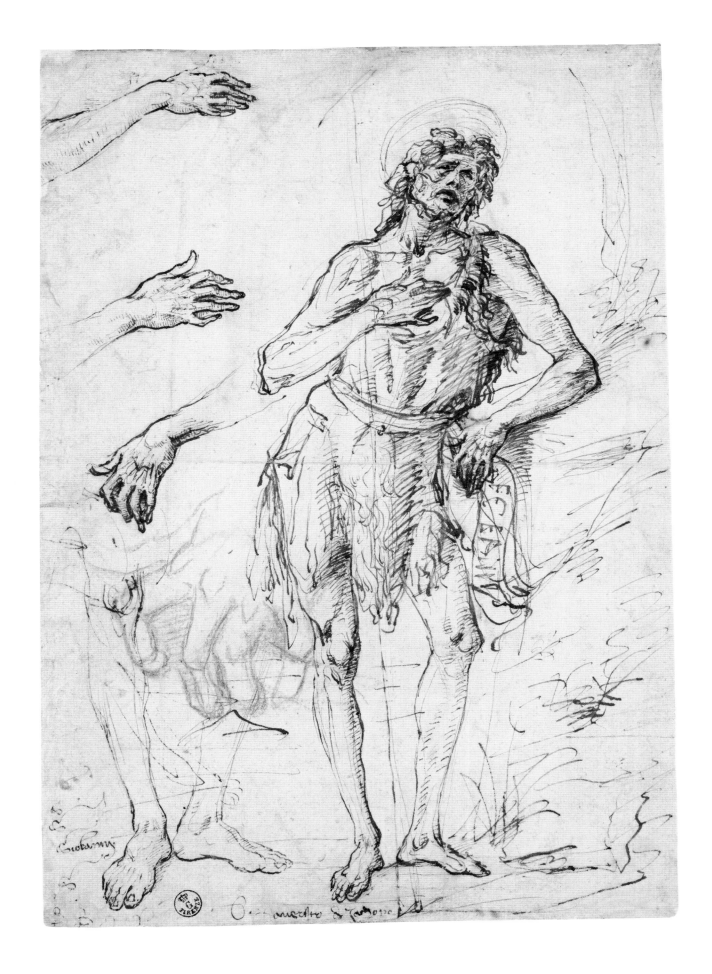

ANTONIO POLLAIUOLO (*c.* 1432–98)

31, 32 Adam; and Eve with the infants Cain and Abel

c. 1475–85 (ILLUSTRATED OVERLEAF)

Black chalk, pen and brown ink, brown wash, 28.2 × 17.7 cm and 27.5 × 18.1 cm
Gabinetto Disegni e Stampe degli Uffizi, Florence (95 F and 97 F)

PROVENANCE

Fondo Mediceo (Nota 1687); Reale Galleria degli Uffizi
(L. 930)

LITERATURE

Berenson 1938, vol. 2, nos 1901–2; Petrioli Tofani 1972,
no. 12 (Eve); Ettlinger 1978, nos 27–8, p. 160; Sisi in
Florence 1992, nos 2.8–2.9; Wright 2005, pp. 184–8, and
nos 14–15, pp. 509–10

Pollaiuolo's highly original conception of
Adam and Eve after their expulsion from
Paradise is inspired by the passage in the Old
Testament (Genesis 3:16–19) that describes
their punishment by God after they had been
tempted by the serpent to eat the forbidden
fruit from the Tree of Knowledge:

> Unto the woman he said, I will greatly
> multiply thy sorrow and thy conception; in
> sorrow thou shalt bring forth children; and
> thy desire shall be to thy husband, and he
> shall rule over thee. And unto Adam he said,
> Because thou hast hearkened unto the voice
> of thy wife, and hast eaten of the tree, of
> which I commanded thee, saying, Thou
> shalt not eat of it: cursed is the ground for
> thy sake; in sorrow shalt thou eat of it all
> the days of thy life; Thorns also and thistles
> shall it bring forth to thee; and thou shalt
> eat the herb of the field; In the sweat of thy
> face shalt thou eat bread, till thou return
> unto the ground; for out of it wast thou
> taken: for dust thou art, and unto dust
> shalt thou return.

Pollaiuolo demonstrates human sympathy,
as well as humour, in imagining the discord
that might have been caused by the couple's
dramatic change of circumstances. Adam's
bitter regret that he acceded to Eve's blandish-
ments to eat from the Tree of Knowledge that
ended their tenure in the Garden of Eden is
clear from his gesture towards his wife, and the
wonderfully expressive upward tilt of his head,
accompanied by a roll of his eyes (fig. 1). Eve's
long-suffering reaction to her partner – a
faraway gaze pointedly ignoring him – suggests

that she has had to endure many such interludes.
This persuasive and blackly comic vision of the
dysfunctional nature of mankind's first family
contrasts with the image of bucolic toil shown
in Maso Finiguerra's slightly earlier depiction
of Adam and Eve, in Frankfurt (fig. 2), a drawing
that comes from the same series of scenes from
Genesis as the British Museum's *Moses on
Mount Sinai* (no. 28).

The bleakness of Pollaiuolo's drawing is
relieved by the symbolism of the stalks of
bearded wheat and grapes held by the two
children that allude to Christ's future sacrifice,
celebrated in sacramental bread and wine.
According to Christian theology, the mystical
transformation of the bread and wine into
the flesh and blood of Christ at Mass is a daily
reminder of his conquest of death and the
offer of immortality to all who follow him.
The typology inspired by St Paul's teachings
that saw Christ as a Second Adam, sent by God
to rescue mankind from the mortality and
sinfulness ushered in by the Expulsion from
Paradise, was extended by early Christian
writers such as Irenaeus (died *c.* 202) to his
mother, the Virgin Mary. Her dutiful accept-
ance of God's command to bear miraculously
his offspring transformed her into a new Eve,
one whose virtue was a mirror image of her
forebear's disobedience. The parallels between
the Old and the New Testament have an added
resonance in the drawing because the symbols
of Christian redemption are held by Cain and
Abel who, according to the Genesis story, will
become in adulthood respectively the perpetra-
tor and victim of the first murder. In Christian
writings Abel, murdered by his jealous brother
because God favoured his altar offering of
sheep fat over the crops grown by Cain, was
seen as a precursor of Christ. Abel's innocent
life as a shepherd and his violent end prefigured
Christ's self-proclaimed role as the Good
Shepherd. The identities of the two children
in the drawing are not specified, so that the
viewer is left wondering if the cherubic infant
gazing up at his mother holding the bunch of
grapes, symbols of Christ's blood, will grow up

Fig. 1
Detail of no. 31 showing head of Adam.

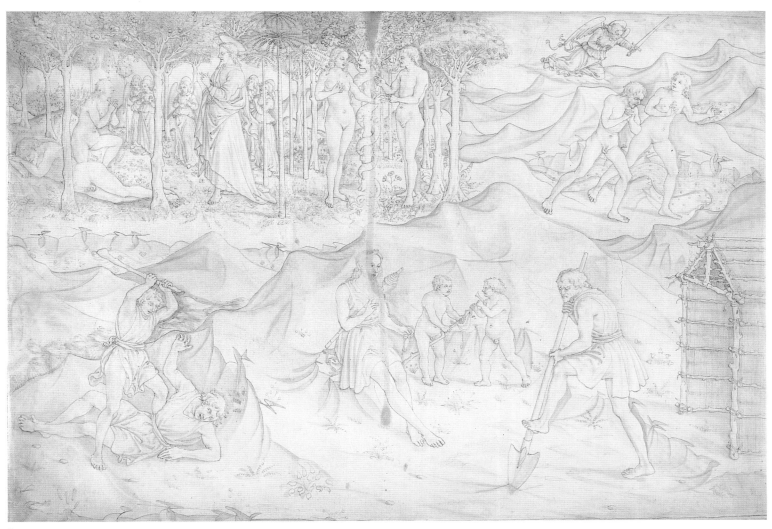

Fig. 2
Maso Finiguerra, *Five scenes from Genesis*, c. 1455–64.
Pen and brown ink, brown wash, on vellum, 28.5 × 41 cm.
Städelsches Kunstinstitut: Städel Museum, Frankfurt.

to spill the blood of his brother or will have his blood spilt by his sibling.

Pollaiuolo departs from the biblical text in showing the figures naked, as it was Adam and Eve's awareness of and shame at their nudity that alerted God to their having eaten from the Tree of Knowledge. The explicit description of the naked Eve, perhaps in order to parallel her fecundity with the fruits of her husband's toil held by their children, is unusual and it seems unlikely that the image was ever intended for wider circulation in the form of an engraving as has sometimes been suggested.[1] The finished pictorial quality of the drawings makes it more likely that they were finished works of art, or were didactic models retained in the studio. In support of the latter idea is the way in which visibility rather than naturalism is paramount in rendering Adam's classically inspired contrapposto pose.[2] Adam's crossed ankles are

both visible and the handle of the hoe is transparent. This suspension of realistic pictorial conventions is at odds with the tangibility of the general description of detail that extends to the bamboo cane used for Eve's spindle, or the tiny wedge used to secure the knotty handle and the blade of Adam's hoe. Perhaps because Eve's pose is relatively straightforward, with none of Adam's torsion and muscular strain, Pollaiuolo is happy to allow overlapping forms, like the right heel or the contour of her right thigh, to be shown naturalistically.

Both drawings were clearly known to other artists as there is a drawn copy in the Uffizi after *Adam*, and a reworked version of the same figure's pose and that of the child seen from behind in the *Eve* drawing is found in an anonymous late fifteenth-century altarpiece of the *Flagellation* formerly in the Cathedral of Atri in the Marches.[3] It has sometimes been suggested

that the two drawings were not pendants but were once a single sheet, yet it seems unlikely that the artist would have thought to place a cave at the centre of the composition. The physical separation of Adam and Eve is yet another factor in Pollaiuolo's acute portrayal of the couple's uneasy relationship. HC

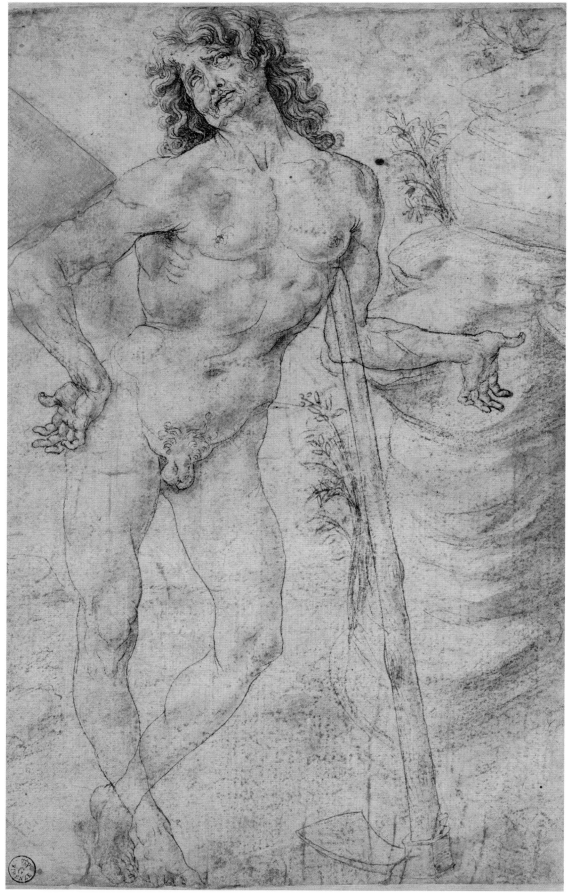

31

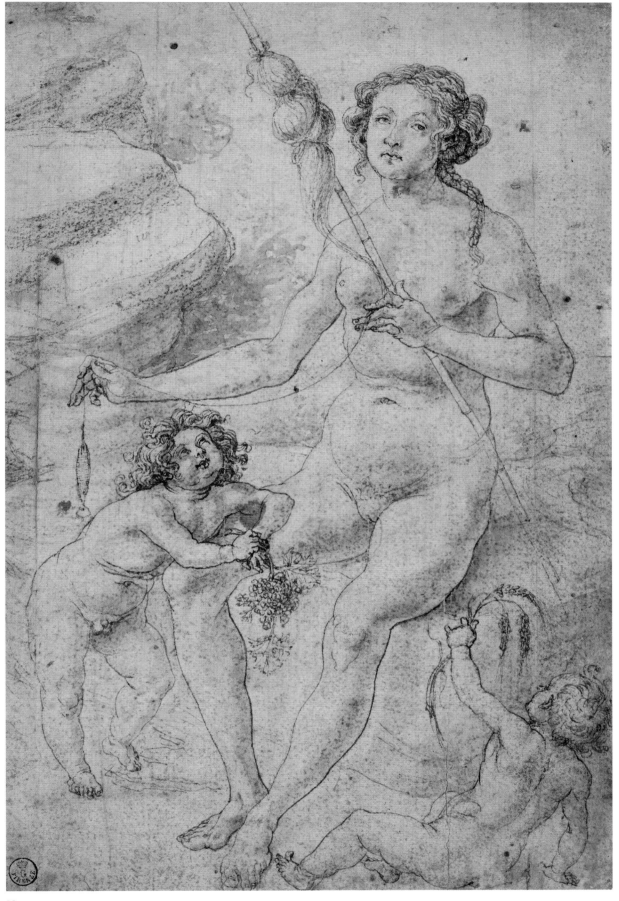

32

PIERO POLLAIUOLO (*c.* 1441–*c.* 1496)

33 Head of Faith

c. 1470

Charcoal (or black chalk), red and white chalk, the contours pricked and the figure's left cheek
also incised,[1] 21.1 × 18.2 cm
Gabinetto Disegni e Stampe degli Uffizi, Florence (14506 F)

PROVENANCE
Ferri, Disegni di Figura (*c.* 1887); Reale Galleria degli Uffizi
(L. 930)

LITERATURE
Berenson 1938, vol. 2, no.1952; Ettlinger 1978, no. 31,
p. 160; Bambach 1999a, pp. 56–8, 239; Wright 2005,
pp. 245–6, and no. 5, p. 507; Melli in Florence 2007, no. 6

This drawing is related to *Faith*, one of the six, now much damaged, paintings of allegorical female figures of theological and cardinal virtues in the Uffizi (fig. 1) by Piero Pollaiuolo, Antonio's youngest brother. These were commissioned in 1469 by the Mercanzia, a body whose function was to oversee Florentine mercantile affairs and to adjudicate trade disputes, for the ground-floor audience hall of their palazzo in the Piazza della Signoria. The

Fig. 2
Pricked contours of no. 33 overlaid on
Faith panel (see fig. 1).

Fig. 1
Piero Pollaiuolo, *Faith*, 1469–70. ?Tempera and
oil, on panel, 157 × 77 cm. Galleria degli Uffizi,
Florence.

paintings – the seventh painted by the young Sandro Botticelli (fig. 2, no. 38) – were originally in the wooden panelling (*spalliera*) in the lower part of the wall where the consuls sat.

Piero was initially commissioned to produce just one panel, *Charity*, in September 1469, in accordance with a previously submitted drawn model. It seems that he cannily judged that the Mercanzia consuls would be more willing to give him the commission if he supplied them a drawing on the same scale as the intended painting, which they could assess *in situ*. This test piece has been plausibly identified as the charcoal and lead-white drawing that scholars attribute to either Piero or his brother Antonio on the back of the *Charity* panel.[2] A few months later, in December 1469, Piero with the help of Antonio successfully argued that he should paint the remaining virtues, thereby thwarting the attempts of Verrocchio, who had submitted a drawing, and other unnamed hopefuls to take a share of the commission.[3] Botticelli was called in to paint *Fortitude* in June 1470, probably due to Piero falling behind the schedule of execution. The paintings must have been completed by March 1472 when payment was made for the framework surrounding them.

This closely pricked cartoon for the head of *Faith* testifies to Piero's careful preparation for this important commission. The employment of a cartoon to ensure the precise transfer of a figure design worked out on paper in the studio, rather than relying on a freehand underdrawing, was a practice that became established in Florentine fresco painting from the 1430s onwards.[4] The present drawing is, however, the first cartoon to survive that can be related to an extant and documented painting.[5] It does not suggest that Piero had studied the pose from a model, with the foreshortening achieved rather crudely through curtailing the upper part of the severely geometrical oval of the figure's head. The artist took more care in rendering the light effects through charcoal rubbed across the surface of the paper with highlights, now very rubbed, in white chalk. Similarly tonal touches of red chalk have been added to suggest the warm glow of flesh and lips. Although there are much earlier instances of red chalk being used as a ground (as is the case with nos 3–4), this appears to be the first surviving example in Italy of its use as a drawing medium.

The primary function of a cartoon was to transfer the outlines of the head and features onto the panel, but a diagram of the pricked lines overlaid on the panel (fig. 2) also shows that Pollaiuolo indicated the borders of the shading on the cheek, temple and neck. The pricking could not convey the subtleties of the drawing, nor the pictorial combination of coloured chalks, and it is likely that the artist intended from the outset to refer to it while painting. In order to preserve the drawing (which shows no sign of chalk or charcoal having been dusted on to the surface) the contours must have been pricked to a blank sheet beneath it, thereby creating a substitute cartoon that could be blackened with chalk or charcoal dust without risking the original. The preservation of the drawing also gave the artist the option of reusing the cartoon for another figure, as he did for the heads of *Prudence* and *Justice* in the same cycle.[6] HC

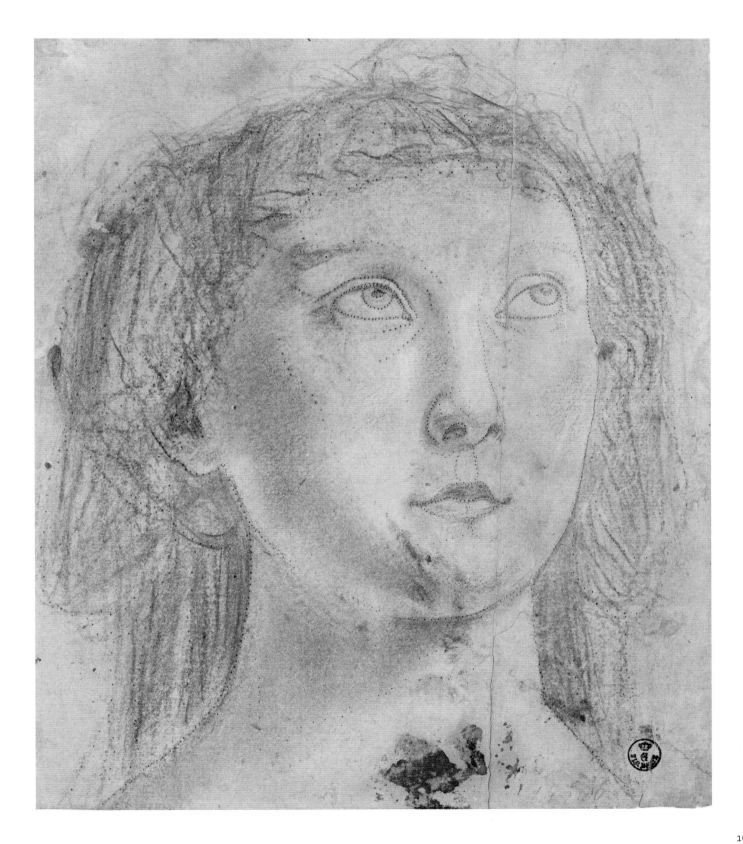

165

34 *Jacob and Esau* from the *Florentine Picture Chronicle*, an album of 55 folios (ILLUSTRATED OVERLEAF)

1470s

Black chalk, pen and brown ink, brown wash, over some stylus underdrawing, 32.6 × 23 cm, each page
The left-hand page inscribed: 'ISAU EIAHOb FUIT ANNO IX.LVIII'
(Esau and Jacob were in the year 1958) and numbered '12' upper right corner of right-hand page
British Museum, London (1889,0527.12 verso/ 13 recto)

PROVENANCE

Acquired by E. Schaeffer of Heidelberg in Florence about 1840; Hofrat Schlosser of Neuburg, by inheritance to his nephew, Baron von Bernus; sold by Gallery F.A.C. Prestel of Frankfurt in 1872 to Clément of Paris; acquired from Clément by J. Ruskin, 1873; volume of 49 folios acquired from Ruskin by J.P. Heseltine for £1,000; acquired from J.P. Heseltine for £1,025 in 1889; folios 13 and 14 presented by the Trustees of the Ruskin Museum, Sheffield, in 1890; folios 9, 22, 36, and 47 presented by Ruskin's cousin, Mrs A. Severn in 1900

LITERATURE

Colvin 1898 (as Maso Finiguerra); Hind 1938, vol. 1, pp. 6–8 (as Maso Finiguerra?); Popham and Pouncey 1950, no. 274 (as Florentine *c.* 1460–70); Phillips 1955, pp. 32–7; Degenhart and Schmitt 1968, vols 1–2, nos 566–620, this opening 572–3 (as Florentine *c.* 1460–70); Oberhuber in Washington 1973, pp. 15–16 (as Baldini); Kubiak 1974, pp. 103–5 (not by Finiguerra); Whitaker 1986, pp. 181–96 (as Baldini and workshop *c.* 1470–75); Zucker 1994, p. 91 (as Baldini); Elen 1995, no. 31 (as attributed to Baldini and workshop); Whitaker 1998, pp. 55–9

This is an incomplete and unfinished pictorial chronicle of the world, recounted through depictions of famous men and women selected from the Bible, classical history, mythology and legend.[1] The figures have no accompanying texts aside from inscriptions identifying them, and for the first 14 folios dates are given as to when they lived, counted from the biblical creation of man. For example, in the present opening, the biblical story of Esau, the huntsman on the right, selling his right of inheritance to his brother Jacob in exchange for a meal (Genesis 25:29–33) is judged to have occurred 1,958 years after Adam's appearance.

The literary and visual sources of the Chronicle

The volume depends on a long-established intellectual tradition conceived by Early Christian writers to weave together classical history and mythology with the Bible. Such schemes were repeated and elaborated in medieval scholarship and these in turn permeated popular chronicles, histories and

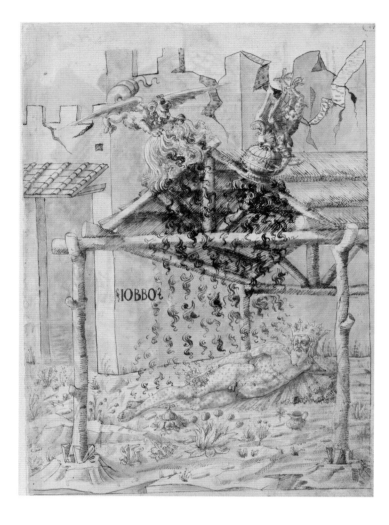

Fig. 1
Anonymous Florentine, *Job reclining on a dung heap* (from the *Florentine Picture Chronicle*, fol. 17 recto), 1470s. Pen and brown ink, brown wash, 32.6 × 23 cm, each page.

collections of myths written in the vernacular and in Latin. The standard division of man's history into six historical periods, or six ages, culminating with the Christian age follows the chronology laid out in *The City of God* written in the mid-first century AD by St Augustine of Hippo. This model was adopted in the *Chronicle* and for the first two periods these chronological boundaries are marked by inscriptions in classical-style wreaths. After this the periods run into each other until they peter out with an unfinished drawing of Milo of Croton, a Greek athlete usually located in the fourth age. The

Chronicle does not follow a single text although the choice of figures is largely conventional aside from some idiosyncrasies, most notably in the disjointed coverage of the Trojan legend, and a taste for the exotic evident in the inclusion of so many Persian, Egyptian and Greek magicians, doctors and poets. The Florentine origins of the volume are clear from the representation of Julius Caesar as the founder of the city (54 verso and 55 recto), although it is symptomatic of its makers' lack of interest in historical accuracy that no attempt is made to portray the Roman's well-known features,

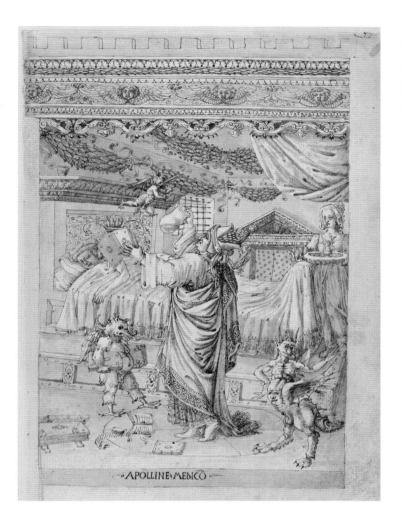

Fig. 2
Anonymous Florentine,
Apollo (from the *Florentine
Picture Chronicle*, fol. 33
recto), 1470s. Pen and
brown ink, brown wash,
32.6 × 23 cm.

nor to include a single recognizable building in the cityscape.

The written and oral tradition that inspired the *Chronicle* was augmented by a visual one stemming from a lost fresco cycle from the early 1430s of *uomini famosi* (famous men) in the Palazzo Orsini in Rome by the Florentine painter Masolino.[2] The appearance of Masolino's representation of 300 full-length figures, arranged chronologically and divided into six ages, is recorded in manuscript illuminations and drawings.[3] There are sufficient similarities in the choice and sequence of the figures in the *Chronicle*, especially in the opening quarter, to suggest that its makers were aware of the Orsini cycle, most likely at second hand. At the same time the choice and manner of representation of figures in the *Chronicle* often differs from Masolino's, such as the non-biblical depiction of the Old Testament prophet Job as a king in one of the most memorable drawings in the volume (fig. 1).[4]

Presentation and execution

In the first three pages of the *Chronicle* each figure is identified by an inscription and an appropriate attribute or setting as in Masolino's Orsini cycle. The original format divided the pages into two tiers of figures running in sequence horizontally across the double-page spread like a comic strip. This was then rejected in favour of a more varied presentation with rows of figures interspersed with representations of one or two of them on a single page, as in that of Apollo, the god of healing (33 recto; fig. 2), or across a double-page spread as with the Jacob and Esau scene. This diversity of format was much better adapted to hold the attention of a viewer turning the pages than the uniformity of Masolino's model. After page 13 the pages are no longer divided horizontally into two tiers, a change that allowed the scale of figures to be increased at the expense of making the coverage more selective. This marked a shift away from the

encyclopaedic nature of the Orsini tradition towards a greater concentration on figures whose deeds, real or imagined, offered scope for engaging narratives and highly wrought descriptions of costume and setting.

The technique of the drawings is consistently black chalk followed by pen and ink, the shade of which is now uneven due in large part to the framing and consequent light exposure of some openings during Ruskin's ownership. Most of the drawings have wash but it is noticeably varied in the subtlety of application, with a highpoint established in the assurance of the shading of the figures in the first age. Ruled stylus underdrawing was often used to prepare the architectural settings, as can be observed around the imposing, if geometrically irregular, wellhead in the Jacob and Esau design. The latter opening precedes the adoption of ruled framing lines first used to isolate Pharaoh in the lower tier of 13 recto. Curiously it was only in the last part of the album that the margin beneath the figures was fitfully utilized for the identifying inscriptions. The adjustments to the format and design clearly demonstrate

that the *Chronicle* was not rigorously planned in advance. Instead its makers gradually revised the traditional manuscript pictorial history to one better adapted to their artistic strengths and to maintaining the interest of the viewer.[5]

Attribution and stylistic influence

The idea that the *Chronicle* might be by more than one hand was tentatively suggested by Arthur Hind (1938), but it was Lucy Whitaker in her 1986 thesis who firmly established that it was a collaborative work by at least two artists, based on an analysis of the stylistic and qualitative differences. Quite how many hands were involved is extremely hard to determine due to the coherence of the volume, indicative of a group of artists schooled in the same tradition and working in close collaboration.[6] An important factor in the visual unity of the book is, as Whitaker first observed, the artists' use of a shared repertory of poses, gestures and even drapery patterns, presumably derived from a studio pattern or model book, to assemble the

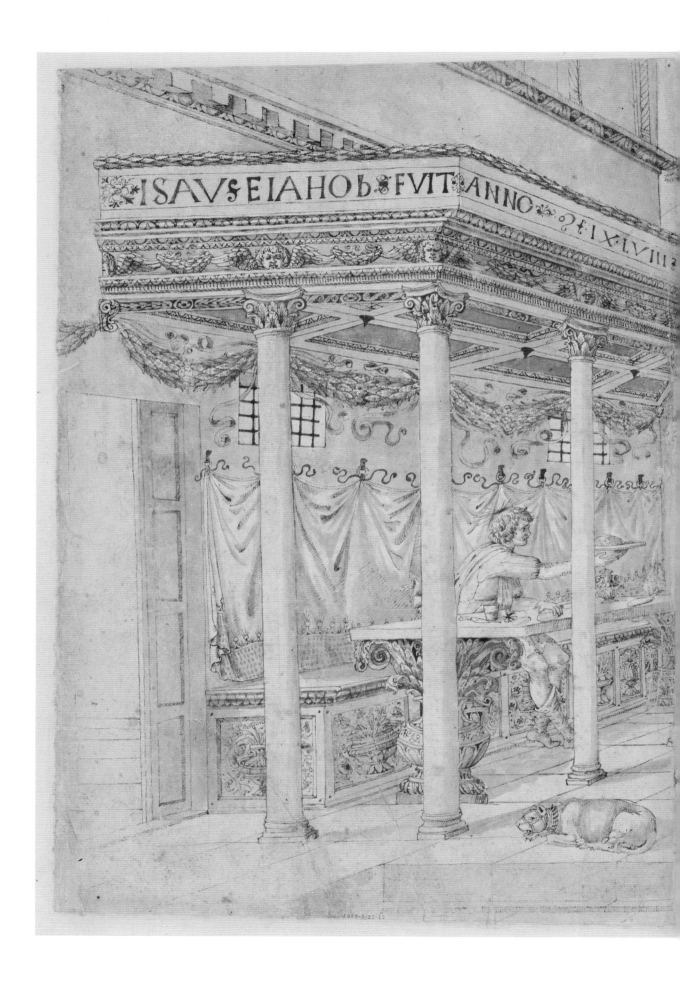

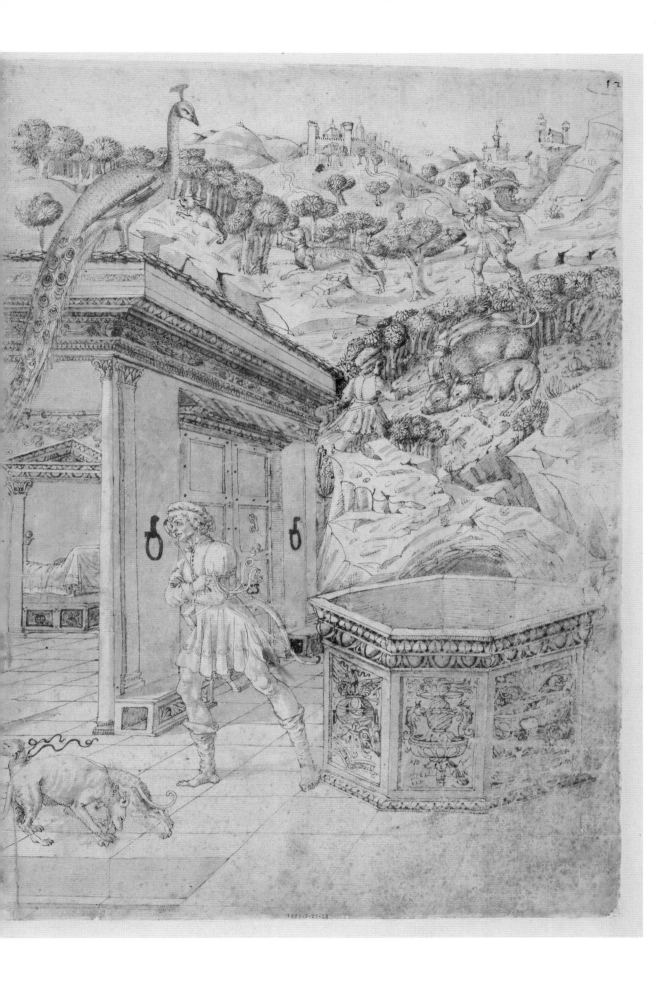

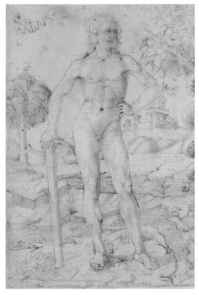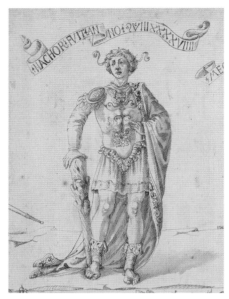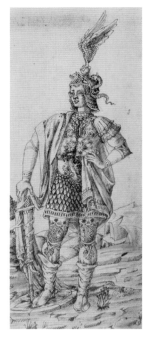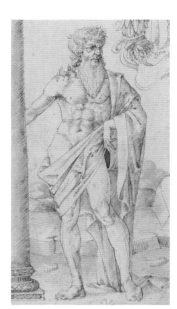

Fig. 3
Composite of four variations on a pose in the *Florentine Picture Chronicle* album:
Adam (fol. 5 recto); Nachor (fol. 9 recto); an unidentified figure (fol. 34 recto); and
Samson (fol. 45 recto).

figures. The varied employment of a pose can be seen in the four-fold repetition of a hand on hip pose (see fig. 3) for Adam (5 recto); Nachor (9 recto); an unidentified figure (34 recto); and Samson (45 recto).

From stylistic similarities in the wiry pen outlines, combined with sparing application of unmodulated areas of wash, and the figure types it is clear that the main source was Maso Finiguerra's drawings, like nos 26–8. The most direct borrowing is a female attendant of the Assyrian king Sardanapalus (56 recto), whose pose is copied from Finiguerra's study of a kneeling woman weaving a wreath in the Uffizi.[7] The *Chronicle* artists also derived inspiration from other Florentine sources, notably Antonio Pollaiuolo, but the pervasive influence of Finiguerra led to the album being attributed to him.[8] The stylistic differences between his drawings and those in the album are too great to make this credible. Recent scholars have tended to attribute the album to the shadowy Florentine goldsmith Baccio Baldini, about whom nothing is known except for Giorgio Vasari's mention of him as a follower of Finiguerra who depended on Botticelli's inventions because of his lack of *disegno*.[9] On the basis of this and a passage in Vasari's life of Botticelli a series of 19 engravings that illustrate an edition of Dante, published in 1481, have been attributed to Baldini. From stylistic comparisons with the Dante group more than a hundred engravings, the so-called Fine Manner

prints, have been given to Baldini in a career beginning soon after his master's death in the mid-1460s.[10] There is, however, no contemporary reference to Baldini making prints, or indeed any certainty as to his dates.

Despite the uncertainties surrounding Baldini, it is unquestionable that the prints ascribed to him and the *Chronicle* share in common a goldsmith-inspired predilection for intricate surface pattern and ornament; a rather rudimentary grasp of perspective (although this is not universally true in the engravings, as shown by the impressive recession in the *Judgement Hall of Pilate*); and similar Finiguerra-

inspired figure types.[11] The *Jacob and Esau* opening exemplifies this kinship because the animals in it with one exception correspond closely to those in a 'Baldini' engraving known in a unique impression in the British Museum (fig. 4).[12] The missing dog, the one with a studded collar in the foreground, appears in reverse, as in the other print, in a circular engraving from the 'Baldini' group.[13] The differences between the drawing and the print, such as the reversal of the poses and the adaptation in the drawing of the dog in the foreground eating a bone, rather than the innards of a hare as in the engraving, indicate

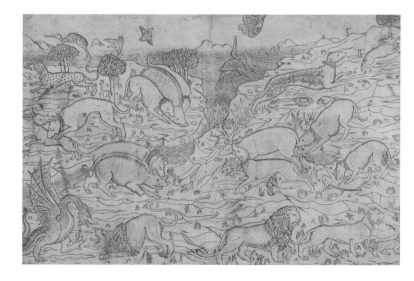

Fig. 4
Attributed to Baccio Baldini, *Pattern sheet of animals and birds*, c. 1460–70. Engraving, 25.8 × 37.8 cm. British Museum, London.

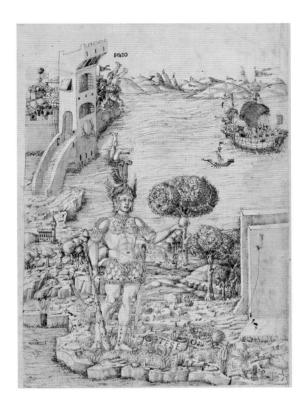

Fig. 5
Anonymous Florentine, *Theseus and the Cretan labyrinth* (from the *Florentine Picture Chronicle*, fols 29 verso and 30 recto) 1470s. Pen and brown ink, brown wash, 32.6 × 23 cm, each page.

that both derive from a common source, rather than one being copied from the other. Many of the animals in the print are also found in pen-and-wash drawings from a dismembered Florentine model book of around 1450 now in the Louvre (see fig. 28 on p.49). The complex nature of the exchange of drawn motifs is underlined by the fact that the various animals were likely derived from an earlier Lombard model book, akin to the one now in the British Museum (no. 2).[14] An even closer link between the *Chronicle* and Florentine printmaking is shown by the similarities between the 'Baldini' engraving *Theseus and Ariadne by the Cretan labyrinth* (fig. 6) and the drawing of the same subject (29 verso and 30 recto; fig. 5).[15] The narrative is less clear in the drawing due to the absence of Ariadne, as well as the confusing juxtaposition of Theseus' outstretched hand with a tree behind him so that it appears as if he were holding an apple rather than a ball of wool.[16]

The correspondence between the Theseus compositions confirms that 'Baldini' and the makers of the *Chronicle* were in close contact, perhaps sharing the same workshop, yet it cannot necessarily be inferred that the print-maker was directly involved in its production. The artist or artists responsible for the 'Baldini' group were more sophisticated in their

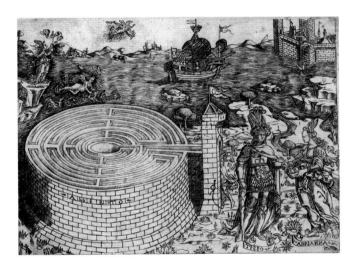

Fig. 6
Attributed to Baccio Baldini, *Theseus and Ariadne by the Cretan labyrinth, c.* 1460–70. Engraving, 20.1 × 26.4 cm. British Museum, London.

draughtsmanship and design than those responsible for the *Chronicle*, and this holds true even in the earliest, most Finiguerra-inspired prints, such as the *Conversion of St Paul* of *c.* 1465.[17] The *Chronicle* is a unique example of how the collaborative ethos of the goldsmith trade, related in part to sharing the high capital costs of the materials needed, was turned to the production of a luxury volume of drawings. The entrepreneurial flair, ambition and inventiveness of the makers of the *Chronicle* is closely linked to the development of

engraving in the city, which was to prove a more enduring, practical and profitable means of harnessing a skill in drawing and design. The ties between printmakers and the creators of the *Chronicle* can be traced back to the studio of the pioneering *maestro di disegno*, Maso Finiguerra. HC

171

35 Hippo

c. 1475

Pen and two shades of brown ink, brown wash, on vellum, 28.2 × 25.6 cm
Inscribed in an old hand: 'del Pittorichio'
Gabinetto Disegni e Stampe degli Uffizi, Florence (375 E)

PROVENANCE

Fondo Mediceo (Nota 1687); Reale Galleria degli Uffizi
(L. 930)

LITERATURE

Morelli 1893, p. 358 (as Antonio Pollaiuolo); Ulmann 1894,
p. 246; Schubring 1916, p. 90; Weller 1943, pp. 254–5;
De Marchi in Siena 1993, no. 58

According to Greek legend, Hippo was
a young woman who threw herself into the
sea to preserve her chastity after she had
been abducted by an enemy fleet or, in some
versions of the story, pirates.[1] She is cited as
an example of female virtue by classical authors
such as Valerius Maximus in his *Facta et Dicta
Memorabilia* (Memorable Sayings and Doings)
of *c.* AD 30, as well as by Italian writers, most
notably Giovanni Boccaccio in his celebrated
De claris mulieribus (Famous women) written in
the early 1360s. The classical heroine enjoyed a
particular vogue in Siena with representations
of her story found on three fifteenth-century
Sienese cassoni, the painted chests decorated
with scenes of exemplary women that were
made to contain the dowries of brides as they
left their parental home and entered their
husbands' houses.[2] As Hippo was rarely
depicted by artists outside Siena, it is safe
to assume that the present representation of
her was made for a Sienese compatriot of the
artist. The use of vellum and the high level of
finish are paralleled in three other drawings by
Francesco di Giorgio in Oxford, Braunschweig
and Florence, all of which were probably made
as finished works of art in their own right.[3]
The present work is perhaps closest to the
Atlas drawing in Braunschweig (fig. 1) in the
choice of classical subject matter and the focus
on the portrayal of motion conveyed through
fluttering tresses of hair and drapery. In all
four drawings of this kind the figure was
drawn before the setting, a dichotomy that
is particularly evident in the *Hippo* drawing
due to the differing colours of the two inks.
In common with other drawings where there
are differences in ink tone, as is the case with
Michelangelo's so-called *Philosopher* (no. 91),
it is probably wrong to assume that the diver-
gences were intended by the artist as they
would originally have both appeared black.

Rather than showing the most recognizable
moment in the classical story – Hippo's suicidal
leap into the sea – the drawing represents the
conclusion of her doomed attempt to outrun
the pirates, caught between the cliff and the
menacing prow of the ship coming in to land.
The low viewpoint, which makes the rock-face
and the horizon of the sea tower above the
figure, and the relief-like flattening out of
Hippo's form and drapery on the frontal plane,
subtly convey a sense of the protagonist's
physical confinement with no means of escape.
The fact that the alluringly topless figure is not
readily identifiable fits a Sienese predilection
for recondite subject matter also manifest in
Francesco di Giorgio's vellum drawing in the
Uffizi, the *Youth standing in a landscape*, whose
allegorical content has only recently been
deciphered.[4] Hippo's desperate flight was
also a subject that allowed the Sienese artist
to showcase his talent for depicting figures in
dynamic motion, akin to his work as a sculptor
of bronze reliefs from the mid-1470s, such as
the *Deposition* in S. Maria del Carmine, Venice,
and the *Chimera* plaquette in the Staatliche
Museen, Berlin.[5] The Uffizi drawing can be
plausibly dated to around the same period.

The dynamism of the *Hippo* is most closely
paralleled in drawings by Francesco di Giorgio's
Florentine contemporary and fellow *maestro
di disegno*, Antonio Pollaiuolo. The similarities
between the two artists even led the great
nineteenth-century connoisseur Giovanni
Morelli to attribute this drawing wrongly
to the Florentine. Morelli's attribution, no
less than the preceding one to the Umbrian
painter Bernardino Pintoricchio based on
an old inscription, is symptomatic of the long-
standing neglect of Sienese Renaissance art.[6]

HC

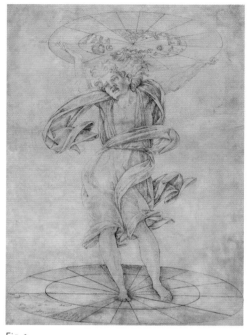

Fig. 1
Francesco di Giorgio Martini, *Atlas*, c. 1470–5.
Pen and brown ink on vellum, 33 × 23.5 cm.
Herzog Anton Ulrich-Museum, Braunschweig.

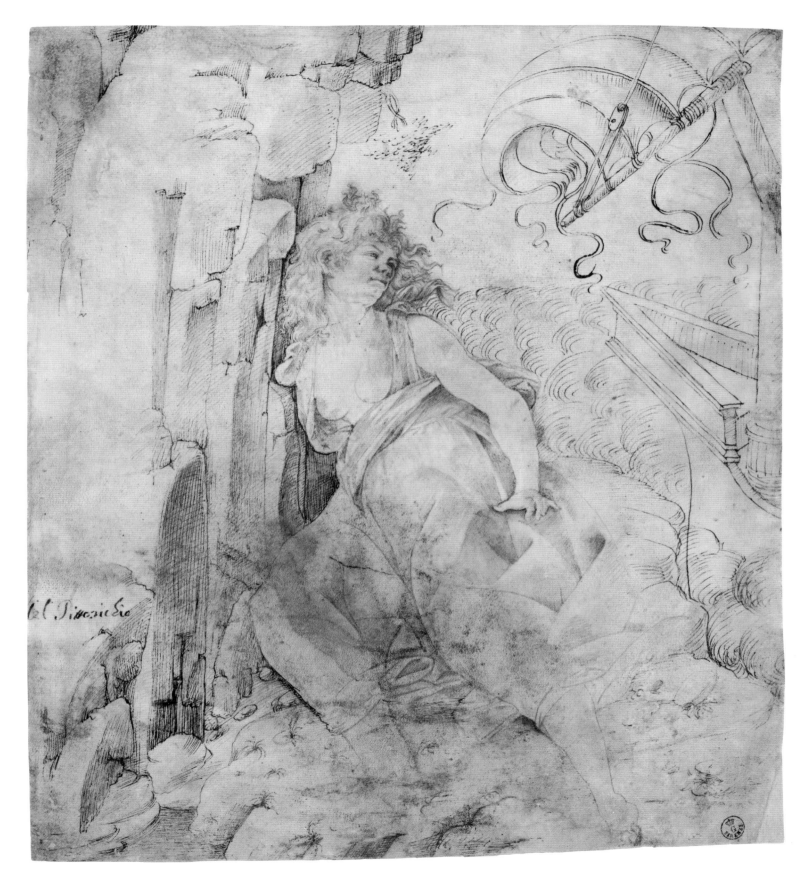

36 Allegory of Abundance or Autumn

c. 1480–5

Black and red chalk, pen and brown ink, brown wash, heightened with lead white, on paper
with an irregular orange-red ground consisting mainly of red lead, 31.7 × 25.2 cm
British Museum, London (1895,0915.447)

PROVENANCE

G. Vasari (?); Greffier F. Fagel; S. Rogers; M. Moore;
Sir J.C. Robinson; J. Malcolm; acquired from Col. J.
Wingfield Malcolm, 1895

LITERATURE

Robinson 1876, no. 14; Popham and Pouncey 1950, no. 24;
Lightbown 1986, vol. 2, no. D3 and under no. C8; id. 1989,
p. 296; Van Cleave 1994, pp. 238–9; Rubin in London 1999,
no. 87; Warburg (1898) 1999, p. 159; Chapman in Berlin
2000, no. 19; Cecchi 2005, p. 226; Zöllner 2005, D. 4;
Körner 2006, p. 262; Van Cleave 2007, p. 70

The modern fascination with Botticelli owes much to his delicate images of feminine beauty as seen in this drawing. The sensuous elegance of the woman is reminiscent of the antique, even if her proportions diverge from the classical canon (although it should be remembered that the prescriptive concepts of classical beauty and harmony formulated by the German archaeologist and art historian Johann Joachim Winckelmann, 1717–68, had yet to be developed). The woman's singular grace is Botticelli's own invention and reflects a cultural milieu in which the present and the antique interacted with elegant ease.

Botticelli's possible antique prototypes do not lessen the modernity of his drawing,[1] which responds to his patrons' cultured interests as seen in his paintings of the same period: *Birth of Venus* in the Uffizi, Florence (fig. 1), *Venus and Mars* in the National Gallery, London, and *Portrait of a young woman* in the Städel Museum, Frankfurt.[2]

Botticelli's fusion of images of classical nymph and contemporary muse laid claim to equal status for the visual arts in relation to literature, *pictura ut poesis* (as is painting so is poetry), at a time when artists appear to have gained the upper hand over earlier humanists such as Guarino da Verona, who had upheld the superiority of literature over painting.[3]

As the pioneering art historian Aby Warburg first recognized, Botticelli's drawing derived from the description of a nymph, wearing a dress similar to that of the virginal hunting goddess Diana as recounted in Book

IX of the Latin poet Ovid's *Metamorphoses* (89–92). The nymph carries an autumnal cornucopia made from the horn that Hercules had earlier broken from the head of the river god Achelous, who had been turned into a bull. Far from offering a visual equivalent of the literary source (*ékphrasis*), Botticelli realizes the subject afresh: thus the woman does not wear a classical tunic but an elegant dress that would have appealed to Botticelli's contemporaries. Equally, the cornucopia that plays a central role in Ovid's account is here unfinished, the artist concentrating instead on the woman and her retinue. Whatever the textual link may have been, it was in the very act of drawing that Botticelli refined his ideas and created images with multiple meanings which, with a little variation, could be employed in a variety of contexts.[4]

The many-layered techniques by which this drawing was created have often been compared with those required for painting in tempera on panel (and can now be precisely identified thanks to the scientific investigations carried out in preparation for this exhibition).[5]

Celebrated in his time as the new Apelles, Botticelli creates in such works a balance between colour and contour, drawing in ever attenuated strokes to convey an idealized, unworldly refinement of beauty. His calmly melancholic women surpass even prescriptions laid down by Alberti: 'In young maidens movements and deportment should be pleasing and adorned with a delightful simplicity, more indicative of gentleness and repose than agitation....'[6]

Despite being unfinished, this is an independent drawing, like Mantegna's *Virtus Combusta* (no. 22). In the nineteenth century it was variously attributed to both Mantegna and Verrocchio.[7] Vasari greatly appreciated Botticelli's drawings, and according to the Feigel catalogue (1801) this drawing was included in Vasari's *Libro de' Disegni*.[8] MF

Fig. 1
Sandro Botticelli, *Birth of Venus*, *c.* 1484. Tempera on canvas,
172 × 278 cm. Galleria degli Uffizi, Florence.

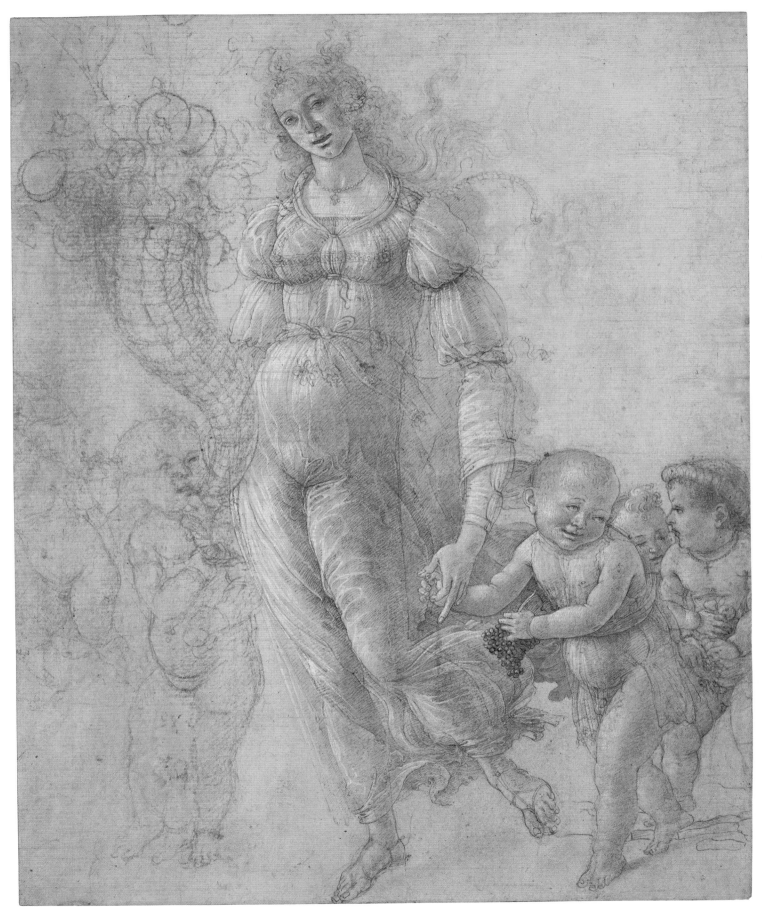

37 Pallas

c. 1491

Black chalk, pen and brown ink, brown wash, heightened with lead white, on paper rubbed with red chalk,
squared twice in black chalk, the contours of the figure pricked, 22.2 × 13.9 cm
Inscribed in an old hand: 'sandro botticello: di/...'
Gabinetto Disegni e Stampe degli Uffizi, Florencee (201 E)

PROVENANCE

Fondo Mediceo (Nota 1687); Reale Galleria degli Uffizi
(L. 930)

LITERATURE

Berenson 1938, vol. 2, no. 575; Wittkower 1938–9;
Lightbown 1989, p. 305; Caneva in Florence 1992, no.
14.3; Galassi 1998, p. 44–5; Bambach 1999a, pp. 128–9,
p. 419 n. 10; Ciseri in Rome 2000, no. 5.17; Pons in Paris
and Florence 2003, no. 24; Cecchi 2005, pp. 300–1, p. 361
n. 32; Zöllner 2005, pp. 282–3; Körner 2006, p. 287

This drawing accords with Botticelli's mature
style and its attribution has rarely been ques-
tioned.[1] The woman is the goddess Pallas, or
Roman Minerva, a favoured subject among the
cultured Medici elite, for whom it was natural
to employ figures from classical mythology as
emblems of contemporary relevance. Botticelli
had depicted the goddess several times in
paint, first as a victory symbol on Giuliano de'
Medici's tournament standard in 1475,[2] and
secondly in *Pallas and the Centaur* (after 1482)
in the Uffizi, Florence.

Fig. 1
A tapestry with Pallas, late 15th century. Private
collection, France.

In this drawing Pallas is shown in a less
common guise as a pacifying divinity, her usual
attributes of the sword and shield replaced by
an olive branch delicately held in her left hand,
while in her right is proffered her helmet with
raised visor (a significant portion of which has
been lost by the trimming of the sheet). Rudolf
Wittkower (1938) thought the influence of
antique statuary in the drawing was mediated
through the Pallas depicted on a medal struck
by Francesco Laurana (*c.* 1430–d. before 1502)
in 1463 for René of Anjou, which was in turn
based on a now lost classical sculpture once
in the Vescovadi collection in Rome.

The sheet has been squared twice in black
chalk, first in light lines on the bare paper over
which the figure was drawn, and secondly upon
completion of the drawing (although without
impinging on the figure itself). The second
squaring was to allow the transfer to a greater
scale of the design that most critics now
consider to be for a tapestry commissioned
by Count Guy de Baudreuil, Abbot of Saint-
Martin-aux-Bois, in 1491 (fig. 1).[3] That the
composition was reused in the studio to the
same scale is suggested by the pricking of the
contours of the figure to allow the transfer
of the image by pouncing (this is most clearly
visible around the feet).

The function of this sheet as a working
drawing is displayed by its various levels of
finish and changes of composition. The initial
drawing in black chalk is visible in many places;
for example, in the figure's right forearm,
shifted downwards when redrawn in pen and
ink, and to the right of the neck. The figure
was modelled with diluted wash over which
clusters of short, oblique strokes of the pen
were used to mark the interior of the drapery
folds. Lead white was applied with the brush
to describe the fall of light from the left, while
the red chalk previously rubbed over the figure
contributes to the saturated hue and precious
effect of the drapery. The most significant
adjustment is the redrawing of the head in pen
further to the left and the consequent adjust-
ment of the outer contour of the left arm.[4] It

Fig. 2
Detail of no. 37 showing the head of Pallas.

may be that Botticelli wanted to keep the
two heads as equal options since they share
an eye (fig. 2). The artist also modified the
goddess's expression, giving her half-open
eyes and mouth.

The disproportioned upper body and sinuous
contours lend the elegant and indisputable
beauty of the figure a gothic flavour; in
contrast, the light dress and long hair appear
to flutter in a breeze in accord with Alberti's
precepts in *Della pittura* on the depiction of
movement.[5] The fusion of traditional and
modern elements in this idealized woman is
seen in many of Botticelli's best-known works.
The only significant difference between her
and the Venus of the Uffizi *Primavera* (1475–82)
is her extended right hand. As Aby Warburg
emphasized in 1898, Botticelli's ideal of
beauty had a correspondent in contemporary
literature, and both visual and literary ideals
reflected contemporary culture more than their
reputedly antique sources.[6] This is conveyed by
the style of the woman's dress, which recalls
those worn at festivals (note the cape added as
an afterthought).

In the Ashmolean Museum in Oxford there
is a drawing of the same subject but of lesser
quality and certainly not autograph. It probably
derives from the Baudreuil tapestry or its
corresponding cartoon.[7] EB

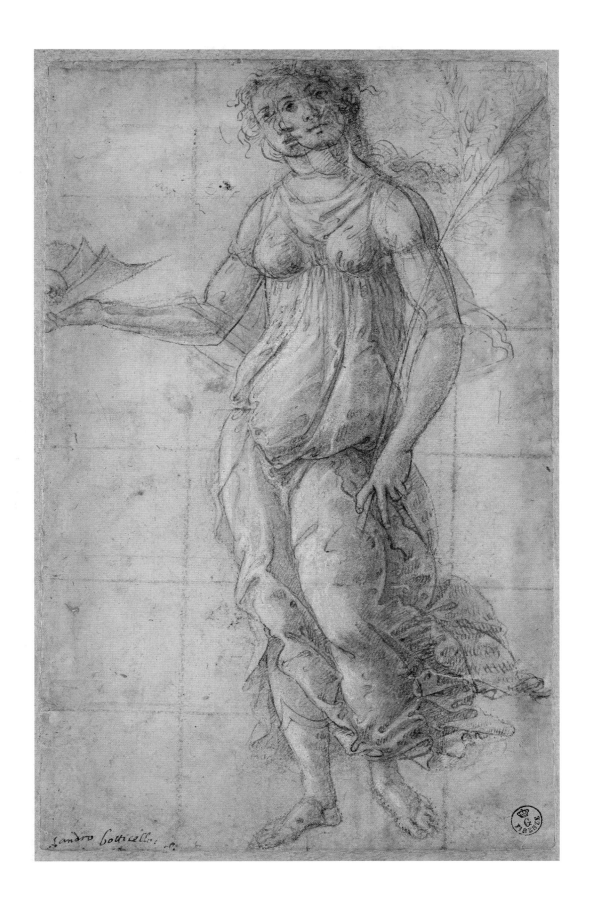

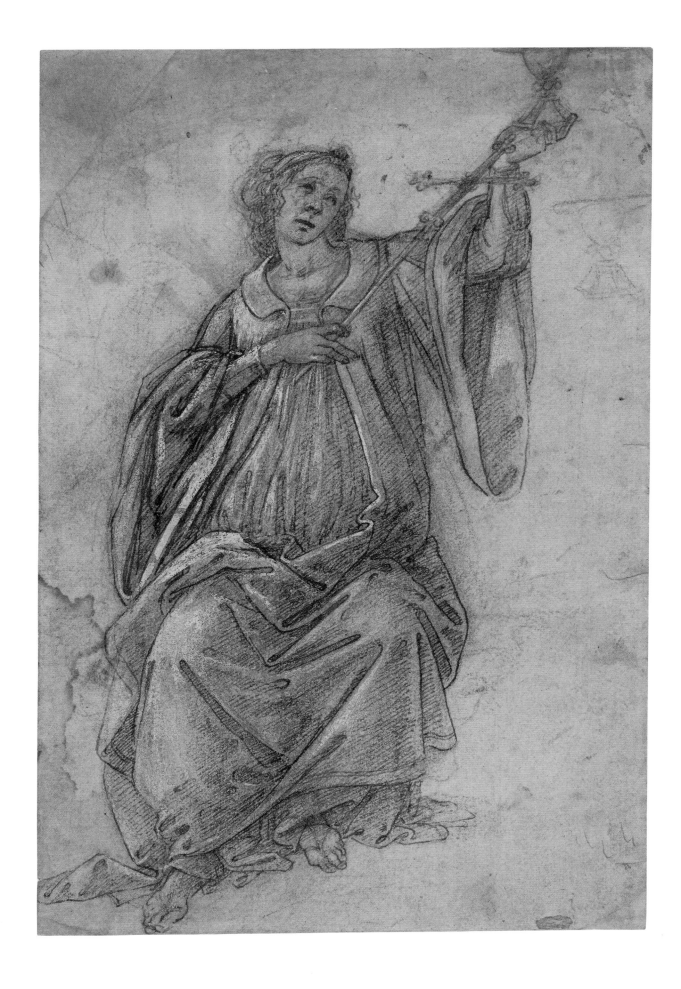

38 Allegorical figure of Faith with chalice, paten and host

c. 1490–1500

Black chalk, pen and brown ink, wash, heightened with lead white, 25 × 16.5 cm
British Museum, London (1895, 0915.448)

PROVENANCE

Sir J.C. Robinson; J. Malcolm; acquired from
Col. J. Wingfield Malcolm, 1895

LITERATURE

Robinson 1869, no. 12; Popham and Pouncey 1950, no. 25;
Bertini 1953, p. 10; Grassi [1960], pp. 181–2; Lightbown
1978, vol. 2, no. D8; id. 1989, p. 308; Chapman in Berlin
2000, no. 21; Cecchi 2005, p. 306; Zöllner 2005, D. 14

Faith raises a chalice and paten in her left
hand, displaying to the devout viewer the
consecrated bread and wine they contain. The
striking verticality provided by this gesture
is reinforced by the slant of the body and the
diagonal compositional line running from the
right foot through the cross held in Faith's
right hand to the resonant Christian symbol
of the chalice in her left. The chalice and paten
were subsequently redrawn in a summary

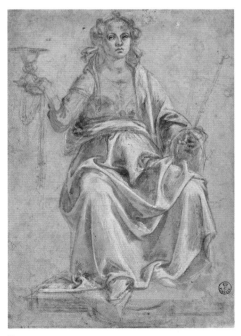

Fig. 1
Circle of Andrea del Verrocchio, *Faith*, later 1460s.
Black chalk, pen and brown ink, brown wash,
heightened with lead white over stylus on paper
rubbed with red chalk, 21.6 × 14.9 cm. Gabinetto
Disegni e Stampe degli Uffizi, Florence.

sketch below Faith's left hand, showing the
attention Botticelli gave to the depiction of
this significant liturgical vessel. It displays
the host (which may have been present in the
chalice above but was lost in the trimming
of the sheet) and is drawn in the same black
chalk as the underdrawing of Faith (seen to
the lower right of the figure).

Botticelli's diagonal parallel hatching in
pen and ink subtly reinforces the upwards
movement of the figure of Faith and helps
impart a vibrant luminosty to the paper.
The resonant and accentuated pen lines over
the modulated tone of the paper give a mono-
chrome effect. Botticelli's *Calumny of Apelles*
in the Uffizi is similarly dated and its figures
convey a comparable sense of commotion and
inquietude. This connection draws attention
to the similarity of Faith's tense illumination
to that of the monochrome niche scupltures
in the painting.

Botticelli's precise purpose in drawing Faith
is not known, although tentative suggestions
have been made, ranging from a study for a
mosaic[1] to a panel for a cassone (large painted
chest).[2] Since Botticelli's graphic work encom-
passed a wide range of activities from designs
for *spallieri* (painted panels to decorate furni-
ture) to liturgical vestments and engravings
(his association with the Florentine engraver
Baccio Baldini, ?1436–87, is documented by
Vasari), the drawing's function remains open
to question.

Faith was drawn at a time Florence was
in the thrall of the fiery Dominican preacher
Girolamo Savonarola (1452–98), who ruled the
city in the mid-1490s. Savonarola's influence
on Botticelli is seen in the dramatic intensity
of the two painted *Lamentations* from this
period.[3] A similar influence is revealed in
Faith's affecting expression of grave emotion,
and her half-closed mouth. Botticelli's
strokes were intended to be more dynamic
than elegant. The unstable pose given to Faith
contrasts with more usual depictions of the
subject by other artists, as seen in an earlier
drawing in the Uffizi (fig. 1). The latter

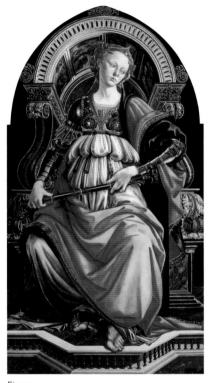

Fig. 2
Sandro Botticelli, *Fortitude*, 1470. Tempera on panel,
167 × 87 cm. Galleria degli Uffizi, Florence.

sheet has provoked varying attributions,
including the name of Botticelli himself.[4]

Although J.C. Robinson attributed the
present sheet to Botticelli in 1869, Berenson
and others later expressed doubts, which
were only definitively rebutted by Popham
and Pouncey in 1950.[5] *Faith* recalls in its
general composition Botticelli's much earlier
panel painting of *Fortitude* executed in 1470
(fig. 2), which completed the series of *Virtues*
commissioned from Piero Pollauiolo for the
ground-floor audience hall of the Palazzo
della Mercanzia in Florence (for Piero's painting
of *Faith* see no. 33, fig. 1). However, upon
sustained observation the differences between
the two works appear substantial and allow
the plausible dating of the sheet to the 1490s.

M F

39 Recto: Standing man tearing a scroll

c. 1485

Black chalk, pen and brown ink, brown wash, heightened with lead white (partly discoloured), 39.4 × 27.4 cm

Verso: Elevations of a coffered dome, wooden construction supporting an arch, an arcade, a pier and three ground plans

c. 1485

Pen and brown ink
Gabinetto Disegni e Stampe degli Uffizi, Florence (155 F)

PROVENANCE

Ferri, *Disegni di Figura* (*c.* 1887); Reale Galleria degli Uffizi (L. 929)

LITERATURE

Fabriczy 1902a; id. 1902b, p. 203; Byam Shaw 1931, pp. 39–44; Berenson 1938, vol. 2, no. 2465; Marchini 1942, p. 105 (Lippi); Fossi in Florence 1955, no. 75; Borsi 1985, p. 483; Bonsanti, Paolucci and Petrioli Tofani in Kyoto 1991, pp. 70–1; Sisi in Florence 1992, no. 2.16; Van Cleave 1994, p. 237; Ames-Lewis 1995b, pp. 51–6; Ciseri in Rome 2000, no. 5.24

Sangallo was both an artist and an architect, and in the latter capacity studied architecture of the classical period, which he first encountered in Rome when he was there between 1465 and 1472. He made numerous drawings of classical remains, but his figurative drawings are rare and the comparisons are thus limited.[1]

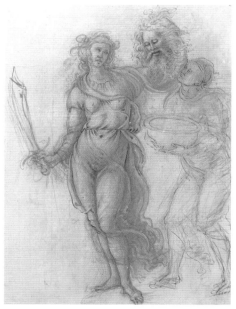

Fig. 1
Giuliano da Sangallo, *Judith with the head of Holofernes*, *c.* 1485. Black chalk, brown wash, heightened with lead white, 37.7 × 27 cm. Albertina, Vienna.

This energetic drawing was first attributed to Sangallo in 1902, linked to a sheet in the Vatican, and subsequently to another in Florence,[2] and all three works display Sangallo's passion for the antique. There is also an affinity between the figure's head and that of Holofernes in a drawing by him in Vienna (fig. 1),[3] and there is another comparable drawing in the Uffizi attributed to Sangallo, *A group of soldiers*.[4]

The sheet is similar in style to Filippino Lippi, and displays an agile handling of the diverse media which recalls Sangallo's exact contemporary and collaborator, Botticelli (see nos 36–8), for whom Sangallo designed the frame for Botticelli's Bardi altarpiece executed in 1485 (the frame is lost but the painting conserved in the Gemäldegalerie, Berlin).[5] The monumentality of the muscular body is emphasized by the flying drapery and seems to accord with an architect's conception of the body as a geometric structure with a columnar solidity. Sangallo has allowed the lively underdrawing in black chalk to show through in many places.

The subject is a classically inspired *exemplum doloris* (an example of suffering) that has been more specifically identified as Moses[6] or the Roman god Jupiter.[7] It has been suggested recently that the subject is Lucretius, based on St Jerome's description of the Latin poet's bouts of madness caused by the imbibing of a love potion.[8] The reference to antique statuary is clear and the pose recalls the celebrated marble group of the *Laocoön* (Vatican Museums, Rome), which Sangallo and Michelangelo studied soon after its discovery in Rome in 1506.[9] This led M. Fossi to date the sheet to *c.* 1514–16, but such a late dating is unlikely.[10] The twisting poses of the *Laocoön* figures must have been known from other sources as they are cited earlier in the Renaissance, for example, in Lorenzo the Magnificent's commission of *c.* 1493 for Filippino Lippi to decorate a lunette with the *Death of Laocoön* in the Villa di Poggio

Fig. 2
Verso of no. 39

a Caiano, a building Sangallo had himself designed.[11]

The verso contains studies in pen and ink related to Sangallo's principal profession (fig. 2). They are drawn rapidly in freehand without a straight edge or measurements. The largest drawing is for a coffered dome in section. Coffering was a Roman invention seen in the Pantheon in Rome, built in the early second century AD, a means of both decorating the interior of a vault or dome and reducing its weight. Sangallo's assimilation of this ancient motif is shown in the way the hexagonal coffering is extended in unorthodox fashion into the spandrel that supports the dome. To the right of this is a brief study of the manner in which the ribs of the dome meet the coffering. At the top right is a sketch of a wooden centring support to allow the

construction of a dome. The three ground plans seem to be related to the sketches in section above, since they are variations on a three-bay scheme with a central dome; the uppermost is overlapped by the faint lines of an arcade and a clear sketch of a pier, presumably related in Sangallo's mind to the dome he had sketched above.

The sketches have been linked to Villa Madama designed by Sangallo's nephew, Antonio da Sangallo (c. 1484–1546), in Rome, but would seem more suited to a religious than a secular building and have a generic, exploratory purpose.[12] Degenhart related the sheet to the Codice Geymüller, an architectural notebook in the Uffizi associated with Giuliano's brother, Antonio da Sangallo (c. 1453–1534).[13]
CC

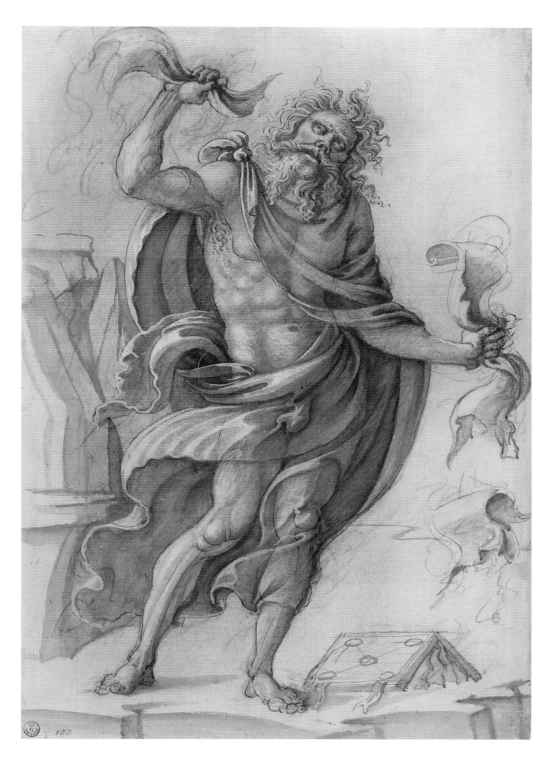

40 # Recto: Head of a woman
c. **1475**

Charcoal (some oiled ?), heightened with lead white, pen and brown ink
on the left eye, 32.4 × 27.3 cm

Verso: Head of a woman (ILLUSTRATED ON P. 185)

Charcoal
British Museum, London (1895,0195.785)

PROVENANCE

J.P. Zoomer (L. 1511); Count A.F. Andréossy; J. Malcolm;
acquired from Col. J. Wingfield Malcolm, 1895

LITERATURE

Morelli 1891, p. 350; Berenson 1938, vol. 1, no. 2782;
Popham and Pouncey 1950, no. 258; Ames-Lewis 1981a,
p. 54; Butterfield 1997, pp. 185–6, figs 246–7; Bambach
1999a, p. 259; Rubin in London 1999, no. 29; Bambach in
New York 2003, no. 3; Covi 2005, pp. 216–18; Syre in
Munich 2006, no. 5

The size of this sheet suggests that it was a
cartoon but one which appears not to have
been used to transfer the composition, since its
contours are unpricked (compare with no. 41).
It is justly considered one of the artist's most
beautiful graphic works.[1] Heads and faces were
the parts of the composition to which a patron
would pay most attention, and it followed that
the artist did likewise. Verrocchio has exploited
the tonal possibilities of the charcoal medium,
softer and more friable than black chalk, to
smooth and blend contours. The striking sense
of form is conveyed as much by the delicate
contrasts of tone as by contour and demon-
strates a technical accomplishment that
anticipates Leonardo's *sfumato*, the soft-edged,
smoke-like modelling achieved through
gradual transition from light to dark.

The drawing is based upon an initial
construction of the face whose lightly drawn
lines are discernible between the eyebrows and
the nostrils, and in the line running through
the centre of the face, down the nose and
through the lips. This technique is also seen
in the *Head of an angel* (no. 41) and reflects the
investigations of Alberti and later Leonardo
into anatomical proportion.

The recto was preceded by an abbreviated
drawing on the verso, also in charcoal. It
depicts the same head similarly inclined and
illuminated from the left, and has an immediacy
that suggests it may have been executed from
life (illustrated on p. 185).[2] The artist has
concentrated on the eyes, nose and mouth,
redrawing the contours, including those under
the chin, to indicate the folds caused by the
model's lowered head. In contrast, the shade
over the right-hand side of the face is described
with light, broad strokes. The woman's right
hand has been rapidly indicated, seen pressed
against her head on her right.

The sheet has been related to another by
Verrocchio in the Uffizi, a preparatory study
for a banner executed for the tournament held
by Giuliano de' Medici in Florence in 1475
(fig. 1).[3] The sketch on the verso in particular
is close to the nymph of the banner study. The
recto head has been linked to that of the Virgin
in the so-called *Madonna di Piazza* in Pistoia
Cathedral, a work commissioned in the mid-
1470s from Verrocchio but largely executed by
his assistant Lorenzo di Credi.[4] Although the
Virgin in the painting differs from this drawing
in the simplicity of her hair style, the resem-
blance between them is sufficiently close to
suggest that Credi took inspiration from
drawings in Verrocchio's workshop, such as
this one, to execute the head in the altarpiece.

A link with Verrocchio's sculptural work
is usually refuted; there is, however, a resem-
blance between the elaborate tresses of the
recto and the *Spes* (goddess of hope) in the
marble monument to Cardinal Niccolò
Forteguerri in Pistoia Cathedral commissioned
after 1473. This resemblance, along with the
link to the standard and the *Madonna di Piazza*,
argue in favour of the established dating of this
sheet to the mid-1470s.

The sheet may well have belonged to Vasari,
since the artist–biographer mentions drawings
by Verrocchio 'in my book done with great
patience and discernment, amongst which are
several female heads of beautiful aspect with
elaborate hairstyles so beautiful that Leonardo
often imitated them'.[5] Vasari's observation is
confirmed by the inspiration of such heads in
Leonardo's early paintings, such as the *Benois
Madonna* of *c.* 1475 now in the Hermitage
Museum, St Petersburg.[6] Two drawings of
heads by Credi (no. 42) and Leonardo (no. 48)
illustrate the way in which the younger artists
translated Verrocchio's teaching, producing
independent works that nevertheless represent
a continuum with their master's method. IR

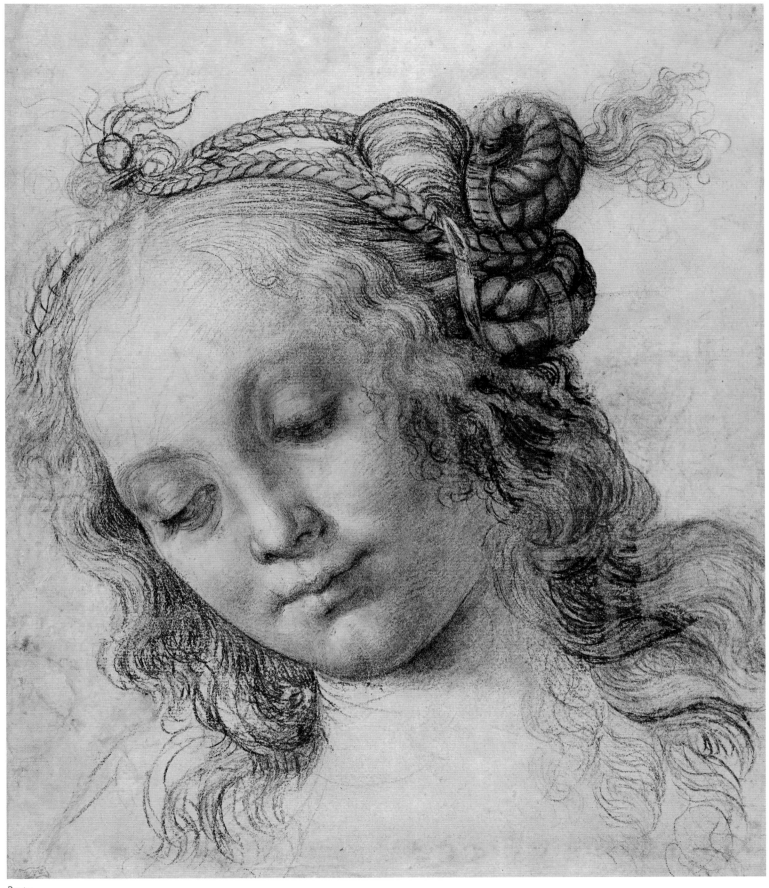

Recto

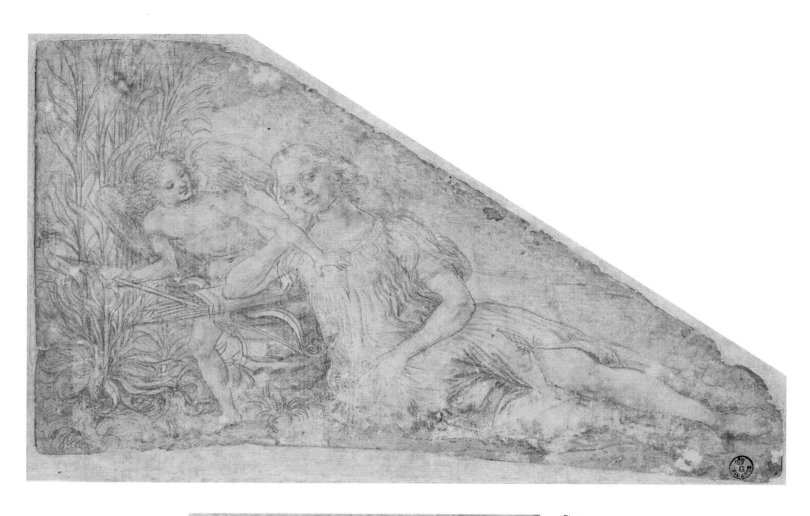

Fig. 1
Andrea del Verrocchio and ?Leonardo da Vinci,
Nymph, *c.* 1475. Metalpoint, brown wash and
black chalk on cream preparation, 14.8 × 25.9 cm.
Gabinetto Disegni e Stampe degli Uffizi, Florence.

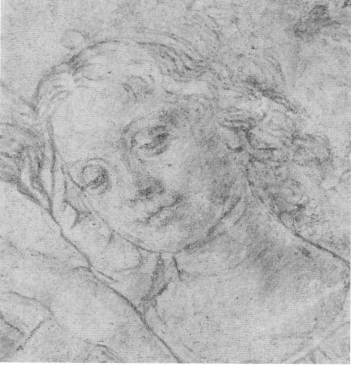

Fig. 2
Detail of fig. 1 showing the head of the nymph.

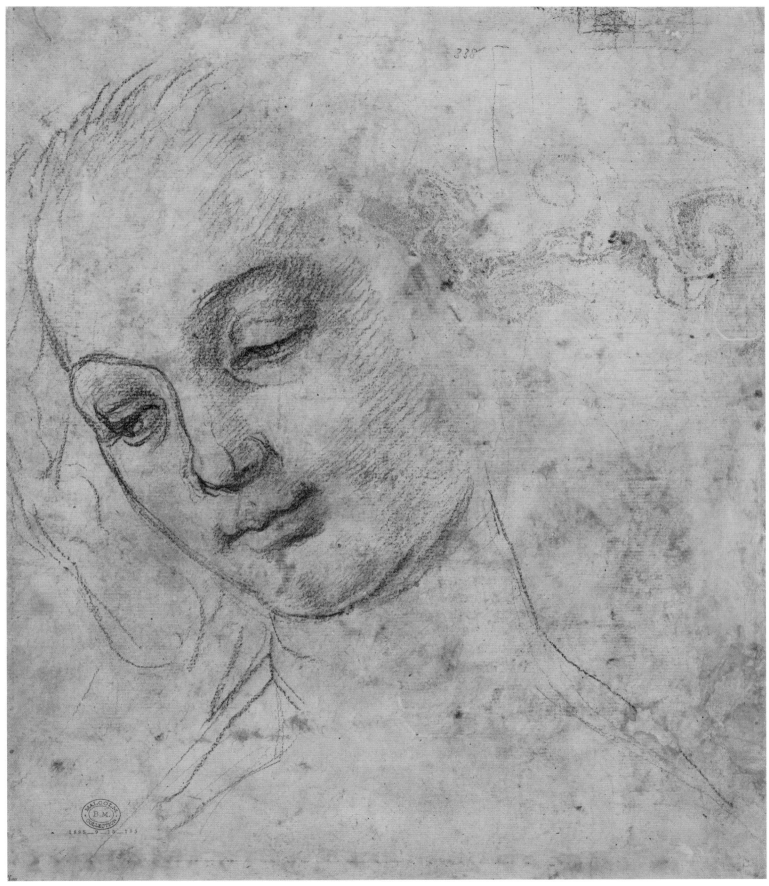

Verso

41 Head of an angel

c. 1475

Black chalk, pen and brown ink, brown wash (? by a studio hand) the contours pricked
and the surface apparently rubbed with pouncing, 21.1 × 18.1 cm
Gabinetto Disegni e Stampe degli Uffizi, Florence (130 E)

PROVENANCE

Ferri, Disegni Esposti (1879–1881); Reale Galleria degli
Uffizi (L. 929)

LITERATURE

Lagrange 1862, no. 121; Morelli 1891, p. 350; Berenson
1938, vol. 2, no. 2781; Petrioli Tofani 1972, no. 14;
Ragghianti Collobi and Dalli Regoli 1975, p. 42; Petrioli
Tofani 1986, p. 57; Adorno 1991, pp. 87, 97, 115, 264;
Monaci Moran in Florence 1992, no. 8.3; Butterfield 1997,
p. 185; Bambach 1999a, pp. 51, 241, 262; Rubin in London
1999, no. 22; Covi 2005, pp. 221–2

In this drawing, Verrocchio has initially drawn
in light strokes of black chalk before reinforcing
the contours.[1] Subsequent pen strokes merge
with the longer cursive strokes of chalk in the
cheeks and strengthen the sense of volume.
The locks of hair and depiction of shadow have
also been intensified with pen and ink, perhaps
by a studio hand.[2] The almost shimmering fall
of light is conveyed not by white heightening,
as some have supposed, but by allowing the
bare paper to show through.[3] Verrocchio's
sculptural sense even when drawing for a
projected painting is revealed here, in the way
he seeks to convey a sense of three dimensions
on paper, through the delicacy of the tonal
shift between light and shade, an approach
that was of great influence on Leonardo.

The face has perhaps been drawn from life
and may have formed part of a larger drawing,
suggested by the parallel strokes to the top left
cut off by the trimming of the sheet, which
could conceivably be indications of a wing. The
drawing's function as a cartoon is revealed by
the pricked contours to allow the transfer of
the figure either to the painting surface or to
another sheet that would have been placed
underneath.[4] The drawing demonstrates the
fundamental role of same-size drawings within
the studio to ensure an exact transfer of the
painter's worked-out design to the under-
drawing. Verrocchio's artistic stature was even
recognized by non-artistic contemporaries in
Florence such as Ugolino Verino (1438–1516),
poet to the court of Lorenzo de' Medici, who
described him as a model for all aspiring

Fig. 1
Andrea del Verrrocchio and Leonardo da Vinci,
Baptism of Christ, c. 1475–80. Tempera on panel,
177 × 151 cm. Galleria degli Uffizi, Florence.

artists in his *De illustrazione urbis Florenti*,
written around 1480–7.[5]

Characteristic of Verrocchio's style are the
prominent forehead and jaw-bone, and the
sense of bone structure beneath the skin, as are
the rounded eyelids and eyebrows, broad nose,
and the mouth with its double arched upper
lip.[6] Indistinct in gender, the face appears to
embody the notion of grace as described in
Marsilio Ficino's platonic theories, appropriate
to the superior nature of an angel.[7]

The sheet has been traditionally attributed
to Verrocchio and was considered an exemplar
of the artist's style by Giovanni Morelli (1816–
91), who sought to apply scientific method to
attribution. Morelli also thought that it might
relate to the right-hand angel in Verrocchio's
Baptism of Christ (Uffizi, Florence)[8] executed
for S. Salvi, Florence, in the mid-1470s (fig. 1).[9]
For the earlier German art historian Passavant
(1787–1861) the angel's meditative down-
wards glance suggested that it was drawn by
Leonardo.[10] More recently, the sheet has been
related to the head of the archangel Gabriel

in the Verrocchio studio panel in the National
Gallery, London, of *Tobias and the Angel*
(1470–80), which recalls the head of this
sheet in reverse although on a different scale.[11]
Nevertheless, these various comparisons
support the dating of the sheet to the
mid-1470s. IR

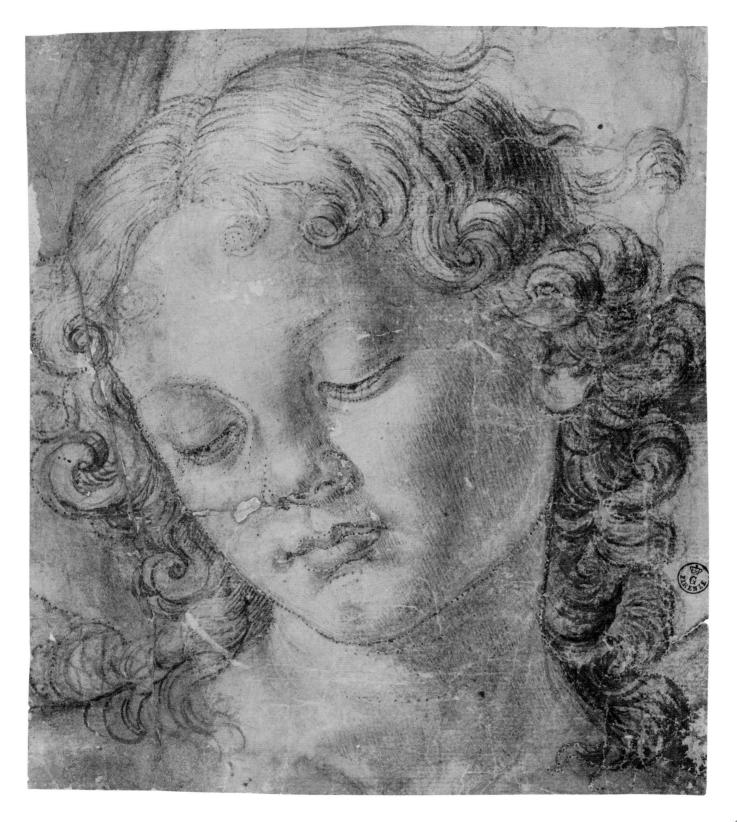

42 Veiled head of a woman

c. 1490

Black chalk (? some pouncing marks along the face and the veil), metalpoint (? silverpoint),
brown wash, heightened with lead white, on pink preparation, 20.5 × 17.7 cm
Inscribed in an old hand: 'Lor.^{zo} di Credi'
Gabinetto Disegni e Stampe degli Uffizi, Florence (1195 E)

PROVENANCE

Fondo Mediceo (Elenco Bassetti, 1699); Reale Galleria
degli Uffizi (L. 929)

LITERATURE

Degenhart 1932, p. 153; Berenson 1938, vol. 2, no. 685;
Dalli Regoli 1966, no. 81; Petrioli Tofani 1987, p. 496;
Bartoli in Rome 2000, vol. 1, no. 5.27

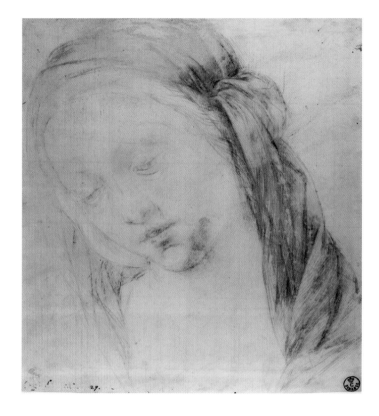

Fig. 1
Infrared reflectograph of
no. 42

Lorenzo di Credi's posthumous reputation has suffered, partly because of the dwindling understanding of the artistic milieu to which he belonged, and also due to the invidious comparison with his fellow pupil in Verrocchio's studio, Leonardo da Vinci.[1] Although Credi's art may lack individuality, his technical proficiency was such that he took over the running of Verrocchio's workshop after the master's departure for Venice *c.* 1480.[2] The workshop system was embedded in the social and economic fabric of Florence, to the extent that the fifteenth-century Florentine historian and poet Benedetto Dei, author of *La cronica dall'anno 1400 all'anno 1500* (*Chronicle from the year 1400 to 1500*), likened God to the head of an atelier to God.[3]

The drawing's traditional attribution to Credi has never been doubted, and it is indeed characteristic of the artist, especially in the precise oval of the face, with its slightly swollen eyelids and mouth.[4] The inclined female head with loose or braided hair and an absorbed gaze was a popular subject in Verrocchio's studio, as it was a pose that could be continually adapted for representations of the Virgin, and Credi produced many drawings and paintings in which this head is reproduced with only small variation.[5] Credi was renowned as a specialist in small devotional paintings, the demand for which was increased by the growth of the merchant class. These images were usually restricted to a small range of subjects and tied to traditional forms of representation, which did not allow for much variation on the established visual canon.

Credi's technique is elegant and meticulous: he drew the initial lines of the composition in metalpoint, on paper prepared with pink pigment to receive the silvery lines of this medium. He then described the form with emphatic strokes of the brush, carrying ink that was diluted for areas of shadow (fig. 1).[6] White was applied with delicate short brush strokes to the eyelids and beneath the eyes (discoloured in places), around the nose and the indentation of the chin, conveying a masterly luminosity, learnt from Verrocchio and further refined through contact with Leonardo.

The oval of the woman's face is accentuated by the hair gathered beneath an elaborately arranged veil that falls over the shoulders, framing the elegant neck. The veil had diverse connotations related to religion and fashion, but also permitted Credi to display his technical accomplishment in the representation of material, a skill shared with others of his contemporaries and seen in other drawings in this catalogue by Fra Filippo Lippi (no. 12), Domenico Ghirlandaio (no. 61) and Boltraffio (no. 71).[7] Credi gives the drapery a luminous and silky quality through the application with a brush of thinned ink, over which he applies a layer of white. By concentrating in this way on the volume and texture of the material, the artist reduces the iconic nature of the face and gives it a more intimate character. Nevertheless, its impeccable devotional qualities were intended to inspire the observer of the final painting. IR

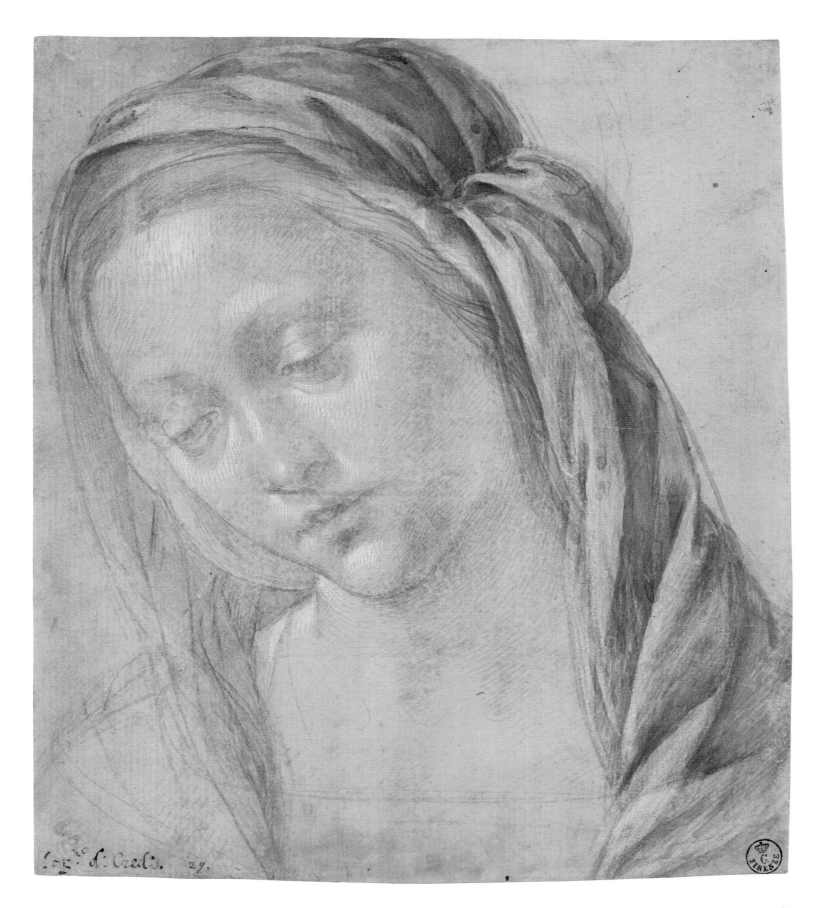

Iog.o d: Credi. 29.

189

43 Three clothed standing women; two standing nude figures; and a kneeling man

c. 1510

Leadpoint (?), pen and brown ink, brown wash, heightened with lead white, 24.4 × 17.5 cm
Gabinetto Disegni e Stampe degli Uffizi, Florence (218 E)

PROVENANCE

Fondo Mediceo (Nota 1687); Reale Galleria degli Uffizi
(L. 929)

LITERATURE

Degenhart 1932, p. 102 (as Gian Jacopo Mattoncini da
Castrocaro); Berenson 1938, vol. 2, no. 1852 A (as Piero di
Cosimo); Dalli Regoli 1966, no. 145; Petrioli Tofani 1986,
p. 96; Cecchi in Florence 1992, no. 6.10; Bartoli in Rome
2000, vol. 1, no. 5.28

Fig. 1
Infrared reflectograph detail of
no. 43; underdrawing of standing
woman on the right.

The attribution of this sheet was not fixed until
it was attributed to Credi by Dalli Regoli and
dated to the early 1500s.[1] Cecchi concurred
but associated it with Credi's later works in the
second decade of the 1500s, such as the *Sacra
conversazione*, now in the Gemäldegalerie Alte
Meister, Dresden.[2] Although there is no precise
correspondence with any known work by
Credi, the oval faces, languorous appearance
and swaying pose of the three clothed women,
one of whom holds a palm of martyrdom in
her left hand, accord well with the artist's
depiction of female saints.[3]

The order in which the drawings were
executed is uncertain: the first drawn on the
sheet is perhaps the pen-and-ink sketch of
a standing female nude to the lower right,
followed by the clothed woman to the left
of her, initially drawn nude as revealed by
infrared. The third stage may be the two much
larger and elaborately clothed figures, the left-
hand one most closely related to the lower
study. The main right-hand figure is allowed to
impinge on the nude among the lower studies,
but not the more finished, clothed one. There
are significant differences in finish between the
three female figures: in the first, smaller one,
the drapery is drawn in bold and dense strokes
of the pen with wash added; in the two studies
above the scale is far greater, allowing the
drapery to be examined in more detail with
wash of varying tone and touches of white to
show where the gathered folds of cloth catch
the light.

The sheet clearly demonstrates Credi's
meticulous method of preparatory study learnt
in Verrocchio's workshop,[4] by which the figure
is defined in stages, starting with the anatomy
and then the face, before clothing the figure
in drapery described in various aspects of
light and shade. Other artists such as Sandro
Botticelli and Filippino Lippi shared this
working method, but without the rigour
practised in Verrocchio's studio.[5]

Infrared reflectography has further revealed
the artist's continual readjustments: the main
right-hand figure was first conceived with her
left arm raised (fig. 1); while the face of the
main left-hand figure has been tilted upwards
from its initial position. The pen is handled
with precision and vitality, the details never
becoming muddled even in the areas where the
media are many layered, such as the shadows.
In comparison with a sheet from early in
Credi's career, such as the preparatory study
in the Louvre of *St Bartholomew* destined for the
Florentine guilds' church of Orsanmichele,[6]
the figures have a greater fluidity, confirming
the late dating of the sheet.

The scarcely clothed bearded man kneeling
before the lower draped woman is perhaps
inspired by one of the kneeling worshippers in
Leonardo's *Adoration of the Magi* (no. 53, fig. 1.).
On a smaller scale to the left of the kneeling
man is a rapid sketch of a nude with his right
arm raised, perhaps St John the Baptist. The
nude figure at the bottom right has been linked
to Dürer's engraving of *Four witches*,[7] while the
lower draped figure depicts in reverse Credi's
paintings of *Venus* in the Uffizi[8] and the *David* in
Christ Church Gallery, Oxford.[9] All these poses
derive from Credi's observation of antique
statuary, a valuable source of inspiration
or sacred themes in the Renaissance. It is
interesting to note the brooch worn by
the main right-hand woman, a motif favoured
by Verrocchio and seen in several works by
Leonardo such as the *Benois Madonna*,[10] in the
Hermitage, St Petersburg, and the *Virgin of
the Rocks*, in the National Gallery, London.[11]

I R

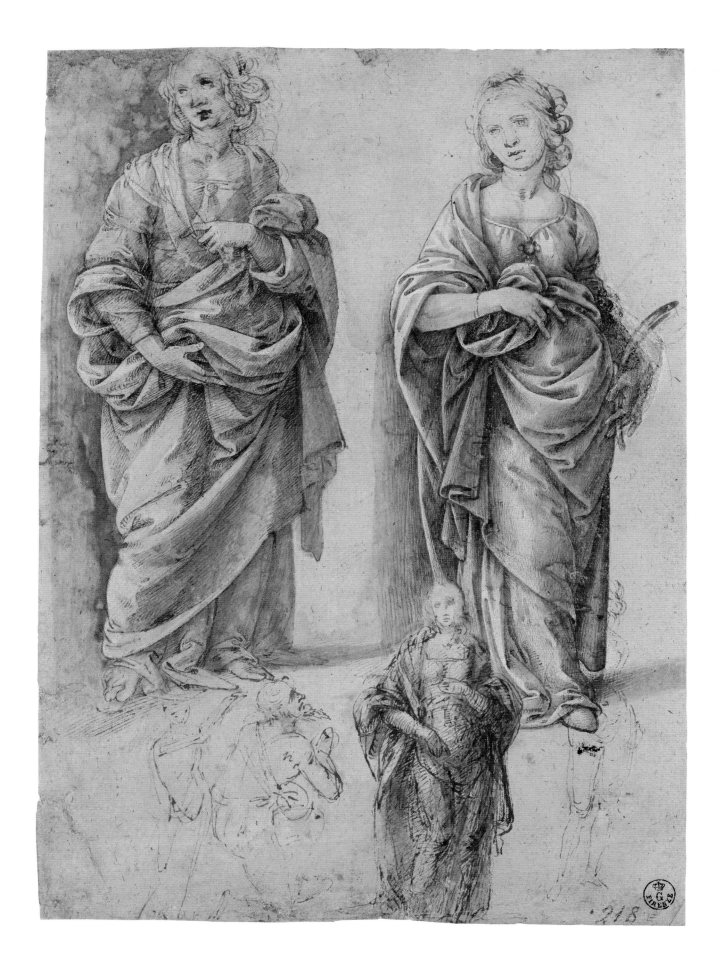

44 Astronomy

c. 1490–9

Leadpoint (?), brown wash, heightened with lead white, 39.3 × 26.1 cm
Gabinetto Disegni e Stampe degli Uffizi, Florence (493 E)

PROVENANCE

Fondo Mediceo-Lorenese (Pelli after 1775–before 1784);
Reale Galleria degli Uffizi (L. 929)

LITERATURE

Degenhart 1932, p. 153 (anonymous 16th century);
Berenson 1938, vol. 2, no. 682 A; Petrioli Tofani in
Florence 1961, no. 17; Dalli Regoli 1966, no. 129; Petrioli
Tofani 1986, pp. 222–3; id. in Florence 1992, no. 3.7

Credi first drew the entire pose of this seated young woman in leadpoint, as infrared reflectography has recently revealed (fig. 1). The artist subsequently built up the elaborate drapery in layers of wash (leaving no bare paper), over which strokes were applied in ink and in white with the brush to demonstrate the fall of light from the left. These long and subtle lines merge to convey a harmoniously asymmetrical mass of folded and hanging drapery,[1] wrapped around the figure's extended right leg beneath

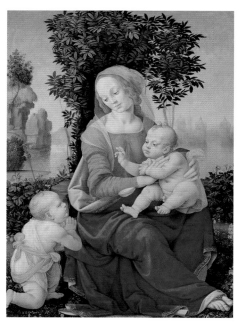

Fig. 2
Lorenzo di Credi, *Virgin and Child with the Infant Baptist*, c. 1510. Oil with tempera highlights on panel, 101.8 × 72.7 cm. The Nelson-Atkins Museum of Art, Kansas City.

which a further gathering of drapery falls to the ground.

The woman's identity as *Astronomy* is demonstrated by the celestial armillary sphere (a skeleton globe consisting of metal rings or hoops representing the orbit of the planets and stars) she holds in her left hand, which she elegantly indicates with her right. Although a knowledge of astronomy was considered an essential for an artist,[2] this representation of an astronomical subject is unusual in the surviving body of work by Credi, which is largely restricted to religious works, especially in the 1490s when he was influenced by the purity of conduct and expression advocated by the Dominican priest and leader of Florence, Girolamo Savonarola.

The unfinished upper portion of *Astronomy* displays the function of the sheet as both a prototype for the figure's drapery, and as an autonomous model to be copied and reused in Credi's workshop.[3] Such a use is suggested by the fact that there is no precise correspondence between *Astronomy* and any known painting by Credi, yet the drapery alone is reproduced exactly in a panel painting of the *Virgin and Child with the Infant Baptist* in Kansas City (fig. 2), as is the slender tree also seen in the drawing, a motif found in several of Credi's works.

The sheet displays the importance of drapery studies in the fifteenth-century workshop, as artists sought to give their works an ever greater sense of truth to life and visual impact. Their research was founded on the observation of antique statuary, in which drapery served to emphasize and delineate the form of the underlying body. The present study may derive from a mannequin, wrapped in cloth dipped in clay slip to allow the prolonged study of light falling over deep folds, thereby employing a method described in contemporary treatises such as those by Antonio di Pietro Averlino called Filarete and Alberti, and later by Vasari in the mid-sixteenth century.[4] It is significant that Verrocchio, whose workshop Credi worked in, was primarily a sculptor who strove to achieve three-dimensional effects in his drawn studies,

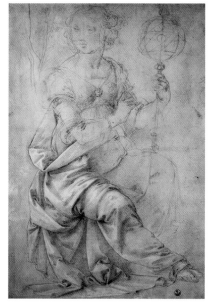

Fig. 1
Infrared reflectograph of no. 44

and his influence can be seen on other Florentine artists in this book, namely Ghirlandaio (no. 60),[5] Fra Bartolommeo (no. 89) and Leonardo's pupil Boltraffio (no. 71). Leonardo was Credi's companion in Verrocchio's studio and another great influence on Credi; Vasari praised Credi as the artist who came closest to matching Leonardo's limpid style.[6]

In Credi's surviving graphic oeuvre this sheet is perhaps closest stylistically to a male figure study in the Musée des Beaux Arts, Paris.[7] It has been suggested that the diagonal pose of the figure's right leg combined with the opposing diagonals of the folds above it derive from the Virgin in Leonardo's cartoon in the National Gallery, London (fig. 1, no. 56).[8] However, Leonardo's composition is dated either to c. 1499 or later, c. 1506–8, and must therefore have been preceded by a model circulating within Verrocchio's workshop, an idea supported by a sheet in the Uffizi given to Verrocchio in which the drapery is similar to that in *Astronomy*.[9] Both Credi and Leonardo would appear to have been inspired by prototypes of their common master Verrocchio. IR

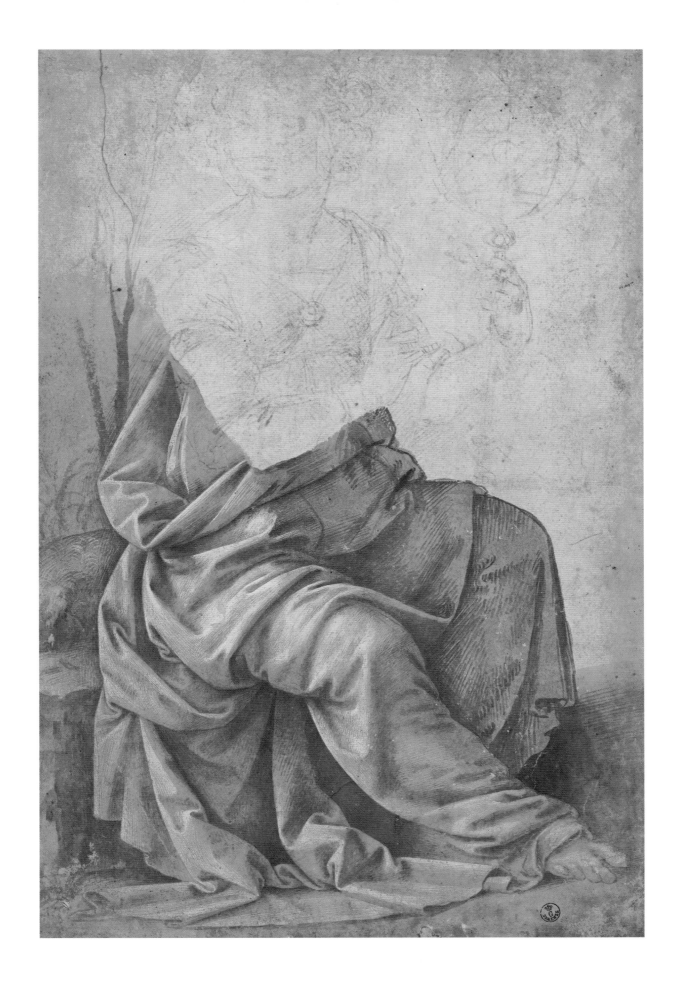

PIETRO VANNUCCI, called PERUGINO (*c.* 1450–1523)

45 Adoration of the Magi

c. 1480–90

Leadpoint, pen and brown ink, 19.2 × 18.2 cm
British Museum, London (1853,1008.1)

PROVENANCE

J. Richardson sen. (L. 2183); W. Esdaile (L. 2617); Sir T.
Lawrence (L. 2445): acquired from W.B. Tiffin, 1853

LITERATURE

Wickhoff 1899, p. 210 (as Fiorenzo di Lorenzo); Fischel
1917, pp. 10–12, 49, 95, pl. 1; Popham and Pouncey 1950,
no. 187; Russell 1974, pp. 644–52; Ferino Pagden 1987,
pp. 79–81, Scarpellini 1991, p. 82; Gentilini 2004, p. 203;
Venturini 2004, p. 332

The *Adoration of the Magi* is thought to relate
to a scene in the fresco cycle executed by
Perugino in the 1480s in a cloister of the
Ingesuiti convent of S. Giusto alle Mura in
Florence.[1] The fresco, along with the church,
was destroyed in the siege of Florence in 1529
but some idea of its appearance can be gained
from Vasari's description 'a Nativity with Magi
of delicate style which [Perugino] executed
with great beauty and lucidity and perfect
finish, in which there were an infinite number
of heads and portraits from life including that
of his master, Verrocchio'.[2] The influence of
the composition, and of the main figures in
particular, is seen in an arched panel of the
same subject by a follower of Perugino in the
Pitti Palace,[3] while a precedent is provided
by the Perugino and studio painting of 1477
now in the Galleria Nazionale dell'Umbria,
Perugia.[4]

The drawing has both a level of detail and
a liveliness that recalls Perugino's frescoes in
the Sistine Chapel (1480–82), including the
Giving of the Keys and in particular the *Baptism
of Christ*, whose groupings of figures and
background landscape are similar to those in
the drawing.[5] Perugino indicated the round-
topped shape of the intended fresco lunette in
summary lines of the pen, around which the
sheet was subsequently cut. The composition
presents an ingenious play of solids and voids:

to the left of the sheet an arcade is depicted in
steep recession, halted in the middle distance
by a single arcade at right angles, and matched
on the right-hand side by tall trees in the
distance. This scheme defines the space in
which the sacred event of Christ's presentation
to the Magi occurs and, according to Vasari's
account, the arcades in the drawing must have
reflected closely those of the real cloister.[6]
The drawing demonstrates Perugino's concern
to connect the pictorial space with the
architectural setting.

The pen and ink was added over an initial
drawing in leadpoint, barely discernible to
the naked eye, rather than black chalk as tradi-
tionally believed (this discovery is the result
of scientific analysis conducted in preparation
for this exhibition). The strokes of the pen
are rigorous and uncrossed, often displaying
hooked ends, the result of the artist's not lifting
the pen for the return stroke; this is seen
especially clearly in the left bay of the arcade
and is a peculiarity of Perugino's style, also
seen in no. 46 and another sheet in the Uffizi,
Study of the Virgin and Child, which reproduces
the motif of the Virgin and Child in an almost
identical way.[7] Perugino also applies his
graphic shorthand to the diversely posed
and vivid figures, some of whose attitudes are
repeated later by his studio, such as the young
king standing in the right foreground.[8]
Perugino's graphic style bears the influence
of his contemporaries in Verrocchio's studio,
such as Credi and Leonardo, and here is
particularly close to Ghirlandaio.[9]

The verso contains a study of the Virgin
and Child and a separate study of a leg, only
discovered in 1944, but their poor quality
suggests that they are copies after original
drawings by Perugino, or a redrawing of an
original drawing in leadpoint. IR

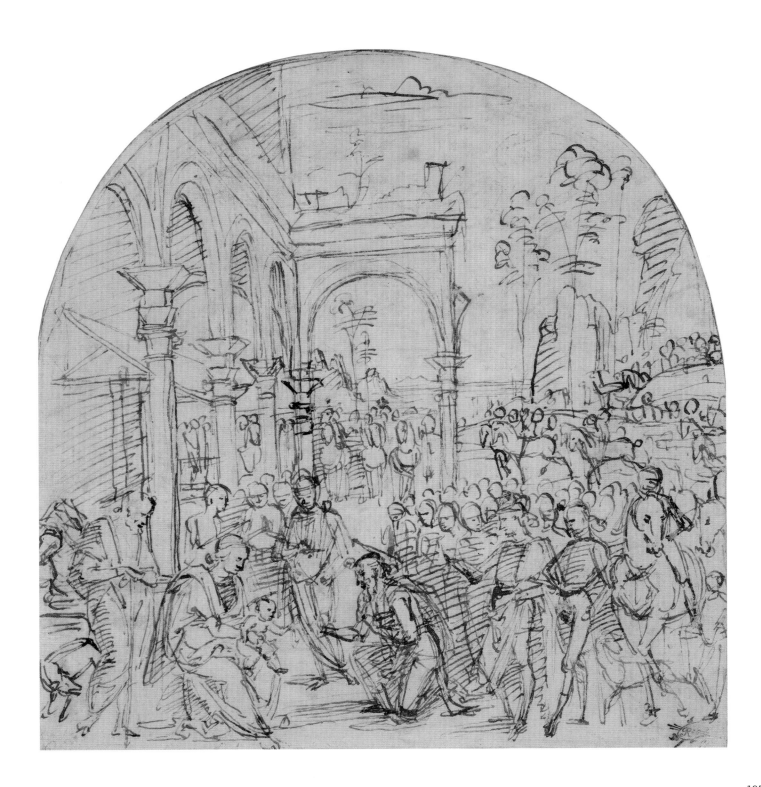

46 Sibyl

c. 1498

Leadpoint (or black chalk?), pen and brown ink, 20.4 × 8.6 cm
Gabinetto Disegni e Stampe degli Uffizi, Florence (399 E)

PROVENANCE

Fondo Mediceo (Nota 1687); Reale Galleria degli Uffizi
(L. 930)

LITERATURE

Ferino Pagden in Florence 1982, no. 27; Scarpellini 1984,
under no. 97; Garibaldi 2004, p. 176; Venturini 2004,
p. 332; Faietti 2006–7, p.176

In 1496 Perugino was commissioned to fresco the audience chamber of the Collegio del Cambio, an institution that was the fulcrum of Perugia's political and commercial activity.[1] The frescoes on the vaults contain representations of the planetary gods within elaborate decoration that owe much to the pictorial schemes of Perugino's Umbrian compatriot, Bernardino Pintoricchio, especially those executed in Rome between 1487 and 1493, which Perugino may have studied at first hand. The walls were reserved for large-scale scenes based on an iconographic programme devised by the Perugian scholar Francesco Maturanzio.[2]

This sheet is preparatory for the fourth sibyl from the right in a group of six in a lunette-shaped scene paired with another on the opposite side of the chamber (fig. 1).[3] In Christian exegesis the sibyls were considered pagan equivalents of the Old Testament prophets and to have similarly foreseen the arrival of Christ.[4] The sibyls are balanced by a matching number of prophets while an image of God the Father appears above; the prophetic role of both groups is indicated by the scrolls they hold (not shown in the present sketch) containing inscriptions chosen, no doubt, by Maturanzio. In turn, there are identifying inscriptions below each figure in the fresco, which indicate that the present study is for the Cumaean sibyl, the most revered prophetess in ancient Rome because of her geographical proximity in Cumae, an ancient Greek colony outside Naples.

Perugino has drawn very rapidly with pen and ink over an initial drawing in either leadpoint or black chalk that is faintly visible in places, for example, along the right-hand contour and on the right forearm.[5] The sketch describes the overall composition of the figure as executed, including the fall of light from the right that casts the sibyl's face into shade. The hatching is oblique and largely without cross-hatching and the lines display Perugino's characteristic hooked ends, for example, over the sibyl's right breast (compare with no. 45).

The sheet has been closely trimmed, to the extent that the figure's bare feet seen in the fresco have been lost. That the larger sheet from which it derives contained similar studies for single figures, either for the same sibyl or those adjacent, is strongly suggested by the fragmentary drawing in pen and ink of a left

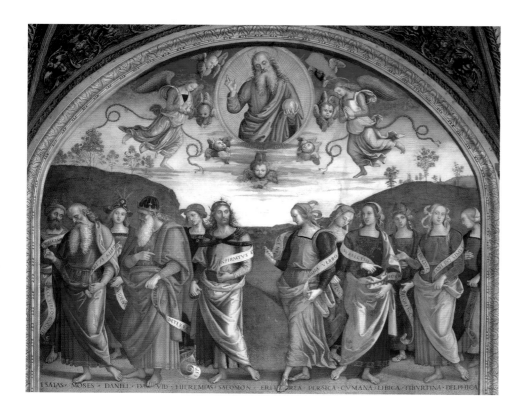

Fig. 1
Pietro Perugino, *God the Father with prophets and sibyls*, c. 1498. Fresco, Sala dell'Udienza, Collegio del Cambio, Perugia.

foot on the verso (fig. 2). It was drawn to a slightly larger scale, with the sheet turned 90 degrees in relation to the recto, and is cut at the top, demonstrating that the sheet once extended significantly in this direction (corresponding to the closely cropped left edge of the recto). The foot matches in both composition and lighting the left foot of King David in the same fresco.[6] The studies Perugino produced for individual figures were almost certainly preceded by an initial summary sketch of the entire composition, of the type seen in no. 45.

Perugino's confident embracing of Verrocchio's sculptural precepts is seen in the way he has drawn the figure swathed in drapery (rather than initially indicating the figure in the nude), while still conveying a sense of the underlying body, such as where the material is stretched over the bent right knee.[7] In turn Perugino's mature graphic style was to be highly influential on the young Raphael, who was receptive to the older master's drawing technique.

Perugino's ideal of female beauty as exemplified in this sketch, a type often to be found in the copious production of paintings by him and his studio, was no less important as a model for the young Raphael. The motif of the sibyl seen in this drawing is anticipated by that of the Virgin in Perugino's *Vision of St Bernard* of 1490 (Alte Pinakothek, Munich) and the correspondence is even greater with the female witness in *The Presentation of the Virgin*, a predella panel of *c.* 1497 (S. Maria Nuova, Fano).[8] The same pose is seen later in the *St Helena* of 1505–7 (Staatliches Lindenau-Museum, Altenburg), a work that clearly displays the influence of Leonardo.[9] EM

Fig. 2
Verso of no. 46 (detail), *Study of a left foot*, *c.* 1498. Pen and brown ink, traces of lead white heightening.

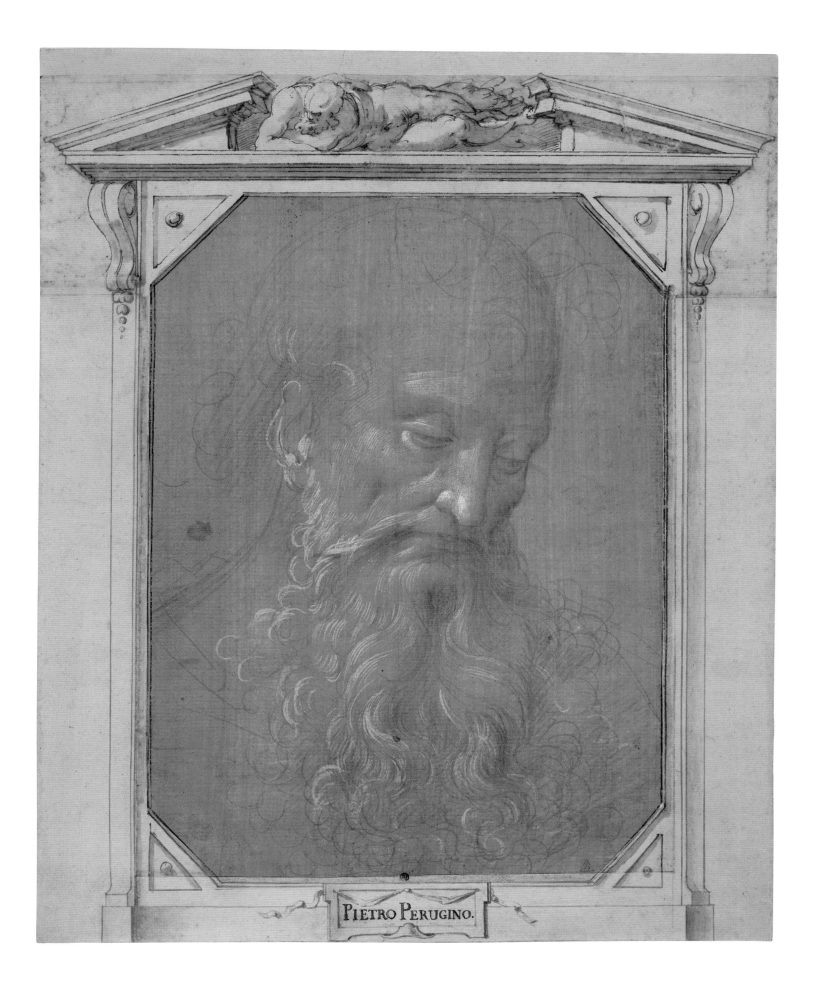

PIETRO PERUGINO.

47 Head of a man with a long beard

c. 1490–1500

Leadpoint and silverpoint, some gum-based (?) glazes in shading, heightened with lead white,
on ochre preparation, 24.6 × 17.8 cm
Inscribed by P.-J. Mariette on mount: 'PIETRO PERUGINO'
British Museum, London (Pp,1.28)

PROVENANCE

G. Vasari; P.-J. Mariette (L. 2097); Marquis de Lagoy
(L. 1710); Richard Payne Knight Bequest, 1824

LITERATURE

Fischel 1917, vol. 1, no. 45, p. 112; Popham and Pouncey
1950, no. 188; Ragghianti Collobi 1974, p. 88; Wohl 1986,
no. 15; Scarpellini 1991, under no. 61

Fig. 1
Infrared reflectograph of no. 47 showing leadpoint
underdrawing.

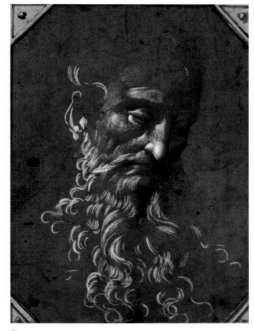

Fig. 2
Ultraviolet reflectograph of no. 47 showing
silverpoint underdrawing and lead white highlights.

The drawn frame to this head of a man demonstrates that the sheet once formed part of Vasari's famous *Libro de' Disegni* (and that its corners have been cut from at least the mid-sixteenth century).[1] The strips beneath the volutes at the top and most of the bottom of the frame were redrawn by the great French collector Pierre-Jean Mariette in the eighteenth century, who copied Vasari's style and no doubt repeated his attribution to Perugino.[2]

Recent scientific analysis has revealed that Perugino drew the head in two types of metalpoint, first employing a leadpoint to draw the outline of the head and the contours of the beard, and secondly picking up a silverpoint to add detail to the eyes and nose (figs 1–2). Since silverpoint is transparent to infrared radiation it disappears in fig. 1, leaving the centre of the face undefined. In fig. 2 the silverpoint and white heightening are emphasized in the ultraviolet reflectograph. Silverpoint is a hard medium of invariable line, which would leave no trace other than an indent on bare paper. The paper has thus been prepared with pigment (in this instance ochre) applied in vertical strokes of the brush, whose striations are clearly visible. Silverpoint requires great confidence on the artist's part, since its marks cannot be rubbed out and tonal variations are only achieved by alterations to the density of the parallel hatching. The tonal range of the medium can be widened through the use of white heightening, applied here in filament-like strokes of the brush to describe the fall of light from the upper left (the direction of which is copied in Vasari's frame). Leadpoint is a softer medium that leaves a mark when drawn across the surface of unprepared paper

and can be easily rubbed out, making it an ideal medium to sketch initial ideas. It also has a pleasing tonal variety in comparison to the inflexible line of silverpoint.

Fischel identified the head as preparatory for St James to the left of the Virgin in the altarpiece Perugino executed for S. Agostino in Cremona (signed and dated 1494), although this would seem unlikely as the light falls from the right in the altarpiece, as noted by Popham and Pouncey.[3] That the sheet remained in the workshop as a point of reference is suggested by the panel painting in Chantilly attributed by Scarpellini to Perugino and his studio, in which there is another head of St James that recalls this drawing.[4]

The drawing is a rare survival in Perugino's graphic oeuvre of a head study, and is the result of a process of idealization that demonstrates the elaborate preparation that a painting demanded. It is in contrast to the other class of Perugino's surviving head studies in which the

subject is derived from life, seen in the black chalk *Man in a headscarf* in the British Museum.[5] A survey of Perugino's surviving drawings shows that in his early works he preferred to use prepared paper surfaces, gradually changing to leadpoint from the early 1500s;[6] this sheet would thus appear to date from a transitional period in which the artist employed both media. The use of two metalpoints is also seen in Filippino Lippi's *Two male nudes* (no. 65). IR

48 Head of a woman looking down

c. 1468–75

Black chalk or leadpoint, brown and grey-black wash,
heightened with lead white (partly discoloured), 28 × 20 cm
Gabinetto Disegni e Stampe degli Uffizi, Florence (428 E)

PROVENANCE

Fondo Mediceo (Nota 1687); Reale Galleria degli Uffizi
(L. 930)

LITERATURE

Berenson 1903, vol. 2, no. 2791 (as copy after Verrocchio);
Berenson 1938, no. 1015 A; Passavant 1969, no. App. 43;
Petrioli Tofani 1972, no. 30; Dalli Regoli and Pedretti 1985,
no. 5; Caneva in Florence 1992, no. 4.15; Wiemers 1996,
p. 147; Brown 1998, pp. 156–7 (as Lorenzo di Credi);
Pedretti in New York 2003, pp. 83–5

The traditional attribution to Leonardo of this
celebrated study has sometimes been ques-
tioned. Reaching a conclusion on this issue is
complicated by the drawing's compromised
condition, as liquid has effaced much of the
wash and white heightening on the right side.
Overall the brown wash is also faded, thereby
altering its tonal balance with the white
heightening and the grey wash that have been
unaffected by light exposure. The yellowing of
the paper has also made the artist's corrections
in now semi-transparent white heightening
more prominent. The use of the heightening
as a correcting fluid to cover over passages,
such as a first attempt at the profile of the chin
(fig. 1) and the shortening of the length of the
hair on the left, is found in other drawings by

Fig. 1
Infrared reflectograph of no. 48 showing detail of
the alterations to the chin.

Verrocchio's circle, such as no. 43.[1] The
drawing's condition has led some scholars to
describe the grey wash or parts of the white
heightening as later retouching, yet the homo-
geneity of these elements argues strongly against
this.[2] For example, a comparable dark wash is
used on the left eye, one of the weakest parts of
the drawing, and in one of the most beautiful
and best preserved passages, the description of
the hair on the far side of the face.

 The woman's features, the viewpoint,
lighting and the meditative atmosphere of the
drawing recall Verrocchio's Berlin *Virgin and
Child* (fig. 2), one of the few paintings generally
believed to be autograph.[3] It is likely that the
drawing was made with such a devotional
painting in mind, as these were a staple element
of Verrocchio's studio production. Another
source of inspiration was Verrocchio's finished
drawings of female heads, like no. 40. Vasari
mentions owning comparable drawings by
Verrocchio of female heads with 'lovely expres-
sions and hair which Leonardo da Vinci used
to imitate for their beauty'.[4] A comparison
between Verrocchio's two studies of heads
(nos 40–1) and the present one seems to rule
out that they could be the work of a single
hand. The Uffizi drawing does not have such a
strong sense of sculptural three-dimensionality,
there is a greater focus on rendering surface
detail and the artist responsible for it struggled
to position the left eye, with one attempt
scratched out and another pen contour of the
eyelid now revealed by the flaking of the white
heightened correction. The rather clumsy
efforts to disguise these alterations with dark
grey wash and now darkened white heightening
disconcertingly makes it appear as if heavy
1960s-style mascara had been applied.

 The suggestion that Lorenzo di Credi might
be the highly gifted, yet inexperienced, pupil of
Verrocchio responsible for the drawing seems
improbable as his finest mature drawings, such
as nos 42–4, are never so delicately or subtly
executed. The same also holds true of other
pupils of Verrocchio in the late 1460s and early
1470s, such as Pietro Perugino and Francesco

Fig. 2
Andrea del Verrocchio, *Virgin and Child*, c. 1470.
Tempera on panel, 72 × 53 cm. Gemäldegalerie,
Staatliche Museen, Berlin.

di Simone.[5] The traditional attribution to
Leonardo seems the most plausible, on the
grounds that he is the only Verrocchio pupil
capable of such technical and artistic finesse.
Yet an attribution by default is always rather
unsatisfactory, and further cause for reflection
stems from its omission from A. E. Popham's
1946 book on Leonardo drawings.[6] Although
there are no comparable figure drawings that
are so heavily inspired by Verrocchio, it is true
that Leonardo's beginnings as a draughtsman
are, like most artists, poorly documented. The
best support for the attribution is a similar
precision of detail in his paintings from the
early 1470s, such as the head of the angel in the
Baptism (fig. 1, no. 41) painted in collaboration
with Verrocchio and in the *Annunciation*, both
in the Uffizi. Such comparisons support the
likelihood that the present drawing was made
when Leonardo's precocious talent was
emerging under Verrocchio's tutelage. HC

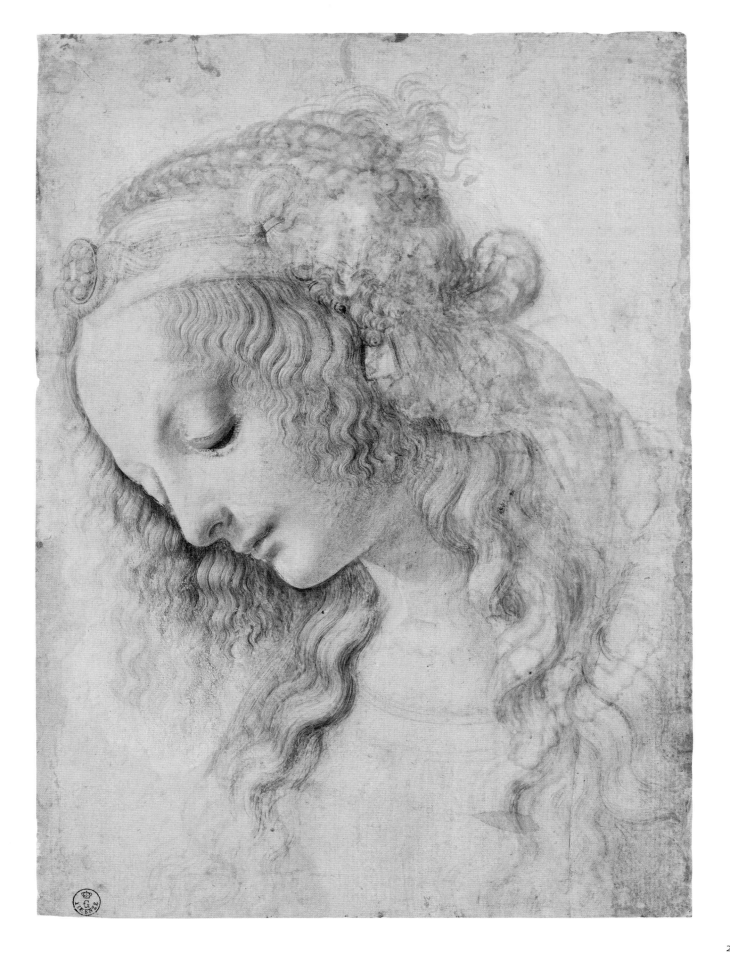

49 Landscape

1473

Pen and two shades of brown ink, 19.4 × 28.5 cm
Inscribed by the artist: 'dì di s[ant]a Maria della neve/addi 5 daghossto 1473' (on the [feast]
of St Mary of the snow, on the day of August 5 1473) and in an old hand: 'Leonardo'
Gabinetto Disegni e Stampe degli Uffizi, Florence (8 P)

PROVENANCE

Fondo Mediceo-Lorenese (Ramirez 1849); Reale Galleria
degli Uffizi (L. 930)

LITERATURE

Berenson 1938, vol. 2, no. 1017; Popham 1946, no. 253;
Petrioli Tofani 1972, no. 29; Kemp 1981, pp. 51–2;
Vezzosi 1984, pp. 8–10; Dalli Regoli and Pedretti 1985,
no. 1; Dillon in Florence 1992, no. 10.1; Brown 1998,
pp. 98–9

This is both the first dated drawing by Leonardo and the earliest landscape study in European art. Dated drawings unrelated to legal contracts are exceptional and it is unclear why the 21-year-old artist decided to inscribe it so precisely with the date and the relevant feast day. The drawing is executed in two shades of ink, with the lighter toned one applied first, seemingly without a preliminary underdrawing like that visible in Leonardo's summary drawing of a landscape with a bridge on the verso (fig. 1).[1] The darker toned ink can be seen on top of the lighter one at the base of the hillside on the left and in the pinnacles of rock that resemble peaks of freshly whipped cream. The changes in the ink tone show that two separate batches of ink were used, but there is no way of knowing the interval that separated the two. The drawing looks to have been executed at speed with the artist evolving a graphic vocabulary capable of recording his impressions of the landscape, one that fully exploited the expressive possibilities and flexibility of the pen. The pace at which the foreground landscape has been sketched only slackens in the sharply focused description of the fractured cliff-face, a motif that gains even greater prominence from its representation at eye level.[2] Leonardo's interest in the way in which the rocks at the top of the cliff and the gorge below have been eroded by the stream is an early indicator of his life-long fascination with the elemental power of water.

The fanciful quality of the fortified town makes it unlikely that the drawing records a specific view, although it is reminiscent of the Arno valley seen from hills around the artist's native Vinci.[3] The ease with which the young artist was able imaginatively to reconfigure naturalistic detail in his rendering of the landscape on the page is replicated in his slightly later studies of a child playing with a cat (see nos 51–2). The extemporary quality of Leonardo's inventiveness is discernible in his few changes of mind, such as in the area around the base of the waterfall where a thin jutting-out section of rock was drawn over an earlier idea of a reed-fringed pool. The structure of the fortress on the far left is similarly unresolved, with the artist choosing to disguise its lack of symmetry by obscuring it through the addition of more bushes on the hillside. Slight alterations of this kind are remarkably few in number bearing in mind the high tempo of execution without any preliminary underdrawing.

The slightly rough-edged nature of the drawing gives it a quality of spontaneity and vividness not found in Piero di Cosimo's landscape (no. 70), yet at the same time it has been carefully constructed. The eye is led backwards through the landscape by the rhythmical play of almost untouched areas of paper with areas of hatching, and the sweep of the foreground landscape towards the left. The contrast between the regular and even penwork in the description of the features, both man-made and natural, in the valley, and the densely worked hillside is also an important element in the recession. As this is the first landscape study to survive it is a matter of speculation whether Leonardo was guided by earlier examples of this genre. The likelihood that there was already a tradition of landscape drawing is suggested by the naturalism of the panoramic views found in paintings by the preceding generation of Florentine painters, in particular Antonio Pollaiuolo and Alessio Baldovinetti (1425–99). The interest in landscape was undoubtedly stimulated by Flemish paintings exported to Florence, and indeed elements of Leonardo's drawing, such as the outcrop of rocks and the bird's-eye view of a vast plain, can be traced to paintings by Jan van Eyck (c. 1395–1441) and his followers from three decades earlier.[4] HC

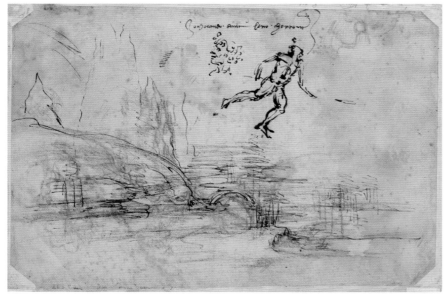

Fig. 1
Verso of no. 49, *Landscape with bridge and figures*, 1473. Pen and brown ink, over black and red chalk.

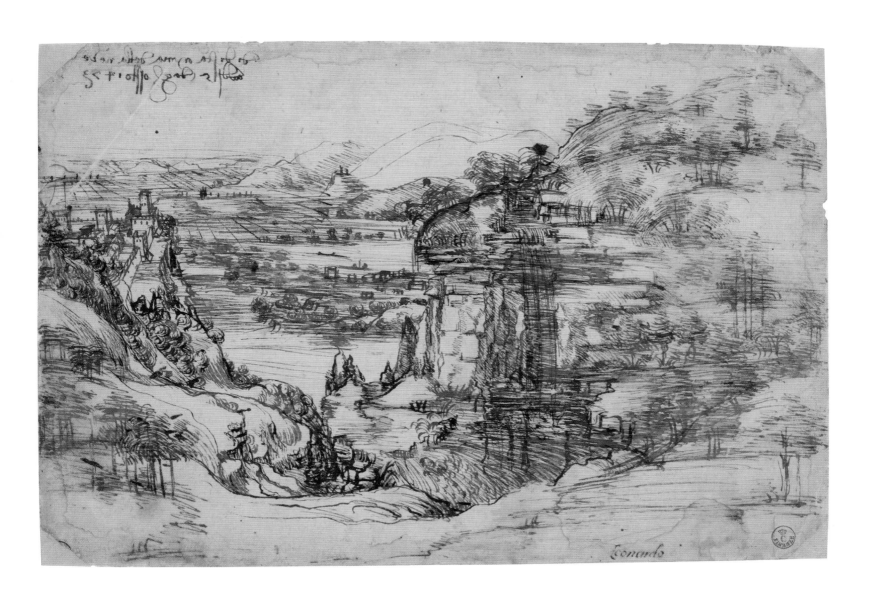

203

50 Bust of a warrior

c. 1475–1480

Silverpoint, on cream preparation, 28.7 × 21.1 cm[1]
British Museum, London (1895,0915.474)

PROVENANCE

W.Y. Ottley; Sir T. Lawrence (L. 2445); Sir J.C. Robinson;
J. Malcolm; acquired from Col. J. Wingfield Malcolm, 1895

LITERATURE

Berenson 1938, vol. 2, no. 1035; Popham 1946, no. 129;
Popham and Pouncey 1950, no. 96; Roberts in London
1989a, no. 2; Natali in Florence 1992, no. 12.5; Brown
1998, pp. 68–73; Wright in London 1999, no. 63

This early masterpiece executed by Leonardo while still in his twenties is a virtuoso display of metalpoint drawing. The technique was a risky one for such a highly wrought design because if a mistake was made it could only be covered over by beginning again with a new layer of preparation, as in the Boltraffio (no. 71), or the offending section could be wiped away leaving an unsightly mark such as in no. 1. The permanency of metalpoint has recorded small changes of mind in the present work, for example, the faint outline of an additional ribbon fluttering from the back of the helmet, and the alteration of the right contour of the shoulder armour. The modifications are so minor that it seems likely that Leonardo must have made preliminary studies of the figure.

The exacting, unforgiving nature of metalpoint was what recommended it as a technique for a tour-de-force sheet of this kind. (Metalpoint had the added advantage of adhering well to the preparation, an important practical element in a work designed to be handled, either as a gift or as a demonstration piece to be retained by the artist to show to prospective patrons.) The tonal range of metalpoint is limited, which means that there is only a slight difference in the intensity of the line when pressure is applied and, unlike with chalk, shaded areas cannot be blended together by stumping or by rubbing them with a moistened finger. The remarkable three-dimensional relief of the figure, a sculptural quality complemented by the crispness of the silverpoint modelling, is achieved primarily by minute adjustments to the density of the parallel hatching.

The drawing is full of contrasts engineered to retain the attention of the viewer. These include the way in which the stillness of the figure is heightened by the agitated fluttering motion of his ribbons and draperies; and Leonardo's switch from the precision of his description of the profile and helmet to a much sketchier, looser mode of drawing for the figure's armour. The visual delight is enhanced by the variety and tactile quality of the surfaces, which range from jowly folds of skin to the hardness of metal, polished and smooth or twisted in spiky, coiled tendrils of acanthus, like those rendered in bronze on Verrocchio's tomb of Giovanni and Piero de' Medici in S. Lorenzo from the early 1470s.[2] The visual invention of the fantastical armour is enlivened by naturalistic touches like the shaggy mane of the lion, and the leathery dragon wing on the helmet that resembles a duck's webbed foot.[3]

The format of the profile portrait was one derived from Roman coinage, but a more direct, if by no means straightforward, source of inspiration for Leonardo was a lost pair of metal, presumably bronze, half-reliefs of *Darius* and *Alexander the Great* mentioned in Giorgio Vasari's biography of Verrocchio.[4] Some idea of the *Darius*, which this drawing most closely resembles, can be gained from later versions of it such as the glazed terracotta reliefs from the Della Robbia workshop once in the Kaiser-Friedrich Museum in Berlin, and another now in Lisbon (fig. 1). The sculpture and drawing have in common the configuration of the nose and chin to form what has been aptly called the 'nutcracker' profile (an early occurrence of a facial type that persisted in Leonardo's art, as can be seen from no. 55). Leonardo has also taken from the relief various details of the armour, including the snarling lion as a means of expressing the warrior's reserve of aggression and ferocity underlying his calm exterior. The drawing's affinity with Verrocchio's sculpture is revealing of Leonardo's debt to his teacher, yet at the same time such a virtuoso display of technical brilliance and artistry was surely intended to advertise the young artist's emergence as an independent master in the second half of the 1470s.[5] HC

Fig. 1
Della Robbia workshop, *Darius*, 1500 or later.
Glazed terracotta, diam. 76 cm. Museu Nacional
de Arte Antiga, Lisbon.

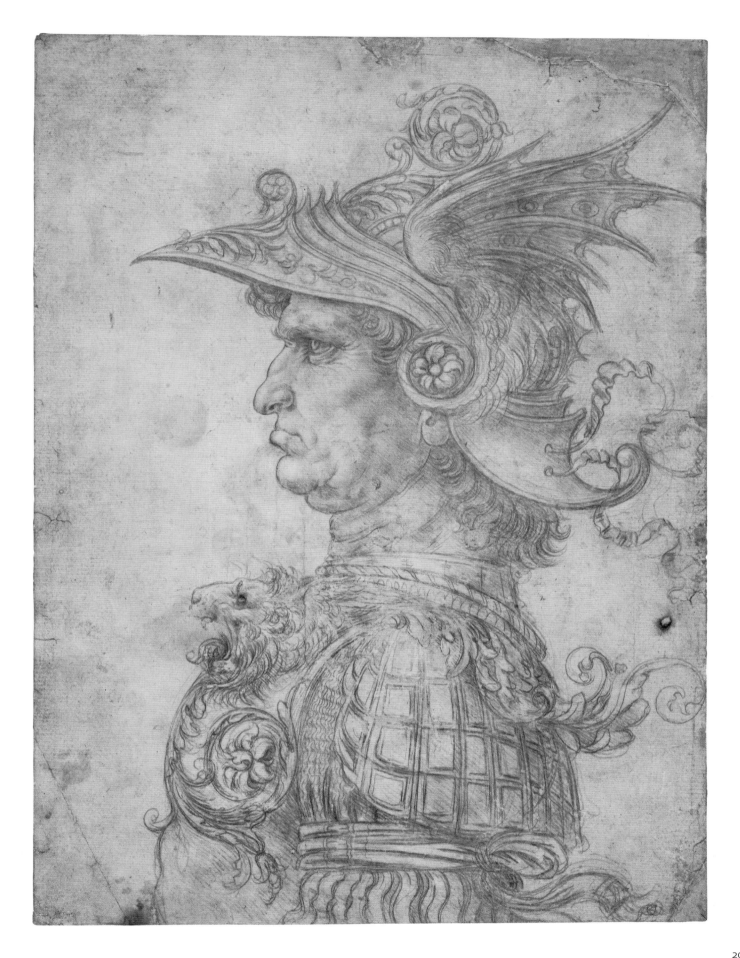

51 **Virgin and Child with a cat; and a male head in profile**

c. 1475–81

Pen and brown ink, over black chalk and some leadpoint,[1] 28 × 19.7 cm
British Museum, London (1860,0616.98)

PROVENANCE

Commendatore V. Genevesio (L. 545); Count C. Bianconi
(according to Lawrence-Woodburn 1860 sale catalogue);
Sir T. Lawrence (L. 2445); S. Woodburn; acquired at
Christie's 1860 sale of Lawrence-Woodburn collection
for £94. 10s.

LITERATURE

Berenson 1938, vol. 2, no. 1024; Popham 1946, no. 11;
Popham and Pouncey 1950, no. 98; Turner in London
1986, no. 3; Bambach in Paris 2003, no. 18; Syre in
Munich 2006, no. 10

Leonardo's boundless creativity is perhaps most tangible in this kind of rapid pen-and-ink sketch in which he poured out on the page a stream of ideas on a related theme. In the quest to keep pace with the flow of ideas, he adopted in such drawings a notational manner to capture the essentials of a pose or an expression – an economy of means most strongly expressed in the small study of the child embracing the cat at the upper left of the sheet. The drawing well illustrates Leonardo's words on making compositional drawings in his unrealized treatise on painting: 'the sketching out of narratives should be rapid, and the arrangement of the limbs not too defined but merely confined to suggesting their disposition.'[2]

Leonardo's determination not to slacken the tempo of execution is demonstrated by passages where the searching contours of a limb or a detail do not quite coalesce into a recognizable form. An example of such an area is found at the centre of the sheet, where it is hard to disentangle the legs of the Christ Child and a first idea for the hind quarters of the cat. The blurred confusion of forms was an inherent part of high-speed drawing and an aspect that Leonardo likely welcomed as a graphic equivalent of the random patterns of stains on walls, or the shape of clouds that inspired him to 'beautiful inventions of many things'.[3] It is striking how the carefully drawn male profile on the right stands apart from the tumultuous penwork that governs the other studies on the page. From the profile's position it is possible that the famously left-handed Leonardo, who would normally work from right to left, began with it as a kind of meditative doodle to test out the pen, like a pianist warming up by playing a set of scales.

The practice of making freewheeling pen sketches of a related theme was one that Leonardo probably picked up from his time in Verrocchio's studio, where he would have seen drawings like the sculptor's celebrated studies of infants in the Louvre (fig. 1).[4] Verrocchio, like his pupil, used such drawings to generate ideas for poses, the speed of his creative powers pitted against and feeding off the rhythmical flow of the pen. Where the two artists differ is the way in which Leonardo's studies of this kind invariably contain some startlingly fresh and vivid observation of pose or behaviour. In the present work, for example, that spark of recognition of Leonardo's powers of perception is fired by details such as the depiction of the pleasure-seeking cat at the lower left avidly rubbing up against the Virgin's leg and lifting its head to encourage Christ to continue his stroking, or in the study above by the Virgin's loving glance at her son's blissful embrace of the cat. Leonardo's astonishing ability to recall such naturalistic detail while drawing at such a high tempo was honed by his practice of making quick metalpoint sketches of poses of figures and animals to fix them in his mind.

This and the following drawing (no. 52) are from a group of six studies from the late 1470s or early 1480s related to a planned, but almost certainly unfulfilled, painting showing the seated Virgin with the Christ Child holding a cat. For further discussion of this project see the following entry. HC

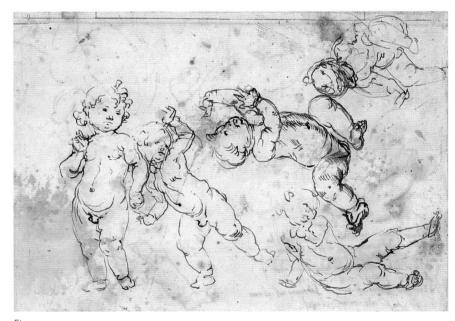

Fig. 1
Andrea del Verrocchio, *Studies of infants*, 1470s. Pen and brown ink, over leadpoint and
black chalk, 15.8 × 21 cm. Musée du Louvre, Paris.

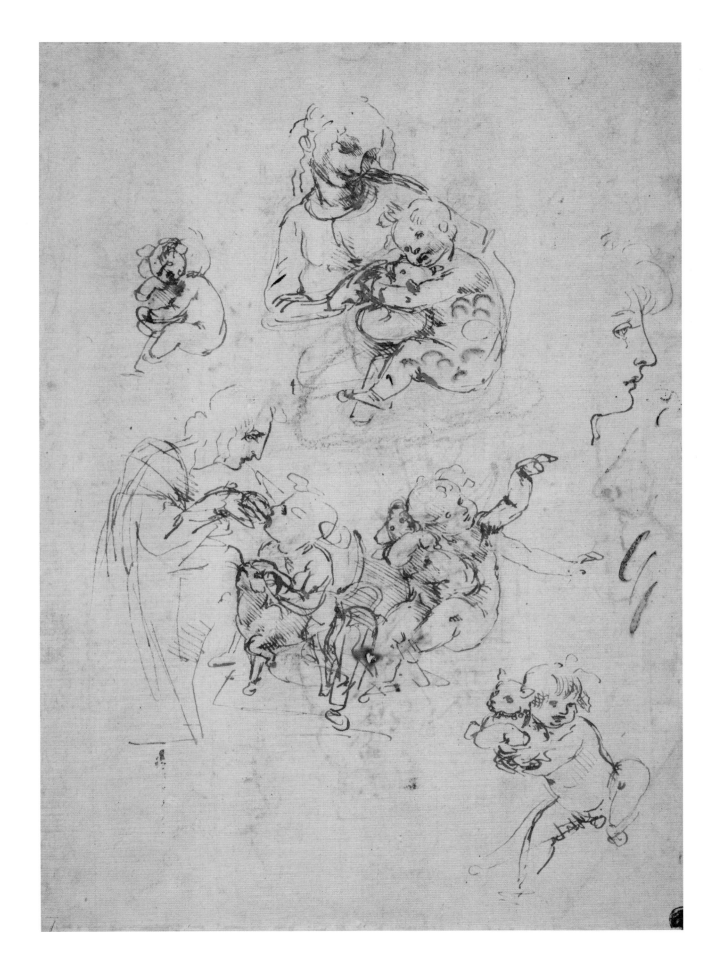

52 Studies of the Infant Christ and a cat

c. 1478–81

Pen and brown ink, over leadpoint,[1] 21.2 × 14.8 cm
British Museum, London (1857,0110.1)

PROVENANCE

Count Moritz von Fries (L. 2903); acquired from Revd
Dr H. Wellesley in 1857 for £31. 10s.

LITERATURE

Berenson 1938, vol. 2, no. 1025; Popham 1946, no. 12;
Popham and Pouncey 1950, no. 99; Turner in London
1986, no. 4; Rubin in London 1999, no. 37; Bambach in
New York 2003, no. 19

Leonardo's graphic exploration of the theme of the Virgin and Child with a cat dates from the years preceding his departure to Milan sometime between September 1481 and April 1483. This drawing and no. 51 are from a group of six pen studies of this subject, three of which are in the British Museum.[2] Leonardo's choice of a cat as a plaything of the Christ Child was unconventional. Apart from the legend that a cat had given birth at the same time as Jesus was born, the animal had no symbolic significance in Christian lore, unlike the lamb or the goldfinch often represented with the Christ Child that alluded to his future Passion.

Devotional paintings of the Virgin and Child were a readily marketable product for a young artist to establish his name, and it is known from a note on a drawing in the Uffizi that Leonardo began work on 'two Virgin Marys' in December 1478.[3] One of the two was most likely the painting known as the *Benois Madonna*, now in the State Hermitage Museum, St Petersburg. Whether Leonardo ever intended to turn his studies of the Virgin and Child with a cat into a painting is debatable as there is no evidence he went further than exploring the theme on paper.[4] However it is clear that he developed the theme in parallel with the Hermitage painting, as the most finished study of the three drawings of the

theme in the British Museum (fig. 50, p. 69) is comparable in format and composition to the design of the finished panel. The drawings are an early example of Leonardo's propensity to branch out from the study of one theme, in this case how to animate a composition of the seated Virgin and her infant son, with little regard as to whether such explorative forays would result in a finished work. This method of working was inherently impractical as regards Leonardo's productivity as a painter; however it may be that drawings such as this helped the artist to develop the fluid and naturalistic interaction of the Virgin and Child that is such an innovative feature of the *Benois Madonna*.

Leonardo probably incorporated a cat to inject dynamism into a conventionally static composition, with the flighty unpredictability of feline behaviour offering greater scope for dramatic, as well as more familiar, interaction than a lamb. The present drawing, which has further studies of the theme on the other side (fig. 1), is mainly devoted to imagining different poses for the child and the cat, with the Virgin only present (apart from her disembodied knees in the lower left study on the recto) in the now very faint leadpoint sketch of her head and upper body in the uppermost study on the verso, a detail only appreciable through infrared reflectography (fig. 2). Leonardo's genius for observation is seen in the interplay between the child and the contented cat on the recto, as well as in the contrasting scene below, where the animal submits to the child's embrace. The cat's ungainly pose is reprised to the right, where the form of the Christ Child is reduced to a shorthand rendition of his arms seizing the animal's twisting midriff. HC

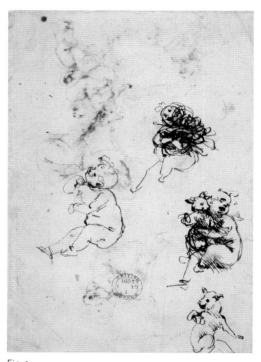

Fig. 1
Verso of no. 52. Pen and brown ink, over leadpoint.

Fig. 2
Infrared reflectograph detail of upper study on verso (fig. 1) showing leadpoint drawing of Virgin.

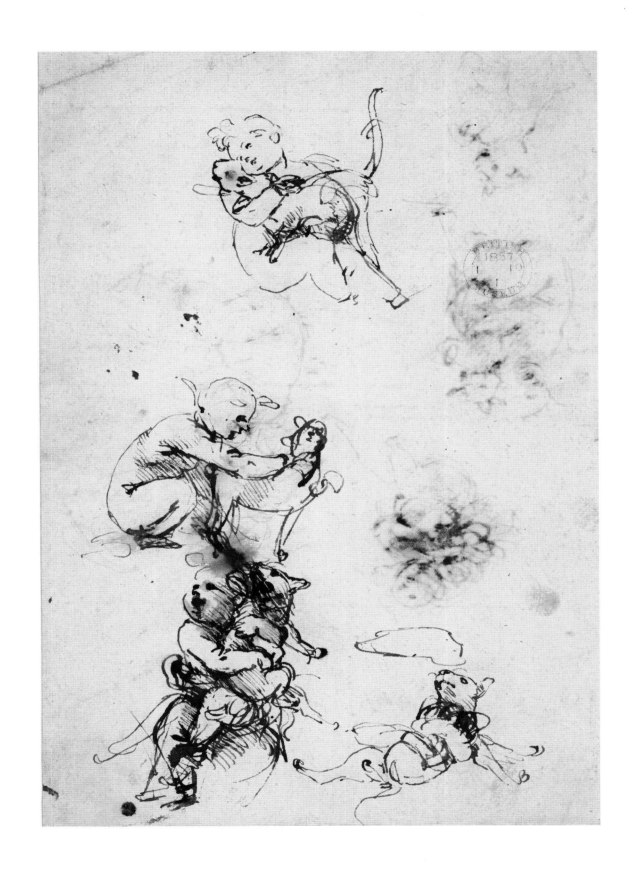

209

53 Study for the setting of the *Adoration of the Magi*

c. 1481

Metalpoint, pen and brown ink, brown wash, heightened with touches of lead white,
over stylus and compass incising, on cream preparation, 16.3 × 29 cm
Inscribed in an old hand: 'Italicum'
Gabinetto Disegni e Stampe degli Uffizi, Florence (436 E)

PROVENANCE

Fondo Mediceo-Lorenese (Ramirez 1849); Reale Galleria
degli Uffizi (L. 930)

LITERATURE

Berenson 1938, vol. 2, no. 1020; Popham 1946, no. 53;
Kemp 1981, pp. 73–4; Dalli Regoli and Pedretti 1985,
no. 8; De Marchi in Florence 1992, no. 7.10

This is a study for the unfinished *Adoration
of the Magi* in the Uffizi (fig. 1), which was
intended for the high altar of S. Donato a
Scopeto just outside the walls of Florence.
Leonardo's father was the notary for the
monastery and he probably had a hand in
steering the commission to his illegitimate son.
Leonardo was already at work on the panel
by March 1481 and in the contract in July he
agreed it would be ready in 24 to 30 months,
but it was never finished because he left for
Milan sometime after September 1481. His
conception of the biblical scene, to judge from
the panel's monochrome brush underdrawing,
was startlingly novel, the normally static
composition pulsing with energy, movement
and, in the background detail of clashing
horsemen, violence.

The sequence of around 15 studies for the
altarpiece suggests that Leonardo may have had
some flexibility in the subject, as some show
the Adoration of the Shepherds rather than the
Magi.[1] The present drawing, which is probably
the latest of the group, is related to the upper
section of the painting. It appears to have
been drawn with two principal aims in mind: to
work out the perspective and to plot the relative
positions of the figures and architecture.
Leonardo began in metalpoint, ruler and
compass to draw the perspective grid. Ruled
lines at the edge of the sheet, slightly trimmed
on the right, define the space, with the base line
of the grid plotted just above the lower edge by
means of various compass points.[2] The drawing
is one of the most virtuoso demonstrations
by any Renaissance draughtsmen of the visual
science of perspective, although one could
quibble that Leonardo's choice of such narrow

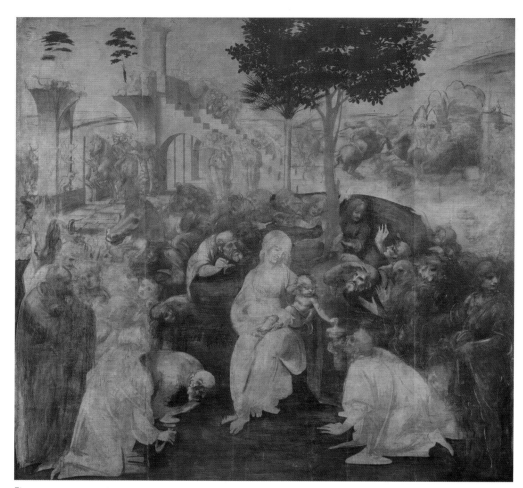

Fig. 1
Leonardo da Vinci, *Adoration of the Magi*, c. 1481.
Oil and some tempera grassa on panel, 243 × 246 cm.
Galleria degli Uffizi, Florence.

horizontal divisions made the compression attendant in such a distant viewpoint highly impractical. The vertical lines do not converge on a central vanishing point, but to one slightly to the right in order to counteract the dominance of the arcade that takes up more than half the space on the left. Another measure to direct the eye towards the right is the enormous barn under construction at the back, the apex of its roof just to the right of centre. The logic of the new structure rising from the old was overturned by Leonardo's revisions in pen that brought it much further forward, with the slender frontal pier supporting the roof placed near the stairs by the seated camel.

The alteration to the barn is one of many changes that Leonardo made to the design when he switched from metalpoint to pen. The change in medium allowed him to discard certain figures, such as the man looking around a pier on the right, and to make numerous adjustments to the poses of the workmen on the left. The final changes were made using a different batch of ink, visible by its darker tonality, along with sparing touches of wash and white heightening. Leonardo's principal focus at this juncture was to clarify the complicated structure of the architecture, which he decided to elevate on a three-step platform, a development that negated the brook with grassy tussocks in the centre. The palimpsest (a manuscript term for an older document that has been erased to make way for a newer one, the earlier layer still visible beneath the more recent writing) of corrections and alterations add to the sense that the design was still in a state of flux and, to judge from the alterations to the figures in the background, this remained the case even while Leonardo was working on the panel itself. In comparison with the drawing the relevant section of the painting is much simplified: the perspective is orientated centrally, the figures reduced in number, the camel deleted, and the structures of the buildings on the left and the far sketchier one on the right are pared-down versions of those in the present study. HC

54 Military machines and a study for a spearhead

c. 1485

Pen and brown ink, over stylus (some drawn with a ruler or a compass), 17.3 × 24.6 cm
Inscribed by the artist, writing right to left: 'quando questo chamina tra sua si vuol levare le roche alle falci accio/
che no ne offendessi alcuna volta e sua' (when this travels through your men, you will wish to raise the shafts
of the scythes, so that you will not injure anyone on your side); under bottom-right machine: 'questo e buono per
ronpre le schiere/ ma vuol seghuito' (this is good for breaking the ranks, but you will want to follow it up); and
above bottom-left machine: 'modo chome sta dentro il charro choperto'; and below it: '8 huomini trarano e que
medesimj/ volteranno il charro e seghuiteranno il nemi[co]' (the way the car is arranged within – eight men operate it,
and the same men turn the car and pursue the enemy)
British Museum, London (1860,0616.99)

PROVENANCE

P.-J. Mariette (according to Lawrence-Woodburn 1860
sale catalogue); Sir T. Lawrence (L. 2445); acquired at
Christie's 1860 sale of Lawrence-Woodburn sale
collection for £36. 15s.

LITERATURE

Berenson 1938, vol. 2, no. 1030; Popham 1946, no. 308;
Popham and Pouncey 1950, no. 107; Kemp in London
1989a, no. 68

The present drawing is one of the best-known
examples of Leonardo turning his inventive
skills to weapon design. Leonardo was not a
pioneer in this respect, as drawings for military
machines were included in the 1449 treatise
De machinis by the Sienese engineer, Mariano

Taccola (1382–1458), and these in turn were
copied and adapted in the volume of machinery,
the *Opusculum de architectura*, made by his
compatriot, Francesco di Giorgio, in the first
half of the 1470s. The *Opusculum* volume,
now in the British Museum, includes some
machines that are conceptually similar to those
in Leonardo's drawing, but the similarities
between them are probably coincidental since
the two only met in 1490 when Francesco
came to Lombardy. Similar designs, including
one of a chariot with scythes, were available to
Leonardo in the elegant woodcut illustrations
accompanying *De re militari* (On the military
arts) by Roberto Valturio, a humanist who
worked for the Riminese ruler and mercenary

captain, Sigismondo Pandolfo Malatesta.
Valturio's book, first published in Latin in
1472 and in a second dual-language edition in
Latin and Italian in 1483, was a key source for
Leonardo, and he seems to have owned a copy
as it is listed as one of his books kept safely
locked in a chest.[1]

Just as Francesco had earlier tailored the
Opusculum to advertise to the Duke of Urbino
how his inventive talent (*ingenium*) could
switch from pacific to bellicose ends, Leonardo
was equally shrewd in judging how to sell
himself as a worthy addition to the court of
Lodovico Sforza in Milan. In Leonardo's letter
of 1482/3 to Lodovico, known only in draft
form, he first described his prowess in nine

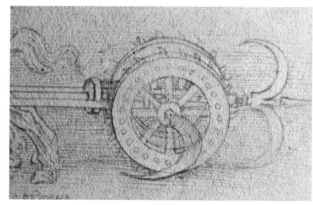

Fig. 1 (left)
Leonardo da Vinci, *Military machines*, *c.* 1485–8.
Pen and brown ink, 17.9 × 26.5 cm.
Biblioteca Reale, Turin.

Fig. 2 (above)
Detail of no. 54 in raking light showing stylus and
compass underdrawing.

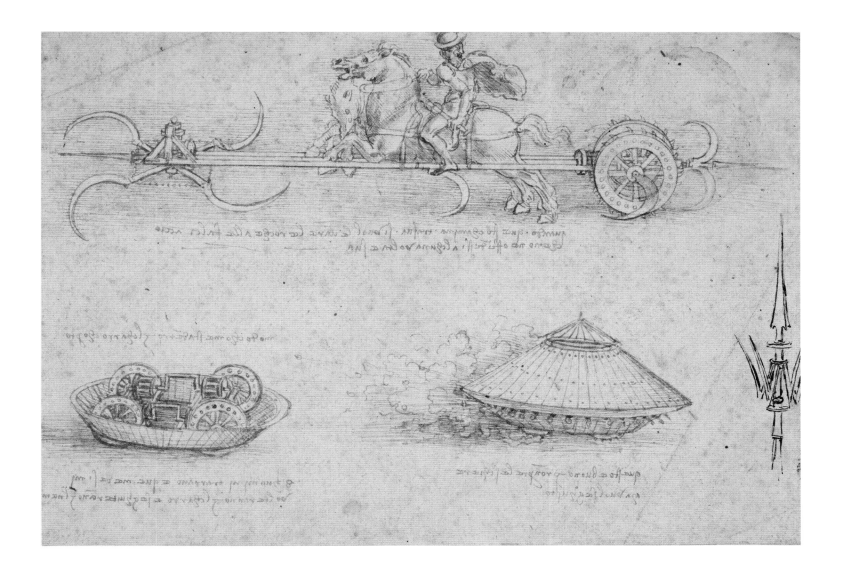

areas of military engineering and weapon design, which include one relevant to the present drawing, namely the manufacture of 'covered vehicles, safe and unassailable, which will penetrate the enemy and their artillery', before mentioning his abilities as an architect, sculptor and painter.[2] The 30-year-old artist's practical experience of the fields listed in the letter was almost certainly limited, although it is known from a note made around 1515 that he witnessed Verrocchio's engineering triumph in 1471 when he made and erected the enormous copper orb on the lantern of Florence Cathedral.[3] Even before his move to Milan, Leonardo's observation of the workings of pulleys, screws and gearing had been directed towards the design of a large-scale

crossbow and a ballista in a drawing of around 1480 in the Uffizi.[4]

The present drawing is generally dated to the mid-1480s, soon after Leonardo's move to Milan, a period when he made a number of drawings for weapons based on his study of Valturio and classical authors such as Vitruvius.[5] Among the artist's designs for a scythed chariot is a drawing in Turin that includes the gruesome detail of the carnage that such a machine might cause (fig. 1). The vulnerability of the horse and rider is addressed in Leonardo's visionary design on the lower half of the present drawing for a tortoise-like wheeled armoured vehicle that he fancifully envisaged could be propelled by eight men. The artist may have begun the sheet with the study of a

spearhead drawn in a different shade of ink on the right.[6] In raking light an underlying stylus underdrawing is detectable, some of it executed with a ruler and, for the wheels of the chariot, a compass (fig. 2). The inscriptions giving details of the function and associated tactics of the weapons appear to be addressed to a military commander, presumably Leonardo's patron Ludovico Sforza, yet they are prompts for a presentation rather than explanatory labels, as the artist's right-to-left handwriting would have required his presence to make them intelligible. HC

55 An old and a young man in profile

c. 1490–1500

Red chalk, 20.9 × 15 cm
Gabinetto Disegni e Stampe degli Uffizi, Florence (423 E)

PROVENANCE

Fondo Mediceo (Nota 1687); Reale Galleria degli Uffizi
(L. 930)

LITERATURE

Berenson 1938, vol. 2, no. 1019; Popham 1946, no. 141;
Dalli Regoli and Pedretti 1985, no. 11; Kemp in London
1989a, no. 35; Fiorio in Venice 1992, no. 83; Bambach in
Paris 2003, no. 56

Leonardo's predilection for drawing an aged male profile facing a youthful one was such that one scholar described it as 'an almost unconscious habit'.[1] The contrast of opposites as a means of expounding the quality of each, in this instance the transience of beauty and the inevitability of human decay, was a standard device in classical rhetoric, and it was a practice that Leonardo recommended in his projected treatise on painting: 'beauty and ugliness seem more effective through one another.'[2] He would have seen the effectiveness of contrasting types in the reliefs of warriors by Verrocchio and his workshop: a grizzled veteran paired with an idealized youth (often identified as Hannibal and Scipio, or Darius and Alexander; see no. 50). Verrocchio's influence is still visible in the aquiline nose and prominent chin of the old man, and the classical profile and abundant curls of the youth in the drawing.[3]

Red chalk was a technique that Leonardo took up seriously in the late 1480s and 1490s, although there are earlier instances of its use before his arrival in the early 1480s at the Sforza court in Milan. The Uffizi drawing most likely dates from the 1490s.[4] The medium's flexibility is exploited by the artist to bring out the differences between the two heads. A tonal approach was adopted to describe the undulating surfaces and depressions of the old man's jowly skin and protruding ear, while the unbroken curves of the youth's face are emphasized through crisp linear hatching akin to that in silverpoint studies. Leonardo also used parallel hatching around the youth's profile to emphasize the three-dimensionality of his form. The tonal possibilities of red chalk are explored in the drawing with variations in the pressure to lighten and darken the line, with the contrasts enhanced by the juxtaposition of shaded areas with untouched areas of paper. In the description of the right-hand figure's wave-like ringlets Leonardo also deepened the shadows by moistening the tip of the chalk. The delicacy and precision of the artist's touch is still powerfully evident, in spite of the light-stained and in places slightly abraded state of the paper (the sheet has also been trimmed at the sides).[5]

The least satisfactory aspect of the drawing is the uneasy spatial relationship between the two figures, most evident in the old man's unnaturally short right arm raised up to the youth's chest. This awkward articulation, a defect also seen in the placement of the right hand in Leonardo's drawn portrait of Isabella d'Este now in the Louvre, probably explains why the gesture was abandoned before the addition of the old man's hand.[6] It is possible that Leonardo intended at the outset only to draw the heads in profile truncated at the neck, a format based on classical coins that he adopted in other studies from the period, like one in the British Museum trimmed from a larger sheet (fig. 1). In the present drawing, he then changed his mind and sketched out a costume for both figures. For the figure on the left the folds of the long coat are clearly defined, but the costume of the youth is only summarily outlined, the lack of finish clear from the absence of modelling on his neck so that it disconcertingly does not appear to be joined to his shoulders. HC

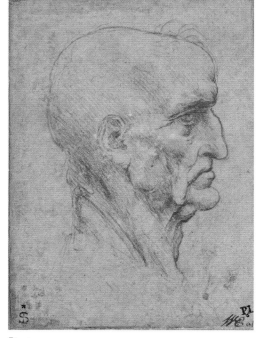

Fig. 1
Leonardo da Vinci, *Male head in profile, c.* 1490–1500.
Red chalk, 10.1 × 7.3 cm. British Museum, London.

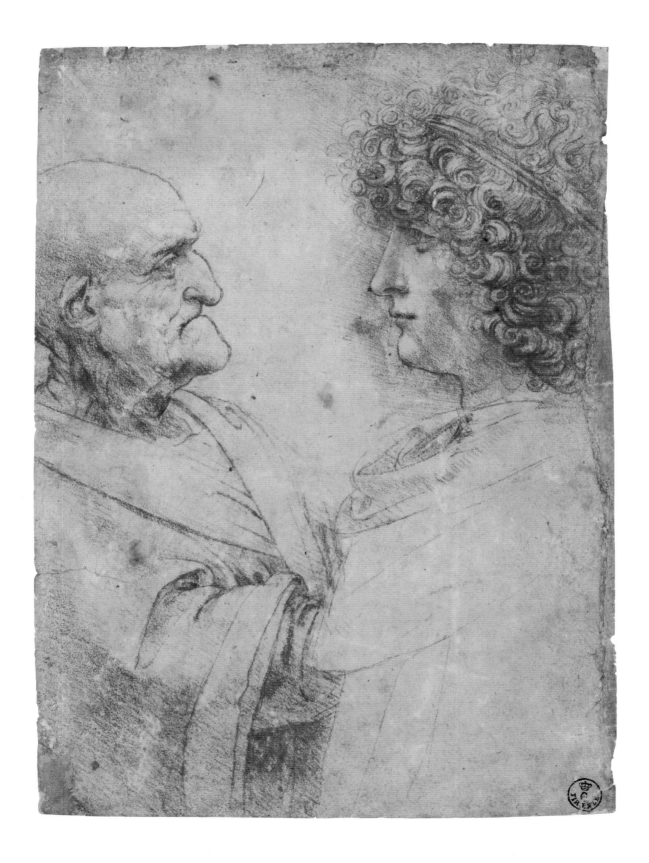

56 Recto: The Virgin and Child with St Anne and the Child Baptist; and machinery designs

c. 1505–8 (ILLUSTRATED ON P. 218)

Pen and brown ink, grey (main study) and brown wash, heightened with lead white (main study), the majority of the studies over black chalk, the scale around the main study executed with a compass over incised lines, 26.5 × 19.9 cm[1]
Inscribed by the artist writing right to left, on right side of sheet: 'pagol data vechia p[er]/ vedere le machie de/ lle pietre tedessce' (Paolo of Tarecchia to see the marks in the German stones); and along lower edge, the second line cut off:
'fa co[n]che dove lac[q]ua' (make locks where the water)

Verso: Profile of an old man; traced-through composition from recto (ILLUSTRATED ON P. 219)

Black chalk
British Museum, London (1875,0612.17)

PROVENANCE

E. Galichon (L. 2445); acquired at 1875 Galichon sale for 13,000 francs

LITERATURE

Berenson 1938, vol. 2, no. 1028; Popham 1946, nos 144 (verso), 175 (recto); Popham and Pouncey 1950, no. 108; Turner in London 1986, no. 5; Kemp in London 1989a, no. 77; Clayton in Venice 1992, nos 23–23a; Bambach in New York 2003, no. 96; Kemp in New York 2003, pp. 151–4

The figurative studies on the recto are preparatory for Leonardo's *Virgin and Child with St Anne and St John the Baptist*, sometimes called the Burlington House cartoon, in the National Gallery, London (fig. 1); generally, although not universally, dated *c.* 1506–8 when the artist shuttled between Florence and Milan.[2] Although Leonardo may well have worked out the composition while in Florence, the likelihood is that the cartoon was mainly, if not exclusively, executed in Milan as it seems to have been known only to artists in that city. This is supported by the work's exclusively Milanese provenance that can be traced back to the painter Bernardino Luini (*c.* 1480/85–1532).[3]

In the last two decades of Leonardo's career he was fascinated by the intricacies of composition and meaning that could be extracted from

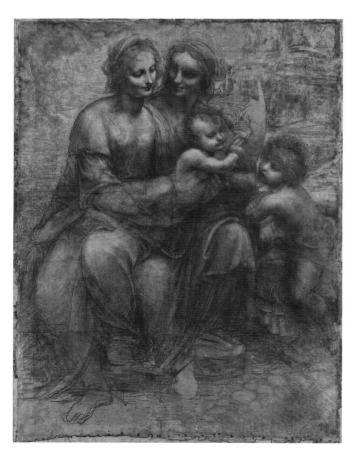

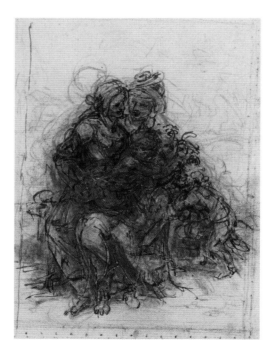

Fig.1 (left)
Leonardo da Vinci, *Burlington House cartoon, c.* 1506–8. Charcoal, black and white chalk, on light brown paper, 141.5 × 106.5 cm. National Gallery, London.

Fig. 2 (above)
Detail of no. 56 recto

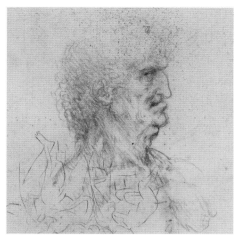

Fig. 3
Verso of no. 56 (detail).

Fig. 4
Sestertius with portrait of emperor Galba
(3 BC–AD 69), diam. 3.3 cm. British Museum,
London.

a composition of the Virgin seated on the lap of her mother, St Anne, with the Christ Child and the Infant Baptist or a lamb. Apart from the cartoon and various drawings depicting this subject, there is a painting now in the Louvre, most likely begun after 1508, and Leonardo also exhibited a small cartoon in Florence in 1501, whose subject, like the later Paris picture, was the Virgin on St Anne's lap with Christ and a lamb. The cartoon is lost and is known from painted copies.[4]

In the present drawing the main study, defined by a freehand frame, was probably executed first (fig. 2). Leonardo's careful construction, with compass points and a ruler, of a scale consisting of 17 units along the bottom and 25 at the side, contrasts with the speed and freedom of his black chalk under-drawing. The measured scale (each unit probably corresponding to a *palmo*, or 7.25 cm) was to enable the design to be enlarged.[5] The under-drawing is all but obliterated by Leonardo's dense reworking of the figures in pen, grey wash and white heightening. The 'brainstorming' method of drawing, one idea superimposed over another in rapid succession with the instability and lack of definition in the forms a key element in the generation of fresh and unanticipated variants of the pose or composi-tion, was one developed by Leonardo 20 years earlier (see nos 51–2).[6] The extensive revisions make it impossible to follow the evolution of the group; nonetheless it can be seen how Christ was shifted from the right to the left. This movement was a consequence of the change in the position of St Anne's legs. Origi-nally she sat frontally (the likely position of her feet can be seen in one foot visible behind the Virgin's right calf and the other to the right of

her daughter's left foot) with Mary seated side-saddle across her lap.[7]

Leonardo was clearly dissatisfied with this arrangement, perhaps because the composition was so concentrated towards the right. His solution was to swap the positions of the two women's legs. This change necessitated the Christ Child be moved leftwards towards his mother. His twisting pose is supported by Mary at his midriff and right calf. This arrange-ment is substantially that of the cartoon except for the omission of Anne's hand. The switch in the position of the Virgin occurred after Leonardo had inked in his initial thought for the group, so that the organic nature of his inventive thought processes is visible – his revisions emerging out of, but not obliterating, what had come before. The open-ended quality of this kind of drawing means that Leonardo may have referred back to it when working on the Louvre painting, where the Virgin's side-saddle pose is resurrected.[8]

The remaining figurative sketches on the sheet were most likely drawn after the main study as they develop alternative poses for the Virgin and Child. The one on the right was probably first as it follows on so closely from the larger one in the atmospheric merging of the forms. The final arrangement of the figures is not that different from the one above, apart from the pose of Christ and the greater contrapposto of the Virgin. The area to the right is difficult to make out as the forms of the Baptist, and perhaps a lamb, are left undefined.[9] The crisp pen-and-wash study of the Christ Child to the left seems tangential to the cartoon as the position of the shadow suggests he is seated on the ground. Above and below this are faint black chalk studies of the Christ

Child, while in the centre Leonardo sketched a variant of the Virgin's seated pose. The idea of the Virgin with her legs crossed is sketched out in the two studies on the left, both of which have been touched in pen. There is no reason to think that the hydraulic studies in the same technique are not coeval as comparable designs involving water date from *c.* 1506–8.[10]

On the reverse of the sheet (fig. 3) Leonardo drew sketchily in soft black chalk a bust-length portrait of a heavy-set male head in profile, a recurrent type in the artist's work (see nos 50, 55) loosely inspired by Roman imperial coin portraits (fig. 4). Partly drawn over it are the outlines of the main study on the recto. This was made by incising the contours from the recto with a sheet of paper rubbed in black chalk held against the verso so that the image was transferred to the back. Most scholars have assumed that Leonardo was responsible for this in order to clarify his final thoughts on the design, yet its crudeness make this seem highly unlikely.[11] The infelicities are suggestive of someone unable to read Leonardo's intentions, hence the merging of the two women so that they resemble conjoined twins, the misreading of the folds of the Baptist's drapery for his foot, and the adult-sized wrist and hand of Christ blessing his cousin that indicate the artist wielding the stylus wrongly thought the gesture was Mary's. Leonardo did on occasion trace his figures to reverse them, but it seems inconceivable that he would have created such a caricature of his earlier design.[12] HC

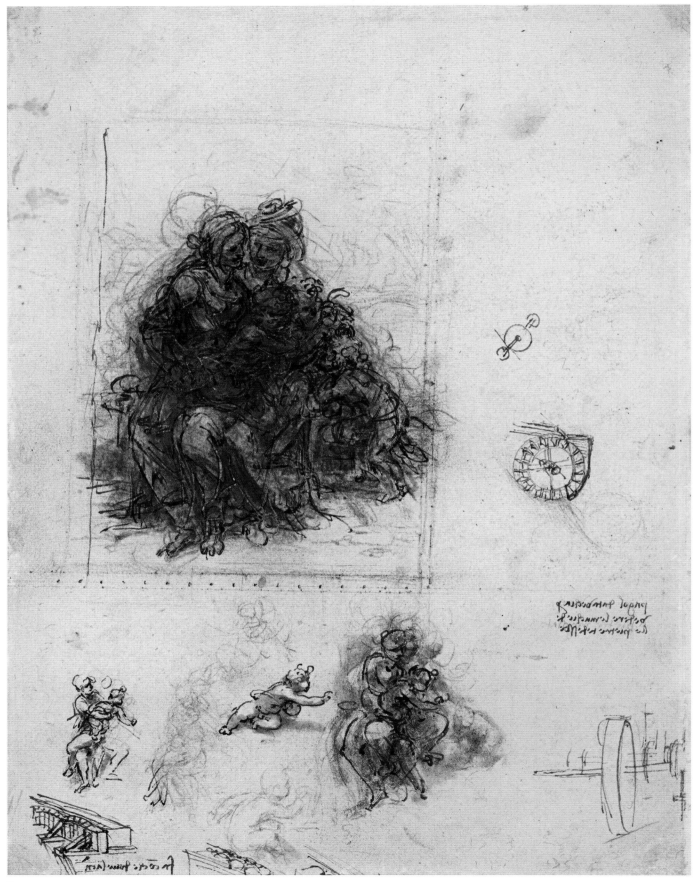

Recto

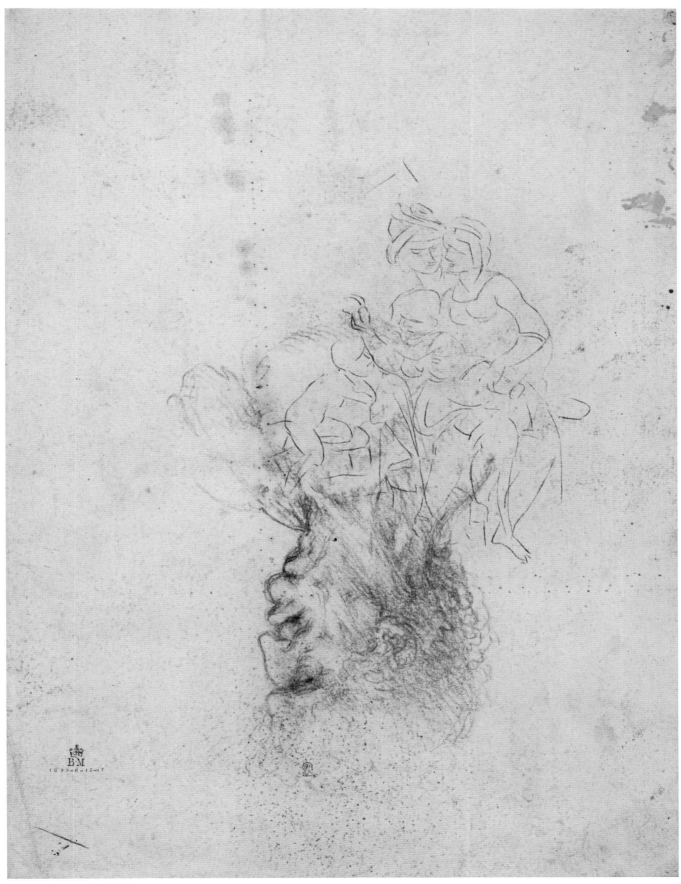

Verso

57 Abdomen and left leg of a nude man

c. 1506–10

Red chalk on orange-red preparation, 25.2 × 19.8 cm
Inscribed by the artist, writing right to left: 'vedi ibo p[er] natale (?)/
che ne grassi resta ca/vato dove a magri e / di rilievo'
('. . ./ the fat is in the hollows, the lean in the relief'?)
British Museum, London (1886,0609.41)

PROVENANCE

Sir T. Lawrence (L. 2445); S. Woodburn; Marquis of
Breadalbane; acquired by A.S. Thibaudeau for the British
Museum at Christie's 1886 sale of Breadalbane collection
for £35

LITERATURE

Berenson 1938, vol. 2, no. 1031; Popham 1946, no. 235;
Popham and Pouncey 1950, no. 112; Clark and Pedretti
1968, under no. 12632; Turner in London 1986, no. 7

The drawing technique adopted by Leonardo
in this work, red chalk on paper with red
pigmentation applied with a brush, was one
that he favoured in the second half of the
first decade of the sixteenth century. He first
employed it a decade or so earlier in his prepa-
rations for the *Last Supper* fresco in S. Maria
delle Grazie, Milan, executed *c.* 1493/5–8.[1] The
warmth and flesh-like colour of this combina-
tion was ideally suited for studying the human
figure and the majority of Leonardo's drawings
that employ it belong to this category, although
not exclusively so as he also made use of it for
drapery and botanical studies.[2]

The present study is informed by Leonardo's
anatomical experience. This is particularly
evident in his lucid description of the structure
of the lower half of the leg, which comes close
to being an *écorché* drawing, the skin peeled
away to reveal the underlying forms of the
muscles beneath. Such knowledge was grounded
in the dissections that Leonardo made in
Florence during the period between 1503 and
1508 when he was working on the never-to-be
completed *Battle of Anghiari* mural for the
Palazzo Vecchio. His dissection of an old man's
corpse in the Hospital of S. Maria Nuova in
Florence during the winter of 1507–8 is the
only documented example of this activity, yet
this cannot have been an isolated one, as on
an anatomical drawing at the Royal Library,
Windsor Castle, of *c.* 1510 he claimed to have
dissected more than ten bodies.[3]

This study provides a textbook example of
Leonardo's habit of working on a motif over
an extended period, which makes the dating of
his drawing problematic. A similar male leg in

profile is found on a sheet at Windsor that on
the basis of the writing can be dated to around
1490, when he worked in Milan (fig. 1).[4] In
comparison with the present work, Leonardo's
focus in the Windsor study is directed more
towards recording the external appearance of
the tensed musculature; however the position
of the figure with his upper body twisted to the
left is found in both drawings. Leonardo seems
to have returned to studying this pose when
he returned to Milan in the period 1506–10.
Comparable studies of the motif in the same
technique as the present one, except for the
addition of pen on top of the red chalk, include
drawings in the Biblioteca Ambrosiana, Milan,
and in the Royal Library at Windsor Castle,
both of which bear inscriptions in Leonardo's
hand that suggest they were executed while he
was in Milan.[5] The inscription on the present
drawing gives no indication as to whether it
was drawn in Florence or Milan, the two cities
where Leonardo divided his time in the years
1506 to 1508, before his eventual return to
Milan after this date. However, the fragmentary
flower watermark on the right edge of the sheet,
similar to one on the Boltraffio drapery study
(no. 71), shows that the drawing was made on
Milanese paper.

Leonardo was the first Italian artist to have
extended his knowledge of human anatomy by
studying dissected bodies, thereby fulfilling the
recommendation given in Alberti's *Della pittura*
(1436) that an artist should work out a pose by
beginning with a skeleton and then clothing
it with muscles and flesh. Recently it has been
suggested that Leonardo may also have been a
pioneer in making sculptural wax *écorché* models
so that he could study anatomy when he did not
have access to corpses.[6] Although in the present
example Leonardo's focus is the musculature
of the male leg, information that was directly
relevant to his activities as a painter, from such
studies grew a curiosity with the workings of
the human body that would lead Leonardo
to embark within a few years on vastly more
ambitious anatomical drawings, which rank
among his most celebrated creations. HC

Fig. 1
Leonardo da Vinci, *Abdomen and left leg of a nude man*,
c. 1490. Pen and brown ink, over black chalk,
19.6 × 31.3 cm. The Royal Collection, Windsor Castle.

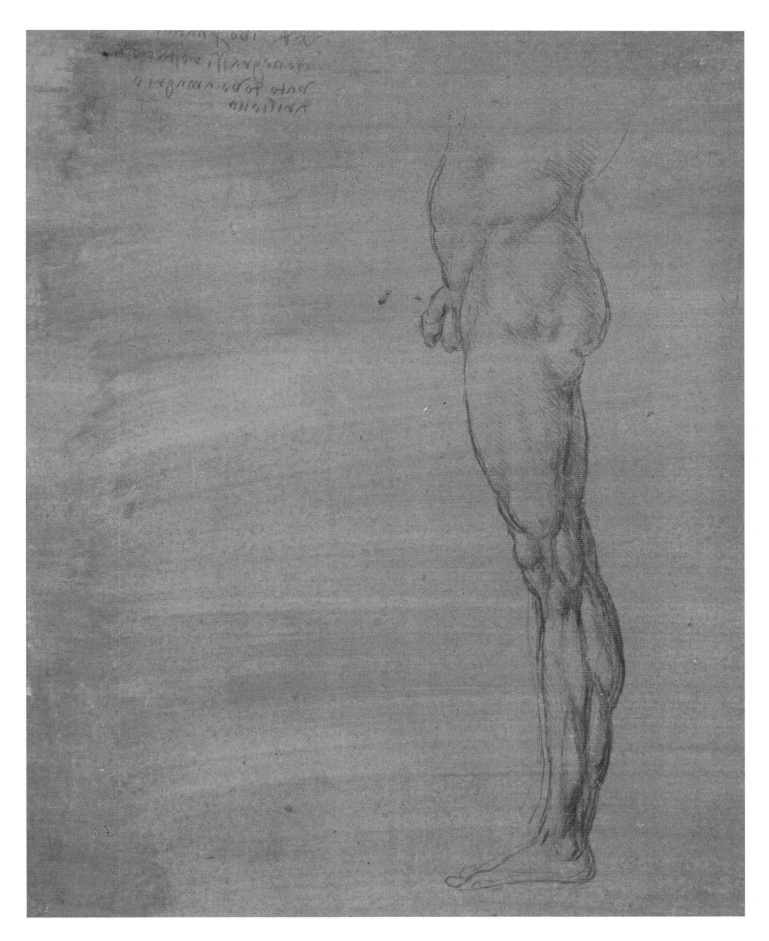

221

58 A woman pouring water from a jug

c. 1486–90

Pen and brown ink, 21.9 × 16.8 cm
Inscribed in an old hand: 'F. giovani egondo'
Gabinetto Disegni e Stampe degli Uffizi, Florence (289 E)

PROVENANCE

Fondo Mediceo-Lorenese (Pelli after 1775–before 1784);
Reale Galleria degli Uffizi (L. 930)

LITERATURE

Lagrange 1862, no. 183; Ferri 1881a, p. 19; Berenson 1938,
vol. 2, no. 869; Petrioli Tofani 1986, p. 128; Cadogan 2000,
no. 83; Kecks 2000, p. 153; Faietti (forthcoming)

This is a preparatory study for the maidservant to the right in the fresco of the *Birth of the Virgin* in the high-altar chapel of S. Maria Novella in Florence. The fresco is from a cycle recounting the lives of the Virgin and St John the Baptist commissioned from Ghirlandaio in 1485 by Giovanni Tornabuoni, head of an illustrious Florentine family closely linked to the Medici. The frescoed figure follows the drawing closely, as in the woman's fluid, almost dancing, movement and fluttering vestments (a motion that suggests wind despite the scene occurring inside), and the illumination from the right in accordance with the actual lighting from the chapel's end wall. The flowing scarf, indicated by a few curls of the pen, is echoed by the lines of the pouring water, details that also appear in the fresco. In common with other artists of the period, notably Botticelli,[1] Ghirlandaio's highly stylized drapery was intended to bring to mind a generic sense of the antique for the viewer, rather than a specific Greek or Roman sculpture.

Ghirlandaio began the drawing directly in pen and ink, including the preliminary outlines, one of which is clearly visible defining the woman's back. The sheet displays the artist's pioneering use of cross-hatching, in which fine meshes of oblique and vertical lines are variously layered to convey form. The hatching is densest in the areas of shadow over the figure's front and in the deepest folds of her flowing mantle that follow the direction of light from the right. Although both parallel and cross-hatching had previously been employed by German and Netherlandish printmakers and in particular by Master ES (active 1450–67), Ghirlandaio's use of it here – to describe the

plasticity of form and fine gradations of tone akin to those on the surface of marble sculpture – is highly original. The artist set a new expressive standard for pen drawing, which had a profound influence on the young Michelangelo, who began his professional life in Ghirlandaio's studio exactly when he was working on the Tornabuoni commission. Michelangelo learnt much from his master's sculptural sense and his admiration for the antique (see no. 91).[2]

The pose established in this drawing was repeated for the figure of Salome in *Herod's Banquet* in the same cycle, whose drapery flows in a similar style as she dances at the presentation of the Baptist's head. *Herod's Banquet* is

placed in the lunette high on the opposite wall, and Ghirlandaio must have felt that the distance between it and the *Birth of the Virgin* in the lowest tier was sufficiently great to allow a partial repetition of this motif. Ghirlandaio's Salome was in turn influenced by Filippo Lippi's eponymous figure in a fresco cycle executed in 1452–66 in Prato Cathedral, a commission that Ghirlandaio may have worked on as an apprentice.[3] The motif of a woman pouring water into an urn may owe something to the medieval iconography of Temperance, passed down in the fifteenth century through images of the Virtues found on tarot cards.[4] RS

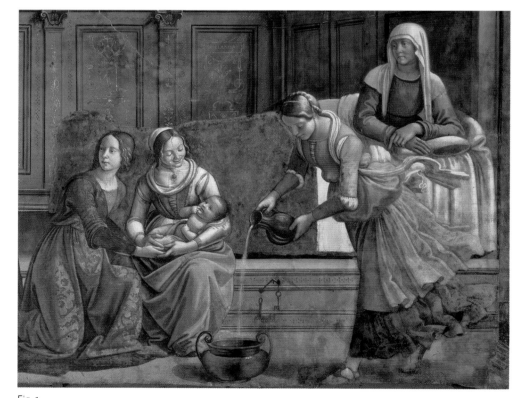

Fig. 1
Domenico Ghirlandaio, *Birth of the Virgin* (detail), 1486–90.
Fresco, Tornabuoni Chapel, S. Maria Novella, Florence.

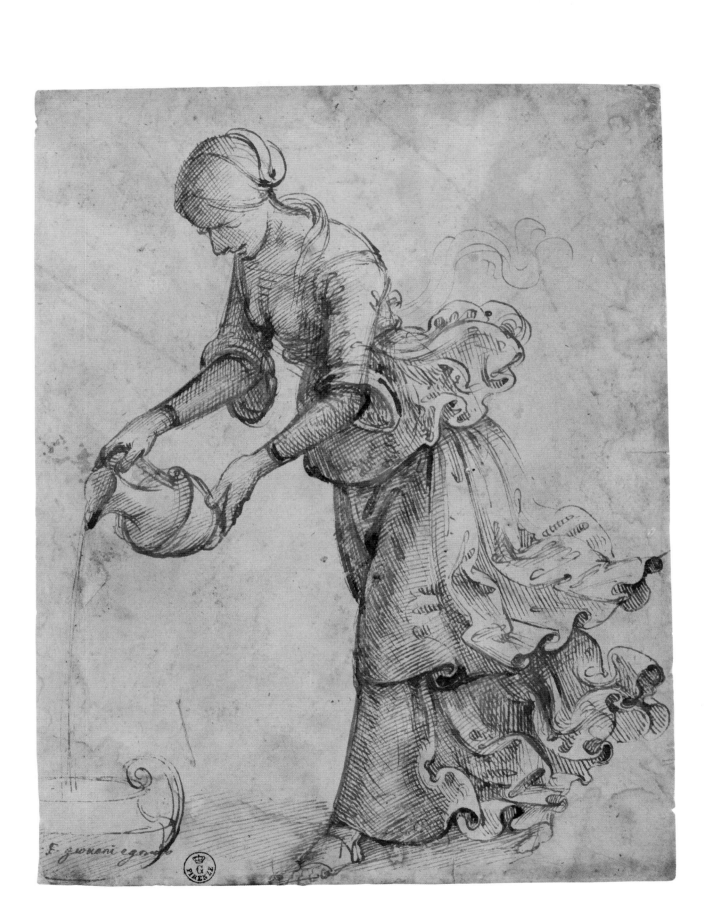

F. giovani egregio

223

59 The Visitation
c. 1486–1490

Pen and brown ink, 26 × 39.3 cm
Gabinetto Disegni e Stampe degli Uffizi, Florence (291 E)

PROVENANCE

Ferri, Disegni Esposti (1879–81); Reale Galleria degli
Uffizi (L. 930)

LITERATURE

Lagrange 1862, no. 182; Ferri 1881a, p. 19; Berenson 1938,
vol. 2, no. 871; Petrioli Tofani 1986, pp. 128–9; De Marchi
in Florence 1992, no. 7.11; Danti 1996, p. 142; Rubin in
ibid. p. 106; Bambach 1999a, pp. 139–40; Cadogan 2000,
no. 84; Kecks 2000, p. 152; Faietti (forthcoming)

The Visitation depicts the meeting of the
Virgin, the figure on the left, and her cousin
St Elizabeth, when both were pregnant (Luke
1:39–55). It is an initial sketch for an episode
in the fresco cycle for the Tornabuoni Chapel
in S. Maria Novella, executed in 1486–1500
by Ghirlandaio and his studio (fig. 1; for details
of this commission see no. 58).[1] The quick and
schematic handling of the pen gives a sense of
the artist's inventive fluency as he set out to
design a scene on the right side of the chapel,
opposite the *Birth of the Virgin* (see no. 58).
Ghirlandaio's facility for narrative was recog-
nized by Vasari, who recounted the artist's
desire to decorate the entire circumference
of Florence's walls with painted histories.[2]

The scene is drawn in the manner of a
sculpted low relief, with the main figures close
to the picture surface (an effect unintentionally
heightened by the trimming of the sheet), their
contours appearing almost sculpted by the pen
but without detaching them completely from
the background.[3] Alterations display the artist's
rapid thought sequence: the heads of the Virgin
and Elizabeth were initially drawn closer
together, before the Virgin's head was shifted
to the left in thick contours (with hatching
added to describe the fall of light from the left)
and the far contour of her back shifted corre-
spondingly. Ghirlandaio must have made this
change to give a more decorous distance
between the women in the instant that St John
the Baptist moved in Elizabeth's womb at the
recognition of Christ. The poses of the two
figures are carefully calibrated to convey
emotion and engage the spectator in what
Alberti called the *istoria* (for an explanation of

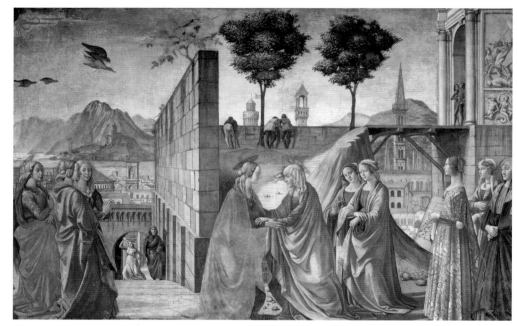

Fig. 1
Domenico Ghirlandaio, *Visitation*, 1486–90. Fresco,
Tornabuoni Chapel, S. Maria Novella, Florence.

this term see p. 54).[4] The background architec-
ture was drawn around the central figures and
shows similar changes of mind, for example in
the more acute perspective given to the wall
on the left flanking the steps leading up to the
foreground. The other figures in the scene
were then added on top of the background
in an extremely abbreviated manner.

The involvement of the spectator is
heightened in the fresco by the inclusion of
portraits of the patrons, the Tornabuoni family,
in a narrative setting of an idealized Florence
whose Roman architecture (seen especially in
the triumphal arch to the right) both ennobles
the story and evokes a classical past in harmony
with the biblical period.[5] This dual function is
displayed by the stone wall (the coursing of
which is anticipated in the drawing) behind
the Virgin, which is reminiscent of a Tuscan
city wall, while also owing something to a
drawing of the Forum of Nerva contained in
the architectural sketch book known as the
Codex Escurialensis (Biblioteca, Monasterio

S. Lorenzo, Escorial), sometimes considered to
derive from Ghirlandaio's workshop.[6] To the left
in the drawing is a hemispherical dome, which
recalls the one designed by Filippo Brunelleschi
for Florence Cathedral, a detail less prominent
in the fresco's northern-inspired landscape
with mountains in the distance.

The verso is stuck down but the pricked
contours of a cartoon of an antique-style
moulding comprised of rows of egg-and-dart
motifs with palmettes are clearly visible. The
design would have been transferred to the wall
through pouncing (the shaking of powdered
charcoal or black chalk over the holes), the
pragmatic recycling of the paper to make the
cartoon after the recto design had served its
purpose probably ensuring the survival of
this rare initial compositional drawing. The
cartoon perhaps relates to the cornice above
the lowest tier of scenes in which *The Visitation*
is also placed.[7] RS

225

60 Study of drapery

1491

Brush and brown wash, heightened with lead white
(over some slight underdrawing in the head),
on paper rubbed with red chalk, 29 × 13.1 cm
Inscribed in an old hand: 'Dom. Grillandaio'
Gabinetto Disegni e Stampe degli Uffizi, Florence (315 E)

PROVENANCE

Fondo Mediceo-Lorenese (Pelli after 1775–before 1784);
Reale Galleria degli Uffizi (L. 930)

LITERATURE

Ferri 1881a, p. 20; Berenson 1938, vol. 2, no. 876; Petrioli
Tofani 1986, p. 139; Cadogan 2000, no. 88; Melli in
Florence 2006b, under no. 31

This drawing is a detailed study of the Virgin's
mantle in Ghirlandaio's *Visitation* panel now in
the Louvre, commissioned in 1491 by Lorenzo
Tornabuoni as the altarpiece for his chapel in
S. Maria Maddalena in Florence (fig. 1).[1] The
artist has applied thin strokes of white with
the brush to convey the illumination from the
left, giving a shimmering quality to create an
impression of the Virgin's forward motion.
The simplified forms are characteristic of the
artist's late style,[2] although the practice of
making brush drapery studies was pioneered
in Verrocchio's studio in the 1460s and 1470s.[3]
It would have followed an initial sketch to
establish the overall composition in the
manner of no. 59.[4]

The simplified appearance of the protruding
limbs and the rigid right leg discernible
beneath the cloth suggest that the drapery was
arranged over a mannequin or lay figure, in a
similar manner to Fra Bartolommeo's drawing
in no. 89.[5] Using a method described by Vasari,
Ghirlandaio must have dipped the cloth in
liquid wax or clay before arranging it on the
mannequin; it would then have stiffened
as it dried to allow prolonged study of the
drapery's undulating forms. Further evidence
of his use of a sculptural model is provided by
the schematic head seen in the ultraviolet-
induced luminescence image (fig. 2).[6] Before
studying the drapery, the artist rubbed the
surface of the paper with red chalk to impart a
warm glow to the figure, a technique Botticelli
also used in no. 36.

The drawing demonstrates the way in which
Ghirlandaio studied the design of drapery afresh
for an important commission, rather than
repeating or adapting an existing model. Such
an emphasis on drapery shows the influence of

Fig. 1
Domenico Ghirlandaio, *Visitation*, 1491.
Tempera and ?oil on panel, 172 × 165 cm.
Musée du Louvre, Paris.

antique statuary, in which vestments provided
compositional interest and revealed the
figure beneath. Antique statuary, including
freestanding figures and multi-figural comp-
ositions on sarcophagi, would have been
available to Florentine artists through the
collections of major patrons, such as the
Medici sculpture garden. The variety of
classical sculptural examples spurred Renais-
sance artists in their representation of the
natural world. Alberti in his *Della pittura*
treatise on painting written in the mid-1430s
described the potential of drapery to
augment the body's form and amplify the

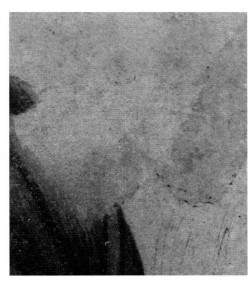

Fig. 2
Ultraviolet-induced luminescence image of no. 60,
showing detail of the Virgin's head.

visual impact of a subject's gestures, conveying
emotion and a sense of inner motivation.[7]

Ghirlandaio included a number of refer-
ences to Giovanna degli Albizzi, the deceased
wife of Lorenzo Tornabuoni, in the painting
for which this drawing is a study. Giovanna
was also represented in the pictorial decoration
commissioned from Ghirlandaio by Lorenzo
Tornabuoni's father, Giovanni, to decorate
the high-altar chapel of S. Maria Novella (see
nos 58–9). Ghirlandaio had become the artist
favoured by the Tornabuoni family to further
their dynastic ambitions, and it was therefore
only to be expected that the artist's output was
interwoven with references to his principal
patrons. Although Lorenzo Tornabuoni would
never have expected to see a working study
such as the present one, his family's continuing
patronage of the artist was in part founded on
the thoroughness of his design process, which
ensured the narrative clarity of his paintings,
and maintained a homogeneous studio style
and level of quality through the provision
of drawings to his assistants to guide the
execution of the finished works in paint. RS

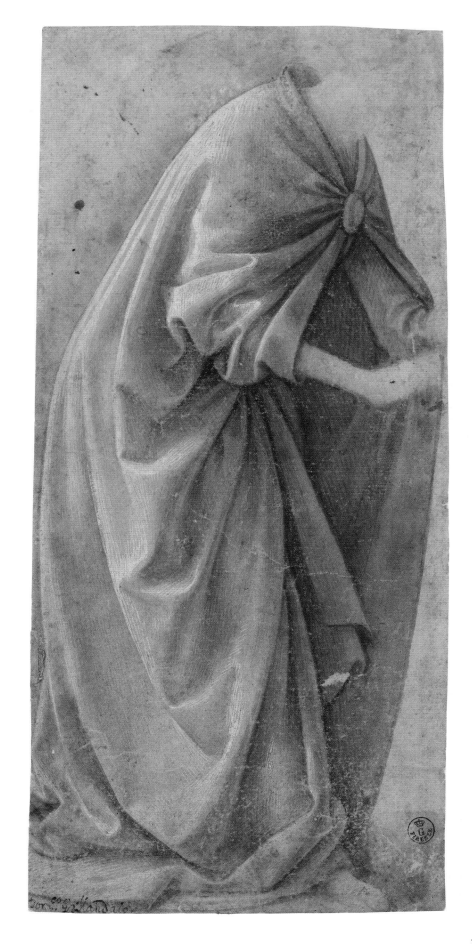

227

61 Bust of a woman

1480–90

Metalpoint (? silverpoint), heightened with lead white, on brown-grey preparation, 33.1 × 25.4 cm
Gabinetto Disegni e Stampe degli Uffizi, Florence (298 E)

PROVENANCE

Fondo Mediceo-Lorenese (Pelli after 1775–before 1784); Reale Galleria degli Uffizi (L. 930)

LITERATURE

Ferri 1881a, p. 19; Berenson 1938, vol. 2, no. 875; Petrioli Tofani 1986, p. 132; Cadogan 2000, no. 87; Kecks 2000, p. 146; Bartoli in Rome 2000, vol. 1, no. 5.26

The description of the woman in this drawing is so particular as to be almost certainly a portrait. The sitter's high social standing is suggested by her plucked eyebrows and diaphanous headdress with its embroidered rim. The artist's sole concentration on the head, illuminated from the right and leaving the bust and shoulders sketchily described, would suggest that the drawing was a preparatory study for an unknown painting rather than an autonomous work for presentation.

Ghirlandaio's interest in unusual physiognomies is shown in the *Portrait of an old man* in Stockholm (fig. 1), executed in the same media but on a pink ground, where the subject's swollen nose is emphasized by it being shown in profile.[1] Ghirlandaio also manipulated the viewpoint to bring out the singular aspects of his subject in the present work, seen in the way the sitter's left eye is flat to the picture surface while her right eye is at an angle. This individualization went against the prevailing classical convention towards idealization, and in this regard Ghirlandaio's work was closer to Northern European portraiture, especially that by Jan van Eyck.[2]

At the same time much of Ghirlandaio's technique derives from his Florentine schooling. The paper was first prepared with pigment to allow the use of a metalpoint medium, probably silverpoint, whose initial lines were lightly applied yet are visible in places, for example in the outer contours of the right cheek. The darker contours were created by applying greater pressure to the tip, while the broader lines were achieved through the use of the blunter, or more worn, end of the metalpoint. The half-tones are provided by the brown-grey

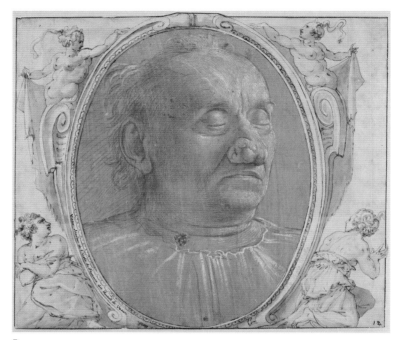

Fig. 1
Domenico Ghirlandaio, *Head of an Old Man*, c. 1490. Metalpoint (? silverpoint), heightened with lead white, on pink preparation, 28.8 × 21.4 cm (55 × 42 cm including mount by Vasari). National Museum, Stockholm.

ground, while delicate and flexible strokes of a fine brush loaded with white pigment describe both the fall of light from the right, and the planes of the face. This technique, by which light appears to adhere to the surface in subtle filaments of white paint, thereby imparting an impression of the almost imperceptible movement of living bodies, was a favoured one of Florentine artists from the 1470s.[3] These stylistic characteristics, as well as the sense of volume, suggest a date for the sheet of the mid-1480s during the execution of the Tornabuoni Chapel in S. Maria Novella, frescoes for which Ghirlandaio must have produced comparable portrait studies for the members of the family and their circle portrayed in the scenes (fig. 1, no. 59).[4]

This sheet is an example of Ghirlandaio's skill as a portraitist, for which he was famous, and reflects the demand for portraiture in

Florence in the second half of the fifteenth century.[5] The Florentine patrician classes appreciated the increasing verisimilitude of the genre, with portraits prized as adornments for their palaces and as a means of familial display in public spaces such as chapels.[6]

This sheet was given to Davide Ghirlandaio in the eighteenth-century inventory of Pelli Bencivenni but this is clearly based on a misconstruction of the Ghirlandaio brothers' differing personalities.[7] It was first given to Domenico by P. N. Ferri in 1881, an attribution that has been generally accepted since, with the notable exception of Alessandro Cecchi, who proposed the name of Filippino Lippi.[8] The clear similarities between this drawing and the Stockholm portrait, however, provide strong evidence in favour of them being by the same hand. RS

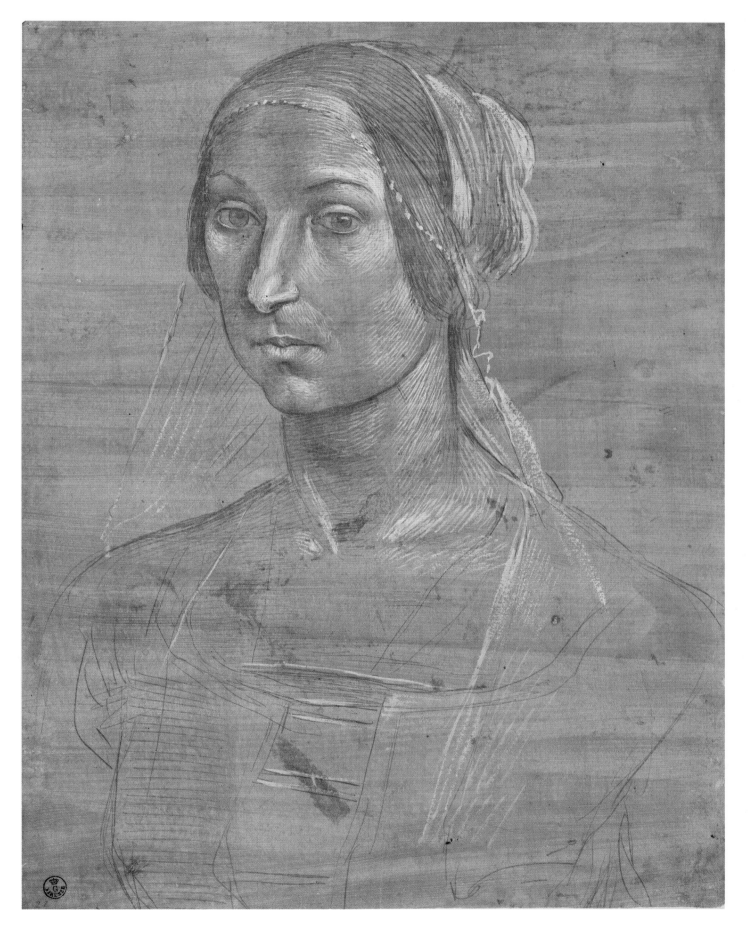

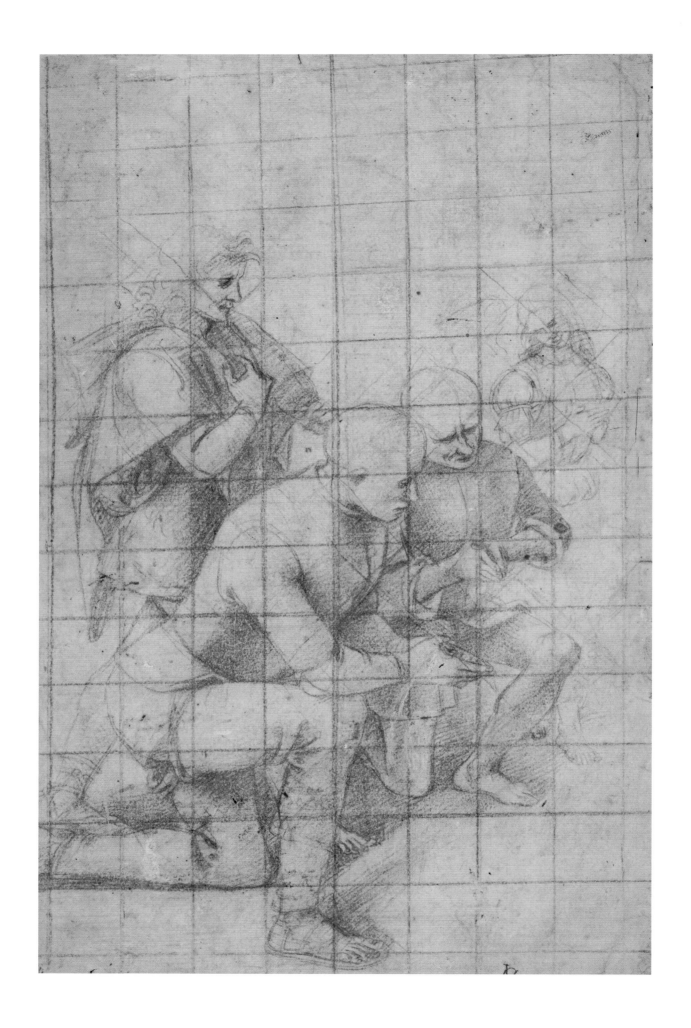

LUCA SIGNORELLI (*c.* 1450–1523)

62 Three shepherds and an angel

c. 1496

Charcoal, squared in charcoal, 38.4 × 24.8 cm[1]
Inscribed in an old hand: 'LS'
British Museum, London (1895,0915.602)

PROVENANCE

W.Y. Ottley; Revd Dr H. Wellesley; Sir J.C. Robinson;
J. Malcolm; acquired from Col. J. Wingfield Malcolm, 1895

LITERATURE

Berenson 1938, vol. 2, no. 2509 E–4; Popham and
Pouncey 1950, no. 235; Van Cleave 1995, vol. 1, no. 18;
Henry in London 1998b, no. 12; Kanter, Testa and Henry
2001, no. 51/2

This is a study for the group of figures on the left side of the *Adoration of the Shepherds* altarpiece recorded in S. Francesco, Città di Castello, in the eighteenth century and now in the National Gallery, London (fig. 1). Several early sources state that the work was executed in 1496 and there is no reason to doubt this date as stylistically it matches paintings by Signorelli from the mid-1490s.[2] The truncated state of the squaring and of the intertwined initials, 'LS', at the lower right, an inscription probably added by an early collector of Signorelli drawings, shows that the sheet has been cut down slightly.[3]

The highly detailed nature of the study is indicative of Signorelli's careful preparation of the composition on paper before starting work on the panel. The technique of the present study has customarily been described as black chalk, a medium that Signorelli helped to popularize for making figure studies in central Italy during the course of his long career, but recent investigation has shown that it was actually executed in charcoal.[4] His exploration of the tonal qualities of charcoal can be seen in the present study, where volumetric effects are achieved principally through light and shade. Signorelli's concern for the sculptural plasticity of his figures, and the underlying geometrical construction of their forms, was a legacy of his training with Piero della Francesca (*c.* 1415–92). The pivotal figure of the kneeling Virgin is not shown in the drawing, but the artist must have worked out the entire group in an earlier study because he already knew that Mary's proximity to the shepherd on the right would obscure most of the lower half of the angel. For this reason he did not bother to draw the parts of the angel's body that would be behind the Virgin. Similarly, the artist knew precisely where to place the shepherd's right foot between the kneeling figures in front of him. The form of the foot behind the foreground shepherd's calf has been included to ensure that the heel and the toes should be correctly aligned. While it is safe to assume that Signorelli must have made a compositional study of the whole group, the survival rate of his studies of this kind is extremely low: only four are found among the 40 works that constitute his graphic corpus.[5] The way in which the artist chose to divide up the group of adorers around the Infant Christ is typical of Signorelli's modular design method, at least to judge by the preponderance of studies of small groups or individual figures.

The present drawing appears from the lack of alterations and changes of mind to be the final design for the group. The ruled squaring would have allowed the figures to be enlarged to the expanded scale of the altarpiece, by means of copying the contents of each square on the drawing to a larger-scale grid. It is unclear whether Signorelli transferred the design directly on to the panel or whether he used a cartoon.[6] For the most complex areas, such as the heads and upper bodies, Signorelli divided the squares into smaller divisions by drawing diagonal lines across them so as to make it easier to copy the detail accurately. Despite the care with which the artist prepared the group, comparison with the paintings shows that he continued to make further adjustments, most notably the addition of a second standing shepherd and of two angels on either side of the one shown in the drawing. To accommodate these additional figures he moved the kneeling figures slightly apart and shifted backwards the left-hand standing shepherd, thereby separating his form more clearly from his companion to his left.

The artist must have retained the drawing in his studio stock as he recycled the poses of the kneeling figures in a later treatment of the same subject now in the Museo Diocesano, Cortona, painted around 1515.[7] HC

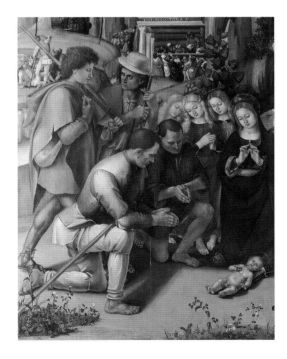

Fig. 1
Luca Signorelli, *Adoration of the shepherds* (detail), 1496. Oil on panel, 215 × 170.2 cm. National Gallery, London.

LUCA SIGNORELLI (*c.* 1450–1523)

63 Four nudes in combat

c. 1500

Black and red chalk, 28.6 × 21.5 cm
Gabinetto Disegni e Stampe degli Uffizi, Florence (1246 E)

PROVENANCE

Ferri, Disegni Esposti (1879–81); Reale Galleria
degli Uffizi (L. 930)

LITERATURE

Berenson 1938, vol. 2, no. 2509 D-2; Petrioli Tofani 1972,
no. 25; Ferino Pagden in Florence 1982, no. 69;
Van Cleave 1995, vol. 1, no. 7

This is most likely a rejected idea for a group of figures in one of the scenes of the Last Judgement painted by Signorelli on the walls of the Cappella Nova (also known as the Chapel of S. Brizio) in Orvieto Cathedral. Signorelli began work in the chapel in 1499 by painting the vault with the saintly elect in heaven witnessing the apocalypse, a decoration left incomplete by Fra Angelico, and the following year he was given the task of decorating the walls below. Over the next four years Signorelli frescoed the upper parts of the walls with narrative scenes inspired by the New Testament Book of Revelations. Below these he painted representations of poets, of which Dante is the only non-classical author, with grisaille roundels depicting scenes from the underworld inspired by their writings. The chapel is undoubtedly Signorelli's masterpiece, the physicality and vitality of his art, especially as regards the depiction of the male body, ideally suited to such a dramatic theme. Even Michelangelo, who was notoriously sparing in his praise for fellow artists, is reported in Vasari's second edition (1568) of his *Lives of the Artists* to have admired Signorelli's decorations and sought inspiration from them for his *Last Judgement*, in the Sistine Chapel in Rome (1536–41).[1]

Michelangelo certainly knew Signorelli (the older artist borrowed money from him in 1513 after he had failed to find work at the court of Leo X) and, with the exception of Leonardo and his teacher Ghirlandaio, no artist of the previous generation had a greater influence on

his development, above all as a draughtsman. The present drawing is an outstanding example of Signorelli's ability to express emotion and movement in the most visceral fashion through the muscular torsion of the male form. This is perhaps best exemplified in the hugely exaggerated shoulder blades of the figure whose head has been brutally forced to the ground, a detail that departs from anatomical accuracy to convey the pressure exerted on him by his smiling assailant. Neither of the two aggressors in the drawing can be identified with certainty as devils, for they lack the horns generally, although not universally, found among the satanic figures in Signorelli's fresco. However, the wispy, curved penis of the right-hand figure is a feature of some of the devils in the work, like the one grabbing the hair of the man in *The Damned led into Hell*. The likelihood is that the figures were conceived either for the last-named scene or for the *Damned*, perhaps more likely the latter as it features a devil binding a man's hands behind his back, albeit posed differently. It appears that the central figure was originally drawn with an erect penis, perhaps with the intention to denote that the sin that had condemned him was Lust, but Signorelli changed his mind and went over it in red chalk.

The use of black and red chalk, a combination found earlier in Piero Pollaiuolo's *Faith* cartoon of around 1470 (no. 33), is one that Signorelli used in five other drawings, one of them related to the Orvieto commission.[2] The use of red chalk to model the bodies gives an added naturalism to the flesh tones (the exclusive use of black chalk for the figure on the right may suggest that the artist intended him to be darkly coloured like a number of the devils in the *Damned* fresco; see fig. 14 on p. 33), while at the same time providing a mid-tone between the untouched areas of now much-yellowed paper and the shaded areas. H C

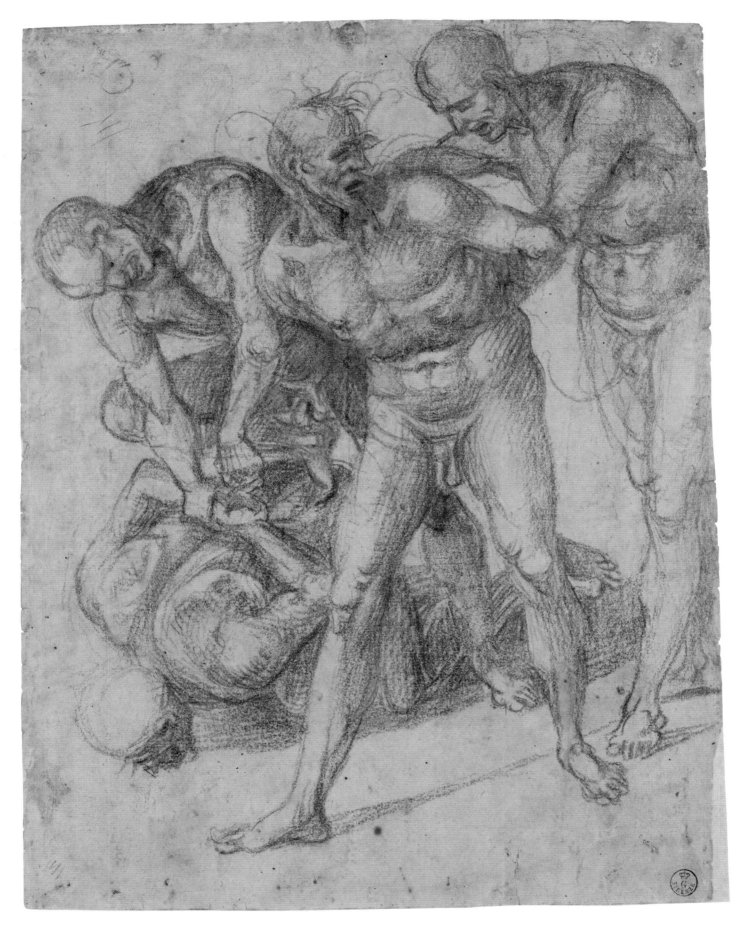

233

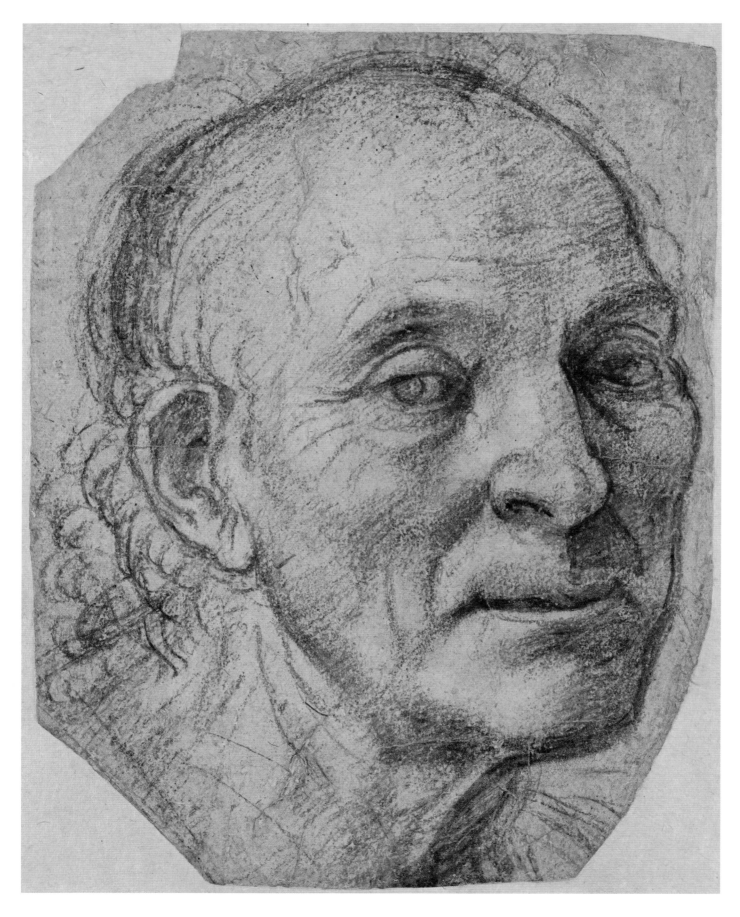

234

LUCA SIGNORELLI (*c.* 1450–1523)

64 Head of an elderly man

c. 1500–10

Black chalk, faint traces of lead white heightening, 19.3 × 24.9 cm
Gabinetto Disegni e Stampe degli Uffizi, Florence (129 F)

PROVENANCE

Ferri, Disegni di Figura (*c.* 1887); Reale Galleria
degli Uffizi

LITERATURE

Berenson 1938, vol. 2, no. 1850 (as Piero di Cosimo);
Ferino Pagden in Florence 1982, no. 65; Van Cleave 1995,
vol. 1, no. 8

This drawing must be from life because the description of the man's features and wrinkled skin are so individualized and particular. The drawing has clearly been cut, which makes it impossible to know the original format, although the less detailed description of the region below the chin suggests it may originally have been bust-length, like Filippino Lippi's metalpoint drawing at Windsor Castle where the focus tails off in a similar fashion (fig. 1).[1] Signorelli's portrayal of the man has a remarkable intimacy and immediacy derived from the close-up viewpoint, and the way in which the sitter returns the gaze of the artist scrutinizing him from the sitter's right. It seems incontrovertible that the drawing is a study of an individual, yet it does not necessarily follow that it was made specifically as a portrait. The aforementioned Lippi drawing at Windsor is, for example, a study of a model whose features were used as the basis for the head of a shepherd in his altarpiece of the *Adoration of the Magi* of 1496 now in the Uffizi (on the reverse of the sheet there is a study for the same figure's praying hands).

The possibility that the drawing was made as source material for a head in a painting cannot be discounted, as Signorelli's works often include characterful representations of elderly men. However, it does not match any heads in his surviving works. Signorelli's dedication to life drawing to heighten the veracity of his paintings is attested by Giorgio Vasari's story of the artist undressing the corpse of his murdered son in order to draw it.[2] While this account cannot be verified, although it is known that Luca's son, Antonio, did die young, it does contain a kernel of truth as regards the fundamental importance to Signorelli of studying from the male figure in his artistic practice. His experience as a draughtsman is evident in his assured command of black chalk in the present work, the head described principally through variations in tone with the untouched paper used as the highlight.

The suggestion that the drawing might be by Piero di Cosimo is clearly mistaken, since it is so close in style to a black chalk drawing of the thirteenth-century Florentine poet Dante in Berlin that bears an old inscription to Signorelli (fig. 2). Thanks to the artist's experience of life drawing, honed in studies such as the present one, he is able to conjure up in the Berlin sheet a vivid sense of the writer's commanding presence and fierce intelligence.

Fig. 2
Luca Signorelli, *Head of a man* (*Dante*), *c.* 1490–1500.
Black chalk, 23.7 × 15.5 cm. Kupferstichkabinett,
Staatliche Museen, Berlin.

In the absence of any links to paintings it is impossible to be certain as to when the Uffizi drawing might have been made. Signorelli's style as a draughtsman in black chalk was remarkably consistent from the 1490s onwards, and as a result the dating advanced here to the first decade of the sixteenth century is only tentative.[3] HC

Fig. 1
Filippino Lippi, *Head of a man looking down*,
c. 1496. Metalpoint heightened with lead white,
on blue-grey preparation, 24.1 × 18.5 cm.
The Royal Collection, Windsor Castle.

65 Two male nudes

c. 1485–8

Silverpoint (left figure) and leadpoint (right figure), heightened with lead white
(partly discoloured), over stylus, on grey preparation, 25.9 × 18.5 cm
British Museum, London (1858,0724.4)

PROVENANCE
Count N. Barck (L. 1959); acquired from W.B. Tiffin, 1858

LITERATURE
Colvin in London 1895, no. 22; Berenson 1938, vol. 2,
no. 1345; Popham and Pouncey 1950, no. 134; Shoemaker
1977, no. 31; Goldner in New York 1997, no. 36

This drawing from life of studio assistants (*garzoni*) is characteristic of Filippino Lippi's surviving graphic oeuvre from the 1470s and 1480s, and the attribution to him, first made by Sidney Colvin in 1895, has never been questioned. The commonplace workshop environment in which the models were drawn is suggested by the two men's muscular yet unidealized bodies, their modesty preserved by tightly fitting undergarments. The seated man wears a cap (initially drawn on a smaller scale and then increased in size), and is perhaps engaged in drawing, judging by the appearance of the flat object he holds over his right knee. His right foot rests on a block, part of which has been lost by the trimming of the sheet. The prominent jaw and long nose of the right-hand figure are sufficiently close to the features of the seated one to suggest that they are perhaps the same model, his standing and frontal pose chosen for contrast.

It seems unlikely that these studies had a specific purpose, but rather were intended by Lippi as exercises to provide a springboard for poses in commissioned works, which could also double as didactic guides for studio assistants. This drawing and similar ones by Lippi, such as two double-sided sheets in Christ Church, Oxford, also dated to the 1480s,[1] display the creative artistic practices of a Florentine workshop, in particular the interest in naturalism reawakened by the study of antique art, in which the classical nude provided the ideal proportions against which even studies from life were measured. The importance accorded to the proportions of the human body by Renaissance artists is reflected in Alberti's recommendation in his artistic treatise written in the mid-1430s that clothed figures be studied first in the nude.[2]

Recent scientific analysis has revealed that the artist employed silverpoint for the seated figure and leadpoint for the standing one (fig. 1). Although the appearance of the marks produced by the two metalpoints is broadly similar, the silverpoint has taken on a distinctly brownish hue over time.[3] Since the seated man has been retouched in leadpoint, and the standing man has none in silverpoint, it can be deduced that the artist drew the standing man subsequently. There are examples of drawings that deliberately combine the softer, more free-flowing technique of leadpoint with the adamantine precision of silverpoint (as is the case with the Perugino head, no. 47), but in the present study the combination seems more likely to be accidental, with the artist picking up the medium closest to hand and using it to

Fig. 1
Infrared reflectograph of no. 65 in which the silverpoint figure on the left is barely visible.

retouch his earlier study. Both figures have white added with the brush to convey the fall of light from the left, seen in the shadow cast by the standing man (a detail omitted in the other figure). The artist also sought to forge a connection between the two, with the standing man appearing to peer over his companion's shoulder to scrutinize his activity.

In both figures the initial strokes of metalpoint were lightly applied and are clearly visible in many places, for example, along the back of the left-hand figure. One of several alterations made to the figures is where Lippi initially drew the right arm of the standing figure only down to the elbow, then shifted the contours slightly to the left before he completed the limb. A similar process may have occurred in the left arm, although the trimming of the sheet makes this unclear. The metalpoints are pressed hard to create the final outlines, the artist employing a wide variety of strokes, oblique and parallel, only rarely crossed in the manner of Ghirlandaio (see no. 58) to model the body. There are dense areas of hatching, on occasion produced without lifting the metalpoint from the surface in dynamic zigzags that nearly impinge on the outer contours, for example in the left arm of the standing figure and the dark hollow of his left armpit. This forceful and varied handling gives a pictorial quality to the figures that is characteristic of Filippino's drawings from the second half of the 1480s, before the artist left Florence for Rome in 1488 (see no. 66). R S

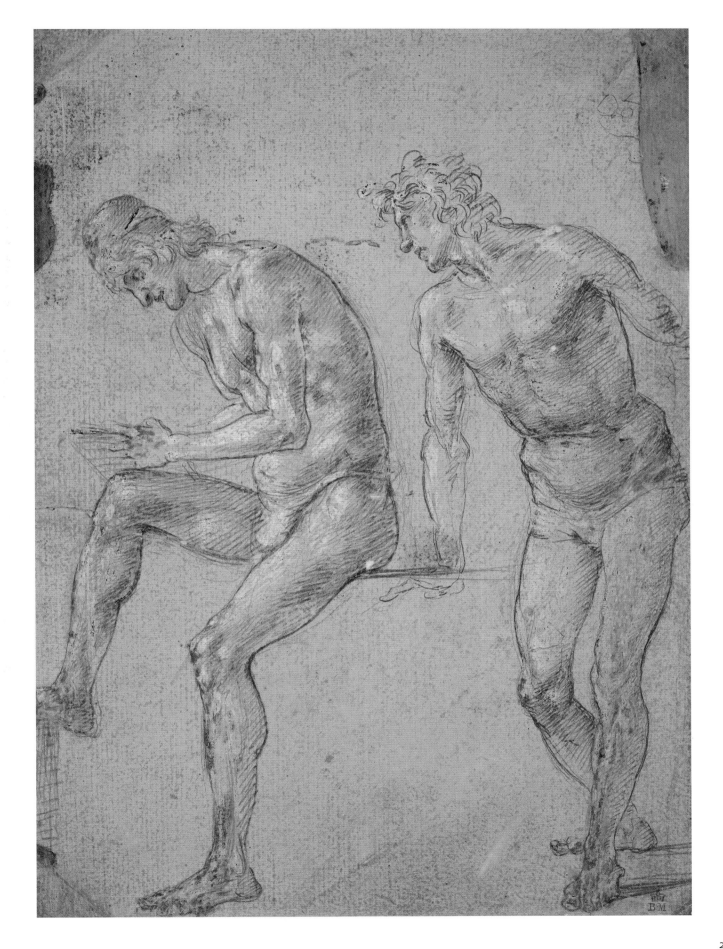

FILIPPINO LIPPI (*c*. 1457–1504)

66 Triumph of St Thomas Aquinas

1488–93

Leadpoint, pen and brown ink, brown wash, on light brown preparation, 29 × 23.8 cm
Inscribed in an old hand: 'Pietro Perugino', '9'
British Museum, London (1860,0616.75)

PROVENANCE

G. Vasari (?); P.-J. Mariette (L. 2097); Sir T. Lawrence
(L. 2445); Marquis de Lagoy (L. 1710); T. Dimsdale
(L. 2426); S. Woodburn; acquired at Christie's 1860 sale
of Lawrence-Woodburn collection for £4

LITERATURE

Berenson 1938, vol. 2, no. 1344; Popham and Pouncey
1950, no. 131; Shoemaker 1977, no. 60; Geiger 1986,
pp. 106–8; Goldner in New York 1997, no. 55; Zambrano
and Nelson 2004, no. 39.d.15

This highly finished drawing is a study for
The Triumph of St Aquinas commissioned in 1488
by Cardinal Oliviero Carafa to decorate the
right-hand wall of his chapel in S. Maria sopra
Minerva in Rome (fig. 1), a church belonging
to the Dominican Order, of which Carafa
had been appointed Protector in 1478. Lippi
worked on the fresco decorations of the chapel
until 1493, a period that had a profound impact
on his artistic style due to his prolonged first-
hand experience of classical art. In turn Lippi's
frescoes, and especially the arrangement of
the figures within a monumental architectural
framework convincingly related to the real
space of the chapel, were of profound influence
on succeeding generations of artists, most
notably on Raphael's fresco of the *Disputa*,
1510–11, in the Stanza della Segnatura in
the Vatican.[1]

The drawing depicts the victorious
culmination of St Thomas Aquinas's disputation
on heresy: the saintly Dominican theologian
is enthroned on a high plinth, flanked by four
seated female personifications, which in the
fresco appear to include Grammar, Logic and
Theology, and above his head two flying angels.
These figures are seated in a square loggia
with pilasters carrying portions of entablature
from which arches spring in the manner of
Brunelleschi's arcades at Santo Spirito in
Florence. The main influence on Lippi's archi-
tecture was the antique monuments of Rome,
as is seen in the barrel-vaulted structures on
either side surmounted with walkways from
which sketchily drawn figures peer down.
At the lower left there is a compact retinue of

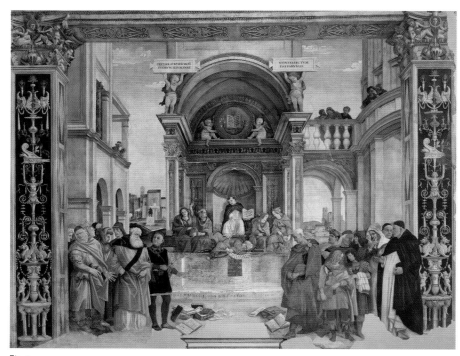

Fig. 1
Filippino Lippi, *Triumph of St Thomas Aquinas*, 1488–93.
Fresco, Carafa Chapel, S. Maria sopra Minerva, Rome.

ecclesiastics including a cardinal identifiable
by his long robes, perhaps intended as a
portrait of the patron. They are in contrast to
the gesticulating and disorderly heretics on
the right, whose defeat is displayed by the piles
of discarded books destined for incineration
in the centre of the composition. Steps in
the centre descend to a narrow ledge with a
balustrade to the left, intended to echo the
real balustrade at the entrance of the chapel
and create an illusion to draw in the spectator.
To the right the artist offered an alternative
design of the foreground with pilasters
arranged along the side of the platform that
supports the figures.

Lippi skilfully blended washes of varying
tonality to portray the illumination from
the right, a sense of depth and an enveloping
atmosphere of shadow and light. The finished
appearance of the drawing suggests that
the likely purpose of the sheet was to allow

discussion of the composition with the patron
at a reasonably early stage in the planning. This
is reinforced by the fact that the spatial qualities
of the sketch (which almost equal Leonardo's
work; see no. 53) are toned down in the fresco,
the architecture of which is simplified (the
lofty arches above Aquinas replaced by a more
Roman-looking groin vault) and displays
a linear symmetry and decorative sensibility
similar to Lippi's near-contemporary
Pintoricchio. Lippi may have considered that
this change to a simpler and weightier style of
architecture more aptly reinforced the abstract
theological subject of the fresco.[2] He also
clarified the composition, perhaps with the
same aim in mind, by reducing the number of
figures shown in the drawing, pushing back
the building occupied by the saint in the centre,
and organizing the heretics into two rather
static groups in the foreground observed by
two Dominicans on the right. RS

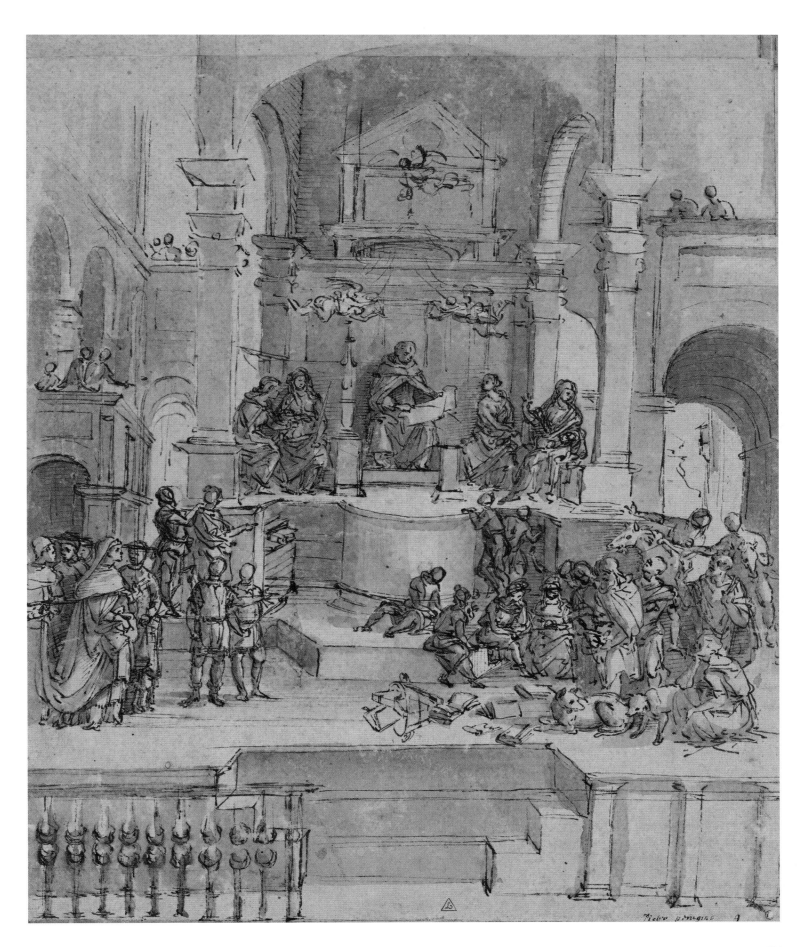

67 Recto: Studies for the Resurrection of Drusiana

c. 1496–1502

Black chalk, pen and brown ink, brown wash, over stylus, 29 × 23.8 cm

Verso: Drusiana

Charcoal
Inscribed in an old hand: 'Filippo di Fra Filippo'; sums and numbers
Gabinetto Disegni e Stampe degli Uffizi, Florence (186 E)

PROVENANCE

Fondo Mediceo-Lorenese (Pelli after 1775–before 1784);
Reale Galleria degli Uffizi (L. 930)

LITERATURE

Halm 1931, p. 410; Berenson 1938, vol. 2, no. 1298; Fossi
in Florence 1955, no. 41; Sale 1976, pp. 160, 257–9;
Petrioli Tofani 1986, p. 82; Goldner in New York 1997,
no. 99; Zambrano and Nelson 2004, no. 40.d.12

This is an early compositional study of an event
in the life of St John the Evangelist recounted
in the *Golden Legend*, the medieval book of lives
of the saints by Jacopo da Varagine, in which
the evangelist brings Drusiana, a Christian
from the Greek city of Ephesus on the west
coast of Anatolia in Turkey, back to life as she
is being carried to her burial. The fresco for
which it is preparatory encompasses the entire
left wall of the Strozzi Chapel in S. Maria
Novella in Florence, the pictorial decoration
of which Lippi began in the late 1480s but
only completed in 1502 (fig. 1).[1]

The urgent handling of the pen displays
the rapidity of the artist's thought and follows
on from an initial drawing in black chalk
visible in many places, especially in the centre,
where Lippi has moved the kneeling bearer
of Drusiana's bier further to the left. He then
added wash with a brush to indicate the fall of
light, thereby giving form to the figures and a
better idea of the final effect of the composition.
Lippi lastly drew the architectural setting in
pen over a sketchy black chalk underdrawing,
in which he experimented with a variety of
sculpture-filled niches flanking a structure
recalling a triumphal arch.

In the centre of the composition the
evangelist raises his arm commandingly above
Drusiana, who sits up on her miraculous return
to life, the effects of which ripple outwards
from the astonished stretcher-bearers to the
staring men on the left and the more composed
women behind the evangelist. Lippi explored
alternative solutions for the stretcher-bearer at

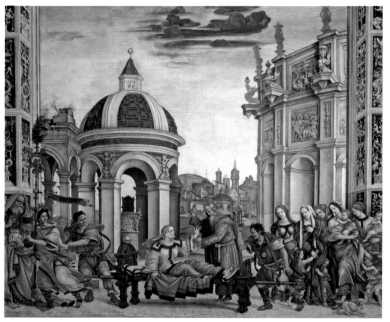

Fig. 1
Filippino Lippi, *The Resurrection of Drusiana*, 1502.
Fresco, Strozzi Chapel, S. Maria Novella, Florence.

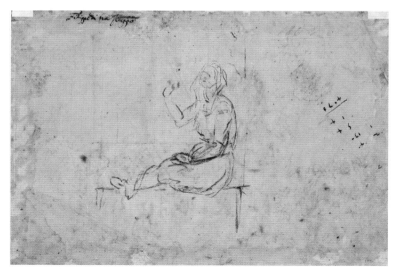

Verso of no. 67

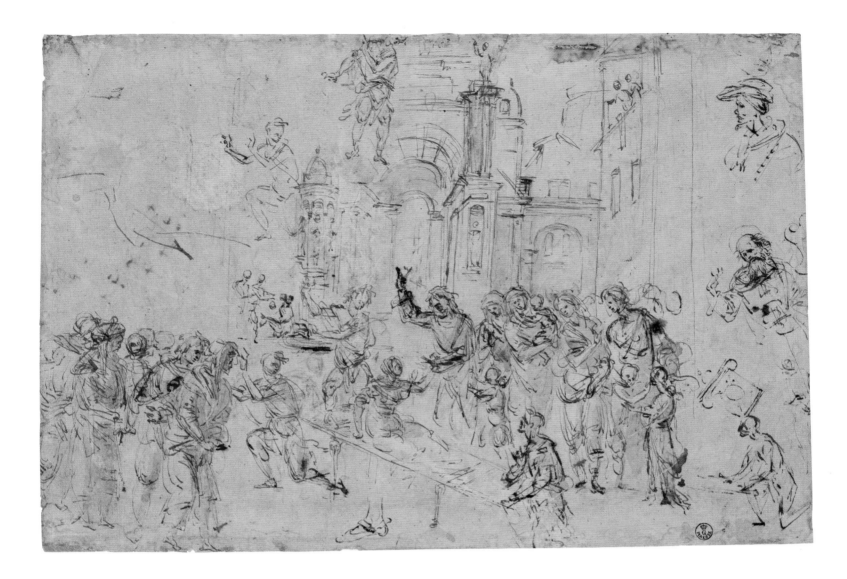

Drusiana's head, one standing, the other kneeling (they are identifiable by the quick lines around the arms and shoulders indicating the straps used to hold the bier, which are clearly visible in the fresco). Both bearers were studied again on a slightly smaller scale before the background was added, hence the lines of the architecture having been cut short around them. The figure of the bearer at Drusiana's feet is also studied afresh, seen on the lower right. Similarly, Lippi repeated the figure of the evangelist to the far right, adjusting his Christ-like appearance by adding a flowing beard over the first oval indication of the head and subsequent halo. Beneath Drusiana's bier is a separate study of a shod right foot, perhaps related to the kneeling bearer above. The head of a turbaned man in profile on the upper right may be an early idea for one of the elders; if so

his orientation would place him to the right of the saint, which in the main study and in the fresco is taken by women and children, with all the male spectators on the left.

As in Ghirlandaio's compositional sketch for the flanking chapel in S. Maria Novella (no. 59), Lippi focuses on the moment of maximum drama. However, whereas Ghirlandaio's figures appear as if in bas-relief, Lippi's occupy a more open space that is articulated through their expansive gestures. Lippi's sole accommodation to the flatness of the picture surface is the background architecture, an area much changed in the fresco where the space is opened up with a distant cityscape introduced in the centre. Lippi's dynamic handling is comparable to Leonardo's work in pen, and if his studies have a somewhat disjointed appearance it is a consequence of

their exploratory nature.[2] The daring inventiveness of the drawing is tempered in the fresco, for example, where the bold diagonal angle of Drusiana's bier is changed to one that is almost parallel to the picture plane.

On the verso is a study for Drusiana turned in the opposite direction, demonstrating that Lippi toyed with reversing the composition. Her form is described in broad and summary strokes of charcoal in contrast to the finer black chalk employed for the initial drawing on the recto. Given the increase in scale it would appear to have been drawn after the recto study, and demonstrates the artist's willingness to consider alternative solutions.
RS

68 Two litter bearers; and a separate study of a left leg

c. 1496–1502

Metalpoint (? silverpoint), heightened with lead white, on pink preparation, 19.6 × 24.2 cm
Gabinetto Disegni e Stampe degli Uffizi, Florence (185 E)

PROVENANCE

Fondo Mediceo-Lorenese (Pelli after 1775–before 1784); Reale Galleria degli Uffizi (L. 930)

LITERATURE

Ferri 1881a, p. 14; Berenson 1938, vol. 2, no. 1297; Fossi in Florence 1955, no. 40; Shoemaker 1977, no. 106; Petrioli Tofani 1986, p. 81; Bartoli in Florence 1992, no. 2.32; Goldner in New York 1997, no. 101; Zambrano and Nelson 2004, no. 40.d.14

This is a study for the two bearers of Drusiana's litter in the fresco for which no. 67 is an earlier preparatory drawing (fig. 1, no. 67). It is en suite with a study in Oxford (fig. 1) of the left-hand figure also in metalpoint on pink prepared paper, which probably once included the right-hand figure before the sheet was cut.[1] As in no. 65, the two models are carefully differentiated: the pose of the left-hand man is determined by his holding of the litter, whereas that of the right-hand figure is one of classically inspired astonishment at Drusiana's resurrection, a miracle the left-hand bearer has only begun to apprehend.

Lippi's handling of the metalpoint has developed further from no. 65 and displays a remarkable variety of line and rapidity of effect, as if employing pen and ink.[2] The figures were initially drawn in light, sweeping strokes (visible especially along the back of the left-hand figure) over which brief and curvilinear lines give a somewhat angular and fragmentary outline to the figures, while volume is added in thick, oblique but uncrossed lines. Lippi imparts a remarkable sense of the movement and tension of the muscles, an effect augmented by the motion of the draperies that appear to be about to tear apart from the strain of containing such dynamic bodies. This attention to muscula-ture is seen in the larger-scale study of the right-hand bearer's left leg, which seems to sprout from his back. It was clearly drawn after the figure, with the aim of altering the angle of the leg, the profile view emphasizing the bulging calf muscle caused by his sudden back-ward movement. The lines beneath the litter are perhaps swiftly abandoned indications of

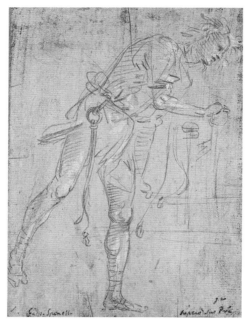

Fig. 1
Filippino Lippi, *A litter-bearer*, *c.* 1496–1502. Metalpoint heightened with lead white on pink preparation, 18 × 13.2 cm. Christ Church Gallery, Oxford.

the swelling calf muscles of this leg. The description of the left-hand figure's buttock beneath the cloth of the tunic shows the artist's attention to the underlying form of the body.

The angle of the litter is the same as in the fresco, as is the oblique fall of light from the right, emphasized not only by thick strokes of white applied with the brush to both figures, but also by the straps and the uprights of the headboard (the leftmost one continued down-wards, probably an indication of one of the feet of the litter). The artist paid great attention to the straps with which the litter is carried: the left-hand figure holds one handle while the other one on his end is carried by the taut strap descending from his neck. By contrast his companion's strap has broken away on one side from the force of his movement, adding to the drama of the event.

The contrasting appearances of Lippi's two metalpoint drawings in this exhibition,

the present one and no. 65, are principally explained by their different functions: no. 68 is a study from the artist's imagination of a motif with a precise destination but one based on Lippi's careful examination of the nude in life as seen in no. 65. The two drawings are separated by the years of Lippi's Roman sojourn, 1488–93 (see no. 66), when the Golden House of Nero (Domus Aurea) built after *c.* AD 64 had recently been rediscovered. The frescoes it contained encompassed both walls and vaults and were hugely influential on Lippi and his artist contemporaries in both terms of style and the organization of large-scale mural compositions. There is a sense in which Lippi's observation of the fluid painting style of Roman frescoes may have encouraged a more rapid, darting style of execution in his drawings, as is seen here. On grounds of style it would seem that no. 68 was drawn closer to the completion of *The Resurrection of Drusiana* fresco, signed and dated 1502, rather than the first granting of the commission in 1487. RS

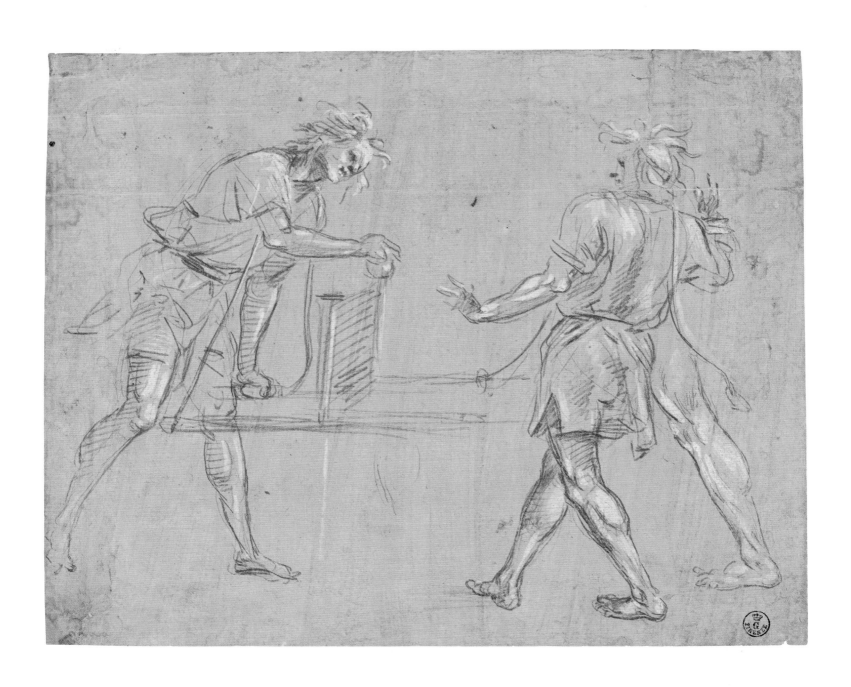

243

69 The Risen Christ; and studies of hands

c. 1495–7

Silverpoint, heightened with lead white (partly discoloured), over stylus indications
(some ruled), on grey preparation, 37.8 × 25.5 cm
Inscribed by G. Vasari on mount: 'RAFFAELLI[no] DEL GARBO PIT[TORE] FIO[RENTI][no]';
and by P.-J. Mariette (?): 'Ex Collectione olim G. Vasari, nunc P. J. Mariette'
British Museum, London (Pp, 1.32)

PROVENANCE

G. Vasari; P.-J. Mariette; Richard Payne Knight Bequest,
1824

LITERATURE

Berenson 1938, vol. 2, no. 764; Popham and Pouncey 1950,
no. 60; Carpaneto 1970, p. 13; id. 1971, pp. 6–7; Bartoli in
Florence 1992, no. 2.33; Goldner in New York 1997,
no. 112

Vasari wrote of Raffaellino del Garbo:

> In his youth he practised drawing more than
> any painter ever had to achieve perfection,
> to the extent that a great number of draw-
> ings survive to show the range of his art,
> … some in metalpoint, others in pen and
> wash, but all on coloured paper with white
> highlights and executed with pride and
> admirable technique seen in many examples
> of beautiful hand in my book of drawings.[1]

That this sheet was among those that Vasari
mentions is shown by the altar-like mount
designed by Vasari with an inscription to
Raffaellino at its base.[2]

The figure in the centre of the sheet is
preparatory for the Resurrected Christ in an
altarpiece executed *c.* 1497 for the Capponi
familial chapel in S. Bartolommeo, immediately
beyond the city walls of Florence at Monte
Oliveto (fig. 1). Although the correspondence
is clear, the drawing has an immediacy and
novelty that the painting lacks. This is in part
due to the nature of a drawn study, especially
one in indelible silverpoint that clearly displays
alterations made as the artist drew, seen in the
fingers of Christ's raised right arm and the pole
of the banner shifted to the left. The major
difference between drawing and painting,
however, is the strikingly different way the
subjects are represented.

The figure in the centre of the sheet is
In the drawing Christ is a beardless youth,
earthbound and eroticized, with the lightly
clinging drapery parted to reveal his genitals.
Raffaellino's study of the figure from a model
posed in the studio is disclosed by the shadow
cast by his feet. In comparison the figure in
the panel is mature and solemn, with weighty

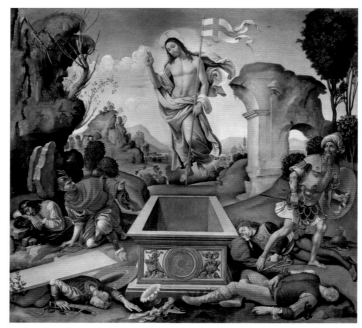

Fig. 1
Raffaellino del Garbo, *Resurrection of Christ, c.* 1495–7.
Oil on panel, 174.5 × 186.5 cm. Galleria dell'Accademia,
Florence.

drapery reconfigured to maintain the decorum
required of representations of Christ (and
which would have required a separate detailed
study in the manner of no. 71).

The artist took inspiration from a classical
prototype, very probably a sculpture of
Dionysus given the youth of the figure and
his wreath of vine leaves, also seen in the one
illustrated as fig. 39 on p. 60. The example of
antique statuary was a major impulse behind
the representation of the nude body in the
fifteenth century – the idealized anatomical
proportions appropriate for conveying the
perfection of the deity incarnate. The drawing
is a remarkable synthesis, in which an
adolescent model posed as the Resurrected
Christ is seen through the prism of antique
sculpture and given a grace and sinuous
contour worthy of Botticelli.

Raffaellino's sensitivity to classical antiquity
derives from his years in Rome in the mid-1490s,

when he assisted Filippino Lippi in the Carafa
Chapel (see no. 66). Lippi employed metalpoint
with unparalleled virtuosity (see nos 65, 68)
and this stimulated Raffaellino's use of the
medium, and, although his strokes appear a
little laboured, he nevertheless succeeds in
imbuing his figures with a lyrical grace.[3]

Raffaellino later turned the sheet 90
degrees to draw a study of a left hand holding
a spherical object and a right hand grasping
an unidentified object, placed to either side
of the study of Christ. They were drawn on a
larger scale but in the same media as the earlier
drawing, and have been identified as prepara-
tory for the left-hand angel in a painting of
the Virgin and Child dated to *c.* 1495.[4] The
drawing demonstrates how fifteenth-century
artists worked concurrently on different
projects, with the artist's thoughts turning,
as did Michelangelo's in nos 93–5, from one
commission to the next. MMR

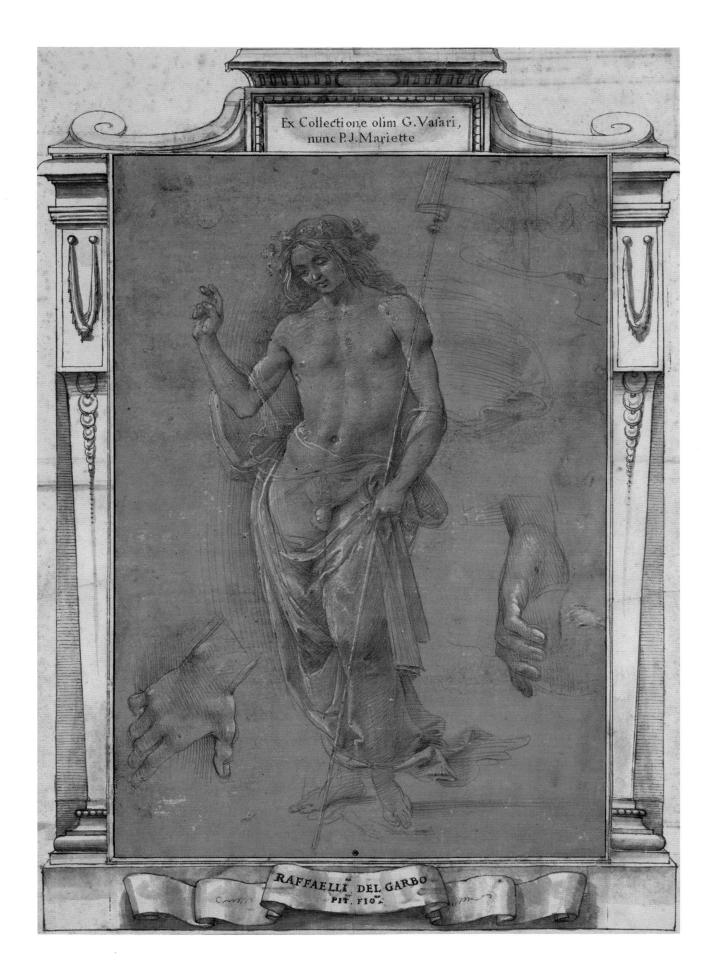

Ex Collectione olim G. Vasari, nunc P. J. Mariette

RAFFAELLI DEL GARBO
PIT. FIO.

245

70 Landscape with the penitent St Jerome
1490–1500

Charcoal (some oiled) and touches of white chalk over stylus,
on five conjoined sheets of paper, 62 × 53 cm
Gabinetto Disegni e Stampe degli Uffizi, Florence (403 P)

PROVENANCE

Ferri, Disegni di Paesaggio (*c.* 1882); Reale Galleria degli
Uffizi (L. 930)

LITERATURE

Giglioli 1928, p. 172; Berenson 1938, vol. 2, no. 1858;
Dillon in Florence 1992, no. 10.2; Nuttall 2004, p. 209;
Geronimus 2006, p. 266; Meijer in Florence 2008c,
under no. 54

This landscape in charcoal, the largest drawing
in the exhibition, has been made by adding
strips to an already large piece of paper (51.8
× 45 cm), two along the lower edge and one
to either long side (with a large repair to the
bottom left). St Jerome kneels in adoration of
a cross that leans against a tree, his right hand
beating his chest in an act of penance. He is
framed by the dark mouth of a stone-arched
cave whose slightly off-centre placing is shown
by the central fold that runs between the saint
and the cross. Behind three precipitous and
craggy hills with gargoyle-like outcrops (the
one on the right almost reaching the full height
of the drawing) a distant landscape is glimpsed,
the only portion of the drawing to be lightly
drawn. This is in contrast to the rest of the
composition, where foreground and distance
are described with an equal bold clarity,
with a sense of recession provided by the
compositional lines and changes in scale. The
abundance of detail – boulders, trees, caves,
paths and ravines crossed by flimsy bridges –
means that the composition cannot be taken in
at a glance, thereby encouraging the viewer's
gaze to journey slowly through the landscape
to unravel its structure: a visual experience
akin to the tortuous progress of the figures
shown toiling up steep mountain paths.
Narrative touches, such as St Jerome's lion
which has wandered from his master's side
to frighten three pack mules on the far left,
only become apparent after prolonged
observation.

The size of the drawing suggests that it
could have been employed by Piero di Cosimo
as a cartoon to produce a painting of similar
dimensions, although none is known. That
Piero produced paintings on this subject is
shown by his painting of *St Jerome in Meditation*
in the Horne Museum in Florence, although
differences in the compositions exclude a direct
connection.[1] Piero's sensibility for landscape
was acknowledged by Vasari in his life of the
artist: he described Piero as drawing inspira-
tion from the marks on walls and clouds, in
which Piero saw 'cavalry battles, the most
fanciful cities, and vast landscapes'.[2] Vasari's
characterization of Piero as a solitary and
eccentric character is belied by the sophistica-
tion of this landscape, drawn with an intricate
yet free network of strokes varying in direction
and pressure to create wide gradations of tone.
His idiosyncratic style is even more evident
in a much smaller pen-and-ink drawing perhaps
preparatory to no. 70 in the Uffizi (fig. 1),
which shows the saint in a very similar land-
scape, although unpopulated and with the
crucifix placed over an altar within the cave.[3]

The present drawing displays Piero's
knowledge of Northern European landscape
paintings that are known to have been commis-
sioned by Florentine families, such as the
Pagagnotti Triptych of *c.* 1480 by Hans Memling
(1430/40–94).[4] Piero's drawing has echoes of
Leonardo's drawn landscapes such as no. 49,
although it differs in the way in which the
landscape is infused with an overt Christian
meaning. This carefully described and rugged
landscape recalls a common medieval subject
known as the Thebaïd, named after a region
in ancient Egypt favoured by hermits and
anchorites. The eremetic setting is evoked by
the winding paths, along which people toil,
and the many caves, such as St Jerome's in the
centre of the drawing and one on the highest
right-hand outcrop, decorated with an ornate
classical arch.[5] RS

Fig. 1
Piero di Cosimo, *Landscape with St Jerome*, 1490–1500.
Pen and ink, 23.6 × 20 cm. Gabinetto Disegni e Stampe
degli Uffizi, Florence.

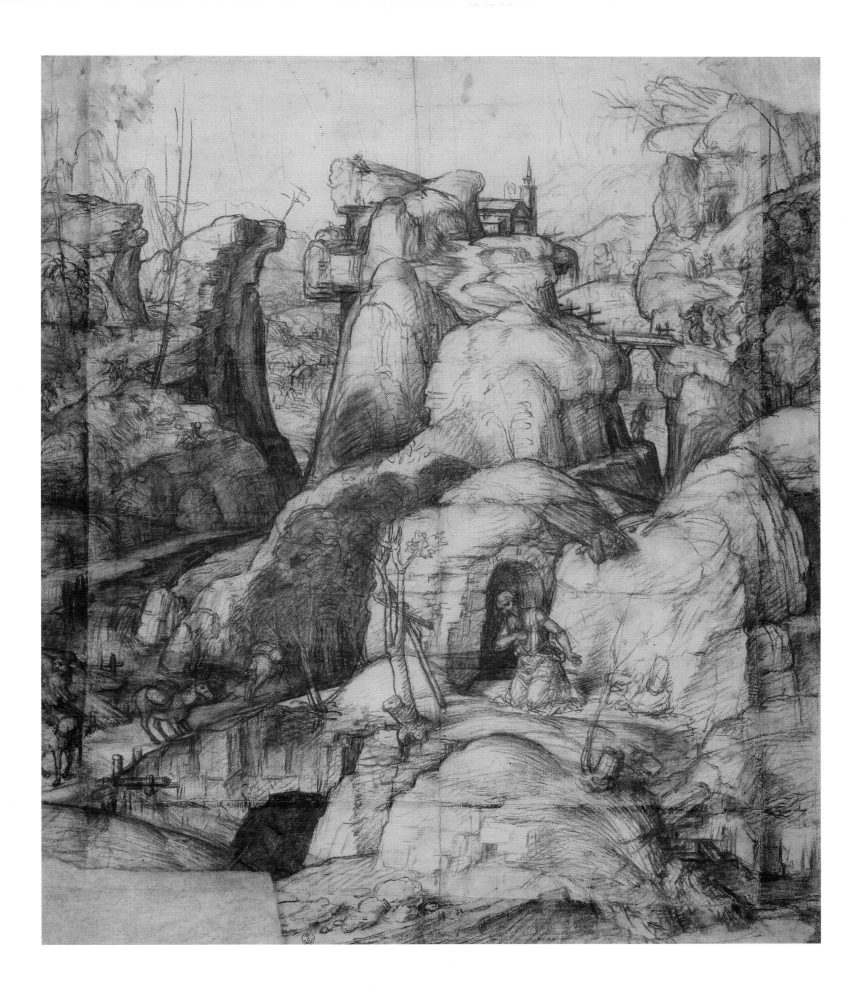

GIOVANNI ANTONIO BOLTRAFFIO (*c.* 1467–1516)

71 Study of a drapery for the Risen Christ

c. 1491

Silverpoint, heightened with lead white, over black chalk, on blue preparation, 18 × 15.5 cm[1]
British Museum, London (1895,0915.485)

PROVENANCE

Sir T. Lawrence (L.2445); Sir J.C. Robinson (L.1433);
J. Malcolm; acquired from Col. J. Wingfield Malcolm, 1895

LITERATURE

Müntz 1898, vol. 1, p. 53; Berenson 1938, vol. 2, no. 1261
D (as copy after Leonardo by Salaì or Melzi); Popham and
Pouncey 1950, no. 127 (as follower of Leonardo); Bora in
Milan 1987, pp. 15, 88 (as d'Oggiono); Sedini 1989, no. 2
(as d'Oggiono or Boltraffio); Fiorio 2000, pp. 79, 138,
no. C10 (? Boltraffio); Marani in New York 2003, p. 167
(as d'Oggiono and ? Boltraffio); Bambach in Paris 2003,
no. 120 (as attributed to Boltraffio); Bora in ibid. p. 324
(as d'Oggiono)

When this drawing was acquired by the British
Museum with the Malcolm collection in 1895
it was thought to be by Leonardo; a few years
later it was connected with the *Resurrection with
St Leonard and St Lucy* in Berlin by Boltraffio
and Marco d'Oggiono (fig. 1).[2] This was origi-
nally in the oratory, later chapel, of St Leonard
attached to the Milanese church of S. Giovanni
sul Muro. For more than a century scholarly

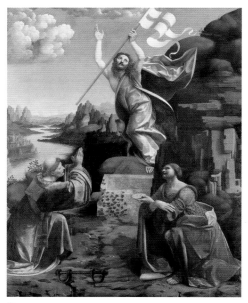

Fig. 1
Giovanni Antonio Boltraffio and Marco d'Oggiono,
Resurrection with St Leonard and St Lucy, 1491–4.
Oil and tempera on panel, 230 × 183 cm.
Gemäldegalerie, Staatliche Museen, Berlin.

debate raged over the painting's attribution,
with some scholars arguing in favour of
Leonardo's participation, at least in the design,
while the names of all his best-known Milanese
pupils (Boltraffio, d'Oggiono, Ambrogio de
Predis) were variously championed.[3] The publi-
cation in 1989 of the contractual documents
revealed that the *Resurrection* was the central,
and only surviving, panel from an altarpiece
commissioned in June 1491 from two artists
in Leonardo's circle, Boltraffio and d'Oggiono
(*c.* 1467–1524), by the Grifi (or Griff) brothers,
siblings and heirs of Leonardo Grifi, Archbishop
of Benevento.[4] The painters were supposed to
finish the work by December 1491, but this
lapsed and a second contract was drawn up
in March 1494, with a completion date set for
two months later.

It is now generally agreed that the two
saints in Berlin were executed by Boltraffio,
while d'Oggiono was responsible for the land-
scape and the Risen Christ. Both artists are
documented in Leonardo's workshop thanks to
his record of his Milanese apprentice, Giacomo
Caprotti called Salaì (*c.* 1480–1524), stealing a
silverpoint from d'Oggiono in September 1490
and one from Boltraffio the following year.[5]
By that date both were probably already in their
mid-twenties, but Leonardo's influence effaced
any earlier artistic training. In the present
work, the crystalline precision of the silver-
point hatching and the blue preparation are
inspired by Leonardo's contemporaneous
metalpoint studies, like those at Windsor
related to the Sforza monument.[6] Boltraffio's
understanding of Leonardo's art was more
subtle and penetrating than his collaborator's,
as can be seen from a comparison between
the crepuscular lighting and psychological
intensity of his two saints with the refined, yet
insipid figure of Christ.[7] Boltraffio's responsi-
bility for this study is proven by the similarity
of the drapery in paintings unanimously
accepted as his work, such as the *Virgin and Child*
in the Szépmüvészeti Múzeum, Budapest.[8]
By the same token, the pneumatic quality of
d'Oggiono's draperies in his independent

Fig. 2
Ultraviolet-induced luminescence image of no. 71
(detail) showing drapery study covered over by the
present layer of preparation. The upright mark at
the top is a stain.

paintings is quite distinct from the metallic
crispness and structural coherence of the folds
in the Berlin painting.[9]

Recent analysis of the drawing has shed
new light on how it was made. The outline of
the drapery and the head and arm were executed
first in black chalk before the folds were gone
over in silverpoint, with white heightening
applied with a brush. The mechanical, unchang-
ing quality of the chalk outlines is reminiscent
of the tracing on the back of no. 56, and it was
probably made the same way, using a sheet of
paper rubbed in black chalk to transfer the
incised contours of an earlier study on to its
surface. It is not impossible that the figure study
traced by Boltraffio might have been the work
of d'Oggiono, his colleague conceding the design
of Christ's drapery because of his greater skill
in this field.[10] Intriguingly ultraviolet imaging
reveals that Boltraffio began the sheet with
a silverpoint drapery study in the lower right
corner that he abandoned and then covered over
with a new layer of preparation (fig. 2).[11] This
drapery does not match any in the painting, but
it seems more likely a first idea for one of the
saints' clothes, as the fold falls to the left unlike
the billowing mantle of Christ. The painted
detail of the cloak follows the drawing closely
although some of its clarity, like the idea of
the material tightening across Christ's torso,
has been blunted and as a consequence the
three-dimensionality of his form is less clearly
articulated in the final work. HC

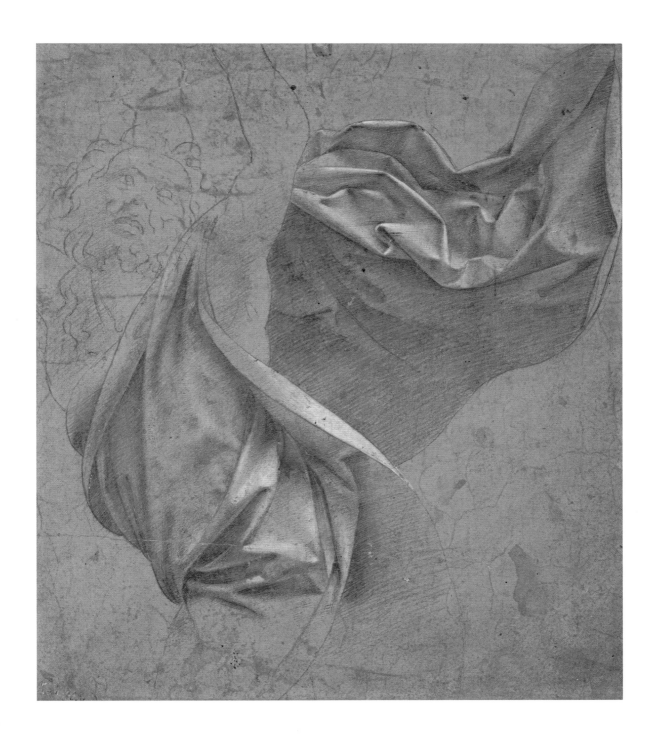

72 Head of a woman

c. 1495–1500

Metalpoint (? leadpoint and silverpoint), heightened with lead white,
on grey preparation, 23.3 × 15.7 cm
Gabinetto Disegni e Stampe degli Uffizi, Florence (426 E)

PROVENANCE

Fondo Mediceo-Lorenese (Ramirez 1849); Reale Galleria
degli Uffizi (L. 930)

LITERATURE

Müller-Walde 1889, p. 130 (as Leonardo); Müntz 1898,
vol. 2, p. 128 (as Leonardo); Fabriczy 1906, p. 40 (as
Napoletano); Suida 1929, p. 179 (as Napoletano); Dalli
Regoli and Pedretti 1985, no. 19 (as anonymous Lombard
1490–1500); Marani in Milan 1987, p. 68; Bora in Bora,
Fiorio, Marani *et al.* 1998, p. 100 (as Napoletano); Fiorio
2000, no. D37 (as ? Napoletano); Agosti in Florence
2001, no. 32

Fig. 1
Leonardo da Vinci, *Head of a woman, c.* 1490.
Metalpoint, 17.9 × 16.8 cm. Musée du Louvre, Paris.

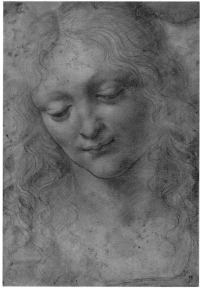

Fig. 2
Master of the Pala Sforzesca, *Head of a young woman,*
c. 1490–1500. Metalpoint, 24.2 × 16 cm.
British Museum, London.

Leonardo's prolonged period in Milan
(1481/2–99) had a profound impact on the city's
artists, the variety of reactions to his presence
there appreciable even from the four Milanese
drawings included in the present selection.
The Leonardesque artists who adopted differing
aspects of his style are a disparate group encom-
passing the handful of painters known to have
been in his studio, like Giovanni Antonio
Boltraffio (no. 71), along with others, such as
Andrea Solario (no. 74) or the Master of the
Pala Sforzesca (no. 72), whose relationship
with Leonardo is undocumented. Leonardo's
Milanese paintings, like the two versions of the
Virgin of the Rocks now in the Louvre and the
National Gallery, London, were dauntingly
complex and alien models for Lombard artists,
and his drawings provided a more accessible
route for them to assimilate his style.

One of the innovations Leonardo introduced
to Milan was metalpoint drawing, a medium
that demanded great manual dexterity to create
relief through fine variation in the density of
the parallel shading. Leonardo made metalpoint
studies until the mid-1490s, and he clearly
encouraged its use among his pupils, as can be
seen from Boltraffio's virtuoso example. In the
late 1480s Leonardo had for the first time to
devise the best means of training students, an
experience that led to him beginning work on
his *Treatise on Painting*, and inevitably he used
his experience of his graphic-based education
in Verrocchio's studio as a template. No artist
prior to Leonardo had studied with such rigour

the pictorial effects of light and shade, and it
is therefore unsurprising that he advocated a
drawing medium that put such an onus on his
pupils to deliberate how these elements should
be deployed to model and describe forms.

The Uffizi study follows another key tenet
of Leonardo's teaching in having been drawn
from life, although the absence of breasts and
the masculine cast of features suggest it was
a young man standing in for a woman. It is
definitely not a copy after a Leonardo drawing;
nonetheless it is inspired by the Florentine's
metalpoint studies in the same vein, such as the
Head of a woman of around 1490 in the Louvre
(fig. 1). Comparison of the two reveals how
close the Uffizi artist had come to matching
Leonardo's technical excellence, while at the
same time not grasping how the softening
of detail seen in the Paris drawing created a
unified whole, as well as an impression of the
woman's pensive state of mind.

The Uffizi drawing is sufficiently close to
Leonardo's style to have long been thought
to be by him, despite it clearly having been
drawn by a right-handed draughtsman.[1] In the
modern era the drawing has generally been

attributed either to Francesco Galli (died
1501), known as Napoletano from his
birthplace, whose activities as a painter have
been reconstructed on the basis of a signed
altarpiece (Kunsthaus Zürich), or to the even
more enigmatic Master of the Pala (altarpiece)
Sforzesca, named after a painting of Ludovico
Sforza and his family adoring the Virgin and
Child from the mid-1490s (Brera, Milan).[2]
No drawing can be securely attributed to
Napoletano, which makes it more hazardous
to attribute this to him, despite the typological
similarities with figures in his paintings such
as the *Virgin and Child* in the Brera.[3] A stronger
claim can be made for the Master of the Pala
Sforzesca, whose style as a draughtsman can
be reassembled on the basis of a few studies
connected to paintings.[4] On stylistic grounds
it seems plausible that it is by the same hand
responsible for the similarly androgynous
female head, inspired by the central protagonist
in Leonardo's *Virgin of the Rocks*, attributed
to the same anonymous master in the British
Museum (fig. 2) on the basis of its similarity
to a painting by him in Berlin.[5] HC

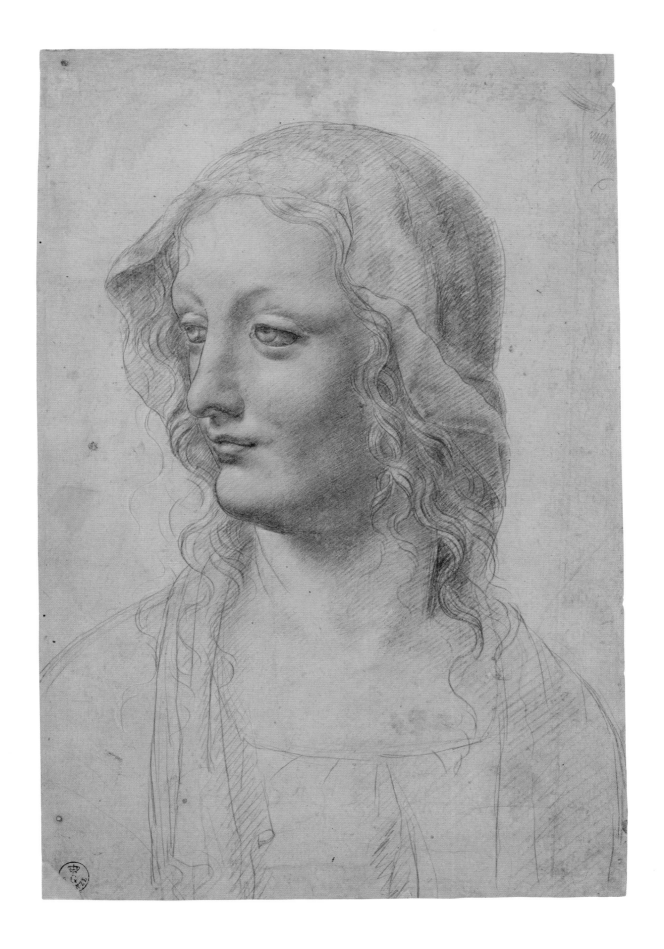

251

BARTOLOMMEO SUARDI, called BRAMANTINO (c. 1465–1530)

73 The Martyrdom of St Sebastian

c. 1495–1505

Brush and brown wash, heightened with lead white (discoloured grey in some areas),
over black chalk, on light brown paper, 40.4 × 57.2 cm
Inscribed in an old hand: 'Romani Bresciano' (i.e. Girolamo Romanino)
Gabinetto Disegni e Stampe degli Uffizi, Florence (15733 F)

PROVENANCE

Ferri, *Disegni di Figura* (*c.* 1887); Reale Galleria
degli Uffizi

LITERATURE

Suida 1953, pp. 93–4, 125, 231; Mulazzani 1978, no. D2;
Agosti in Florence 2001, no. 37

The traditional attribution of this drawing
of St Sebastian, a late third- or early fourth-
century saint allegedly employed as an officer
in the imperial bodyguard who was martyred
because of his Christian faith, to the Brescian
painter Girolamo Romanino (1484/7–?1560)
was overturned in favour of Bramantino, a
Lombard artist of the previous generation,
around a century ago.[1] The drawing fits
Bramantino's preference amongst his small
graphic corpus of just over a dozen works for
working in brush and wash with white height-
ening, and the attribution has consequently
never been doubted.[2] Surprisingly for a work
that must rank among the most original
Lombard drawings of the period it had never
been exhibited prior to 2001.[3] Bramantino
took his name from the Urbino-born architect
and painter, Donato Bramante (?1433/4–1514),
who settled in Milan in the late 1470s just
before the arrival of Leonardo at the Sforza
court. Bramante is best known as an architect,
and his few surviving paintings produced in
Lombardy, as well as the massive print of
a ruined classical temple engraved in 1481
after his design by Bernardo Prevedari, already
demonstrate a strongly architectural sensibility.
His command of perspective and an admiration
for the imposing grandeur and ornamentation
of classical buildings are qualities that were
absorbed by Bramantino, as can be seen from
the present work.

The Uffizi sheet is a masterful example of
drawing with the brush over a black chalk
underdrawing. Such a complex composition
must have been planned on paper in advance and
there are only a few signs of adjustments, like
the cloak added to the soldier to the left of the
saint. Brush drawing is generally associated with

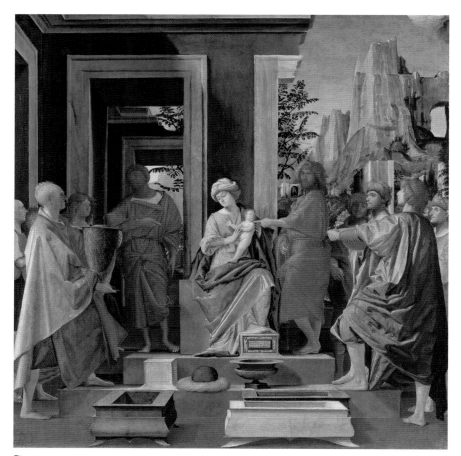

Fig. 1
Bramantino, *Adoration of the Magi*, *c.* 1495–1500.
Oil on panel, 56.8 × 55 cm. National Gallery, London.

the atmospheric painterly approach of Venetian
artists, as in the work of Carpaccio, for example
(no. 80), and as such stands apart from the linear
tonality of metalpoint drawings by Bramantino's
Leonardesque contemporaries (see nos 71–2).[4]
Although the lighting effects are much broader
than in Leonardo's compositions, Bramantino
was not untouched by his influence, as can be
seen in his use of light and shadow to direct the
eye around the design. Bramantino's deploy-
ment of lateral framing figures (the one on the
damaged left side has almost certainly been
trimmed), his tactile evocation of natural forms
evident in the description of the roughness of

the bark contrasted with the smoothness of
Sebastian's naked flesh, and the adoption of a
low viewpoint echo Andrea Mantegna's works
from the 1450s, like the frescoes in the Ovetari
Chapel in Padua or the predella panels of the
S. Zeno altarpiece in Verona. He may well have
studied such paintings inspired by the admira-
tion shown for them by Bramante, as well as by
the earlier generation of Lombard painters, like
Bernardino Butinone (*c.* 1450–1510). Mantegna's
influence did not, however, extend to Bramantino
choosing to show St Sebastian frontally with his
body peppered with arrows, as he appears in
the Paduan's three paintings of the theme.[5]

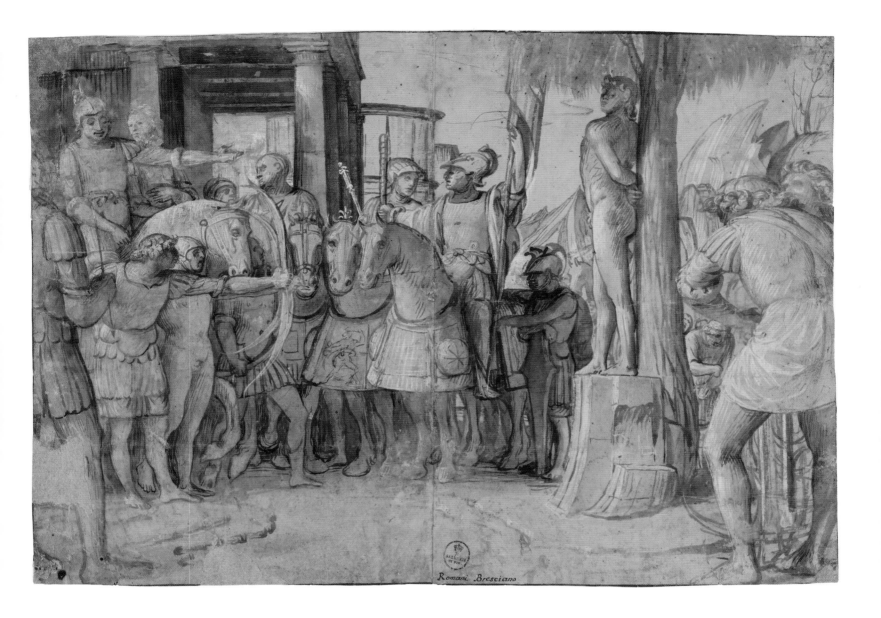

Romani Bresciano

The dating of Bramantino's work is problematic as there are no sure dates before the *Month* tapestries, designed some time between 1501 and 1508 for Gian Giacomo Trivulzio, followed by a trip to Rome in 1508, where he painted briefly in the Vatican apartments. The monumentality of the drawing has sometimes been linked to Bramantino's experience of Rome, but such elements are already present in works generally dated to before this trip, such as the *Adoration of the Magi* in the National Gallery of around 1495–1500 (fig. 1).[6] The drawing shares with the painting the still solemnity of the figures and a notable originality in the narrative, exemplified by the casual indifference of the soldiers charged with executing the saint, and the intimation by the jagged peak that rises up behind the saint of the arrows that will shortly pierce his flesh. The scale and finish of the drawing are unmatched in Bramantino's work and its function cannot be precisely defined. It seems most likely that it was made either as a finished work of art, or to show to a patron as a final design for a projected painting. HC

74 Lamentation

c. 1507–9

Pen and brown (two shades) and some grey ink, grey and brown wash,
over black chalk, on paper prepared with a light brown wash, 18.9 × 18.6 cm
British Museum, London (1895,0915.771)

PROVENANCE

Sir J.C. Robinson; J. Malcolm; acquired from Col. J.
Wingfield Malcolm, 1895

LITERATURE

Loeser 1897, p. 356; Béguin in Paris 1985, no. 42;
Brown 1987, no. 47

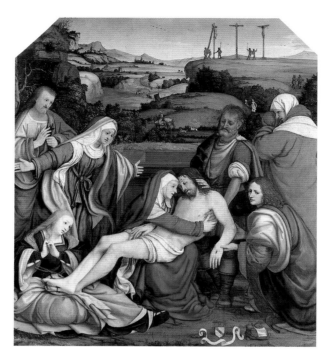

Fig. 1
Andrea Solario, *Lamentation*, *c.* 1507–9.
Tempera and oil on canvas, 176 × 161.5 cm.
Musée du Louvre, Paris.

When this drawing was acquired by the British Museum in 1895 it was ascribed to the Milanese sculptor Bambaia (*c.* 1483–1548), an idea tentatively advanced by its former owner, John Charles Robinson (1824–1913). The latter was a brilliant connoisseur and, while in this instance he was mistaken, his analysis of it in his 1869 catalogue of the Malcolm collection is acute: 'the composition consisting of eight figures, is equally balanced, i.e. treated in a symmetrical and architectonic manner, and there can be little doubt that it is the design of a sculptor, intended to be executed in alto-rilievo [high relief].'[1] The drawing is in fact by the Milanese painter Andrea Solario, and it is a study for a painting (fig. 1) that was unknown before the Louvre acquired it in 1978.[2] The relief-like arrangement of the figures in the drawing as well as in the finished work is, as Robinson rightly observed, highly sculptural. Solario worked exclusively as a painter but he came from a Lombard dynasty of sculptors, including his three brothers, and it is thus unsurprising that his work has a strongly sculptural flavour.

The Louvre painting dates from Solario's period in France from 1507 to 1510, where he had been invited by Cardinal Georges d'Amboise (1460–1510) to decorate the chapel of the château at Gaillon, the palace of the archbishops of Rouen in Normandy.[3] The altarpiece bears the cardinal's arms and was therefore commissioned by him or in his honour by his nephew and namesake who succeeded him as Archbishop of Rouen. Its original location is unrecorded. The drawing shows that Solario originally planned the narrative to occur soon after Christ had been taken from the cross, while in the painting he

or his patron moved it forward to the moment before the placing of his body in the sarcophagus shown behind the figures. The change is significant as it altered the emotional tenor: the highly expressive, agitated gestures and expressions of grief in the drawing, befitting the first physical contact with Christ's dead body, have been tempered in the painting to a more contemplative, contained grieving.

Solario is counted among Leonardo's Milanese followers, and his admiration for him is discernible in the drawing from the grief-stricken expression of Joseph of Arimathea, the figure supporting Christ's upper body, which recalls those of the apostles in Leonardo's *Last Supper*, and in the similarity between the position of the Virgin's legs and those of her counterpart in the Florentine's *Virgin and Child with St Anne* painting now in the Louvre, Paris. In the painting this debt is most clearly expressed in the pose of St John in the right foreground, which has been adapted from that of the angel in Leonardo's *Virgin of the Rocks*

(National Gallery, London). In the drawing the three foreground mourners are all female, but in the canvas the relative positions of John and the right-hand Mary have been swapped to ensure a male presence there. Solario's quotation from Leonardo's Milanese paintings would have been readily appreciated by the patron and his circle because of the knowledge of his work stemming from the French domination of Milan, a city governed by the cardinal's nephew, Charles d'Amboise. Solario's invitation to France, a decade before Leonardo went there, may have partly arisen from his incorporation of Leonardesque elements, as the Florentine painter was so hugely admired. Yet Solario had never been a pupil of Leonardo and his style owed just as much to his study of Venetian art during his time in the city during the first half of the 1490s, as can be seen in the similarity between his use of modulated areas of wash to register light and that of his Venetian contemporary Vittore Carpaccio (no. 80). HC

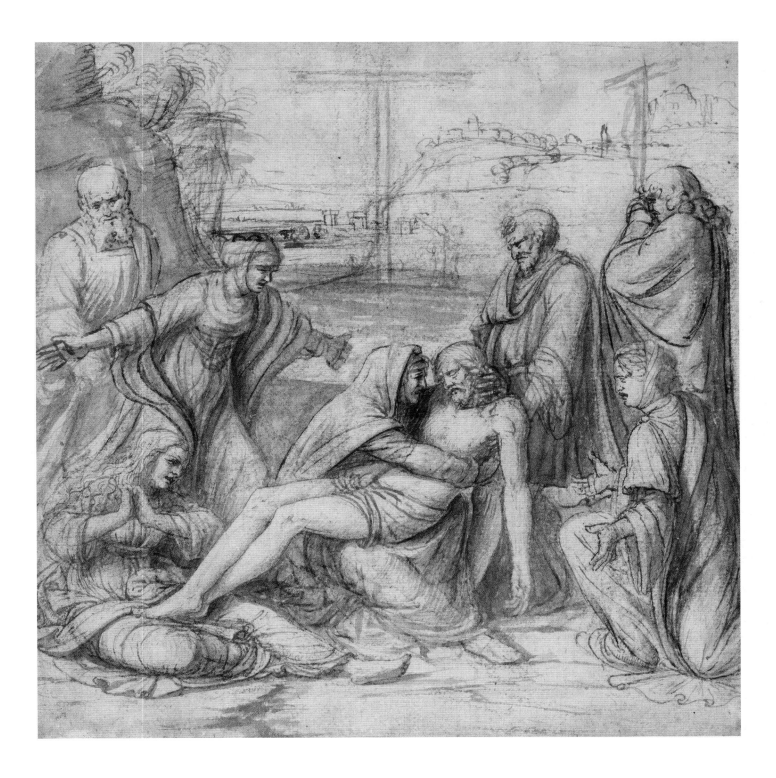

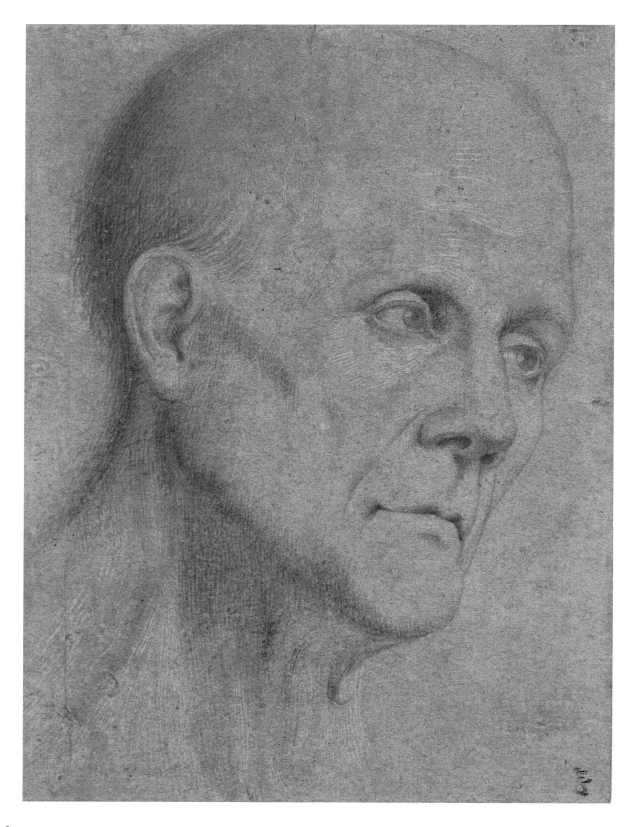

256

ALVISE VIVARINI (1442/53–1503/5)

75 Head of an elderly man

c. 1485–95

Brush and brown wash, heightened with lead white,
over black chalk, on blue-grey paper, 21.3 × 15.6 cm
British Museum, London (1876,1209.619)

PROVENANCE

W. Mayor (L.2797); acquired from J. Hogarth & Sons in 1876

LITERATURE

Mayor 1875, no. 216 (as Giovanni Bellini); Hadeln 1925,
pl. 80; Tietze and Tietze-Conrat 1944, no. 2247; Popham
and Pouncey 1950, no. 259; Pallucchini 1962, pp. 73, 141,
no. 282; Steer 1982, no. 42

When this drawing was acquired in 1876 it
was believed to be by Giovanni Bellini, the son
of Jacopo (no. 16) and the brother of Gentile
(nos 17–19), in accordance with the opinion
of its former owner, William Mayor. Giovanni
Bellini's drawings are now considered to be
extremely rare – a recent study listed fewer
than 20 in a career extending over six decades –
and the present sheet is one of numerous works
that were fancifully ascribed to him in the past.[1]
The suggestion that it was by Bellini's younger
contemporary, Alvise Vivarini, was made by the
German scholar of Venetian art, Detlev von
Hadeln, and his idea has never subsequently
been doubted.

 The poor survival rate of Venetian drawings,
compared with those of central Italian and
particularly Florentine artists, also holds true
of Vivarini, whose graphic corpus consists of
only three drawings, one of which, *Studies of
hands*, now in the Frits Lugt collection in the
Institut Néerlandais in Paris (fig. 1), is drawn
in brush like the present one.[2] The six hands on
the Lugt drawing can be matched with varying
degrees of precision to those of saints in three
paintings by Alvise from the early 1480s.[3] The
Lugt sheet is generally described as life studies
made in preparation for the paintings, but
the high degree of finish and the unity of the
subject matter suggest that the hands were
more likely copied from preparatory drawings
as a compendium of related motifs for Vivarini
and his assistants. An idea of the source
material from which the Lugt drawing was
assembled can perhaps be gained from the less
polished study of a left hand in black chalk
and white heightening on the verso (fig. 2).[4]
 The brush drawing of a male head on the

recto can be confidently assigned to Vivarini
on the basis of the similarity of its meticulously
refined handling to that of the Lugt drawing,
and the two are probably coeval. The physical
type of the elderly man accords well with
Vivarini's depiction of St Bernardino in his
1485 triptych now in the Museo Nazionale
di Capodimonte, Naples, although the corre-
spondence is not sufficiently close to link it
specifically to that painting or indeed to any
surviving work by the artist.[5] The inclusion of
naturalistic details like the vein in the temple
picked out in white heightening is indicative
of Vivarini's powers of observation, but such
touches are at odds with the generalized treat-
ment of the neck and shoulders that make it
hard to imagine that he was studying the head
directly from a posed model. Vivarini's method
of drawing with the brush is predominantly
linear with the outlines of the features carefully
defined through contour lines. His modelling

Fig. 2
Verso of no. 75, *Study of a hand, c.* 1485–95. Black
chalk, brown wash (?), heightened with lead white.

of the form through shading, in areas such as
the line of the jaw, is similarly precise with
upright strokes of the almost dry brush. Such
linearity was an intrinsic part of the familial
style that Alvise took over from the productive
workshop established by his father, Antonio
(active 1440–76/84), and uncle, Bartolommeo
(active 1440–d. after 1500) in Murano. Alvise's
conservative style was not untouched by the
atmospheric subtleties of Giovanni Bellini's
paintings linked to his increasing mastery of
oil technique in the 1480s, and there is a hint
in the present drawing of a more painterly
approach in the modelling of the back of the
figure's head. The way in which the form in
this area is described through shadow rather
than outline, the contours melting into the
surrounding penumbra so that it is impossible
to be certain quite where the edges are located,
is a graphic equivalent of Bellini's mature
painting style.[6] It is revealing to compare
Vivarini's rather tentative experimentation in
tonal brush drawing with the much more
advanced efforts of his younger contemporary
Vittore Carpaccio, such as nos 80–81. HC

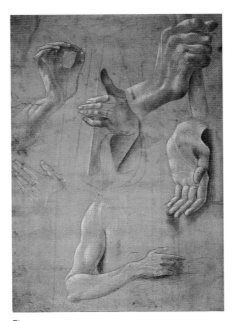

Fig. 1
Alvise Vivarini, *Studies of hands, c.* 1480. Metalpoint,
brush and grey-brown wash, heightened with lead
white, on salmon-pink preparation, 27.9 × 19.4 cm.
Frits Lugt collection , Institut Néerlandais, Paris.

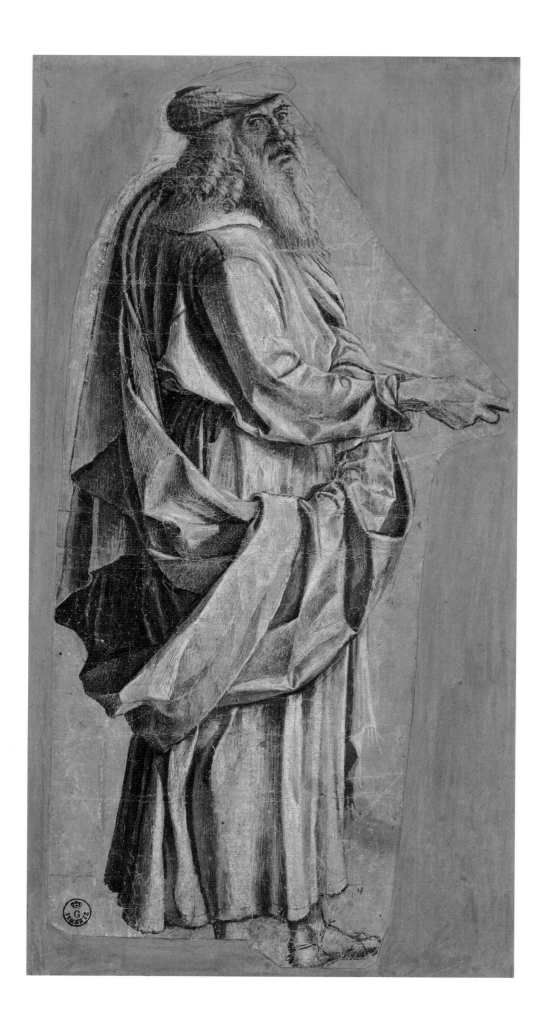

76 A bearded man with a turban

c. 1490–1500

Brush and grey wash, heightened with lead white (partly discoloured), over black chalk, on grey-blue paper, the figure silhouetted and laid down on another sheet with the top of the turban made up, 27.5 × 13.6 cm
Gabinetto Disegni e Stampe degli Uffizi, Florence (337 E)

PROVENANCE

Annibale Ranuzzi (?); Cardinal Leopoldo de' Medici (?); Ferri, Disegni Esposti (1879–1881); Reale Galleria degli Uffizi (L. 930)

LITERATURE

Habich 1893, no. 668, p. 162 (as Montagna); Schönbrunner and Meder 1901, vol. 6, no. 677 (as Previtali); Gamba 1914, no. 6 (as Montagna); Hadeln 1925, p. 65 (as Previtali); Tietze and Tietze-Conrat 1944, no. A 1371 (as studio of Gentile Bellini); Puppi 1962, no. 3, p. 170 (as Previtali); Meyer zur Capellen 1972, no. Z 4 (as copy after Montagna); Petrioli Tofani 1986, p. 150; Rearick in Paris 1993, p. 279 (as not by Previtali); Agosti in Florence 2001, no. 24

It has recently been suggested that this may be the drawing described in 1674 by Annibale Ranuzzi, an agent of the Medici family in Bologna, as a possible purchase for Cardinal Leopoldo de' Medici: 'a figure of a standing old man, wash and white heightening by Gosmé ferrarese [i.e. Tura], very old'.[1] It was kept as Tura until the late 1800s when it was moved to Bartolomeo Montagna, under whose name it still remains.[2]

Montagna was the leading painter in Vicenza, a city, like its close neighbour Padua, under the control of Venice some 65 km to the east. Like many aspiring young artists in the Veneto, Montagna's artistic training included a period in Venice, perhaps including a short tenure in the early 1470s in the workshop of Giovanni Bellini. While he was there Montagna was probably instructed in brush drawing with wash and white heightening, a graphic technique that was most closely attuned to Bellini's light-saturated, tonal approach to painting. Bellini employed the technique in a bust-length study on blue paper of *St Anthony Abbot* from the first half of the 1460s, now in the Royal Collection, Windsor Castle, one of the more securely attributed works in his much-contested graphic oeuvre.[3] Although other Venetian artists, like Alvise Vivarini, used this technique (see no. 75), Bellini's artistic dominance probably underlies the popularity of brush drawing among the generation of painters like Montagna, Giovanni Battista Cima (nos 77–8) and Vittore Carpaccio (nos 79–81), who came of age in the 1480s.

Fig. 1
Bartolomeo Montagna, *The Virgin with two angels*, *c.* 1490–1500. Brush and blue wash, heightened with lead white, on blue-grey paper, 38.2 × 27.2 cm. Staatliche Graphische Sammlung, Munich.

The attribution to Montagna is based entirely on stylistic comparison with his small corpus of around ten brush drawings, as well as more general similarities with his paintings. The volumetric quality of the figure's drapery that imparts such a sense of his monumental presence, the ingenious motif of the tucked-in folds of his cloak around his body leading the eye around his form, is consistent with the strongly sculptural flavour of Montagna's work, the legacy of his youthful study of the Donatello-inspired paintings of Paduan artists such as the young Andrea Mantegna. The agitated surface play of the folds in the Uffizi drawing – the reliefs and depressions of the fabric articulated through tonal contrasts between the white highlights, differing concentrations of wash and the blue-grey of the paper used as a mid-ground – can be paralleled in other brush drawings by the artist, such as the study of *The Virgin Mary with two angels* in

Munich (fig. 1).[4] The Uffizi drawing can be dated to the 1490s as the sharply accented lighting of the folds and their bulkiness are most comparable to paintings of that period.[5]

The attribution to Montagna has frequently been doubted because the drawing unquestionably served as the model for Moses in the painting of the *Crossing of the Red Sea* by Andrea Previtali (*c.* 1480–1528), now in the Accademia, Venice (fig. 2).[6] While it is mostly safe to assume that the same artist was responsible for any drawings related to a painting, Pintoricchio's use of Gentile Bellini's study of a janissary demonstrates that it is not always so (see no. 17). It seems unlikely that the Uffizi drawing was made for the painting because the figures are lit from opposite directions. Moreover, even taking into consideration Previtali's training in Giovanni Bellini's studio, it is highly improbable that he would continue to draw in the manner of an artist from a previous generation for a painting thought to date from the end of his career.[7] Previtali's borrowing of Montagna's figure, based either on knowledge of the drawing or on a now lost related painting, is replicated in his use of poses and compositions by other artists, including Albrecht Dürer and Lorenzo Lotto. HC

Fig. 2
Andrea Previtali, *Crossing of the Red Sea* (detail), *c.* 1520. Oil on canvas, 132 × 213 cm (whole painting). Galleria dell'Accademia, Venice.

77 St Jerome
c. 1489

Brush and brown wash with heightening in lead white and brown wash, over black chalk
or leadpoint, on a brick-red preparation, 22.8 × 9.4 cm
Gabinetto Disegni e Stampe degli Uffizi, Florence (281E)

PROVENANCE

Fondo Mediceo (Nota 1687); Reale Galleria degli Uffizi
(L. 930)

LITERATURE

Burckhardt 1905, p. 124; Hadeln 1925, pp. 62–3; Tietze
and Tietze-Conrat 1944, no. 656; Coletti 1959, no. 34(b);
Humfrey 1983, no. 191; Agosti in Florence 2001, no. 21

The drawing is related to the figure of
St Jerome in Cima's altarpiece, dated 1489,
painted for S. Bartolommeo, Vicenza, and now
in the Museo Civico (fig. 1).[1] The painting,
which is the artist's earliest dated work, was
commissioned by Girolamo and Giacomo
Sangiovanni, whose name-saints are repre-
sented to the right and left respectively of the
enthroned Virgin and Child at the centre. The
drawing must date from the final stages of
the design process after the pose of the saint
had been established, as there are no signs of
revisions to the outline. The artist's thorough
analysis of the overall composition in now
lost preparatory studies is demonstrated by
the singular manner in which Jerome holds his
attribute, his early fifth-century translation of
the Bible into Latin. Viewed in isolation in the
drawing this detail seems both awkward and
unnatural, yet in the context of the finished
composition the position of the book imparts
depth to the otherwise frontal pose of the
saint, while also adding a downward diagonal
to balance the upward direction of the
drapery folds.

The correspondence between the painted
and drawn figures is extremely close, the only
significant difference between them being the
inclusion of part of the lower left section of
the saint's robe that is obscured by the base
of the Virgin and Child's throne in the canvas.
The pose and costume of the figure is defined
entirely through strokes of white heightening,
the delicacy of which is paralleled most closely
in Alvise Vivarini's brush drawings (see no. 75
and fig. 2, no. 75). The highlights stand out
from the brick-red preparation, the tonality
of which has been darkened in passages by the
sparing application of brown wash to indicate

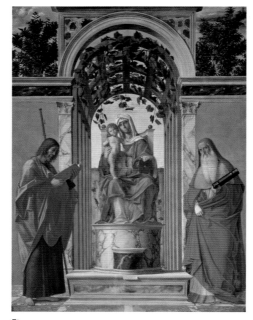

Fig. 1
Giovanni Battista Cima, *The Virgin and Child with
St James and St Jerome*, 1489. Tempera on canvas,
214 × 179 cm. Museo Civico, Vicenza.

shaded areas. The drawing was made to map
out the relative tonal values of the figure, with
the brightest areas, such as the white gloves
and beard, denoted by the thickest application
of white heightening. The artist's attentiveness
to lighting is probably linked to his use of
tempera, an egg-based medium whose rapid
drying did not allow the colours to be blended
so that the progression from light to dark had
to be carefully planned in advance, beginning
with the deepest shadows and working
through to the highlights.

The choice of a dark red ground to set off
the white highlights is rare in Venetian drawings,
as locally manufactured blue paper was normally
used in place of an opaque ground. This probably
explains why the drawing was traditionally
attributed to the Florentine painter, Benozzo
Gozzoli, based on an old inscription on the
reverse. Cima's source of inspiration need
not have been a drawing from central Italy as
pinkish-red preparation, albeit in the more

commonly found technique of red chalk mixed
with water, is found on both sides of a drawing
in the British Museum that has a good claim
to be by Giovanni Bellini from the 1460s.[2] This
similarity between the two artists' graphic
methods is further evidence of Cima's close
study of Bellini, although it is uncertain if he
ever actually spent time in the older artist's
workshop after an initial training in his native
town of Conegliano, situated some 50 km
north of Venice.[3]

The artist may well have used this drawing
as the basis for the figure of St Jerome in his
altarpiece, *St John the Baptist with Sts Peter,
Mark, Jerome and Paul*, in the Venetian church
of Madonna dell'Orto, dating from the early
1490s.[4] Cima frequently recycled his figural
inventions and he must have had a large stock
of drawings and cartoons, which he and his
busy workshop used to facilitate the extensive
production of versions and repetitions of his
paintings. Fewer than ten drawings by his hand
survive, perhaps because none of his five sons
followed in his footsteps and thus the contents
of his workshop were not handed down to the
next generation. HC

78 Christ as Saviour of the World (*Salvator Mundi*)

c. 1490–1500

Brush and green and grey-brown wash, heightened with lead white,
over some stylus around the head, on blue paper, 39.5 × 19.2 cm
British Museum, London (1895,0915. 803)

PROVENANCE

Sir J.C. Robinson; J. Malcolm; acquired from Col. J.
Wingfield Malcolm, 1895

LITERATURE

Burckhardt 1905, p. 144 (as Pasqualino); Hadeln 1925,
p. 63; Tietze and Tietze-Conrat 1944, no. A 659 (as ?
Mantegna); Popham and Pouncey 1950, no. 41; Coletti
1959, no. 34(a); Humfrey 1983, no. 193

According to an inscription written on the
back by the drawing's former owner, the
English collector and connoisseur John Charles
Robinson, this was bought by him in Rimini
in 1860 as a work by the famous painter of the
region, Melozzo da Forlì (1438–94). The
drawing's low viewpoint may have suggested
this idea, as Melozzo is best known for his
illusionistic rendering of foreshortened figures
in ceiling decorations. Stylistically it has little
to do with Melozzo's work; instead the blue
paper and the description of the figure through
light and shade are quintessentially Venetian.

Fig. 1
Funeral stele of Lisandra, Asia Minor, late
2nd century BC. Marble, 56 × 39 × 8 cm.
Museo Archeologico Nazionale, Venice.

The specific attribution to Cima, which
followed one to his obscure assistant
Pasqualino Veneto (active 1496–1504), has
long been accepted.[1] It cannot be linked to any
finished work by Cima; nonetheless the figure
is closely comparable in type and conception
to those in his paintings. In particular, Christ's
classically inspired contrapposto pose with one
leg projecting forward, the volumetric solidity
of his body emphasized by columnar vertical
folds of the shift worn beneath, was a formula
that Cima repeatedly used in paintings from
the second half of the 1480s onwards.[2]

The classical monumentality of the figure
has sometimes been linked to Andrea
Mantegna, yet the clinging drapery folds and
the motif of one arm caught in a sling-like loop
of his cloak can be linked more precisely with
Hellenistic sculptures. Venice's eastern trading
links meant that Venetian collectors were able
to acquire unrivalled collections of Greek
antiquities, such as the second-century BC
funeral stele from Asia Minor, formerly in the
Grimani Collection and now in the Museo
Archeologico Nazionale, Venice, in which the
pose of the deceased is closely comparable to
that of Christ in the drawing (fig. 1).[3] Cima
was certainly not alone in his admiration for
such works as can be seen from similar stylistic
borrowings found in the sculptures of Tullio
Lombardo (*c.* 1455–1532) and his brother
Antonio (*c.* 1458–?1516).[4] The present drawing
is difficult to date as Cima's style was remarkably
consistent throughout his career, but perhaps
the strongest stylistic parallels are with his
paintings from the 1490s and early 1500s, such
as his *St Helena* in the National Gallery of Art,
Washington, or the *St Catherine of Alexandria*
in the Wallace Collection, London.[5]

The three-dimensional quality of the sheet
is achieved by the unusual means of a dark
green wash ground for all the drawn areas, so
that they stand out more prominently from
the blue of the paper. Over this base colour
modulated washes of grey-brown watercolour
have been used to establish the shadows on the
right side of the body. The nuances of lighting

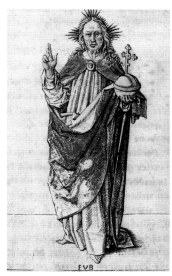

Fig. 2
Monogrammist FVB, *Christ as Salvator Mundi* (detail),
c. 1475–1500. Engraving with hand colouring,
8.9 × 5.5 cm. British Museum, London.

are much more subtle than in the earlier
Uffizi drawing (no. 77), the greater delicacy
of the transition from light to dark perhaps
inspired by Cima's preference for oil as the
binding medium for his paintings from the
1490s onwards. The care with which it has
been executed may denote that it was done
as a finished work of art in its own right. The
likelihood that it was a private devotional
commission would fit the unconventional nature
of the subject, with the sphere held by Christ,
representing the world saved by his incarnation,
without the customary cross surmounting it,
as well as the omission of his normal gesture
of blessing. The singularity of Cima's treatment
can be seen by comparing it to a contemporary
Netherlandish engraving of the subject (fig. 2).
The representation of Christ full length
provides a further indication that the drawing
was not preparatory for a painting, because
the north Italian pictorial tradition of *Salvator
Mundi* compositions was as bust-length figures,
as in Carlo Crivelli's two painting of the
subject from the 1470s and 1480s.[6] HC

79 Triumph of St George

c. 1501–8

Pen and brown ink, over red chalk (some ruled) and compass points in the lower scale, 23.5 × 41.6 cm
Inscribed by the artist below the scale: 'pie diexe e mexo scharso' (just under ten and a half feet);
and in an old hand: 'di Vittor Scarpazza' and '11'
Gabinetto Disegni e Stampe degli Uffizi, Florence (1287 E)

PROVENANCE

Fondo Mediceo (Nota 1687); Reale Galleria degli Uffizi
(L. 930)

LITERATURE

Hadeln 1925, p. 54; Tietze and Tietze-Conrat 1944,
no. 597; Lauts 1962, no. D 13; Petrioli Tofani 1972, no. 24;
Muraro 1977, pp. 38–9; Fortini Brown 1988, pp. 210, 213;
Brooke 2004, pp. 309–10

This is a study for one of Carpaccio's canvases
for the Scuola di S. Giorgio degli Schiavoni,
the confraternity of the Dalmatians resident
in Venice. Carpaccio's nine paintings executed
from around 1501 to 1508 are still *in situ* on
the ground floor, although whether they were
originally located there or in the room above
is uncertain as the building was reorganized
later in the century.[1] The cycle depicts four
themes: two New Testament scenes with the
other paintings dedicated to episodes from
the lives of the scuola's dedicatory saints,
George, Jerome (see no. 80) and Tryphon.
Details of the commission are scant, but it
is likely that it might have been inspired in

part by a 1502 gift to the scuola of a relic of
St George.

The three St George canvases relate to his
encounter with a dragon in Libya based on
the account in the *Golden Legend*, a thirteenth-
century compendium of lives of the saints by
Jacopo da Varagine. The first depicts the saint's
mounted combat to rescue the princess of
Silene, offered as a sacrifice to prevent the
dragon attacking the town. The present work
relates to the successive episode when George
instructed the princess to lead the wounded
dragon into Silene on a leash made from
her girdle. He then promised to kill it if the
citizens converted to Christianity. George's
baptism of the king and queen is the subject
of the third canvas.

The Uffizi sheet is a working study for
the *Triumph of St George* (fig. 1), complete
with a scale at the bottom that the artist's note
describes as consisting of just under ten and a
half Venetian feet or *piedi*, a unit of just under
35 cm, that tallies closely to the width of the
canvas, 360 cm.[2] The inclusion of a scale

suggests that this painting was the first to be
designed, as it is identical in size to the *George
fighting the dragon*, and it seems unlikely that
he needed to note the dimensions more than
once.[3] While it might appear illogical to design
the central canvas first, its pivotal position in
the triumvirate meant that its composition to
some extent determined the others. Before
beginning the drawing Carpaccio had probably
established the design in earlier, and now lost,
studies, as the red chalk underdrawing is bold
and confident. The pen and ink used to fix
the outlines is no less decisive. Sometimes
Carpaccio chose to ignore the red chalk (leaving
out, for example, the dragon's leash held by
the saint, one of the musicians on the left and
a tower above the gateway on the right), while
also adding in pen details that are not present
in the underdrawing, such as the spiral staircase
and the column surmounted by a statue in
the right background. The artist's aim in the
drawing appears to have been to establish the
grouping of the figures in relation to the saint,
and their relationship with the architectural

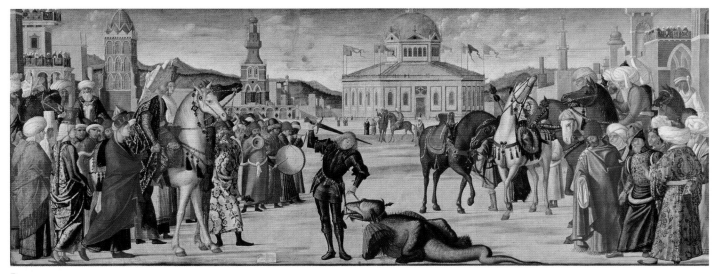

Fig. 1
Vittore Carpaccio, *Triumph of St George*, c. 1501–8.
Oil and tempera, on canvas, 141 × 360 cm.
Scuola di S. Giorgio degli Schiavoni, Venice.

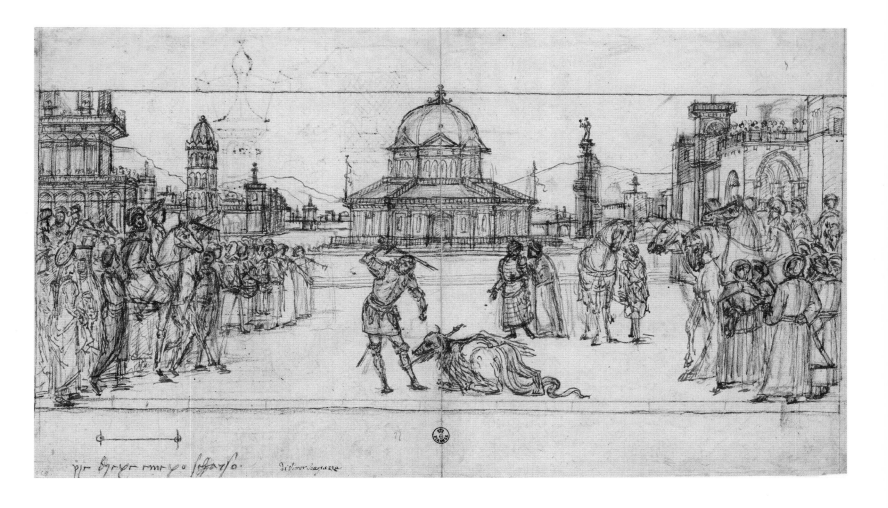

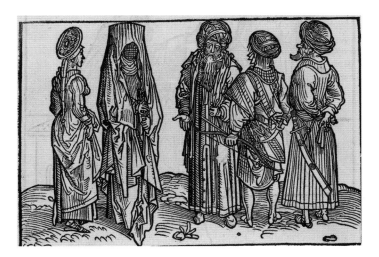

Fig. 2 (above)
Erhard Reuwich, *Middle Eastern costumes* from
Bernhard von Breydenbach's *Peregrinationes in
terram sanctam*, 1486. Woodcut with additional
hand-colouring, 8 × 12 cm. British Museum, London.

Fig. 3 (left)
Detail of two women in no. 79, based on
Reuwich's woodcut.

setting. Comparison with the painting shows
that he continued to make adjustments, most
notably by increasing the scale of the figures
and by encircling them more closely around
the central protagonist.[4]

For the architectural setting and for some
of the figures, Carpaccio sought inspiration
from a favoured source for his Middle Eastern
settings: the woodcut illustrations by Erhard
Reuwich (*c.* 1455–*c.* 1490) for Bernhard von
Breydenbach's account-cum-guidebook
of his pilgrimage to the Holy Land, the
Peregrinationes in terram sanctam published in
Mainz in 1486.[5] For example, the pose and
costumes of the three women, one of whom is
the princess, in the left corner of the drawing
are modelled on one of the woodcuts (fig. 2).[6]
For the setting he also freely adapted the
Dome of the Rock from Reuwich's plan of
Jerusalem for the domed building at the
centre of the drawing, while the tower to the
left of it is inspired by Reuwich's illustration
of the Holy Sepulchre.[7] HC

80 The Vision of St Augustine

c. 1501–8

Pen and brown ink (some drawn with a ruler), brown-grey wash, over leadpoint and stylus
(architectural setting) some drawn with a ruler or a compass, 27.8. × 42.6 cm
Inscribed by an old hand: 'Muller'
British Museum, London (1934,1208.1)

PROVENANCE

Acquired by the Art Fund for the British Museum from
Colnaghi for £650; presented by the Art Fund, 1934

LITERATURE

Tietze and Tietze-Conrat 1944, no. 617; Popham and
Pouncey 1950, no. 35; Roberts 1959, p. 293; Lauts 1962,
no. D 27; Muraro 1977, pp. 53–4; Gentili 1996, p. 87;
Aikema in Venice 1999, no. 18; Brooke 2004, pp. 303–4

Like the preceding drawing this is related to
Carpaccio's cycle in the Scuola di S. Giorgio
degli Schiavoni, Venice, of *c.* 1501–8 (for the
details of this commission see no. 79). The
painting (fig. 1) follows *Jerome leading the tame
lion into the monastery and the Obsequies of Jerome*
in the cycle, and was long thought to depict
this saint working in his study, despite its
puzzling position after a canvas showing
his funeral.[1] This was resolved in 1959 when
the subject was identified as the Vision of

St Augustine, an episode related to miraculous
events following St Jerome's death in AD 420
recounted in an apocryphal letter purportedly
by Augustine.[2] This related how one evening,
while writing a letter to Jerome asking his
views on the bliss of souls in Paradise, a subject
that Augustine was contemplating writing
about, an unnatural light and fragrance
suddenly entered his room. The voice of
Jerome then told Augustine that he had just
died and gone to heaven, and that it was
presumptuous for any mortal even to attempt
to comprehend such a state.

The prime importance of light in the narra-
tive probably motivated this unusually detailed
study of it in the present drawing. The highly
pictorial and polished nature of the work
contrasts with the more improvisatory study
in the Uffizi for the same cycle (no. 79).[3] The
differences between them can be explained by

the drawings having been made at different
stages in Carpaccio's preparation, with the
present one made right at the end of the
process and doubtless guided, in view of the
absence of corrections or any visible under-
drawing, by previous studies. Apart from the
drawing's function as a guide for the artist
while working on the canvas, the high finish
suggests that it may also have been shown to
Carpaccio's patrons for their approval of the
setting. A greater level of supervision (or re-
assurance on the part of the artist) would befit
such an esoteric and rarely depicted subject.
The lack of detail in the delineation of the figure
has led scholars to speculate that Carpaccio was
awaiting instruction on how to portray a patron
of the scuola in the guise of Augustine, but
this overlooks the fact that he did much the
same thing in his compositional study for the
Obsequies of Jerome from the same cycle, at the

Fig. 1
Vittore Carpaccio, *The Vision of St Augustine*, c. 1501–8.
Oil and tempera on canvas, 144 × 208 cm.
Scuola di S. Giorgio degli Schiavoni, Venice.

Fig. 2
Detail of no. 80

Universitetsbibliotek, Uppsala, in which the monks in the foreground are defined in the most cursory manner while the setting behind them is meticulously described in pen and wash.[4] In both cases, the artist only outlined the figures either because he had already made detailed studies of them or intended to do so.

The interior of the study plays a key part in the painting because its contents create an impression of the character and intellect of a protagonist who is otherwise passive. The scattered books, scientific instruments and bronze statuettes in the painting evoke the breadth of Augustine's learning, while the central position of the altar in the niche with his bishop's mitre and crosier on either side of a gilded statue of the Risen Christ make clear that his intellect is directed towards God's service. The light flooding in from the right is the only pictorial means Carpaccio uses to

signal the miraculous nature of the event. Its unnatural source is subtly indicated by the evening light that casts shadows from the opposite direction on the studded shutters in the book-strewn room seen through the doorway on the left (fig. 2).[5]

Despite the high level of finish of the drawing, comparison with the painting shows that Carpaccio continued to refine the design. He regularized the approximate perspective found in the drawing with a vanishing point focused on the right wrist of the saint. He revised a number of details, most notably substituting the dog for the ermine observing the saint, thereby including an animal symbolizing fidelity rather than one associated with purity. He also added more books and objects on the floor and shelves to move the viewer's attention more gradually backwards.[6] HC

81 Recto: Head of a middle-aged man

c. 1510–20

Brush and brown ink, heightened with lead white, over black chalk,
on blue paper, 26.7 × 18.7 cm

Verso: Two youths

c. 1510–20

Brush and brown ink, heightened with lead white, over black chalk,
on blue paper
British Museum, London (1892,0411.1)

PROVENANCE

7th Duke of Marlborough (?); acquired from J.P. Heseltine
for £120 (with another Carpaccio drawing; Popham and
Pouncey 1950, no. 37) in 1892

LITERATURE

Hadeln 1925, pp. 56–7; Tietze and Tietze-Conrat 1944,
no. 612; Popham and Pouncey 1950, no. 36; Lauts 1962,
no. D 29; Muraro 1977, pp. 48–9

The excellent condition of the drawing, especially as regards the sparkling contrast of the blue of the paper and the white highlights, provides a means of imagining the rich colouristic effect that once prevailed in less well-preserved Venetian drawings of comparable technique by Carpaccio's contemporaries, like the studies by Antonio Vivarini (no. 75) and Giovanni Battista Cima (no. 78). The drawing is a masterful example of Carpaccio's talent for capturing a pose or expression with great economy of means through the combination of black chalk, principally used to indicate shading, followed by wash and white heightening applied with the brush.

The studies were most likely made for a specific purpose, although the corresponding painting has either been lost or was never realized. The absence of a related commission has resulted in a wide variety of suggested dates for the likely execution of the drawing, ranging from the 1490s to the second decade of the sixteenth century. The discrepancy demonstrates the difficulty of establishing a chronology of Carpaccio's drawings because his style changed relatively little. Even when a connection between a study and one of his paintings can be made, it is often hard to define precisely the nature of that relationship. In part this is because Carpaccio liked to recycle his drawings in various modified forms to such an extent that it is sometimes difficult to be sure in which painting the motif first originated.[1]

In addition, in cases where the connection between a figure in a drawing and a painting is clear cut, it cannot always be assumed that one is a study for the other, because he also made drawn copies after details of his finished compositions in order to record them for future use.[2] With such uncertainties in mind it would be unwise to be overly dogmatic about the likely dating; however the broad atmospheric quality of the description of the figures on both sides of the sheet, the outlines of the forms defined through tone rather than contour, is paralleled most closely in studies from the end of his career.[3]

The recto has been described by one scholar as a portrait and the verso as most likely to have been drawn from life, but it is difficult to determine if this categorization is accurate.[4] The features of the Venetian patrician seen in profile on the recto, such as his bushy hair flowing out from under a close-fitting hat,

are similar to those of a number of figures in various narrative cycles by Carpaccio.[5] The drawing on the verso is clumsy in certain passages, most notably in the unnaturally truncated right arm of the rear figure, but the observation of light is consistent with the unquestionably autograph recto. The awkward articulation and the lack of detail could be explained either by his using wooden mannequins to model the figures, or by his long experience of life drawing which allowed him to set such generalized poses down on paper without needing to see models before him. Carpaccio certainly did on occasion make life drawings, as is testified by his study of a male nude in the British Museum (fig. 1), yet it would have been impractically slow for him to have executed similar studies from a posed model for more than a small proportion of the protagonists in the multi-figured narrative cycles that were his speciality.[6] HC

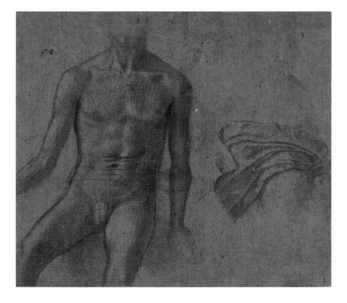

Fig. 1
Vittore Carpaccio, *Male nude and drapery, c.* 1495. Black chalk, on blue-grey paper, 19.7 × 21.9 cm. British Museum, London.

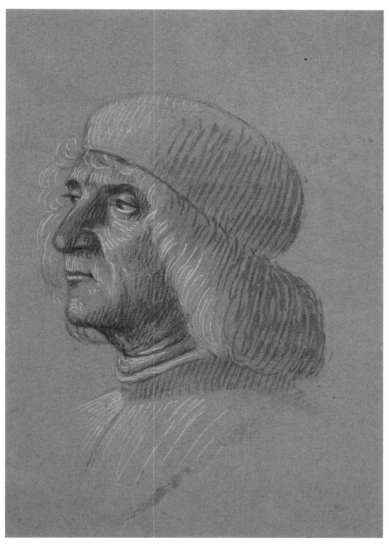

Recto

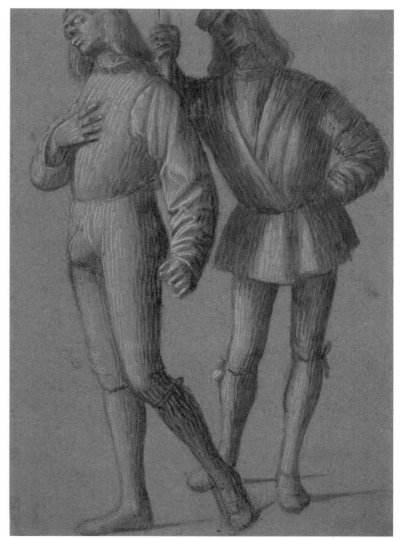

Verso

269

82 A dead grey partridge

c. 1504

Brush and watercolour, 25.7 × 15.2 cm
Inscribed in an old hand in ink, top left (written vertically): '1511'; and in a more modern one:
'g Tetras' (*tétras* is French for grouse), 'Gray Partridg' and '23'[1]
British Museum, London (SL,5264.23)

PROVENANCE

H. Sloane Bequest , 1753

LITERATURE

Popham 1928, no. 2; Tietze and Tietze-Conrat 1944,
no. 64; Popham and Pouncey 1950, no. 5; Levenson 1978,
no. 13; Koreny in Vienna 1985, no. 6; Dal Pozzolo in
Venice 1999, no. 93, p. 388; Ferrari 2006, no. D. 2

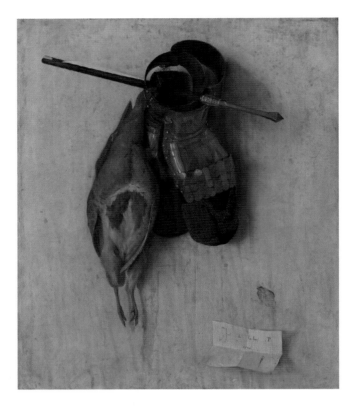

Fig. 1
Jacopo de' Barbari, *Still-life with
a dead partridge*, 1504. Oil on panel,
52 × 42.5 cm. Alte Pinakothek, Munich.

This exquisitely detailed watercolour by the Venetian painter and printmaker, Jacopo de' Barbari, was formerly part of an album from Hans Sloane's collection of bird drawings, the majority by the English artist George Edwards (1694–1773).[2] The attribution is based on the Venetian character of the drawing, most notably the downward brush shading as in Carpaccio's wash drawings (see nos 80–1), and the appearance of a similar bird in Barbari's signed and dated still-life painting of 1504 in Munich (fig. 1).[3] The panel, which is the earliest independent still-life painting in European art, dates from Barbari's time (1503–5) at the court of the keen huntsman, Frederick III (the Wise), Elector of Saxony.

The present work is the only example of a watercolour among Barbari's minuscule surviving graphic corpus of four drawings.[4] He must surely have made many more before embarking on it because his command of the medium is so sure. His acute description of the form and texture of the plumage is achieved through a variety of means, such as the tiny flicking strokes of an almost dry brush loaded with dark pigment over a slightly variegated background wash of lighter grey to render the bird's breast. Barbari was not unique among northern Italian artists to use watercolour; Andrea Mantegna and Bartolommeo Montagna did so on occasion in combination with pen for finished presentation-type drawings, and more pertinently it had a long tradition for being used to make accurate studies of animals, birds and plants in the production of Lombard drawing books (see no. 2), by artists such as Giovanni de' Grassi and Pisanello, as well as by illuminators, especially of herbals.[5]

An additional stimulus for Barbari to experiment with watercolour was the virtuoso employment of it by the German painter and printmaker, Albrecht Dürer (1471–1528), whom he first met in Venice in 1495.[6] Dürer's earliest surviving watercolours are landscapes and townscapes inspired by the sights he saw on his travels to and from Italy in the mid-1490s, while his studies of animals are slightly later in date, like the celebrated hare of 1502 now in the Albertina in Vienna, executed after his return to his native city of Nuremberg.[7] Barbari clearly profited from his study of such drawings in Dürer's studio in Nuremberg when Barbari worked there from 1500 to 1503 while in the service of the Holy Roman Emperor Maximilian I. Although Dürer did sometimes turn to his watercolour studies as a source for landscapes and animals included in his engravings and paintings, they were clearly

made for their own sake, as the degree of their finish and detail is far greater than his normal preparatory studies.

Similarly, it seems improbable that Barbari should have gone to the trouble of making the present drawing only as a study for the Munich panel. The likelihood that it was an independent study is reinforced by the differences between his depictions of the birds in the two works. The partridge's body in the painting hangs at a slight angle due to the proximity of the greaves (armour that protects the shins), while the chocolate-brown feathers on the underside of its body are more prominent and symmetrical than their counterparts in the drawing. The present drawing is the clearest evidence that Dürer granted Barbari access to his studio, thereby providing him with an unrivalled opportunity that no other Italian artist could match, to study the watercolours kept there.[8] HC

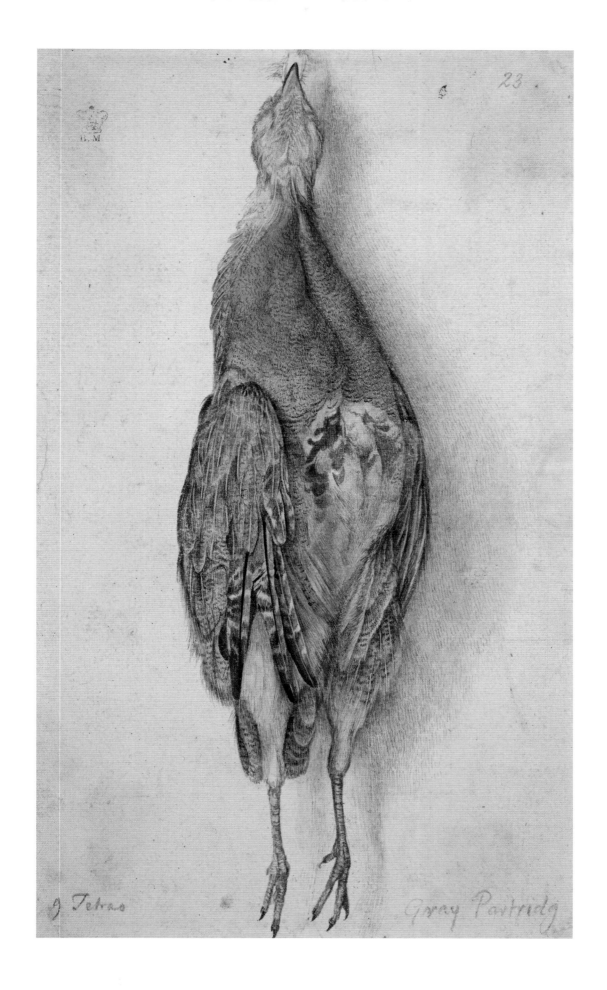

♂ Tetrao

Gray Partridg

23.

271

83 Cloaked woman seen from behind; and a child

c. 1480–5

Pen and brown ink, brown wash, heightened with lead white
(the outlines of the child pricked and the verso rubbed with black chalk),
24.2 × 14.7 cm
Gabinetto di Disegni e Stampe degli Uffizi, Florence (1444 F)

PROVENANCE

Ferri, *Disegni di Figura* (*c.* 1887); Reale Galleria degli Uffizi (L. 929)

LITERATURE

Harck 1886, pp. 68–9; Venturi 1888, p. 405; Ferri 1890, p. 217; Popham 1933, pp. 23–4; Ortolani 1941, p. 182; Turrill 1986, pp. 264–6; Manca 1992, pp. 172–3; Molteni 1995, pp. 99–101, 103, 210 n. 75; Allen in London 1999b, pp. xix–xx; Agosti in Florence 2001, pp. 108–12, n. 11; Marini in Ferrara 2007, no. 161.

Our knowledge of drawing in Renaissance Ferrara is fragmentary, and this is reflected in our information on Ercole de' Roberti as a draughtsman. Although the Dukes of Ferrara are documented as having held Roberti's drawings in high esteem in the late fifteenth century, the artist's graphic corpus is small and includes a number of drawings whose attribution is insecure and which have not been properly related to his paintings.[1]

In this light, the present drawing takes on added significance through its clear relation to the woman and child to the right of the Virgin in *The Procession to Calvary* (fig. 1), one of two predella panels (narrative paintings placed in the lowest tier of an altarpiece) executed for S. Giovanni in Monte in Bologna in 1482–6 (see no. 84).[2] The other predella depicts *The Arrest of Christ*, and both are now in the Gemäldegalerie Alte Meister, Dresden. The motif of the standing woman in a slightly uneasy pose, seen from behind and wrapped in a voluminous dress, derives from a number of sources which include the older Ferrarese artist, Francesco del Cossa (*c.* 1430–*c.* 1477), and was used earlier by Roberti himself in the predella of *The Miracles of St Vincenzo Ferrer* (Vatican Museums, Rome) for the Griffoni polytypch painted 1473–5.[3] The composition appears to have become a stock drawing in Roberti's studio, employed for both male and female subjects.

Catherine Turrill first noted in 1986 that the outlines of the child had been pricked for transfer and the verso rubbed with black chalk in correspondence to the woman on the recto.[4] For Turrill this shows the woman was to be transferred through the incision of the contours (although there is no evidence this has taken place). The child is only outlined in pen and ink, in contrast to the woman, to whom the artist also applied ink wash and lead white with the brush to describe the volume and the fall of light. The alternating interpretation of the sheet is represented by Manca, who acknowledged its high quality but considered the sole pricking of the child's contours to suggest that the drawing is a copy after the painting.

These reservations are explained by some rigidity in the handling, the spiky appearance of the drapery and a simple chiaroscuro, yet these characteristics accord with the clear outlines and incised appearance of drawings securely attributed to Roberti. There are discernible variations between the drawing and the executed work: in the painting the closed mouth of the woman is open in pain and the headdress and dress are more attentively composed. This suggests that the drawing is preparatory to the painting rather than a copy that simplifies the details. Denise Allen has demonstrated that the measurements of the drawing and painted figure correspond exactly. This strongly suggests that the sheet was used to transfer the composition on to the panel, although Roberti may have begun the sheet as a study of the drapery, employing it subsequently as a cartoon.[5]

The balance of scholarly opinion now favours Roberti's authorship, on the basis of the drawing's clear preparatory function and the high quality of its execution. The predella is dated to the first half of the 1480s, before the artist's return to Ferrara, and this makes the drawing a chronological benchmark for Roberti's graphic works. GM

Fig. 1
Ercole de' Roberti, *Christ on the way to Calvary*,
c. 1480–5. Oil on panel, 35 × 118 cm. Gemäldegalerie
Alte Meister, Staatliche Kunstsammlungen Dresden.

Fig. 2
Detail of fig. 1

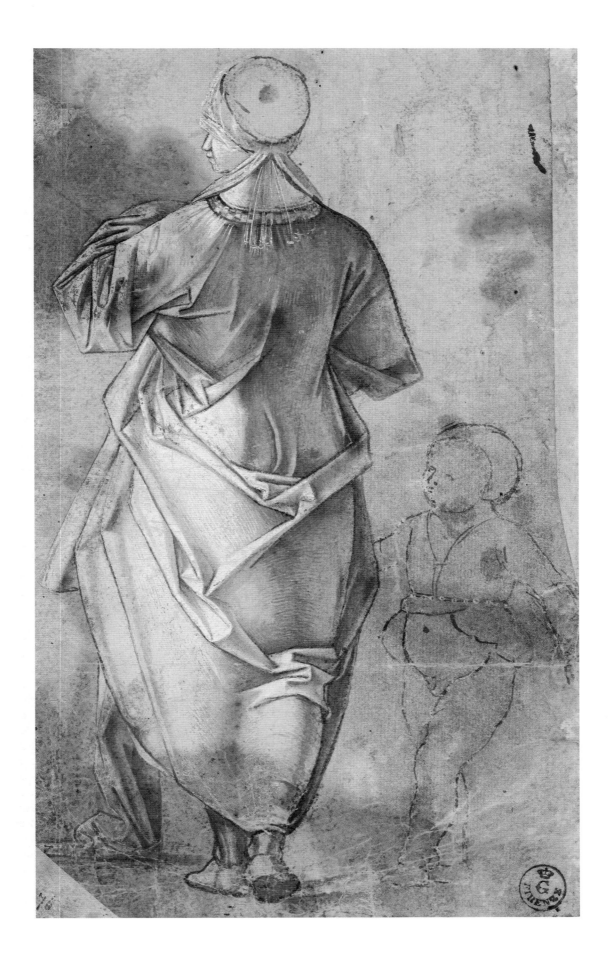

273

84 The Coronation of the Virgin witnessed by (from left to right) St Victor, St John the Baptist, St Augustine, St John the Evangelist, St Jerome and St Sebastian

c. 1500–1

Pen and brown ink and brown wash, 20.8 × 19.3 cm
Inscribed, possibly by Filippo Baldinucci: 'Fra Filippino'
Gabinetto Disegni e Stampe degli Uffizi, Florence (178 E)

PROVENANCE

Fondo Mediceo-Lorenese (Pelli after 1775–before 1784);
Reale Galleria degli Uffizi (L. 930)

LITERATURE

Frizzoni 1876, p. 226, n. 2; Longhi 1934, p. 219; Brown 1966,
pp. 140–1, 144–5, 336; Petrioli Tofani 1972, no. 22; Petrioli
Tofani 1986, pp. 78–79; Faietti in Bologna and Vienna 1988,
no. 70; Negro 1989, no. 3; Faietti 1994a, pp. 197, 203–4,
209, n. 37; Agosti in Florence 2001, no. 60; Negro and
Roio 2001, p. 110; Faietti in Bologna 2002, p. 66

The burgeoning interest in the study of
Lorenzo Costa as a draughtsman means there
is now a reasonably large group of drawings
attributed to him, although a clear under-
standing of his central role in the art of
Emilia-Romagna in the late fifteenth century
has been hindered by the diverse appearance
of the sheets gathered under his name.[1]

As Gustavo Frizzoni first recognized in
1876, the drawing is preparatory to the panel
of the *Coronation of the Virgin with Saints*,
commissioned for the high altar of S. Giovanni
in Monte in Bologna where it still remains
(fig.1).[2] This clear link and the fact that the
work is signed and dated 1501 makes the
drawing an unassailable point of reference for
the reconstruction of the graphic oeuvre of
Costa, an artist whose style is typical of the
early classicism of Bolognese art at the time
of the ruling Bentivoglio dynasty.

The *plein-air* landscape in the drawing is
also present in the painting, although not
without some changes, seen, for example, in
the addition of trees to the sides, which give a
symmetry to the composition, and a bucolic
group of figures where the background hills
slope into the delicate plains of the horizon.
If the chorus-like effect of the circled figures
in the celestial vision in the drawing is a little
less marked in the painting, the connection
between the saints and the heavenly assembly
is made more effective in the finished work
by raising the gazes of all the saints except
St Augustine.[3]

Costa has fixed the outlines of the planned
painting with quick strokes of the pen over

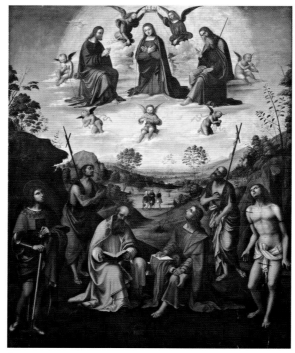

Fig. 1
Lorenzo Costa, *Coronation of the Virgin*, 1501.
?Oil on panel, 283 × 165 cm. S. Giovanni in Monte, Bologna.

Fig. 2
Lorenzo Costa, *St Jerome* (?), *c.* 1500–10.
Pen and brown ink and brown wash,
11.8 × 4.3 cm. Fondazione Giorgio Cini, Venice.

which diluted washes of ink have been applied
with the brush. The delicate luminosity of
the drawing suggests that the sheet was to be
presented to the patron, as Costa probably
did with his *Christ in the house of Simon the
Pharisee* at Oxford, datable to a few years later.[4]
Nevertheless, the drawing has a distinctly
exploratory character compared to the some-
what formal, archaizing appearance of the
painting, whose spatial character is still deter-
mined by a fifteenth-century classicism. The
elongated figures are permeated with a delicate
sentiment and arranged in various attitudes
characteristic of the artist, as is seen in the
correspondence between the aged St Jerome
resting on his cross (second from the right)
and a similar figure on a sheet in Venice (fig. 2),
a link first noted by Marzia Faietti.[5]

The drawing's precise proportions go hand
in hand with the more naturalistic tendency of
Costa's work towards the end of the fifteenth

century, marked by a freer and more personal
style under the influence of Perugino. The
renowned Italian art critic, Roberto Longhi
(1890–1970), was the first to see in this work
the results of an artistic dialogue between
Florence and Bologna and in particular the
influence of Filippino Lippi's rapid handling of
the pen (see no. 67); the drawing's similarity to
the Florentine painter's style is demonstrated
by the seventeenth-century attribution to him
on the lower edge, often speculatively identified
as by Filippo Baldinucci (see p. 81). A likely
although undocumented sojourn by Costa
in Tuscany could explain the change in style,
begun in the altarpiece of 1497 commissioned
by Giacomo Ghedini for S. Giovanni in Monte,
towards more airy and lively compositions in
which figures with a strong psychological
character are placed within a symmetrical
framework.[6] GM

85 St Cecilia before the prefect Almachius

c. 1505

Pen and brown ink, 17.7 × 29 cm
Inscribed, possibly by Filippo Baldinucci: 'Fra filippino.'
Gabinetto Disegni e Stampe degli Uffizi, Florence (166 E)

PROVENANCE

Fondo Mediceo-Lorenese (Pelli after 1775–before 1784);
Reale Galleria degli Uffizi (L. 930)

LITERATURE

Ferri 1890, p. 291; Longhi 1940, pp. 148–9 (Aspertini);
Brown 1966, pp. 179–80; Lucco 1985, p. 150; Petrioli
Tofani 1986, pp. 72–3 (Aspertini); Faietti in Bologna and
Vienna 1988, no. 71; Negro in Di Giampaolo 1989, no. 12
(Bagnacavallo senior); Faietti 1994a, pp. 203–9; Faietti and
Scaglietti Kelescian 1995, no. 9R; Negro and Roio 2001,
no. 51.a.b; Faietti in Bologna 2002, p. 67

This vibrant and rapidly penned study is
preparatory for a fresco in the Oratory of
St Cecilia in Bologna (fig. 1), part of a pictorial
cycle that Lorenzo Costa and the other leading
Bolognese artists of the period, Francesco
Francia (*c.* 1450–1517) and Amico Aspertini
(see no. 86), were employed 1505–6. It marks
the summit of the Bolognese Renaissance
under the patronage of the ruling Bentivoglio
before Giovanni II Bentivoglio's fall from
power in 1506.

Ten episodes from the life of St Cecilia
contained in the *Golden Legend*, a mid-thirteenth-
century manual on the lives of the saints by
Jacopo da Varagine (see no. 20), are painted
on the walls of the Oratory. They recount
how Cecilia, of noble Roman family, became
a Christian and dedicated her virginity to
God. Forced into marriage, she persuaded her
husband Valerian to forgo his marital rights
and be baptized himself by Pope Urban.
Valerian's brother Tiburtius also converted
and both siblings were martyred by the prefect
Almachius in Rome. This drawing is a creative
depiction of the episode in which Cecilia as
the wife of Valerian was called to account by
Almachius; at this meeting she refused to offer
a sacrifice to the idols and was condemned to
execution in a bath of boiling water. Subse-
quent scenes relate how this left her unharmed
and she was sentenced a second time, although
three strokes of the executioner's axe did not
succeed in decapitating her.

The way Costa explores his design is clearly
seen in the redrawing of the group of soldiers

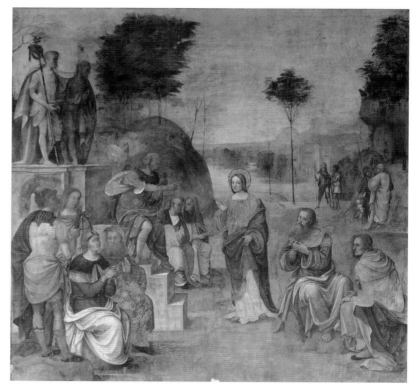

Fig. 1
Giovanni Maria Chiodarolo, or Bagnacavallo the Elder
(?), *St Cecilia before the prefect Almachius, c.* 1505.
Fresco. Oratorio di S. Cecilia, Bologna.

to the far right (the first drawn soldiers can be
seen to the left), which gives more space to the
briefly described yet evocative landscape, and
improves the focus on Almachius and St Cecilia.
The effectiveness of Costa's composition is in
contrast to the more conventional quality of
the fresco, whose style reflects the other scenes
executed by older masters. This suggests that
the fresco was executed not by Costa himself
or Francesco Francia but by a pupil of either
one of these two older masters.[1]

The drawing has been attributed to a
number of artists other than Costa, including
Aspertini, Giovanni Maria Chiodarolo (active
1490–1520) and more recently Bagnacavallo
the Elder (1484–1542), who began his career
working on this cycle.[2] Our better understanding
of Aspertini and Costa as draughtsmen permits

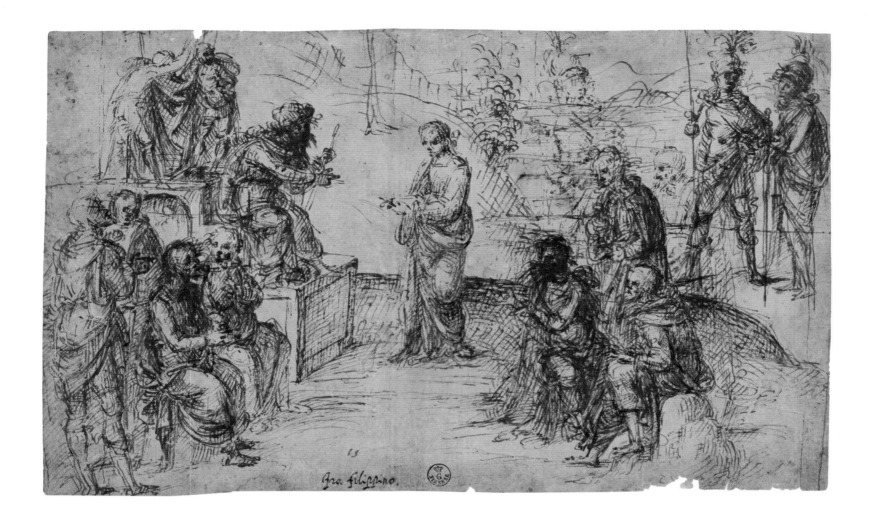

us to assign the sheet to Costa with some
certainty. The drawing shows the renewed
influence on Costa of Florentine artists
such as Filippino Lippi (nos 65–8) and Fra
Bartolommeo (nos 87–90). This influence
is displayed by the old inscription to Lippi
(considered by some to be by Filippo
Baldinucci) on both this sheet and the slightly
earlier *Coronation of the Virgin* (no. 84).

This drawing shows an irregular handling
of the pen characteristic of Costa's drawings
from the early sixteenth century. This is
also seen in his only known engraving, *The
Presentation of Christ in the Temple* (fig. 2),
related to a painting dated 1502, formerly
in Berlin.[3] There are equally close analogies
with a drawing by Costa of *Three Women* in
the British Museum of *c.* 1504.[4] GM

Fig. 2
Lorenzo Costa, *Presentation
of Christ in the Temple*, c. 1502.
Engraving, 15.7 × 13.3 cm.
British Museum, London.

86 Bust of a young man (Giovanni Achillini)

c. 1508–10

Black and red chalk, on discoloured paper (with some later retouching in brown wash), 39 × 28.5 cm
Inscribed in an old hand: 'M.[agiste]r ALEX.[ande]r/ ACHILLIN.o/ AN.[nis] XXIII.'
Gabinetto Disegni e Stampe degli Uffizi, Florence (1445 F)

PROVENANCE

Annibale Ranuzzi; Cardinal Leopoldo de' Medici; Fondo
Mediceo-Lorenese (Pelli after 1775–before 1784); Reale
Galleria degli Uffizi (L. 929)

LITERATURE

Longhi 1956, pp. 149–50; Forlani Tempesti in Florence
1976, vol. 1, no. 66; Vaccari 1980, no. 17; Scaglietti
Kelescian in Bologna 1988, no. 80; Faietti in Faietti and
Scaglietti Kelescian 1995, pp. 43, 60–1, no. 47; Agosti in
Florence 2001, no. 67; Zacchi in Bologna 2008, no. 106

This portrait was attributed to Francesco
Francia in a group of drawings documented
as sent to Florence in a letter of 1674 from
Annibale Ranuzzi, an agent of the Medici
family in Bologna, to Cardinal Leopoldo
de'Medici.[1] For some time now it has been
attributed instead to Francia's younger Bolognese
compatriot Amico Aspertini. The rounded form
of the head and bust anchored in space recalls
Aspertini's frescoes executed towards the end
of the first decade of the sixteenth century in
the chapel of S. Agostino in S. Frediano, Lucca,
suggesting the drawing was executed around
the same time. Roberto Longhi, for whom the
sheet lay somewhere between Raphael and the
Dutch painter Lucas van Leyden (*c.* 1494–1533),
gave a similar date around 1510. The drawing
does recall Raphael's portraits executed
after 1505.[2]

The outline of the figure and the framing
lines appear to be in the same ink as the old
but not autograph inscription to Alessandro
Achillini (1463–1512). The subject is more
likely Alessandro's younger brother Giovanni,
known as Filotèo (1466–1538),[3] a poet and
classical scholar, who was portrayed in an
engraving by the Bolognese printmaker
Marcantonio Raimondi (*c.* 1480/82–before 1534;
fig. 1).[4] Aspertini's fascination with classical art
was doubtless strongly influenced by Giovanni,
with whom the artist had documented contact.
The artist, however, must have also known
Alessandro, a renowned doctor and Aristotelian
philosopher.[5] Many Achillini family members are
listed as members of the Bolognese Confraternity
of Buon Gesù, along with Aspertini.[6]

Fig. 1
Marcantonio Raimondi, *A man sitting on a rock and
playing a guitar (portrait of Giovanni Achillini called
Filotèo)*, *c.* 1504–5. Engraving, 18.4 × 13.6 cm.
British Museum, London.

Shared antiquarian interests cemented the
friendship between Aspertini and Giovanni,
who described his young artist friend as bizarre
and learned in his poem *Viridario* (1504).[7]
Giovanni's considerable collection of medals,
antique marble sculpture, commemorative
plaques, urns, and probably gems and small
bronzes, would have appealed to Aspertini's
passionate interest in antiquity, which led
him to make more than one trip to Rome.[8]

Although Aspertini's attention to
physiognomy was influenced principally by
the example of Leonardo and Northern
European expressionism, his interest in the
subject was also fuelled by Alessandro Achillini
who promoted the scientific study of physiog-
nomy in his treatise *Inquiry into physiognomy
and chiromancy*, published in 1503.[9] This no
doubt inspired the often bizarre physiognomies
seen in Aspertini's crowd scenes and the
occasional yet vivid portraits of penetrating
psychological introspection, which demonstrates
Aspertini's independence from the prevailing
canons of beauty.[10]

Fig. 2
Amico Aspertini, *Portrait of Alessandro Achillini*,
before 1521. Tempera on canvas, 92 × 82.5 cm.
Galleria degli Uffizi, Florence.

The naturalistic treatment of Giovanni
Achillini in this drawing is tempered with a
certain idealization: Aspertini is sensitive to his
friend's character, giving him a calm expressive
tension intended to convey the subject's serious
moral purpose and interior grace. This intense
psychological exploration finds parallels in
German art of the period, for example the
portrait of Christoph Scheurl, a disciple of
the renowned humanist lecturer at Bologna
University, Filippo Beroaldo the Elder, by
Lucas Cranach the Elder (1472–1553).[11] It has
been noted that the artist's idealizing intent
precluded an accurate representation of the
sitter's age (he would have been over 40).[12]

There are two known portraits by Aspertini
of Alessandro Achillini, one in the frontispiece
to the latter's *Annotationes anatomiae* (1520)
containing the observations he made during
his public anatomy demonstrations,[13] and
another which has recently come to light in
a private collection and is now in the Uffizi
(fig. 2).[14] The latter is in all likelihood the
portrait documented in the possession of
Paolo Giovio, Achillini's pupil at Padua, which
had hitherto only been known through the
painted copy in the Ambrosiana in Milan
and an engraving in the 1577 edition of the
Elogia, a collection of biographical outlines
of illustrious men written by Giovio.[15] MF

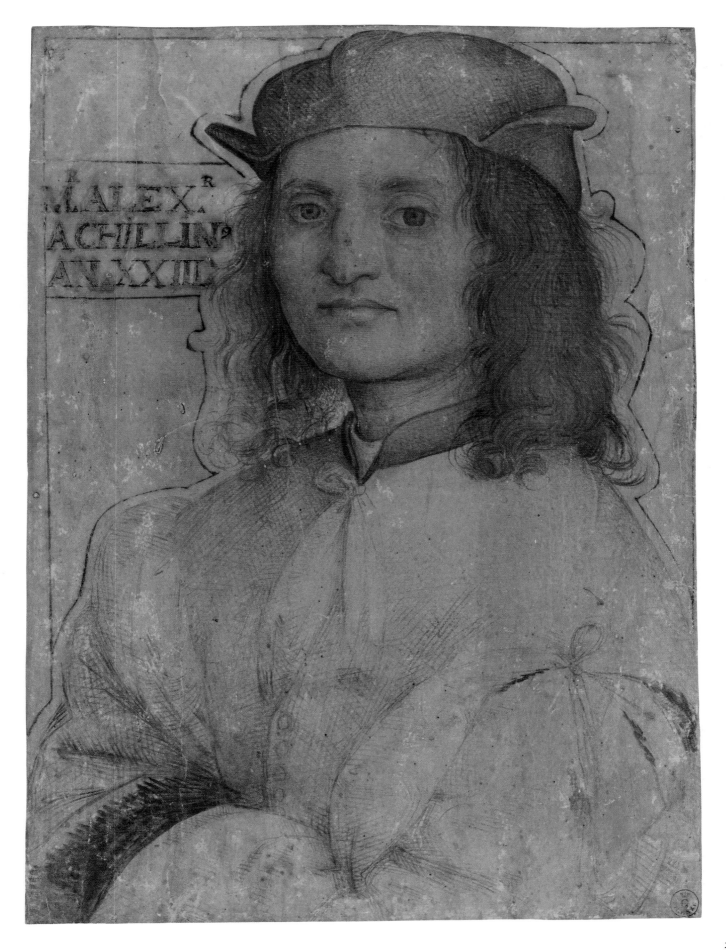

BARTOLOMMEO DI PAOLO, called BACCIO DELLA PORTA
or FRA BARTOLOMMEO (1472–1517)

87 The Virgin and Child with the Child Baptist; studies for the head of a female saint, an angel, a woman's head and bust in profile to the left, and a left hand; two studies of the Child Baptist; and a study for a decorative motif

c. 1490–1500

Pen and two shades of brown ink, brown wash, 16.4 × 22.2 cm
Gabinetto Disegni e Stampe degli Uffizi, Florence (1234 E)

PROVENANCE

Fondo Mediceo-Lorenese (Pelli Bencivenni before 1793);
Reale Galleria degli Uffizi (L. 930)

LITERATURE

Frantz 1879, p. 229; Knapp 1903, p. 292; Gabelentz 1922,
vol. 2, no. 172; Sandberg-Vavalà 1929, p. 9, pl. IIc (r.);
Berenson 1938, vol. 2, no. 286; Dalli Regoli 1974, p. 53;
Hopkinson 1974–5, p. 54; Petrioli Tofani 1987, pp. 513–14;
Fischer in Florence 1986a, no. 4; Fischer in Paris 1994,
under no. 6; Fischer in Florence 1996, under no. 14

This is a characteristic sheet in pen and ink from early in Fra Bartolommeo's career when the artist's style was still linked to fifteenth-century artistic tradition, as is seen in the lucid definition of form and the homogeneous fine meshes of both parallel and cross-hatching (often in strokes of remarkable length), suggesting the artist's knowledge of Northern European engravers, and Dürer especially.[1] The hatching has been emphasized with the application of wash, and the hard contours tend to simplify form and reduce the sense of depth.

The recto contains many studies gathered around the Virgin seated in three-quarter profile to the left, probably the first to be drawn on the sheet, whose head forms a trinity with those of the Christ Child and the Infant Baptist, counterbalanced by the complex knot of drapery to the lower right. The head of the Virgin was then studied in greater detail to the upper left and a halo added. The artist appears to have then moved right, adding two heads of women in profile, the upper of whom is perhaps the Virgin, the lower perhaps an attendant judging from the turban. Subsequently drawn to the left of these two heads is a hand appearing from behind a curtain or drapery. Immediately above the Virgin is the head of an angel turned in profile to the right, whose pen strokes do not impinge on the study below, suggesting its later execution, perhaps

intended as an addition to a Virgin and Child composition of which numerous painted versions issued from Bartolommeo's studio.[2]

Fra Bartolommeo's study of the Virgin and Child reflects his knowledge of Leonardo's drawings before his departure to Milan, in which the tender relationship between a mother and child is explored in unending rhythmic movement as seen in no. 51.[3] Other Florentine artists such as Francesco Granacci (*c.* 1469–1543) and Filippino Lippi were equally inspired by Leonardo to develop the mother and child theme.[4] To the right on the sheet are two studies for the Child Baptist; rapidly drawn with thicker strokes of the pen, the lower of which is perhaps related to the Christ Child in the *Sacra Conversazione with St Catherine of Siena* in the Louvre.[5] A further use of the sheet is displayed by the pilaster, in part cut and drawn with the sheet turned 90 degrees clockwise.[6]

The verso contains a study of the penitent St Jerome, drawn with the sheet turned vertically (fig. 1). The handling of the pen is of a piece with the recto, the saint's asceticism accentuated by his shrunken skull and large hands clasped in prayer. The position of the figure on the sheet and the cut drapery to the far right (Jerome's robe discarded on a boulder?) shows that the sheet has been significantly trimmed on the right edge, accounting for the cutting of the pilaster study and the Child Baptist's feet on the recto. There is a more summary drawing of the St Jerome with the saint holding a crucifix in the Louvre.[7] This drawing and the present one are often linked to two similar painted versions of *St Jerome in the Wilderness* of much-debated attribution.[8] Although neither drawing can be directly related to these devotional paintings, they would appear to have been executed around the same time. CG

Fig. 1
Verso of no. 87, *Study of the penitent St Jerome,*
c. 1490s. Pen and brown ink, 22.2 × 16.4 cm.

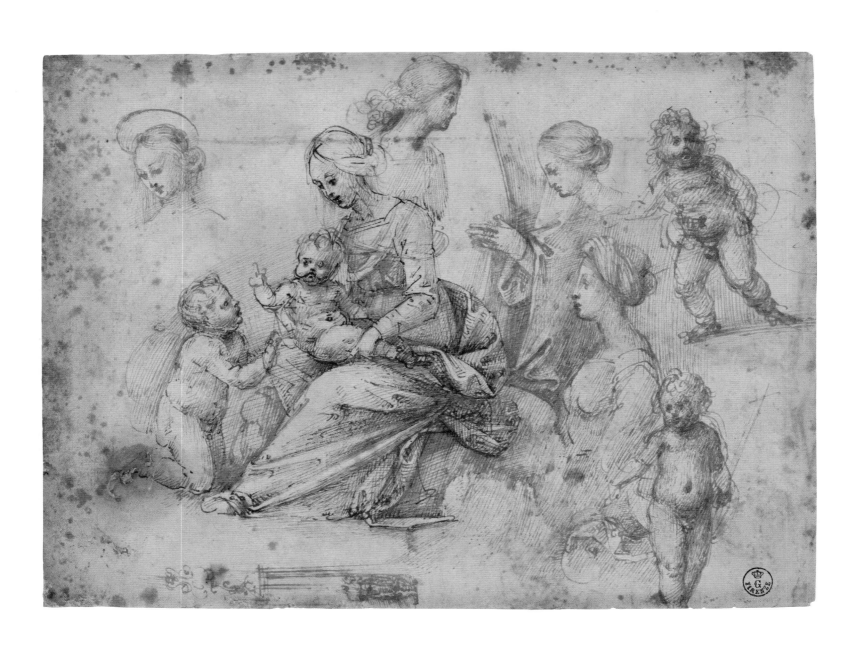

BARTOLOMMEO DI PAOLO, called BACCIO DELLA PORTA
or FRA BARTOLOMMEO (1472–1517)

88 Christ in Judgement

c. 1500

Black and white chalk, heightened with lead white, on light brown paper, 27 × 19.1 cm
Gabinetto Disegni e Stampe degli Uffizi, Florence (455 E)

PROVENANCE

Fondo Mediceo-Lorenese (Ramirez 1849); Reale Galleria degli Uffizi (L. 930)

LITERATURE

Frantz 1879, p. 226; Degenhart 1934, pp. 227–8; Berenson 1938, vol. 2, no. 238; Forlani in Florence 1961, p. 29, no. 40; Fahy 1969, pp. 153–4; Holst 1974, p. 280; Fahy 1976, p. 72; Borgo 1976, p. 269, no. 31a; Petrioli Tofani 1986, p. 204; Fischer in Florence 1986a, pp. 42–4, no. 9; Turner in London 1986, under no. 28; Fischer in Rotterdam 1990, under no. 6

Fig. 1
Fra Bartolommeo and Mariotto Albertinelli, *Last Judgement*, 1499–1500. Detached fresco, 357 × 374 cm. Museo di S. Marco, Florence.

This and the following work are preparatory studies for the figure of Christ in the *Last Judgement* commissioned in 1499 by Gerozzo Dini, clerk of the Florentine hospital of S. Maria Nuova, to decorate his mother's tomb in the hospital's cemetery, the Chiostro delle Ossa (fig. 1).[1] Fra Bartolommeo's intensive preparation for the composition is reflected in the nearly 60 surviving studies for individual figures, including two more for the figure of Christ in the Museum Boijmans Van Beuningen, Rotterdam (figs 1–2, no. 89),[2] although there are none for the whole composition, which must have required equally careful study.[3] Vasari records a completed cartoon and 'other drawings' for the composition, made available to Fra Bartolommeo's assistant, Mariotto Albertinelli (1474–1515), to complete the fresco when Bartolommeo stopped work on the commission to become a Dominican novice in July 1500.[4]

The present work shows the bulky figure of Christ sitting square to the picture plane as in the fresco, a common manner of representing Christ in Judgement in the fifteenth century. The mass of changes show that Christ's right arm was first drawn lowered in sign of benediction to the elect in the lower left of the fresco. His hand was then raised as in the painting in a more forceful gesture directed towards the damned on the lower right. The shadows and interior of the folds of drapery over Christ's legs were created by rubbing the black chalk, probably with a stump (a rolled-up piece of paper, leather or cloth with blunted ends).

Highlights were then added in lead white, the artist's last addition to the sheet, which give a stasis to the lower half of the drawing in contrast to the much redrawn contours of the upper body, barely highlighted in white chalk. In places the artist has allowed the warm hue of the paper to show, in order to enliven the surface, for example, over Christ's left foot (where the lightly drawn lines of the black chalk underdrawing are also visible). The sheet has been closely trimmed and portions of the drawing lost, notably Christ's raised right hand, and the head of a cherub along the bottom edge. This cherub and another indistinctly seen to the lower right signify Christ's supernatural elevation in the absence of a visible throne.

The other three studies related to this figure display the progression of the artist's thoughts as he continually modified Christ's pose to arrive at the definitive solution seen in the fresco, in which the Saviour is turned towards the damned on the lower right, his right hand raised in condemnation, his left indicating the spear wound in his side. The black chalk in the two Rotterdam drawings is similarly employed, the reworked contours fixed to some extent by the subsequent application of white lead which, in combination with the warm-coloured paper similarly exploited in no. 88, give the sombre effects of a monochrome painting. Both the Boijmans drawings illustrate solutions for the position of Christ's head, which are developed further in no. 89, probably the last of the series.

In this and the two Boijmans sheets Fra Bartolommeo is seen for the first time to exploit methodically the tonal range of black and white chalk to give his figures great solidity, employing blended *sfumato* effects that seem to be inspired by Leonardo's use of the technique.[5] CG

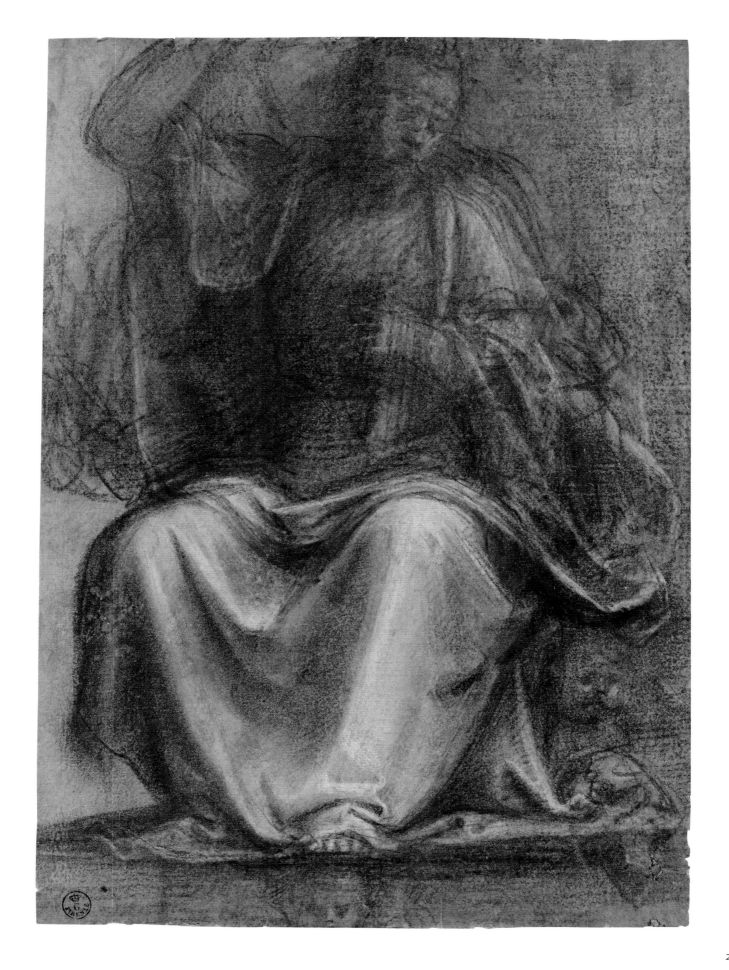

BARTOLOMMEO DI PAOLO, called BACCIO DELLA PORTA
or FRA BARTOLOMMEO (1472–1517)

89 Drapery for a figure of Christ in Judgement

c. 1500

Brush and grey-brown and white distemper on linen with
a dark grey preparation, 30.5 × 21.2 cm
Inscribed in an old hand (partly erased): 'LEONARDO da VINCI'
British Museum, London (1895,0915.487)

PROVENANCE

P. Crozat; E. Jabach; P. Sandby (L. 2112); W.Y. Ottley (?);
Sir T. Lawrence (L. 2445); S. Woodburn; Sir J.C. Robinson
(L. 1433); J. Malcolm; acquired from Col. J. Wingfield
Malcolm, 1895

LITERATURE

Ottley 1823, p. 22; Robinson 1876, no. 49 (Leonardo);
Degenhart 1934, pp. 224–31; Berenson 1938, vol. 2,
no. 2731A (Sogliani); Fahy 1969, pp. 153–4; Borgo 1976,
no. 31b; Fahy 1976, p. 72; Fischer in Florence 1986a under
nos 2–3, 9; Turner in London 1986, no. 28; Viatte in Paris
1989, under no. 24; Fischer in Rotterdam 1990, under
no. 6; Py 2001, under no. 14; Boubli 2003, p. 32;
Van Cleave 2007, p. 116

Fra Bartolommeo's authorship of this drawing
and its relationship to the figure of Christ for
the fresco of the *Last Judgement*, now detached
and displayed in S. Marco, Florence (fig. 1, no.
88), was first recognized by the great English
artist and connoisseur of the early nineteenth
century, W. Y. Ottley. In contrast to no. 88
and the other two drawings for this figure in
Rotterdam (figs 1–2), the present drawing is
executed entirely with the brush, in grey-
brown and white distemper (pigment mixed
with size) on linen, whose surface provides
a perfect textured support. This painterly
method of drawing, combined with the
compositional advances, suggest that
no. 89 is the closest in the group of four to
the execution of the fresco.

Fra Bartolommeo described in bold
chiaroscuro the silky drapery that falls symmet-
rically over Christ's shoulders then follows the
lines of the torso, and resolved the way it joins
the drapery folded over Christ's lap, unclear in
no. 88. Soft and broad brush strokes are blended
to give a striking three-dimensionality to the
drapery over which there is a subtle play of light,
in contrast to the abbreviated description of the
left hand and torso, and the putti to either side
of Christ whose outlines give an idea of the
appearance of the now hidden underdrawing.

Christ's head and raised right forearm were
rubbed out while still wet, displaying the
artist's readiness to reconsider his composition
even in an advanced stage of the design process

Fig. 1
Fra Bartolommeo, *Study for Christ*, c. 1500.
Black chalk heightened with lead white on light
grey preparation, 28.8 × 21.7 cm. Museum Boijmans
Van Beuningen, Rotterdam.

Fig. 2
Fra Bartolommeo, *Study for Christ*, c. 1500.
Black chalk heightened with lead white on grey
preparation, 28.4 × 20.9 cm. Museum Boijmans
Van Beuningen, Rotterdam.

(although they were never redrawn).[1] The four
sheets of this sequence display the artist's study
of a wide variety of complimentary variants,
or small modifications, made to an established
composition, approaching the final design by
ever finer levels of finished study.[2] The tubular
appearance of Christ's torso in no. 89 strongly
suggests that Fra Bartolommeo employed a
mannequin, fashioned from either wood or
clay, over which was arranged cloth previously
dipped in liquid clay or wax to allow the
prolonged study of the stiffened drapery.
It shows how a painter's technique (and
ambition to convey solid, three-dimensional
form) could overlap with that of a sculptor.[3]
It was a technique also fostered by Verrocchio,
both a sculptor and painter, and one in turn
adopted by Leonardo who greatly influenced
Fra Bartolommeo, as Vasari records.[4] Leonardo
also pioneered the use of brush for the detailed
modelling of drapery. It is therefore not

surprising that Fra Bartolommeo's drawings
in the same technique were often confused
with the older master's as can be seen from an
old attribution to Leonardo inscribed on the
bottom edge.[5]

Leonardo's theory behind the depiction of
drapery (and one to which Bartolommeo would
no doubt have subscribed) is described in his
notes for an uncompleted treatise on art:

> vestments should display a sense of the
> real body beneath … indeed drapery is
> most properly employed when life is sensed
> beneath, that is, when it is not simply a mass
> of cloth falling from a body, as many artists
> seem to think, such as those who take
> delight in filling a figure with various folds,
> without considering the overall effect, and
> the proper purpose of drapery to clothe
> the body with grace.[6]

CG

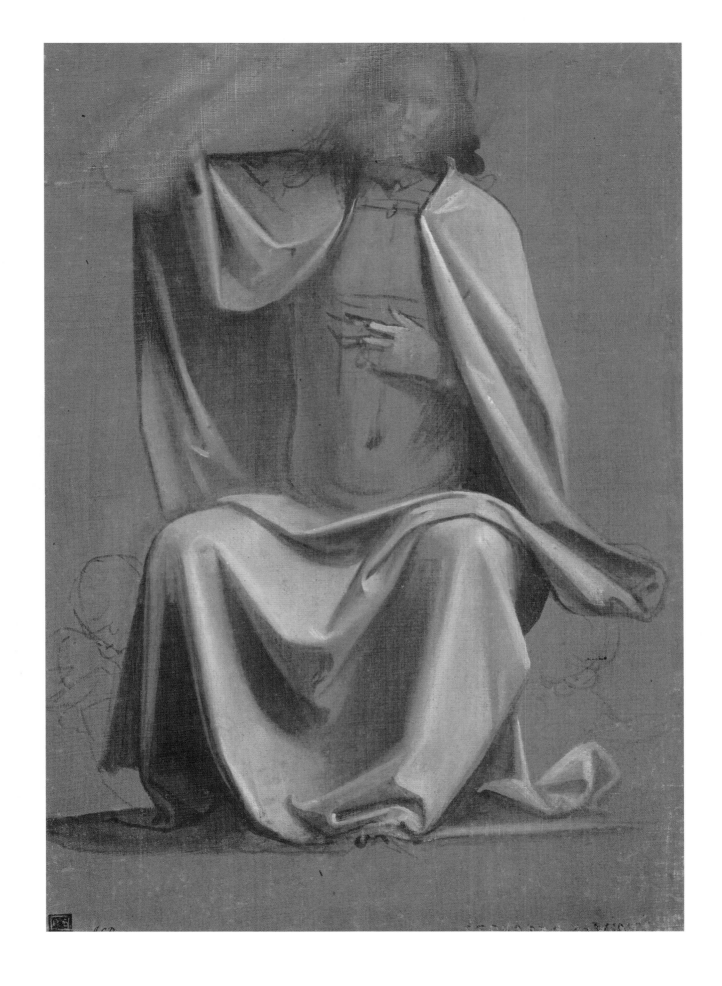

90 Wooded ravine spanned by a stone bridge with travellers on a road leading up a hill

c. 1495–1508

Pen and brown ink, 21.5 × 28.8 cm
British Museum, London (1957,1129.66)

PROVENANCE

Fra Paolino da Pistoia; Suor Plautilla Nelli; Convent of
S. Caterina in Piazza S. Marco, Florence; Cavalier F.M.N.
Gabburri; W. Kent (?); acquired at Sotheby's 1957 sale
of Fra Bartolommeo landscape album

LITERATURE

Fleming 1958; Kennedy 1959; Härth 1960; Berenson 1961,
vol. 2, p. 72, no. 6; Alinari XX 1978, no. 3; Turner in
London 1986, no. 48

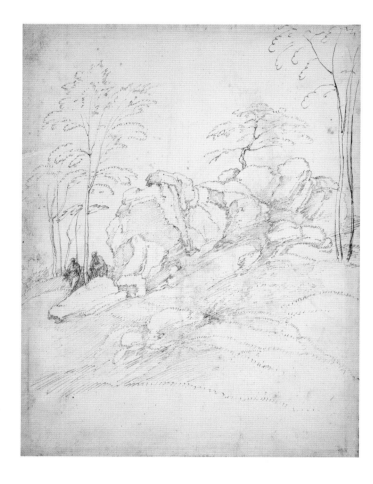

Fig. 1
Fra Bartolommeo, *Two figures
near a large boulder on the crest
of a hill, trees at either side,*
c. 1495–1508. Pen and brown ink,
28.5 × 21.3 cm. British Museum,
London.

This innovative landscape executed in fine and agile strokes of the pen is framed to the left by two tall trees drawn in long lines that dwindle going down the sheet as the ink runs dry. Two figures wade in the water of a stream flowing under a stone bridge, which is the focus of the composition. To the right a striding figure holding a long pole and a rider with a wide-brimmed hat disappear behind a boulder on a road, which leads up a hill to buildings that are just discernible among trees, and whose inhabitation is suggested by the travellers heading towards them and the line of smoke rising from a chimney.

There is a very similar landscape in the British Museum by Fra Bartolommeo on a sheet of almost identical proportions, although orientated vertically (fig. 1). Both belonged to a group of 41 landscape drawings that had been mounted in an album by the Director of the Florentine Accademia del Disegno, Niccolò Gabburri (1675–1742), and remained intact until the sale of the album in 1957.[1] Fra Bartolommeo's authorship of the drawings in the album, in which depictions of topographically recognizable landscapes alternate with studies of rocks and trees, has been unanimously accepted through their links with his painted backgrounds and their similarity with the few landscape drawings by the artist known prior to the appearance of the volume.[2] This remarkable series of drawings demonstrates that Bartolommeo together with Leonardo was one of the first artists to draw landscapes with the sole intention of representing the natural world. Whereas in Leonardo's landscapes the force of nature is central, Bartolommeo concentrates on the intimate relationship between humans and their natural surroundings, seen in the artist's attention to buildings, farms, small holdings, villas, monasteries and convents within the landscape, which reflect his upbringing in the rural outskirts of Florence and his stays after he became a Dominican novice in 1500 in the country retreat in Pian del Mugnone of the Florentine Dominicans of San Marco.[3]

Despite the innovative subject matter, these landscapes display Bartolommeo's Florentine artistic training in the clear structure (here a play of uprights and diagonals) that unites the individual elements, described purely in pen and ink, by evoking the uniform fall of light.[4] The artist's landscape drawings give the vivid impression of having been drawn *en plein air*. This homogeneous appearance and format strongly suggest that the drawings derive from a sketch book whose bifolios (a single folded sheet divided in two) were split at some point, perhaps when Gabburri made his album, although it is an intervention that could have equally occurred earlier.

On grounds of style this group of landscape drawings is given a date range of 1495 to 1508.[5] The Dominican association accounts for the landscapes' survival since they, along with the other drawings in Bartolommeo's studio at

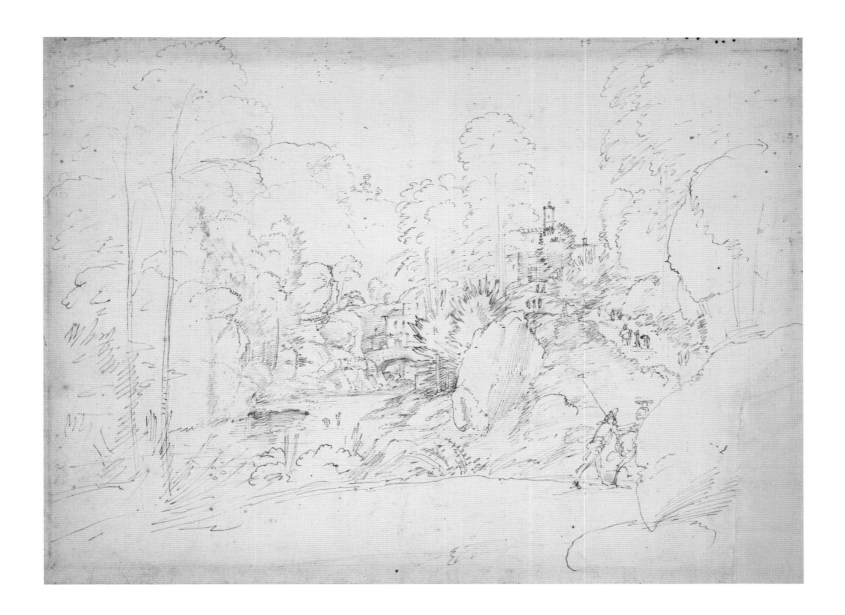

his death, passed to the artist's fellow monk, Fra Paolino da Pistoia, after whose death in 1547 they passed to Suor Plautilla Nelli in the female Dominican convent of S. Caterina da Siena opposite S. Marco.[6] Gabburri acquired the landscapes and the other 600 or so sheets deriving from Bartolommeo's studio in 1725 or 1727, from which he created 'two beautiful and big volumes'[7] (later acquired intact by the Museum Boijmans Van Beuningen, Rotterdam).[8] CG

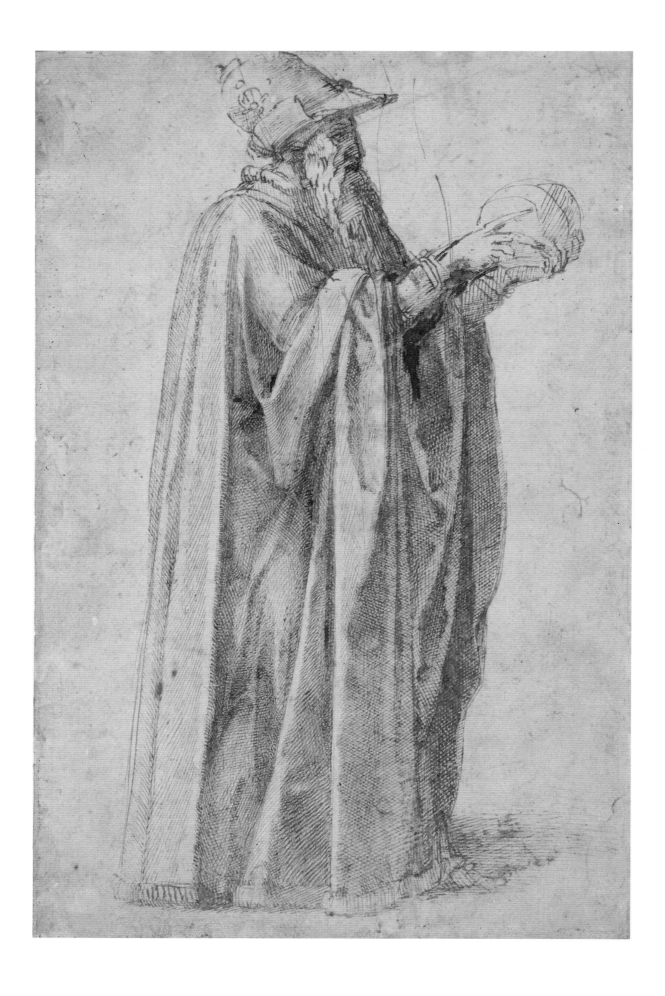

91 An old man wearing a hat (so-called *Philosopher*)

c. 1495–1500

Pen and two shades of brown ink, 33.1 × 21.4 cm
British Museum, London (1895,0915.498.)

PROVENANCE

J.D. Lempereur; B. Constantine; T. Dimsdale; Sir. T. Lawrence (L. 2445); S. Woodburn; Sir J.C. Robinson; J. Malcolm; acquired from Col. J. Wingfield Malcolm, 1895

LITERATURE

Berenson 1938, vol. 2, no. 1522; Tolnay 1943, pp. 67, 179, no. 6 (r.); Tolnay 1945, pp. 137, 202, no. 43 (v.); Wilde 1953, no. 1; Dussler 1959, no. 171; Barocchi 1962, under no. 234; Hartt 1971, no. 21 (r.), no. 245 (v.); Tolnay 1975–80, no. 6; Gere and Turner in New York 1979, no. 1; Sisi in Florence 1985, pp. 20–1; Perrig 1991, pp. 21, 24–5, 67; Hirst in London 1994, p. 16; Chapman in London 2005, no. 5, pp. 56, 58 (r.), 117 (v.)

The subject of this drawing by the young Michelangelo is enigmatic. The scallop badge on the hat identifies the figure as a pilgrim, perhaps St James the Great, whose symbol is the scallop shell and whose shrine was a great site of pilgrimage.[1] This is likely if the object in the figure's hands is taken to be a skull, since St James met his martyrdom through decapitation. The hat is also that of a pilgrim, as is seen, for example, in the much earlier *Journey to Emmaus* by Tommaso da Modena (1325/6–79) (fig. 2).[2] The great twentieth-century scholar Charles de Tolnay identified the subject as an alchemist, owing to its similarity to a figure by Dürer in Vienna.[3] This is possible, given the contemporary interest in alchemy, as shown, for example, by the translations of the mystical Greek writings attributed to Hermes Trismegistus, the *Corpus Hermeticum*, most notably by Marsilio Ficino (1433–99) but also by Ludovico Lazzarelli (1447–1500), whose full-length portrait in the manuscript of his poem *Fasti Christianae Religionis* recalls this drawing.[4]

The lack of iconographic precision may stem from Michelangelo having loosely adapted the figure from one painted by an earlier artist.[5] Michelangelo's main focus seems to be an exploration of how to convey volume by adapting Ghirlandaio's technique of pen cross-hatching (see no. 58).[6] The undulating folds of the cloak are described in finely wrought meshes of pen strokes, with which

Michelangelo evokes the sheen of marble by allowing the bare paper to show through. The artist's concentration on sculptural form resulted in him largely ignoring the body under the cloak, and depicting the garment in an illogical manner (only the raised arms keep the hem level). There is a similar sheet by Michelangelo in the Albertina, Vienna, of a heavily cloaked figure, probably after Masaccio, which also displays the artist's use of two tones of ink, probably less noticeable when first drawn.[7] This suggests that both the London and Vienna drawings date from *c.* 1495–1500.[8]

Michelangelo must have valued this drawing, since he took it with him to Rome and used the blank verso for the study of the head of a young turbaned man at the time of the Sistine Chapel ceiling (1508–12; fig. 1).[9] He first sketched the head in long strokes of the stylus then outlined the head in red chalk,

Fig. 2
Tommaso da Modena, *Journey to Emmaus* (detail), *c.* 1357–65. Detached fresco, Museo Civico di S. Caterina, Treviso.

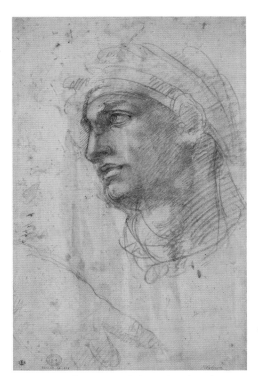

Fig. 1 Verso of no. 91, *Head of a youth and a right hand*, *c.* 1508–10. Black and red chalk, pen and brown ink, over stylus (head); black chalk (hand).

before employing black chalk to describe the outlines rapidly and for the more detailed modelling of the face, revealing the stylus underdrawing in many places (for example around the nostrils and outlining the cheek). The neck was shifted further to the right by extending the broad diagonal lines that create the shading on the right. The profile was adjusted using parallel strokes in pen and ink both to block out the earlier profile and to suggest the background against which the face is seen. This shows Michelangelo's awareness of the need for the head to be seen clearly on a high ceiling. The head is similar to those of the *ignudi*, the elegantly posed nude men, who frame the narrative scenes in the ceiling.[10] To the lower left is a sketch in black chalk of a right hand, drawn to a larger scale than the head; its position on the sheet suggests it postdates the head. The verso gives an idea of the countless lost working drawings Michelangelo must have produced for the Sistine ceiling, not just for executed figures but also for the many inventions that were either discarded or altered. CC

92 Recto: A youth beckoning; and a right leg

c. 1504

Pen and two shades of brown ink; black chalk (leg study), 37.4 × 22.8 cm
Inscribed by the artist: 'barba', 'Ero ig[n]udo or son vestito ogni mal me'; and in a contemporary hand:
'charissimo sa ... chome abiano visto meno' (perhaps the beginning of a letter)

Verso: Eight studies of nude children; a Virgin and Child; and a woman in profile

c. 1504

Leadpoint, some gone over in pen and brown ink; the Virgin and Child in black chalk (?)
Inscribed by the artist: 'lessandro manecti'; and in a contemporary hand: 'chosse de bruges ch..'.
British Museum, London (1887,0502.117)

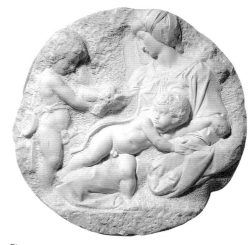

Fig. 1
Michelangelo, *Taddei Tondo, c.* 1503–6.
Marble, diam. 106.8 cm.
The Royal Academy of Arts, London.

PROVENANCE

P. Crozat; P.-J. Mariette (L. 2097); T. Dimsdale (L. 2426); Sir T. Lawrence (L. 2445); S. Woodburn; presented by H. Vaughan, 1887

LITERATURE

Tolnay 1943, pp. 71, 163, 185–7, no. 21 (v.), no. 23 (r.); Wilde 1953, no. 4; Dussler 1959, no. 169; Barocchi 1962, vol. 1, p. 4; Salmi, Tolnay and Barocchi 1964, no. 16; Hartt 1971, no. 4; Tolnay 1974, p. 10; id. 1975–80, vol. 1, no. 48; Turner in London 1986, no. 11; Perrig 1991, p. 27 (as Benvenuto Cellini); Joannides 1994, p. 23; Echinger-Maurach in Florence 1999, no. 72; Joannides 2003, under no. 9; Chapman in London 2005, no. 13, pp. 88, 90 (r. and v.)

Michelangelo's study of antique art began towards the end of the 1480s, while he was an apprentice in the informal academy centred on Lorenzo de' Medici's sculpture garden at S. Marco in Florence, which was looked after by Donatello's former pupil and bronze caster Bertoldo di Giovanni (died 1491).[1] Michelangelo's growing understanding of antique sculpture (particularly of the male nude) is seen in this drawing, which recalls one of the *Horse tamers* on the Quirinal (fig. 2 on p. 119) and most obviously the *Apollo Belvedere* (fig. 37 on p. 59). At the time of Michelangelo's first visit to Rome in 1496, this was displayed at S. Pietro in Vincoli, the residence of Cardinal Giuliano della Rovere, the future Pope Julius II (1443–1513).[2]

The black chalk study of a right leg was drawn first on the sheet. Michelangelo then turned the sheet by 90 degrees to sketch in pen and ink the beckoning figure, a masterly synthesis of an antique prototype and a model from life. Michelangelo drew the torso in outline, before adding the head and neck (revealed by the continuous outer contour of the shoulders beneath) and describing the

musculature of the torso with short parallel and hatched strokes, which give an effect akin to a sculptor's clawed chisel on marble. The artist then readjusted and thickened the contours, seen in his widening of the figure's right hip and his adjustment of the left arm. The hand has been lost by the trimming of the sheet.

Michelangelo substituted the classical equilibrium of the *Apollo* with a graceful yet unstable moving position, emphasized by the rapid curtailing of the lower legs (the left calf immediately adjusted leftwards) and the figure's undrawn right arm. The word '*barba*' (beard) in the artist's hand perhaps suggests Michelangelo's intention to further differentiate this figure from the beardless *Apollo*.[3] The pose would have been unrealizable in marble and indeed was drawn in preparation for a fresco of *The Battle of Cascina*, a famous victory of Florence over Pisa in 1364. The fresco was commissioned for the Salone del Gran Consiglio in the Palazzo Vecchio and, although never realized, Michelangelo produced a cartoon in the years 1503–4, which became what the Florentine sculptor Benvenuto Cellini (1500–71) called the 'school of the world' before being dismembered and lost.[4] A figure in this pose does not appear in copies of the lost cartoon but was probably intended to show a Florentine soldier warning of the approaching enemy. The pose is seen further developed in black chalk on the recto of no. 95, and the motif of the outstretched left arm was to be reused by Michelangelo in the Sistine *Adam*.[5]

The verso contains studies of nude children drawn in pen and ink over leadpoint, with a further now faint sketch, probably in black chalk, of the Virgin and Child in the upper left corner. The extent of the leadpoint under-

drawing was revealed in the recently taken infrared image (fig. 2) that brought to light hitherto invisible, or near invisible, figure studies and details especially in the lower half of the sheet. The infrared proves the studies on the verso were unquestionably made in connection with Michelangelo's unfinished marble sculpture, the Taddei Tondo (fig. 1), since the figure in the centre with a bowl attached to his drapery just above his buttocks (a detail not gone over in pen) is so similar in pose to the Infant Baptist in the relief. The first studies of infants were made in the lower half of the sheet turned upright, with the sculptor concentrating on the figure of the Baptist seen sideways on moving towards his cousin, the Christ Child. Michelangelo explored variant poses of the Baptist stepping forward in an upright position with the left arm outstretched, or more actively bending his upper body forwards. The abbreviated form held by the Baptist in the leadpoint study at the lower left is perhaps a goldfinch, a symbol of Christ's Passion, but it is unclear if this detail is included in the other figures. The female head in profile nearby is perhaps a preliminary idea for the Virgin observing the Baptist in the sculpture. The remaining figures of children, drawn to a slightly larger scale, were executed in the same media with the sheet turned on its side, probably beginning at the right where the central study of the Baptist overlaps two earlier sketches and then continues to the other side by rotating the paper 180 degrees.

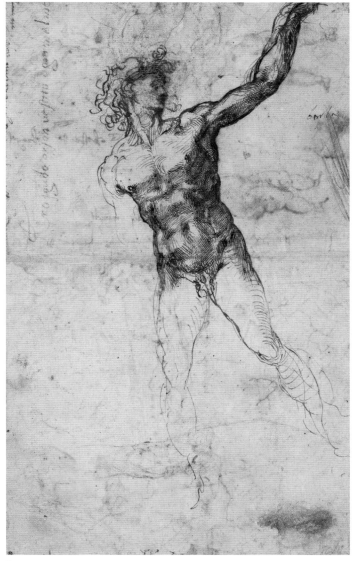

Recto

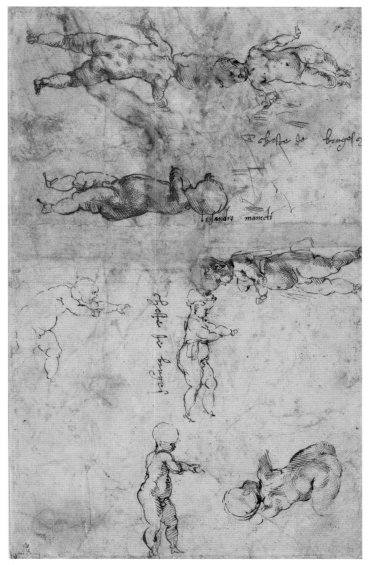

Verso

An inscription in pen and ink, '*chosse de bruges*'
(things of Bruges), refers to Michelangelo's
commission for the *Bruges Madonna* (see
nos 93–4).[6] CC

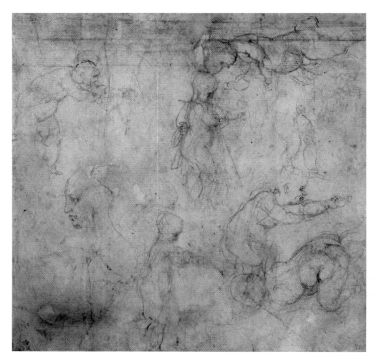

Fig. 2
Infrared reflectograph of
no. 93 verso (detail).

93 Recto: Two standing figures; and a battle scene

c. 1503–4

Pen and brown ink; unconnected lines in black chalk, 18.5 × 18.1 cm
Inscribed by Michelangelo: 'Deus inomine/ tuo salvu[m]me fac' [first verse of Psalm 53];
'[d]olore sta[n]za nell inferno'; 'dol'; 'dio devotame[n]te'; and in a more recent hand: 'Michel Ange'

Verso: Capitals; small studies of figures

c. 1503–4

Pen and brown ink, the capitals over leadpoint
Inscribed by Michelangelo: 'Molti anni fassi qual felicie in una/ brevissima ora si lame[n]ta e dole/ o p[er] famosa o p[er] antica prole/ altri s i[n] lustra e n u[n] mome[n]to i[m]bruna./ Cosa mobil non e che socto el sole/ no[n] vi[n]c[e] morte e cha[n]gi la fortuna'
British Museum, London (1895,09,15.496)

PROVENANCE

J.D. Lempereur (L. 1740); W. Dyce; Sir. J.C. Robinson;
J. Malcolm; acquired from Col. J. Wingfield Malcolm, 1895

LITERATURE

Berenson 1938, no. 1521; Tolnay 1945, vol. 2, pp. 184–5; Wilde 1953, no. 3; Dussler 1959, no. 170; Salmi, Tolnay and Barocchi 1964, no. 11; Berti 1965, vol. 2, pp. 410, 415, n. 23; Hartt 1971, no. 22; Tolnay 1974, pp. 11, 13; id. 1975–80, vol. 1, no. 36; Sisi in Florence 1985, no. 16; Hirst in Washington and Paris 1988, under no. 6; Cordellier 1991, pp. 48–54; Perrig 1991, pp. 19, 30 (as Benvenuto Cellini); Joannides 2003, under no. 5; Chapman in London 2005, no. 15, pp. 75, 94–5 (r.), 73, 95 (v.); Amy 2006, pp. 484–7

The numerous studies on the recto and verso of this sheet display the complex variety of ideas and projects with which Michelangelo was engaged on his return to Florence from Rome in 1501, one of the most productive periods of his career. The sheet is notable for containing on the verso one of Michelangelo's first known poems, four lines from an incomplete sonnet whose last two lines convey his life-long preoccupation with the passage of time and mortality: 'There isn't a moving thing under the sun/ that death does not defeat and fortune change.'[1]

The cavalry battle with the left edge as the bottom was the first study to be drawn on the recto, in a technique of remarkable vitality and increasing brevity as the artist's pen moved from left to right. It is an early idea for the projected *Battle of Cascina* fresco (see also nos 92, 94–5), and displays both Michelangelo's study of Leonardo and his desire to better his elder who was to provide a pendant battle scene to Michelangelo's in the Palazzo Vecchio, also never to be realized.[2]

Michelangelo then turned the sheet by 90 degrees in relation to the battle scene and

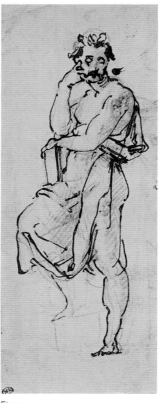

Fig. 1
Michelangelo, *An apostle holding a book*, *c.* 1503–5. Pen and ink over black chalk, 20.1 × 7.8 cm. Musée du Louvre, Paris.

Fig. 2
Verso of no. 93 matched with verso of fig. 1.

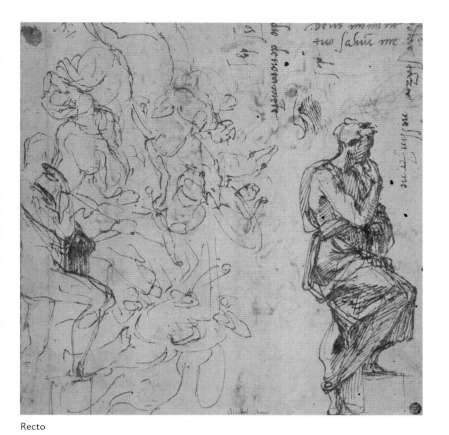

Recto

Verso

quickly drew a nude man on the left edge of the sheet, portions of which have been lost by trimming, but which cannot have extended much further considering the way the figure impinges on the earlier drawing. Michelangelo then sketched the figure to the right in the same pose, over which he added drapery before picking up another sheet also containing *Cascina* studies (no. 94), to repeat the study of the same figure at almost one and a half times the size. This third study on no. 94 is drawn over a still visible initial indication of the underlying body in the same pose as the previous two studies but the drapery is more developed, a long vertical fold falling down the back then looping over the raised right leg.

The studies are for the sculpture of an apostle, one of all 12 apostles commissioned from Michelangelo by the Opera del Duomo (committee of works of Florence Cathedral) in April 1504 after the artist had fulfilled his contract to sculpt the marble *David* of 1501–3. Michelangelo only succeeded in beginning *St Matthew*, for which these studies cannot be preparatory given the great differences in

composition (fig. 2, no. 99).[3] In this sequence of three studies we can trace Michelangelo's evolving conception of a figure to be carved from a rectangular marble block.[4]

It was often thought that these *Apostle* sketches demonstrated Michelangelo's intention to have the apostle's profile as the main view.[5] However a fragment discovered in the Louvre in 1991 shows the same figure from the opposite view, and that the studies on nos 93–4 are therefore for the side view of the sculpture, representing the marble block in depth (fig. 1).[6] The fact that the Louvre fragment was cut from the same piece of paper as no. 93 is clearly demonstrated by the matching of the versos (fig. 2). The Louvre *Apostle* is thus shown to have been drawn at right angles to the *Apostles* in profile on no. 93 recto, in correspondence with the artist's habit of turning the sheet by 90 degrees to begin a fresh study – partly to avoid the distraction of a previous study, and partly to find space on sheets generally tightly packed with drawings.[7] Unlike the profile studies it is drawn over black chalk (which explains the brevity of the lines in pen and ink)

and shows the book upon which the apostle rests his left hand more clearly. It demonstrates the amount of preparatory drawing from a variety of viewpoints that a sculpture required.[8]

The other drawings on the verso display how Michelangelo transforms a Corinthian capital into a grotesque form: the capital drawn with the right edge as the bottom shows the flanking birds with their necks intertwined, whereas the capital drawn with the left edge as the bottom has the birds' tails interlocked, Michelangelo only describing the tail of the bird on the right. The mask and fantastical birds were studied again with the sheet turned 90 degrees clockwise, the head of the bird now on the Louvre fragment. On the right margin of the verso are small outline studies for the Cascina composition, parts of which have been lost by trimming. A similar outline figure on the left margin is the genesis of the central twisting figure seen in both a compositional sketch for *Cascina* in the Uffizi and a highly finished study in the British Museum.[9] CC

94 A male nude and studies for an apostle and for the Virgin and Child; a capital

c. 1503–4

Black chalk (the male nude), leadpoint (Virgin and Child studies, one with five ruled lines), pen and brown ink, 27.3 × 26.2 cm
Gabinetto Disegni e Stampe degli Uffizi, Florence (233 F)

PROVENANCE

Ferri, Disegni di Figura (*c.* 1887); Reale Galleria degli Uffizi (L. 929)

LITERATURE

Berenson 1938, vol. 1, no. 1625; Tolnay 1943, pp. 185, 188, 255; Dussler 1959, no. 488; Barocchi 1962, no. 1; Hirst 1963, pp. 66–9; Barocchi in Florence 1964, no. 5; Forlani Tempesti 1970, p. 82; Hartt 1971, no. 24; Tolnay in Florence 1975, no. 3; Tolnay 1975–80, vol. 1, no. 37; Hirst 1986, pp. 43 ff.; id. 1988, pp. 5, 32–5, 37, 43; id. in Washington and Paris 1988, no. 6; Cordellier 1991, pp. 48, 52; Echinger-Maurach 1991, pp. 69, 305; Théberge in Montreal 1992, no. 1; Florence 1996, no. 22; Echinger-Maurach in Florence 1999, no. 2

Fig. 1
Verso of no. 94, *Lower half of a copy of Donatello's marble sculpture of 'David'*, *c.* 1503–4. Black chalk (or charcoal), heightened with lead white, on paper rubbed with black chalk or charcoal, 26.2 × 27.3 cm.

This sheet is one of Michelangelo's most important working drawings to survive from 1503–4 when he was working on the *Battle of Cascina* cartoon.[1] Like the two British Museum studies (nos 93, 95) to which it is closely related, it shows Michelangelo's habit of using all the available space for studies, often for a variety of projects, with ideas for one flowing into another.

First drawn on the sheet in black chalk is a nude man seen from behind, now much rubbed, in which Michelangelo concentrated on the figure's contours and the modelling of the head and torso in light and shade, in contrast to the *Youth beckoning* (no. 92) where the pen is used for the detailed description of the musculature of the torso. The figure was destined for the unrealized fresco of *The Battle of Cascina*, although like no. 92 it has no direct correspondence in copies of the lost cartoon. It would appear, however, to be the starting point for a similar figure seen in reverse who dresses in haste, as seen in the engraving of 1524 known as *Les grimpeurs* by Agostino Veneziano (*c.* 1490–after 1536) derived from the lost cartoon.[2] The figure was adapted to form a composition of three soldiers studied on a sheet in the British Museum (no. 95), which are some of the earliest surviving examples of Michelangelo's use of black chalk.

The figure standing with his right foot resting on a block follows on from those in no. 93 (where it is discussed in greater detail). To the bottom left is a small study in pen and ink of a male model resting on a support to hold his pose, in all likelihood an early idea for another of the sculpted apostles, given the gracefully restrained pose well suited to the limits imposed by being carved from a marble block. A similar pose is seen in a background nude in Michelangelo's panel painting known as the *Doni Tondo* (1503–4)[3] in the Uffizi, as well as the figure of the Christ Child in the *Bruges Madonna* (see below), showing how the artist adapted poses for different projects.[4]

To the lower right of the sheet is an inventive interpretation of a Corinthian capital, with the birds' beaks tightly pressed and a mask on the abacus above.[5] This capital and those with which it is linked on no. 93 have been implausibly related to Michelangelo's early ideas for Pope Julius II's tomb commissioned in 1505.[6] Wilde suggested they were for the house built by the Opera del Duomo for Michelangelo to produce the apostle sculptures.[7] They seem unlikely decoration for a workshop and more suitable for the niches planned for the *Apostles*.[8]

Distributed around the remaining space on the sheet on the recto are five studies for a sculpture of the Virgin and Child. They are extraordinarily vital, and display Michelangelo's method of studying a motif in a quick succession of small drawings. Three are drawn in leadpoint, with the left edge as the bottom. In the group to the far left Christ has been redrawn in pen slipping down from his mother's lap; the group immediately to the right has been completely redrawn in pen and shows Christ suckling at his mother's breast, the Virgin wearing a headdress and veil. This drawing has five equally spaced horizontal

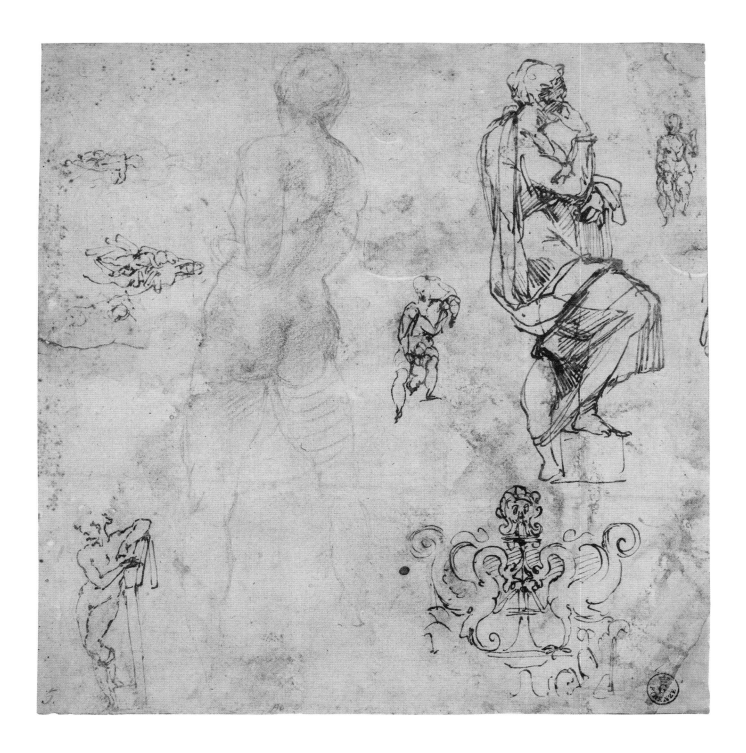

lines drawn in leadpoint to judge the proportions in relation to a marble block, almost certainly for the *Bruges Madonna* (fig. 2, no. 95), for which there is a related study on no. 95 recto, where the commission is discussed further.[9] To the right of this is another group with only the child redrawn. In the same direction as the larger studies are two more small sketches of the same subject in pen and ink, perhaps also over leadpoint.[10]

Drawn on the verso in black chalk on paper rubbed with the same medium and with white highlights (discoloured) is the lower half of a copy from Donatello's life-sized early marble sculpture of *David* (fig. 1).[11] It testifies to Michelangelo's direct observation of his predecessor's works, and was perhaps made in preparation for his lost bronze *David*, cast in early 1503.[12] It is drawn at right angles to the main studies on the recto and demonstrates

that the sheet must originally have extended considerably in the direction (corresponding to the right edge of the recto, along which there are the cut lines of a lost drawing). The examination of the verso in preparation for this exhibition excludes the idea that it is a separate sheet of paper stuck down on to the recto.[13] CC

95 Recto: A group of three nude men; and the Virgin and Child

c. 1503–4

Black chalk (nude men); pen and brown ink over leadpoint (Virgin and Child), 31.5 × 27.7 cm

Verso: Two putti; a nude; a left leg

c. 1503–4 (ILLUSTRATED ON P. 299)

Black chalk (the man), pen and brown ink over leadpoint (the putti), pen and brown ink
(the left leg and the quatrain), leadpoint (the fragments of verse)
Inscribed by Michelangelo: 'Amicho'; 'Sol io arde[n]do all'ombra mi rima[n]go/ qua[n]d el sol de suo razi el
mo[n]do spogla [*sic*]/ ogni altro p[er] piaciere p[er] doglia/ prostrato in terra mi lame[n]to e pia[n]gho';
'...ch[e] febo alle ... nora/ ... ti del suo uago e bel sogiorno/ ... do all ombra mi refugi el giorno/ del suo lume
le cha[m]pagnie mora/ ... doue sia d una mie dolora/ ... mo ... discolora'
British Museum, London (1859,0625.564)

PROVENANCE

B. Buontalenti; Casa Buonarroti; acquired from
M. Buonarroti, 1859

LITERATURE

Berenson 1938, vol. 2, no. 1479; Tolnay 1943, nos 15–16
(r. and v.), pp. 187–8; Wilde 1953, no. 5; Dussler 1959,
no. 162; Hartt 1971, no. 27; Salvini 1971, p. 137; Tolnay
1975–80, vol. 1, no. 46; Gere and Turner in New York
1979, no. 2; Hirst 1986, pp. 43–9; id. 1988, pp. 27, 33–4, 43;
Perrig 1991, p. 26 (as Benvenuto Cellini); Oberhuber 1992,
pp. 39–41; Hirst in London 1994, no. 20; Joannides 2003,
under no. 9; Chapman in London 2005, no. 14, pp. 75 (r.),
90–91 (r. and v.)

Vasari describes how Michelangelo in old age
burnt a great number of his drawings, so that
his oeuvre would appear 'nothing less than
perfect', and no one would see the way 'he toiled
and stimulated his creativity'.[1] This sheet and
the others to which it is related in this catalogue
are just the type of working drawings that
Michelangelo did not want others to see – and
indeed very few survive, not just through
destruction at the artist's own hand but due to
the inevitable results of dispersal and wear of
such fragile objects. Unlike no. 91, this drawing
would appear to have remained in Florence,
where it was acquired by the British Museum
directly from Michelangelo's descendants in
the nineteenth century.[2]

The group of three soldiers for the *Battle
of Cascina* was the first to be drawn, in black
chalk, on the recto. The same group is studied
on the verso, although only the right-hand
figure is complete due both to the trimming
of the sheet, which has cut the middle figure
from the torso upwards, and the abbreviated
description of the left-hand nude, whose head
and right shoulder are just visible. The right-
hand figure on the verso is very explorative,

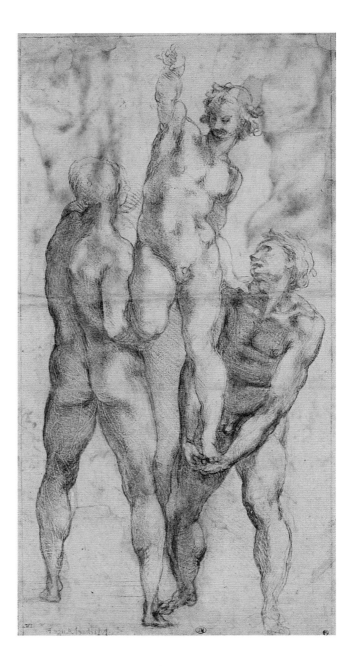

Fig. 1
Michelangelo, *Two nude men
lifting a third*, *c.* 1503–4. Black
chalk over stylus, 33.4 × 17.4 cm.
Musée du Louvre, Paris.

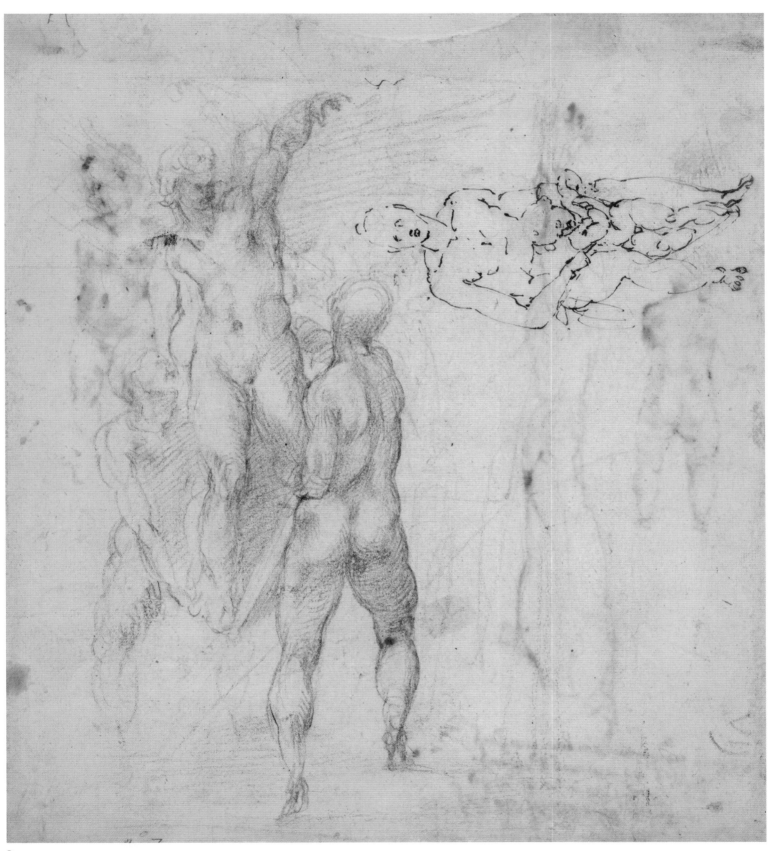

Recto

Fig. 2
Michelangelo, *Bruges Madonna*, 1503–4/5.
Marble, h. 128 cm. Church of Notre Dame, Bruges.

Fig. 3
Infrared reflectograph of no. 95 recto
showing lead point underdrawing.

with various outlines and the legs shifted considerably. The same figure is studied again on a similar scale but with fewer changes of mind in no. 94. The figure is included on the right-hand side of the nude group studied on a smaller scale on the recto of no. 95, which is of greater finish and modelled using blended strokes of the chalk.[3]

The recto group is related to a subsequent and more finished drawing in black chalk over stylus in the Louvre; it is in reverse and is known as the 'acrobats', since the centre nude is raised up by his companions pointing towards the approaching enemy (fig. 1).[4] The gesture derives from the antique sculpture of the *Apollo Belvedere* (see no. 92), but in the present sheet is subject to Michelangelo's usual reconfiguration, adjusted further to the left to arrive at the solution of the Louvre drawing with the arm considerably foreshortened.[5] The exploratory stage of the group on no. 95 recto is seen in the way the cupped hands of the left-hand figure do not meet the foot of the sentry he hoists (he has been interpreted as drying his foot, the soldiers having been surprised while bathing, yet his left leg is

lightly indicated below).[6] The ungainly quality of the 'acrobats' is probably the reason they were dropped from the completed cartoon, as near contemporary copies of the lost work do not show it.[7]

Drawn at right angles to the earlier *Cascina* study is a study in pen and ink for the *Bruges Madonna* (fig. 2), over an initial sketch in leadpoint (fig. 3) showing Christ's left arm in a different position. The model's torso shows Michelangelo's usual practice of substituting a man for a woman. It represents a stage beyond that of the quick sequence of small studies on no. 94 (also drawn on a sheet of *Cascina* studies) in which mother and child are described only in outline, occasionally broken as the artist followed the underdrawing, with the oblong format related to the shape of the marble block.[8] The *Bruges Madonna* was the only sculpture that Michelangelo succeeded in completing during this period, and it was quickly dispatched to Bruges, the home town of the commissioning Mouscron brothers, wealthy Flemish cloth merchants, accounting for the hazy knowledge of it among his contemporary biographers.[9]

On the verso with the sheet inverted, and partly over the earlier *Cascina* study, is a rapid anatomical study of a left leg, drawn with long pen strokes to describe the bones beneath the skin. The autograph four lines above were written by Michelangelo in the same medium. The poem conveys the notion that evening brings rest to all but the lovesick, an idea borrowed from the Florentine poet Petrarch whose poems, along with those of his compatriot Dante, Michelangelo is said to have known almost entirely by heart.[10] To the left are a further six lines of verse in leadpoint, now barely legible.[11] These lines are among the earliest examples of Michelangelo's work as a poet, a creative form that in common with drawing offered a conduit for him to express his most private feelings.

Drawn to either side of these earlier drawings are two studies in pen and ink of the same child, seen from the front and rear. They are considered to be in sequence with those on no. 92 verso for the *Taddei Tondo*, with which they share an almost identical technique.[12] In the same ink to the top right are trials of the pen and the word, '*Amicho*' (friend). CC

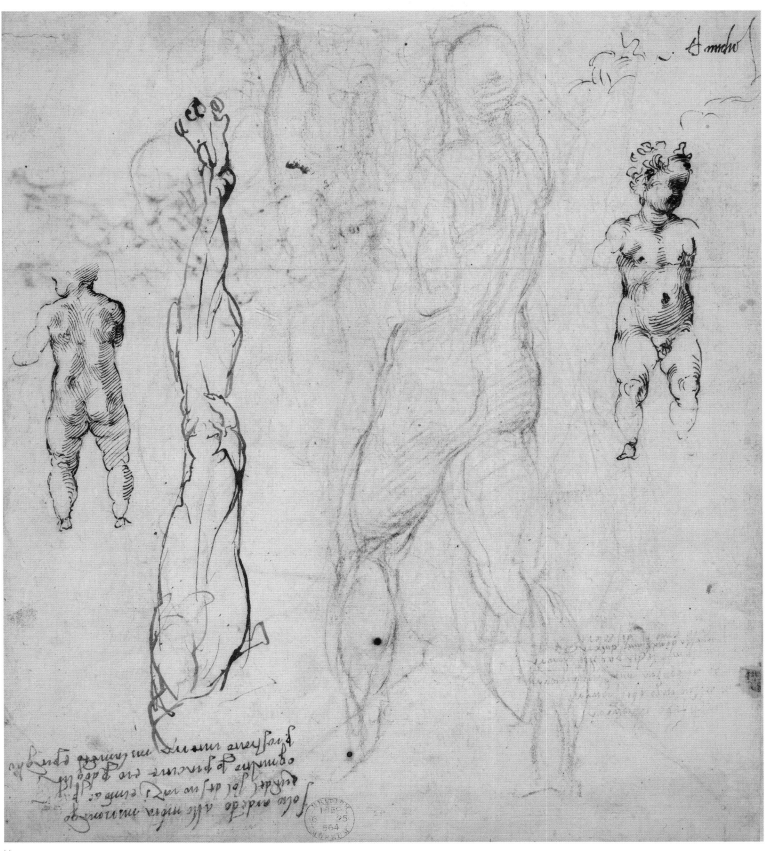

Verso

96 Head of a woman; and four faint studies of heads in the margin by a childish hand

c. 1502–3

Silverpoint, on a warm white preparation,[1] 25.7 × 19 cm
British Museum, London (1895,0915.611)

PROVENANCE

J.-B. Wicar (?); W.Y. Ottley; Sir T. Lawrence (L. 2445);
William II, King of the Netherlands; Revd Dr H. Wellesley;
J. Addington; J. Malcolm; acquired from Col. J. Wingfield
Malcolm, 1895

LITERATURE

Pouncey and Gere 1962, no. 3; Gere and Turner in London
1983, no. 18; Joannides 1983, no. 35; Knab, Mitsch and
Oberhuber 1983, no. 69

This is a study for the head of the Virgin in Raphael's painting of around 1502–3 in the Norton Simon Museum, Pasadena (fig. 1).[2] It exemplifies Raphael's precocious skill as a draughtsman as he was probably no more than 20 when he made it. Already apparent is his gift for abstraction, seen in the drawing's lucid harmony created through the rhythmical play of geometrical forms. The oval of the head is echoed in the form of the brooch and the downward direction of the gaze reinforced by

Fig. 1
Raphael, *Madonna and Child*, c. 1502–3. Oil on panel, 55.2 × 40 cm. Norton Simon Museum, Pasadena.

a descending sequence of curves, beginning with her parted hair and continued in the shape of her eyes, nose, mouth and chin. Raphael's emphasis on establishing the underlying structure is apparent from the way in which the contours of the jaw and neck have been gone over so that they stand out. The description of the features is similarly emphatic, with greater pressure exerted on the metalpoint to make areas of shadow beneath the nose and mouth. These darker accents contrast with the soft evenness of touch in the minimal modelling in parallel and some cross-hatching on the woman's face and neck. Comparison with the finished work shows only a few minor adjustments. These include the veil moved slightly forward, covering her left ear and showing less of her hair. In addition, the Virgin's brooch is smaller and is a different shape.

The downward look of the Virgin and the sense of thoughtful reverie conveyed through her slightly pursed lips are vital elements in the painting's narrative. Not unusually for a devotional painting of this subject, Raphael's depiction alludes to Christ's future sacrifice.[3] The awareness of both protagonists as to their fate is signified by the Book of Hours, open so that the first lines of the mid-afternoon prayer (*Nones*) can just be made out.[4] This identifies the time of day in which the painting is set, registered in the long shadows of the trees, and more importantly it signifies that the Christ Child has just read the prayers that commemorate his crucifixion and death at this hour.

The painting dates from the period when Pietro Perugino's influence was at its strongest. The timing and nature of the association between the two artists is much contested; nonetheless it is evident that Raphael had access to Perugino's workshop in Perugia and quickly assimilated his style.[5] Raphael's choice of silverpoint to make a detailed study of this kind may have been inspired by Perugino's example, as can be seen by comparison with no. 47. Although Raphael made one study from a posed male figure for the Virgin's pose, such

Fig. 2
Infrared reflectograph of no. 96 verso showing detail of leadpoint figure.

is the abstracted perfection of the woman's features in the present work it seems unlikely that he was drawing from a model.[6]

On the verso there is a black chalk study, the head gone over in pen, of a young man, which is generally agreed to be too feeble to be by Raphael. However, infrared imaging has revealed a hitherto unnoticed sketch in leadpoint of a seated female figure in the upper right of the sheet (fig. 2). The geometrical simplification of the form is paralleled in numerous other drawings by Raphael (as in no. 98), and it is likely that this faint study is a very early idea for the pose of the Norton Simon Virgin. The figure is shown three-quarter length, as in a subsequent life study of the pose in silverpoint in the Palais des Beaux-Arts, Lille, with her gaze directed towards her raised left arm intended to hold the book, while her right arm is positioned to support her infant as in the finished painting.[7] HC

97 Cartoon for St George

c. 1504–5 (ILLUSTRATED ON P.305)

Pen and brown ink, over black chalk, the contours of the
figures pricked for transfer, 26.5 × 26.7 cm
Gabinetto Disegni e Stampe degli Uffizi, Florence (530 E)

PROVENANCE

Fondo Mediceo (Nota 1687); Reale Galleria degli
Uffizi (L. 930)

LITERATURE

Petrioli Tofani 1972, no. 41; Ferino Pagden in Florence
1982, no. 59; Joannides 1983, no. 62; Knab, Mitsch and
Oberhuber 1983, no. 126; Ferino Pagden in Florence 1984,
no. 9 (in drawing section); Bambach 1999a, pp. 97, 298

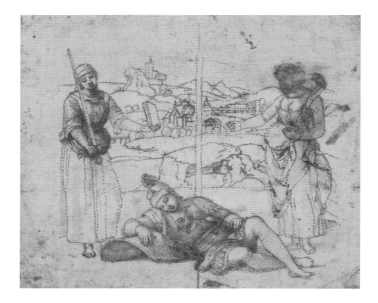

Fig. 1
Raphael, *Cartoon for the Vision of
the Knight*, *c.* 1504. Pen and brown
ink over stylus, the outlines pricked,
18.3 × 21.5 cm. British Museum,
London.

This is a cartoon for the main figures in
Raphael's *St George*, painted *c.* 1504–5 (Louvre,
Paris; fig. 3).[1] The painting was probably
commissioned, along with a *St Michael*, also
now in the Louvre, to celebrate the investiture
of Duke Guidobaldo da Montefeltro of Urbino
and his adopted heir Francesco Maria della
Rovere into the chivalric royal orders of France
and England in 1503–4.[2] George's status as the
patron saint of England made the subject an
appropriate one to honour Henry VII's award
of the Order of the Garter to Guidobaldo in
1504.[3] Raphael added a classical note through a
reference to the marble *Dioscuri* in Rome in the
pose of the saint's horse (see fig. 1 on p. 119).
The closeness of the quotation suggests he
had seen the sculpture on an undocumented
trip to the city.[4]

Raphael began the drawing by outlining
the figures in black chalk. Traces of the under-
drawing are most visible around the dragon's
front legs. The pen drawing over the chalk is
remarkably crisp and purposeful with varied
hatching, cross-hatching and inked-in areas
for deep pools of shadow used to describe the
forms. The left edge of the panel is indicated
by a vertical line; the corresponding one on
the other side is missing as the sheet has been
slightly trimmed. The only significant change
of mind is to George's cloak, with a fold added
so that the saint's face would stand out against
the dark cloth. The emphasis on establishing
sculptural volume through hatching is reminis-
cent of contemporaneous pen drawings by
Michelangelo (see nos 92–3). This suggests that
Michelangelo, who was notoriously reluctant
to show his drawings, may have made an excep-
tion for Raphael, whose relative youth and

provincial artistic training may have led the
sculptor to disregard him as a potential rival.[5]

The Uffizi drawing gives an insight into
Raphael's meticulous preparation for his
production of small-scale courtly paintings.
The fact that it does not include the landscape
background, as is found in the cartoon in
the British Museum for another of Raphael's
private commissions of the period, the *Vision
of a Knight* in the National Gallery, London
(*c.* 1504; fig. 1), does not exclude it from being
the cartoon for the Louvre painting. Raphael
sometimes painted his landscapes freehand,
as he did in *The Procession of Calvary* of *c.* 1504
in the National Gallery, in which infrared
reflectography shows that only the figures
have underdrawing derived from a cartoon,
and he may have done the same for the Louvre
work.[6] In order to transfer the design of the
St George, either to prepare a cartoon including
a landscape or to the panel of the Louvre
painting, the main outlines of the saint and
the two animals were pricked with a pin. This
was a laborious process and for this reason,
along with the need to simplify the design to
ensure its legibility, much of the finer detail

of the modelling was omitted. The only
indication of the background was a pricked
horizon line just above the saint's waist. The
pricked drawing would then have been pounced,
the process whereby chalk or charcoal dust
was rubbed through the holes to leave a dotted
outline on the surface below. Traces of the
pouncing can be seen through a microscope
in the holes on the recto. A smudged area of
chalk around the dragon's head on the verso
shows that it was also pounced (fig. 2), but
as the image is the reverse of that in the
painting the copying of this detail probably
occurred later.[7]

Even after making such a detailed drawing
Raphael continued to make small adjustments
to the figures, such as the addition of a bridle
and reins to the horse and a broken lance in the
foreground; the transformation of the curved
rear part of the saddle into part of the saint's
armour; and the alteration of the saint's expres-
sion by closing his mouth. An X-radiograph
of the panel shows that he continued to make
revisions as he painted, including a shift in
the position of the horse's head and the
elimination of a bridge on the left.[8] HC

Fig. 2
Verso of no. 97 showing pricked
outlines with area of black chalk
pouncing.

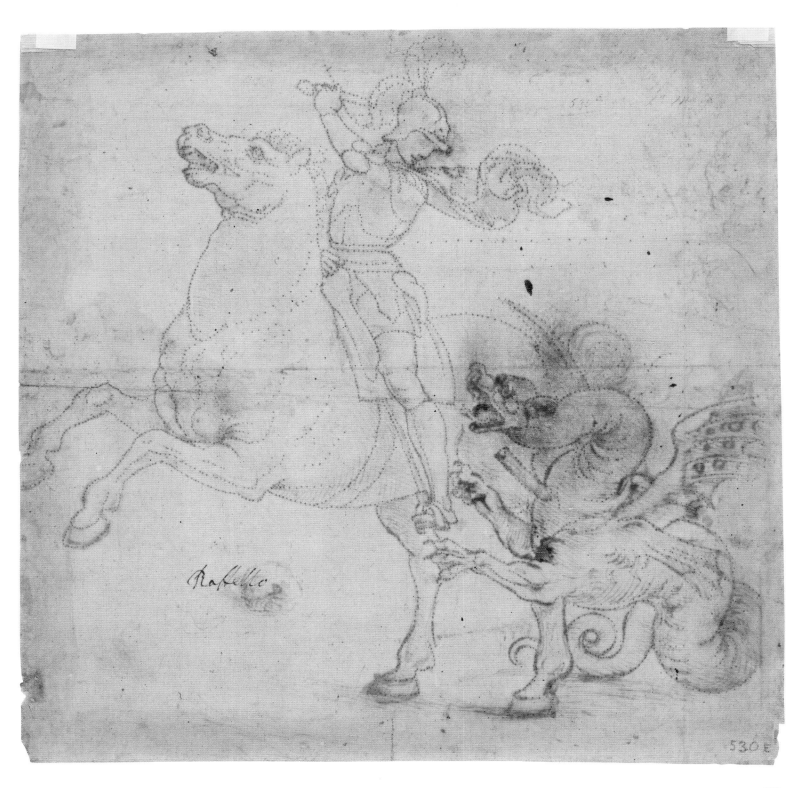

Fig. 3
Raphael, *St George, c.* 1504–5.
Oil on panel, 30.7 × 26.8 cm.
Musée du Louvre, Paris.

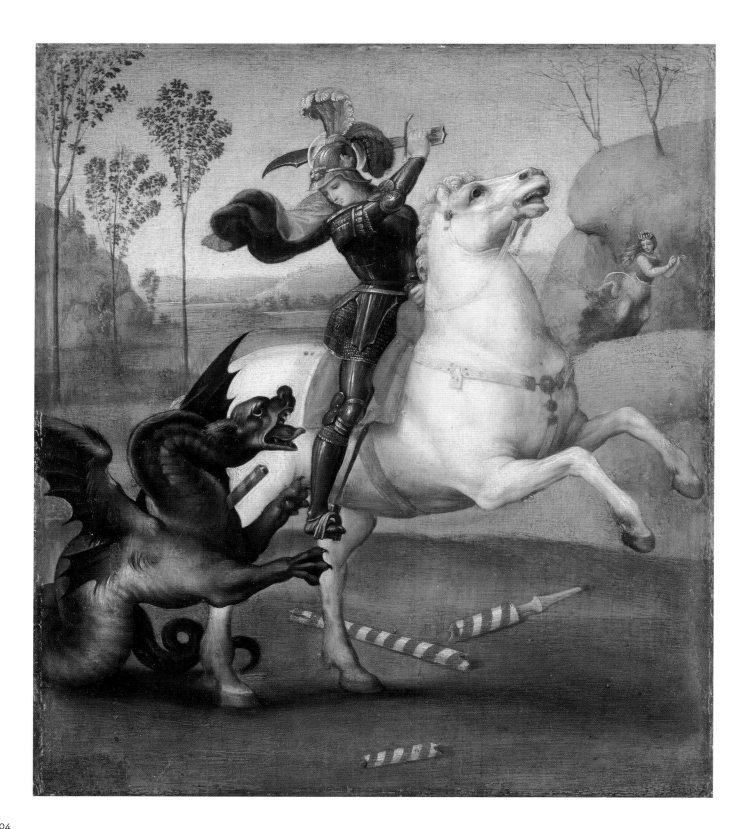

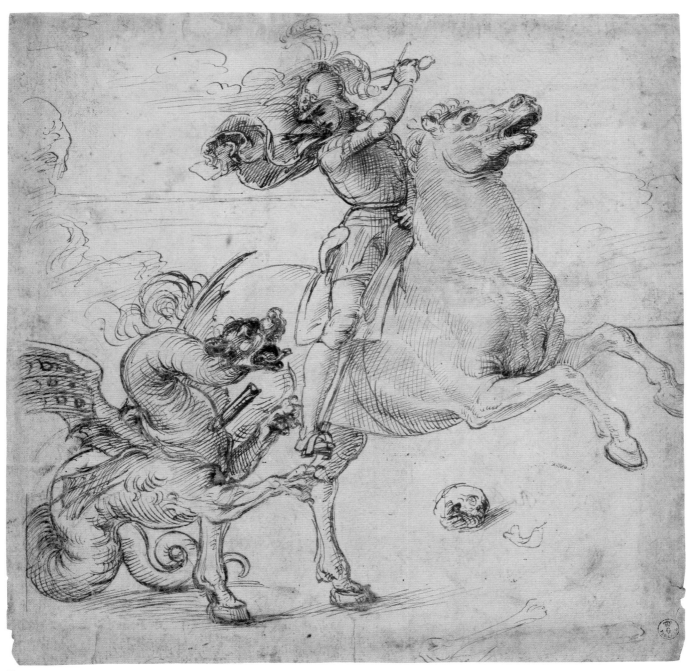

Recto

305

98 Studies of the Virgin and Child

c. 1506–7

Pen and brown ink, over traces of red chalk, 25. 3 × 18.3 cm
British Museum, London (Ff,1.36)

PROVENANCE

A. Pond; C.M. Cracherode Bequest, 1799

LITERATURE

Pouncey and Gere 1962, no. 19; Gere and Turner in
London 1983, no. 84; Joannides 1983, no. 180; Knab,
Mitsch and Oberhuber 1983, no. 161; Rosand 2002,
pp. 112–17; Chapman in London 2004, no. 63

Raphael's free-flowing explorations in pen of a single theme are inspired by Leonardo's 'brainstorming' drawings like nos 51–2 executed some 30 years earlier. The responsiveness of the pen made it the ideal medium for rapid, high-tempo studies of this kind, where the action of drawing at speed served as catalyst for fresh invention as the lines on the page suggested new variations to explore. The importance of keeping the pen moving is why Raphael adopted Leonardo's way of amending a pose in a welter of lines, which are sometimes so dense that the original one is almost obliterated. Where Raphael diverges from Leonardo's example is the way in which his figures are generated through intersecting segmental curves, rather than the angular contours of the Florentine's work. This highlights a more profound difference between the two in terms of their source of inspiration: Raphael's art was underpinned by his innate feel for abstract geometrical forms, whereas Leonardo's was fuelled by naturalistic observation that bubbles through even his most impromptu drawing in the vividness of a gesture or expression.

Raphael took up this method of drawing because it was an ideal means of formulating ideas for a series of paintings of the Virgin and Child made as devotional works in the years 1504 to 1508, spent largely in Florence. Leonardo's graphic musings of this kind rarely went any further, but the practically minded Raphael was not so profligate and almost all of the studies on this sheet can, with varying degrees of certainty, be associated with paintings. The study at the lower centre is the one most closely linked to a painting, the poses of the two figures being repeated with slight variation in the *Bridgewater Madonna* of *c.* 1507

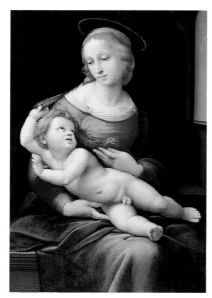

Fig. 1
Raphael, *The Virgin and Child* (*The Bridgewater Madonna*), *c.* 1507. Oil on wood transferred to canvas, 81 × 56 cm. Duke of Sutherland Collection, on loan to the National Gallery of Scotland, Edinburgh.

in the Duke of Sutherland's collection (fig. 1).[1] Raphael derived the twisting pose of the Infant Christ from his counterpart in Michelangelo's unfinished marble relief of around 1503–4, then in the collection of his patron, the Florentine patrician, Taddeo Taddei, and now in the Royal Academy of Arts, London (fig. 2, no. 92).

Raphael's sensitivity to the expressive variations of the Virgin and Child theme through minimal adjustment to their positions is well demonstrated by the study immediately to the right of the main one. The pose of the Virgin in this is almost identical to the one below it, but the baby no longer thrusts himself across her lap and is instead cradled in a manner that recalls the *Pietà*. A somewhat similar arrangement of the two figures is found the *Colonna Madonna* of *c.* 1507–8 in the Gemäldegalerie Berlin, although in the painting Christ is more upright and his mother is seated facing to the left holding an open book in her left hand.[2] The study at the top with the Christ Child held at shoulder height by the Virgin may have served

as a starting point for the *Small Cowper Madonna* of *c.* 1505–6 in the National Gallery of Art, Washington.[3] The bond between mother and son is underlined further in the study immediately to the right where the heads of the two figures touch and Christ reaches out to embrace the Virgin. This motif had a particular resonance in Florence because it was explored in reliefs in varying media by Donatello, the best known of which is the marble *Pazzi Madonna* of 1422, now in the Bode Museum, Berlin. The Virgin and Child appear in comparable positions, but again reversed from those in the drawing, in Raphael's *Tempi Madonna* of *c.* 1507–8 (Alte Pinakothek, Munich).[4]

Investigation undertaken for this exhibition has revealed that Raphael continued his exploration of the motif on the verso of the drawing obscured by an old backing sheet.[5] In a hitherto unseen red chalk drawing, first detected by infrared reflectography, the artist studied the Virgin looking down towards her son, who reclines on her lap and gazes upwards at her (fig. 2).[6] HC

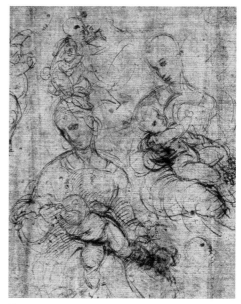

Fig. 2
Verso of no. 98 as seen from the recto when placed on a lightbox.

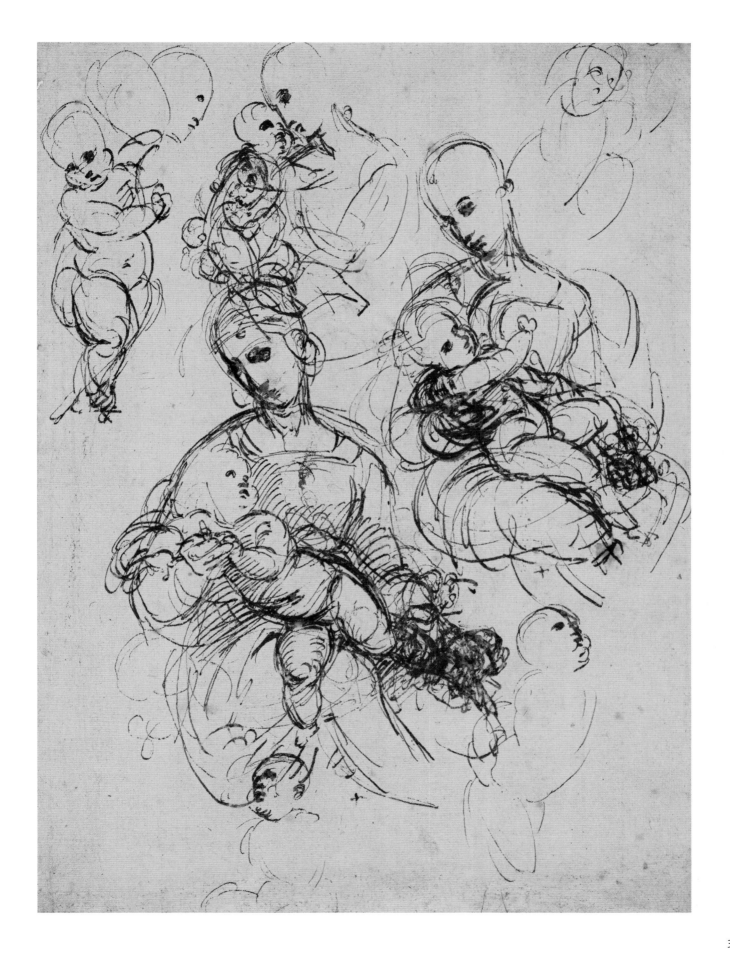

99 Recto: The Entombment

c. 1506

Pen and brown ink, over black chalk and stylus, 22.8 × 31.8 cm
Inscribed in an old hand: 'Raffello'

Verso: Bearded man

c. 1506 (ILLUSTRATED ON P. 311)

Pen and brown ink, British Museum, London (1855,0214.1)

PROVENANCE

P. Crozat (?); Marquis de Lagoy (L. 1710); T. Dimsdale
(L. 2426); Sir T. Lawrence (L. 2445); William II, King of
the Netherlands; presented by C. Hall (L. 551), 1855

LITERATURE

Pouncey and Gere 1962, no. 12; Gere and Turner in
London 1983, no. 78; Joannides 1983, no. 133; Knab,
Mitsch and Oberhuber 1983, no. 199; Chapman in
London 2004, no. 71

The recto is a study for the *Entombment* dated
1507 (fig. 1), painted for the Baglioni chapel in
the church of S. Francesco al Prato in Perugia,
and now in the Villa Borghese, Rome.[1] This
drawing, along with the following one from
the Uffizi (no. 100), are among the last in the
sequence of 16 preparatory studies that docu-
ment the evolution of the work from a static,
meditative Lamentation to one in which there
is an emphasis on movement and dramatic
expression.[2] The care that Raphael lavished
on the design reflects the significance of the
commission for the young artist. The patron,
Atalanta Baglioni, came from one of the
leading families in Perugia; moreover the
chapel was directly opposite another that
housed one of Raphael's finest and most
Peruginesque paintings, *The Coronation of
the Virgin*, painted around 1503, now in the
Vatican Pinacoteca. The church also contained
several altarpieces by Perugino.[3] The Baglione
commission was therefore an opportunity
for Raphael to demonstrate his development
beyond Perugino to a thoroughly modern
style inspired by Leonardo, Michelangelo and
other Florentine masters. As it turned out it
was to be Raphael's last painting for Perugia
before his move to Rome, but in 1505 when
he received the commission he may well have
imagined that the Umbrian city would remain
a lucrative source of patronage, as it had done
for Perugino.

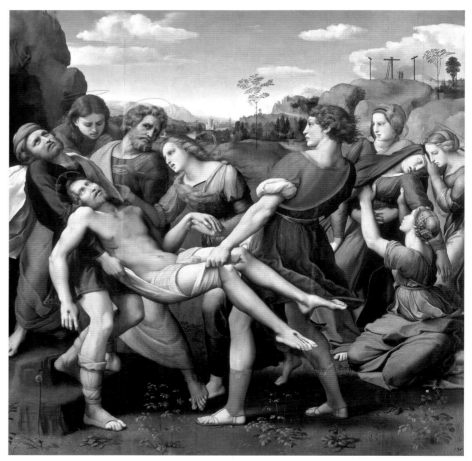

Fig. 1
Raphael, *The Entombment*, 1507. Oil on panel,
184 × 176 cm. Villa Borghese, Rome.

This drawing marks Raphael's decision
to change the altarpiece's subject from a
Lamentation to the related, but intrinsically
more active, one of the transportation of
Christ's body to the tomb. This narrative
shift enabled Raphael to introduce a greater
degree of the dynamism inspired by Florentine
and classical models, while at the same time
heightening the emotional tenor.[4] The fact that
the work's emotive force depends principally
on the depiction of the suffering of the women
who loved Christ has a particular resonance
due to the circumstances surrounding its
commission. The *Entombment* was an altarpiece
for a funerary chapel for Atalanta's son,
Grifonetto, whom she had witnessed being
murdered in a family feud in 1500, and where
she too was to be laid to rest in 1509.[5]

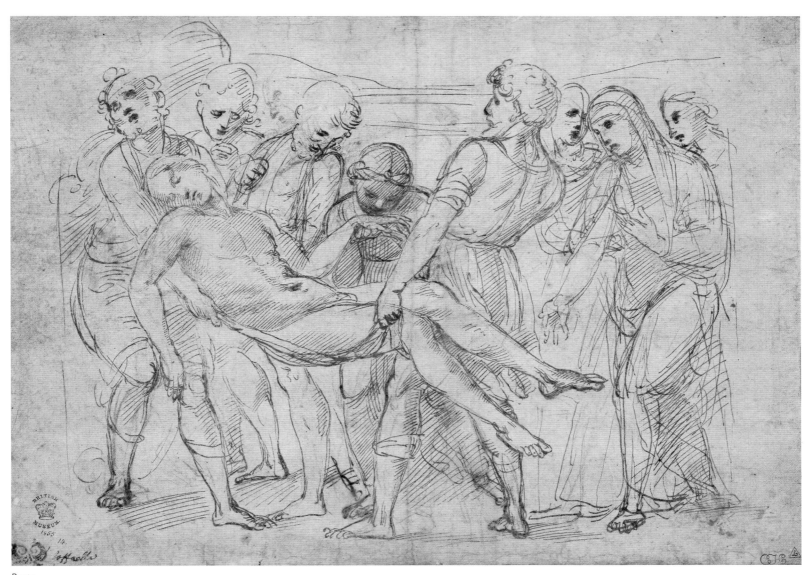

Recto

The black chalk outlines of the figures are drawn over a preliminary, and now barely discernible, sketch in stylus. The black chalk was then gone over with pen and ink and can only be seen in passages where Raphael changed his mind, most notably in the adjustment of the position of the head of the bearer to the left of the Magdalene kissing Christ's hand. Fitting nine figures, divided into two separate groups, into an almost square panel required considerable ingenuity, and Raphael kept in mind the space he had to play with by indicating roughly in broken vertical pen lines the composition's lateral limits as he had done earlier with the *St George* (no. 97).[6] The drawing's design has an emphatic leftward movement built around the two bearers carrying Christ's body to the tomb, a motif modelled on classical reliefs of Meleager, and reinforced by the motion towards them by the Magdalene in the centre and the Virgin on the right. In the painting Raphael achieved a more balanced design through the self-contained group of women around the fainting Virgin Mary, who anchor the right-hand side.

The drawing has the look of having been executed at speed, with staccato parallel hatching used to summarily indicate the lighting, and the artist crossing out in a flurry of pen strokes, rather than stopping to correct, the awkwardly positioned right leg of the Virgin. Raphael's urgency to put down the essentials of the design can also be seen in the unfinished state of the woman's head on the far right and the pared-down description of the Virgin's other female attendant. In spite of the rapidity of execution Raphael was able, with an extraordinary economy of means, to impart in the protagonists' features some idea of their physical, in the case of the left-hand bearer straining to carry the body, or emotional state, as with St John's doleful gaze downwards to the corpse being carried past him on the left.

The alteration in pen to the head of the bearer to the right of St John was retained in the painting. The change may well have been inspired by Michelangelo's unfinished statue of

Fig. 2
Michelangelo, *St Matthew*, 1506.
Marble, h. 216 cm.
Galleria dell'Accademia, Florence.

St Matthew now in the Galleria dell'Accademia in Florence (fig. 2). The marble statue, intended for Florence Cathedral, is now known to have been executed during Michelangelo's brief stay in Florence between April and November 1506 and left unfinished when he departed for Bologna.[7] Raphael's interest in the unfinished marble is clear from his drawing of it on the verso. This is not a straight copy as he adjusted certain details of the sculpture, adding greater facial expression to the barely blocked-out head; changing the rope-like drapery that leaves the torso uncovered to a more regular classical tunic; and moving the left leg to a more frontal position. The verso almost certainly dates from the same time as Raphael's work on the *Entombment*, because in one of the preparatory studies for the painting he experimented with using a variant of the marble's pose for one of the bearers.[8] Although in the painting the influence of Michelangelo's *St Matthew* is more muted, the study on the verso makes clear how Raphael used drawing to analyse and absorb the Florentine's work.[9]

HC

Verso

100 The Entombment

c. 1506

Pen and brown ink, over black chalk, squared in stylus and red chalk, and then pen and ink,
the head and right shoulder of the leftmost bearer pricked,[1] 29 × 29.7 cm
Gabinetto Disegni e Stampe degli Uffizi, Florence (538 E)

PROVENANCE

Fondo Mediceo (Nota 1687); Reale Galleria degli
Uffizi (L. 930)

LITERATURE

Ferino Pagden in Florence 1982, no. 63; Joannides 1983,
no. 62; Knab, Mitsch and Oberhuber 1983, no. 202;
Ferino Pagden in Florence 1984, no. 11 (in drawing
section); Bambach 1999a, p. 122

Fig. 1
Infrared reflectograph of fig. 1, no. 99 (detail)
showing traces of squaring.

This is the last in the sequence of studies for the Borghese *Entombment* of 1507 (see fig. 1, no. 99); for details of the commission see the previous entry. The sheet has been squared twice. The grid of red chalk and stylus 2.8 cm squares precedes the pen and black chalk, while the slightly smaller (2.4 cm) squaring in pen and ink was drawn over the figures. The function of the first grid in red chalk was to facilitate the copying and probably the enlargement of the group from an earlier and, in view of the unusually large size of the Uffizi sheet, most likely smaller-scale study. The purpose of the squaring in pen was to allow Raphael to copy the finished drawing on an enlarged scale, either to a cartoon or on to the panel itself.[2] The recent discovery of squaring in the underdrawing of the *Entombment* suggests that Raphael might have copied squared drawings such as this one directly on the panel (fig. 1). This contradicts Giorgio Vasari's account in the second (1568) edition of his *Lives of the Artists* that Raphael created a cartoon for the painting in Florence.[3]

The influence of Raphael's time in Florence is undeniable in the present study, with his use of Michelangelo-inspired cross-hatching (compare no. 92). Raphael's reason for adopting this way of drawing was arguably driven more by practical considerations than a wish simply to emulate the sculptor. The use of cross-hatching with minimal emphasis on outline constrained him to focus on the overall compositional effect, with a particular regard for the lighting. The artist's determination in this regard is highlighted by his pared-down description of Christ's head almost without outline. The stringent simplification of form

is only relaxed in the description of the two women, where something of Raphael's familiar style can be seen in the detailing of costume, and the repeated curving strokes that define their contours.

The squaring on the sheet shows it has been slightly trimmed at the top (the top level of red squares is truncated) but not at the sides. This signifies that a separate study must have been made of the Virgin Mary and her attendants. Raphael's unusual decision to divide the composition might be due to the diverse nature of the two figure groups that required studies of a differing approach and style. The figures in the foreground of the painting stand in a narrow relief-like space around Christ's supine form, their shapes silhouetted against the background. The Holy Women, by contrast, form a much more three-dimensional, interlocking group. The method of drawing adopted in the Uffizi sheet would not have been suitable for studying the Holy Women. This is clear from the difficulty of making out the right wrist and hand of the Magdalene, the young woman

in the centre who reaches forward to touch Christ's head and hand for the last time before his body is placed in the tomb. The limitations of using hatching alone to describe form explain why Raphael did not draw like this again, preferring for finished drawings of a comparable function to use a combination of cross-hatching and more linear modelling or pen and wash.[4]

Comparison with the painting shows that Raphael made many adjustments of costume, expression and pose. The most significant of these is the suppression of the Holy Woman behind the Magdalene, which occurred at an advanced stage with the figure covered over by a knoll and a slender tree. This change also entailed transferring the suppressed figure's turning pose to the rearmost Holy Woman so as to link the two groups.[5] That Raphael was willing to make such alterations after an exhaustive process of preparatory study is an indication of his unrelenting search for improvement. HC

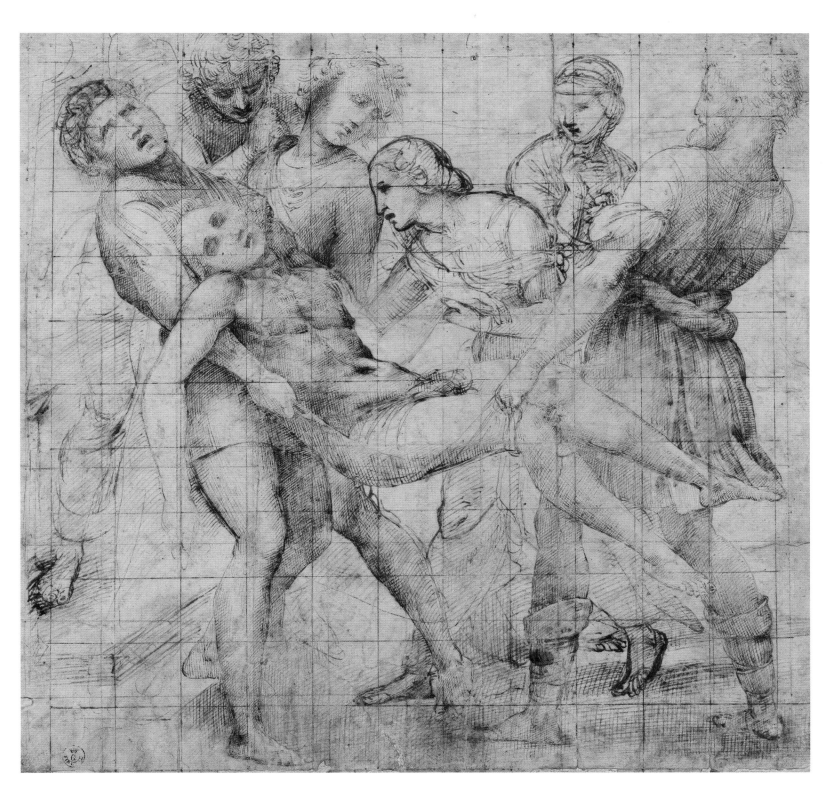

313

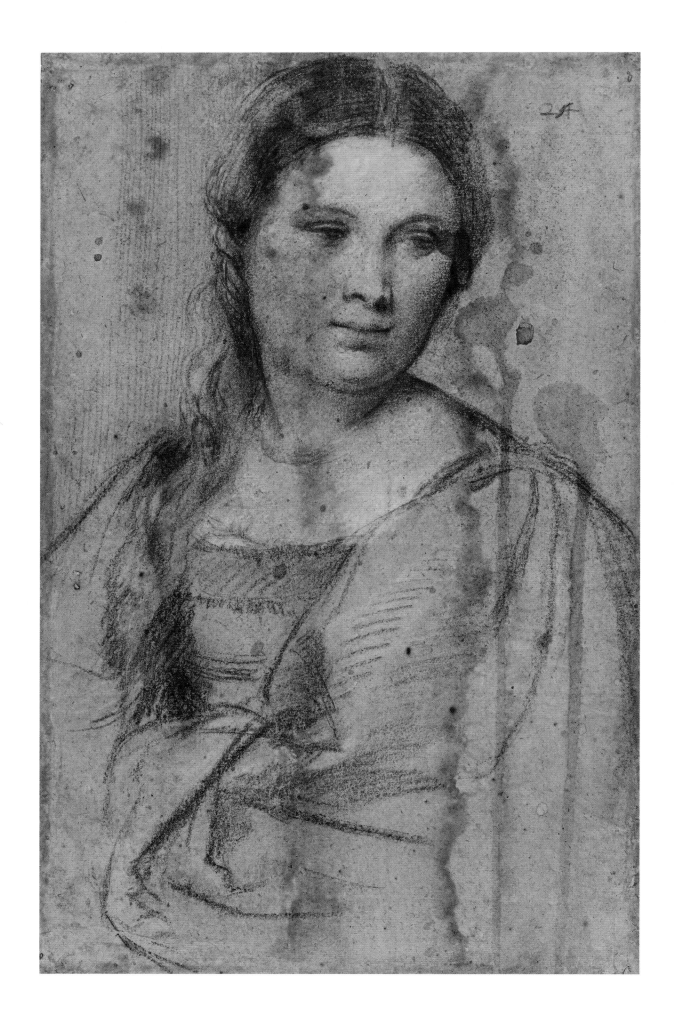

314

TITIAN (c. ?1485/90–1576)

101 Portrait of a young woman in profile to the right

c. 1510–15

Black and white chalk, on faded blue paper, 41.8 × 26.5 cm
Inscribed in an old hand: 'Tiziano Vecellio: 24', corrected to '25'
Gabinetto Disegni e Stampe degli Uffizi, Florence (718 E)

PROVENANCE

Ferri, Disegni Esposti (1879–1881); Reale Galleria degli
Uffizi (L. 930)

LITERATURE

Hadeln 1924, pp. 47–8; Frölich-Bum 1928, n. 7, p. 195;
Popham in London 1931, no. 262; Tietze and Tietze-
Conrat 1944, no. A 1899 (as Romanino); Pallucchini 1969,
vol. 1, p. 330; Wethey 1971, no. 114; Rearick in Florence
1976, no. 16; Pignatti 1977, p. 168; Petrioli Tofani 1986,
pp. 313–14; Wethey 1987, no. 23; Chiari Moretto Wiel
1989, no. 8; Joannides 2001, p. 212; Rearick 2001,
pp. 40–41.

This remarkably large drawing is justly
considered a masterpiece from early in Titian's
career. It depicts a young woman turned in
three-quarter profile whose fleshy attractive-
ness is accentuated by the undulating tresses
that gather over her right shoulder, and then
fall over her right breast where they appear
lighter, perhaps interwoven with a veil.[1] The
black chalk has a soft, crumbly quality that
reveals the texture of the paper over which it is
drawn, and this is exploited by Titian to great
effect in his description of the soft outline of
the woman's face and her vaguely melancholic
gaze downwards, complimented by the barely
indicated lips that form a pensive smile. The
atmospheric chiaroscuro of the chalk veils the
contours it describes with velvety intensity,
especially in the woman's left shoulder, now
seen against a stained and yellowed paper
whose original blue is better judged from the
rarely exposed verso (fig. 1). The woman's
bodice is only sketchily indicated although
her skin is described with (now faded) white
heightening, also employed on her broad fore-
head and around her eyes, nose and mouth.

Titian's pictorial conception of drawing is
seen in the intense chromatic effects favoured
over linear precision, and the warm enveloping
light, both of which give a sense of the
woman's interior mood as well as her physical
presence. It is a rare surviving example of a
portrait drawing by a Venetian artist from the
Renaissance and one of the very few drawings
to survive by Titian's hand. It displays the

growing contemporary interest in portraiture
and should be understood as an autonomous
work of art rather than as preparatory to a
painting.[2] Titian's blurring of the distinctions
between painting and drawing is shown by his
practice of sketching the initial composition
for a painting directly on the support in black
chalk.[3] The recto has often been compared with
Titian's oil portrait of a woman known as *La
Schiavona* (fig. 2) from around 1510–12, in the
National Gallery, London, with which it has
many similarities including the style of dress.[4]
A prodigious number of portraits would issue
from Titian's studio during the course of his
career, not just of alluringly portrayed women
but of male sitters including popes and
cardinals, emperors and doges.

Fig. 2
Titian, *Portrait of a woman (la Schiavona)*,
c. 1510–12. Oil on canvas, 119.4 × 96.5 cm.
National Gallery, London.

The verso bears a drawing of a young
woman in black chalk whose very summary
nature and damage by damp explains its critical
neglect until noted by W. R. Rearick in 1976.
The woman portrayed would seem the same as
the recto with a similarly plump chin, although
turned to the left, and thus making it impossible
to judge whether it preceded or followed the
recto. Rearick related the study to the second
woman from the right in the fresco dated 1511
of the *Miracle of the Speaking Child* in the Scuola
del Santo, Padua.[5] A closer analogy perhaps is
with the marble relief portrait depicted in *La
Schiavona*. The first documented ascription of
this sheet to Titian was by P. N. Ferri in 1881
and this has with justification endured, despite
occasional opinions to the contrary.[6] CG

Fig. 1
Verso of no. 101, *Study of a woman seen in three-
quarters profile to the left, c.* 1510–15. Black chalk,
on blue paper.

NOTES TO CATALOGUE ENTRIES

1

1 The attribution was suggested by Luciano Bellosi in Florence 1978. The attribution to the Master of the Bambino Vispo of a drawing in Düsseldorf (see Degenhart and Schmitt 1968, vol. 1–2, no. 195 is rejected in the 1978 catalogue entry).

2 For the identification of the artist see Van Waadenoijen 1974, 1983 and Syre 1979.

3 For the dating and reconstruction of the altarpiece see Gordon 2003, pp. 364–74.

4 The 'X-shaped' decussate cross, which later became common in representations of St Andrews was not frequently adopted by 15th-century Florentine artists. The saint is, for example, shown holding a normal cross in Lorenzo Monaco's San Benedetto altarpiece in the National Gallery, London (illustrated as fig. 1, no. 4) and in Masaccio's panel from the Pisa altarpiece in the J. Paul Getty Museum, Los Angeles.

5 A similar arrangement of figures on the page, albeit without the ruled lines, is found in a dismembered album of pen studies thought by Degenhart and Schmitt to be Umbrian, c. 1375–1400 (op. cit., vol. 1–1, nos 68–73), but which is perhaps more likely to be Tuscan, c. 1400; see Elen 1995, no. 5, for the attribution and location of these works.

2

1 1855,0811.91 verso.

2 The number of animal drawings may also to some degree be due to unequal patterns of survival. They transcended stylistic changes, and thus retained their usefulness to later artists, whereas figure studies were more likely to be judged outmoded and therefore discarded.

3 For Mitchell as a collector see Stephen Coppel's essay in Houston 1996, pp. 159–68.

4 All the drawings are illustrated in Schmitt 1997.

5 Elen 1995, no. 3, and Scheller 1995 provide an extensive bibliography on the Bergamo album.

6 See Van Tuyll van Serooskerken 2000, nos 2–3.

3

1 The episode on the recto is from John 4:1–28 and on the verso John 9:1–7.

2 Vasari mentions Galante da Bologna in his biography of Lippo di Dalmasio, Vasari 1966, vol. 2, p. 300.

3 Although the mount is described as Vasari's by Popham and Pouncey (1950), in his 1946 article, the latter had described it more circumspectly as 'an architectural border similar in style to those which frame drawings known to have come from Vasari's celebrated *Libro de disegni*. The mount is accepted as from the *Libro* by Ragghianti Collobi (1974, vol. 1, p. 32; vol. 2, figs 19–20), but it is listed under Simone Martini. She suggests that the Galante attribution was added later to a blank Vasari cartouche. If it is not from the *Libro* it absolves Vasari from having misidentified such a clearly Sienese drawing as Bolognese.

4

1 Gordon 2003, pp. 162–87.

2 An argument in favour of the London painting post-dating the Uffizi one is given in Thomas 1995, pp. 214–20.

3 A similar red-chalk ground is found in two albums by Pisanello in the Louvre; see Paris 1996, pp. 457–62.

4 Bellini in Florence 1978 identifies him as St Paul, but this cannot be right as he is beardless and the object he holds seems to be a staff, not a sword, with a hook at the end of it rather like the one at the top of St Lawrence's flagstaff. The hook at the end looks a little like the end of a sword, but this is due to it abutting part of the saint's halo.

5 The fullest comparison of the two works and their chronology is given by Gordon 2003, pp. 181–2.

6 For this see Eisenberg 1989, pp. 143–4.

7 Degenhart and Schmitt's suggestion in their entry on the drawing that the verso was drawn with a reed pen seems unlikely, as passages such as the saint's curls would be impossible to achieve with such an inflexible

4 As was first observed by Pouncey in his 1946 article on the drawing.

5 Davies and Gordon 2001, p. 18, pl. 15.

6 Jaffé 1994, vol. 1, no. 147.

7 The most extensive discussion of the drawings' function is Ames-Lewis's article (1992b). He argued that they were probably preparatory for panel painting because their technique was like that recommended by Cennino Cennini for the underdrawing of such paintings. This went against Millard Meiss's observation (Tintori and Meiss 1967, pp. 28–9) that panels in this upright format were rare and it was more likely that they were for a fresco cycle like the one in the Collegiata, San Gimignano, traditionally attributed to Barna da Siena. Although comparable New Testament narrative panels do exist, like Simone Martini's Antwerp or Orsini polyptych (Martindale 1988, pp. 171–3, pls X–XIII), it seems more likely in view of the chronological gap between Christ's miracles shown in the British Museum and his Passion at Chatsworth that they belong to a larger cycle treating his life.

8 For example, Sano di Pietro's *Christ and the woman of Samaria* in the predella of the 1478 Assumption altarpiece now in the Pinacoteca Nazionale, Siena (Torriti 1977, nos 259–60).

9 The attribution to Lippo Vanni was first suggested by Meiss (1955, pp. 137–42), while Andrea di Bartolo's name was proposed by Lawrence Kanter in his unsigned entry in the Matthiesen Fine Art Ltd catalogue, *Gold Backs 1250–1480,* London, 1996, p. 124. In recent correspondence Kanter has suggested that the drawings date from the first decade of the 15th century, the same period as Andrea's *Madonna and Child* in the Brooklyn Museum triptych. Degenhart and Schmitt (1968, vol. 1–1) thought a drawing in the Uffizi (22 E; their no. 107) was by the same hand, but this is more likely Florentine (see Bellini in Florence 1978, no. 3).

nib. Broad, inky lines can be made by using the outer edge of a quill pen.

8 For example in his *Verification of St Francis's Stigmata* in the Galleria Pallavicini, Rome; see Eisenberg 1989, fig. 191.

9 Although Melli's analysis of the recto differs slightly from mine, I should acknowledge my debt to her entry in Florence 2006a. The other accepted drawings by the artist, namely a double-sided sheet in Berlin and manuscript underdrawings (see Florence 2006a, pp. 230–1, 285–91), are of little help in resolving this question because they are so much more finished.

5

1 For the number of drawings see Zucker 1981, n. 5, p. 438. The total given here omits the *Standing saint reading* sold at Colnaghi's in 1971 as it is a modern fake; see Hebborn 1991, pp. 321–7, fig. 83.

2 The Uffizi drawings with the Baldinucci inscription include Degenhart and Schmitt 1968, vol. 1–2, nos 206–7, 215, 217, 219.

3 In Ferri 1890 summary catalogue of the Uffizi drawings, pp. 141–3.

4 Degenhart and Schmitt 1968, vol. 1–2, no. 202.

5 The two figures are identified by Degenhart and Schmitt in their entry (1968) as Peter and Paul but there seem to be no firm grounds for this. The object held by the left-hand saint could be a scroll rather than a key, and the right-hand one is perhaps more likely an evangelist with a quill in one hand and a book in the other.

6

1 Colvin wrote 'attribution doubtful' above the hand-written entry for the drawing in the interleaved departmental copy of the second (Robinson 1876) edition of the Malcolm catalogue. The drawing must have been acquired by Malcolm between 1876 and his death in 1893, but it is not mentioned in Malcolm's typed list of prices paid for works in his collection.

2 Degenhart and Schmitt 1968, vol. 1–2, no. 221.

3 The fresco is illustrated as fig. 3 on p. 429 in Zucker 1981.

4 Vasari 1971, vol. 3, p. 113.

7

1 For an account of the changes in attribution see Karet 2002.

2 Degenhart first put the drawings together in his entry on Stefano in Thieme-Becker, vol. 31, 1937, pp. 526–30.

3 Karet 2002, no. 11.

4 Karet 2002, nos 1, 3–6, 8, 11.

8

1 Herald 1981, pp. 53–6, 127–33.
2 The portraits of Sigismund are in the Louvre; see Cordellier in Paris 1996, nos 49–50.
3 An additional reason for dating it to this decade is the costume, which is like that shown in Rabbi Jacob ben Asher's illuminations in the 1435 Mantuan manuscript of the *Quattro ordine* (Vatican Library) and in Domenico Veneziano's *Adoration of the Magi* tondo in the Gemäldegalerie, Berlin from the late 1430s, although it should be said that similar clothes are found in illuminations in the Bible of Borso d'Este (Biblioteca Estense, Modena) from the second half of the 1450s.
4 Probably the best comparison was provided by the Louvre (1996) and National Gallery (2001) Pisanello exhibitions, where the drawing could be seen in close proximity to the exquisite drawing of a falconer in the Institut Néerlandais, Paris, now generally agreed to be by a close follower of the artist; for this see London 2001, p. 75. The volumetric quality of the present work is matched neither in the Paris drawing nor in other workshop drawings like those in the so-called *Taccuino di viaggio* (Travel sketchbook); see Degenhart and Schmitt 2004, vol. 3–2.
5 For the drawings of horses see Verona 1996, nos 58–65.
6 The Louvre drawing is no. 70 in Paris 1996; the medal is reproduced in colour in London 2001, p. 1.
7 The Louvre drawing (inv. 2275), along with other related costume studies, is discussed by Cordellier in Paris 1996, nos 60–8.
8 Such as the *Fall of Phaeton* made as a gift by Michelangelo for Tommaso de' Cavalieri in the early 1530s and now in the Royal Collection at Windsor Castle; Popham and Wilde 1949, no. 430.

9

1 This connection was first made by Campbell Dodgson (1894, pp. 259–60); previously the drawing had been attributed to the Florentine artist Andrea del Castagno, on the basis of his having painted Florentine traitors hanging by one foot.
2 An exhaustive guide to scholarly opinion on this subject and a full bibliography is given by Cordellier in his entries in the Paris 1996 and Verona 1996 Pisanello exhibition catalogues (see notes 3, 4). A small schematic drawing of a gibbet on a sheet of studies in the Louvre (inv. 2368; no. 194 in the Paris 1996 exhibition) has also sometimes been associated with the S. Anastasia fresco.
3 No. 152 in Paris 1996 and no. 41 in Verona 1996 Pisanello exhibitions.
4 No. 42 in Verona 1996 Pisanello exhibition.
5 This follows Degenhart and Schmitt's assessment, although I am not persuaded that the present drawing is the earliest in the sequence.
6 The description of the woman as a dwarf was first made by Luke Syson in London 2001.

10

1 Vasari 1971, vol. 3, p. 269. On Fra Angelico as a miniaturist, see Scudieri, 'Frate Giovanni Angelico da Fiesole … eccellente pittore e miniatore …', in Florence 2007a, pp. 12–24.
2 The exceptions are Pope-Hennessy (1952, p. 205), who attributed it to Zanobi Strozzi, subsequently giving it to Fra Angelico (1974, p. 235); and Grassi (1960, no. 21).
3 Museo di San Marco, Florence. Gradual no. 558, c. 33 v; see Florence 2007a, pp. 58–9, no. I/1.
4 Palladino in New York 2005, no. 25.

11

1 The exceptions are Morelli (1892, col. 443), who considered it a fake, and Dalli Regoli (1960), who gave the sheet to the circle of Lippi.
2 GDSU, inv. no. 673 E verso; Ruda 1993, no. D7, pls 191, 390.
3 Berenson's attribution to Lippi's assistant Fra Diamante (c. 1430–c. 1498) was followed by Pittaluga 1949, p. 207; Dalli Regoli placed it in the circle of Lippi (1960, pp. 200–2).
4 Ruda 1993, p. 331 and Goldner in New York 1997, no. 2.
5 Id., pl. 172; Holmes 1999, figs 145, 183.

12

1 Ruda 1993, cat. 61, pls 136–7.
2 Id., pp. 336–7, cat. DW4
3 See for example Sandro Botticelli's *Madonna and Child with two angels* (1468–9), in Galleria di Capodimonte, Naples; Paris 2003, no. 29.
4 For the iconography of the painting see Aronberg Lavin 1981; Ruda 1993, pp. 245–51.
5 Matthew 13:45–6.
6 Inv. 8350. This link was suggested by Ruda 1993, pp. 339–40, pl. 124.

13

1 The sheet was attributed to Bonfigli by Ferri (1881a, p. 21), noting the link with the Perugia fresco; Berenson (1932, pp. 91–101) first recognized Gozzoli's hand. On the attribution of the sheet see Dillon in Florence 1992, no. 10.5 and Mencarelli in Perugia 1996, no. 11.
2 For the dating of the sheet and its relationship to the fresco see Mencarelli, 'Gli affreschi della cappella dei Priori', in Perugia 1996, pp. 71–85.
3 Galleria Nazionale dell'Umbria, Perugia, Santi 1985, no. 2.
4 For Gozzoli's career see Padoa Rizzo 2003.
5 For the perspective lines in stylus and the conservation of the sheet see Melli 2000.
6 Padoa Rizzo 2003, pp. 99–128.

14

1 On the *Dioscuri* see Bober and Rubenstein 1986 no. 125; Nesselrath 1988, pp. 196–8; R. Roani, 'Ancient Models and their Derivations: The Dioscuri', in Athens 2003, vol. 1, p. 127.
2 Melli 2009, pp. 68–9; id. in Montefalco 2002, no. 21.
3 Ames-Lewis 2003, p. 38. On this topic see Fusco 1982 and Forlani Tempesti 1994.
4 Alberti (Malle ed.) 1950, pp. 99, 109.

15

1 Roccasecca (2000) denies that this is a 15th-century drawing; id. in Florence 2001, no. VI.1.2.
2 Inv. 1757A; Florence 1978, no. 77.
3 Vasari 1971, vol. 3, pp. 62–3.
4 Parronchi 1964.
5 Vasari 1971, vol. 3, p. 258.

16

1 The consensus that the pen lines were added later is challenged by Röthlisberger (1956, p. 359), who states that Bellini planned them to be in this medium from the outset. Degenhart and Schmitt (1990, vol. 2–5, p. 245) concur with this view, except for two pages

(62, 85) that they believe were overdrawn by another hand.
2 Eisler 1989, Appendix E, p. 532.
3 'El libro grande in carta bombasina de disegni de stil de piombo fu de man de Jacomo Bellino'; Morelli 1884, p. 220.
4 See Cicogna 1853, vol. 6, pp. 756–8.
5 Röthlisberger (1956) and Elen (1995) conclusively scotched the casual collection theory first proposed by Fröhlich-Bum (1916) and developed by Tietze and Tietze-Conrat (1944, pp. 106–110).
6 For the codicological analysis of the album see Elen in Eisler 1989 and in Elen 1995, pp. 427–63.
7 Degenhart and Schmitt (1990, vol. 2–5, p. 248) believe that the ink and wash additions are by Jacopo and the differences are due to stylistic changes over the decade-long period of execution.
8 Eisler 1989, Appendix E (documents and dates), p. 533.
9 As was first noted by Röthlisberger (1956, p. 360).
10 Like the lance held by the figure in 1855,0811.35 recto; there are other examples where the continuation of a figure looks to have happened when Jacopo made the left-hand extension, such as the rear quarters of the horse on the verso of 1855,0811.52.
11 1855,0811.33 verso and 1855,0811.34 recto.
12 1855,0811.76 verso.
13 A concise overview of this question is provided in Elen's excellent entry (1995).
14 The relationship was first noted by Robertson (1981, p. 15).
15 Christiane Joost-Gaugier (1974, p. 31) describes the London album as a 'kind of de luxe picture book'. In her opinion the Paris volume served the same function. Degenhart and Schmitt (1990, vol. 2–5, p. 238) see the albums as autonomous works in which the artist experimented freely with ideas.
16 For Bellini's perspective see Joost-Gaugier 1975, pp. 1–16.
17 1995,0506.7; see London 1998b.
18 Eisler 1989, Appendix E, p. 531.
19 Cordellier 1995, doc. 61, pp. 134–40.
20 Joost-Gaugier (1975, pp. 19–23) suggests that some of the non-biblical narratives Bellini used may have been inspired by contemporary literature.
21 Eisler 1989, figs 49–51.
22 Eisler's suggestion (1989, p. 98) that Giovanni, Gentile and other assistants had a hand in the left-hand pages should be discounted. Degenhart and Schmitt (1990, vol. 2–5, p. 248) believe that the London album was executed over a ten-year period.
23 'It is reasonable to assume that the London volume may have served as a kind of sketch-book for the more precious and elaborate Paris book'; Röthlisberger 1956, p. 364.
24 For the links between Giovanni Bellini and St Francis see K. Christiansen, 'Giovanni Bellini e la maniera devota', in Toscano and Valcanover 2004, pp. 123–53.

17, 18

1 Nos 24–30 in Boston and London 2005. I should acknowledge that this entry draws heavily on the excellent entry in that publication. The Isabella Stewart Gardner drawing is no. 32.
2 Meyer zur Capellen 1985, fig. 39, reproduces examples of Gentile's signature, but it is difficult to compare handwriting of such different types.
3 Ibid. nos D.3, D.5–D.6, figs 67–74.
4 For details on the artist see Boston and London 2005, pp. 126–7. The attribution to him was advanced by Maria Andaloro (1980) and Julian Raby (1991).
5 Chong in Boston and London 2005, p. 122.
6 Such as Pisanello's double-sided drawing in Chicago Art Institute (1961,331) and London 2005, p. 122.
7 His costume can be compared to the representation

of a janissary dated 1581 in Melchior Lorck's series of woodcuts, based on his journey to Constantinople in the second half of the 1550s (BM,1871,0812.4594).

8 The authors of the Boston and London catalogue (2005, p. 101) compare it to hats worn by women belonging to the Druse sect recorded in 19th-century anthropological photographs.

9 Scarpellini and Silvestrelli 2004, fig. 57.

19

1 For the accuracy of de' Barbari's view, see Schulz 1978.

2 A similar combination is found in the representation of the Piazzetta in the Circle of Lorenzo Bastiani painting of *The arrival of a dignitary* in the Museo Correr, Venice; Fortini Brown 1988, pl. 101.

3 *Procession in the Piazza San Marco* (1496), *The Miracle of the Bridge at San Lorenzo* (1500) and *The Miraculous healing of Pietro de' Ludovici* (c. 1501); Meyer zur Capellen 1985, nos A 19–A 21.

4 Ibid., doc. 39. Benozzo Gozzoli's *Siege of Perugia* study (no. 13) is an earlier example of an urban topographical view.

5 Ibid. nos D3, 5.

6 Brown and Lorenzoni 1996, p. 280; the documents relating to Gentile's involvement in this project are given by Meyer zur Capellen (1985, pp. 113–14).

20

1 Mantegna's depiction is derived from the 13th-century account given in da Varagine, 1990, vol. 1, p. 413.

2 An old copy in pen and ink in the Louvre (inv. RF 1870-525) shows that the original sheet has been cut down to the right: Ekserdjian in London and New York 1992, p. 135, under no. 11. The verso of a drawing by Marco Zoppo in the British Museum (1995,0506.7) is an original response to the fresco (Chapman in London 1998b, no. 8).

3 Fiocco 1933, p. 186; id. 1937, fig. 171; Mezzetti in Mantua 1961, no. 129; Heinemann 1962, p. 188 (reproduces the Louvre copy in error, pl. 143); Tietze and Tietze-Conrat 1944, p. 74 and no. A296 (Mantegna); Rearick in Paris 1993, p. 276 (Bellini).

4 Colvin 1911–12, no. 26, hypothetically by Donatello.

5 An example is in Musée des Beaux-Arts, Rennes, inv. 794.1.2501; a detailed entry by Patrick Ramade with bibliography is in Modena and Rennes 1990, no. 2.

6 Witness the underdrawing of Mantegna's St Zeno panel; see Verona 2006, fig. 4, p. 26; fig. 1, p. 66.

7 Ames-Lewis 1992a, pp. 268–71; Landau 1994, p. 177; Landau and Parshall 1994, pp. 65 ff. The extent of Mantegna's involvement in printmaking is the subject of much debate (denied by Syson 2009, pp. 526–35).

8 Inv. 345, recto.

9 Inv. WAG 1995.324: exhibited Verona 2006, no. 8.

10 Inv. 147, recto. De Nicolò Salmazo in Verona 2006, no. 10 (c. 1460); Faietti 2006, p. 81; Mazzotta in Paris 2008, no. 43.

11 Inv. 1985.100. Lightbown 1986, no. 178.

12 Inv. 1909, 0406.3, recto and inv. 1895,0915.780 respectively.

13 On Francesco Rosselli, see Oberhuber in Washington 1973, pp. 47–59; Landau 1994, pp. 176–7; Landau and Parshall 1994; Zucker 1994, pp. 1–109.

14 On Baccio Baldini, see Oberhuber in Washington 1973, pp. 13–39; Landau 1994, p. 176; Landau and Parshall 1994; Zucker 1993, pp. 89–284. On the Master of the Vienna Passion, see Landau and Parshall 1994, pp. 67, 94–5; Zucker 1989, pp. 149–60; id. 1993, pp. 29–88.

15 For the head on the verso (brush, carbon-based black ink, and also with the inscription 'Mantenga'), not unanimously attributed to Mantegna, see Ekserdjian

in London and New York 1992, no. 11 (perhaps for Mantegna's giant head formerly in the Ovetari Chapel entrance, but now destroyed); Hirst 1992, pp. 320–1; De Nicolò Salmazo 1993, p. 82; Goldner 1993, p. 172; De Nicolò Salmazo 2004, p. 126 and no. 1 v (first idea for St James in no. 20); Faietti 2006, pp. 83–5.

21

1 Niello (from the Latin *nigellum*) is a black sulphur compound for filling in engraved designs on metal plates. Niello prints are impressions taken from these plates – their appearance recalls pen and ink drawings in outline. Niello plates were also used as decoration in their own right in both the ecclesiastical and domestic spheres.

2 Staatliche Graphische Sammlung, Munich, inv. 3065. The engraving is Bartsch.XIII,231,6. For the drawing, see Ekserdjian in London and New York 1992, no. 44; Marini in Verona 2006, no. 17 (c. 1470–80); Mazzotta in Paris 2008, no. 94. For the engraving, see Lightbown 1986, no. 206; Landau in London and New York 1992, nos 4–6; Marini in Verona 2006, no. 18 (c. 1470–80); Aldovini in Paris 2008, no. 95; and Syson (2009, pp. 526–35) who argues against Mantegna's direct involvement, reopening the debate on this contested issue.

3 Christiansen 1993, p. 608. On the significance of *Della pittura* for Mantegna there is a vast bibliography with differing conclusions; for a bibliographic overview see Faietti 2008b, no. 1. I believe that although Mantegna's knowledge of Alberti's precepts cannot be ruled out, his works display an indisputable originality and independence.

4 Alberti (Grayson ed.) 1980, Book II, ch. 31 (consulted at www.liberliber.it). This translation is by Grayson (1972), from Alberti's Latin.

5 Di Nicolò Salmazo (2004, p. 194). Thode (1897, pp. 114–15) was the first to consider the drawing a preparatory study or variant of Mantegna's Brera *Lamentation*, followed by Berenson (1901–16, vol. 2, 1902, p. 50).

6 The connection with one of the statues of a *Dying* or *Wounded Gaul*, such as the versions in the Museo Archeologico, Venice, the Louvre, Paris, and the Museo Archeologico Nazionale, Naples, is generic rather than clear-cut, also on the grounds of chronology. See Bober and Rubinstein 1986, nos 149–51.

22

1 In the Louvre and the British Museum respectively. For the drawing (1860,0616.85), see Lightbown 1986, no. 195, with previous bibliography; Ekserdjian in London and New York 1992, no. 154; L'Occaso and Romani in Paris 2008, no. 148.

2 See especially Förster 1901, pp. 78–87; Massing in London 1981, no. 125; id. 1990, pp. 177–84; no. 48. The subject is a complex moral allegory with multiple possible sources, such as Galeno's *Protrepticus*, Lucian's *De Calumnia* or the *Tabula Cebetis*, a dialogue in Greek translated into Latin from the mid-1490s onwards.

3 Bartsch XIII, 304, 17/303, 16, respectively. Boorsch in London and New York 1992, no. 148; Aldovini in Paris 2008, nos 146–7. Knowledge of Mantegna's composition was spread by Da Brescia's engraving of the *Virtus Combusta*, the influence of which is seen in Raphael's *Massacre of the Innocents*, where the mother at the centre is close to the young woman in the engraving led over the abyss, as this was noted by Pogány-Balás 1980, p. 66. This composition was studied by Raphael in various drawings and in turn reproduced in engraving (Bartsch XIV, 19, 18/21, 19/21, 20).

4 Förster 1901, p. 86; Kristeller 1902, doc. no. 102, pp. 545–6 and doc. no. 112, p. 550.

5 The author will return to this argument at a later date.

6 Förster 1901, p. 87; Massing in London 1981, no. 125. See Agosti 2005, p. 168, n. 55, p. 190 on the earlier incorrect readings concerning both the location and technique.

7 For the differences between no. 22 and its engraving (with *Virtus Combusta*), and a detailed analysis of the transfer of the figures, see Ekserdjian and Landau in London and New York 1992, no. 147, according to whom the engraver worked directly under Mantegna's supervision. Slightly different conclusions will be drawn by the author at a later date.

8 As seen in the drawings of *Three Divinities* (British Museum, 1861,08,10.2) and *Three cherubs playing with masks* (Louvre, inv. 5072). See Mazzotta and Romani in Paris 2008, under no. 143 where these stylistic characteristics are discussed.

9 Lucianus 1862, 58, pp. 57–61.

10 'The painter has nothing other than white with which to show the highest lustre of the most highly polished sword, and only black to show the deepest shadow of night. This composition of white and black has such power that, when skilfully carried out, it can express in painting brilliant surfaces of gold and silver and glass. Consequently, those painters who use white immoderately and black carelessly, should be strongly condemned'; Book II, ch. 47. Italian text consulted at www.liberliber.it, Alberti (Grayson ed.) 1980.

11 Jones 1987, pp. 71–90; Faietti 2008b, pp. 227–34.

23

1 Alberti (Grayson ed.) 1980, Book II, ch. 31 (consulted at www.liberliber.it).

2 Bartsch XIII. 232. 8. For recent bibliographies, see Lightbown 1986, no. 207; Landau in London and New York 1992, no. 48; Marini in Verona 2006, nos 22–3; Boorsch in Paris 2008, no. 113 (1st state). Syson (2009, pp. 526–35) argues against Mantegna's direct involvement in printmaking.

3 Translated from the Latin: '[...] *qui omnes regulas ac pingendi rationes posteris aperuit …* ' The text continues:. '*et non solum penicillo omnes excedit, verum etiam arrepto calamo seu carbone extinto in ictu oculi hominum aetatum ac diversorum animalium veras imagines ac effigies diversarumque nationum, habitus, mores ac gesta figurat, ut quasi se movere videantur*'; cited in Romano 1981, p. 29.

4 A critical edition of the passage is in Rupprich 1956–69, vol. 1, 1956, p. 309. For recent comments, see Faietti in Rome 2007, pp. 80–7 and Fara 2007, p. 67, under no. 8.

5 *Ulixes pro Andrea Mantegna pictore, dicto Squarzone, pro quadam moniali*, Biblioteca Estense, Modena, ms. III. D. 22 ('La mano industriosa e l'alto ingegno/l'imagine, raccolta nel concepto/scolpì in pictura propria viva et vera'); cited in Santucci 2004, p. 60.

6 Translated from the Latin: '*non assuefacta sequi animi intelligentiam et promptitudinem*'.

7 Translated from the Latin: '*facilitatem eius et certitudinem manus rerum cognitione et arte*'.

8 Quote given to Mantegna in Battista Fiera's dialogue *De Iusticia pingenda* published in 1515 (cited in Romano 1981, pp. 79–80). Translated from the Latin: '*cum pictor tamen is sim, qui de lineis etiam praecipuam diligentiam curem* [...]'.

24

1 Technical examination reveals iron-gall and carbon black ink.

2 First proposed by J.P. Richter in 1885 (Popham and Pouncey 1950, p. 158). For the other drawings

attributed to Tura, one each in the Kupferstich-kabinett, Staatliche Museen, Berlin, the Uffizi and the Museum Boijmans Van Beuningen, Rotterdam, see nos 76–8 respectively in Ferrara 2007.

3 National Gallery, London, inv. NG 3070.

4 Toffanello (1997, p. 18) noted the flying arrows.

5 Tura painted a very similar loggia in his early canvas of the *Virgin and Child with a female saint and St Jerome*, c. 1455, in the Musée Fesch, Ajaccio (recently exhibited in Paris 2008, no. 22). It is a motif which displays the influence of Paduan art of the 1450s.

6 Wilde considered the drawing for a small altarpiece (Popham and Pouncey 1950, p. 158). Tura's *Pietà* panel in the Museo Correr, Venice (45 × 31 cm), is such a small devotional work. Chapman (London 1998a, p. 62) pointed out that such an arrangement, with the saints' heads above the Virgin and Child, occurs in Niccolò Pizzolo's sculpted relief for the Ovetari Chapel in Padua.

7 Campbell (1997, p. 63) suggested the drawing may have been a design for another artist to follow.

8 Tura's concern for his materials is shown by his trip to Venice in 1469 to procure pigments and gold (Molteni 1999, p. 224).

9 The conservation of the sheet and the explanation of the way the sheet has been folded are the work of Jenny Bescoby in the Department of Conservation in the British Museum. Traces of gold pigment from an old mount in the creases caused by the folds show that the folding occurred early in the sheet's history (it would seem a very unlikely thing for a subsequent collector to do).

10 The identity of the patron is equally unknown: the presence of both St Francis and St Dominic would rule out either Franciscan or Dominican patronage since the two orders were fiercely competitive. Manca (2000, p. 133) put forward the name of Tura's employer, Ercole I d'Este (1431–1505), on the grounds of his close ties with both orders.

25

1 In Popham and Pouncey's entry they erroneously cite Sotheby's rather than Christie's as the auction house responsible for the 1854 Woodburn sale.

2 Two of the drawings were excluded for prudish reasons as they included representations of female nudes, fols 22, 25.

3 The information on the two Macigni owners of the volume is taken from Dodgson 1923, p. 7.

4 G. Campori, *Lettere artistiche inedite*, Modena, 1866, p. 317.

5 Elen suggested that four leaves are missing through misreading the '6' on page 33 recto as '30'. This folio cannot have been at the end of the album as the worm-holes are consistent with the pages at the beginning of the book. The pattern of worm-holes in the album, which correspond to insects eating their way from either the front or the back, differs markedly according to the position of the folio.

6 Lilian Armstrong suggested that some of these may have been preparatory for woodcuts for book illustrations; see Armstrong 1993, pp. 79–95.

7 The other two are *The Death of Pentheus* (an ancient king of Thebes killed by Bacchus' female followers, the Maenads) and the goddess of love, Venus, in armour, the so-called *Venus victrix* (fols 21, 25).

8 'It seems most probable that the drawings were prepared to accompany a text'; Armstrong 1976, p. 309.

9 The sleeve of the right-hand figure is decorated with a device or *impresa*, as was first noted in London 1998b, p. 66, fig. 23.

10 See Rovetta, Monducci and Caselli 2008, pp. 99–141. For Arlotti's intellectual circle see pp. 100–102. The

predella of the *Baptism* altarpiece also contains figures inspired by the Rosebery album, such as the pointing soldier based on one in fol. 9.

11 The three roundels are illustrated on p. 129 in Rovetta, Monducci and Caselli 2008.

26

1 'Disegnò benissimo e assai, e nel libro nostro v'è di molte carte di vestiti, ignudi e di storie disegnate d'aquerello', Vasari 1971, vol. 3, p. 501.

2 Carl 1983, p. 518, docs 19–20, 26. Elen (1995) suggests that some of the Uffizi and Louvre figure drawings by Finiguerra could have been part of an octavo drawing book.

3 For the critical fortunes of Finiguerra as a draughtsman see Melli 1995, pp. 17–26.

4 See Konrad Oberhuber's entry on Finiguerra in Washington 1973, pp. 1–9 and Kubiak 1974. Whether all the drawings included in Melli's monograph of 1995 are by Finiguerra is perhaps debatable: a handful seem more likely to be the work of students.

5 In Rucellai's notebook or *zibaldone*, the relevant entry probably dates from around 1471; see Perosa 1960, vol. 1, pp. 23–4. The significance of this term is discussed by Wright, 'Antonio Pollaiuolo, "Maestro del Disegno"', in Cropper 1994, pp. 131–46.

6 'Vo essere uno buono disegnatore e vo ventare uno buono architettore' on 115F (fig. 1); Melli 1995, no. 68.

27

1 This point is made by Angelini in Florence 1986b, no. 137.

2 756 Orn; Melli 1995, no. 10.

28

1 Melli 1995, no. 126.

2 Ibid. no. 124.

3 Kubiak (1974, p. 98) rightly observed the present drawing's stylistic similarities with Filippo Lippi's *Adoration of the Magi* tondo in Washington. The influence of Lippi explains Popham and Pouncey's attribution of this drawing to his follower Francesco Pesellino. Whitaker (1998) noted that the man with three pigtails seen from behind, left of centre, is based on the figure standing to the left in Baldovinetti's painting of *The Transfiguration* for the SS. Annunziata silver chest in S. Marco, Florence.

4 Rosselli engraved two versions of *The Flood*; Hind 1938, vol. 1, nos B.III.1, 3.

5 For the question of dating see Zucker 1994, pp. 4–5.

6 The walled town was used in reverse in Rosselli's *Adoration of the Magi*; Hind 1938, vol. 1, no. B.III.2.

7 There are two states of the print, with Rosselli adding identifying inscriptions below the figures of Moses and Aaron in the second one. Hind and Zucker record only six impressions of the print.

29

1 When the strip was added is not recorded in conservation records, but it post-dates Popham and Pouncey's 1950 catalogue, as can be seen from the catalogue illustration. The observation that the drawing was cut in two and was missing a section was made by Ede (1924). The two pieces of the Hercules study were likely reunited by the time the drawing was in Richardson's collection: his collector's mark is stamped in the lower right corner of the recto, which signifies

that this was considered the more important of the two sides. There is a possibility that the division occurred after Richardson's death in 1745, but if so it was quickly rectified as the drawing was listed as a single item in the 1845 British Museum register of Fawkener's 1769 bequest. Putting the drawing on a lightbox shows that the chain lines do not quite match and that the lower piece should be moved slightly to the left.

2 I owe this suggestion to my colleague Jenny Bescoby. The technique of the verso cannot be verified through examination with a microscope because the surface of the paper is covered with synthetic netting.

3 The identification was made by Giovanni Morelli. It was first published with the correct name in an 1891 British Museum guide and two years later in Morelli's posthumous publication (1893, p. 30, n. 2).

4 Wright 2005, nos 42a–42b. The paintings were recorded in the Gondi collection in Florence in 1609.

5 Examples of the pose in Pollaiuolo's work include the *Apollo and Daphne* panel in the National Gallery, London; the *Battle of the nude men* engraving; and a number of the designs with scenes from the life of St John the Baptist he supplied for embroidered vestments for the Baptistery in Florence (1469–80); see Wright 2005, figs 68, 137, 203, 206, 233. Classical precedents include sarcophagi reliefs that are known to have been copied in the 15th century, such as ones showing the story of Adonis or Marsyas' contest with Apollo; Bober and Rubinstein 1986, nos 22, 29. For Pollaiuolo's study of classical sculptural models see Fusco 1979 and 1982.

30

1 Isaiah 40:3.

2 Janson 1963, no. 94.

3 This order goes against Alison Wright's view (2005) that the chalk preceded the pen. It is admittedly extremely hard to be sure of the sequence but it seems more logical to presume that the chalk details followed on from the drawing of the entire pose.

4 Ettlinger's suggestion (1978) that 'Giovanni' is a reference to the subject seems improbable as the saint's attributes of sheepskin tunic and reed cross make him readily identifiable. For the most recent discussion in favour of Möller's attribution to Salvestro, see Melli 2007. To my judgement there is an enormous qualitative gulf between the present work and a double-sided drawing of St John the Baptist in the Uffizi (357 E; Melli 2007, illustrated on pp. 59, 70). The hard inflexible outlines of the recto seem alien to Antonio, to whom Melli is inclined to attribute it, even taking into account its ruinous condition. The sketches of the saint on the verso are much livelier and more spirited, but formal and stylistic comparisons with 699 E are not sufficiently close to convince me that they are related to the same project or, more crucially, that they are by the same hand. I see no convincing reason to think that both sides of 357 E are not by a single artist, most likely one in Antonio or Piero's workshop.

5 According to Wright (2005, p. 165) the calligraphy is not identical with that of the artist's 1494 letter to Virginio Orsini, the only surviving example of Antonio's handwriting, but nonetheless she now believes the drawing to be by him. In her essay as in no. 26, n. 5, she doubted the attribution because of the presence of Salvestro's 'signature' and because the 'rapid but uncertain penstrokes are not characteristic of Antonio's otherwise confident hand'.

6 Vasari 1971, vol. 3, p. 504.

7 Wright 2005, figs 208–9.

31, 32

1 Sisi in Florence 1992. To gain a sense of what was seen as permissible in this regard, the drawings can be compared to the c. 1500–10 engraving of the same subject by the Florentine printmaker and engraver Cristofano Robetta (Hind 1938, vol. 1, no. 4, p. 199).

2 Adam's cross-legged pose derives from the figure of Desire (Pothos) by the Greek sculptor Scopas; see Cocke 1980, p. 30. Alison Wright (2005) notes that the cross-legged pose for Adam is found in a cassone in the Victoria and Albert Museum (her fig. 148) with three terracotta reliefs of scenes from Genesis by the workshop of Lorenzo Ghiberti from c. 1415.

3 The copy in the Uffizi is 96 F; the ex-Atri painting is reproduced as fig. 346 in Wright's monograph (2005).

33

1 This differs from the technical description given in the catalogue Florence 2007 which includes brown wash.

2 Ettlinger (1978, no. 30), Bambach (1999a, pp. 237–9) and most recently Tartuferi (in Florence 2007, no. 3) give it to Piero; for the opposite view see Wright 2005, pp. 243–4. A definitive judgement is hard to reach since Piero's capabilities as a draughtsman can be judged only on the present work, which remains the only certain drawing by him. For a more expansive view of Piero's graphic corpus see Melli (2007, pp. 64–7).

3 A preliminary drawing by Verrocchio for the project is in the Uffizi (208 E; no. 7 in Florence 2007).

4 Paolo Uccello seems to have been the first Florentine painter to have made use of cartoons for figures, see Bambach 1999a, pp. 197–219.

5 Piero was not alone in making such drawings for panel paintings in this period, as is attested by the use of one by Piero della Francesca (c. 1415–92) for the head of St Michael from his polyptych completed by 1469 for Borgo San Sepolcro, now in the National Gallery, London; see Dunkerton and Plazzotta in London 2002, p. 63.

6 As was observed by Alessandro Cecchi (in Wright 2005, p. 245). Melli (2007, p. 124) noted that the dimensions and contours of the head of Faith are similar to those of Charity and Temperance.

34

1 The volume lacks the opening four pages, as is indicated by the sequence of numbers written in pen and ink that run from 5 to 59 in the top right corner, which explains the absence of a title page and any designation of the beginning of the first age. When these pages and the binding were lost is not clear, as the volume's provenance only goes back as far as 1840, when it was acquired in Florence. One of the Chronicle's owners, the Victorian writer John Ruskin, took it apart and framed sheets individually, and it had to be put back together when it was acquired by the British Museum in 1889. Six pages given away by Ruskin were reunited with the rest of the album in 1890 and 1900. Not all the pages were numbered and mistakes were made in the sequence: folios 31 and 33 were, for example, swapped around (as is shown by the continuation of the roof from 33 verso to 32 recto). I would like to acknowledge my debt to Lucy Whitaker for her help in writing the present entry. She kindly lent me a copy of her 1986 thesis, on which I have heavily relied, and read a draft of this entry.

2 For details of this work and some of the manuscript copies after it see Mode 1972.

3 References to these are given in ibid., p. 370. A sixth manuscript record of the cycle, probably by a Cremonese hand, was sold at Sotheby's, London, 3 July 1984, lot 64; see Whitaker 1986, pp. 227–84.

4 Based on a vernacular 15th-century translation of Isidore's Chronica Maiora; see ibid.; pp. 148–9.

5 The lack of pre-planning evident in the rather haphazard development of the album's arrangement even extends to the use of at least four different stocks of paper identifiable through variations in the watermark; see Elen 1995.

6 Lucy Whitaker and I recently went through the album and agreed that it was executed by at least five hands.

7 For more examples of borrowings from Finiguerra see Whitaker 1994, p. 191. The relevant Uffizi drawing is 91 F; Melli 1995, fig. 67.

8 The similarities between the pose of Herod in Antonio Pollaiuolo's Baptistery vestments dating from 1469–80 and that of Aristotle in the Chronicle help to date the volume to the 1470s; see Whitaker 1992, p. 183.

9 For what is known about Baldini see Oberhuber in Washington 1973, pp. 13–21 and Zucker 1994, pp. 89–93. He is not mentioned in the Finiguerra documents published by Doris Carl in 1983.

10 The shallowness of the engraved lines that impart such a delicate, silvery quality to the 'Baldini' prints, such as the series of Sibyls and Prophets as well as the circular prints of secular subjects (the so-called Otto prints), strongly suggests that the number of impressions was small. The extraordinary rarity of early Florentine engravings, with many of them known through a single impression, might point to the city's early printmakers not conceiving the newly imported technology as a means of mass-producing images. I am grateful to Mark McDonald for his guidance on this issue.

11 Hind 1938, vol. 1, no. A.II.9.

12 Ibid., no. A.II.2.

13 Ibid., no. A.IV.16.

14 Degenhart and Schmitt 1968, vol. 1–1, no. 154; vol. 1–3, pls 185–9 (where it is dated c. 1400); Elen 1995, no. 18.

15 Hind 1938, vol. 1, no. A.II.16.II.

16 Whitaker (1986, pp. 61–4) notes other examples of the Chronicle artists borrowing figures from 'Baldini' prints.

17 Hind 1938, vol. 1, no. A.II.10.

35

1 Schubring identified the subject. In Maximus's account it is unnamed enemies of Greece, while Boccaccio describes Hippo's abductors as pirates.

2 Workshop of Giovanni di Paolo (Walters Art Museum, Baltimore; Zeri 1976, vol. 1, pp. 124–5); Guidoccio Cozzarelli and Bernardino Fungai (see Schubring 1915–23, nos 468 and 483 respectively).

3 Adam and Eve at Christ Church Gallery, University of Oxford; an Atlas in the Herzog Anton Ulrich-Museum, Braunschweig; and a Youth standing in a landscape in the Uffizi; see London 2007, nos 31, 40–1.

4 See Syson's entry in London 2007, no. 41.

5 Nos 68 and 70 in Siena 1993.

6 The attribution to Francesco di Giorgio was first made by Ulmann in 1894.

36

1 See Rubin in London 1999, no. 87, on the motif of the putto perhaps inspired by a cameo of Dionysus originally in the Medici collection and now in the Museo Archeologico Nazionale, Naples.

2 The drawing is repeatedly discussed in the latest monographs on the artist (see Literature), to which the reader is referred for information on the mentioned paintings. On Botticelli's mythological allegories see also Acidini Luchinat 2001.

3 In a vast bibliography on Botticelli, noteworthy is Dempsey's reading of Warburg's theories (Paris and Florence 2003, pp. 25–37).

4 On the iconographic relationship between the drawing and two paintings by followers of Botticelli, one of which is in Chantilly, see Popham and Pouncey 1950, no. 24.

5 See the description of no. 36 on the 'Collection database; at www.britishmuseum.org/research.

6 Alberti 1980, Book II, ch. 42 (consulted at www.liberliber.it). This translation is by Grayson 1972 from Alberti's Latin. See Book II, ch. 45 for Alberti's seven predilected movements for the description of hair.

7 London, T. Philipe, 29 May 1801, lot 115 (as Mantegna); London, Christie's, 6 May 1856, lot 923 (as Verrocchio).

8 See Lightbown 1978, vol. 2, no. D3. Herbert P. Horne discerned on the mount a fragment seemingly from a Vasari mount: Horne 1986, vol. 2, pp. 187–8. It also belonged to Vasari's Libro de' Disegni, according to Kurz 1937, p. 13 and Ragghianti Collobi 1974, vol. 1, p. 80. A Vasari provenance is also suggested for the Pallas (no. 37), ibid. 1974, vol. 1, p. 81. The decorative motifs on the verso of no. 36 are drawn in pen, probably iron-gall ink, partly diluted.

37

1 For Horne (1986), it is after Botticelli. Berenson concurred (1903), later changing his opinion tentatively in favour of Botticelli (1938 and 1961). On the provenance of the drawing see no. 36, n. 8.

2 The lost standard is documented by Vasari 1971, vol. 3, p. 513.

3 Cecchi in Rome 2000, vol. 1, no. 5.18.

4 Van Cleave 1994, p. 238. This sequence is suggested by the absence of black chalk underdrawing in the left head.

5 Alberti 1980, vol. 2, ch. 45.

6 Warburg (1898) 1999, pp. 157–64.

7 Ashmolean Museum, Oxford (Parker 1956, no 7); Lightbown 1978, vol. 2, no. D14.

38

1 Gamba (1936, p. 167) makes reference to the mosaics in the vaults of the S. Zanobi Chapel in Florence Cathedral; but as Cecchi confirms (2005, pp. 274, 277), Botticelli would appear to have had a marginal role in this project.

2 Lightbown 1978.

3 Museo Poldi Pezzoli, Milan; Alte Pinakothek, Munich.

4 Inv. no. 208 E. The uncertain attribution demonstrates work still needs to be done to identify the various artists working in Florence at the time; study is also required on the organization of the numerous work-shops. The drawing was long attributed to Antonio Pollaiuolo but inventoried as Botticelli in the late 19th century. It was later given to Verrocchio or his studio in relation to the Mercanzia competition, then to Biago d'Antonio (1446–1536) and then again to early Botticelli; not to mention Piero del Pollaiuolo in prob-able relation, again, to the Mercanzia Virtues. For the complex history of attributions see Bartoli 1999, n. 38, pp. 45, 31 (young Botticelli?); Cecchi 2005, p. 176, n. 5 (Piero del Pollaiuolo); Melli in Florence 2007, no. 7 (Verrocchio, with much retouching by another hand). For the drawing's provenance see Petrioli Tofani 1986, pp. 91–2. Carmen Bambach favoured Biago d'Antonio (verbal communication, April 2009). The name of Verrocchio has been taken up again recently by Jill Dunkerton and Luke Syson (verbal communication, September 2009), who will consider the drawing as

part of their study of a painting in the National Gallery, London (inv. 2508). K. Christiansen agrees with the author that a better understanding of the structure of Verrocchio's workshop is required for a secure attribution to be established (verbal communication, September 2009).

5 Berenson (1903, vol. 2, no. 578; 1938, vol. 2, no. 578; 1961, vol. 2, no. 578) attributes it to a follower of Botticelli, even if he seems hypothetically to accept it in 1938, vol. 2, p. 333; Van Marle 1931, vol. 12, p. 274 and Horne (first pub. in 1908), vol. 2, p. 253, consider it to be a school drawing; an exhaustive bibliography is found in Lightbown 1978, vol. 2, no. D8.

39

1 Sangallo's *Sienese Notebook* (Biblioteca Comunale, Siena). See Morello 1998.
2 Cod. Barb. Lat. 4424 (18 v.); Uffizi 262 F. Inventoried by P.N. Ferri (c. 1887) as anonymous 16th century.
3 Albertina, inv. 4862: Berenson 1938, vol. 2, no. 2473. Fabriczy 1902a made this link.
4 Uffizi, inv. 616 Orn.
5 Described as being 'After Botticelli' in Ferri's inventory (c. 1887).
6 Byam Shaw 1931, pp. 39–40.
7 Berenson 1938, vol. 2, no. 2425.
8 The drawing would thus illustrate Lucretius tearing up his writings in a love-induced fury in a rocky landscape evoking the poet's *De rerum natura* (Sisi in Florence 1992, p. 59).
9 According to the account by Sangallo's son Francesco, Michelangelo and his father paid a visit at the Pope's bidding to the recently discovered *Laocoön* in the vineyard of Felice de' Fredis on the Oppio hill (see Settis 2006, pp. 16–17).
10 Fossi in Florence 1955, p. 28, no. 75.
11 The painting was never completed but the composition is recorded in two drawings by Lippi, Uffizi, inv. 169 and Pushkin Museum, Moscow (previously in the Franz Koenigs Collection, Rotterdam), and also a painted copy on panel by the Maestro di Serumido formerly in the Scharf Collection, London. Lippi's composition would seem to presuppose the knowledge of an antique representation like that found much later in Pompeii. For the Villa di Poggio a Caiano commission see Nelson 1992, pp. 45 ff.
12 Ferri (c. 1887) made the connection with the Villa Madama, commissioned by Cardinal Giulio de' Medici, later Pope Clement VII.
13 Degenhart (1955), pp. 221 ff., 255, n. 335.

40

1 Thiis 1913, p. 118.
2 Covi (2005, p. 217) considers that there was a now lost intermediary drawing between the verso and the recto.
3 Inv. 212 E. For the history of the sheet see Marani 2003, p. 156.
4 Covi 2005, pp. 174–80.
5 Vasari 1971, vol. 3, p. 538.
6 Hermitage Museum, St Petersburg, inv. 2773.

41

1 Bambach 1999a, p. 262.
2 Covi 2005, p. 221. For further comment on the retouching in pen on this and a similar sheet in Christ Church Picture Gallery, Oxford, see Ames-Lewes and Wright in Nottingham and London 1983, under no. 72 and Bambach in New York 2003, under no. 1.

3 Covi 2005, p. 221.
4 Bambach (1999a, p. 262) suggests that the sheet may have been pricked prior to drawing.
5 *De illustratione urbis Florenti*, 1583, pp. 132–3. On innovations in Verrocchio's art that prefigured certain Baroque and Renaissance trends, see Covi 2005, p. 256.
6 Crutwell 1906, p. 10.
7 Chastel 1964, pp. 298, 300.
8 Inv. 1890, 8358.
9 Morelli's characterization of Verrocchio's heads is still pertinent: 1. the forehead high and a little unnatural; 2. the eyes wide and large with long eyelashes; 3. the brow barely indicated through shade; 4. the nostrils, like Botticelli's, a little swollen and round (although Botticelli's are more elongated); 5. the lips are given an undulating movement (Morelli 1891, p. 350).
10 Passavant 1969, p. 57.
11 Adorno 1991, p. 115. On the attribution of the National Gallery panel (NG 781), see Penny in London 1999, no. 21.

42

1 Lastri 1791–5, vol. 1, pl. XXXI: 'Of the three school-mates and friends, Lionardo da Vinci, Pietro Perugino and Lorenzo di Credi, the latter was the least gifted, demonstrating in his work what attention to detail and clarity can do but without advancing Art like the other two.'
2 For the modern reassessment of Credi see Dalli Regoli 1966, pp. 77–88; Bartoli in Rome 2000, vol. 1, no. 5.27, p. 207.
3 See London 1999, p. 82.
4 The only dissenter was Degenhart (1932, p. 102), who thought it was a study by Tommaso di Stefano for the Santo Spirito *Sacra conversazione*.
5 For example the Virgin in the *Sacra Conversazione* in the Louvre (inv. 257) or that in Pistoia Cathedral with St John and St Donato.
6 Scientific analysis has revealed dots along the edge of the veil that may derive from the pouncing of the pricked outlines of a preceding sheet. However, a layer of white heightening prevents a definitive confirmation.
7 On this point see Dalli Regoli 2004, p. 79.

43

1 Dalli Regoli 1966, no. 145. On the history of the attributions see Petrioli Tofani 1986, p. 96.
2 Inv. no. 15, no. 145. Cecchi in Florence 1992, no. 6.10.
3 Bartoli in Rome 2000, vol. 1, no. 5.28.
4 Vasari 1976, vol. 4, p. 303.
5 Galassi 1998, p. 74.
6 Louvre, inv. 1791 E recto.
7 Dalli Regoli 1966, p. 166.
8 Inv. 1890,3094 (reserve collection).
9 Christ Church Picture Gallery, inv. 0057.
10 Hermitage Museum, St Petersburg, inv. 2773.
11 National Gallery, London, inv. 1093.

44

1 Dalli Regoli 1976, pp. 44–5.
2 For example, Ghiberti stated the importance of knowing the 'facts of astrology because [...] who does not possess this will not understand the reason behind things'; Ghiberti 1947, p. 4.
3 '[In Verrocchio's studio and elsewhere] drapery becomes the object of a process of elaboration independent of the characterization of a subject and the composition as a whole'; Dalli Regoli 1976, p. 40.

4 Filarete 1972, vol. 2, Book XXIV, pp. 676–7; Alberti 1973, Book II, ch. 45; Vasari 1966, vol. 2, pp. 89–90, 112.
5 To whom this drawing was once attributed, see Petrioli Tofani 1986, pp. 222–3.
6 Vasari 1976, vol. 4, p. 299. Lorenzo absorbed the more innovative aspects of Leonardo, fusing them into a more traditional style.
7 Inv. 1180.
8 Dalli Regoli 1966, p. 61
9 Uffizi, inv. 443 E.

45

1 Fischel (1917, p. 10) first suggested this link, accepted by most scholars subsequently.
2 Vasari 1971, vol. 3, p. 602.
3 Pitti Palace, no. 341. On the dating of the panel see Russell 1974, pp. 648–50; concerning its various attributions see Baldini in Florence 2005, no. 1.
4 Perugia, Galleria Nazionale dell'Umbria (no. 180).
5 Ferino Pagden 1987, p. 81.
6 Vasari 1971, vol. 3, pp. 599–600.
7 56 E; see Florence 1982, no. 5.
8 Concerning the repetition of subjects and the reuse of cartoons in particular, see Bambach 1999a, pp. 86–91, and Hiller von Gaertringen 1999. Gentilini (2004, p. 203) suggests that the S. Giusto fresco is the source of inspiration for a small altarpiece dated c. 1495 produced by Andrea della Robbia's workshop, with which Perugino had close links.
9 Cadogan 2000, pp. 115–6; Faietti 2006–7, p. 181.

46

1 Most of Perugia's noble families belonged to the Collegio del Cambio (see Scarpellini 1984, pp. 43–6; Garibaldi 2004, p. 168).
2 On Francesco Maturanzio and the iconographic programme see Sartore in Perugia 2004, pp. 589–93 (with previous bibliography).
3 On the dating of the scenes see Ferino Pagden in Florence 1982, no. 27; Scarpellini 1984, p. 45. For Pintoricchio's Roman commissions see ibid., p. 45; Garibaldi 2004, pp. 170–1. On the variety of finishes that the restoration in 1994 revealed, see ibid. p. 169. For the history of the sheet's attribution see Ferino Pagden in Florence 1982, no. 27 (with full previous bibliography). The link with the Collegio del Cambio fresco was first made by Pasquale Nerino Ferri in his inventory of 1887.
4 On the iconography of sibyls see the entry 'Sibilla' in Cassanelli and Guerriero 2004, vol. 2, pp. 1293–5; Settis 1985, p. 447.
5 Observation with the microscope suggests that the underdrawing is metalpoint, and since the paper is unprepared, this must therefore be leadpoint.
6 See Ferino Pagden in Florence 1982, no. 27.
7 No. 43 by Lorenzo di Credi of a decade or so later also displays the pre-eminent influence of Donatello and antique art in general. On Verrocchio's influence on Perugino, and the method of studying the figure in isolation in particular, see Ferino Pagden in Milan 1986, pp. 42–4; id. 1987.
8 On this painting see Marcelli in Perugia 2004, p. 314. The correspondence between this sketch and the predella has been previously noted by Scarpellini (1984, p. 43) and Garibaldi (2004, p. 175).
9 See Scarpellini 1984, no. 146.

47

1 Ragghianti Collobi 1974, vol. 1, p. 88; vol. 2, fig. 242.
2 The different inks that Vasari and Mariette employed

(iron gall and carbon-based respectively) are visible to the naked eye.

3 Fischel 1917, no. 45; Popham and Pouncey no. 188.
4 Musée Condé, Chantilly, inv. PE 15, under Andrea D'Assisi called l'Ingegno.
5 1895,0915.600; Popham and Pouncey 1950, no. 190. For a survey of Perugino's graphic oeuvre see Ferino Pagden 1987 and Venturini in Perugia 2004, pp. 331–5. Perugino's interest in portraiture suggests that he may have taken casts from live models in a similar manner to Verrocchio (Gentilini 2004, pp. 202–203).
6 Ferino Pagden 1987, p. 95.

48

1 Another example of this practice is the female head in the Uffizi (1254 E); Covi 2005, fig. 198.
2 Berenson (1903) thought that some of the white heightening on the forehead, nose, chin and throat was later retouching, while Dalli Regoli (Dalli Regoli and Pedretti 1985) questioned the touches on the ear and along the contour. Petrioli Tofani (1972) thought that there were probably some additions in white heightening. For Passavant the dark wash was a later addition.
3 Covi 2005, pp. 188–92.
4 Vasari 1971, vol. 3, p. 538.
5 An interesting comparison is the metalpoint drawing of the head of a woman in the Louvre (18.965) sometimes attributed to Verrocchio, but more likely the work of an able pupil; see Caneva in Florence 1992, no. 4.14.
6 It is also omitted from Leonardo's graphic work in Zöllner 2003.

49

1 The landscape is definitely by Leonardo as it resembles so closely the recto. The attribution of the other studies on the sheet is less certain, although it is not inconceivable that the Antonio Pollaiuolo-inspired figures are by his hand.
2 As was noted by Brown 1998.
3 For discussion of the possible location see Vezzosi 1984.
4 For Leonardo and Flemish painting, see Nuttall 2004, pp. 146–7, 199. The best parallels are with a painting of the *Stigmatization of St Francis* of *c.* 1430–2 by a follower of Jan van Eyck (Philadelphia Museum of Art) that was clearly known to Florentine artists.

50

1 Silver-based metalpoint confirmed by XRF and Raman spectroscopy investigation; for an explanation of these terms see appendix on pp. 330–31.
2 Butterfield 1997, no. 7; Covi 2005, pp. 89–98.
3 A detail most likely inspired by the marble lavabo (a basin used by priests to wash their hands) in the Old Sacristy in S. Lorenzo, Florence, attributed to Donatello by Giorgio Vasari, but ascribed in the two recent monographs on Verrocchio either to Antonio Rossellino (Butterfield 1997, no. 1) or to Verrocchio himself (Covi 2005, pp. 93–4).
4 Vasari 1971, vol. 3, p. 535.
5 For contrasting conclusions on the link between the drawing and the lost relief see Brown's recent monograph on Leonardo (1998) and Covi's on Verrocchio (2005). The lost reliefs may possibly post-date the drawing, as the likely date of the gift of them by Lorenzo de' Medici to the King of Hungary is around 1480 (Butterfield 1997, p. 157), although on the other hand Vasari's reference does not describe them as

having been made specifically for this purpose. Nonetheless the type of the lost *Darius* is found earlier in Verrocchio's sculpture, as can be seen from his *Beheading of St John* relief made for the silver altar of the Florentine Baptistery between 1477 and 1483.

51

1 Traces of leadpoint detected with XRF around right shoulder of Virgin in upper study; the main under-drawing is black chalk.
2 Kemp (ed.) 1989, p. 225.
3 'Belle invenzioni di varie cose'; ibid. p. 222.
4 RF 2; see Natali in Florence 1992, no. 6.5.

52

1 Leadpoint identified with XRF.
2 Popham 1946, nos 8b–14.
3 446 E; see Cecchi in Florence 1992, no. 6.6.
4 X-radiograph images (see fig. 130 in New York 2003) of a Leonardo circle painting of *The Virgin and Child with a Lamb* in the Brera, Milan, show that the animal embraced by the child was originally a cat before the artist changed his mind.

53

1 Popham 1946, nos 39–53. The sheet in the Musée Bonnat, Bayonne (Popham no. 39) is the clearest example of Leonardo working out an *Adoration of the shepherds*.
2 Leonardo indicated by the compass marks in the eighth square from the left that each unit is divisible by ten, to make 120 units along the base line.

54

1 For Valturio's influence on Leonardo, see Bambach in New York 2003, no. 51.
2 English translation in Kemp 1989, p. 251.
3 Bibliothèque de l'Institut de France, Paris, ms. G, fol. 84v.
4 446 E verso; see Cecchi in Florence 1992, no. 6.6.
5 Comparable designs for scythed chariots are found in the Royal Collection, Windsor Castle (see Popham 1946, no. 309); Biblioteca Reale, Turin (ibid. no. 310); and in the Codex Atlanticus, Biblioteca Ambrosiana, Milan (ibid. no. 311).
6 The design matches closely one on a page of studies of spearheads and maces, from one of Leonardo's notebooks from the same period (named Paris B), now in the Institut de France, fol. A.2 recto; illustrated in Paris 2003, no. 144 A.

55

1 Popham 1946, p. 63.
2 Pedretti 1964, p. 51.
3 The identification of this ideal type by Popham and others as a portrait of Leonardo's assistant Salaì seems fanciful; see Clayton in Edinburgh and London 2003, p. 53.
4 Such as studies of infants at the Royal Collection, Windsor Castle (Popham 1946, no. 21). Red chalk is also used for one of the sketches on the reverse of the Uffizi *Landscape* (no. 49).
5 I should acknowledge that the unanimous acceptance of the drawing by modern Leonardo critics has been questioned by Martin Clayton, who told me that when he saw it in the Louvre exhibition (2003) he wondered

if it was a copy. The faithful copies of Leonardo's chalk drawings by his pupil Francesco Melzi that we looked at together at Windsor did not, at least to my eyes, appear to possess the energy and variety of touch that I detected in the Uffizi drawing.
6 Popham 1946, no. 172.

56

1 The white pigment in the main study has been identified by XRF and Raman analysis as calcium carbonate.
2 For the alternative view that Leonardo executed the London cartoon in Milan in 1499–1500, see Carol Plazzotta's entry in London 2004, no. 49, and Zöllner 2003, no. XX, p. 235. I am most grateful to Luke Syson from the National Gallery for discussing his ideas on Leonardo's chronology with me. Although we hold divergent opinions as to whether the National Gallery work is before or after a lost 1501 one, we both agree that there is insufficient evidence to rule out the other's view on the matter.
3 A Michelangelo drawing of *c.* 1502–6 in the Ashmolean Museum, Oxford (Tolnay 1975–80, vol. 1, no. 17; Joannides 2007, no. 1), is often cited as having been inspired by the London cartoon, but its likely inspiration seems to have been the lost 1501 work and perhaps Leonardo's drawn studies of this theme from the Florentine period. Luini used the Burlington cartoon as the basis for a painting now in the Biblioteca Ambrosiana, Milan.
4 The best known of these is the one by the Sienese painter Andrea Brescianino (*c.* 1487–1525) destroyed in the Second World War. This and a copy after it in the Prado Museum, Madrid, are illustrated in Zöllner 2003, p. 237. The relevant texts related to Leonardo's various treatments of this theme are given in their original form and in English in New York 2003, under no. 95.
5 The various stages in the construction of the scale are analysed in Kemp's essay, 'Drawing the boundary', in New York 2003 (pp. 151–4), based on the work of Kemp's student Edward Ford. The actual dimensions of the London cartoon accord fairly closely with the scale if the units are *palmi*.
6 The dating of the drawing and the cartoon to the Florentine period is supported by stylistic similarities with other drawings securely datable to these years. The free black chalk drawing comes close to the Royal Collection at Windsor Castle's *Neptune* (Popham 1946, no. 205), and the combination of pen and ink over black chalk is paralleled in the studies for Leda found in a sheet also at Windsor (Popham 1946, no. 212).
7 My reading of the drawing is dependent on Martin Clayton's lucid entry in Venice 1992.
8 The drawing in the Louvre (Popham 1946, no. 174 B) must be close in date to the present one and seems to represent a reversion to the original scheme of the figures, but with Christ on the left.
9 Wasserman (1970, p. 197) detected no less than two lambs with the Infant Baptist in this area. A useful synopsis of the dating and sequence as regards the London cartoon is provided by Budny (1983).
10 Carlo Pedretti (1982, p. 104) has argued that a study of the interaction between water and a concave surface at Windsor (12666) was originally part of this sheet. This hypothesis can be disproved thanks to a tracing of the chainlines of the paper of the Windsor sheet kindly made for me by Martin Clayton. The chainlines of the British Museum drawing are 2.5 cm apart, some 4 mm narrower than those on the Windsor fragment. Popham and Pouncey drew comparisons with water wheel drawings of *c.* 1508 on folio 165 recto of the Arundel MS in the British Library, London.
11 The acceptance of Leonardo's involvement is articulated most recently in the entry in New York 2003; see

also Budny 1983, p. 38. Pedretti (1968, p. 28) denied that the verso outline could be autograph, a view that Martin Clayton tells me he shares.

12 An example of Leonardo tracing figures from the recto to the verso is found in one of the Virgin and Child with a cat studies in the British Museum (Popham 1946, no. 9 A and B; Popham and Pouncey 1950, no. 97).

57

1 Such as the head of St Bartholomew (?) in the Royal Library, Windsor (Popham 1946, no. 168).
2 Two drapery studies of c. 1504 in this technique are at Windsor Castle (Popham 1946, nos 207 A, 207B), and in the same collection from around this period there is a group of botanical studies (Popham 1946, nos 275–8).
3 Windsor, RL 19070 verso; the relevant passage is quoted in Italian and English in New York 2003, under no. 113.
4 Popham 1946, no. 221. Around the same period Leonardo also made a study of a male in profile in silverpoint on blue preparation, also in Windsor (Popham 1946, no. 222).
5 Ambrosiana (illustrated in colour in Milan 2008, no. 17) and Windsor (Popham 1946, no. 230); for the inscriptions see Richter 1883, vol. 1, nos 1456 and 810 respectively.
6 Kwakkelstein 2004.

58

1 The most famous example being the Uffizi Primavera, c. 1482.
2 Chapman in London 2005, pp. 51–8. For Ghirlandaio's use of hatching see Ames-Lewis 1981a, p. 50; id. 1989, pp. 117–20. On the use of hatching in relation to the study of the antique see Faietti 2009 (forthcoming a).
3 Ames-Lewis 1981b. For the possible relationship with Filippo Lippi's Prato frescoes see Davies 1909, pp. 110–11, and Bartoli in Florence 1992, no. 2.31.
4 On the iconography of Temperance see Moakley 1966, p. 75; Ceri Via in Ferrara 1987, p. 67; Cecchi 2005, pp. 96–102; Berti in Mantua 2006a, p. 302.

59

1 Cadogan (2000, pp. 127–30, no. 84) does not consider no. 59 a first idea for the fresco but rather as having been executed in a later moment in order to study the relationship of the figures to the background architecture.
2 Vasari 1971, vol. 3, p. 491.
3 Faietti (forthcoming).
4 Alberti 1960–73, vol. 2, pp. 41–5.
5 For this suggestion see Baxandall 1978, pp. 56–64 and Shearman 1992, pp. 10–56.
6 Codex Escurialensis, fol. 57v. See Danti 1996, p. 142; Nesselrath 1996; Benzi 2000a, pp. 475–96; Benzi 2000b; Scaglia 2004; Marías 2005, pp. 14–35.
7 De Marchi in Florence 1992, no. 7.11; Bambach 1999a, pp. 139–40.

60

1 Cadogan 2000, no. 36. The church was rebuilt from 1481 to the design of Giuliano da Sangallo. It passed from the Cistercians to the Carmelites in the 17th century and was rededicated to S. Maria Maddalena dei Pazzi on her canonization in 1669.
2 Cadogan 1983b, pp. 286–7; Cadogan 2000, p. 297, no. 89.

3 Ragghianti-Dalli Regoli 1975; Dalli Regoli 1979, pp. 35–48; Cadogan 1983a, pp. 27–62; Viatte in New York-Paris 2003; Bambach 2004, pp. 44–55.
4 See Cadogan 2000, pp. 133–6.
5 First noted by Meder 1978, vol. 1, pp. 415–17, vol. 2, pl. 43.
6 Dots are revealed around the chin, perhaps the result of pouncing, in which case they would be black chalk; if not pounced, they may be leadpoint.
7 Alberti 1973, vol. 2, pp. 41–5.

61

1 The sheet has been interpreted as an autonomous post-mortem portrait. For the resulting painting by Ghirlandaio in the Louvre see Caneva in Florence 1992, no. 4.8.
2 See Campbell (1998, pp. 105–12).
3 Ragghianti Collabi and Dalli Regoli 1975.
4 Cadogan 2000, p. 296, n. 87.
5 Vasari 1971, vol. 3, pp. 478–81.
6 Ames-Lewis 1989; Van der Velden 1998; Warburg 2004.
7 Pelli (after 1775–before 1784), 'Universale VI', no. 1.
8 Cecchi 2005, p. 75.

62

1 The medium has hitherto been described as black chalk, but examination under the microscope, plus the greyish tone, shows that it is charcoal. This identification was made by Jenny Bescoby and Judith Rayner.
2 Henry (London 1998b) compares it to Signorelli's Nativity (c. 1493–6) at the Museo e Gallerie Nazionale di Capodimonte, Naples; Kanter, Testa and Henry 2001, no. 45.
3 Van Cleave (1995, vol. 1, p. 3) noted a similar monogram on other autograph Signorelli drawings: Christ at the column in the Uffizi; Four Apostles in the British Museum, Four nudes and a Flagellator in the Louvre, her nos 11, 16, 18, 26, 29.
4 For the development of black chalk in central Italy, see Van Cleave 1994.
5 These are Descent from the Cross at the Musée des Beaux-Arts, Besançon; the fragmentary Death of Lucretia in the Uffizi Gallery; the British Museum's Dante and Virgil with Ugolino and Ranieri; and the Circumcision at the Museum Boijmans Van Beuningen, Rotterdam; Van Cleave 1995, vol. 1, nos 4, 9 verso, 17, 33 verso.
6 Examination of the panel did not reveal what transfer method was used; see Henry in London 1998a.
7 Kanter, Testa and Henry 2001, no. 114.

63

1 Visual evidence for the continuing appeal of the chapel is provided by the recent appearance of a drawn copy after a section of the Sermons and Deeds of the Antichrist by Federico Zuccaro, probably made when he was in Orvieto in 1570; see Jean-Luc Baroni, An Exhibition of Master Drawings and Oil Sketches, New York and London 2004, no. 1.
2 The five drawings are: St Francis, a study for the Money Lenders in the Orvieto Antichrist in the Louvre; a drawing in the Museum Boijmans Van Beuningen, Rotterdam; a cartoon in the Nationalmuseum, Stockholm; and A couple embracing in the Staatsgalerie, Stuttgart; Van Cleave 1995, vol. 1, nos 27–8, 33–5.

64

1 Popham and Wilde 1949, no. 13; Goldner in New York 1997, no. 75.

2 Vasari 1971, vol. 3, p. 638.
3 Ferino Pagden dated it to the 1480s and Van Cleave to c. 1510.

65

1 Christ Church Picture Gallery, Oxford (inv. 1339). These drawings were mounted together by Vasari for his Libro de' Disegni.
2 Alberti 1973, vol. 2, p. 36. On this point see Shoemaker's essay in Cropper 1994, pp. 261–3.
3 Bambach (New York 1997, p. 24) first suggested the use of two types of metalpoint on this sheet and another in the Pierpont Morgan Library, New York (1951.1). See also Melli 2006, no. 22 and Melli (forthcoming).

66

1 C. Bernardini (Il Bagnacavallo Senior, Rimini 1990, pp. 24–5) suggests a link to Raphael's milieu.
2 Geiger 1986, pp. 89–113 (particularly p. 90).

67

1 Fossi (in Florence 1955), Shoemaker (1977, no. 105) and Goldner (in New York 1997, no. 99) date the drawing to the final phase of the frescoes, c. 1495–1500. Halm (1931, p. 410), Scharf (1935, no. 192), Neilson (1938, pp. 102–4) and Sale (1976, pp. 160, 257), on the other hand, date the drawing to the initial period of execution based on the similarity of the architecture to that of the Carafa Chapel (see no. 66). For the dating see also Fischer in Rotterdam 1990, pp. 261–5 and Cecchi in Florence 1992, no. 7.13.
2 See Nelson (Paris and Florence 2003, p. 91) for observations on Filippino's varying graphic style on the basis of function.

68

1 The view of Goldner (New York 1997, no. 100) in contrast to Byam Shaw (1976, no. 35).
2 Goldner (New York 1997, p. 17).

69

1 Vasari 1976, vol. 4, p. 116.
2 The mount was cut in line with the top of the sheet and replaced with an inscription by Mariette. A similar intervention is seen in no. 47.
3 Compare the face of Christ with that of the Virgin in a drawing at Christ Church Picture Gallery, Oxford (see New York 1997, no. 115).
4 Sold at Christie's, London, 23 June 1967; Berenson 1963, vol. 2, pl. 1158; Carpaneto 1970, p. 13.

70

1 Geronimus (2006, p. 340, no. 65) argues for the connection between no. 70 and the Horne St Jerome.
2 Vasari 1971, vol. 4, p. 62.
3 Meijer in Florence 2008c, no. 54.
4 Divided between the Uffizi, Florence and the National Gallery, London: Nuttall in Florence 2008c, no. 34. Other paintings by Memling of potential influence are Portrait of a young man, Metropolitan Museum, New York (ibid. no. 34). Meijer (Florence 2008c, under no. 54) relates the rocks in no. 70 to Memling's St Christopher triptych, Groeningemuseum, Bruges.
5 Russo 1987.

71

1 Technical data confirmed by XRF and Raman investigation.
2 The connection was made by Müntz (1898).
3 The painting's scholarly history is summarized by Fiorio (2000).
4 Janice Shell and Grazioso Sironi, 'Giovanni Antonio Boltraffio and Marco d'Oggiono: "The Berlin Resurrection of Christ with Sts Leonardo and Lucy"', *Raccolta Vinciana*, vol. 23, 1989, pp. 119–54.
5 Richter 1883, vol. 2, pp. 438–9.
6 Popham 1946, nos 69, 72–3, 77.
7 Müntz (1898) suggested that the head of St Leonard was based on one on a sheet of studies by Leonardo in the Uffizi dated 1478 (Popham 1946, no. 127). The resemblance between the two is fairly generic; nonetheless it does suggest that Leonardo's drawings may well have been used as a basis for the figures in the Berlin painting.
8 Fiorio 2000, no. A4.
9 Comparison with d'Oggiono's Berlin drapery study related to the Musée des Beaux-Arts, Strasbourg's *Visitation* (Sedini 1989, nos 64–5) supports Alessandro Ballarin's contention that the present work and the drapery study, also in Berlin, related to the Hermitage *Madonna Litta*, are both by Boltraffio; as reported in Fiorio 2000, no. B2.
10 Fiorio (2000, p. 138) first suggested that the drawing may be a collaborative work or by one artist based on a study by the other. She was unaware of the traced element of the drawing that makes this idea more plausible.
11 The imaging by Giovanni Verri also revealed a Milanese flower watermark like the one found on Leonardo's study of a leg (no. 57). The directions of the brush strokes in the application of the ground differ in the top and bottom half, presumably as a result of a new layer having been added below.

72

1 The drawing's critical history is given by Agosti in Florence 2001.
2 For Napoletano see Fiorio in Bora, Fiorio, Marani *et al.* 1998, pp. 199–210 and for the Master of the Pala Sforzesca see Marani in ibid. pp. 179–98. For the latter, the study by Romano, Binaghi and Collura (1978) remains fundamental. The drawing's attribution to the Master of the Pala Sforzesca was made by Alessandro Ballarin in an unpublished paper given at a 1984 conference on Boltraffio.
3 Illustrated as fig. 79, p. 201 in Fiorio's essay in Bora, Fiorio, Marani *et al.* 1998.
4 Such as the metalpoint *Virgin and Child* in the British Museum, which is a study of a painting formerly in the Cora collection in Turin (Popham and Pouncey 1950, no. 292).
5 Attribution by Binaghi in Romano, Binaghi and Collura 1978, p. 28. The drawing is perhaps related to the artist's painting of the *Virgin and Child* in Berlin (fig. 29 in Marani's essay in Bora, Fiorio, Marani *et al.* 1998).

73

1 The attribution is that of Gustavo Frizzoni (1840–1919), but there is no record of when he made it.
2 For his graphic corpus see Mulazzani 1978.
3 I owe my knowledge of the drawing to its inclusion in Giovanni Agosti's memorable Uffizi exhibition (Florence 2001).
4 Suida's attribution (1953) to Bramante of the metal-point and white heightening on blue preparation *St Christopher* of *c.* 1490 in the Statens Museum for Kunst, Copenhagen, opens up the possibility that

Bramantino might on occasion have adopted this method of drawing, but whether it is by the artist is questionable.
5 Awareness of Mantegna's treatment of the theme in Lombardy is demonstrated by Vincenzo Foppa's painting of the subject, now in the Museo d'Arte Antica del Castello Sforzesco, Milan; illustrated in Brescia 2002, p. 196.
6 Suida (1953) dated the drawing after Rome, while Mulazzani (1978) suggested it was from the early 1500s. Giovanni Agosti, following Alessandro Ballarin's unpublished chronology, placed it *c.* 1495–1500. Charles Robertson kindly informed me that he believes that the drawing is coeval with the tapestries (*c.* 1501–8), on the basis of the similarities of certain details, such as the costume of the soldiers in *January*.

74

1 Robinson 1869, no. 324.
2 The attribution to Solario was first aired in Charles Loeser's 1897 review of the Malcolm exhibition following a suggestion made to him by the Sardinian writer Enrico Costa. For the critical history of the drawing see Brown 1987.
3 The painting is dated '15..', but the last digits have been erased.

75

1 Goldner 2004.; see also Faietti in Padua 2006, pp. 81–9.
2 The two other drawings are in the Royal Collection, Windsor Castle, and in the Frits Lugt collection, Institut Néerlandais, Paris; Steer 1982, nos 43–4.
3 The *Madonna and Child with six saints* (1480; Galleria dell'Accademia, Venice); *St John the Baptist and St Jerome* (Denver Art Museum, Denver, Colorado), in Steer 1982, nos 28, 12. From the differences in detail it is clear that the Lugt hands cannot have been copied from the finished paintings.
4 The position of the hand is not far from that of Christ in a painting of 1498 in the Brera, Milan; Steer 1982, no. 18.
5 For the Naples painting see Steer 1982, no. 19.
6 It is likely that Bellini also made brush drawings, but there are no absolutely certain examples of such works in his corpus.

76

1 By Giovanni Agosti in Florence 2001 no. 24.
2 The drawing's critical history is summarized succinctly by Agosti in ibid.
3 Goldner 2004, pp. 250–1.
4 Parker 1927, no. 57. Puppi in his 1962 monograph perversely rejected as autograph the Munich drawing and an equally characteristic drawing by Montagna in the same technique in the Louvre (8258), suggesting instead that they might be by his pupil Speranza.
5 Such as the figures in the altarpiece of 1496–1500 formerly in S. Monica, Vicenza, and now in the Brera, Milan; Puppi 1962, fig. 92 and M. Tanzi in Zeri 1990, no. 177. Agosti in Florence 2001 dated the drawing slightly earlier, comparing the drapery to that of St John the Baptist in the altarpiece of around 1485 formerly in S. Bartolommeo, Vicenza, and now in the Museo Civico, Vicenza; Puppi 1962, fig. 37.
6 The link between the two was made by Gustav Ludwig, according to Schönbrunner and Meder 1901.
7 For the date of the painting see Moschini Marconi 1962, no. 298; Meyer zur Capellen 1972, no. 78; and

Zampetti and Chiappini 1975, under no. 77. Secure examples of drawings by Previtali are not known, although if Rearick (2001, p. 45) is correct in attributing to him two chalk portrait studies in the Uffizi (685 E and 688 E) then it is impossible that he could have drawn the present study.

77

1 For the drawing's critical history see Agosti in Florence 2001. The painting is no. 160 in Humfrey's monograph (1983) on Cima.
2 Popham and Pouncey 1950, no. 18; Goldner 2004, pp. 236–8.
3 For discussion of Cima's formation see Humfrey 1983, pp. 25–6.
4 Humfrey 1983, no. 157.

78

1 It was first published as Cima by Hadeln (1925), although his name had been suggested at an earlier date in the British Museum's departmental register for the Malcolm collection, where the entry reads: 'Venetian School (Manner of Cima ?).'
2 The earliest example seems to be the figure of St Peter in the Olera polyptych, Bergamo, of *c.* 1486–8; Humfrey 1983, no. 108.
3 Favaretto, De Paoli and Dossi (eds) 2004, no. III.6.
4 In such works as the tomb of Doge Andrea Vendramin of *c.* 1488–94 in SS. Giovanni e Paolo, Venice, and in the reliefs they produced for the Cappella dell'Arca in the Santo, Padua.
5 Humfrey (1983) dated it slightly earlier, *c.* 1485–90, while Hadeln (1925) thought it was a late work. The two paintings are nos 165 and 73 in Humfrey's monograph.
6 In the predella of the high altar in the cathedral at Ascoli (1473), and in a panel now in the El Paso Museum of Art (Kress Collection), Texas, probably from an altarpiece painted in 1482 for the convent of S. Francesco, Force; Lightbown 2004, figs 52, 125.

79

1 For the original arrangement of the cycle see Fortini Brown 1988, pp. 288–9.
2 The Venetian *piede* was 34.8 cm; see Zupko 1981, p. 196.
3 The last canvas is smaller, 139 × 285 cm, including a made-up section on the left added to fill a gap left open for a doorway.
4 The differences between the painting and the drawing are most fully analysed in Brooke's 2004.
5 As was first noted by Sidney Colvin (1897, pp. 193–4). Carpaccio used the prints from Breydenbach's publication as a source for buildings in the St Ursula cycle for the Scuola di Sant'Orsola executed in the 1490s (Lauts 1962, nos 1–9) and in the cycle executed for the Scuola di S. Stefano painted between 1511 and 1520 (ibid. nos 26–30).
6 The leftmost figures are the subject of a drawing in the University Art Museum, Princeton; Muraro 1977, pp. 73–5, fig. 15.
7 The sloppily drawn tower in pen and ink over black chalk on the verso is also inspired by one of the woodcuts in Breydenbach's book. The studies on the verso are accepted as autograph by Lauts (1962), while Muraro (1977) believes the penwork to be later. In my view the drawings are more likely the work of an assistant imitating his master's free adaptation of the woodcuts in the book.

80

1 Lauts 1962, nos 12–13.
2 By Helen Roberts (1959).
3 The level of finish led Muraro (1972) to think that it was made after the painting for documentary purposes. This seems unlikely on two counts. First, it seems improbable that Carpaccio should need to make such a detailed record of a painting he knew would remain in Venice; in addition the highly unusual subject matter would not make it a composition that could readily be recycled.
4 Muraro 1977, fig. 18. The most recent opinion that the blankness of the drawn figure is related to the figure of Agostine in the fresco being a portrait is offered by Gentili (1996, pp. 85–90). His argument demolishing the suggestion that Carpaccio portrayed the Byzantine cleric and patron Cardinal Bessarion is entirely convincing, but it is impossible for want of any comparable portraits to know if his alternative identification of Angelo Leonino, Bishop of Tivoli, who granted an important indulgence to the scuola in 1502, is correct. Although most scholars assume it must be a portrait, the features of the saint are remarkably similar to those of other male figures in Carpaccio's work; see for example those in his *Salvator Mundi and the Four Evangelists* in the Contini Bonacossi Collection, Florence, or the St Roch in his altarpiece of 1516 in Capodistria Cathedral (Lauts 1962, nos 49, 39).
5 This observation goes against Gentili's suggestion (1996, p. 66) that the scene is set after sunset.
6 My analysis of the drawing is indebted to Caroline Brooke's excellent recent article (2004).

81

1 A good example of the uncertainty in connecting Carpaccio's drawings to his work as a painter is the double-sided drawings in the Frits Lugt Collection, Paris; see Muraro 1977, pp. 72–3.
2 For example, the studies of three bishops in the British Museum (Popham and Pouncey 1950, no. 32; Muraro 1977, fig. 3) are, in my opinion, a simplified record after the figures in *The Arrival of St Ursula* in Rome of *c.* 1490–8 now in the Galleria dell'Accademia, Venice, and not a study for it. For each figure Carpaccio completed the pose obscured in the painting by overlapping figures so as to make them useful models for future reference.
3 Such as the two studies in the Uffizi; Muraro 1977, figs 27–8. An approximate dating of the second of these (1471 E) is supplied by the recto, which is connected to a lost or never realized *Judgement of St Stephen* for the Scuola di S. Stefano cycle, begun in 1511 and completed in 1520. Carpaccio's brush drawings from the 1490s, such as the study in the National Museum of Fine Arts, La Valletta, Malta, related to the St Ursula cycle (Muraro 1977, fig. 9), are generally more linear and delicate in the handling of the wash and white heightening. The late dating of the present work was opposed by Muraro, who followed Colvin (1897, p. 203) in thinking it to have been executed in the 1490s. The quality of the verso is in the author's view higher than the Carpaccio studio copies, such as the one in the Isabella Stewart Gardner Museum (Muraro 1977, figs 76–7).
4 See Muraro 1977.
5 Comparable heads in profile are found in his St Ursula and St Stephen cycles. A more plausible candidate as a portrait drawing by Carpaccio is the fine black chalk drawing in the Uffizi (Muraro 1977, fig. 50) that Lauts doubted for lack of comparable works (1962, no. D 19).
6 Popham and Pouncey 1950, no. 32; Muraro 1977, fig. 16. Lauts connected this study to Carpaccio's

painting *Dead Christ with the Virgin, St John and Joseph of Arimathaea* in the Contini Bonacossi Collection, Florence, executed *c.* 1495 according to Lauts, or to *c.* 1515 according to Muraro (Lauts 1962, pl. 50).

82

1 The false Dürer monogram in the top left corner mentioned by Popham (1928) is no longer extant. It was probably lost when the drawing was taken out of the British Library album, an operation that resulted in the upper corners needing to be repaired.
2 The drawing was most likely pasted in the album after it had entered the British Museum.
3 It was the British Museum curator and later Keeper of Prints and Drawings, A.E. Popham, who made the discovery and first published it in 1928.
4 Ferrari 2006, D 2–5. I have not counted the *Christ in a Swiss private collection* (Ferrari's D 1), as the attribution to Barbari does not, at least to my eyes, appear at all certain.
5 For Mantegna's use of coloured washes, see no. 22; a drawing with watercolour by Montagna was sold at Sotheby's, New York, 25 January 2006, lot 40. The development of natural history and botanical drawings in Italy is covered in Pächt's seminal 1950 article.
6 Almost 30 years later in a letter of 1523 Dürer still recalled Barbari showing him a drawing of two figures; see Ferrari 2006, doc. 21. Koreny in Vienna 1985 argues that it was Barbari who inspired Dürer to use watercolour to study dead birds, like the *Pochard hanging from a nail* in the Museu Calouste Gulbenkian, Lisbon (no. 7 in Vienna 1985).
7 No. 43 in Vienna 1985.
8 The only other Italian drawing in this medium generally reckoned to have been inspired by Dürer is the landscape in the Uffizi traditionally attributed to the Venetian painter Marco Basaiti (1700 F; no. 43 in Venice 1999). The attribution is impossible to verify as Basaiti is otherwise unknown as a draughtsman. The truncation of the composition on one side with a straight edge denotes that it is most likely a copy after a painted or drawn landscape, rather than one taken directly from nature.

83

1 See Allen in Los Angeles 1999, p. xv, and Agosti in Florence 2001, p. 26.
2 This was first noted by Pasquale Nerino Ferri in a manuscript note dated 1883. For the most recent discussion of the painting see Cavalca in Ferrara 2007, no. 151.
3 So-called because the altarpiece was commissioned for the Griffoni Chapel in S. Petronio in Bologna. The work was dismembered in the 18th century. The main panels were executed by Francesco del Cossa, one of which, *St Vincent Ferrer*, is now in the National Gallery, London.
4 Turrill 1986, p. 265.
5 Allen in Los Angeles 1999, pp. xix–xx.

84

1 See Bologna 1988, pp. 268–70; Faietti 1994a, pp. 197–207; Agosti in Florence 2001, pp. 291–301; Faietti in Bologna 2002, pp. 66–7.
2 Frizzoni (1876); Charles de Brosses saw this painting during his trip to Italy in the 18th century. On the painting see Negro and Roio 2001, no. 34 (with previous bibliography).
3 Brown 1966, pp. 140–1.
4 Christ Church Picture Gallery, Oxford (Byam Shaw 1976, no. 861; Baker in Oxford 2008, pp. 154–5).

5 Faietti in Bologna1988, pp. 269–70. See also Marini in Venice 2007, no. 2 (with previous bibliography).
6 This stylistic development followed his early career in Ferrara under the influence of Tura and Cossa and his subsequent sharing of the artistic arena in Bologna with Francesco Francia. A recent explanation of Costa's reputed critical disfavour judges the influence to run in the opposite direction. See Roio 2002, pp. 39–58.

85

1 See Faietti in Bologna 1988, no. 71, with previous literature.
2 On the attributional history of the drawing see Faietti 1994a, pp. 203–4.
3 On the engraving see Faietti in Bologna 1988, no. 69.
4 Popham and Pouncey 1950, no. 43 (1881,0709.76).

86

1 6 January 1674; see Fileti Mazza 1993, vol. 1, p. 47; vol. 2, pp. 552, 965, no. 1.
2 See the separate portraits of Agnolo Doni and Maddalena Doni, both in the Galleria Palatina in Florence.
3 Franzoni 1990, pp. 305–6.
4 Bartsch XIV,349,469: Faietti in Bologna 1988, pp. 123–5, no. 17.
5 Faietti 1995, pp. 89–94.
6 Id. 2004, pp. 51–74.
7 Published in 1513: Achillini 1513, carta CLXXXVII verso.
8 Described in Alberti 1588, carta 339 recto and verso.
9 Title translated from Latin: *Quaestio de subiecto physionomiae et chiromantiae*. Published in Bologna by Giovanni Antonio Benedetti, this was a methodological introduction to Bartolomeo Della Rocca's compilation published the following year, *Chyromantiae et Physionomiae Anastasis* (see Zambelli 1978, pp. 61–2).
10 Aspertini's portraits tend to be dated towards the end of the first decade and into the second decade of the 16th century.
11 Beroaldo was close to Francesco Francia (Faietti 1994, p. 9).
12 Zacchi in Bologna 2008, no. 106 (not exhibited).
13 Published posthumously by Girolamo Benedetti, ed. Giovanni Achillini.
14 Recently exhibited: see Urbini in Bologna 2008, no. 143.
15 Faietti 2009, p. 61. Giovio's *Elogia* in part corresponded to his collection of portraits in his Como villa.

87

1 On Fra Bartolommeo's use of pen and wash see Fischer in Florence 1996, p. 13.
2 Vasari 1976, vol. 4, p. 89. Sandberg-Vavalà (1929, p. 9) related this composition to five analogous drawings, only one of which in the Graphische Sammlungen, Munich (inv. 2160 r.), is accepted by Fischer as an early work (Fischer in Florence 1986, p. 34). Fischer (in Florence 1986, no 5, fig. 8) notes a similar Virgin and Child to no. 87 on the recto (to the upper left) of another sheet in the Gabinetto Disegni e Stampe degli Uffizi, Florence (inv. 1244 E).
3 The Child Baptist and an angel are also seen in a sheet in the Ashmolean, Oxford (inv. P.II.14), see Bambach in New York 2003, no. 15r and a sheet in the British Museum, 1856,0621.1 (ibid., p. 144, figs 71–2).
4 As seen in two sheets in the Uffizi, inv. nos 373 E and 147 E respectively.
5 Fischer 1982, figs 1, 10, 14–16.

6 Related to the grotesque pilaster decoration in the *Annunciation* in Volterra (Knapp 1903, p. 292, fig. 11), although the summary character of the drawing does not allow for a precise link to be made.

7 Inv. RF 5552 (Fischer in Paris 1994, no. 6).

8 One of the paintings is in the Staatliche Museen, Berlin (Geismeier, Nützman and Michaelis 1990, p. 13, no. 16), the other formerly in the Benson Collection, London. For the stylistic analysis, iconography and attribution of the two paintings see Fischer in Paris 1994, p. 27; id. in Florence 1996, pp. 77–9, no. 14.

88

1 Vasari 1976, vol. 4, pp. 90–1; Holst 1974, p. 315. The contract dated 22 April 1499 stipulated the subject of the fresco and that the work should be completed by 4 July of the same year. The fresco was badly damaged by damp in the lower half and was repainted by Matteo Rosselli in 1628 (Bagnesi Bellincini 1909, p. 63). The cloister was demolished in 1657 and the fresco moved in nine portions to another site within the hospital. The continuing poor conservation of the fresco caused its lifting in 1781 and mounting on a gesso ground over a metal frame, in turn restored in the 1980s (see Fischer 1990, pp. 181–3; Damiani in Florence 1996, pp. 163–72, no. 44).

2 Inv. N 77, N 67; Fischer in Rotterdam 1990, no. 6. See also Fischer in Florence 1986a, pp. 42–4, no. 9.

3 Gabelentz 1922, vol. 1, pp. 139–40; Fischel 1929; Holst 1974.

4 Vasari 1976, vol. 4, p. 107. On Albertinelli's intervention see Holst 1974, p. 316 and Fischer in Florence 1986a, p. 43, no. 10.

5 See Fischer in Florence 1996, p. 14, and also pp. 13–17 for a discussion of the artist's graphic technique.

89

1 Scientific investigation conducted for this exhibition using ultraviolet-reflected false colour displays a restoration in zinc or titanium white on the lower edge of the fresco beneath Christ's right knee.

2 Boubli 2003, pp. 31–2. On the artist's working method see also Fischer in Florence 1986a, pp. 12–15; id. in Florence 1996, pp. 16–17.

3 Vasari 1976, vol. 4, p. 101, records Fra Bartolommeo's use of mannequins.

4 Ibid. p. 89.

5 Viatte in Paris 1989, no. 24; id. in New York 2003, pp. 110–19; Bambach 2004. On the drawing of drapery in Renaissance Florence see Petrioli Tofani in Florence 1992, pp. 81–92 (with literature). On the history of Fra Bartolommeo's paintings in distemper, often of controversial attribution, see Fischer in Florence 1986a, pp. 32–3, no. 3 (with literature). Another fine example is in the British Museum, 1895,0915.488.

6 Leonardo da Vinci 1995, pp. 354–5.

90

1 Gronau 1957, pp. ii–v; Fischer in Rotterdam 1990, p. 375. Within this group of drawings there is also a sheet with copies from Dürer (Musée du Louvre, inv. RF 5565 r; Fischer 1989). On Fra Bartolommeo's landscapes and their provenance see Fischer's exhaustive contributions: Fischer 1989, pp. 301–42; id. in Rotterdam 1990, pp. 375–400 (with previous literature); id. in Paris 1994, p. 48. See also Turner in London 1986, no. 49; Bambach in New York 2009, no. 4.

2 The landscapes previously known amounted to a dozen or so, conserved in Oxford, Paris, Vienna and Florence; see Fischer 1989, n. 3, p. 335 with previous literature.

3 Fischer 1989, pp. 330, 334; id. in Rotterdam 1990, pp. 375–6; id. in Paris 1994, p. 48. Fischer has categorized five types of landscape within Fra Bartolommeo's landscapes: landscapes with monasteries, urban landscapes, landscapes with smallholdings, rocky landscapes, and landscapes copied from German and Flemish masters (Fischer 1989).

4 Fischer 1989, p. 344; id. in Rotterdam 1990, pp. 375–7; id. in Paris 1994, p. 48.

5 Fischer in Florence 1986a, p. 54; id. 1989, p. 329. Ellis (1990, pp. 12–13; 1993, p. 178) believes Fra Bartolommeo drew landscapes his entire career.

6 For a profile of Suor Plautilla Nelli see Faietti 2008a (with previous literature).

7 F.M.N. Gabburri, *Vite di pittori*, vol. 1, c. 872, Biblioteca Nazionale Centrale, Florence, MS. Palat. A.B. 95, Striscia 1378. On Gabburri see Turner 2003; Barbolani di Montauto 2006.

8 On the two albums acquired by the Museum Boijmans Van Beuningen, Rotterdam see Gronau 1957, pp. I–V; Fleming 1958, p. 227; Fischer in Florence 1986a, pp. 11–12; id. in Rotterdam 1990, p. 375 (with previous literature).

91

1 Hartt 1971, no. 21.

2 Another example is in Domenico di Bartolo's fresco of the *Distribution of Alms* (1440–44) in the S. Maria della Scala Hospital in Siena.

3 Tolnay 1943, no. 6; the Dürer sheet is in the Graphische Sammlung Albertina, inv. 3062 (Winkler 1936, pp. 64–5, no. 87). Dürer in turn would appear to have derived his figure from Gentile Bellini (Tietze and Tietze-Conrat 1937).

4 Yale MS 391.

5 Wilde suggested Masaccio or Ghirlandaio (1953, p. 2).

6 Tolnay 1974, p. 8.

7 Graphische Sammlung Albertina, inv. 116, R129 r. For the Albertina drawing see Hirst 1988, pp. 59–60 and id. in Washington and Paris 1988, no. 2. Hirst (in London 1994, p. 16) dates no. 91 to c. 1495–1500; Tolnay (1975) even earlier, to 1490–2.

8 Wilde (1953, no. 1) dated the sheet to 1501–3, when Michelangelo was working on the two apostle sculptures for the Piccolomini Chapel in Siena Cathedral.

9 Chapman in London 2005, p. 117. Hartt (1950, p. 242) considered the head to be for the sculpture of the Virgin in the Medici Chapel and thus dated to the 1520s. Tolnay (1975) suggested the head could be preparatory for Lazarus in Sebastiano del Piombo's painting *The Raising of Lazarus* in the National Gallery, London, based on drawings by Michelangelo dated 1516. The use of many media seen here is consistent with Michelangelo's style.

10 For Wilde (1953, pp. 3–4) the head is close (in reverse) to both the partially destroyed *ignudo* above the *Delphic Sibyl* and *Adam*.

92

1 See N. Baldini, '*Quasi Adonidos hortum*. Il giovane Michelangelo al giardino mediceo delle sculture', in Florence 1999, pp. 49–56.

2 In 1509 Julius II transported the *Apollo* to the Vatican where in 1511 it was displayed in the sculpture courtyard (Haskell and Penny 1982, pp. 148–51).

3 Chapman in London 2005, p. 88. Carmen Bambach (1997, p. 68) draws attention to Perrig's failure to account for this autograph inscription when attributing the sheet to Cellini.

4 Cellini, *La Vita*, book 1, ch. 12 (consulted ed. G.G. Ferrero ed., *Opere di Benvenuto Cellini*, Turin 1971, p. 82).

5 For Tolnay (1975, p. 59) no. 92 recto follows nos 93–4, although he agrees with dating no. 92 to 1503–4, as does Echinger-Maurach 1998, pp. 331–8.

6 Berenson (1961, p. 274) also saw no link between these studies and the *Bruges Madonna*. The child to the top right is similar to the Christ Child in a sheet in Berlin (Kupferstichkabinett, Staatliche Museum, Berlin, inv. 1363).

93

1 M. Buonarroti, *Rime* (Girardi ed.), 1967, no. 1 (trans. Saslow 1991, no. 1).

2 Rather than Michelangelo copying a motif by Leonardo, as Kenneth Clark supposed (Clark 1935, vol. 1, p. XLIII).

3 Milanesi 1875, p. 624. Michelangelo only began to sculpt the figure after the arrival of the marble block in Florence in March 1506 (Amy 2000). After Michelangelo's departure to Rome in 1508 the sculptures were allocated instead to Jacopo Sansovino, Benedetto da Rovezzano, Baccio Bandinelli and Andrea Ferrucci.

4 The pose is inspired by Donatello's early sculpture of a *Bearded Prophet* for the campanile of Florence Cathedral.

5 Wilde 1953, p. 6.

6 Cordellier 1991. See also Echinger-Maurach 1998, p. 321. The drawing was described as anonymous 17th-century Italian, 'St John the Evangelist', in M. d'Arleux, *Inventaire manuscript des dessins du Cabinet des dessins du Louvre*, 1797–1827, no. 7359. A wooden polychrome sculpture of the Evangelist by the Castilian artist Alonso Berruguete (c. 1488–1561) is based on Michelangelo's composition (perhaps known through a lost three-dimensional model) and also suggests the identity of Michelangelo's apostle in these studies to be St John the Evangelist (Joannides 2003). It is significant that no. 93 has a French provenance.

7 Discussed by Cordellier 1991, p. 52.

8 Observed by Hirst (1988, p. 62) in relation to drawings for the sculptures for the Medici Chapel.

9 Uffizi 613 E and British Museum 1887,0502.116 (Wilde 1953, no. 6). Frey (1909–11, vol. 3, no. 13b) first made this link.

94

1 Ferri first listed the drawing as a copy and then as school of Michelangelo following Berenson (1903, vol. 2, no. 1625), who then accepted the black chalk nude as autograph in his second edition (1938). It was subsequently given to Michelangelo in an undated archival note (Petrioli Tofani 1991, p. 104), an attribution confirmed by Barocchi (1962) and most authorities subsequently, including Tolnay.

2 Hirst in Washington and Paris 1989, p. 18; Théberge in Montreal 1992, pp. 86, 88, no. 1. The engraving is Bartsch XIV.318.423. Veneziano also engraved the figure alone (Bartsch XIV.344.463).

3 Berti 1965, vol. 2, no. 34, n. 22.

4 The motif also appears in *The Flood* on the Sistine Chapel ceiling.

5 For Tolnay the capitals anticipate those for the Palazzo dei Conservatori on Rome's Campidoglio of 1563 (Tolnay 1975, p. 53, no. 37).

6 Tolnay in Florence 1975, p. 20, no. 3.

7 Wilde 1953, p. 8. The house, '*in Pitti, difaccia al monastero del Cestello*', built by Michelangelo and Simone del Pollaiuolo called Cronaca, no longer exists.

8 Echinger-Maurach 1991, pp. 69, 305; id. in Florence 1999, no. 2; Joannides 2003, no. 5. Chapman (in London 2005, p. 73) associated them with the niches

in the lower tier of the Piccolomini Chapel in Siena Cathedral.

9 The lines were noted by Echinger-Maurach in Florence 1999, no. 2, p. 174.

10 Hirst (1988, p. 32) and Echinger Maurach (in Florence 1999, no. 2) discern a sixth diminutive study, but the present author has been unable to do so.

11 The verso was considered autograph by Wilde (1953, p. 5, n. 1) and apocryphal by both Dussler (1959, no. 488), who dates it to c. 1515, and Hartt (1971, no. 24).

12 Barocchi in Florence 1964, no. 5. There is a study for Michelangelo's bronze *David* in the Louvre (Joannides 2003, no. 4).

13 Suggested by Cordellier (1991, p. 52, n. 48). I am grateful to Marzia Faietti and Piera Giovanna Tordella for having examined this sheet with me.

95

1 Vasari 1987, vol. 6, p. 108.

2 Thornton and Warren 1988.

3 Barocchi (1962, vol. 1, pp. 3–6) considers the figure on no. 94 recto a moment of passage between no. 95 and the cartoon.

4 Musée du Louvre, Département des Arts graphiques, inv. 718 (r.); Berenson 1938, no. 1598. Joannides 2003, no. 9 (r.) (for whom the recto is perhaps related to a lost composition, *The Martyrdom of the Ten Thousand*).

5 See Salvini (1971, p. 137) on Michelangelo's 'contamination' of his antique visual sources.

6 See Wilde 1953, no. 5, for the various interpretations of this group.

7 The lines to either side of the centre nude have been interpreted as wings, a motif that would not have accorded with a battle scene (see ibid. p. 10).

8 Tolnay 1974, p. 11, judged this sketch to have been made in 1506 after the statue but this would seem unlikely, especially given the underdrawing, adjusted in pen and ink.

9 Documents show that Michelangelo received an advance for the sculpture in December 1503 and that it was probably completed by 31 January 1506, in which year it was sold to the 'Moscheroni' (Mouscron) family for 4,000 Dutch florins.

10 M. Buonarroti, *Rime* (Girardi ed.), 1967, no. 2: 'I alone keep burning in the shadows/ when the sun strips the earth of its rays;/ everyone else from pleasure, and I from pain,/ prostrate upon the ground, lament and weep.' (trans. Saslow 1991, no. 2).

11 Girardi 1967, Appendix, no. 10.

12 Berenson 1938, fig. 533.

96

1 XRF has shown that the profile at the lower right was drawn in leadpoint.

2 Meyer zur Capellen 2001, no. 11.

3 A likely model for Raphael's composition is devotional paintings by the Umbrian artist Pintoricchio, who made several images of the Christ Child reading a holy text watched by his mother in the early 1490s; for example those in the North Carolina Museum of Art, Raleigh, and the Cleveland Museum of Art; see Scarpellini and Silvestrelli 2004, pls 22, 26.

4 For the inscription see Van Buren 1975.

5 For a recent discussion of the relationship between the two artists see Henry and Plazzotta in London 2004, pp. 15–34.

6 Palais des Beaux-Arts, Lille, 442; Joannides 1983, no. 34r. Further confirmation of this is provided by the earliest surviving study for the painting, a quick compositional pen drawing in the Ashmolean Museum, Oxford, in which the Virgin's features differ little from those in this study (ibid. no. 32r).

7 Ibid. no. 34r.

97

1 Meyer zur Capellen 2001, no. 13. The description of the drawing as a study for a cartoon was first made by Carmen Bambach (1999).

2 Giovanni Paolo Lomazzo's *Trattato dell'arte della pittura, scultura et architetettura* (1585) refers to the painting as having been made for the Duke of Urbino; Shearman 2003, p. 1313. For the circumstances of the commission see Shearman 1970, n. 22, p. 77; Cecil Clough's slightly different interpretation is reported in Ferino Pagden's entry on the drawing in the 1984 Florence exhibition.

3 For the date of Guidobaldo's election see Clough 1967, p. 206.

4 For further evidence of such a journey see Shearman 1977, p. 132.

5 For Raphael and Michelangelo see Henry and Plazzotta in London 2004, pp. 37–8. Examples of Michelangelo's hostility to showing his drawings are given in Chapman in London 2005, p. 27.

6 For images of the panel's underdrawing see London 2002, no. 8. A slightly later example of Raphael painting a landscape around figures prepared with a cartoon is the *Madonna del Cardellino* in the Uffizi.

7 As was observed by Bambach (1999a, pp. 96–7); she gives other examples of pricked drawings having been pounced from both sides.

8 Béguin 1987, pl. 229a.

98

1 Meyer zur Capellen 2001, no. 33.

2 Ibid. no. 36.

3 Ibid. no. 23.

4 Ibid. no. 37.

5 The drawing on the verso was first noted by Satoko Tanimoto and Giovanni Verri.

6 A similar pose but in reverse is found in a drawing in the Albertina, Vienna (Joannides 1983, no. 181), which shares so much with the present drawing that they must surely have been executed at much the same time.

99

1 Meyer zur Capellen 2001, no. 31.

2 Joannides 1983, nos 124–42, 148v, 158v.

3 The two Perugino paintings are the *Resurrection* (Vatican Pinacoteca), commissioned in 1499, and his *St John the Baptist and four Saints* (Galleria Nazionale dell'Umbria, Perugia); Scarpellini 1984, nos 100, 168, figs 177–181, 272. In addition Perugino had also been commissioned in 1505 by Giuliano and Sinibaldo Martinelli to paint an altarpiece for the church; however the resulting work, the *Martyrdom of St Sebastian* (Galleria Nazionale dell'Umbria, Perugia; Scarpellini 1984, no. 201, fig. 309) was only finished in 1518. For details see A.M. Sartore, 'Nuovi documenti su alcune committenze a Perugino in Perugia', Perugia 2004, pp. 603–5.

4 A recent summary of Raphael's sources for the painting is given by S. Settis in Rome 2006, pp. 87–101.

5 The circumstances of the commission are well expounded in Nagel 2000, pp. 113–35.

6 For Raphael's use of units of scale in the *Entombment* drawings see E.-S. Kang and M. Kemp in Rome 2006, pp. 77–85. I have been unable to detect the eight unit markings that they discern along the lower edge of the present drawing.

7 The dating of the sculpture was resolved in Amy 2000.

8 Joannides 1983, no. 130r. It has been suggested that Raphael's desire to refer to Michelangelo's figure may have been strengthened by the Baglioni chapel's dedication to St Matthew; Cooper 2001, p. 561.

9 Michelangelo's resentment at Raphael's debt to his work is voiced in his jibe, 'what he had of art, he had from me'; Shearman 2003, vol. 1, pp. 928–9.

100

1 Bambach (1999a, p. 122) notes that the crudeness of the pricking suggests it was not done in Raphael's workshop.

2 This observation on the two grids is once again due to Carmen Bambach (1999a).

3 For discussion of the underdrawing see Coliva in Rome 2006, pp. 56–7. The squaring and the absence of *spolveri* (dots of charcoal dusted through the pounced holes of a cartoon) argue in favour of Raphael not having made a cartoon of the whole design, although it would not exclude him having made a same-size drawing for important details such as heads.

4 Comparable pen-only squared drawings are the *Holy Family with a Pomegranate* of c. 1507–8 (Palais des Beaux-Arts, Lille), made for Domenico Alfani; Joannides 1983 no. 174r. Examples of pen-and-wash studies include the *Hosea and Jonah* of c. 1511–12 for the Chigi chapel in S. Maria della Pace, Rome, in the Armand Hammer collection, National Gallery of Art, Washington, and the Louvre design for the *Pasce Oves* Sistine Chapel tapestry of c. 1514–15; Joannides 1983 nos 297 and 360 respectively.

5 Coliva in Rome 2006, p. 56.

101

1 The woman's hairstyle recalls the early *Portrait of a Young woman with a mirror (Vanitas)* in the Bayerische Staatsgemäldesämmlungen, Munich (Wethey 1975, no. 37, fig. 34).

2 Wethey 1987, pp. 10–12.

3 J. Fletcher, 'Titian as a Painter of Portraits' in *Titian*, exh. cat., ed. D. Jaffé, National Gallery, London, 2003, p. 34.

4 Chiari Moretto Wiel (1989, p. 84, no. 8) also dates this drawing to 1511 in relation to the Padua fresco (see text and n. 5 below).

5 Rearick's suggestion was rejected by Muraro (1978, p. 132, n. 3) but accepted by Oberhuber (in Venice 1976, pp. 23–4, 43), who related the recto study to a sheet in the Fondation Custodia in Paris (inv. no. 1502), which he considered preparatory to the fresco. For the Custodia drawing see Chiari Moretto Wiel 1988, no. A-9, p. 66. Titian received his first payment for the frescoes in Padua on 23 April and the balance on 2 December 1511 (Rearick in Florence 1976, pp. 37–8, no. 16; id. 1977, pp. 179–80).

6 Ferri 1881a, p. 42. Among the contrasting attributions are Monneret de Villard 1904, p. 48 (Giorgione); Hetzer 1920, p. 132 (who questioned the attribution to Titian); Tietze and Tietze-Conrat 1944, no. A 1899 (Girolamo Romanino).

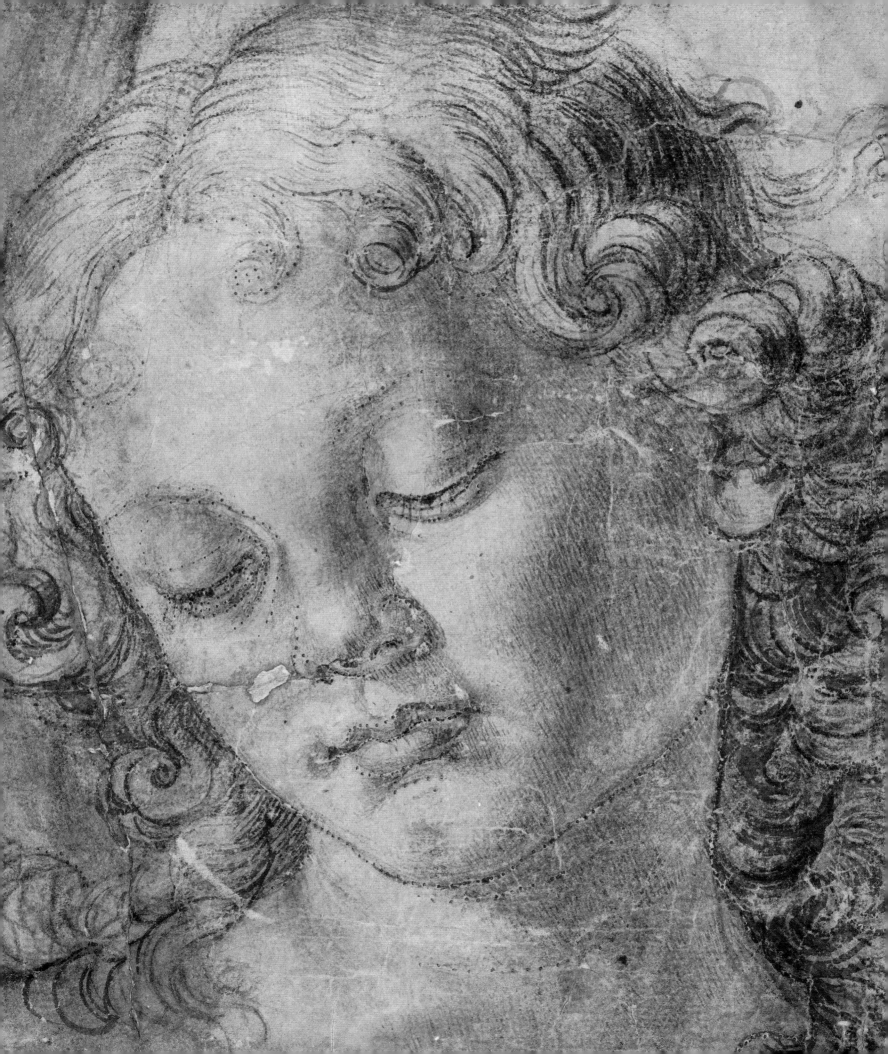

KEY TO UFFIZI PROVENANCES

These are the abbreviations used for the provenances of the catalogued drawings from the Gabinetto Disegni e Stampe degli Uffizi, Florence:

Reale Galleria degli Uffizi
This refers to the Uffizi stamp given to most of the drawings, followed by a Lugt number, a reference to F. Lugt, *Les Marques des Collections de Dessins et d'Estampes*, Amsterdam, 1921, with a supplement, 1956.

Fondo Mediceo (Nota 1687)
This is a manuscript inventory of the drawings in the late Cardinal Leopoldo de' Medici's albums and a separate group of 193 drawings. It is conserved in the Archivio di Stato, Florence. The inventorial reference is Guardaroba f. 779 (*Affari diversi*, insert no. 9, cc. 995–1027).

Fondo Mediceo (Elenco Bassetti 1699)
This is a manuscript inventory dated October 1699 of a group of objects received into Cosimo III's collection from Lorenzo Gualtieri. It is conserved in the Archivio di Stato, Florence. The inventorial reference is Guardaroba f. 1026 (*Quaderno Generale delle robe Fabbricate di S.A.S., primo*, B, 1696–1702, cc. 156–66 v).

Fondo Mediceo-Lorenese (Pelli after 1775–before 1784)
This is a manuscript inventory of drawings by G. Pelli Bencivenni written after 1775 and before 1784. It is conserved in the Gabinetto Disegni e Stampe degli Uffizi, Florence (ms. 102).

Fondo Mediceo-Lorenese (Ramirez 1849)
This is a manuscript catalogue of selected drawings in the Uffizi by A. Ramirez di Montalvo. It is dated 1 February 1849 and conserved in the Gabinetto Disegni e Stampe degli Uffizi, Florence (ms. 143).

Ferri, Disegni Esposti (1879–81)
This is a manuscript catalogue by P. N. Ferri of the drawings on public display in the Uffizi, dated 1879–81 and conserved in the Gabinetto Disegni e Stampe degli Uffizi, Florence.

Ferri, Disegni di Paesaggio (c. 1882)
This is a manuscript catalogue by P. N. Ferri of landscape drawings in the Uffizi. It is conserved in the Gabinetto Disegni e Stampe degli Uffizi, Florence.

Ferri, Disegni di Architettura (1885)
This is a catalogue of the Uffizi's architectural drawings by P. N. Ferri published in Rome in 1885 (*Indice geografico-analitico dei disegni di architettura civile e militare esistenti nella R. Galleria degli Uffizi*).

Ferri, Disegni di Figura (c. 1887)
This is a manuscript catalogue of the figure drawings 'in cases from no. 1 to no. 18,940' by P. N. Ferri. It is conserved in the Gabinetto Disegni e Stampe degli Uffizi, Florence.

Detail of no. 41 (opposite)

Scientific investigation

As part of the preparations for this exhibition, the Department of Conservation and Scientific Research of the British Museum (with support from The Andrew W. Mellon Foundation) undertook a comprehensive research project on the drawings. Many of the results have contributed to the entries in this catalogue. A simplified glossary of the technical terms used in the book, together with some methodological detail, is provided below. It should be stressed that all the types of examination used were non-contact, non-destructive and non-invasive, and posed no risk to the drawings.

IMAGING TECHNIQUES

Imaging techniques record the effects of the interaction between light and matter. They were used in this study to provide information about the materials of the drawings, their construction and their condition. Light is a form of radiation and is part of the electromagnetic spectrum. Three ranges – visible light, ultraviolet (UV) and infrared (IR) – were used in this study. Each type of electromagnetic radiation has a different wavelength, which is measured in nanometers (nm): for this study we define ultraviolet radiation as falling between 100 and 400 nm, visible light between 400 and 700 nm, and infrared radiation between 700 and 2000 nm.

Visible imaging

Visible imaging (more properly visible-reflected imaging) reproduces what can be seen by eye and provides a comparison for the interpretation of results obtained with other imaging techniques. Visible imaging using a raking light source – that is light shone at a steep angle to the surface (visible-raking imaging) – can also provide valuable information on the profile of the surface under investigation, while images taken under magnification, normally through a microscope provide evidence of details. Visible imaging using backlighting (visible-transmitted light), normally provided by placing the drawing on a light box, can give useful information about the condition of the drawing and show features such as watermarks.

Infrared imaging

Infrared (IR) radiation is reflected, absorbed and transmitted by surfaces in a similar way to visible light. However, IR radiation reacts with matter differently and is generally more penetrative. IR-reflected imaging records the IR radiation reflected from a surface. Some materials, such as iron-gall ink, which are opaque to visible light, are almost entirely transparent to IR radiation. In contrast, carbon-based black materials are completely opaque to both visible light and IR radiation. IR imaging can often be used to reveal carbon-based underdrawings (the initial sketches or preliminary drawings used by the artist) otherwise hidden below other materials.

Additionally, careful choice of specific energy ranges of IR radiation means that the degree of penetration of the surface can be controlled. This can help to characterize the behaviour of different materials and provide preliminary identifications of materials for further targeted investigations. For example, azurite and ultramarine, two commonly used blue pigments, show very different reflective properties in the IR (700–900 nm) range and, as already mentioned, iron-gall ink is transparent to IR radiation above 1000 nm. Two different IR ranges were used in this study, 800–1000 nm and 800–1700 nm. The images made in the 800–1000 nm range are referred to as Infrared-reflected images while those in the 800–1700 nm range are referred to as Infrared reflectographs (IRR image).

Ultraviolet imaging

Unlike IR radiation, ultraviolet (UV) radiation is not penetrative. This property makes UV radiation ideal for the characterization of the topmost layers on paintings or drawings. Ultraviolet-reflected imaging records the ultraviolet radiation reflected from a surface.

When irradiated with UV radiation, some materials emit visible light. This phenomenon, the 'glow in the dark' effect, is called UV-induced luminescence. The term luminescence refers to a photochemical property of matter and it includes a number of well known phenomena, such as fluorescence and phosphorescence. Generally, organic materials, such as paper, organic colourants, varnishes and organic binders, show luminescence properties.

ANALYTICAL TECHNIQUES

Two analytical techniques were used to examine the drawings, X-ray fluorescence spectroscopy and Raman spectroscopy. Given the right type of equipment both can be used to make measurements directly on a drawing. No sampling or contact is required, and no damage is caused by the analysis.

X-ray fluorescence spectroscopy (XRF)

X-ray fluorescence spectroscopy is a non-destructive technique for determining the elemental composition of a surface. The technique works by exposing an object to a beam of X-radiation. These X-rays interact with the surface, causing secondary X-rays to be produced. The secondary X-rays are detected by the equipment and displayed as a spectrum on a computer screen. The energy of the secondary X-rays is used to identify which elements are present at the surface while the peak heights indicate how much of each element is present. Unfortunately, it can be difficult to produce truly quantative analyses if the surface exposed to the X-ray beam is not flat or if there are variations in composition between interior and surface layers (for example where corrosion layers are present), or where there are very thin layers; in this study the analysis of very thin metal-point layers was particularly problematic. In general, XRF will only determine the composition of surface layers, but the penetration depth depends on the density of the material. In the case of the works catalogued here, the drawings and their preparatory layers are very thin and there is almost always some interference from the supports (either paper or vellum).

The greatest disadvantage of XRF in the context of this project is that it only provides evidence of which element(s) are present at the surface of an object; it will not give any further information at compound or molecular level, such as which elements are bonded together to form a particular substance. For example, although calcium was detected in many of the white preparation layers, it is impossible to differentiate between calcite (calcium carbonate), gypsum (calcium sulphate) and bone white (calcium phosphate) by XRF alone. Problems such as this can be resolved by Raman spectroscopy, which gives molecular information.

(Micro-) Raman spectroscopy

Raman spectroscopy is a non-destructive technique for determining the compounds present on a surface.

The technique depends on light scattering. In the case of the equipment used in this study it works by directing a very low energy laser beam at the surface of the object. Most of this light is reflected unchanged, but a small amount interacts with the material under analysis to produce scattered radiation of a different wavelength, a phenomenon termed 'Raman scattering'. The scattered light is collected and used to produce a spectrum. The amount of scattering (and change in wavelength it causes) is specific to the chemical bonds present in the molecules, so that these spectra provide a fingerprint by which the molecule can be identified against a reference database. For this work, areas of interest were located using an integral optical microscope (either horizontally or vertically). The fine focus and high power lenses used meant it was possible to select and individually identify single grains of pigments or other materials and hence to separate out the individual colours used in mixtures and to focus on the finest of lines.

SATOKO TANIMOTO AND GIOVANNI VERRI
Department of Conservation and Scientific Research, British Museum

Acidini Luchinat, C. (1980) 'Niccolò Gaddi collezionista e dilettante del Cinquecento', *Paragone* 31, 359/361, pp. 141–175.

— (2001) *Botticelli. Allegorie mitologiche*, Milan.

Achillini, G.F. (1513) *Viridario*, Bologna.

Adorno, P. (1991) *Il Verrocchio. Nuove proposte nella civiltà artistica di Lorenzo il Magnifico*, Florence.

Agosti G. (2005) *Su Mantegna I*, Milan.

Alberti, L.B. (1588) *Descrittione di tutta Italia* (1550), Venice.

— (1950) *Della Pittura*, ed. L. Mallè, Florence.

— (1960–73) *De Pictura*, in *Opere volgari*, ed. C. Grayson, Bari.

— (1966) *On Painting*, trans. J.R. Spencer, New Haven and London.

— (1972) *On Painting*, trans. C. Grayson, London.

— (1975) *De pictura*, ed. C. Grayson, Rome.

— (1980) *De pictura*, ed. C. Grayson, Bari.

Alinari XX (1978) *Biblioteca di Disegni. XX Maestri Toscani del Cinquecento (Fra Bartolommeo, Andrea del Sarto and their Followers: Albertinelli-Fra Paolino-Granacci-Sogliani-Franciabigio-Antonio di Donnino)*, intro. by J. Shearman, cat. by C. Coffey, Florence.

Allen, D. (1999), 'Some observations on Ercole de' Roberti as painter-draughtsman', in Los Angeles, pp. XV–XXIV.

Ames-Lewis, F. (1981a) *Drawing in Early Renaissance Italy*, New Haven and London.

— (1981b) 'Drapery "pattern"-drawings in Ghirlandaio's workshop and Ghirlandaio's early apprenticeship', *Art Bulletin* 63, pp. 49–62.

— (1987) 'Modelbook drawings and the Florentine quattrocento artist', *Art History* 10, pp. 1–11.

— (1989) 'On Domenico Ghirlandaio's responsiveness to North European art', *Gazette des Beaux Arts* 114, pp. 111–22.

— (1992a) 'A northern source for Mantegna's "Adoration of the shepherds"', *Print Quarterly* 9, 3, pp. 268–71.

— (1992b) 'Drawing for panel-painting in trecento Italy: reflections on workshop practice', *Apollo* 135, pp. 353–61.

— (1995a) 'Benozzo Gozzoli's Rotterdam sketchbook revisited', *Master Drawings* 33, pp. 388–404.

— (1995b) 'Drawing for secular subjects in late quattrocento Florence', *Apollo* 142, 405, pp. 51–6.

— (2003) 'Benozzo Gozzoli e l'immagine di sé come artista', in *Benozzo Gozzoli: viaggio attraverso un secolo; convegno internazionale di studi (Firenze–Pisa, 8–10 gennaio 1998)*, ed. E. Castelnuovo and A. Malquori, Ospedaletto, Pisa, pp. 27–40.

Amy, M.J. (1997) 'Michelangelo's commission for "Apostle" statues for the Cathedral of Florence', Ph.D. thesis, New York University, New York.

— (2000) 'The dating of Michelangelo's *St Matthew*', *Burlington Magazine* 142, pp. 493–6.

— (2006) 'Michelangelo's drawings for "Apostle" statues for the cathedral of Florence', *Viator* 37, pp. 479–517.

Andaloro, M. (1980) 'Costanzo da Ferrara: gli anni a Costantinople alla corte di Maometto II', *Storia dell'arte* 38/40, pp. 185–212.

Argan, G.C. and B. Contardi (1990) *Michelangelo architetto*, Milan.

Armstrong, L. (1976) *The paintings and drawings of Marco Zoppo*, New York.

— (1993) "Marco Zoppo e il libra dei disegni del British Museum: riflessioni sulle teste "all'antica"', ed. B. Giovanucci Vigi, *Marco Zoppo: Cento 1433–1478 Venezia*, Bologna, pp. 79–95.

Aronberg Lavin, M. (1981) 'The joy of the bridegroom's friend: smiling faces in Fra Filippo, Raphael, and Leonardo', in *Art the Ape of Nature. Studies in Honor of H.W. Janson*, New York, pp. 193–210.

Bagnesi Bellincini, P. (1909) 'Due documenti sul Giudizio Universale di fra Bartolommeo', *Rivista d'Arte* 6, 1, pp. 62–5.

Baldini, U. (ed.; 1973) *L'opera completa di Michelangelo scultore*, Milan.

Baldinucci, F. (1845) *Notizie de' professori del disegno da Cimabue in qua,* Florence 1681–1728, Florence.

Bambach C. (1990) 'Book Review, M. Hirst, "Michelangelo and his Drawings"', *Art Bulletin* 72, pp. 493–8.

— (1997) 'A Review of A. Perrig, "Michelangelo's Drawings"', *Master Drawings* 35, 1, pp. 67–72.

— (1999a) *Drawing and Painting in the Italian Renaissance workshop: theory and practice, 1300–1600*, Cambridge.

— (1999b) 'The purchase of cartoon paper for Leonardo's "Battle of Anghiari" and Michelangelo's "Battle of Cascina"' in *I Tatti Studies: Essays in the Renaissance*, ed. W. Kaiser, Florence, pp. 105–33.

— (2004) 'Leonardo and drapery studies on "tela sottilissima di lino"', *Apollo* 159, 503, pp. 44–55.

Barbolani di Montauto, N. (2006) 'Francesco Maria Niccolò Gabburri "gentiluomo intendente al pari d'ogni altro e dilettante di queste bell'arti"', in *Storia delle arti in Toscana, Il Settecento*, ed. M. Gregori and R.P. Ciardi, Florence, pp. 83–94.

Barocchi, P. (1962) *Michelangelo e la sua scuola. I disegni di Casa Buonarroti e degli Uffizi*, 2 vols, Florence.

— and R. Ristori (1973) *Il Carteggio di Michelangelo*, Florence.

Bartoli, R. (1999) *Biagio d'Antonio*, Milan.

Bartsch, A. (1803–21), *Le peintre graveur*, 21 vols, Vienna.

Battisti, E. (1965) 'Il Mantegna e la letteratura classica', in *Arte, pensiero e cultura a Mantova nel primo Rinascimento in rapporto con la Toscana e con il Veneto: atti del 6. Convegno Internazionale di Studi sul Rinascimento, 1961*, Florence, pp. 23–56.

Baumgart, F. (1937) 'Die Jugendzeichnungen Michelangelos bis 1506', *Marburger Jahrbuch für Kunstwissenschaft* 10, pp. 209–62.

Baxandall, M. (1978) *Pittura ed esperienze sociali nell'Italia del Quattrocento*, Turin.

Beauvais, L. (2000) *Inventaire Général des Dessins École Française, Charles Le Brun 1619–1690*, Paris.

Béguin, S. (1987) 'Nouvelles recherches sur le "Saint Michel" et le "Saint George" du Museé du Louvre', in *Studi su Raffaello: atti del Congresso Internazionale di Studi*, ed. M.S. Hamoud and M.L. Strocchi, Urbino, pp. 455–64.

Bellori, G.P. (1976) *Le Vite de' Pittori, Scultori ed Architetti moderni*, ed. E. Borea, Turin.

Benzi, F. (2000a) 'Baccio Pontelli a Roma e il "Codex Escurialensis"', in *Sisto IV, le arti a Roma nel primo Rinascimento*, ed. F. Benzi, Rome.

— (2000b) 'L'autore del "Codex Escurialensis" identificato attraverso alcuni disegni erratici dell'Albertina di Vienna', *Römische historischeMitteilungen* 42, pp. 307–21.

Berenson, B. (1901–16) *The Study and Criticism of Italian Art*, 3 vols, London.

— (1903) *The Drawings of the Florentine Painters*, 2 vols, London.

— (1932) 'Due o tre disegni di Benozzo Gozzoli', *L'Arte* 35, pp. 90–103.

— (1938) *The Drawings of the Florentine Painters*, 3 vols, Chicago and London.

— (1961) *I disegni dei pittori fiorentini*, 2 vols, Milan.

— (1963) *Italian Pictures of the Renaissance. A List of the Principal Artists and Their Works, with an Index of Places: Florentine School*, 2 vols, London.

Berti, G. (2006) 'I cosiddetti "Tarocchi del Mantegna"' in Mantua 2006a, pp. 298–307.

Berti, L. (1965) 'I disegni' in *Michelangelo. Artista. Pensatore. Scrittore*, with contributions from C. de Tolnay et al., Novara.

— (1953) *Botticelli, I Grandi Maestri del Disegno*, Milan.

Bertini, A. (1945) *Michelangelo fino alla Sistina*, Turin.

Bober, P.P. and R. Rubinstein (1986) *Renaissance Artists and Antique Sculpture*, London and Oxford.

Bora, G., M.T. Fiorio, P.C. Marani and J. Shell (1998) *The Legacy of Leonardo: Painters in Lombardy 1490–1530*, Milan.

Borgo, L. (1976) *The Works of Mariotto Albertinelli*, New York and London.

Borsi, F. and S. (1992) *Paolo Uccello*, Milan.

Borsi, S. (1985) *Giuliano da Sangallo. I disegni di architettura e dell'antico*, Rome.

Boubli, L. (2003) *L'atelier du dessin italien à la Renaissance. Variante et variation*, Paris.

Brinckmann, A.E. (1925) *Michelangelo Zeichnungen*, Munich.

Briquet, C.M. (1923) *Les filigranes: dictionnaire historique des marques du papier dès leur apparition vers 1282 jusqu'en 1600*, 4 vols, Leipzig.

Brooke, C. (2004) 'Vittore Carpaccio's method of composition in his drawings for the Scuola di S. Giorgio Teleri', Master Drawings 42, pp. 303–14.

Brown, C.M. (1966) 'Lorenzo Costa', Ph.D. thesis, Columbia University, New York.

— and A.M. Lorenzoni (1996) '"Concludo che non vidi mai la più bella casa in Italia": the frescoed decorations in Francesco II Gonzaga's suburban villa in the Mantuan countryside at Gonzaga (1491–1496)', Renaissance Quarterly 49, pp. 268–302.

Brown, D.A. (1987) Andrea Solario, Milan.

— (1998) Leonardo da Vinci, Origins of a Genius, New Haven and London.

Brugnoli, M.V. (1964) Michelangelo, Milan.

— (1978) Michelangelo, Milan.

Budny, V. (1983) 'The sequence of Leonardo's sketches for "The Virgin and Child with Saint Anne and the Infant Baptist"', The Art Bulletin 65, pp. 34–50.

Buonarroti, Michelangelo (1967) Rime, ed. E.N. Girardi, Bari.

Burckhardt, R. (1905) Cima da Conegliano: ein venezianischer Maler des Übergangs vom Quattrocento zum Cinquecento, Leipzig.

Butterfield, A. (1997) The Sculptures of Andrea del Verrocchio, New Haven and London.

Byam Shaw, J. (1931) 'Seven sheets from a sketch-book by Antonio da Sangallo the Elder', Old Master Drawings 6, December, pp. 39–44.

— (1976) Drawings by Old Masters at Christ Church, Oxford, Oxford.

— (1978) Maestri veneti del Quattrocento: Stefano da Zevio, Pisanello, Jacopo Bellini, Antonello da Messina, Gentile Bellini, Giovanni Bellini, Mantegna (Biblioteca di disegni 3), Florence.

— (1983) The Italian Drawings of the Frits Lugt Collection, 3 vols, Paris.

Cadogan, J.K. (1983a) 'Linen drapery studies by Verrocchio, Leonardo and Ghirlandaio', Zeitschrift für Kunstgeschichte 46, pp. 27–62.

— (1983b) 'Reconsidering some aspects of Ghirlandaio's drawings', Art Bulletin 65, pp. 274–90.

— (2000) Domenico Ghirlandaio, Artist and Artisan, New Haven and London.

Callmann, E. (1974) Apollonio di Giovanni, Oxford.

Campbell, L. (1998) 'The making of early Netherlandish painted portraits' in The Image of the Individual. Portraits in the Renaissance, ed. N. Mann and L. Syson, London, pp. 105–12.

Campbell, S.J. (1997) Cosmè Tura of Ferrara: Style, Politics and the Renaissance City, 1450–1495, New Haven and London.

— (2006) The cabinet of Eros: Renaissance mythological painting and the Studiolo of Isabella d'Este, New Haven and London.

Carl, D. (1982) 'Zur Goldmiedfamilie Dei, mit neuen Dokumenten zu Antonio Pollaiuolo und Andrea Verrocchio', Mitteilungen des Kunsthistorischen Institutes in Florenz, no. 26, pp. 129–66.

— (1983) 'Documenti inediti su Maso Finiguerra e la sua famiglia', Annali della Scuola Normale Superiore di Pisa, Classe di Lettere e Filosofia, series 3, 13, 2, pp. 507–54.

Carpaneto, M.G. (1970) 'Raffaellino del Garbo: I parte', Antichità viva 9, 4, pp. 3–23.

— (1971) 'Raffaellino del Garbo: II parte', Antichità viva 10, 1, pp. 3–19.

Cassanelli, R. and E. Guerriero (2004) Iconografia e arte cristiana, Milan.

Castelli, P. (1996) 'Aby Warburg e Ghirlandaio: questioni di metodo', in Domenico Ghirlandaio 1449–1994, Atti del convegno Firenze 1994, ed. W. Prinz and M. Seidel, Florence, pp. 199–212.

Cavaciocchi, S. (ed.; 1992) Produzione e commercio della carta e del libro secc. XIII–XVIII, Atti della 'Ventitreesima Settimana di Studi' 15–20 aprile 1991, Prato.

Cecchi, A. (2005) Botticelli, Milan.

Cennini, C. (1960) The Craftsman's Handbook, trans. D.V. Thompson, New York.

— (1971) Il libro d'arte, ed. F. Brunello, Vicenza.

Ceri Via, C. (1987) 'I Tarocchi cosiddetti del Mantegna. Origine, significato e fortuna di un ciclo di immagini', in Ferrara 1987, pp. 49–75.

Chastel, A. (1964) Arte e umanesimo a Firenze, Turin.

Chiari Moretto Wiel, M.A. (1988) 'Per un catalogo ragionato dei disegni di Tiziano', Saggi e memorie di Storia dell'Arte, pp. 21–99, 211–71.

— (1989) Tiziano: Corpus dei disegni autografi, Milan.

Christiansen, K. (1993) 'The case for Mantegna as printmaker', Burlington Magazine 135, pp. 604–12.

Ciappelli, G. and P.L. Rubin (ed.; 2000) Art, Memory and Family in Renaissance Italy, Cambridge.

Cicogna, E.A. (1824–53) Delle inscrizioni veneziane, 6 vols, Venice.

Clark, K. (1935) A Catalogue of the Drawings of Leonardo da Vinci in the Collection of His Majesty the King, at Windsor Castle, Cambridge.

— and C. Pedretti (1968) The Drawings of Leonardo da Vinci in the Collection of Her Majesty the Queen at Windsor Castle, 3 vols, London.

Clough, C.H. (1967) 'The relations between the English and Urbino courts, 1475–1508', Studies in the Renaissance 14, pp. 202–18.

— (ed.; 1976) Cultural aspects of the Italian Renaissance: Essays in Honour of Paul Oskar Kristeller, Manchester.

Cocke, R. (1980) 'Masaccio and the Spinario, Piero and the Pothos: observations on the reception of the Antique in Renaissance painting', Zeitschrift für Kunstgeschichte 43, pp. 21–32.

Cole Ahl, D.C. (1996) Benozzo Gozzoli, New Haven.

Coletti, L. (1959) Cima da Conegliano, Venice.

Colvin, S. (1897) 'Über einige Zeichnungen des Carpaccio in England', Jahrbuch der Königlich Preussischen Kunstsammlungen 18, pp. 193–205.

— (1898) A Florentine picture-chronicle being a series of ninety-nine drawings representing scenes and personages of ancient history sacred and profane: reproduced from the originals in the British Museum … / by Maso-Finiguerra, London.

— (1911–12) The Vasari Society for the Reproduction of Drawings by Old Masters, 7, London.

Commissione Vinciana (1928–36) I manoscritti e i disegni di Leonardo da Vinci pubblicati dalla Reale Commissione Vinciana. Disegni a cura di Adolfo Venturi 1–4.

Condivi, A. (1998) Vita di Michelangelo, ed. G. Nencioni, Florence.

— (1999) The Life of Michelangelo, trans. A.S. Wohl, ed. H. Wohl, Pennsylvania.

Cooper, D. (2001) 'Raphael's altar-pieces in S. Francesco al Prato, Perugia: Patronage, setting and function', Burlington Magazine 143, pp. 554–61.

Cordellier, D. (1991) 'Fragments de jeunesse. Deux feuilles inédites de Michel-Ange au Louvre', Revue du Louvre et des Musées de France 41, 2, pp. 43–55.

— (1995) 'Documenti e Fonti su Pisanello', Verona Illustrata 8.

Covi, D.A. (2005) Andrea del Verrocchio, Life and Work, Florence.

Cropper, E. (ed.; 1994) Florentine drawing from the time of Lorenzo the Magnificent, papers from a colloquium held at the Villa Spelman, Florence 1992, Bologna.

Crutwell, M. (1906) 'Un disegno del Verrocchio per la "Fede" nella Mercatanzia di Firenze' in Rassegna d'Art, 6, pp. 8–10.

Dalli Regoli, G. (1960) 'Un disegno giovanile di Filippo Lippi', Critica d'arte 7, no. 39, pp. 199–205.

— (1966) Lorenzo di Credi, Milan.

— (1974) 'Piero di Cosimo. Disegni noti e ignoti', 1, Critica d'arte 21, no. 133, pp. 49–65.

— (1976) 'Il "piegar de' panni"', Critica d'Arte 41, pp. 35–48.

— (2004) 'Lorenzo di Credi e la pittura di devozione. Il Tondo Casati', Critica d'Arte 47, pp. 75–88.

— (2007) 'La fuggitiva. Una Giovane donna in fuga: problemi intorno a un disegno fiorentino del '400', Critica d'arte 69, pp. 7–59.

— and C. Pedretti (1985) I disegni di Leonardo da Vinci e della sua cerchia nel Gabinetto Disegni e Stampe degli Uffizi a Firenze, Florence.

Danti, C. (1996) 'Osservazioni sulla tecnica degli affreschi della Cappella Tornabuoni' in Domenico Ghirlandaio 1449–1994, ed. W. Prinz and M. Seidel, Florence, pp. 96–108, 141–49.

Davies, G.S. (1909) Ghirlandaio, London.

Davies, M. and D. Gordon (2001) The Italian Schools before 1400, London.

Degenhart, B. (1932) 'Die Schüler des Lorenzo di Credi', Münchner Jahrbuch der bildenden Kunst 9, pp. 95–161 (also published as an offprint, Munich).

— (1934) 'Eine Gruppe von Gewandstudien des jungen Fra Bartolommeo', Münchner Jahrbuch der bildenden Kunst 11, pp. 222–31.

— (1937) 'Zur Graphologie der Handzeichnung: die Strichbildung als stetige Erscheinung innerhalb der italienischen Kunstkrise', Kunstgeschichtliches Jahrbuch der Bibliotheca Hertziana 1, pp. 223–340.

— (1955) 'Dante, Leonardo und Sangallo (Dante Illustrationen Giuliano da Sangallos in ihrem Varhältnis zu Leonardo da Vinci und zu den Figurenzeichnungen der Sangallo)', Römisches Jahrbuch für Kunstgeschichte 7, pp. 101–287.

— and A. Schmitt (1968) Corpus der Italienischen Zeichnungen 1300–1450: Teil I: Süd- und Mittelitalien, 4 vols, Berlin.

— and A. Schmitt (1980) Corpus der Italienischen Zeichnungen 1300–1450: Teil II: Venedig, 1300–1400, addenda zu Süd- und Mittelitalien, 3 vols, Berlin.

— and A. Schmitt (1990) Corpus der Italienischen Zeichnungen 1300–1450, Teil II: Venedig, Jacopo Bellini, 4 vols, Berlin.

— and A. Schmitt (2004) Corpus der Italienischen Zeichnungen 1300–1450: Teil III: Verona, Pisanello und seine werkstatt, 2 vols, Berlin.

Delacre, M. (1938) Le dessin de Michel-Ange, Brussels.

Dempsey, C. (2003) 'L'amore e la figura della ninfa nell'arte di Botticelli' in Paris and Florence 2003, pp. 25–37.

De Nicolò Salmazo, A. (1993) Il soggiorno padovano di Andrea Mantegna, Cittadella.

— (2004) Andrea Mantegna, Geneva and Milan.

Di Giampaolo, M. (1989) Disegni emiliani del Rinascimento, Milan.

Dodgson, C. (1894) 'Ein Studienblatt des Vittore Pisano zu dem Fresko in S. Anastasia zu Verona', *Jahrbuch der Königlich Preussischen Kunstsammlungen* 15, pp. 259–60.

— (1923) *A book of drawings formerly ascribed to Mantegna: presented to the British Museum in 1920 by the Earl of Rosebery*, London.

Donati, L. (1958) 'Le fonti iconografiche di alcuni manoscritti urbinati della Biblioteca Vaticana', *La Bibliofilia* 60–1 pp. 48–129.

Dussler, L. (1959) *Die Zeichnungen des Michelangelo*, Berlin.

Dwyer, E.J. (1970–1) 'A note on the sources of Mantegna's "Virtus Combusta"', *Marsyas* 15, pp. 58–62.

Echinger-Maurach, C. (1991) *Studien zu Michelangelos Juliusgrabmal*, 2 vols, Hildesheim.

— (1998) 'Zu Michelangelos Skizze für den verlorenen Bronzedavid und zum Beginn der "gran maniera degli ignudi" in seinem Entwurf für den Marmordavid', *Zeitschrift für Kunstgeschichte* 61, pp. 301–38.

Ede, H.S. (1924) 'Two drawings by Antonio Pollaiuolo', *Burlington Magazine* 45, pp. 41–3.

Eisenberg, M. (1989) *Lorenzo Monaco*, Princeton.

Eisler, C. (1989) *The Genius of Jacopo Bellini, the Complete Paintings and Drawings*, New York.

Ekserdjian, D. (2006) *Parmigianino*, New Haven and London.

Elen, A.J. (1995) *Italian Late-Medieval and Renaissance Drawing-Books from Giovanni de' Grassi to Palma Giovane, a Codicological Approach*, Leyden.

Ellis, C.S. (1990) 'Two Drawings by Fra Bartolommeo', *Paragone* 479/81, pp. 3–19.

— (1993) 'Review of Fra Bartolommeo exhibition, Museum Boymans-van Beuningen, Rotterdam 1990', *Master Drawings*, vol. 31, n. 2, pp. 176–9.

Ettlinger, L.D. (1978) *Antonio and Piero Pollaiuolo*, Oxford.

Fabriczy, C. von (1902a) `Giuliano's da Sangallo figürliche Kompositionen', *Jahrbuch der Koniglich Preuszischen Kunstsammlungen* 13, Berlin, p. 105.

— (1902b) *Die Handzeichnungen Giuliano's da Sangallo: kritisches Verzeichnis*, Stuttgart.

— (1906) 'Review of G. Carotti, "Le opere di Leonardo, Bramante e Raffaello", Milan, 1905', *Reportorium für Kunstwissenschaft* 29, pp. 39–41.

Fahy, E. (1969) 'The earliest works of Fra Bartolommeo', *Art Bulletin* 51, 2, pp. 142–54.

— (1976) *Some Followers of Domenico Ghirlandaio*, New York and London.

Faietti, M. (1994a) 'L'influsso della cultura fiorentina nell'evoluzione stilistica del disegno bolognese tra la fine del Quattrocento e gli inizi del Cinquecento' in Cropper 1994, pp. 197–216.

— (1994b) '1490–1530: influssi nordici in alcuni artisti emiliani e romagnoli', in *La pittura in Emilia e in Romagna. Il Cinquecento. Un'avventura artistica tra natura e idea*, ed. V. Fortunati, Bologna, pp. 9–47.

— (1995) 'Capitolo sesto. Le frequentazioni dell'artista. Prolegomeni ad una futura ricerca', in *Amico Aspertini*, M. Faietti and D. Scaglietti Kelescian, Modena, pp. 89–94.

— (2004) 'Amico's friends: Aspertini and the Confraternita del Buon Gesù in Bologna' in *Drawing Relationships in Northern Italian Renaissance Art. Patronage and Theories of Invention*, ed. G. Periti, London, pp. 51–74.

— (2006) 'Andrea, disegnatore con "maschera"' in Padua 2006, pp. 81–9.

— (2006–7), 'Perugino disegnatore nel fondo storico degli Uffizi', *Proporzioni. Annali della Fondazione Roberto Longhi* 7/8, pp. 174–89.

— (2007) '"Aemulatio versus simulatio". Dürer oltre Mantegna' in Rome 2007, pp. 80–7.

— (2008a) '"In the shadow of the Friar": the Uffizi drawings attributed to Plautilla Nelli, in *Plautilla Nelli (1524–1588): the painter-prioress of Renaissance Florence*, ed. J.K. Nelson, Florence, pp. 99–117.

— (2008b) 'L'alfabeto degli artisti', in *Linea I. Grafie di immagini tra Quattrocento e Cinquecento*, ed. M. Faietti and G. Wolf, Venice, pp. 227– 45.

— (2009) 'Amico Aspertini Bologna', *The Burlington Magazine* 151, 1270, pp. 59–61.

— (forthcoming) 'L'uso della penna in alcuni disegni italiani del Quattrocento. Varietà fenomenologica e di significato', *Mitteilungen des Kunsthistorisches Institutes in Florenz*.

— and D. Scaglietti Kelescian (1995) *Amico Aspertini*, Modena.

— and G. Wolf (ed.; 2008) *Linea I: grafie di immagini tra Quattrocento e Cinquecento*, Venice.

Fara, G.M. (2007) *Gabinetto Disegni e Stampe degli Uffizi. Inventario Generale delle Stampe I. Albrecht Dürer: originali, copie, derivazioni*, Florence.

Favaretto, I., M. De Paoli and M.C. Dossi (ed.; 2004) *Museo Archeologico Nazionale di Venezia*, Milan.

Ferino Pagden, S. (1987) 'Perugino's use of drawings: convention and invention', in *Drawings Defined*, ed. W. Strauss and T. Felker, New York, pp. 77–102.

Ferrari, S. (2006) *Jacopo de' Barbari: un protagonista del Rinascimento tra Venezia e Dürer*, Milan.

Ferri, P.N. (1881a) *Catalogo dei disegni esposti al pubblico nel corridoio del Ponte Vecchio nella R. Galleria degli Uffizi con l'indice alfabetico dei nomi degli Artefici*, Florence.

— (1881b) *Catalogo delle stampe esposte al pubblico nella R. Galleria degli Uffizi con l'indice alfabetico degli incisori …*, Florence.

— (1890) *Catalogo riassuntivo della raccolta di disegni antichi e moderni posseduta dalla R. Galleria degli Uffizi di Firenze*, Rome.

— (1895–1901) *Catalogo dei disegni cartoni e bozzetti esposti al pubblico nella R. Galleria degli Uffizi ed in altri Musei di Firenze compilato da Pasquale Nerino Ferri ispettore preposto al Gabinetto dei disegni e delle stampe nella detta Galleria*, Florence.

Filarete (1965) *Filarete's Treatise on Architecture, being the Treatise by Antonio Averlino, Known as Filarete*, trans. J.R. Spencer, 2 vols, New Haven and London.

— (1972) *Trattato di architettura*, ed. A.M. Finoli and L. Grassi, 2 vols, Milan.

Fileti Mazza, M. (ed.; 1993) *Archivio del collezionismo mediceo. Il cardinal Leopoldo*, 2 vols, Milan and Naples.

— (2009) *Storia di una collezione. Dai libri di disegni e stampe di Leopoldo de' Medici all'Età moderna*, Florence.

Fiocco, G. (1933) 'Andrea Mantegna o Giambellino', *L'Arte*, New series 4, pp. 185–99.

— (1937) *Mantegna*, Milan.

Fiorio, M.T. (2000) *Giovanni Antonio Boltraffio: un pittore milanese nel lume di Leonardo*, Milan.

Fischel, O. (1917) 'Die Zeichnungen der Umbrer', *Jahrbuch der königlich preuszischen Kunstsammlungen* 38, vol. 1, pp. 1–72; vol. 2, pp. 1–188.

— (1929) 'Three unrecorded drawings for Fra Bartolommeo's *Last Judgment*', *Old Master Drawings*, vol. 4, pp. 33–6.

Fischer, C. (1982) 'Remarques sur *Le Mariage mystique de sainte Catherine de Sienne* par Fra Bartolommeo', *La Revue du Louvre et des Musées de France* 31, no. 3, pp. 167–80.

— (1989) 'Fra Bartolommeo's landscapes drawings', *Mitteilungen des Kunsthistorischen Institutes in Florenz* 33, 2/3, pp. 301–42.

— (1990) 'Fra Bartolomeo e il suo tempo', in *La chiesa e il convento di San Marco a Firenze*, Florence, pp. 179–211.

— (1996) 'Fra Bartolomeo disegnatore', in Florence 1996, pp. 13–17.

Fleming, J. (1958) 'Mr. Kent, art dealer, and the Fra Bartolommeo drawings', *The Connoisseur* 141, p. 227.

Fletcher, J. (1998) 'I Bellini' in *La bottega dell'artista tra Medioevo e Rinascimento*, ed. R. Cassanelli, Milan, pp. 131–53.

Fletcher, S. (2001), 'A closer look at Mantegna's prints', *Print Quarterly* 18, 1, pp. 3–41.

Forlani Tempesti, A. (1994) 'Studiare dal naturale nella Firenze di fine "400"', in Cropper 1994, pp. 1–16.

Forlani Tempesti, A. and A. Petrioli Tofani (1972) *I grandi disegni italiani degli Uffizi di Firenze*, Milan.

Förster, R. (1901) 'Studien zu Mantegna und den Bildern im Studienzimmer der Isabella Gonzaga. 1', *Jahrbuch der Preußischen Kunstsammlungen* 22, pp. 78–87.

Fortini Brown, P. (1988) *Venetian Narrative Painting in the Age of Carpaccio*, New Haven and London.

Fossi Todorow, M. (1966) *I disegno del Pisanello e della sua cerchia*, Florence.

Frantz, E. (1879) *Fra Bartolommeo della Porta: Studie über die Renaissance*, Regensburg.

Franzoni, C., 'Le raccolte del "Teatro" di Ombrone e il viaggio in Oriente del pittore: le "Epistole" di Giovanni Filoteo Achillini', *Rivista di letteratura italiana* 8, 2 (1990), pp. 287–335.

Frey, K. (1897) *Die Dichtungen des Michelagniolo Buonarroti*, Berlin.

— (1909–11) *Die Handzeichnungen Michelagniolos Buonarroti*, Berlin.

Frizzoni, G. (1876) 'Gli affreschi di S. Cecilia in Bologna', in *Il Buonarroti*, series 2, 11, pp. 215–31.

Fröhlich-Bum, L. (1916) 'Bemerkungen zu den Zeichnungen des Jacopo Bellini und zu seiner Kunst', *Mitteilungen der Gesellschaft für verfielfältigende Kunst, Beilagen der grafischen Künste*, 39, pp. 41–56.

—(1928) 'Studien zu Handzeichnungen der Italienischen Renaissance', *Jahrbuch der Kunsthistorischen Sammlungen in Wien*, new series, 2, pp. 163–98.

Fusco, L. (1979) 'Antonio Pollaiuolo's use of the antique', *Journal of the Warburg and Courtauld Institute* 42, pp. 257–63.

— (1982) 'The use of sculptural models by painters in fifteenth-century Italy', *Art Bulletin* 64, pp. 174–94.

Fusconi, G., A. Petrioli Tofani, S. Prosperi Valenti Rodinò and G.C. Sciolla (1992) *Drawing, the Great Collectors*, Milan.

Gabelentz, H. von der (1922) *Fra Bartolomeo und die florentiner Renaissance*, 2 vols, Leipzig.

Galassi, M.C. (1998) *Il disegno svelato. Progetto e immagine nella pittura italiana del primo Rinascimento*, Nuoro.

Galli, A. (2005) *I Pollaiolo*, Milan.

Gamba, C. (1914) *Disegni di Scuola Veneta dei Secoli XV e XVI*, Florence.

— (1936) *Botticelli*, Milan.

Gargan, L. (1978) *Cultura e arte nel Veneto al tempo di Petrarca*, Padua.

— (1992) 'Oliviero Forzetta e la nascita del collezionismo nel Veneto', in *La pitture nel Veneto: il Trecento*, ed. M. Lucco, 2 vols, Milan, pp. 503–16.

Garibaldi, V. (2004) *Perugino*, Cinisello Balsamo.

Gasparotto, D. (2002) 'Due note parmigianesche', *Aurea Parma* 86, pp. 379–90.

Gaurico, P. (1999) *De Sculptura,* ed. and trans. P. Cutolo, Naples.

Geiger, G.L. (1986) *Filippino Lippi's Carafa Chapel, Renaissance Art in Rome*, Kirksville.

Geismeier, I., H. Nützman and R. Michaelis (1990), *Staatliche Museen zu Berlin, Gemäldegalerie Malerei 13–18. Jahrhundert im Bodemuseum*, Berlin.

Gentile, A. (1996) *Le storie di Carpaccio, Venezia, i Turchi, gli Ebrei,* Venice.

Gentilini, G. (2004) 'Perugino e la scultura fiorentina del suo tempo', in *Pietro Vannucci il Perugino: atti del Convegno Internazionale di studio 25–28 ottobre 2000*, ed. L. Teza, Perugia, pp. 199–227.

Gere, J.A. (1953) William Young Ottley as a collector of drawings, *The British Museum Quarterly* 18, pp. 44–53.

Geronimus, D. (2006) *Piero di Cosimo: Visions Beautiful and Strange*, New Haven.

Ghiberti, L. (1947) *I commentari*, ed. O. Morisani, Naples.

Giglioli, O.H. (1928) 'Disegni italiani di paese nella Galleria degli Uffizi', *Dedalo* 9.

Gilbert, C.E. (1980) *Sources and Documents, Italian Art 1400–1500,* Englewood Cliffs.

Glasser, H. (1965) 'Artists' Contracts of the Early Renaissance', Ph.D. thesis, Columbia University, New York.

Goldner, G. (1989) 'A drawing by Desiderio da Settignano', *Burlington Magazine* 131, pp. 469–73.

— (1993) 'Review of *Andrea Mantegna*, ed. J. Martineau, 1992', *Master Drawings* 31, 2, pp. 172–6.

— (1994) 'A drawing by Masaccio: a study for the Brancacci chapel', *Apollo* 140, pp. 22–3.

(2004) 'Bellini's drawings', in *The Cambridge Companion to Giovanni Bellini*, ed. P. Humfrey, Cambridge, pp. 226–55.

Goldscheider, L. (1951) *Michelangelo Drawings*, London.

Gordon, D. (2003) *National Gallery Catalogues: the Fifteenth Century Italian Paintings, Volume I,* London.

Grassi, L. [1960] *I disegni italiani del Trecento e Quattrocento. Scuole fiorentina, senese, marchigiana, umbra*, Venice.

Gronau, C. (1957) *Catalogue of Drawings of Landscapes and Trees by Fra Bartolommeo, sold at Auction on Wednesday the 20th November ... at Sotheby & Co.*, London.

Habich, E. (1893) 'Handzeichnungen italienischer Meister in photographischen Aufnahmen von Braun and Co. in Dornach, kritisch gesichtet von Giovanni Morelli Lermolieff) XI', *Kunstchronik, Leipzig* 4, 9, pp. 156–62.

Hadeln, D.F. von (1924) *Zeichnungen des Giacomo Tintoretto*, Berlin.

— (1925) *Venezianische Zeichnungen des Quattrocento*, Berlin.

Halm, P. (1931) 'Das unvollendete Fresko des Filippino Lippi in Poggio a Caiano', *Mitteilungen des Kunsthistorischen Institutes in Florenz*, vol. 3, 6–7, pp. 393–427.

Hanegraaf, W.C. (2003) *Lodovico Lazzarelli and the Hermetic Christ: at the Sources of Renaissance Hermetism*, Leiden.

Harck, F. (1886) *Gli affreschi del palazzo di Schifanoia in Ferrara*, Ferrara.

Härth, I. (1960) 'Zu Landschaftszeichnungen Fra Bartolommeos und seines Kreises', *Mitteilungen des Kunsthistorischen Institutes in Florenz* 9, 2, pp. 125–30.

Hartt, F. (1950) 'Review of C. de Tolnay, *Michelangelo II: The Sistine Ceiling; Michelangelo III: The Medici Chapel*',

Art Bulletin 32, 3, pp. 239–50, also published separately, New York.

— (1971) *The Drawings of Michelangelo*, London.

Haskell, F. and N. Penny (1982) *Taste and the Antique. The Lure of Classical Sculpture 1500–1900* (2nd edn), New Haven and London.

Hebborn, E. (1991) *Drawn to Trouble, the Forging of Old Masters: an Autobiography of Eric Hebborn*, Edinburgh.

Heinemann, F. (1962) *Giovanni Bellini e i belliniani*, 2 vols, Venice.

Herald, J. (1981) *Renaissance Dress in Italy 1400–1500,* London and New Jersey.

Hetzer, T. (1920) *Die früher Gemälde des Tizian: eine stilkritische Untersuchung*, Basel.

Hiller von Gaertringen, R. (1999) *Raffaels Lernerfahrung in der Werkstatt Peruginos: Kartonverwendung und Motivübernahme im Wandel*, Munich.

— (2004) 'Uso e riuso del cartone nell'opera del Perugino: l'arte fra vita contemplativa e produttività', in *Pietro Vannucci il Perugino: atti di convegno internazionale di studio*, ed. L. Teza and M. Santanicchia, Perugia, pp. 335–50.

Hind, A.M. (1938–48) *Early Italian Engraving, a Critical Catalogue,* 7 vols, London.

Hirst, M. (1963) 'Michelangelo drawings in Florence', *Burlington Magazine* 105, pp. 166–71.

— (1986) 'I disegni di Michelangelo per la "Battaglia di Cascina" (ca. 1504)', in *Tecnica e stile. Esempi di pittura murale del Rinascimento italiano, The Harvard University Center for Italian Renaissance Studies at Villa I Tatti*, ed. E. Borsook and F. Superbi Gioffredi, Cinisello Balsamo, pp. 43–58.

— (1988) *Michelangelo and his Drawings*, New Haven and London.

— (1992) 'Review of Mantegna exh., London and New York', *Burlington Magazine* 134, pp. 318–21.

Hochmann, M. (1993) 'Les dessins et les peintures de Fulvio Orsini et la collection Farnèse', *Mélanges de l'École Française de Rome, Italie et Méditerranée* 105, 1, 1993, pp. 49–91.

Holmes, M. (1999) *Fra Filippo Lippi. The Carmelite Painter*, London.

— (2004) 'Copying practices and marketing strategies in a fifteenth-century Florentine Painter's workshop', in *Artistic Exchange and Cultural Translation in the Italian Renaissance City*, ed. S.J. Campbell and S.J. Milner, Cambridge, pp. 38–74.

Holst, von C. (1974) 'Fra Bartolommeo und Albertinelli. Beobachtungen zu ihrer Zusammenarbeit am Jüngsten Gericht aus Santa Maria Nuova und in der Werkstatt von San Marco', *Mitteilungen des Kunsthistorischen Institutes in Florenz* 18, pp. 273–318.

Hope, C. (1981) 'Artists, patrons and advisers in the Italian Renaissance', in *Patronage in the Renaissance*, ed. G.F. Lytle and S. Orgel, Princeton, pp. 293–343.

Hopkinson, M. (1974–5) 'A Fra Bartolommeo drawing once owned by William Roscoe', *Walker Art Gallery Liverpool. Annual Report and Bulletin* 5, pp. 50–59.

Horne, H.P. (1986) *Alessandro Filipepi commonly called Sandro Botticelli painter of Florence* (1908), Italian trans. and ed. C. Caneva, Florence, 2 vols.

Humfrey, P. (1983) *Cima da Conegliano*, Cambridge.

— (1993) *The altarpiece in Renaissance Venice*, New Haven and London.

Hunter, D. (1978) *Papermaking, the History and Technique of an Ancient Craft*, New York.

Jackobsen, E. (1904) 'Die Handzeichnungen der Uffizien in ihren Beziehungen zu Gemälden, Skulpturen und Gebäuden in Florenz', *Repertorium fur Kunstwissenschaft* 27, pp. 112–32, 251–60, 322–31, 401–29.

Jacopo da Varagine (1990) *Leggenda Aurea*, trans. C. Lisi, 2 vols, Florence.

Jaffé, M. (1994a) *The Devonshire Collection of Italian Drawings, Tuscan and Umbrian Schools*, vol. 1, London.

— (1994b) *The Devonshire Collection of Italian Drawings, Roman and Neapolitan Schools,* vol. 2, London.

Janson, H.W. (1963) *The Sculpture of Donatello*, Princeton.

Joannides, P. (1983) *The Drawings of Raphael*, Oxford.

— (1994) 'A propos d'une sanguine nouvellement attribuée à Michel-Ange. La connaissance des dessins de l'artiste en France au XVIe siècle', *Revue du Louvre* 46, 3, pp. 15–29.

— (2001) *Titian to 1518: the Assumption of Genius*, New Haven.

— (2003) *Michel-Ange, élèves et copistes*, Paris.

— (2007) *The Drawings of Michelangelo and his Followers in the Ashmolean Museum,* Cambridge.

Jones, R. (1987) 'Mantegna and materials' in *I Tatti studies* 2., pp. 71–90.

Joost-Gaugier, C. L. (1974) 'The "sketchbooks" of Jacopo Bellini reconsidered', *Paragone* 297, pp. 24–41.

— (1975) 'Jacopo Bellini's interest in perspective and its iconographical significance' in *Zeitschrift für Kunstgeschichte*, 38.1975, pp. 1–28.

Kanter, L., B.G. Testa and T. Henry (2001) *Luca Signorelli: the Complete Paintings,* London.

Karet, E. (2002) *The Drawings of Stefano da Verona and his Circle and the Origins of Collecting in Italy; a Catalogue Raisonné,* Philadelphia.

Kecks, R.G. (2000) *Domenico Ghirlandaio und die Malerei der Florentiner Renaissance*, Munich and Berlin.

Kemp, M. (1981) *Leonardo da Vinci: the Marvellous Works of Nature and Man,* London.

— (ed.; 1989) *Leonardo on painting: an anthology of writings by Leonardo da Vinci with a selection of documents*, New Haven and London.

— (1990) *The Science of Art*, New Haven and London.

Kennedy, R.W. (1959) 'A Landscape Drawing by Fra Bartolommeo', *Smith College Museum of Art Bulletin* 39, pp. 1–12.

Knab, E., E. Mitsch and K. Oberhuber (1983) *Raffaello i disegni*, Florence.

Knapp, F. (1903) *Fra Bartolommeo della Porta und die Schule von San Marco*, Halle.

Körner, H. (2006) *Botticelli*, Cologne.

Kristeller, P. (1901) *Andrea Mantegna*, London.

— (1902), *Andrea Mantegna*, Berlin.

— (1907) 'Der Venezianische Kupferstich in XV Jahrhundert', *Mitteilungen der Gesellschaft für vervielfältingende Kunst* 8, pp. 199–229.

— (1910) *Die Tarocchi: zwei italienische Kupferstichfolgen aus dem XV. Jahrhundert*, Berlin.

Kubiak, R.J. (1974) 'Maso Finiguerra', Ph.D. thesis, University of Virginia.

Kurz, O. (1937) 'Giorgio Vasari's *Libro de' Disegni*', *Old Master Drawings*, vol. 12, pp. 1–15, 32–44.

Kwakkelstein, M.W. (2004) 'New copies by Leonardo after Pollaiuolo and Verrocchio and his use of an "écorché" model: some notes on his working methods as an anatomist', *Apollo* 159, pp. 21–9.

Ladis, A. (1982) *Taddeo Gaddi, Critical Reappraisal and Catalogue Raisonné*, Columbia and London.

Lafranconi, M. (1998) 'Antonio Tronsarelli: A Roman collector of the late sixteenth century', *Burlington Magazine* 140, pp. 537–50.

Lagrange, L., (1862) *Catalogue des Dessins de Maîtres exposés dans la Galeria des Uffizi a Florence, Gazette des Beaux-Arts*, no. 12, pp. 535–54.

Landau, D. (1994) 'Printmaking in the age of Lorenzo', Cropper 1994, pp. 175–180.

— and P. Parshall (1994) *The Renaissance Print 1470–1550*, New Haven and London.

Lastri, E. (1791–5) *Etruria Pittrice*, ed. N. Pagni and G. Bardi, 2 vols, Florence.

Lauts, J. (1962) *Carpaccio Paintings and Drawings, Complete Edition*, London.

Lazzi, G. and Ventone, P. (2007) *Simonetta Vespucci. La nascita della Venere fiorentina*, Florence.

Leonardo da Vinci (1995) *Libro di Pittura. Fascimile edition of the Codice Urbinate lat. 1270, Biblioteca Apostolica Vaticana*, ed. C. Pedretti and C. Vecce, Florence.

Levenson, J.A. (1978) 'Jacopo de' Barbari and northern art of the early sixteenth century', Ph.D. thesis, New York University, New York.

Lightbown, R. (1978) *Sandro Botticelli*, vol. 1: *Life and Work*; vol. 2: *Complete Catalogue*, London.

— (1986) *Mantegna with a Complete Catalogue of the Paintings, Drawings and Prints*, Oxford.

— (1989) *Sandro Botticelli*, London.

— (2004) *Carlo Crivelli*, New York and London.

Lincoln, E. (2000) *The Invention of the Italian Renaissance Printmaker*, New Haven and London.

Loeser, C. (1897) 'I disegni italiani della raccolta Malcolm', *Archivio storico dell'arte* 2–3, pp. 341–59.

Longhi, R. (1934) *Officina ferrarese*, Rome.

— (1940) *Ampliamenti nell'officina ferrarese*, Florence, 1940.

— (1956) 'Ampliamenti nell'officina ferrarese (1940)', in *Officina ferrarese*, Florence.

Lucco, M. (1985) 'La cultura figurativa al tempo del codice Hammer', in Bologna 1985, pp. 143–54.

Lucianus (1862), *Opere di Luciano voltate in italiano da Luigi Settembrini*, vol. 3, Florence.

McGrath, T. (1997) 'Colour in Italian Renaissance drawings: reconciling theory and practice in central Italy and Venice', *Apollo* 146, pp. 22–30.

MacLagan, E. (1921) 'A stucco after Verrocchio', *Burlington Magazine* 39, pp. 131–8.

McMahon, A.P. (1956) *Leonardo da Vinci, treatise on painting*, Princeton.

Manca, J. (1992) *The Art of Ercole de' Roberti*, Cambridge.

— (2000) *Cosmè Tura, the Life and Art of a Painter in Estense Ferrara*, Oxford.

Marani, P.C. (2003) 'Leonardo's Drawings in Milan and their influence on the graphic work of Milanese Artists', in New York 2003, pp. 155–90.

Marchini, G. (1942) *Giuliano da Sangallo*, Florence.

— (1975) *Filippo Lippi*, Milan.

Mardersteig, G. (1939), 'Nuovi documenti su Felice Feliciano da Verona', *La Bibliofilia* 41, pp. 102–10.

Marías, F. (2005), 'El Codex Escurialensis, problemas e incertidumbres de un libro de digujos de antigüedades del último quattrocento', *Reales sitios* 42, pp. 14–35.

Martindale, A. (1988) *Simone Martini*, Oxford.

Martini, G.S. (1956) 'La bottega di un cartolaio fiorentino della seconda metà del quattrocento: nuovi contributi biografici intorno a Gherardo e Monte di Giovanni', *La Bibliofilia* 58.

Massing, J.M. (1990) *Du texte à l'image: la calomnie d'Apelle et son iconographie*, Strasbourg.

Mayor, W. (1875) *A brief chronological description of original drawings and sketches by the Old Masters ... formed by ... W. Mayor*, London.

Meder, J. (1978) *The Mastery of Drawings*, trans. W. Ames, New York.

Meiss, M. (1955) 'Nuovi dipinti e vecchi problemi', *Rivista d'arte* 30, pp. 107–45.

Meissner, G. (ed.; 1992– in progress) *Saur Allgemeines Künstlerlexikon: die bildenden Künstler aller Zeiten und Völker*, 60 vols, Munich.

Melli, L. (1995) *Maso Finiguerra: i disegni*, Florence.

— (2000) 'Sui "libri di disegni" di Benozzo Gozzoli: l'"Assedio di Perugia" degli Uffizi e gli "Studi di teste" dell'Accademia di Venezia', *Mitteilungen des Kuns historischen Institutes in Florenz* 54, pp. 169–92.

— (2002) 'Il Disegno per Benozzo', in Montefalco 2002, pp. 117–29.

— (2007) 'I disegni dei Pollaiolo agli Uffizi', in *La stanza dei Pollaiolo, i restauri, una mosta, un nuovo ordinamento*, ed. A. Natali and A. Tartuferi, Florence, pp. 55–71.

— (2009) 'Fra Giovanni Angelico disegnatore', in Rome 2009, pp. 63–70.

— (forthcoming) 'I disegni a punta metallica di Filippino Lippi: una scelta funzionale', *Mitteilungen des Kunst-historischen Institutes in Florenz*.

Meyer zur Capellen, J. (1972) 'Andrea Previtali', Ph.D. thesis, Würzburg University.

— (1985) *Gentile Bellini*, Stuttgart.

— (2001) *Raphael: A Critical Catalogue of His Paintings, Volume I: The Beginnings in Umbria and Florence ca. 1500–1508*, Landshut.

Milanesi, G. (1875) *Le lettere di Michelangelo Buonarroti pubblicate coi ricordi ed i contratti artistici per cura di Gaetano Milanesi*, Florence.

Moakley, G. (1966) *The Tarot Cards Painted by Bonifacio Bembo for the Visconti-Sforza Family. An Iconographic and Historical Study*, New York.

Mode, R.L. (1972) 'Masolino, Uccello and the Orsini "Uomoni Famosi"', *Burlington Magazine* 114, pp. 369–78.

Möller, E. (1926) 'Wie sah Leonardo aus?', *Belvedere* 9–10, pp. 29–46.

— (1935) 'Salvestro di Jacopo Pollaiuolo dipintore', *Old Master Drawings* 38, pp. 17–21.

Molmenti, P. (1905–8) *La storia di Venezia nella vita private dalle origini alla caduta della repubblica*, 3 vols, Bergamo.

Molteni, M. (1995) *Ercole de' Roberti*, Milan.

— (1999) *Cosmè Tura*, Milan.

Monneret de Villard, U. (1904) *Giorgione*, Bergamo.

Morelli, G. (1891) *Kunsthistorische Studien über Italienische Malerei. Die Galerie zu München und Dresden*, Leipzig.

— (1892) 'Handzeichnungen Italienischer Meister', *Kunstchronik*, new series, 3 cols 441–5.

— (1893) *Kunstkritische Studien über Italienische Malerie*, Leipzig.

Morelli, J. (1884) *Notizia d'opere di disegno*, Bologna.

Morello, G. (1998) 'Nuove ricerche sul "Libro dei disegni" di Giuliano da Sangallo (Barb. Lat. 4424) 'in *Tutte le opere non son per istancarmi: raccolta di scritti per i settant'anni di Carlo Pedretti*, ed. F. Frosoni, Rome, pp. 263–78.

Moschini Marconi, S. (1962) *Galleria dell'Accademia di Venezia, opere d'arte del secolo XVI*, Rome.

Moustier, B. de (2008) 'The Italian drawings collection of the Marquis de Lagoy', *Master Drawings* 46, pp. 175–86.

Mulazzani, G. (1978) *L'opera completa di Bramantino e Bramante pittore*, Milan.

Müller-Walde, P. (1889) *Leonardo da Vinci*, Munich.

Müntz, E. (1898) *Leonardo da Vinci: artist, thinker, and man of science*, London and New York.

Muraro, M. (1963) 'Review of Ugo Procacci "Sinopie e affreschi"', *Art Bulletin* 45, pp. 154–7.

— (1977) *I Disegni di Vittore Carpaccio*, Florence.

— (1978) 'Grafica tizianesca', in *Tiziano e il manierismo europeo*, ed. R. Pallucchini, Florence, pp. 127–49.

Nagel, A. (2000) *Michelangelo and the Reform of Art*, Cambridge.

Negro, E. (1989) *Disegni emiliani del Rinascimento*, ed. M. Di Giampaolo, Milan.

Negro, E. and N. Roio (2001), *Lorenzo Costa: 1460–1535*, Modena.

Neilson, K.B. (1938) *Filippino Lippi*, Cambridge.

Nelson, J. (1992) 'The later works of Filippino Lippi from his Roman sojourn until his death (c. 1489–1504)', Ph.D. thesis, Institute of Fine Arts, New York University, New York.

Nesselrath, A. (1982) 'Antico and Monte Cavallo', *Burlington Magazine* 124, pp. 353–7.

— (1988) 'Simboli di Roma', in Rome 1988, pp. 195–205.

— (1996) 'Il "Codice Escurialense"', in *Domenico Ghirlandaio 1449–1994*, ed. W. Prinz and M. Seidel, Florence, pp.175–98.

Nova, A. (1992) 'Salviati, Vasari, and the reuse of drawings in their working practice', *Master Drawings* 30, pp. 83–102.

Nuttall, P. (2004) *From Flanders to Florence, the Impact of Netherlandish Painting 1400–1500*, New Haven and London.

Oberhuber, K. (1976) 'Introduzione' in Venice 1976, pp. 15–45.

— (1992) 'A newly found drawing for the Battle of Cascina', *Studies in the History of Art. 33. Michelangelo Drawings*, ed. C. Hugh Smyth, Washington, pp. 39–41.

O' Malley, M. (2004) 'Subject matters: Contracts, designs, and the exchange of ideas between painters and clients in Renaissance Italy' *Artistic Exchange and Cultural Translation in the Italian Renaissance City*, ed. S.J. Campbell and S.J. Milner, Cambridge, pp. 17–37.

— (2005) *The business of art: contracts and the commissioning process in Renaissance Italy*, New Haven and London.

Ornato, E., P. Busonero, P.F. Munafò and M. Speranza Storace (2001), *La carta occidentale nel tardo medioevo*, Rome.

Ortolani, S. (1941) *Cosmè Tura, Francesco del Cossa, Ercole de' Roberti*, Milan.

Ottley, W.Y. (1823) *The Italian School of Design*, London.

Ovidio (2000) *Opere*, II, *Le Metamorfosi*, trans. G. Paduano, Turin.

Pächt, O. (1950) 'Early Italian nature studies and the early calendar landscapes', *Journal of the Warburg and Courtauld Institute* 13, pp. 13–47.

Padoa Rizzo, A. (2003) *Benozzo Gozzoli. Un pittore insigne, 'pratico di grandissima invenzione'*, Milan.

Pallucchini, R. (1962) *I Vivarini (Antonio, Bartolomeo, Alvise)*, Venice.

— (1969) *Tiziano*, 2 vols, Florence.

Panofsky, D. and E. (1992) 'Pandora und die Unwissenheit: Rosso Fiorentino', in *Die Büchse der Pandora. Bedeutungswandel eines mythischen Symbols*, Frankfurt, pp. 53–8.

Parker, K.T. (1927) *North Italian Drawings of the Quattrocento,* London

— (1956) *Catalogue of the Collection of Drawings in the Ashmolean Museum,* Oxford.

Parronchi, A. (1964) 'Paolo o Piero?', in *Studi sulla dolce prospettiva*, Milan, pp. 532–48.

Passavant, G. (1969) *Verrocchio: Sculptures, Paintings and Drawings.* Complete edition, London.

Passavant, M. (1836) *Tour of a German Artist in England with Notices of Private Galleries, and Remarks on the State of Art,* 2 vols, London.

Pedretti, C. (1951) 'Leonardo da Vinci e il poeta bolognese Gerolamo Pandolfi da Casio de' Medici', *La Mercanzia* 5/6, pp. 5–47.

— (1964) *Leonardo da Vinci on Painting, a Lost Book (Libro A) Reassembled from the Codex Vaticanus and from the Codex Leicester,* Berkeley and Los Angeles.

— (1968) 'The Burlington House cartoon', *Burlington Magazine* 110, pp. 22–8.

— (ed.; 1982) *The Drawings and Miscellaneous Papers of Leonardo da Vinci in the Collection of Her Majesty the Queen at Windsor Castle, Plants and Water Studies,* London and New York.

Perosa, A. (ed.; 1960–81) *Lo Zibaldone di Giovanni Rucellai,* 2 vols, London.

Pesenti, A. (2006) 'The use of drawings in the communication between artists and patrons in Italy during the fifteenth and sixteenth Centuries', Ph.D. thesis, Courtauld Institute of Art, London.

Perrig A. (1991) *Michelangelo's Drawings. The Science of Attribution*, New Haven and London.

Petrioli Tofani, A. (ed.; 1972) *I grandi disegni italiani degli Uffizi di Firenze,* Milan.

— (1986) *Gabinetto Disegni e Stampe degli Uffizi. Inventario – 1. Disegni Esposti*, Florence.

— (1987) *Gabinetto Disegni e Stampe degli Uffizi. Inventario – 2. Disegni Esposti*, Florence.

— (1991) *Gabinetto Disegni e Stampe degli Uffizi. Inventario – Disegni di figura 1*, Florence.

— (2005) *Gabinetto Disegni e Stampe degli Uffizi. Disegni di figura 2*, Florence.

Phillips, J.G. (1955) *Early Florentine Designers and Engravers: Maso Finiguerra, Baccio Baldini, Antonio Pollaiuolo, Sandro Botticelli, Francesco Rosselli; a comparative analysis of early Florentine nielli, intarsias, drawings and copperplate engravings,* Cambridge, MA.

Pignatti, T. (1977) 'Fondazione Giorgio Cini. Esposizioni: Disegni di Tiziano e della sua cerchia. Tiziano e la silografia veneziana del Cinquecento', *Pantheon* 35, pp. 168–70.

Pincus, D. and B. Shapiro Comte (2006) 'A drawing for the tomb of Dante attributed to Tullio Lombardo', *Burlington Magazine* 148, pp. 734–46.

Pittaluga, M. (1949) *Filippo Lippi*, Florence.

Pogány-Balás, E. (1980) *The Influence of Rome's Antique Monumental Sculptures on the Great Masters of the Renaissance*, Budapest.

Pope-Hennessy, J. (1952) *Fra Angelico,* London.

— (1974) *Fra Angelico*, London (2nd edn).

Popham, A.E. (1928) *The Vasari Society for the Reproduction of Drawings by Old and Modern Masters, second series,* vol. 9.

— (1932) *The Vasari Society for the Reproduction of Drawings by Old and Modern Masters,* second series, vol. 13.

— (1933) 'Ercole de' Roberti', *Old Master Drawings* 8, pp. 23–5.

— (1946) *The Drawings of Leonardo da Vinci,* London.

— (1967) *Italian Drawings in the Department of Prints and Drawings in the British Museum: Artists working in Parma in the Sixteenth Century,* 2 vols, London.

— (1971) *Catalogue of the Drawings of Parmigianino,* 3 vols, New Haven and London.

— and Pouncey, P. (1950) *Italian Drawings in the Department of Prints and Drawings in the British Museum: The Fourteenth and Fifteenth Centuries,* 2 vols, London.

— and J. Wilde (1949) *The Italian Drawings of the XV and XVI Centuries in the Collection of His Majesty the King at Windsor Castle,* London.

Popp, A.E. (1922) *Die Medici-Kapelle Michelangelos*, Munich.

— (1925) 'Review of A.E. Brinkmann, "Michelangelo-Zeichnungen", Munich, 1925', *Belvedere/Forum* 8, pp. 72–5.

Porzio, F. (ed.; 1998) *The Legacy of Leonardo, Painters in Lombardy 1490–1530,* Milan.

Pouncey, P. (1946) 'Two Simonesque drawings', *Burlington Magazine* 88, pp. 168–72.

— and J.A. Gere (1962) *Italian Drawings in the Department of Prints and Drawings in the British Museum: Raphael and his Circle,* 2 vols, London.

Procacci, U. (1961) *Sinopie e affreschi,* Milan.

Puppi, L. (1962) *Bartolomeo Montagna*, Venice.

Py, B. (2001) *Everhard Jabach Collectionneur (1618–1695), Les Dessins de Inventaire de 1695*, Paris.

Ragghianti Collobi, L. (1954) Review of Popham and Pouncey, 1950, *Critica d'arte*, pp. 596–600.

— (1974) *Il Libro de' Disegni del Vasari,* 2 vols, Florence.

— and G. Dalli Regoli (1975), *Firenze, 1470–1480. Disegni dal modello. Pollaiolo, Leonardo, Botticelli, Filippino,* Pisa.

— P.A. Rossi and C. Soddu (1986), 'Il calice di Paolo Uccello uno e senza limite', *Critica d'arte* 51, n. 8, pp. 85–92.

Rearick, W.R. (1977) *Biblioteca di Disegni. V, Maestri veneti del Cinquecento*, Florence.

— (2001) *Il disegno veneziano del Cinquecento,* Milan.

Richter, J.P. (1883) *The Literary Works of Leonardo da Vinci,* 2 vols, London.

Roberts, H.I. (1959) 'St Augustine in "St Jerome's Study": Carpaccio's paintings and its legendary sources', *Art Bulletin* 41, pp. 283–301.

Robertson, G. (1981) *Giovanni Bellini,* New York.

Robinson, J.C. (1869) *Descriptive Catalogue of Drawings by the Old Masters, forming the Collection of John Malcolm of Poltalloch, Esq.,* London.

— (1876) *Descriptive Catalogue of Drawings by the Old Masters, forming the Collection of John Malcolm of Poltalloch, Esq.* (1st edn 1869), 2nd edn with additional entries not by Robinson, London.

Roccasecca, P. (2000) 'Il Calice degli Uffizi: da Paolo Uccello e Piero della Francesca a Evangelista Torricelli e l'Accademia del Disegno di Firenze', in *La fabbrica della scultura: scultori e botteghe d'arte a Roma tra XVIII e XIX secolo,* ed. O. Rossi Pinelli, Rome, pp. 65–78.

Roio, N. (2002) '"Sfortuna" del Francia e del Costa', *in Studi di storia dell'arte* 13, pp. 39–58.

Romano, G. (1981) 'Verso la maniera moderna: da Mantegna a Raffaello', in *Storia dell'arte italiana. Parte seconda. Dal Medioevo al Novecento*, vol. 2. *Dal Cinquecento all'Ottocento. I. Cinquecento e Seicento*, Turin, pp. 3–85.

Romano, G., M.T. Binaghi and D. Collura (1978) *Il Maestro della Pala Sforzesca,* Florence.

Rosand, D. (2002) *Drawing Acts: Studies in Graphic Expression and Representation*, Cambridge.

Röthlisberger, M. (1956) 'Notes on the drawing books of Jacopo Bellini', *Burlington Magazine* 98, pp. 358–64.

Rovetta, A., E. Monducci and C. Caselli (2008) *Cesare Cesariano e il Rinascimento a Reggio Emilia*, Milan.

Rowlands, J. (ed.; 1984) *Master Drawings and Watercolours in the British Museum*, London.

Rubin, P. (1996) 'Domenico Ghirlandaio and the meaning of history', in *Domenico Ghirlandaio 1449–1994*, W. Prinz and M. Seidel, pp. 96–108.

Ruda, J. (1993) *Filippo Lippi. Life and Work with a Complete Catalogue*, London.

Ruhmer, E. (1958) *Tura: Paintings and Drawings,* London and New York.

— (1966) *Marco Zoppo,*Vicenza.

Rupprich, H. (1956–69) *Dürer. Schriftlicher Nachlass,* 3 vols, Berlin.

Russell, F. (1974), 'Towards a reassessment of Perugino's lost fresco of the *Adoration of the Magi* at San Giusto alle Mura', *Burlington Magazine*, 116, pp. 646–52.

Saci, M.P. (1999) *Ludovico Lazzarelli da Elicona a Sion,* Rome.

Sale, J.R. (1976) 'Filippino Lippi's Strozzi Chapel in Santa Maria Novella', Ph.D. thesis, University of Pennsylvania.

Salmi, M., C. de Tolnay, and P. Barocchi (1964) *Disegni di Michelangelo*, Milan.

Salvini, R. (1965) 'La Pittura', in *Michelangelo. Artista. Pensatore. Scrittore*, vol. 1, Novara, pp.149–271.

— (1971) 'La Battaglia di Cascina. Saggio di critica delle varianti' in *Studi in onore di Valerio Mariani*, Naples.

Sandberg-Vavalà, E. (1929) 'Four drawings by Fra Bartolommeo', *Burlington Magazine* 55, pp. 3–15.

Santi, B. (1985) *Galleria Nazionale dell'Umbria. Dipinti, sculture e oggetti dei secoli XV–XVI*, Rome.

Santoro, M. (1994) *Storia del libro italiano, libro e società dal Quattrocento al Novecento,* Milan.

Santucci, P. (2004) *Su Andrea Mantegna*, Naples.

Saslow, J. (1991) *The Poetry of Michelangelo: an Annotated Translation*, New Haven.

Scaglia, G. (2004) 'El *Codex Escurialensis* llevado por el artista a La Calahorra en el otoño de 1509', *Archivo español de arte* 77, pp. 375–83.

Scarpellini, P. (1984) *Perugino*, Milan.

— (1991) *Perugino*, 2nd edn.

— and M.R. Silvestrelli (2004) *Pintoricchio,* Milan.

Scharf, A. (1935) *Filippino Lippi*, Vienna.

Scheller, R.W. (1995) *Exemplum, Model-Book Drawings and the Practice of Artistic Transmission in the Middle Ages (ca. 900–ca. 1470)*, Amsterdam.

Schmitt, A. (1997) *Der Meister der Tiermusterbuchs von Weimar,* Munich.

Schönbrunner, J. and J. Meder (1896–1908) *Handzeichnungen alter Meister aus der Albertina und anderen Sammlungen,* 12 vols, Vienna.

Schubring, P. (1915–23) *Cassoni: Truhen und Truhenbilder der italienischen Frührenaissance: ein Beitrag zur Profanmalerei im Quattrocento,* 3 vols, Leipzig.

— (1916) 'Francesco di Giorgio', *Monatshefte für Kunstwissenschaft* 9, pp. 81–91.

337

Schulz, J. (1978) 'Jacopo de' Barbari's view of Venice: map making, city views, and moralized geography before the year 1500', *Art Bulletin* 60, pp. 425–74.

Sedini, D. (1989) *Marco d'Oggiono: tradizione e rinnovamento in Lombardia tra Quattrocento e Cinquecento,* Milan.

Serafini, A. (1911) *L'epopea cristiana nei dipinti di beato Angelico: con appendice di documenti tratti dall'archivio dell'Opera di Orvieto,* Orvieto.

Settis, S. (1985) 'Le Sibille di Cortina', in *Renaissance Studies in Honor of Craig Hugh Smyth*, ed. A. Morrogh and F. Superbi Gioffredi, Florence, pp. 437–64.

— (1999) *Laocoonte. Fama e stile*, Rome.

Shearman, J. (1970) 'Raphael at the court of Urbino', *Burlington Magazine* 112, pp. 72–8.

— (1977) 'Raphael, Rome, and the Codex Escurialensis', *Master Drawings*, 15, 1977, pp. 107–146

— (1992) *Arte e spettatore nel Rinascimento italiano*, Milan.

— (2003) *Raphael in Early Modern Sources*, 2 vols, New Haven and London.

Shoemaker, I.H. (1977) 'Filippino Lippi as a Draughtsman' Ph.D. thesis, Columbia University, New York.

Simon, E. (1971) 'Dürer and Mantegna 1494', *Anzeiger des Germanischen Nationalmuseums*, pp. 21– 40.

Steer, J. (1982) *Alvise Vivarini: his Art and Influence,* Cambridge.

Steinberg, S.H. (1996) *Five Hundred Years of Printing,* revised J. Trevitt, London.

Strehlke, C.B. (2004) *Italian Paintings 1250–1450 in the John G. Johnson Collection and the Philadelphia Museum of Art,* Philadelphia.

Suida, W. (1929) *Leonardo und sein Kreis,* Munich.

— (1953) *Bramante pittore e il Bramantino,* Milan.

Syre, C. (1979) *Studien zum 'Maestro del Bambino Vispo' und Starnina,* Bonn.

Syson, L. (2009), 'Reflections on the Mantegna exhibition in Paris', *Burlington Magazine* 151, pp. 526–35.

Tanimoto, S., G. Verri, D. Saunders *et al.* (2009) 'Technical examination and analysis of Andrea Mantegna's "Virtus Combusta"', *Technè*, pp. 35–40.

Testa, G. (1996) *La Cappella Nova o di San Brizio nel Duomo di Orvieto,* Milan.

Thiébaut, D. (2008) *Autour du Saint Sébastien D'Aigueperse: les années 1478–1490* in Paris 2008, pp. 209–14.

Thieme, U. and F. Becker (1907–1950), *Allgemeines Lexikon der bildenden Künstler von der Antike bis zur Gegenwart*, 37 vols, Leipzig.

Thiis, J. (1913) *Leonardo da Vinci. The Florentine Years of Leonardo and Verrocchio,* London.

Thode, H. (1897) *Mantegna: mit 105 Abbildungen nach Gemälden, Kupferstichen und Zeichnungen,* Bielefeld.

— (1908–13) *Michelangelo. Kritische Untersuchungen über seine Werke*, 3 vols, Berlin.

Thomas, A. (1995) *The Painter's practice in Renaissance Tuscany,* Cambridge.

Thornton, D. and J. Warren (1988) 'The British Museum's Michelangelo Acquisitions and the Casa Buonarroti', in *Journal of the History of Collections* 10, 1, pp. 9–29.

Tietze H. and E. Tietze-Conrat (1937) *Kritisches Verzeichnis der Werke Albrecht Dürers*, 2 vols, Basel.

— (1944) *The Drawings of the Venetian Painters in the 15th and 16th Centuries*, New York.

— (1955) *Mantegna: Paintings, Drawings, Engravings,* London.

Tintori, L. and M. Meiss (1967) *The paintings of the Life of St Francis in Assisi: with notes on the Arena Chapel and a 1964 appendix,* New York.

Toffanello, M. (1997) 'I primi vent'anni di attività di Cosmè Tura alla luce dell'analisi tecnica', in *Dialoghi di storia dell'arte* 4/5, pp. 10–20.

Toker, F. (1985) 'Gothic architecture by remote control: an illustrated building contract of 1340', *Art Bulletin* 67, pp. 67–95.

Tolnay, C. de (1943) *Michelangelo. I. The Youth of Michelangelo,* Princeton.

— (1945) *Michelangelo. II. The Sistine Ceiling,* Princeton.

— (1948) *Michelangelo. III. The Medici Chapel,* Princeton.

— (1968) 'Le Madonne di Michelangelo: a proposito di due disegni della Vergine col Bambino al Louvre', *Mitteilungen des Kunsthistorischen Institutes in Florenz* 13, 3/4, pp. 343–66.

— (1974) *I disegni della gioventù di Michelangelo e un suo disegno inedito nella Farnesina. Conferenza*, Accademia Nazionale dei Lincei, Rome.

— (1975–80) *Corpus dei disegni di Michelangelo,* 4 vols, Novara.

Torriti, P. (1977) *La Pinacoteca Nazionale di Siena, i dipinti dal XII al XV secolo,* Genoa.

Toscano, G. and F. Valcanover (ed.; 2004) *Da Bellini a Veronese: temi di arte veneta, Studi di arte veneta, 6,* Venice.

Turner, N. (2003) 'The Italian drawings collection of Cavaliere Francesco Maria Niccolò Gabburri (1676–1742)', in *Collecting Prints and Drawings in Europe, c. 1500–1750*, ed. C. Baker, C. Elam and G. Warwick, Aldershot, pp. 183–204.

Turrill, C. (1986) 'Ercole de' Roberti's altarpieces for the Lateran Canons', Ph.D. thesis, University of Delaware.

Ulmann, H. (1894) 'Bilder und Zeichnungen der Brüder Pollajuolo', *Jahrbuch der Königlich Preussischen Kunstsammlungen* 15, pp. 230–47.

Vaccari, M.G. (1980) *Maestri emiliani del Quattro e Cinquecento*, Florence.

Valentiner, W.R. (1950) *Studies of Italian Renaissance Sculpture*, London.

Van Buren, A.H. (1975) 'The canonical office in Renaissance painting: Raphael's Madonna at Nones', *Art Bulletin* 57, pp. 41–52.

Van Cleave, C. (1994) 'Tradition and innovation in the early history of black chalk drawing', in Cropper 1994, pp. 231–43.

— (1995) 'Luca Signorelli as a Draughtsman', Ph.D. thesis, Oxford University.

— (2007) *Master Drawings of the Italian Renaissance*, London.

Van der Velden, H. (1998) 'Medici votive images and the scope and limits of likeness,' *The Image of the Individual. Portraits in the Renaissance*, ed. N. Mann and L. Syson, London, pp. 126–37.

Van Marle, R. (1931) *The Development of the Italian Schools of Painting*, The Hague.

Van Tuyll van Serooskerken, C. (2000) *The Italian Drawings of the Fifteenth and Sixteenth Centuries in the Teyler Museum,* Haarlem, Ghent and Doornspijk.

Van Waadenoijen, J. (1974) 'A proposal for Starnina: exit the Maestro del Bambino Vispo?', *Burlington Magazine* 116, pp. 82–91.

— (1983) *Starnina e il gotico internazionale a Firenze,* Florence.

Vasari, G. (1878–81) *Le vite de' più eccellenti pittori, scultori e architettori*, ed. G. Milanesi, 7 vols, Florence.

— (1960) *Vasari on Technique,* trans. L.S. Maclehose, New York.

— (1966–87) *Le vite de' più eccellenti pittori, scultori e architettori nelle redazioni del 1550 e 1568*, ed. R. Bettarini and P. Barocchi, 11 vols, Florence.

Venturi, A. (1888) 'L'arte ferrarese nel periodo d'Ercole I d'Este. II', *Atti e memorie della R. Deputazione di storia patria per le province di Romagna*, series 3, 6, pp. 350–422.

Venturini, L. (2004) *Breve nota su Perugino disegnatore,* in Perugia 2004, pp. 331–5.

Verini, Ugolini (1583) *De illustratione urbis Florentiae libri tres*, Paris.

Vezzosi, A. (1984) *Toscana di Leonardo,* Florence.

Viatte, F. (2003) 'The early drapery studies' in New York 2003, pp. 110–19.

Villata, E. (1999) *Leonardo da Vinci: i documenti e le testimonianze contemporanee*, Milan.

Waagen, G. (1854–7) *Treasures of Art in Great Britain*, 4 vols, London.

Wallace (1994) *Michelangelo at San Lorenzo: The Genius as Entrepreneur*, Cambridge.

Warburg, A. (1999) 'Sandro Botticelli' (1898), in *Aby Warburg, The Renewal of Pagan Antiquity, Contributions to the Cultural History of the European Renaissance,* intro. by K.W. Forster, trans. D. Britt, Los Angeles, pp. 157–64.

— (2004), 'Arte del ritratto e borghesia fiorentina', in *Opere I. La Rinascita del paganesimo antico e altri scritti (1889–1914)*, ed. M. Ghelardi, Turin, pp. 267–318.

Wasserman, J. (1970) 'A re-discovered cartoon by Leonardo da Vinci', *Burlington Magazine* 112, pp. 194–204.

Weinberger M. (1945) Review of Tolnay 1943, *Art Bulletin* 27, pp. 69–74.

Weller, A.S. (1943) *Francesco di Giorgio 1439–1501,* Chicago.

Weppelmann, S. (2003) 'Spinello Aretino's "Canonization of Thomas Becket" and trecento drawing practice', *Master Drawings* 41, pp. 3–13.

Wethey, H. (1971) *The Paintings of Titian: II, the Portraits,* London.

— (1975) *The Paintings of Titian: III, the Mythological and Historical Paintings*, London.

— (1987) *Titian and His Drawings with Reference to Giorgione and Some Close Contemporaries*, Princeton.

Whistler, C. (2004) 'Life drawing in Venice from Titian to Tiepolo', *Master Drawings* 42, pp. 370–96.

Whitaker, L. (1986) '*The Florentine Picture Chronicle* – a reappraisal', Ph.D. thesis, Courtauld Institute of Art, London.

— (1994) 'Maso Finiguerra, Baccio Baldini and the Florentine Picture Chronicle', in Cropper 1994, pp. 181–96.

— (1998) 'Finiguerra and early Florentine printmaking', in *Drawing 1400–1600*, ed. S. Currie, Aldershot, pp. 45–71.

White, J. (1959) 'The reliefs on the façade of the Duomo of Orvieto', *Journal of the Warburg and Courtauld Institute* 22, pp. 254–302.

Wickhoff, F. (1899) 'Über einige italienische Zeichnungen im Britisch Museum', *Prussian Jahrbuch Kunstsammlungen* 20, pp. 202–15.

Wiemers, M. (1996) *Bildform und Werkgenese: Studien zur zeichnerischen Bildvorbereitung in der italienischen Malerie zwischen 1450 und 1490*, Munich.

Wilde, J. (1953) *Italian Drawings in the Department of Prints and Drawings in the British Museum. Michelangelo and his Studio*, London.

Winkler, F. (1936) *Die Zeichnungen Albrecht Dürers*, vol. 1, Berlin.

Winner, M. (ed.; 1992) *Der Künstler über sich in seinem Werk: internationales Symposium der Bibliotheca Hertziana, Rom 1989*, Weinheim.

Wittkower, R. (1938–9) 'Transformations of Minerva in Renaissance imagery', *Journal of the Warburg and Courtauld Institutes*, vol. 3, pp. 194–9.

Wohl, H., 'The eye of Vasari' (1986), *Mitteilungen des Kunsthistorischen Institutes in Florenz* 30, pp. 537–68.

Woods-Marsden, J. (1986) 'The sinopia as preparatory drawing: the evolution of Pisanello's tournament scene', *Master Drawings*, 23–4, pp. 175–92.

— (1987) 'Preparatory drawings for frescoes in the early quattrocento: the practice of Pisanello', *Drawings Defined*, ed. W. Strauss and T. Felker, New York, pp. 49–61.

— (1988), *The Gonzaga of Mantua and Pisanello's Arthurian Frescoes*, Princeton.

Wright, A. (2005) *The Pollaiuolo Brothers, the Arts of Florence and Rome*, New Haven and London.

Zambelli, P. (1978) 'Aut Diabolus aut Achillinus. Fisionomia, astrologia e demonologia nel metodo aristotelico', *Rinascimento*, 2, 18, pp. 59–86.

Zambrano, P. and J. Katz Nelson (2004), *Filippino Lippi*, Milan.

Zampetti, P. and I. Chiappini (1975), 'Andrea Previtali', *I Pittori Bergamaschi, il cinquecento I*, ed. P. Zampetti, Bergamo, pp. 87–166.

Zeri, F. (1976) *Italian Paintings in the Walters Art Gallery*, Baltimore.

— (ed.; 1990) *Pinacoteca di Brera, Scuola veneta*, Milan.

Zöllner, F. (2003) *Leonardo da Vinci 1452–1519. The Complete Paintings and Drawings*, Cologne.

— (2005) *Sandro Botticelli*, Munich, Berlin and New York, 2005.

Zucker, M.J. (1981) 'Parri Spinelli drawings reconsidered', *Master Drawings* 19, pp. 426–41.

— (1989) '"The Madonna of Loreto". A newly discovered work by the Master of the Vienna Passion', *Print Quarterly* 6, 2, pp. 149–60.

— (1993) *The Illustrated Bartsch. 24 Commentary Part 1 ('Le Peintre-Graveur 13 [Part 1])*, Early Italian Masters, New York.

— (1994) *The Illustrated Bartsch, 24, Commentary Part 2, Early Italian Masters*, New York.

Zupko, R.E. (1981) *Italian Weights and Measures from the Middle Ages to the Nineteenth Century*, Philadelphia.

EXHIBITION CATALOGUES

Athens (2003) *In the Light of Apollo: Italian Renaissance and Greece*, 2 vols, Athens, National Museum (exh. cat. ed. M. Gregori).

Berlin (2000) *Sandro Botticelli: der Bilderzyklus zu Dantes Göttlicher Komödie*, Kupferstichkabinett, Staatlichmuseen, Berlin (exh. cat. ed. H.-T. Schulze Altcappenberg).

Bologna (1985) *Leonardo, il Codice Hammer e la Mappa di Imola presentati da Carlo Pedretti: arte e scienza a Bologna in Emilia e Romagna nel primo cinquecento*, Palazzo del Podestà, Bologna (exh. cat. ed. C. Pedretti, Florence).

Bologna (1998) *Figure: disegni dal Cinquecento all'Ottocento nella Pinacoteca Nazionale di Bologna*, Pinacoteca Nazionale and Accademia di Belle Arti, Bologna (exh. cat. ed. M. Faietti and A. Zacchi).

Bologna (2002) *Il Cinquecento a Bologna: disegni dal Louvre e dipinti a confronto*, Pinacoteca Nazionale, Bologna (exh. cat. ed. M. Faietti).

Bologna (2007) *Il segno dell'arte: disegni di figura nella collezione Certani alla Fondazione Giorgio Cini (1500 – 1750)*, Fondazione Cassa di Risparmio, Bologna (exh. cat. ed. V. Mancini and G. Ravanello).

Bologna (2008) *Amico Aspertini 1474–1552: artista bizzarro nell'età di Dürer e Raffaello*, Pinacoteca Nazionale, Bologna (exh. cat. ed. A. Emiliani and D. Scaglietti Kelescian).

Bologna and Vienna (1988) *Bologna e l'Umanesimo 1490–1510*, Pinacoteca Nazionale, Bologna, and Graphische Sammlung Albertina, Vienna (exh. cat. ed. M. Faietti and K. Oberhuber).

Boston (2002) *Cosmè Tura: Painting and Design in Renaissance Ferrara*, Isabella Stewart Gardner Museum, Boston (exh. cat. ed. S.J. Campbell, Milan).

Boston and London (2005) *Bellini and the East*, Isabella Stewart Gardner Museum, Boston, and National Gallery, London (exh. cat. C. Campbell and A. Chong).

Brescia (2002) *Vincenzo Foppa*, Santa Giulia, Brescia (exh. cat. G. Agosti, M. Natale and G. Romano).

Edinburgh and London (2003) *Leonardo da Vinci, the Divine and the Grotesque*, Holyroodhouse, Edinburgh, and Queen's Gallery, London (exh. cat. M. Clayton).

Ferrara (1987) *I tarocchi le carte di corte*, Castello Estense, Ferrara (exh. cat. ed. G. Berti and A. Vitali).

Ferrara (2007) *Cosmè Tura e Francesco del Cossa. L'arte a Ferrara nell'età di Borso d'Este*. Galleria Civica d'Arte Moderna and Museo Civico d'Arte Antica, Ferrara (exh. cat. ed. M. Natale).

Florence (1955) *Mostra di disegni di Filippino Lippi e Piero di Cosimo*, Gabinetto Disegni e Stampe degli Uffizi, Florence (exh. cat. M. Fossi).

Florence (1961) *Mostra del disegno italiano di cinque secoli*, Palazzo Strozzi, Florence (exh. cat. ed. P. Barocchi, A. Forlani, M. Fossi Todorow).

Florence (1964) *Michelangelo. Mostra di disegni, manoscritti, documenti*, Casa Buonarroti and Biblioteca Laurenziana, Florence (exh. cat. P. Barocchi).

Florence (1975) *I disegni di Michelangelo nelle collezioni italiane*, Galleria degli Uffizi, Florence (exh. cat. C. de Tolnay).

Florence (1976) *Tiziano e il disegno veneziano del suo tempo*, Galleria degli Uffizi, Florence (exh. cat. W.R. Rearick)

Florence (1978) *I disegni antichi degli Uffizi, i tempi del Ghiberti*, Gabinetto Disegni e Stampe degli Uffizi, Florence (exh. cat. L. Bellosi, F. Bellini and G. Brunetti).

Florence (1982) *Disegni umbri del Rinascimento da Perugia a Raffaello*, Gabinetto Disegni e Stampe degli Uffizi, Florence (exh. cat. S. Ferino Pagden).

Florence (1984) *Raffaello a Firenze*, Palazzo Pitti, Florence (exh. cat. S. Ferino Pagden).

Florence (1985) *Michelangelo e i maestri del quattrocento*, Casa Buonarroti, Florence (exh. cat. C. Sisi).

Florence (1986a) *Disegni di Fra Bartolommeo e della sua scuola*, Gabinetto Disegni e Stampe degli Uffizi, Florence (exh. cat. C. Fischer).

Florence (1986b) *Disegni italiani del tempo di Donatello*, Gabinetto Disegni e Stampe degli Uffizi, Florence (exh. cat. A. Angelini).

Florence (1992) *Il disegno fiorentino del tempo di Lorenzo il Magnifico*, Gabinetto Disegni e Stampe degli Uffizi, Florence (exh. cat. ed. A. Petrioli Tofani).

Florence (1996) *L'età di Savonarola, Fra Bartolomeo e la scuola di San Marco*, Palazzo Pitti-Museo di San Marco, Florence (exh. cat. ed. S. Padovani, M. Scudieri and G. Damiani).

Florence (1999) *Giovinezza di Michelangelo*, Palazzo Vecchio and Casa Buonarroti, Florence (exh. cat. K. Weil-Garris Brandt and C. Acidini Luchinat)

Florence (2001) *Disegni del Rinascimento in Valpadana*, Gabinetto Disegni e Stampe degli Uffizi, Florence (exh. cat. G. Agosti).

Florence (2001b) *Nel segno di Masaccio. L'invenzione della prospettiva*, Galleria degli Uffizi, Florence (exh. cat. F. Camerota).

Florence 2005, *Perugino a Firenze. Qualità e fortuna di uno stile*, Cenacolo di Fuligno, Florence (exh. cat. ed. C. Proto Pisani)

Florence (2006a) *Lorenzo Monaco, a Bridge from Giotto's Heritage to the Renaissance*, Galleria dell'Accademia, Florence (exh. cat. ed. A. Tartuferi and D. Parenti).

Florence (2006b) *I disegni italiani del Quattrocento nel Kupferstich-Kabinett di Dresda*, Istituto Universitario Olandese, Florence (exh. cat. L. Melli).

Florence (2007) *La stanza dei Pollaiolo, i restauri, una mostra, un nuovo ordinamento*, Galleria degli Uffizi, Florence (exh. cat. ed. A. Natali and A. Tartuferi).

Florence (2007b) *Fra Giovanni Angelico: pittore miniatore o miniatore pittore?*, Museo di S. Marco, Florence (exh. cat. M. Scudieri and S. Giacomelli).

Florence (2008a) *Guercino, la scuola, la maniera. I disegni agli Uffizi*, Gabinetto Disegni e Stampe degli Uffizi, Florence (exh. cat. N. Turner with essays by M. Faietti, E. Cropper, P.G. Tordella and N. Turner).

Florence (2008b) *L'amore e la grazia: Raffaello la 'Madonna del Cardellino' restaurata*, Palazzo Medici Riccardi, Florence (exh. cat. M. Ciatti and A. Natali).

Florence (2008c) *Fiamminghi e Olandesi a Firenze: disegni dalle collezioni degli Uffizi*, Gabinetto Disegni e Stampe degli Uffizi, Florence (cat. ed. W. Kloek and B. Meijer).

Houston (1996) *Landmarks in Print Collecting: Connoisseurs and Donors at the British Museum since 1753*, Museum of Fine Arts, Houston (exh. cat. ed. A. Griffiths).

Houston and London (2001) *Earth and Fire: Italian Terracotta Sculpture from Donatello to Canova*, exh. cat., Museum of Fine Arts, Houston, and Victoria and Albert Museum, London (exh. cat. ed. B. Boucher).

Kyoto (1991) *Firenze. Arte del Rinascimento e restauro*, National Museum of Modern Art, Kyoto, et al. (exh. cat. A. Bonsanti, A. Paolucci and A. Petrioli Tofani).

London (1895) *Guide to an Exhibition of Drawings and Engravings by Old Masters, principally from the Malcolm Collection*, British Museum, London (exh. cat. S. Colvin).

London (1931) *Italian Drawings Exhibited at the Royal Academy, Burlington House*, Royal Academy of Arts, London (exh. cat. A.E. Popham).

London (1981) *Splendours of the Gonzaga*, Victoria and Albert Museum, London (exh. cat. ed. D. Chambers and J. Martineau).

London (1983) *Drawings by Raphael from the Royal Library, the Ashmolean, the British Museum, Chatsworth and other English Collections*, British Museum, London (exh. cat. J.A. Gere and N. Turner).

London (1986) *Florentine Drawings of the Sixteenth Century*, The British Museum, London (exh. cat. N. Turner).

London (1989a) *Leonardo da Vinci*, Hayward Gallery, London (exh. cat. J. Roberts and M. Kemp).

London (1989b) *Art in the Making: Italian Painting before 1400*, National Gallery, London (exh. cat. D. Bomford, J. Dunkerton, D. Gordon and A. Roy, with contributions by J. Kirby).

London (1994) *Making and Meaning: the Young Michelangelo*, National Gallery, London (exh. cat. M. Hirst and J. Dunkerton)

London (1996) *Old Master Drawings from the Malcolm Collection*, The British Museum, London (exh. cat. M. Royalton-Kisch, H. Chapman and S. Coppel).

London (1998a) *Padua in the 1450s: Marco Zoppo and His Contemporaries*, British Museum (exh. cat. H. Chapman).

London (1998b) *Signorelli in British Collections*, National Gallery, London (exh. cat. T. Henry).

London (1999) *Renaissance Florence, the Art of the 1470s*, National Gallery, London (exh. cat. P.L. Rubin and A. Wright, with contributions by N. Penny).

London (2001) *Pisanello, Painter to the Renaissance Court*, National Gallery, London (exh. cat. L. Syson and D. Gordon).

London (2002) *Art in the Making, Underdrawing in Renaissance Paintings*, National Gallery, London (exh. cat. ed. D. Bomford).

London (2004) *Raphael from Urbino to Rome*, National Gallery, London (exh. cat. H. Chapman, T. Henry and C. Plazzotta, with contributions by A. Nesselrath and N. Penny).

London (2005), *Michelangelo Drawings: Closer to the Master*, British Museum, London (exh. cat. H. Chapman).

London (2007) *Renaissance Siena, Art for a City*, National Gallery, London (exh. cat. L. Syson, A. Angelini, P. Jackson, F. Nevola and C. Plazzotta).

London and New York (1992) *Andrea Mantegna*, Royal Academy of Arts, London, and The Metropolitan Museum of Art, New York (exh. cat. ed. J. Martineau).

Los Angeles (1999) *Ercole de' Roberti. The Renaissance in Ferrara*, J. Paul Getty Museum (exh. cat. ed. D. Allen and L. Syson).

Manchester (1982) *The Arrogant Connoisseur: Richard Payne Knight 1751–1824*, Whitworth Art Gallery, Manchester (exh. cat. ed. M. Clarke and N. Penny).

Mantua (1961) *Andrea Mantegna*, Palazzo Ducale, Mantua (exh. cat. ed. G. Paccagnini).

Mantua (2006a) *A casa di Andrea Mantegna: cultura artistica a mantova nel Quattrocento*, Mantua, Museo Casa del Mantegna (exh. cat. ed. R. Signorini).

Mantua (2006b) *Andrea Mantegna e i Gonzaga, Rinascimento nel Castello di San Giorgio*, Castello di San Giorgio, Mantua (exh. cat. ed. F. Trevisani).

Milan (1986) *Perugino, Lippi e la bottega di San Marco alla Certosa di Pavia: 1495–1511*, Pinacoteca di Brera, Milan (exh. cat. B. Fabjan).

Milan (1987) *Disegni e dipinti leonardeschi dalle collezioni milanesi*, Palazzo Reale, Milan (exh. cat. ed. G. Bora, L. Cogliati Arano, M.T. Fiorio and P.C. Marani).

Milan (1991) *Le Muse e il Principe*, Museo Poldi Pezzoli, Milan (exh. cat. ed. A. Di Lorenzo).

Milan (2008) *L'Ambrosiana e Leonardo*, Biblioteca Ambrosiana, Milan (exh. cat. P.C. Marani, M. Rossi and A. Rovetta).

Modena and Rennes (1990), *Disegno, les dessins italiens du Musée de Rennes*, Galleria Estense, Modena, and Musée des Beaux-Arts, Rennes (exh. cat. ed. P. Ramade).

Montefalco (2002) *Benozzo Gozzoli: allievo a Roma, maestro in Umbria*, Pinacoteca-Museo, Montefalco (exh. cat. ed. B. Toscano and G. Capitelli, pub. Milan).

Montreal (1992) *The Genius of the Sculptor in Michelangelo's work*, Montreal Museum of Fine Arts (exh. cat. ed. D.L. Bissonnette).

Munich 2006, *Leonardo da Vinci: die Madonna mit der Nelke*, Alte Pinakothek, Munich (exh. cat. C. Syre, A. Rühl, W. Augustyn *et al.*).

New York (1979) *Drawings by Michelangelo from the British Museum*, Pierpont Morgan Library, New York (exh. cat. J.A. Gere and N. Turner).

New York (1997) *The Drawings of Filippino Lippi and his Circle*, The Metropolitan Museum of Art, New York (exh. cat. G. Goldner, C. Bambach and A. Cecchi).

New York (2003) *Leonardo da Vinci Master Draftsman*, The Metropolitan Museum of Art, New York (exh. cat. ed. C. Bambach).

New York (2005) *Fra Angelico*, The Metropolitan Museum of Art, New York (exh. cat. ed. L. Kanter and P. Palladino).

New York (2009) *Raphael to Renoir. Drawings from the Collection of Jean Bonna*, The Metropolitan Museum of Art, New York (exh. cat. ed. S. Alsteens, C. Bambach, G. Goldner, C. Ives, P. Stein and N. Strasser).

Nottingham and London (1983) *Drawing in the Italian Renaissance Workshop: an Exhibition of Early Renaissance Drawings from Collections in Great Britain*, Nottingham University Art Gallery, Nottingham, and Victoria and Albert Museum, London (exh. cat. F. Ames-Lewis and J. Wright).

Oxford (2008) *40 Years of Christ Church Picture Gallery: still one of Oxford's best kept secrets*, Christ Church Picture Gallery, Oxford (exh. cat. ed. J. Thalmann)

Padua (2006), *Mantegna e Padua 1455–1460*, Musei Civici, Padua (exh. cat. D. Banzato, A. De Nicolò Salmazo *et al.*).

Paris (1985) *Andrea Solario en France*, Musée du Louvre, Paris (exh. cat. S. Béguin).

Paris (1989) *Léonard de Vinci : les études de draperie*, Musée du Louvre, Paris (exh. cat. ed. F. Viatte).

Paris (1993) *Le siècle de Titien: l'age d'or de la peinture à Venise*, Grand Palais, Paris (exh. cat. ed. M. Laclotte and G. Nepi Sciré).

Paris (1994) *Fra Bartolommeo et son atelier. Dessins et peintures des collections françaises*, Musée du Louvre, Paris (exh. cat. C. Fischer).

Paris (1996) *Pisanello, le peintre aux sept vertus*, Musée du Louvre, Paris (exh. cat. D. Cordellier, C. Lanfranc de Panthou, E. Moench *et al.*).

Paris (2003) *Léonard de Vinci: dessins et manuscripts*, Musée du Louvre, Paris (exh. cat. F. Viatte and V. Forcione).

Paris (2008) *Mantegna 1431–1506*, Musée du Louvre, Paris (exh. cat. ed. G. Agosti and D. Thiébaut).

Paris and Florence (2003) *Botticelli e Filippino. L'inquietudine e la grazia nella pittura fiorentina del Quattrocento*, Musée du Luxembourg, Paris, and Palazzo Strozzi, Florence (exh. cat. ed. D. Arasse, P. De Vecchi and J.K. Nelson [Italian edn 2004]).

Perugia (1996) *Un pittore e la sua città: Benedetto Bonfigli e Perugia*, Galleria Nazionale dell' Umbria, Perugia (exh. cat. V. Garibaldi)

Perugia (2004) *Perugino il divin pittore*, Galleria Nazionale dell'Umbria, Perugia (exh. cat. ed. V. Garibaldi and F.F. Mancini).

Rome (1988) *Da Pisanello alla nascita dei Musei Capitolini: l'antico a Roma alla vigilia del Rinascimento*, Musei Capitolini, Rome (exh. cat. ed. M. Calvesi).

Rome (2000) *Sandro Botticelli: pittore della Divina Commedia*, Scuderie del Quirinale, Rome (exh. cat. ed. S. Gentile).

Rome (2006) *Raffaello da Firenze a Roma*, Galleria Borghese, Rome (exh. cat. ed. A. Coliva).

Rome (2007) *Dürer e l'Italia*, Scuderie del Quirinale, Rome (exh. cat. ed. K. Hermann Fiore).

Rome (2009) *Beato Angelico. L'alba del Rinascimento*, Musei Capitolini, Rome (exh. cat. ed. A. Zuccari, G. Morello and G. de Simone).

Rotterdam (1990) *Fra Bartolommeo, Master Draughtsman of the High Renaissance. A selection from the Rotterdam albums and landscape drawings from various collections*, Museum Boijmans Van Beuningen, Rotterdam (exh. cat. C. Fischer).

Siena (1993) *Francesco di Giorgio e il Rinascimento a Siena 1450–1500*, Chiesa di Sant'Agostino, Siena (exh. cat. ed. L. Bellosi).

Venice (1976) *Disegni di Tiziano e della sua cerchia*, Fondazione Giorgio Cini, Venice (exh. cat. ed. K. Oberhuber).

Venice (1992) *Leonardo and Venice*, Palazzo Grassi, Venice (exh. cat. P.C. Marani, P. Humfrey, M. Kemp *et al.*).

Venice (1999) *Il Rinascimento a Venezia e la pittura del Nord ai tempi di Bellini, Dürer, Tiziano*, Palazzo Grassi, Venice (exh. cat. ed. B. Aikema and B.L. Brown).

Verona (1996) *Pisanello*, Museo di Castelvecchio, Verona (exh. cat. ed. P. Marini).

Verona (2006) *Mantegna e le Arti a Verona*, Palazzo della Gran Guardia, Verona (exh. cat. ed. S. Marinelli and P. Marini).

Vienna (1985) *Albrecht Dürer und die Tier- und Pflanzenstudien der Renaissance*, Graphische Sammlung Albertina, Vienna (exh. cat. F. Koreny).

Washington (1973) *Early Italian Engravings from the National Gallery of Art*, National Gallery of Art, Washington D.C. (exh. cat. J.A. Levenson, K. Oberhuber and J.L. Sheehan).

Washington (1991) *Circa 1492: Art in the Age of Exploration*, National Gallery of Art, Washington, D.C. (exh. cat. ed. J.A. Levenson).

Washington and Fort Worth (1996) *Michelangelo and his Influence: Drawings from Windsor Castle*, National Gallery of Art, Washington, D.C., and Kimbell Art Museum, Fort Worth (exh. cat. P. Joannides).

Washington and Paris (1988) *Michelangelo Draftsman*, National Gallery of Art, Washington and Musée du Louvre, Paris (exh. cat. M. Hirst).

WEBSITES

www.kubikat.org

Online library catalogue of three German Art Institutes: Bibliotheca Herziana, Rome; Kunsthistoriches Institute, Florence and Zentralinstitut für Kunstgeschichte, Munich.

www.britishmuseum.org/research/search_the_collection_database.aspx

Online catalogue of British Museum drawings.

INDEX

Entries in **bold** refer to exhibited artists:
figures in *italics* refer to illustrations

PHOTOGRAPHIC ACKNOWLEDGEMENTS

All objects are reproduced with the permission of the institutions to which they belong as stated in the catalogue entries and captions. Below is a list of further acknowledgments and copyrights. The numbers in **bold** refer to the catalogue entries.

INTRODUCTION

Fig. 2, p. 18 Copyright © of the Board of Governors of The Courtauld Institute of Art

Fig. 12, p. 31; fig. 20, p. 39 Alinari Archives, Florence

Fig. 14, p. 33 Tom Henry

Fig. 15, p. 33 © The Trustees of the National Gallery

Fig. 27, p. 47 © Comune di Arezzo

Fig. 28, p. 49 © Musée du Louvre/Angèla Dequier

Fig. 30, p. 50 © RMN, Paris/Thierry Le Mage

Fig. 45, p. 63 © Museum Boijmans Van Beuningen, Rotterdam

Fig. 48, p. 67 Fig. 48 © National Gallery of Scotland (purchased with the aid of The Art Fund and the Pilgrim Trust 1975).

CATALOGUE ENTRIES

no. 2, fig. 1, p. 90 © Biblioteca Civica Angelo Mai, Bergamo

no. 3, fig. 1, p. 92 © Museo Thyssen-Bornemisza, Madrid

no. 3, fig. 2, p. 94 Reproduced by permission of the Chatsworth Settlement Trustees

no. 4, fig. 1, p. 96; **56**, fig. 1, p. 216; **no. 62**, fig. 1, p. 231; **no. 73**, fig. 1, p. 252; **no. 101**, fig. 2, p. 315 © The Trustees of the National Gallery

no. 7, fig. 1, p. 104; **no. 36**, fig. 1, p. 174; **no. 69**, fig. 1, p. 244; **99**, figs 1, 2, pp. 308, 310 Alinari Archives, Florence with permission of Ministero per i Beni e le Attività Culturali

no. 8, fig. 2, p. 106; **no. 93**, fig. 1, 2 (verso of fig. 1), p. 292 © RMN/Michèle Bellot

no. 9, fig. 1, p. 108 Giraudon/The Bridgeman Art Library

no. 9, fig. 2, p. 108 © The Frick Collection, New York

no. 12, fig. 1, p. 114; **no. 29**, fig. 1, p. 156; **no. 33**, fig. 1, p. 164; **no. 38**, fig. 2, p. 179; **no. 41**, fig. 1, p. 186; **no. 53**, fig. 1, p. 210 Soprintendenza Speciale per il Patrimonio Storico, Artistico ed Etnoantropologico e per il Polo Museale della città di Firenze

no. 14, fig. 1, p. 119; **no. 78**, fig. 1, p. 263 Filippo Camerini

no. 16, fig. 3, p. 128 © RMN/Gérard Blot

no. 17, fig. 1, p. 130; **no. 72**, fig. 1, p. 250; **no. 95**, fig. 1, p. 296 © RMN/Thierry Le Mage

no. 17, fig. 2, p. 131; **no. 84**, fig. 1, p. 274 © 1990. Photo Scala, Florence

no. 19, fig. 2, p. 135 Cameraphoto Arte Venezia/The Bridgeman Art Library

no. 20, fig. 1, p. 136; **no. 86**, fig. 2, p. 278 Marzia Faietti

no. 21, fig. 1, p. 138; **no. 76**, fig. 1, p. 259 © Staatliche Graphische Sammlung, Munich

no. 25, fig. 5, p. 149 © Ufficio beni culturali della Diocesi di Reggio Emilia – Guastalla

no. 28, fig. 1, p. 154 © bpk/Hamburger Kunsthalle/Elke Walford

no. 30, fig. 1, p. 158 By permission of the Ministero per i Beni e le Attività Culturali. Foto Soprintendenza BSAE di Siena e Grosseto

no. 31, fig. 2, p. 161 © Städel Museum, Frankfurt am Main

no. 33, fig. 2, p. 164 Photo montage by Mina Mileva

no. 35, fig. 1, p. 172 © Herzog Anton Ulrich-Museums Braunschweig, Kunstmuseum des Landes Niedersachsen; photo: Bernd Peter Keiser

no. 44, fig. 2, p. 192 © The Nelson-Atkins Museum of Art; photo: Mel McLean

no. 46, fig. 1, p. 196; **58**, fig. 1, p. 222; **67**, fig. 1, p. 240; **76**, fig. 2, p. 259 Alinari Archives, Florence

no. 48, fig. 2, p. 200 © bpk/Gemäldegalerie, SMB / Jörg P.

no. 51, fig. 1, p. 206 © RMN/René-Gabriel Ojéda

no. 54, fig. 1, p. 212 By permission of the Ministero per i Beni e le Attività Culturali, Biblioteca Reale, Turin

no. 57, fig. 1, p. 220; **64**, fig. 1, p. 235 The Royal Collection © Her Majesty Queen Elizabeth II

no. 59, fig. 1, p. 224 Niccolò Orsi Battaglini/Alinari Archives, Florence with permission of Ministero per i Beni e le Attività Culturali

no. 60, fig. 1, p. 226; **no. 74**, fig. 1, p. 254 © RMN/Hervé Lewandowski

no. 61, fig. 1, p. 228 © National Museum, Stockholm

no. 64, fig. 2, p. 235 © bpk/Kupferstichkabinett, SMB/Jörg P.

no. 66, fig. 1, p. 238 © Photoservice Electa/Quattrone

no. 68, fig. 1, p. 242 By permission of the Governing Body of Christ Church, Oxford

no. 71, fig. 1, p. 248 © bpk/Gemäldegalerie, SMB/Jörg P.

no. 79, fig. 1, p. 264 Giraudon/The Bridgeman Art Library

no. 80, fig. 1, p. 266 The Bridgeman Art Library

no. 82, fig. 1, p. 270 © bpk/Bayerische Staatsgemäldesammlungen

no. 85, fig. 1, p. 276 By permission of MiBAC, Archivio fotografico Soprintendenza BSAE, Bologna

no. 88, fig. 1, p. 282 Finsiel/Alinari Archives, Florence with permission of Ministero per i Beni e le Attività Culturali

no. 89, figs 1, 2, p. 284 © Museum Boijmans Van Beuningen, Rotterdam

no. 91, fig. 2, p. 289 Photo: Luigi Baldin

no. 92, fig. 1, p. 290 © Royal Academy of Arts, London

no. 95, fig. 2, p. 298 © Paul Maeyaert/The Bridgeman Art Library

no. 97, fig. 3, p. 304 © RMN

no. 100, fig. 1, p. 312 By permission of the Soprintendenza Speciale per il Patrimonio Artistico ed Etnoantropologico e per il Polo Museale della città di Roma; photo supplied by Luca Pezzati, Istituto Nazionale di Ottica Applicata, Florence.

Every attempt has been made to trace accurate ownership of the copyrighted visual material for this book. If any unintentional omission has been made, please notify the publisher who will correct all subsequent editions.